Viewpoints
Readings in Art History

Second Edition

Carole Gold Calo

Stonehill College

Prentice
Hall

Upper Saddle River, New Jersey 07458

Library of Congress Cataloging-in-Publication Data

Viewpoints : readings in art history / [edited by] Carol [i.e. , Carole] Gold Calo.--2nd ed.
 p. cm.
 Rev. ed. of: Writings about art. 1994.
 ISBN 0-13-959396-9
 1. Art. I. Calo, Carole Gold. II. Writings about art.

 N7425.V56 2001
 700--dc21 00-040082

Editorial/Production Supervision and Interior Design: *Harriet Tellem*
Publisher: *Bud Therien*
Assistant Editor: *Kimberly Chastain*
Prepress and Manufacturing Buyer: *Sherry Lewis*
Cover Designer: *Bruce Kenselaar*

This book was set in 10/12 Palatino by Carlisle Communications Inc. and was printed and bound by Courier Westford. The cover was printed by Phoenix Color Corporation.

© 2001 by Prentice-Hall, Inc.
A Division of Pearson Education
Upper Saddle River, New Jersey 07458

Previously published as *Writings About Art.*

Printed in the United States of America
10 9 8 7 6 5 4 3 2 1

ISBN 0-13-959396-9

Prentice-Hall International (UK) Limited, *London*
Prentice-Hall of Australia Pty. Limited, *Sydney*
Prentice-Hall Canada Inc., *Toronto*
Prentice-Hall Hispanoamericana, S.A., *Mexico*
Prentice-Hall of India Private Limited, *New Delhi*
Prentice-Hall of Japan, Inc., *Tokyo*
Pearson Education Pte. Ltd., *Asia*
Editora Prentice-Hall do Brasil, Ltda., *Rio de Janeiro*

This book is dedicated to:

The memory of Leslie Cohen Levin—
dear friend, confidante, and co-conspirator—
whose courage and zest for living inspired
all who knew her,

and

My husband Andrew and sons Nicholas and Brett,
my anchors.

Contents

Introduction

This second edition of *Writings about Art,* retitled *Viewpoints: Readings in Art History,* offers art history and art appreciation students a comprehensive selection of readings that explore thematic, historical, cultural, and formal issues from various critical perspectives. The essays have been grouped by topic: Art and Spirituality; Art Patronage; Art and Politics; Public Art; Issues Concerning Race and Ethnicity; Art and Gender; and Art, Science, and Technology. The readings may be studied and discussed within each thematic section, or professors and students may choose to consider them in an order more in keeping with the content of a particular course. For example, in an historical survey, a chronological treatment may prove most effective, beginning with Scully's "The Sacred Mountain in Mesopotamia, Egypt, and the Aegean." For an art appreciation class discussing various media and techniques, the professor may opt to group the essays according to architecture, drawing, painting, sculpture, prints, and photography.

For all courses the readings chosen provide students with the opportunity to practice critical thinking skills necessary to fully comprehend and appreciate essays about various topics in art. Through a range of written assignments that encompass summary, analysis, and evaluation, students themselves may develop proficiency in writing about art. Following are suggestions of several ways to use the essays in *Viewpoints.*

Summarize: Extract and restate the major points made by the author. Any of the essays included in the anthology may be summarized.

Analyze: Break down the whole essay into separate component parts so that they can be considered as distinct interrelated units. For example, Frederick Hartt's essay "Art and Freedom in Quattrocento Florence" links changes that occurred in Florentine painting and sculpture during the first thirty years of the fifteenth century to particular political, economic, and social situations. Students can analyze the separate events and how they affected the style and iconography of particular sculptures and paintings.

Compare and contrast: A comparison might be made of works within one essay or of points made in several essays. In reading Albert Elsen's "Images of Gods," a student might compare and contrast characteristics of sculptural representations of Buddha and Apollo. The student could also compare traditional images of Christian spirituality as discussed by Elsen

with African concepts of the spirit world as explained by Rosalind Hackett in "Envisioning and (Re)presenting the Spirit World."

Interpret: Determine inferences and unstated assumptions implied in an essay. "Read between the lines" to find an underlying tone or attitude implying the author's opinions as opposed to pure fact. Richard Leppert's interpretations of female and male nudes in well-known paintings may be discussed and compared to more conventional interpretations.

Evaluate/critique: Assess the overall accuracy and effectiveness of a particular essay. Is the essay well written? Do the arguments appear grounded in sound reasoning or evidence? Is the author fair in his or her treatment of the subject? For example, does Vincent Scully convince the reader of the sacred symbolism of ancient architecture? How does he effectively present his points?

Consider different methodologies: The readings in this anthology represent various methodologies used by scholars and critics to write about art. Most authors have combined several methods in their essays, including formalist and stylistic analyses, the iconographic approach, contextual methodologies, the psychoanalytic method, and semiotic readings.

A **formalist analysis** considers the aesthetic effects of the use of formal elements of composition: line, shape, color, space, light, etc. While none of the essays in this anthology is strictly formalist, many authors do engage in formal analysis as part of a broader approach.

Stylistic analysis examines various styles and their changes over time or place. Comparisons are often made between the characteristics of art from different geographic areas or historical periods. Students might consider whether or not specific stylistic elements characterize art during the Harlem Renaissance as they read Mary Schmidt Campbell's "Introduction to Harlem Renaissance: Art of Black America."

The **iconographic approach** focuses on the meaning of a work of art, its subject matter, symbolism, and interpretation. Albert Boime, in his essay titled "The Iconography of Napoleon," studies the intended and inferred meanings of representations of Napoleon Bonaparte.

Contextual methodologies place art in its particular social, political, religious, or ideological context. For example, in "Inventing 'the Indian' " Julie Schimmel examines how nineteenth-century depictions of Native Americans in American Art reflect societal attitudes of a white America. Art historians analyzing art from a **Marxist** perspective, as in Toby Clark's "Propaganda in the Communist State," view the significance of artworks in relation to their political and socio-economic roles in society. **Feminist** art historians like Griselda Pollock, author of "Modernity and the Spaces of Femininity," challenge traditional white male readings of images by women and/or of women to explore women's experiences both as artists and as subject matter in art. More recently a surge of interest in **gender studies** has expanded the feminist approach to consider broader gender issues in society

as reflected in Helaine Posner's catalogue essay, "The Masculine Masquerade: Masculinity Represented in Recent Art."

The **psychoanalytic method** is explained by Laurie Schneider Adams in "Psychoanalysis I: Freud," in which the theories of Sigmund Freud are applied to the analysis of works of art. A psychoanalytical approach may also include psychobiography and references to various psychoanalaytical theories.

Semiotic readings of art are based on the study of signs as cultural expressions that have meaning beyond their literal identities. Semiotics as applied to art includes **Structuralism, Post-Structuralism,** and **Decontructionism** (Adams, *Methodologies of Art*. New York: HarperCollins/Icon Editions, 1996, p. 133). The Structuralists attempted to de-emphasize the role of the author/artist in favor of discerning universal mental structures or cultural signs that could be decoded. The Post-Structuralists reinstated the humanistic by exploring the significance of the spectator. **Deconstructionism** deconstructs the notion of fixed signs and essential meanings to allow for a more dynamic fluidity in which meanings change according to different contexts. Margot Lovejoy explains how photography is being used as a vehicle for deconstructing Modernism in her essay, "The Electronic Era and Postmodernism."

The readings in this second edition represent the widest possible spectrum—chronologically, geographically, culturally, and thematically. The selections have been thought through again and updated to spark the interest of the contemporary student of art and art history. In whatever way the essays are approached, it is my hope that they will inspire creative thinking among students and professors alike and elicit strong responses that will lead to animated class discussion. I am confident that this multifaceted anthology will serve as a catalyst for deeper investigation into the many dimensions of art as it reflects aspects of our lives today and the lives of previous generations.

Carole Gold Calo

Acknowledgments

I would like to thank the staff at Prentice Hall for their assistance in the creation of this second edition, particularly, Kimberly Chastain, Assistant Editor, for Art; Martha Francis, Copy Editor; and Kathy Ringrose, Art Research Specialist. I am especially grateful to Harriet Tellem, Production Editor, for her advice and guidance.

Special thanks goes to those who reviewed the first edition: Joseph P. Becherer, Grand Rapids Community College; Shirlee Byrd, San Jose City College; Michael Capetan, University of Michigan; Patricia Johnston, Salem State College; Virginia Marquardt, Marist College; and Tom Sarrantonio, SUNY New Paltz. Their comments and suggestions were carefully considered as I revised the book.

I would also like to express my appreciation to Stonehill College for granting me a sabbatical leave in Spring 2000 to complete this manuscript and for providing me with student assistance throughout the project. Through the Stonehill Undergraduate Research Experience Program, David Perry worked with me selecting and editing the readings. Fine Arts Work/Study student Marta Butkiewicz assisted with various clerical tasks. Regina Egan and Betsy Dean from the MacPhaidin Library provided timely assistance.

Of course, I am indebted to the authors of the readings included in *Viewpoints* and to the professors and students whose positive response to *Writings about Art* was the catalyst for producing a revised edition.

About the Author

Carole Gold Calo holds a Ph.D. in Art History from Boston University. She is Director of the Fine Arts Program and an Associate Professor of Art History at Stonehill College, N. Easton, MA. She has previously published with Prentice Hall *Writings about Art* and a Student Study Guide to Marilyn Stokstad's *Art History (Vol. I)*. She has written articles for *Arts Magazine, The Public Art Review, The New Art Examiner, Art New England,* and *Sculpture Magazine*.

Part I

Art and Spirituality

Since earliest times, human beings have attempted to understand the inherent mysteries of life, to explain the inexplicable. The evolution of complex mythologies in various cultures and the formalization of religion indicate the enduring quest to understand what is ultimately incomprehensible, to feel a sense of control over forces one cannot see or touch. The three essays in this section explore how art and architecture have, throughout civilization, served religion and human spirituality.

It is remarkable that thousands of years ago, with very basic engineering tools, civilizations constructed huge monuments to honor the divine. In his essay, "The Sacred Mountain in Mesopotamia, Egypt, and the Aegean," from *Architecture: The Natural and the Manmade,* Vincent Scully considers correspondences between the natural landscape and manmade "mountains" by which access is gained to the gods. The ancient Mesopotamians built colossal mud-brick ziggurats on open plains as metaphorical stairways to the celestial realm. A political, civic, and religious center combined, the brightly painted, stepped pyramidal structure emphatically symbolizes a theocratic society. Yet, according to the author, the architectural complexity of the ziggurat, with its various stairways and platforms leading to a temple at the apex, reflects the Mesopotamian conception of the relationship between the human and the divine. When the king ascended to the temple, he served as the intercessor between his people and gods who were often fickle and unpredictable.

By contrast, the Egyptian pyramid, also a manmade "mountain," reflects a different concept of the relationship between ruler and gods. Evolving from stepped to smooth, four-sided pyramids, the huge limestone structures at Gizeh attest to the power and immortality of the Pharoahs who are buried within. The shape of the pyramid is a symbolic tribute to the sun-god Ra, from whom it was believed the Pharoahs were descended. Predictability, stability, timeless order, and a smooth passage from life on earth to the afterlife are reflected in these royal tombs. During the New Kingdom in Egypt

burial sites were hidden in cliffs, and monumental architecture shifted to temples to honor the gods. These temples incorporated flora and plant life in their column designs and were axially oriented to accompany the flow of the Nile River, symbolizing continuity.

In the Aegean, the natural landscape provided the people of Ancient Crete with sacred mountains. Scully contends that the breastlike/womblike natural configurations of mountain ranges at Knossos and Phaistos symbolize the Earth Mother. Thus palace courtyards, the chapel, and even the king's throne room were oriented in such a way as to acknowledge and honor the power of that deity.

Vincent Scully's study can be related to other civilizations and religious architecture as well. In another essay in *Architecture: The Natural and the Manmade,* he notes that Pre-Columbian civilizations also created manmade sacred mountains and that Native Americans worship nature spirits and build moundlike altars on rooftops. One can apply these ideas to religious architecture produced by other cultures as well. Consider the Buddhist mound or hill-like stupa and its ritualistic circumambulatory walk or the Hindu rock-cut temple, womblike in its dark enclosure, evoking a sense of connection with the mysteries of a life force. The Gothic cathedral can be related to the sacred mountain, for its extraordinary height is symbolic of ascension to the heavens and is intended to elicit in the Christian worshiper a transcendental response.

While architecture has always served religion and spirituality, it is in sculpture and painting that religions have given actual form to their respective concepts of divinity. Albert Elsen offers a comparative analysis of images from three religions: pagan Greek, Buddhism, and Christianity.

In "Images of Gods" Elsen traces the evolution of images of the Greek god Apollo, explaining the various roles he played in Greek civilization from "keeper of the flocks" to first Olympic victor to the god embodying youth, beauty, moderation, and justice. Apollo was interpreted anthropomorphically in the most perfect human form. Unlike Apollo, Buddha was an actual man, Prince Siddhartha, who lived between 563 and 483 B.C.E. in Nepal and committed himself to reforming Brahminism and to teaching "the Eightfold Path," with the ultimate goal of achieving Nirvana and breaking the cycle of reincarnation. Early references to Buddha were symbolic, rather than figurative: the wheel (of his doctrine), a tree (under which he reached Enlightenment), his footprints. However, by the second century C.E., Buddha was shown in human form, and except for regional variations, the imagery has remained consistent. He is shown with symbolic features, such as topknot (wisdom), elongated earlobes (royal birth), tuft of hair on his forehead (emanation of light), wheels on the soles of his feet (the wheel of his doctrine), and Mudras (symbolic hand gestures). Whereas Apollo is idealized to be anatomically perfect, Buddha's anatomy appears without skeletal or muscular structure, released from the bondage of his humanness.

Christ has been depicted since the birth of Christianity in various roles with different meanings. Initially shown as the Good Shepherd and as a teacher, with the legalization of Christianity in the early fourth century, he was for the first time shown enthroned, ruler of the earthly and spiritual realms. Images of Christ are denatured and stylized to emphasize His divinity. During the Romanesque period, Christ was also viewed as supreme judge, central figure in Second Coming and Last Judgment scenes, many of which were carved in relief for exterior church tympanums. By the Gothic period, Christ was increasingly humanized in interpretations of the "Beau Dieu," the closest approximation to the idealization seen in pagan Apollo statues. Finally Elsen compares the deaths of Christ and Buddha—the violent painful, tragic Crucifixion of Christ to the serene passing into a union with the universe experienced by Buddha. Elsen's study can be a springboard for observing later representations of Christ and Buddha and exploring how Hindu deities or African spirits are depicted.

According to Rosalind Hackett in "Envisioning and (Re)presenting the Spirit World," it is widely believed in various parts of Africa that some artistic forms derive from and evoke spiritual forces. Unlike pagan Greek, Buddhist, and Christian sculptures, which are referential in nature, African sculpture is believed to embody spiritual forces through activation: enacting an event or performance by sacrifice or by applying herbal preparations. The author draws parallels to the divine power medieval Christians thought to be embodied in the relics of saints, which in current Western society has become obscured. In African art a direct connection exists between the aesthetic experience and the experience of the object's "supernatural powers." Masks in particular mediate between the human and spirit realms as the human wearing the mask makes music and dances and as rituals are performed. A mystical transformation occurs in the performer as he is filled with the presence of the spirit.

Formal and stylistic differences are apparent when comparing the generally more abstract African forms to the representational imagery found in ancient Greek, Buddhist, or Christian art. African sculpture is not based on verisimilitude, for fear that realistic figures might have unwarranted magical powers. Yet whether the imagery is realistic, idealized, stylized, or abstract, each culture attempts to access the supernatural through art.

Chapter 1

The Sacred Mountain in Mesopotamia, Egypt, and the Aegean

Vincent Scully

When Hugh Ferriss conceived of his skyscraper masses as riding high over the Metropolis of Tomorrow, . . . [h]e might have thought of his buildings . . . as ziggurats, like those that once towered over the cities of Mesopotamia, which were the very first cities of all constructed by mankind. . . . The ziggurat of Ur, a vast mass of brick moldering in the plain, is still the best preserved of them all and has been the most spectacularly reconstructed in model form. . . . [T]he ziggurat of Ur, along with those of the other Mesopotamian cities, was built with no natural mountains in view on the flat sea-level land of the lower Tigris-Euphrates valley. It was intended to connect the earth and the sky, which, in Mesopotamian myth, had been forcibly separated long before.

. . . [T]he ziggurats were climbed by a priest-king, who sacrificed to his people's gods on the summit. The king was the protector of the city and the builder of its walls. Those walls were everything; they were the city's major protection against all the other cities, with which it was more or less perennially at war. So the wall was honored in Sumerian architecture, its mass exaggerated, its face embellished. Ur's ziggurat still shows those qualities. Its walls are all organized in vertical planes; the mass *lifts* hugely. . . . There is no sense whatever of a human body, only of the mountain. The walls advance to buttresses and recede into deep niches in multiple planes; their surfaces are enlivened by pilasters, accentuating the mountainous, thrusting bulk of the mighty brick masses in every possible way.

The stairway rises as if ascending a high, broad mountain, wide-shouldered, blotting out the sky. It is a heroic stair, and with it the concept of the epic hero arises. He is the king, and is identified in particular with Gilgamesh, a king of Uruk, whose incomparable epic dominates the literature of the ancient East until the destruction of Assurbanipal's library at Nineveh in the late seventh century B.C. Gilgamesh builds the walls of Uruk and scales the heights of the Lebanon to obtain cedars for his temple doors. He finds a

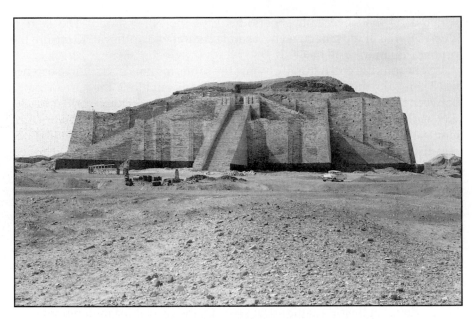

Ziggurat of Ur. *3rd millenium* B.C.E. *(Hirmer Fotoarchiv)*

friend and loses him to the captious gods, seeks immortality and sees it stolen by a serpent—ubiquitous symbol of the earth's power—and finds at the end that only his work in the city remains. . . .

The city thus affords all the immortality that human beings can attain, and the king is the most qualified of humankind to achieve long-lasting works within it. It is he who ascends the sacred mountain, like Gilgamesh or Naram-Sin on his stele, the king who climbs the ultimate conical peak, rising to the sun and the moon, and wears the regal, godlike crown, conical and bull-horned itself. The king must do this because nothing is to be hoped for from the gods. They are heartless and wholly irresponsible. Unlike Jehovah, who, dangerously unbalanced though he abundantly shows himself to be, nevertheless signs a covenant with his people guaranteeing his relatively sane behavior under certain conditions, they, the Mesopotamian gods, never sign anything. Their flood is brought about for no particular reason. They are mad and have no justice in them.

Not so in Egypt. There, gods and men alike are governed by the concept of ma'at, which is justice itself. The king, Narmer, more or less contemporary with Naram-Sin, need only act out the idea of power; he need not struggle to achieve it. His relief carving is flat rather than cylindrical and muscular like that of the Sumerian king. He is not an epic hero but the very embodiment of cosmic justice. He rules over an ordered land. There are no warring cities in it; in Narmer's day, really no cities at all. It is one great agricultural structure,

watered by the never-failing periodicity of the Nile's flood. The land is always fertile. It must be ruled by a single centralized authority to ensure the proper irrigation of all its fields.

The afterlife will naturally be just the same, for how else could existence be? There, too, the farmers will lead the animals out along the narrow paths between the rectangular fields and settle them down with their fodder for the day as they tend the always-productive land. They are workers on an agricultural assembly line, and they can rest at ease only during the flood, hunt and fish and think about the life to come. Then, however, they have their other great task, which is to build the Pharaoh's permanent habitation, his pyramid tomb. We may assume, I think, that despite the view of the matter held in later ages, they did so willingly, since the Pharaoh's immortality clearly had something central to do with the quality of their lives on earth and, in their view, hereafter. The reliefs and paintings in Egyptian tombs show the whole structure: the Nile flowing through the ordered fields with their people; the hawk, Horus, unblinking, looking toward the east, riding across the whole of Egypt in the Sun Boat of Ra.

The tombs are laid out in the sand on the west bank of the Nile, on the higher desert at the side of the setting sun. By the early third millennium King Zoser of the Third Dynasty decides that his tomb should be a mountain, visible to all those working in the fields below it. So his architect, Imhotep, who was to be honored as a sage throughout Egyptian history, steps the tomb up and back to shape a mountainous mass, not of brick, as in Mesopotamia, but of cut stone. Still, the influence of Mesopotamia is obvious at Saqqâra, but there is no stairway, no temple on the top, no drama. . . . Once again, heroic action is not required. The image of the Pharaoh, his *ka,* resides down below. He himself is probably with the sun, and the emblem of his immortality, his mountain, dominates the skyline where the sun goes down.

Nevertheless, the wall around the sacred precinct at Saqqâra is Mesopotamian enough, with setbacks and pilasters on the Mesopotamian model, though linearized and flattened by the smooth certainties of Egyptian sensitivity. The plan, too, shows the Egyptian difference. While the manmade mountain rises within a walled enclosure, as at Ur, everything else is totally unlike Mesopotamia. The plan is utterly abstract, static, and fixed; there is no struggle embodied in it. The entire Mesopotamian plan is pushed in and out, embodying every kind of change over time and endless competition between various sacred precincts for building room. The Mesopotamian plan is thus urban, center-city in every fundamental way, responding to pressures from every side; the Egyptian is the unstrained emblem of a permanent conceptual order imprinted on the open desert and oriented precisely north–south.

But entry into Zoser's precinct shows that the principle of imitation is also at work there. It involves the impermanent architecture of vegetable materials. The engaged columns along the entrance passageway are carvings in stone of reeds bound together and capped with clay, a technique of build-

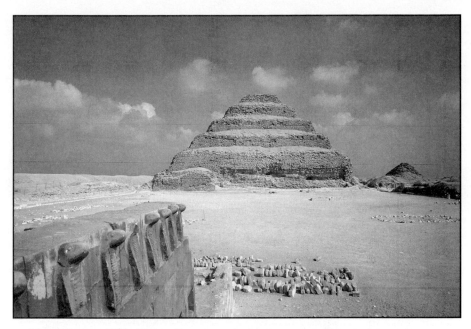

Stepped Pyramid of King Zoser *at Saqqara, Egypt. c. 2750 B.C.E. (Hugh Sitton/Stone)*

ing still to be seen in Egyptian villages today. The buildings representing the Pharaoh's *heb-sed* festival (they have no interiors) imitate the kind of vaulted swamp architecture of reeds that can still be seen in the community houses of the marsh Arabs of Iraq. In the North Building, near the Pharaoh's tomb chamber, the walls are set with engaged papyrus stalks; their buds open in a bell. From these, the stepped pyramid hulks massively near at hand, a man-made mountain right enough.

But directly opposite the entrance passage to the sacred enclosure and on axis with the pyramid itself, there is a wall crowned by cobras. . . . At Saqqâra, the serpents mark a critical point of vantage. From their wall, the pyramid shows exactly on axis, therefore in pure profile. In this view, its mass wholly dematerializes, since nothing about it causes the mind's eye to supply it with any other sides, let alone the other three it actually possesses. It seems instead to step back like a weightless stairway, mounting to the heavens. It is a flat folded plane, and it is climbing into the sky itself, carrying Zoser with it, one supposes. . . . Its magic conquers gravity and enforces belief in transcendence.

That triumph over matter, with its escape from every terrestrial limitation and even from earthly weight, seems to have dominated Egyptian thinking about the pyramid from that time onward. Its mass is progressively smoothed over. . . . It achieves its climactic grouping at Gizeh, where, at enormous scale,

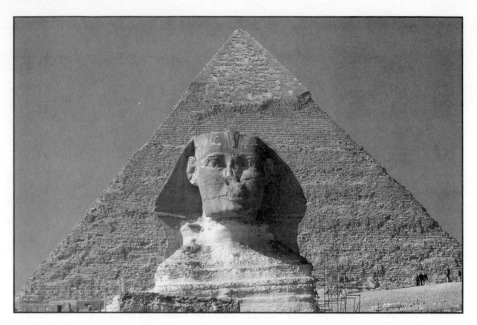

Pyramid of Khafre (Chephren) and Sphinx. *Gizeh, Egypt. 2500 B.C.E. (Neil Beer/PhotoDisc, Inc.)*

the avoidance of the appearance of weight is almost entirely achieved from every viewpoint, not only from an axial one. The four planes of the pyramids' faces slant back and recede, disappearing to a point in the sky. In a perspective view, the mind of the observer will supply only one other side rather than two. One thus "sees" the pyramid as a tetrahedron. Already some of the reality of the mass is disappearing. On closer approach to a single face, the entire plane slants weightlessly away. . . .

Originally, all the faces of the pyramids at Gizeh were sheathed in gleaming white limestone, blindingly bright, sending out reflections far across the plain. The cult was of Ra, the sun, and the pyramids were indeed transformed into pure sun's rays, pure light. . . .

It was into light itself that the Pharaoh was, at least symbolically, loaded. One thinks of the obelisk, Ra's major symbol, capped with a pyramidion: It is as if the pyramids at Gizeh capped mighty obelisks, buried, directed toward the sun. Indeed, the entire group can be seen as a battery of missiles aimed at the sun, taking position at just the right spot for a clear shot at it, on the great bank of desert that rises above the Nile plain at the point where it begins to widen out to the delta. . . . And what must have seemed to the Egyptians to be the special magic of the site supplied that battery with a gunner. An outcropping of rock suggested the form of the Sphinx, the lion-bodied Pharaoh. He bears Chephren's face and rises above Chephren's val-

ley temple below his pyramid. . . . It is the critical position in relation to the whole group, which deploys in behind the Sphinx while he gazes unblinking into the eastern sun, rising across the Nile.

Below him, Chephren sat in his temple in multiple effigies, all alike, his head supported by the unblinking hawk, so that he too became a Horus capable of staring at the sun. There is no decoration in the temple, nor in any of the pyramids at Gizeh—no imitation whatever of natural forms. It is all abstract, as unadorned as a rocket motor; its magic is mechanical, perfect; its only imagery is of light. . . .

. . . Menkare and his queen, of the third pyramid, await the moment of transcendence with absolute confidence. There is nothing in the history of art so wholly at peace with the triumphant self as their faces are, unless it is the face of Chephren with his totemic hawk, which was too godlike for later times. During the Middle Ages, a puritanical emir turned his cannon on the face of the Sphinx; its expression of total assurance filled him with holy rage. Menkare and his wife share the Sphinx's calm. Why should they not? They had conquered death, laying their battery of human intelligence unerringly on the sun.

Mankind has never felt so confident again. The mood faded in Egypt itself almost at once, with the end of the Fourth Dynasty, and the single most consistent movement in Egyptian architecture thereafter was a kind of regressive return to the security of the earth and the imitation of its forms. A sail up the Nile to the site of the New Empire city of Thebes on the east bank brings us to a point where the western cliffs across the river opposite the city open into a vast shape, today called Quinain, "horned," which is capped by a roughly pyramidal mound on the cliff's summit between the horns. The whole formation strongly suggests the horned-disk headdress that is worn by the cow goddess, Hathor, the earth goddess, herself. The horns also resemble an inverted pyramid, and directly below them the Middle Kingdom Pharaoh Mentuhotep IV placed his tomb. In it, the pyramid had dwindled markedly in size and was surrounded by deep colonnades. The manmade pyramid was now content to reflect the natural form in the earth.

In the tomb of Queen Hatshepsut of the Eighteenth Dynasty, placed right next to Mentuhotep's, the pyramid disappeared completely, and the tomb was cut deep back into the cliff itself. Hatshepsut would seem to have positioned herself as closely as she could to the magical shape in the cliff, but, not placed to reflect the inverted pyramid and perhaps not caring to do so, returned to the earth entirely instead. Before her chamber, she laid out broad garden parterres, prefiguring in plan those of seventeenth-century France but probably planted thick with trees. So Hatshepsut's tomb is in one sense entirely natural in its manmade correlatives of tomb as cavern and garden grove as orchard and forest.

Finally, the mound on the summit of the cliffs, when it is approached from the other side, marks the Valley of the Kings, where later Pharaohs were

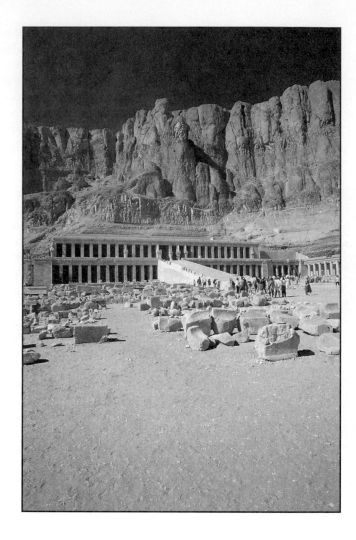

**Tomb Temple of
Queen Hatshepsut**
*at Deir-el-Bahari,
Egypt. c. 1480–1450
B.C.E. (Corbis
Digital Stock)*

laid to rest in the body of the earth. . . . From the valley, the mound is nippled and strongly resembles the breast of Hathor herself. The dismantling of the magical machine that re-created the rays of the sun could go no further. One returns to the sacred mountain in its traditional form. The whole process suggests an abandonment of what can only be called inventive technology in favor of ancient organic traditions embedded deep in the consciousness of mankind.

Thebes itself lay across the river. It contained at least two large temples of Amon, a local god, primarily of fertility, thus of the proper flow of the Nile and the growth it brought forth. One of Amon's temples lies along the riverbank, stretching downstream as with the river's flow. . . . The god's house is

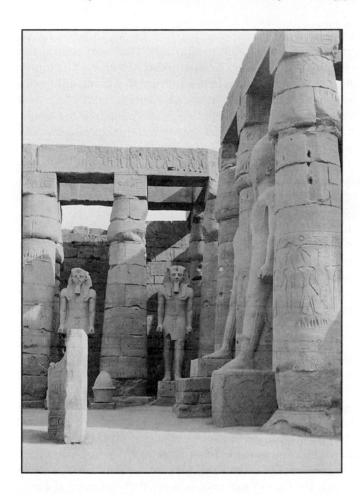

Temple of Amon
at Luxor, Egypt,
Court of Ramses
II. c. 1280–1260
B.C.E. (Omnia,
Hulton
Getty/Liaison
Agency, Inc.)

upstream; the court before it is defined, indeed choked, by fat, soft-looking columns imitating the forms of papyrus plants bound together with their buds closed. . . . Amon's temple is all vegetable growth of river plants, while a current like that of the Nile flows from the narrow darkness of his sanctuary outward to court after court, hall after hall, added over the generations. The hypostyle hall uses open papyrus columns, like those engaged in the wall at Saqqâra. Their smooth bells spread broadly to mask the impost blocks they support, upon which the beams of the ceiling were placed. Hence, as seen from below, the ceiling would have seemed to float like the sky.

In the temple at Luxor, the hypostyle hall was never finished, leaving the two rows of high columns standing alone. But inland, in the Temple of Amon at Karnak, which was also part of ancient Thebes, the central columns of the hypostyle hall were surrounded by multiple rows of the short, fat, closed-bud columns that were needed to set them off. . . . The entire complex

must have been experienced as a great swamp, like the swamps of Egypt before the all-powerful Pharaoh was able to drain the land and control the Nile's flow.[1] We are wholly in the hands of older gods once more. The innermost row of short columns supports clerestory windows that bring light from above into the central row. More than ever, the sky above the high central columns would have seemed to float, elevated as it was above the major source of light itself. So the current flows sluggishly out through the choked vegetation and rushes triumphantly at last through the final gates, like the cliffs of the Nile upstream, and along the Avenue of Rams before it. The force of the Nile has been released, flowing from the god. Amon gives forth the waters of fertility to the waiting land. That is why his image is often rendered ithyphallic; he fertilizes with his flow.

Once shaped, the great New Empire temple type hardly changed over the centuries, except perhaps to insist ever more richly upon the vegetable softness of its column forms. . . .

By [Roman] times[s], the old cult of Ra and of his sacred mountains of light had long since receded into the past; indeed, the slapstick account of the building of the pyramids written by Herodotus in the fifth century B.C. shows us that its every meaning had been forgotten long before. But during the second millennium B.C., the cult of the sacred mountain as such continued with unabated force throughout the Ancient East and in the Aegean.

Minoan Crete was apparently its purest sanctuary, and its deepest traditions would seem to have directed all the major rituals of religious and political life in that sea kingdom. All the Cretan palaces are oriented toward sacred mountains and adjust their courtyards to them. Knossos, the very seat of kingship, is oriented on Mount Jouctas, cone-shaped and cleft, where, in later myth, the Cretan Zeus was buried. The palace at Phaistos is directed toward Mount Ida, wide-horned, where Zeus was born. So in Crete, unlike Egypt and Mesopotamia, the sacred mountains were there in natural form. They did not need to be constructed by mankind. Instead, the manmade forms were laid out to complement and receive their mass with open courtyards from which they dominated the view. There, in their sacred presence, the major rituals of kingship took place.

At Knossos, a traveler coming from the northern shore of Crete is led along a single-file pathway toward the north side of a long, rectangular courtyard. There, a short stair mounts directly to the central axis of the court, with a columned portico rising up above it on the right-hand side. The view from this spot is directed in a strong diagonal across the court toward the southern propylon, beyond which a mounded hill rises, with Mount Jouctas lifting full and silent beyond it.

Beneath the summit of that mountain was a cave sanctuary of the goddess of the earth, and she, as embodied in Cretan ceramics . . . , wears a headdress that is both conical and horned, so reproducing her mountain's mass

and profile. The roofs of the palace, certainly flat, may also have been crowned with horns, as its excavators thought, and as it is shown in frescoes and gems. The goddess would seem to be the old earth mother of Paleolithic times brought up to date, big-breasted as of old but svelte and elegant, though still the being from whom the horned animals, the food of mankind, are born. She is also the Earth-Shaker, mother of terrors.

At Knossos, the southern propylon, the most elaborate gateway to the palace, is directly on axis with the mountain, as is the range of rooms behind it. One of these contains the pillar cult of the goddess, set deep in the earth. Another is the throne room . . . , where the king sat in a little throne just big enough to hold him. Through its bucket seat and high back, a deep ripple like an earthquake tremor runs, while long ripples flow as well through the frescoes on the wall behind it, and fires seem to spring up from the earth below. Knossos is, in fact, placed at a point of maximum seismic disturbance, and the king, representing his people, received that force in his own body.

If we believe Greek myth he may also have been, at least at times, bull-masked as Poseidon, Earth-Shaker, the goddess's consort, bringing on the earthquake through her power and in a sense sacrificing himself to her. So as the horned beasts of Paleolithic times ran along their cave walls deep in the womb of the earth, and as the horned dancers took up their burden for them in places shaped by men, so here the major event for which the courtyard was formed was the great bull dance, an ultimate refinement of all the rituals that had been directed to the earth since Paleolithic times. The bull charged straight. The spectators on the flat roofs of the palace could see him and the horned mountain at the same time. He brought its power down into the courtyard, where human beings received it and hugged it to themselves, seizing the horns and propelled by them through the air like birds. . . .

At Phaistos, there was no throne room, so that the axis of the courtyard could itself run directly toward the mountain. . . . We can understand how the Greeks associated the former with death—did it recall or suggest the conical tholos tombs of the Mycenaean lords?—and the latter with birth, as the mountain opens in a kind of exalted physical release and joy. To celebrate the axis of view to Mount Ida, the doorway in the court at Phaistos that leads toward the mountain is flanked by niches in which round columns are engaged. . . . It is a rich manipulation of column and wall not to be found again until Roman times. Of course, as from much of the court at Knossos, the view of the mountain itself would have been blocked from the doorway by the mass of the buildings, but that did nothing to mitigate the potent magic of the alignment or the fact that all of it was perfectly visible from farther out in the court and from the roofs—from which, as at Taos or Puye, the essential ceremonies were in any case always best viewed.

The relationship of humanity to nature is made abundantly clear: Nature's mountains dominate, as does the goddess who surmounts them and

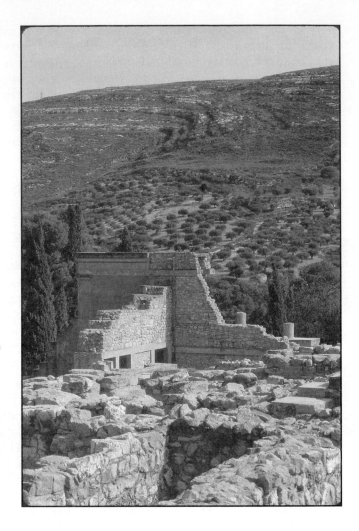

Palace at Knossos. *Herakleon, Crete, Greece. 1600–1400* B.C.E. *(Wolfgang Kaehler Photography), 2000 www. wkaehlerphoto. com*

whose body in fact they are. The manmade courtyard opposes no counter-sculptural presence to the natural forms but simply receives them in its hollow, just as, in their rituals, the dancers receive their horned force. So mankind is dependent and, as it saw itself, youthful. . . .

Note

1. The germ of this concept is in Wilhelm Worringer, *Egyptian Art*, London, 1928, esp. pp. 62–63.

Chapter 2

Images of Gods

Albert Elsen

The history of religion tells us that gods made men in their own likeness, but the history of art tells us that men have remade the gods into their own image. Art has served no more important purpose than giving a visible presence to gods. For millennia, art provided visual reminders of celestial authority and made more intelligible the nature of deities. The sculptured or painted image of the god was the focus of worship and ritual, and it also gave to the faithful a feeling of reassurance and protection. Ancient Greek cities, for example, placed a statue of their tutelary god on the battlements to ensure their defense. The focusing of the imagination upon great and mysterious objects of worship is one means people have used to liberate themselves from the bondage of mundane facts. Investing the god with material form also satisfied mortal curiosity and the desire for familiarity with and recourse to the god. The act of making a sculpture or painting of a god was both an honorific gesture and a means of coming to terms with the supernatural. The finished work of religious art also provided a visible ethic to guide people in the conduct of their lives. Today we need not believe in the religions that inspired the images of Apollo, Buddha, and Christ to be impressed and moved by them. Their greatness as works of art transcends time and the boundaries of religious belief. Still, unless we can share to some extent the original concepts and emotions that produced this sacred imagery, we cannot fully appreciate the awe, wonder, and gratification with which it was received at the time of its creation. Nor can we appreciate the achievement of the artists who first brought this imagery into being. To content oneself with considering only the visual or aesthetic value of religious art is to miss the equally rewarding experience of learning about significant human attempts to discover and give form to the truth of existence. Sacred imagery shows how elastic is the potential of the human body, which has been represented in so many ways to accommodate such divergent concepts, and how flexible is the human mind that has accepted religious art as real, or at least as convincing and sincere.

Apollo

On the temple of his sacred precinct at Delphi were inscribed the precepts of Apollo:

> Curb thy spirit.
> Observe the limit.
> Hate hybris.
> Keep a reverent tongue.
> Fear authority.
> Bow before the divine.
> Glory not in strength.
> Keep woman under rule.

In his study *The Greeks and Their Gods,* W.K.D. Guthrie has summarized Apollo's value to the Greeks by observing that Apollo is the embodiment of the Hellenic spirit. Everything that distinguishes the outlook of the Greeks from that of other peoples, and in particular from that of the barbarians who surrounded them—beauty of every sort, whether in art, music, or poetry or in the qualities of youth, sanity, and moderation—is summed up in Apollo. Above all, he was the guardian against evil, the god of purification and of prophecy. Any good Greek could see in Apollo the preacher of "Nothing too much" and "Know thyself." Under his most important and influential aspect may be included everything that connects him with principles of law and order. Primarily, he represents the Greek preference for the intelligible, the determinate, and the measurable, as opposed to the fantastic, the vague, and the formless. Apollo was also looked to as a god of nature and was known as "keeper of the flocks." He was the first Olympic victor. He presided over the transition from boyhood to manhood, and he was variously shown as a war-like god who carried a silver bow and as a patron of the arts who played upon a lyre. Concomitantly, he was thought of as the god of both physical and spiritual healing, capable of purifying the guilty. Finally, he was the patron of civilized situations. . . .

. . . From his first appearance in art, Apollo was interpreted *anthropomorphically,* that is, as having human characteristics, and was depicted in perfect physical form.

The pediment of the Temple of Zeus at Olympia . . . shows Apollo at a legendary nuptial ceremony intervening in a disruption caused by drunken centaurs who were trying to abduct the bride. He epitomizes the Greek ideal of "the cool." The idea being developed in this Apollo parallels other changes in Greek art. The rigid, frontal symmetry of the earlier statues . . . has been broken by the profile position of the head and by the gesture of the right arm, raised to restore order. Made in mid-5th century B.C., this Apollo departs from the Archaic figures in his softer, more sensuously modeled body, which results in a more subtle joining of the body parts and the limbs to the torso. The treatment of the muscular fold of the pelvis, a Greek sculptural convention, affirms the perfect fit of the thighs in the socket of the torso, like the

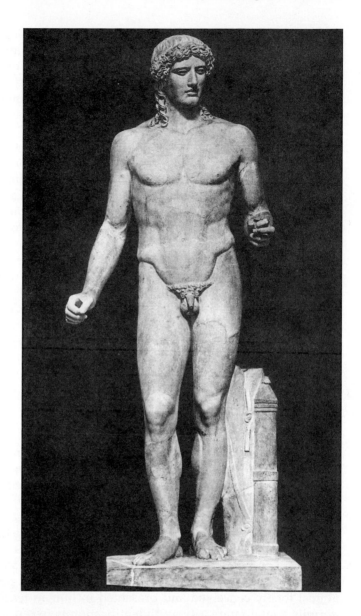

Apollo. *Roman copy after Phidias' original of c. 460 B.C.E., Marble. (Foto Marburg/Art Resource, NY)*

modulated juncture of a column capital with the lintel above. The . . . full-round conception of the body admits successive and varied silhouettes. . . . [Such statues] prompted the 5th-century Athenian public to voice the opinion that their best sculptors could portray beautiful *men*, but not beautiful gods. Even the great sculptor Polyclitus was not immune to this criticism. . . . Scaled larger than the other figures in the composition and placed in the center—both of which are older devices for establishing hierarchy—the god has

been assured his authority. The ideal proportions, physical development, and facial features immediately set the god apart from the mortals and centaurs who surround him. It was, however, the . . . qualities of grace and physical self-confidence that endowed this Apollo with dignity and divine identity and with great self-control. Thus, despite the emphasis on corporeality, the portrayal epitomizes conduct and restraint, as well as law and order, through presence and gesture.

Although close in date to the Olympia *Apollo,* the Classical *Apollo* of the sculptor Phidias carries even further the sensual possibilities of the body. The rigid axis through the center of the body has been eliminated, and the weight is placed on the right leg in a hip-shot pose that creates a more active balance of the body—one of the great achievements of Classical Greek sculpture. In this system of *contrapposto* (or "counterpoise"), the movement of each portion of the body is an ideal compositional counterpart to the Apolline tradition of harmony between spirit and body. The strength of the still-idealized visage and the impressive physique, coupled with the resilient pose, assist in conveying a feeling of authority that has now become more humane. . . . The perfect proportioning of the torso is a striking lesson in moderation, in avoidance of physical or sensual excess.

At the end of the 4th century, the military conquests of Alexander the Great extended the rule of Greece throughout the Near East and into Egypt. This political domination spread Greek art and civilization to many different peoples and thus produced a heterogeneous culture termed *Hellenistic.* In general, the effect of this new internationalism on sculpture was an increasing development toward the more realistic depiction of nature and toward more complex and vigorous compositional mobility.

The Hellenistic *Apollo Belvedere* depicts the god in decided movement, with his draped left arm extended. It is believed that originally his left hand held the silver bow, his military attribute. The controlled movement permits illustration of Apollo's supreme physical grace and, by implication, his intellectual discipline. While retaining obvious idealized traits in face and body, the *Apollo Belvedere* is the most lifelike, and hence the most nonsacred, of the Apolline sculpture we have discussed, and this change corresponds to political and sculptural developments in Greece as a whole. This last figure also suggests why the Greek religion declined in power. The gods are almost totally conceived and presented in human terms, an attitude that permits a fatal familiarity and identification between god and worshiper. This congruence of identity is apparent in spite of the fact that many of Apollo's attributes are beautifully incorporated within the sculpture. The handsome figure, with its athletic and dancerlike grace, retains a suggestion of the purity of mind and body and of the faculty of wisdom so cherished by the Greeks. In all these images of Apollo, the Greeks sought to present the beauty of the god's mind and of morality through the medium of a beautiful human body. The mastery of sculptural mobility achieved by the

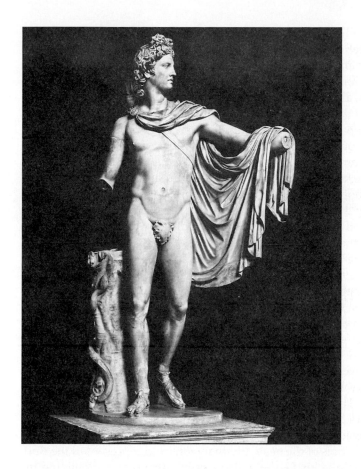

Apollo Belvedere.
Roman copy after Greek original of late 4th century B.C.E., Marble. (Vatican Museums. Alinari/Art Resource, NY)

artists, while powerfully evoking the personality or temper of the god, may ultimately have caused the weakening of his divine efficacy.

Buddha

The Buddha is traditionally presumed to have lived between 563 and 483 B.C. in the region of Nepal on the border of India. Born a prince, he became a reformer of the Brahmanist religion and a great ethical teacher whose sermons in many ways paralleled those of Christ. Like Christ, Buddha emphasized meditation and good works and viewed this life as filled with pitfalls. Also like Christ, he did not work toward the establishment of a complex religious order in his own lifetime; the formal religion that evolved from his teaching came long after his death. Buddhism is composed of two main sects. The Mahayana (Great Vehicle) or "pious" sect looks upon the Buddha as a god possessing the power of miracles and protecting the faithful from harm. He is lord of the universe. This sect developed strongly in China and Japan from its origins in India. The Hinayana (Lesser Vehicle) or "rationalist" sect

looks upon the Buddha as a great, but human, sage who provided a code of ethics that could deliver humanity from the sources of misery. His image in art was a reminder and not an actual presence, similar to images of Christ in Western art. The Hinayana sect was strongest in Southeast Asia, in Burma, Cambodia, Ceylon, and Thailand.

The history of the images of the Buddha goes back to the first centuries before our era, when he was not shown in human form but was represented by symbols—his footprints, the Wheel of Learning, the tree under which he achieved Enlightenment, an altar, or an honorific parasol recalling his princely origin. The faithful could achieve communion with Buddha by meditating on the symbols that induced his presence. One of the early sculptures that does not show the actual form of the Buddha . . . portrays an evil spirit menacing the divine throne. Although the Buddha is physically absent, his attributes, such as the throne and his footprints, as well as the reverent attitude of the court, are indicative of his sacred presence. This initial unwillingness to give tangible form to the Buddha has a parallel in Early Christian art, and there are no images of the Buddha or Christ dating from their own lifetimes. To have given tangible form to either of the gods may have seemed at first a contradiction of their divine being. The incentives for Buddhist artists to change were the growing competition with Hinduism and exposure to Roman and Late Greek art.

Perhaps the earliest freestanding sculpture of Buddha was made in Mathura, India, during the 2nd century A.D. and is termed a Bodhisattva, or potential Buddha. This powerful figure, the Bodhisattva of Friar Bala . . . stands about 8 feet (2.4 meters) tall and was originally situated before a tall column. Atop the column was a stone parasol, 10 feet (3 meters) wide, which was carved with symbols of the heavenly mansions and represented the Buddha's royalty. The lion at his feet was also a regal attribute, symbolizing the Buddha as the lion among men. The rigid, frontal, and squarish formation of the body sets it apart from the Mediterranean art of the time and argues that the standing Buddha image was of Indian origin. The symbolism and body type, however, are markedly different from Hindu sculpture of the 1st century, such as the sandstone god Siva. . . . In this representation, the god is designated both by a human form and by his attribute—a giant phallus that was known as a *lingam*. Though it was accessible only to Hindus, who could enter the sanctuary of the temple where it was housed and daily annointed with oil, this Hindu icon helps us to understand why the Buddhists overcame objections to imaging the local figure of their worship.

When the Buddha was finally given human form by the Gandhara artists, in the 1st or 2nd centuries of our era—roughly seven centuries after his death—his body was a materialization of concepts similar to those the symbols had conveyed. The tasks facing the early sculptors of the Buddha included the incorporation of 32 mystic signs of his superhuman perfection: among these were the cranial protuberance, symbolic of wisdom; elongated earlobes, indicative of royal birth; a tuft of hair on his forehead, which like the

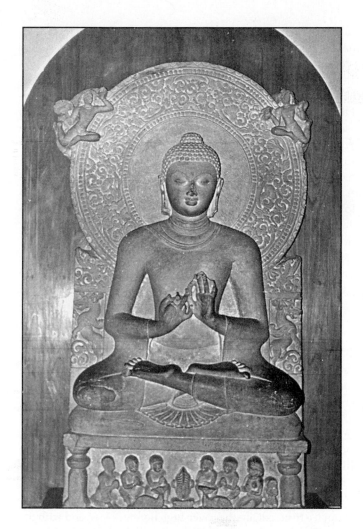

**Buddha Preaching
in the Deer Park.**
*320–600 C.E.,
Sandstone. (The
Granger
Collection)*

sundial halo signified his emission of light; spoked wheels on the soles of his
feet to symbolize the progress of his doctrine and the power of the sun; and
a series of ritual hand gestures, or *mudras*. The Buddha's right hand pointed
downward meant his calling of the earth to witness his triumph over evil and
his Enlightenment or dispensation of favors; his right hand raised was to dis-
pel fear and give blessings. By joining his thumb and forefinger, the Buddha
set the wheel of his doctrine in motion.

Of greater challenge to the artist was the endowment of the Buddha's
body with metaphorical significance; according to tradition, the face of the
Buddha is likened to an egg, the eyes to lotus buds or petals, the lips to ripe
mangoes, the brow to the god Krishna's bow, the shoulders to an elephant's
head, the body taper to that of a lion, and the legs to the graceful limbs of a
gazelle. The sculpture had to embody the sacred flame or fiery energy of the

Buddha and his preterhuman anatomy. Finally, the sculptor had to impart to the statue that ultimate state of serenity, perfect release from pain, and deliverance from desire that the Buddha achieved in *nirvana*. According to his teachings, inward tranquillity was to be gained by first appeasing the senses, for only then could the mind become well balanced and capable of concentrated meditation. The sensuousness of Indian art is partly explained by this attitude that the senses should not be denied but rather should be used as the first stage in a spiritual ascent whereby the faithful would ultimately be purged of attachment to the self and the world's ephemeral delights and achieve a more perfect spiritual union with their gods and ideals. This confidence in the need for and mastery of the sensual explains why Greek art such as the Apolline sculptures would have appealed to the early Buddhists, who used it.

Without question, the seated Buddha statue is indigenous to India and is a native solution to the problem of how to give artistic incarnation to the Great Teacher and god. The seated position was favored, for in the life of the Buddha it is recorded that after six years of penance he at last came to the Tree of Wisdom, where the ground was carpeted with green grass, and there vowed that he would attain his Enlightenment. Taking up the seated, cross-legged position with his limbs brought together, he said, "I will not rise from this position until I have achieved the completion of my task." It seems likely that the model or prototype for the seated Buddha was the earlier Hindu mystical system of *yoga*, which was constantly before the eyes of the early Indian artists and which was recorded as having been the means of the Buddha's achievement of nirvana. The objective of yoga is enlightenment and emancipation, to be attained by concentration of thought upon a single point, carried so far that the duality of subject and object is resolved into a perfect unity. The Hindu philosophical poem the *Bhagavad-Gita*, described the practice of yoga:

> Abiding alone in a secret place, without craving and without possessions, he shall take his seat upon a firm seat, neither over-high nor over-low, and with the working of the mind and of the senses held in check, with body, head, and neck maintained in perfect equilibrium, looking not round about him, so let him meditate, and thereby reach the peace of the Abyss; and the likeness of one such, who knows the boundless joy that lies beyond the senses and is grasped by intuition, and who swerves not from the truth, is that of a lamp in a windless place that does not flicker.

Through yoga one may obtain the highest state of self-oblivion. It involves highly developed discipline in muscular and breath control and the ability to clear one's mind of all superficial sensory preoccupation in order to concentrate upon a single object or idea. The discipline of yoga seeks not only control of the physical body but also a cleansing and rebuilding of the whole living being. The human body transformed by yoga is shown free not only from defects but also from its actual physical nature. The sensation of light-

ness, or release from the bondage of the body, induced by yoga produces the "subtle body.". . . .

In the Deer Park Buddha, there is no reference to skeletal or even muscular substructure; the body appears to be inflated by breath alone. There is no trace of bodily strain caused by the posture. The seated attitude is firm and easy, indicating the Buddha's mastery of yoga. Unlike the proportions of the Classical Apollo, which were based on the living body, those of the Buddha had become almost canonical by this time and were based on a unit called the *thalam,* equivalent to the distance between the top of the forehead and the chin. The symmetrical arrangement of the body makes of it a triangle, with the head at the apex and the crossed legs as the base. The face, wearing the "subtle smile," is marked by the symbolic lotus-form eyes and ripe lips. The downcast eyes shut off his thoughts from the visible world. Such compositional devices were employed, for the most part, because the sculpture was meant to be contemplated and viewed metaphorically. . . .

While repetition is frequent in the images of Apollo and Christ, Buddhist art exhibited far greater adherence to a prototype for almost fifteen hundred years. The successive replication in Buddhist imagery stems partly from a belief in the magical efficacy of certain prized statues; copies of these were thought to partake of the original's power. Furthermore, the Buddhist artist was not encouraged to work from a living model or to rely on natural perception. With the help of fixed canons, it was his obligation to study the great older images, meditate on them, and then work from his inspired memory. Because the Buddha's beauty defied apprehension by the senses, the artist worked from a conception nourished by existing images and metaphors.

Christ

Good Shepherd and Teacher The first known paintings of Christ seem to date no earlier than A.D. 200 and are found in the Christian catacombs on the outskirts of ancient Rome. Once believed to be secret refuges from persecution or underground churches where large congregations would assemble, these catacombs were actually burial chambers connected by long passages; they were known to and inspected by the Roman government. Their lack of ventilation and restricted size precluded their use for worship services. . . .

Among the first images of Christ, found in the catacombs and in funerary sculpture, are those showing him as the "Good Shepherd," which was a familiar image in Greek art. . . . There is ample evidence to confirm that the Christians recognized and valued the similarity between Christ as the shepherd and Orpheus, the son of Apollo who descended into Hades and sought through the charm of his singing and playing to save his wife Eurydice from the Underworld. The Greek mythological figure had much in common with both Apollo and Christ, since he was associated with salvation, sacrifice, love, and protection. The shepherd image was an ideal expression of the Early Christian community, which was characterized by a close relationship

between priest and congregation: the priest was seen as the shepherd, the congregation as the flock. The artistic presentation of the shepherd amid nature was also fitting, for the Early Christian view of paradise was comparable to that of the Roman poet Vergil—a beautiful sylvan paradise where the soul could repose, ruled over by a gentle shepherd. Christ as the shepherd, whose coming Christian theologians saw prophesied in Vergil's writings, thus ruled over a bucolic world as if in a Golden Age. . . . Second-century Christian saints also used the image of a magnificent garden to describe the paradise in which the soul would find rest.

In a 4th-century sarcophagus, the shepherd is surrounded by winged angels harvesting grapes. Such small, childlike figures were customarily substituted for representations of adults in Roman art of this type. Both the angels and the vineyard derive directly from pagan sources in which the grape harvest and wine alluded to premature death and regeneration. This explains the choice of theme for the sarcophagus of a deceased Christian who was well-to-do. Christian art that dates from before the 5th century mostly interprets the Jesus of the Gospels, or *the historical Jesus*—Jesus as the Messiah and not as a divinity. In the Lateran Sarcophagus, Jesus as the shepherd stands upon an altar, which suggests his death and sacrifice for mankind. His resurrection provided hope and a spirit of optimism for the

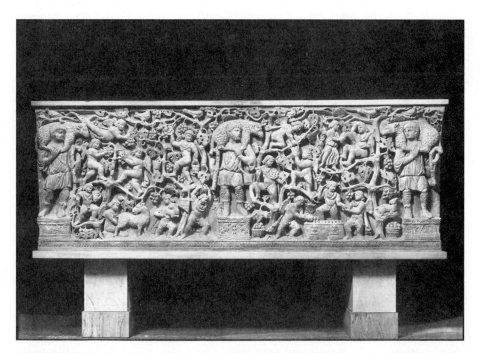

Christ as the Good Shepherd. *350–400 c.e., Marble. (Archivi Alinari/Art Resource, NY)*

Early Christian community and its converts. There is no stress on Christ's militant or royal nature before the 4th century. The artistic prototype of the historical Jesus seems to have been late Greek and Roman paintings and statues of seated or standing philosophers . . . a type associated with the contemplative or passive life. Artists in the late Roman period often worked on pagan figures at the same time they were fulfilling Christian commissions. Sometimes carved sarcophagi were completed except for symbols or faces; thus they could be purchased by either pagan or Christian clients and finished to suit their purpose.

. . . In the 4th century, Christianity received Imperial support and was no longer the private religion it had been in its earlier phases. The Church was reorganized along the lines of the Roman Empire, the priesthood became an autocracy, and theology and art were subjected to radical transformation and formalization. The external forms and the cult aspect of religion that had been criticized by the historical Jesus became prominent. One of the earliest manifestations of this momentous change is the famous sarcophagus of Junius Bassus, Prefect of Rome, who like Constantine was baptized on his death bed. The carving, which is in the pagan style of the time, was finished in 359 by a sculptor who imposed a new and strict order to his reliefs in terms

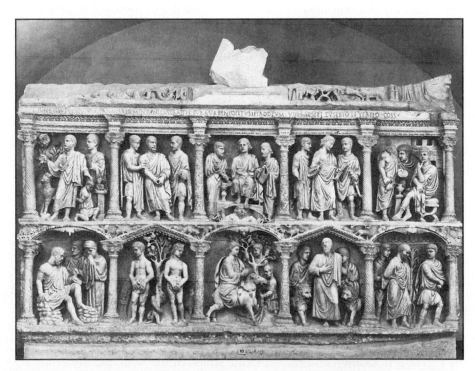

Sarcophagus of Junius Bassus. *c. 359 C.E., Marble. (Fabrica di San Pietro)*

of their architectural framing and symbolic sequence and juxtaposition. Christ occupies the center of both registers, and the flanking images are symmetrical and of a symbolic formality. Innovational were the two central scenes of Christ's royalty: his entry into Jerusalem, equivalent to a monarch's state entry or advent into a city, and his enthronement with the pagan symbol of the cosmos under his feet, indicative of his world sovereignty. The Imperial imagery is thus transferred to Christ, just as Christian and pagan terms for a ruler's greatness were similar. Christ is enthroned between Peter and Paul, to whom he assigns, respectively, the founding of his Church and the spreading of the Gospel. (Roman emperors were similarly shown between consuls.) The youthful beardless Christ may suggest, just as his contemporary catacomb counterpart does, his imperviousness to time. (In later images, Christ is shown with a beard; for theologians, an old head could also signify eternity.)

In the 6th century, the Byzantine Emperor Justinian ordered an ambitious mosaic series for the apse of the Church of San Vitale in the city of Ravenna, which he had just conquered from the Goths. The mosaic of the enthroned Christ flanked by angels and Sts. Vitalis and Ecclesius . . . in the half-dome of the apse reflects the transition from the historical Jesus to the *theological Jesus*. The incarnate Messiah has been replaced by the Son of God, the humanity and humility of the shepherd by the impersonality of a celestial ruler over the hierarchy of religious government. The doctrines that lay behind this mosaic were not those that had been taught by Jesus himself; in San Vitale, the theology of the Incarnation and the Second Coming is the essential subject of the mosaic.

Like a Roman or Byzantine emperor . . . , Christ holds an audience in which he grants and receives honors. Bishop Ecclesius donates the Church of San Vitale to Christ, and Christ gives the crown of mercy and martyrdom to St. Vitalis. This is preeminently sacred art; the more mundane attitudes of earlier Christian imagery have been replaced. The event transpires outside a specific time and place, an intention affirmed by the fact that these saints lived in different centuries. Also, St. Ecclesius presents a replica of the exterior of the church, and at the same time, the mosaic showing the donation is inside this very edifice. Christ sits upon the heavens, yet mystically he is also within the heavens, and beneath his feet flow the four rivers of Paradise. This mosaic demonstrates how theologians had reconciled the divinity and authority of Christ with that of the earthly emperors who acknowledged obedience to him. Christ rules the heavens, while the emperor Justinian, shown in an adjacent but lower mosaic, rules the earth. The relative informality of earlier Christian imagery has been replaced by a complex series of artistic devices conveying the concept of Christ as the Second Person of the Holy Trinity. This mosaic is a dramatic example of how meaning in art is conveyed . . . Besides its privileged location and the symbolic shape of the field, the materials are precious and semiprecious stones and glass. Against the gold background of

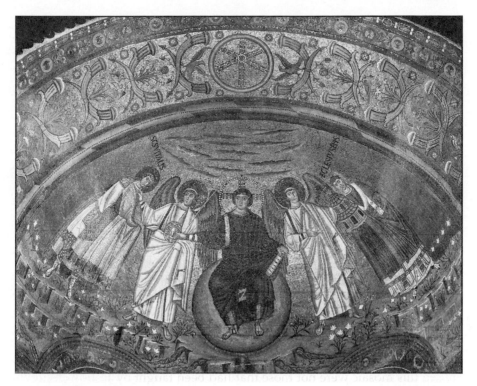

Christ Enthroned with Saints Vitalis and Ecclesius. *San Vitale Ravenna, Italy. c. 530 C.E. (Scala/Art Resource, NY)*

the heavens, symbolizing the ineffable light of God, the youthful, beardless Christ sits attired in the Imperial purple and gold. Certain postures and colors were Imperial prerogatives. Contrasting with the attendant figures who must stand in his presence, Christ is frontal and larger; he appears oblivious of those around him. His ritual gestures of investiture and acceptance make a cross shape of his body, accentuating his centrality in the image and in Christian dogma. Thus scale and gesture may be symbolic, as well as the type of composition. Although the mosaicists may have been inspired by St. John's descriptions of the radiance of Heaven, like the Evangelist, they based the attributes and qualities of divinity on their experience of the highest form of earthly authority known to them, on the magnificent court ceremonies of the temporal monarchs.

The San Vitale mosaic embodies changed aesthetic forms as well as dogma. Each figure, for example, is sharply outlined, with every detail clearly shown as if the viewer were standing close to each subject. The figures do not overlap, and they are all seen as being near the surface of the mosaic, which accounts for their great size. The scene has only limited depth, and no attempt has been made to re-create atmospheric effects or the light and

shadow of earthly perception. Positive identification of the role and status of each figure had to be achieved. The colors are rich and varied, but their use over large areas is governed by symbolism. The composition is closed, or strongly self-contained, so that there is no suggestion that the frame cuts off any significant area or action. The figures display, at most, a limited mobility, for their static quality is meant to reflect a transcendent nature and to induce a meditative state in the reverent viewer. Thus artist and theologian combined to give a physical presence to dogma by creating imagery of an invisible, divine world.

More than a century before the San Vitale mosaics were executed, there was painted on a wall of one of the Ajanta caves of northern India a scene of the Buddha in Majesty . . . that bears a striking similarity to these mosaics in its use of formal devices—such as centrality, frontality, and pose and gesture—to show authority. It is possible that both the Ravenna mosaic and the Ajanta fresco were influenced by Eastern sources such as Persian art, which, along with Roman art, provided models for the representation of rank in the late-antique world. The Buddha is enthroned between the sinuous figures of Bodhisattvas (exceptional beings who are capable of reaching nirvana but who renounce the possibility in order to teach others how to attain it) and two of his disciples. Courtiers are shown in the background. Buddha's gesture of teaching and his robe and posture are as ritualistic as those of Christ in the mosaic. Lions guard his throne, and he and the disciples have halos shown under ceremonial parasols, further symbols of royalty. The flower-strewn background and wall suggest the garden of a palace, a special place that only the faithful are privileged to see and comprehend.

The great Byzantine images of Christ and those in the Early Christian basilicas of Italy are found within the churches. By the beginning of the 12th century, however, French Romanesque sculptors had transferred sacred images to the exterior of the edifices, as seen, for instance, in the great relief carved over the doorway of the Church of St-Pierre in Moissac. . . . This change did not as yet result in a conception of Christ as being of the world of the living. While adopting the ceremonial and sacred traits of the San Vitale image, the Moissac sculptor forcefully added new ideas to the conception of the lordly Christ. Wearing a crown, Christ is a feudal king of kings, surrounded by elders who are his vassals. His remoteness is reinforced by the great difference in scale between his figure and the representatives of humanity. All glances are directed toward Christ as to a magnetic pole. From his immobile frontal figure, the composition moves outward in waves. Angels and evangelical symbols, intermediate in scale between Christ and the elders but more closely proportioned to Christ, serve to impress upon the onlooker the hierarchical nature of the universe and to bridge the figures in motion with the motionless Christ. Here Christ is like the awesome Old Testament God, commanding and completely aloof. He is thus shown as the Redeemer and God of Judgment at the Second Coming. His beauty does not derive from

the comely proportions with which Apollo was endowed; rather it is of an entirely impersonal and unsensual nature, appealing to thought and faith.

Christ as Judge There is no analogy in either the Apolline or the Buddhist religion to Christ's Second Coming and the Last Judgment, which are the themes of many of the most dramatic and interesting Christian works of art. . . .

The ordered and legal aspect of the final judgment is stressed by the artist at Conques in both his composition and his disposition of the figures. Each zone and compartment of the scene is strongly separated by a thick stone border on which are written the virtuous phrases, the teachings of the Church, and so on, appropriate to the location. This composition reflects a view of the universe as strongly ordered, so that everyone in it was consigned to a definite area, just as the living at the time had little difficulty in defining their own status in the feudal system. Thus the image of the universe on the last day becomes a projection of the real world as it was involved in the social, economic, and political structures of the time. The authority and absolute dominance of Christ over the scene is achieved by his centrality and great scale. He sits immobile and frontal as a symbol of power; he gestures upward with his right hand toward Heaven on his right side, with his left hand he points downward to Hell.

The upper zone of the scene contains angels carrying the Cross, the symbol of the Passion and the Second Coming on the day of justice. The central position given to the Cross and the downward movement of the angels draw the eye centripetally to the Supreme Judge. On Christ's right, in the largest zone, is a procession of the saved, who proceed in homage toward the ruler of Heaven. They are led by Sts. Peter, Anthony, and Benedict, who symbolize the origins and rule of the Church. The saints lead a royal figure, believed to be Charlemagne, who had been a benefactor of the Abbey of Ste-Foy. The moral implied by this arrangement is that Charlemagne got into Heaven not by force of the crown he carries but through the prayers and efforts of the holy men—an unsubtle admonition to the secular rulers of the time to support the Church. On Christ's left (our right), in another zone, are those consigned to Hell, nude and cramped in awkward poses, experiencing all sorts of painful indignities and punishments inflicted with enthusiasm by demons.

The lowest zone is divided into two large porticoes known as *basilican castrum*. Between these, literally on the roofs at the point where the buildings come together, the weighing of souls take[s] place; this is also the principal axis of the Cross and Christ. Next to the weighing-in on the left, armed angels are rousing the dead from their coffins, and on the right demons are pummeling the resurrected. In the center of the left portico (that on Christ's right) sits Abraham, who receives the souls of the deceased into his bosom. Entrance to Heaven is through a heavy open door, which reveals a fine

medieval lock and set of strong metal hinges. The entrance to Hell is through the jaws of the Leviathan, whose head protrudes through the door to Hell. . . . The Book of Daniel (7:7) describes the terrifying Leviathan that God has created. Hell is ruled over by the seated Devil, surrounded by his squirming subjects. In the treatment of Hell and the Devil, medieval artists had their greatest freedom and could give vent to their fantasies, repressions, and humor. Here as elsewhere, by far the more interesting of the two sides is that dealing with the damned. . . .

The Beau Dieu The judicial and authoritarian aspects of the Byzantine Christ are continued but somewhat relaxed in the 13th-century French sculpture of the Beau Dieu from the Cathedral of Amiens. The figure of Christ stands between the main doors of the cathedral and below the scene of the Last Judgment. Beneath Christ's feet are the lion and serpent, symbolic of the evil he conquers. Both in his location and in his appearance, Christ is more accessible to the congregation. He stands before the doors to his house not as a guard but as a host, like a gallant feudal lord. This humanizing of Christ into an aristocratic ideal is reflected in his new familiar name, "the Handsome God," a title in many ways unthinkable at Moissac and Daphné. This investing of Christ with a more physically attractive, a more tender aspect accompanies his re-entrance into the world of the living and the reduction of the sacrosanct nature of the art itself. The transition has been from the Byzantine Pantocrator, Lord of All the Universe, to the more human dignity of the Gothic lord of men.

The *Beau Dieu* has an idealized countenance that bears instructive comparison with the head of the *Apollo* from Olympia. . . . The Gothic head is noticeable for its sharp features and subdued sensuality, indicating an essentially Christian attitude toward the body. This is particularly marked in the treatment of the mouth. The more pronounced ovoid outline of the Christ image, enhanced by the long tightly massed hair, and the axial alignment of the symmetrical beard, the nose, and the part of the hair give the deity an ascetic and spiritualized mien. Despite the generalized treatment of the forehead, cheeks, and hair, the Amiens Christ possesses a more individualistic character than does the Olympian god, who is totally unblemished by the vicissitudes of mortal existence. The eyes of the Gothic Christ are worked in greater detail in the area of the eyelid, and the upper arch is more pointed than the simplified perfect arc of the *Apollo's* upper lids. In both sculptures, details of the eyeballs were originally added in paint. The Gothic Christ lacks the calm of the Classical Apollo.

Comparison of a Buddha sculpture with a 13th-century head of Christ from the French Gothic cathedral of Reims provides us with a summation of two radically divergent tendencies in the respective art forms of Buddhism and Christianity. The Buddhist head reveals the development toward anonymity in the celestial countenance, a refusal to glorify a specific individ-

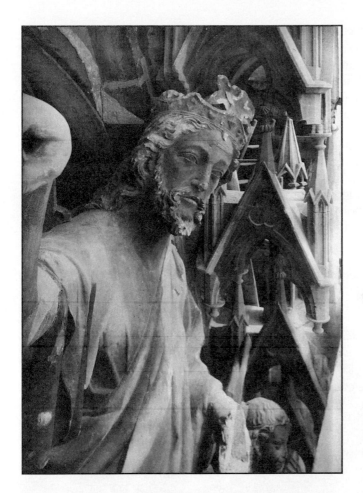

Head of Christ.
Detail from
Coronation of the
Virgin, middle
portal, west
facade, Reims
Cathedral. 13th
century C.E. (Art
Resource, NY)

ual. It seeks a pure incarnation of that spirit of Buddhism that conceives of the Buddha as representing the incorporeal essence of a religious attitude. The smile on the Buddha's lips recalls his wisdom and sublimity, which he attains in the *abyss,* or sphere beyond nirvana. The Reims Christ wears the marks of his passionate earthly sojourn in the worn and wrinkled surface of his face, and we sense that this deity has a unique and dramatic biography. There is no intimation of past experience, of trial and pathos, in the images of either Buddha or Apollo. Christ's face, however, speaks to us of a tragic personal drama; it displays or implies a far subtler range of feeling than the faces of the other two deities. The Gothic sculptor wished the viewer to read tenderness, compassion, pain, and wisdom in the lines of the divine face. The Reims sculptor may even have taken a French king—perhaps Louis IX (St. Louis)—for his model, so that Christ was now literally presented in terms of man, or *a* man.

The Deaths of Christ and Buddha

Western Christian art, like its theology, is dominated by the execution of its God. Buddha's death came tranquilly: for three days, he lay on his right side, with his head resting on his hand, until he passed into the final nirvana . . . in which he was freed from reincarnation. Buddhist art as a consequence does not know the pathos of Christian images. Christ's physical and spiritual anguish on the cross has no counterpart in Buddhist or Greek art. . . .

One of the most impressive and personal interpretations of the theme of the Crucifixion is that by Matthias Grünewald (d. 1528), which occupies one of the main panels of the *Isenheim Altarpiece.* Painted probably between 1512 and 1515, the altarpiece was intended for the monastery church of the hospital order of St. Anthony in Isenheim, Alsace. The monastery's hospital treated patients with skin diseases such as leprosy and syphilitic lesions. It was

Matthais Grünewald, **The Crucifixion,** *center panel of the exterior of Isenheim Altarpiece. Completed 1515 C.E., Oil on wood. (O. Zimmerman, Musee d'Unterlinden-Colmar)*

thought that skin disease was the outward manifestation of sin and a corrupted soul. New patients were taken before the painting of the Crucifixion while prayers were said at the altar for their healing. They were confronted with this larger-than-life painting of the dead Christ, whose soulless body was host to such horrible afflictions of the flesh. Only the Son of God had the power to heal the sinner, for Christ had borne all the sorrows of the flesh that garbed the Word. The previous regal, authoritarian, and beautiful incarnations of Christ were replaced by the image of the compassionate martyr. The vivid depiction of the eruptions, lacerations, and gangrene of the body were intended to encourage patients' identification with Christ, thereby giving them solace and hope. . . . Grünewald probably drew upon the vision of the 14th-century Swedish saint Birgitta, who wrote:

> The crown of thorns was impressed on His head; it covered one half of the forehead. The blood ran in many rills . . . then the color of death spread . . .

> After He had expired the mouth gaped, so that the spectators could see the tongue, the teeth, and the blood in the mouth. The eyes were cast down. The knees were bent to one side, the feet were twisted around the nails as if they were on hinges . . . the cramped arms and fingers were stretched.

Grünewald's image of Christ goes beyond this description in exteriorizing the body's final inner states of feeling. The extreme distension of the limbs, the contorted extremities, and the convulsive contraction of the torso are grim and eloquent testimony to Grünewald's obsession with the union of suffering and violence in Christ. He focused so convincingly on the final rigidifying death throes that the feet, a single hand, or the overwhelming face alone suffices to convey the expiration of the entire body. The brutal stripping of the living wood of the Cross is symbolically in accord with the flagellation of Christ. Cedar, used for the vertical member of the Cross, was also employed in the cure for leprosy. The hopeful message of the painting can be seen in the contrast between the light illuminating the foreground and the murky, desolate landscape behind—a device signifying Christ's triumph over death. Miraculously present for this Crucifixion, John the Baptist intones, "I shall decrease so He shall increase." Men and women are enjoined to humble themselves in order to renew their lives in God. The static doctrinal and symbolic right half of the painting contrasts with the extreme human suffering and emotion to the left, seen in the grieving figures of St. John, the Virgin, and Mary Magdalen. Grünewald's painting and religious views seem to have stressed a communal response to tragic but elevating religious experience. Psychologically and aesthetically, each figure, like the composition as a whole, is an asymmetrical, uneasy synthesis of polarities.

Through the images we have seen, it is possible to trace the changing conceptions of Christ, from his depiction as a humble messianic shepherd, through the kinglike God to be revered from afar, to the God-like king who

could be loved as a benevolent ruler, and finally to the Man of Sorrows, whose own compassion evoked the pity of suffering humanity. The transformation of sacred art proceeded differently for Apollo and the Buddha. Apollo's effigy began as sacred art and terminated in the profane imagery of a beautiful youth. The Buddha's early interpretation progressed from a humane individuality toward the sacrosanct impersonality of the 6th and 7th centuries. To comprehend the effectiveness of Greek, Indian, and Christian artists in uniting form and idea, one may exchange in the mind's eye the head of the Reims *Christ* for that of the *Apollo* at Olympia, the Lotus throne of Buddha for Christ's role in the Conques relief, the nude figure of Apollo for the *Beau Dieu* of Amiens Cathedral—or finally, transfer the San Vitale Christ to the Grünewald altar painting. . . .

Chapter 3

Envisioning and (Re)presenting the Spirit World

Rosalind I. J. Hackett

. . . African art has long fascinated its observers . . . over its purported capacity to embody spirit forces and empower its users and beholders. Such reactions derive, in part, from popular Western thinking which has generally over-emphasized animist and polytheistic notions within African thought. But it also stems from the commonly held belief in many parts of Africa that some, if not many, artistic forms derive from, depend on, and bring forth, spiritual forces. Western academics have often failed to do justice to this aspect of African art. Leon Siroto wrote an important essay in 1976 entitled "African Spirit Images and Identities," which unmasked the ways in which Western academic interpretation had downplayed the "very significant area of traditional concern with spirits" in favor of identifying figures as ancestors. . . .

African art works are rarely believed to embody spiritual power in their own right; rather they must be activated in some way. It is frequently the act of sacrifice which turns a simple piece of wood into a powerful mask or statue, but it may also be activated or animated by an event or performance, the addition of medicines, herbal preparations, or accessories, or its (frequent) association with a person of ritual authority. This may be a one-time consecration or repeated ritual act. Many communities would say that the power of ritual objects increases with use over time. . . . The activation of such works of art may involve multiple artists, agents, and audiences. . . .

Before moving on, we should mention briefly two concepts related to our discussion of the embodiment of spiritual forces. The first is that of containment. Several works in the "Secrecy" exhibition staged by the Museum for African Art in New York are containers for hidden things (Nooter 1993:52). Some secrets, such as relics or powerful medicines, may be made known by a swelling or protrusion (usually in the stomach area), or by a mirror over a cavity in a figural sculpture. . . . Other secret forces or powers may be concealed as in the case of the protective and empowering breath of an ancestor which is held to be hidden in a Bemba figure (Nooter 1993:cat. 27). Accumulation, through the collage or assemblage of various materials,

whether nails, cloth, animal skins, shells or bones, or in the form of chalk drawings (Rosen 1989), is also linked to containment, and the generation or presence of spiritual power. . . .

The question of the links between aesthetic experience and the experience (awe, fear, veneration, mystification) of an object's credited "supernatural" powers is also relevant to our concerns. . . . Do they mutually enhance one another? . . . Aṣẹ or power is an integral part of the Yoruba aesthetic which triggers an affective response in the audience. Expressed either separately or jointly through the visual, verbal, and performing arts, aṣẹ imbues sound, space and matter with energy to restructure existence, transform the physical world and also to control it" (1994a). . . .

The attribution of personhood to ritual objects is addressed insightfully and critically by Wyatt MacGaffey in one of his many publications on Kongo *minkisi,* which are usually referred to in English somewhat problematically as "fetishes" (1990). These objects are particularly relevant to the concerns of this chapter, as they appear to the European mind to confound the distinction between persons and objects. They are fabricated and yet may be invoked to produce desired effects, have a will of their own, and may influence human behavior. MacGaffey perceptively suggests that instead of asking why Africans fail to distinguish adequately between people and objects, we might reverse the question and ask why we make such a dubious distinction. The answer lies partly in the realization that thingness and personhood are culturally constructed. Western tendencies toward commodification in the modern world obscure the memory of the divine power medieval Christians attributed to relics of saints. . . .

Masks and Metaphysics

It is the area of masking that has generated the most discussion regarding the question of spirit representation and embodiment. The idea of the "mask" is infused with European assumptions of disguise and pretence (Napier 1988; Jedrej 1980; Pernet 1992). Masks are complex symbolic objects, reversing what is normal, i.e. ,people are normally visible and spirits are not (hence their common use in rites of transition, such as initiation and death) (Jedrej 1980:225f.; Bentor 1994). The stylistic reversals in masks (such as slit or projecting eyes and mouths) and accompanying super- or non-human costumes make them believable as spirits (Ottenberg 1988a: 78). Masks are also ideally suited to condensing and redistributing power (Tonkin 1979, 1988), and for treating fundamental oppositions, such as the differences between men and women. Their association with ambiguity, paradox and irony enables them to serve as "agents of ideology" and provide symbolic strategies for dealing with social change (Jordán 1993). Masks are widely used in Africa and, because of the element of disguise, some form of transformation of the identity of the wearer is assumed by outside observers (Cole 1985). . . .

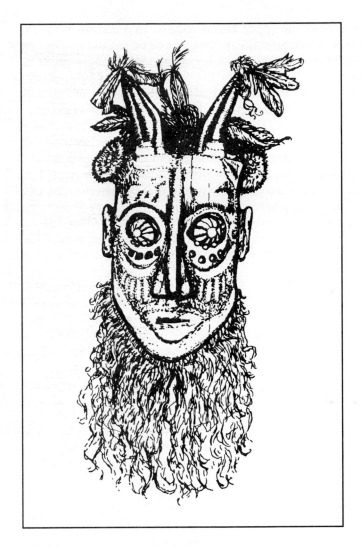

Kuba/Bushoong mask. *Zaire.* (*Stanley Collection of African Art, University of Iowa Museum of Art*)

Masks . . . play an important role in many parts of Africa in mediating between the human and spirit worlds. But this role can only be understood if the masks are situated as part of a larger, dramatic event where particular kinds of experience are created, and boundaries between audience and performer may, through mutual interaction, be dissolved or reinforced (Tonkin 1988). . . . The powers of the masks are activated as much by the human skills of the performers, and by contextual factors such as music and dance, as by the various sacrifices and rituals. Dramatic feats are linked to concealed charms and medicines, and the dramatization of the invocation and emergence of masks from anthills or underground holes makes it all believable for

the spectators. Even if aesthetic appreciation appears to predominate at the conclusion of a successful performance, failure would be treated as a matter of communal concern because of the possible calamitous repercussions from the spirits or ancestors. . . .

We should now try to examine more closely the notions of mystical transformation associated with masking, and the capacity of masks both to reveal and conceal spirit forces. The moral and metaphysical question of what happens when someone puts a mask on is lucidly explored by John Picton in his study (1990) of masquerading traditions of the Ebira people who inhabit the area immediately southwest of the confluence of the Niger and Benue rivers in Nigeria. He is careful to point out that the redefinition of a performer's identity may even occur prior to, and is therefore not always dependent on, the wearing of a mask. Picton describes how, even when a masked performer (*eku*) removed his mask when visiting houses, he was still addressed by the name of the mask and consulted for its oracular and healing powers. . . .

In Picton's words: "[t]he mask, with its costume and accoutrements, is the acceptable face, so to speak, of something, a power, an energy, a metaphysical presence, otherwise too dangerous to see" (ibid.:192). Not only does this re-identification involve secrecy . . . but also danger and rites or sacrifices may precede or succeed the performance. In some cases, possession is involved as for the Yoruba *egungun* masqueraders whose swirling, multi-layered costumes are believed to embody the ancestors. In contrast . . . there are masks which are held to be "the literal embodiments of metaphysical energy, or presence, or 'spirit' " (ibid.:193). Secrecy is less of an issue here since the mask reveals rather than conceals. The embodiment can be either permanent (as in the case of the masks of Dan forest spirits in Liberia) or temporary (such as the *ekine* water spirit masks of the Kalabari). . . .

Visualizing the Spirits

Many African cultures have developed a rich and imaginative array of visual forms—statues, carved posts, altars, stools, pots, textiles, as well as masks—to give substance and life to the spiritual world in ways that allow humans some measure of conceptual access, communication, and control. . . . In contrast to many European artists, African sculptors generally do not seek verisimilitude in their figures, mainly due to the common fear that likenesses may have magical power (Kramer 1993:194). Some sculptors may even seek solitude to avoid unintentionally incorporating the face of a living person. The reason given by the Bobo as to why they do not use anthropomorphous masks is because human survival depends on receiving the gifts of Dwo, the intermediary between Wuro, the creator, and human beings. The latter must renounce arrogance—the arrogance of duplicating the divine creative act—in order to receive this beneficence (Le Moal 1980). But it is important to note

that there are some societies which never developed "any tradition of elabo-
rated images that were vested with inherent powers" such as the Asante of
Ghana. Tom McCaskie attributes this in part to the conceptualization of the
abosom or gods/spirits as being evanescent like the wind and difficult to "cap-
ture" because of their capricious wills (1995:108f.).

Wande Abimbọla, a major exponent of Yoruba thought, reminds us that
each *orisa* or divinity in the Yoruba pantheon is believed to have its own sep-
arate identity and existence independent of any images through which it is
represented. By turning to the ancient texts of the Ifa divination corpus, he
argues, this is made more clear. There we learn that the divinities originally
came to earth in human form, but then departed. People looked for objects
closely associated with them (e.g., medicine may be made from garments and
footprints), and these developed into artistic representations. These forms
derived their power from frequent use and contact, and by association with
a particular individual (nearly half the Yoruba gods are held to be apotheo-
sized humans) or office. This also illustrates well the "slippage" between
notions of presentation and representation. The image of the deity or *ere orisa*,
once ritually consecrated can no longer be criticized. It is held to be (increas-
ingly, with use) the locus of the deity's power, but is not the deity itself. The
Yoruba know that images are not unique and can be replaced. There are many
other forms of invoking the deities, such as through divination, sound, dance
and drumming.

Nature spirits and spirit mates

The Baule peoples of central Côte d'Ivoire carve human figures to rep-
resent two types of familiar spirits that may be diagnosed by a diviner as
causing problems for an individual. These figures illustrate well the links
between aesthetics and beliefs about the spirit world (Ravenhill 1994). The
first kind is the nature spirit or *asie usu* (Vogel 1980). These spirits are believed
to inhabit untamed nature and natural phenomena. They are either male or
female, with personal names, life histories, and spouses. Those who have
reportedly seen them in the forest describe them as "immoderate in appear-
ance," as either hideous or beautiful, and often with feet turned backwards.

Dramatic possession by these spirits is an indication that an individual
should become a spirit medium. Not all clairvoyants are requested by their
spirits to carve figures, but those that do will "feed" them, so that many
exhibit sacrificial encrustations of blood believed to make them more power-
ful. Figures which are put on public view to enhance the medium's sessions
are more likely to be clean and painted than those that are kept in private
rooms. The attractiveness of the carved figures is believed both to tame the
nature spirits' harmful impulses and provide a locus where they can be con-
tacted and appeased. The extravagant features of the spirits are not deliber-
ately reproduced, rather they are made to look beautiful in order to lure and
civilize the spirits. In return, the spirits dictate through dreams to the diviner,

Baule nature spirits. *Cote d'Ivoire. (Stanley Collection of African Art, University of Iowa Museum of Art)*

carver, or client, their preferences for choice of wood, form, posture, and decoration, such as wearing a beard or carrying a baby.

The second type of Baule figure is carved to represent the "mate" a man or woman had in the other world before coming to this one. These spirits are called *blolo bian* ("man from the Other World") and *blolo bla* ("woman from the Other World"). Women have male spirits and men have female ones. Everyone is believed to possess such a spirit, but only those who have troubles caused by them must create a shrine to their spirit mates. . . .

. . . Problems are often, but not exclusively, sexual—infertility for a woman (women are predominantly blamed for this), or failure to retain women for a man. One night a week is reserved during which one "sleeps" with the spirit and has intercourse in dreams. It is through dreams also that the spirit mate dictates how it would like to be portrayed. In the course of the relationship, the surface of the figure may be modified through ritual cleaning, applications of oil, kaolin or paint (Ravenhill 1980:7). The spirit partner may even ask for a new figure to replace one it is dissatisfied with.

There is a general sense that the figure has to be beautiful (elongated neck, downcast eyes, clearly delineated facial features, composure, dignity, strong calf muscles—for both men and women—and ample pelvic circle and breasts in the case of women alone) in order to be efficacious in "presentifying" and placating a spirit. The miniature idealized figure is said to "bring down" or "create" the invisible mate in tangible form—rendering it present both "here" and "there" (Ravenhill 1994:27). . . . As Susan Vogel (1980) emphasizes, some knowledge of Baule concepts of good and evil, which are more situational and not as absolute as in Christianity or Judaism, for example, is crucial to understanding Baule aesthetic choices and judgments, which are predicated on ethical values as much as they are on more formal, visual qualities. . . .

Given the "other worldly," i.e., beyond the world of humans, provenance of many of these spirits, the channels of communication merit examination. Dreams are one means whereby spirits are believed to determine the manner in which they should be manifested and sustained (Fischer 1978). The Dan people who inhabit the hinterland of Liberia and the Côte d'Ivoire believe a type of bodiless spirit inhabits the forest and difficult, mountainous terrain. Dan spirits have names, personalities, and definite characteristics, and generally prefer to be part of the human world. For this reason, the spirit will appear in a dream to a sympathetic individual, requesting her or him to be responsible for its manifestation. In return, the spirit may furnish its human friend with divinatory powers, animal strength or political influence. The spirit dictates how it should be manifested and sustained—whether as a bundle of fur, horns or shells or as a "mobile, living manifestation," namely a mask. It is the wooden face masks that are held to really embody the spirits, even if they are not actually worn. The masks are believed to be alive and people say that they can be heard gnashing their teeth. They receive sacrificial offerings even when the spirit has not revealed itself to a masker, and it is kept on a mat within a family home. . . .

The case of Ṣango

Deities in sculptural form are another of the most obvious illustrations in many people's minds of the relationship between art and religion. Statues representing deities who protect those who work in the field of art or crafts, such as the Igbo deity, If ẹ Nwe Nka (Ikenga Metuh 1985:5), perhaps epitomize this relationship. Ṣango, the deified fourth king of Ọyọ, in western

Ṣango staff.
*Nigeria. (Stanley
Collection of
African Art,
University of Iowa
Museum of Art)*

Nigeria, offers a fine example of the range of imagery that may be associated with a particular divinity. . . . There are many myths surrounding Ṣango's reign and death. Some accounts portray him as a tyrannical leader, who was dethroned by his people and then went and hanged himself. His supporters learned the art of causing violent thunderstorms, and claimed it was his vengeance. He was declared to be a deity who required sacrifices and an appropriate priesthood. Another version recounts how, in playing with magical powers, he inadvertently caused a great storm to occur, killing all his wives and children except his wife, Oya. In disgrace he left the capital and hanged himself. These and other myths convey the sense of ambiguity about the power of Yoruba kings, and the dangers of an excessive desire for power in human beings more generally.

A Sango festival offers a "conflict of imagery." The praise singer recites poems (*oriki*) that convey the god's fiery temper, capricious behavior, and destructive power, while the carver's *ose* or dance wand portrays a woman kneeling in "quiet supplication before her lord, effortlessly balancing upon her head the twin thunderbolts of Sango" (Pemberton in Drewal et al. 1989: 162). The Sango worshipper must suffer the unpredictable behavior of their deity, who hurls down his ancient celts with fearful lightning in the midst of thunderstorms. . . .

Sango, too, is believed to descend to the world of humankind and possess his worshippers. He is the giver of children and protector of twins or *ibeji*. The *ose* Sango or shaft with double axehead already signifies the deity's vital force, although the dance must activate the possession trance and actualize the deity (M.T. Drewal 1986). However, it is the priest as mediator who is represented in the dance wand, not the deity. The twinned celts represent the priest's inner spiritual reality with Sango 's power imbedded in the head and emanating from the top. The head of the Sango priest has been prepared with power substances to stimulate possession. Distinctive female hairdos (shaved to the crown and braided down the back) worn by Sango priests convey the idea of swelling which is a way of describing possession trance. The fact that it is mostly women who are depicted in the *ose* further signifies the special role women play as nurturers of the gods. The sculpture symbiotically relates the deity and priest in the same way as the trance performance. There is a wonderful case of ambiguity and transference here—as the deity is represented/presented by the object/priest. . . .

Another sculptural form associated with Sango is a bowl carrier or *arugba* Sango. It depicts a seated or kneeling female figure, holding a large bowl above her head. The bowl contains Sango's thunder celts and portions of kola nuts and other offerings which form part of the weekly sacrifice to the deity. . . .

Beyond Masks and Figures

It would be wrong to assume that masks and figures are pre-eminent in terms of embodying spirit forces. In the case of the Omabe masking tradition within one northern Igbo community near Nsukka in Nigeria, a being (or group of beings) known as Omabe and associated with the justice, peace and welfare of the community is believed to be present not just in the masquerades but also in objects of a nonmaterial nature (Ray and Shaw 1987). The shrine complex located in each village is also considered to be the "mouth" of Omabe. Offerings take place on the earthen mound there and music, another form of embodiment, is performed there. But it is the ritual objects and sacrificial materials, first buried and then distributed among the Omabe priests, that signal the arrival of Omabe in the community from the underworld via the sacred forest, and not the emergence of the masquerades. Localized deities are also believed to be manifest in figures known as Onumonu. They appear with ritual objects—a bundle of ritual materials consisting of wads and long

strips of cloth, congealed sacrificial matter, feathers and loops of copper—on their backs which are clearly distinguished from the masked figure. In fact the medicine is also known as Onumonu and embodies the deity, transforming the bearer, who carries it, from human being to spirit. He falls down mute, his movements controlled by the deity and his perceptions extended beyond the normal. Yet because he is "conceptually separable" from the Onumonu which turns him into a spirit, he is able to discuss his experiences unlike the bearer of a masked spirit. . . .

The significance of substances is strikingly illustrated in the case of the large Bamana sculptures or *boliw,* whose most important magical ingredients are hidden in the center of a thick black coating (Brett-Smith 1983). These imposing sculptures depict cows, human beings, or round solid balls. They are unappealing to Western collectors because of their unpleasing appearance, but they are the most sacred objects for the Bamana. These "metaphorical stomachs," as Brett-Smith describes them, derive their terrifying power to judge and execute from the fact that "they assemble in one dense, compact object the poisons the Bamana most fear, namely the human and animal excrement used to create their exterior shell" (ibid.:50). Their mysterious and secretive power is further enhanced by the fact that they are sequestered in the sacred grove and only seen by high-ranking elders of the secret society. As spirits, they transcend and control the uncontrollable desires of men. But the extraordinary power of the *boliw* lies in the way in which they reverse normal processes by putting the poisonous feces on the outside and their "skin" in the form of a wrapped cloth on the inside. Since such cloths are linked to childbirth, the sorcerers who construct such objects are thereby appropriating the most fundamental characteristic of women—the right to produce and control life. Such sexual transgressions are both empowering and threatening and so must be kept from public view.

We turn now to pots as containers of spiritual forces. Despite the fact that making pottery is as significant a medium of art as the metalwork or woodcarving which are the province of the smith, and is just as central to African ritual and religious observance, the potter does not enjoy equal status (Herbert 1993:ch.8). In fact, potting, which is frequently dominated by women, is an even more ancient art. In many parts of Africa, pots accompany people from the cradle to the grave—serving as the vessels in which to bury the placenta or to contain the spirit of the ancestral dead. But they do more than just symbolize life cycle changes: they are in many cases equated with people—in the widest sense, to include ancestors, nature spirits, and divinities. The pots may actually contain spirits, whether permanently or temporarily in certain ritual contexts. This complex and fluid interaction between the spirit and human worlds may be indicated by anatomical decoration, such as breasts, or through socially and culturally constructed markers. . . .

The Mafa and Bulahay of northern Cameroon provide an example of how a special relationship is conceived between pots and persons, with anal-

ogous decorations (David et al. 1988). . . . Both the Mafa and Bulahay believe that pots can be used to trap spirits, or when ritually closed, to hold them. Some pots are made with bars across the mouths for this purpose, whereas others are kept sealed. David et al. surmise that the decoration of the pots does not merely protect the pot and its contents from external powers, but it serves to set up a "ritual boundary to protect the weaker from the stronger— whether the dangers emanate from the inside out or the outside in" (ibid.:374). . . .

What is interesting about these various pots which are believed to contain spirits is that they are generally the most elaborately decorated ones and are more likely to be hidden from view (Sterner 1989). But even the less decorated domestic pots may be put to "sacred" use after being discarded.

The Yungur of northeastern Nigeria, like other peoples in the area, also make anthropomorphic ceramic vessels to contain ancestral spirits (Berns 1990). These pots or *wiiso* are more than depictions of their subjects—the meanings they carry are linked to their "active role in constructing and maintaining the world in which the Yungur live." They contain the spirits from which the creator god, Leura, is said to create new life. Women play a key role here in that they are the primary producers of the pots which facilitate the transformation of the dead into spirits and as mothers they perpetuate the lineages. . . .

Concluding Remarks

This chapter has attempted to present a more nuanced, yet far from exhaustive, overview of questions and manifestations of spirit embodiment and representation in African art. We have seen how complex the subject becomes when one necessarily takes into account the range of beliefs, ritual practices, experiences, forms, symbols, aesthetic devices, accoutrements, mediators, as well as historical and socio-cultural factors.

In conclusion, we may briefly note how the influence of Western buyers and museum curators may be revealing in terms of these issues. For example, it was reported at the beginning of this century that the Fang of Gabon readily sold their reliquary guardian figures but steadfastly retained their (irreplaceable) family skulls as relics (Siroto 1976:16). So the figures served more as "points of contact" or as means of dispelling threatening forces. If the village were attacked, it was the relics that were sought rather than the guardian figures. Masks associated with secret societies and initiation rites are normally excluded from public viewing, yet representations of some Senufo masquerades, such as the Nassolo—a buffalo-like mythical animal—appear on cloth which is sold to foreigners (Laget 1984). But the Senufo designers say that the buyers are only interested in the aesthetic aspect of the cloth, and that a graphic representation of a symbol is not sacrilegious since the power of the mask resides in its actual presence. The decontextualizing of objects in the museum context has naturally raised questions about loss of authenticity and

disempowerment (see Nooter Roberts 1994). Yet the staging of the Museum of African Art's "Face of the Gods: Art and Altars of Africa and the African Americas," curated by Robert Farris Thompson, demonstrated how objects could (re)discover "life" in a museum setting because of the responses of both visitors and artist-practitioners.

Once one begins to probe the depths of the question of presentation and representation of the spirit world in African art, one is also struck by the shortcomings of Western perspectives on the subject, notably the inflexible duality of much Western thought. Its over-discriminated and undefined categories of body and soul, and mind and soul prove logically inconsistent and are not borne out in practice. . . . More attention needs to be paid by scholars to the less obvious, but no less important (Freedburg 1989:60), aniconic forms of expression and embodiment. The various examples discussed in this chapter challenge any assumptions regarding a correlative relationship between the apparent visual importance of an art work and its perceived spiritual potency. The visual and performing arts remain a powerful medium for communicating and negotiating with the spirit world. Whatever the beliefs of particular societies or individuals concerning spirit manifestation through art works and/or performance, one thing seems clear: art, with its capacity to express ambiguity and secrecy, serves to reveal the limitations of human knowledge and the finitude of the human condition. It bears remembering that despite the Western ethnographer's quest for explanation and coherence, many Africans are content to live with the mysteries and ambiguities of life.

Bibliography

Abimbola, Wande, ed. 1975. *Yoruba Oral Tradition, Poetry in Music, Dance and Drama*. The African Languages and Literatures Series, no. 1, Ife: Department of African Languages and Literatures.

Bentor, Eli. 1994. "'Remember Six Feet Deep:' Masks and the Exculpation of/from Death in Aro Masquerade," *Journal of Religion in Africa* 24,4 (November): 323–38.

Brett-Smith, Sarah. 1982. "Symbolic Blood: Cloths for Excised Women," in *RES* 3 (Spring):15–31.

—1983. "The Poisonous Child," *RES* 6 (Fall):47–64.

David, Nicholas, Judy Sterner and Kodzo Gavua. 1988. "Why Pots are Decorated," with comments, *Current Anthropology* 29,3 (June):365–90.

Drewal, Margaret Thompson. 1986. "Art and Trance among Yoruba Shango Devotees," *African Arts* 20,1:60–7, 98–9.

Fardon, Richard. 1990. *Between God, the Dead and the Wild: Chamba Interpretations of Religion and Ritual*. Washington, D.C.: Smithsonian Institution Press.

Fischer, Eberhard. 1978. "Dan Forest Spirits: Masks in Dan Villages," *African Arts* 11,2 (January):16–23, 94.

Fischer, Eberhard and Hans Himmelheber. 1984. *The Arts of the Dan in West Africa*. Zurich: Museum Rietberg.

Freedburg, David. 1989. *The Power of Images: Studies in the History and Theory of Response.* Chicago, IL: University of Chicago Press.

Jedrej, M. C. 1980. "A Comparison of Some Masks from North America, Africa, and Melanesia," *Journal of Anthropological Research* 36,2 (Summer):220–30.

— 1986. "Dan and Mende Masks: a Structural Comparison," *Africa* 56,1:71–80.

Jordán, Manuel. 1993. "Masks as Ironic Process: Some *Makishi* of Northwestern Zambia," *Anthropologie et société,* 17,3.

Kramer, Fritz W. 1993. *The Red Fez: Art and Spirit Possession in Africa.* Trans. by Malcolm Green. London: Verso.

Laget, Elisabeth. 1984. *Bestiaires et génies: dessins sur tissus sénoufo.* Paris: Quintette.

Le Moal, Guy. 1980. *Les Bobo: nature et fonction des masques.* Paris: ORSTOM.

MacGaffey, Wyatt. 1977. "Fetishism Revisited: Kongo *Nkisi* in Sociological Perspective," *Africa* 47:140–52.

— 1988. "Complexity, Astonishment and Power: The Visual Vocabulary of Kongo Minkisi," *Journal of Southern African Studies* 14,2 (January):188–203.

— 1990. "The Personhood of Ritual Objects: Kongo *Minkisi,*" *Etnofoor* 3,1:45–61.

MacGaffey, Wyatt and Michael D. Harris. 1993. *Astonishment and Power.* Washington, D.C.: Smithsonian Institution Press.

McCaskie, T. 1995. *Asante: State and Society in African History.* Cambridge: Cambridge University Press.

Napier, A. David. 1986. *Masks, Transformation, and Paradox.* Berkeley and Los Angeles, CA: University of California Press.

—1988. "Masks and Metaphysics: An Empirical Dilemma," in *West African Masks and Cultural Systems,* ed., Kasfir, 231–40.

Nooter, Mary (Polly) H. 1990. "Secret Signs in Luba Sculptural Narrative," *Iowa Studies in African Art,* vol. II, 35–49.

— ed., 1993. *Secrecy: African Art that Conceals and Reveals.* New York, NY: The Museum for African Art.

Ottenberg, Simon. 1975. *Masked Rituals of Afikpo.* Seattle, WA: University of Washington Press.

— 1988a. "Psychological Aspects of Igbo Art," *African Arts* 21,2:72–82.

— 1988b. "Religion and Ethnicity in the Arts of a Limba Chiefdom," *Africa* 58,4:437–65.

— 1990. "Response by Simon Ottenberg," *African Art Studies: the State of the Discipline,* Washington, DC: National Museum of African Art, 125–34.

— 1994. "Ambiguity and Synthesis in Religious Expression in Contemporary Eastern Nigerian Art," Paper presented at the Tenth Satterthwaite Colloquium on African Religion and Ritual, 16–18 April.

— 1995. "Christian and Indigenous Religious Issues in the Work of Four Contemporary Eastern Nigerian Artists. Symposium on African Art, New York, 19–23 April.

Pernet, Henry. 1987. "Ritual Masks in Nonliterate, Cultures," *Encyclopedia of Religion,* ed., Eliade, 263–9. New York, NY: Macmillian.

— 1992. *Ritual Masks: Deceptions and Revelations.* Columbia, SC: University of South Carolina Press. Trans. from the French by Laura Grillo.

Picton, John. 1988. "Some Ebira Reflexions on the Energies of Women," *African Languages and Cultures* 1,1:61–76.

— 1989. "On Placing Masquerades in Ebira," *African Languages and Cultures* 2,1:73–92.

— 1990. "What's in a Mask?," *African Languages and Cultures* 3,2:181–202.

Ray, Keith and Rosalind Shaw. 1987. "The Structure of Spirit Embodiment in Nsukka Igbo Masquerading Traditions," *Anthropos* 82:655–60.

Roberts, Mary Nooter. 1994. "Does An Object Have a Life?" in *Exhibition-ism: Museums and African Art,* eds., Mary Nooter Roberts and Susan Vogel, with Chris Müllen, 37–55. New York, NY: Museum for African Art.

Rosen, Norma. 1989. "Chalk Iconography in Olokun Worship," *African Arts* 22,3:44–53, 88.

— 1993. "The Art of Edo Ritual," in *Divine Inspiration,* Galembo, 33–45.

Simon, Kavuna. 1995. "Northern Kongo Ancestor Figures," in *African Arts* 28,2 (spring):49–53, 91. Trans. by Wyatt MacGaffey.

Siroto, Leon. 1976. *African Spirit Images and Identities.* Essay accompanying exhibition catalogue, Pace Gallery, New York, 6–22.

— 1979. "Witchcraft Belief in the Explanation of Traditional African Iconography," in *The Visual Arts: Plastic and Graphic,* ed., Justine M. Cordwell, 241–91. The Hague: Mouton.

Tonkin, Elizabeth. 1988. "Cunning Mysteries," in *West African Masks and Cultural Systems,* ed., Kasfir, 241–52.

Vogel, Susan. 1980. "Beauty in the Eyes of the Baule: Aesthetics and Cultural Values." Working Papers in the Traditional Arts, 6. Institute for the Study of Human Issues, Philadelphia, PN.

— ed. 1981. *For Spirits and Kings: African Art from the Paul and Ruth Tishman Collection.* New York, NY: Metropolitan Museum of Art.

— 1987. "Introduction" and Notes, in *Perspectives: Angles on African Art.* New York, NY: The Center for African Art.

— ed. 1988. "Introduction," in *ART/artifact.* New York, NY: The Center for African Art.

—1991. "Elastic Continuum," in *Africa Explores: 20th Century African Art,* ed., Vogel, 32–55. New York, NY: The Center for African Art.

Part II

Art Patronage

Patrons are those individuals or institutions that commission, purchase, and promote art. Historically art patrons have served a crucial role in supporting individual artists and influencing taste. During the Middle Ages the Church was a major patron, commissioning illuminated manuscripts and religious objects and employing many artisans to participate in erecting and decorating extraordinary cathedrals. During the Renaissance the definition of patronage expanded to include not only popes as representatives of the Church, but also politically influential workers' guilds and wealthy private patrons, such as the Medici family, as well.

A study of "The Mechanics of Seventeenth-Century Patronage" was undertaken by Francis Haskell in his book *Patrons and Painters: A Study in the Relations Between Italian Art and Society in the Age of the Baroque*. Haskell argues that the creation and placement of major paintings in Baroque Rome may be attributed to the efforts of certain popes, cardinals, and noblemen. A number of cardinals, in particular, were especially active in promoting young painters from their own native cities by locating living quarters for them in Rome, facilitating introductions to potential clients, and providing commissions to decorate titular churches and family palaces.

Artists found themselves engaged in various types of relationships with patrons. A most desirable, but not entirely common, arrangement has been described as "servitu particolare," whereby the artist was housed in the patron's palace and given regular employment by the patron and his family or friends. More often a painter worked in his own studio and was at liberty to accept commissions from numerous clients. A contractual agreement was typically drawn up between artist and client for each artwork, stipulating measurements, subject matter, perhaps the number and identity of figures, and time limit. Expenses were often determined according to the reputation and skill of the artist and the cost of the materials. In Holland, unlike Italy, Dutch painters sold their work in the open marketplace, often specializing in

a particular genre of interest to wealthy upper middle class buyers. In both situations clients affected the way a painting was executed, as artists sought to satisfy their demands and appeal to their taste. In France taste was institutionalized under Louis XIV's Minister of Fine Arts, Le Brun, extending beyond Versailles to permeate French arts entirely.

The eighteenth-century in Europe saw a shift in influence to the landed gentry and French aristocracy, whose taste leaned toward a less bombastic, more intimate and prettified style, replete with playful eroticism, until Enlightenment didacticism contributed to a Neoclassical sobriety. In mid-eighteenth-century China, however, the Qianlong emperor was the most influential force, creating "a legacy of taste for unshakeable imperial pomp, massive projects, and occasional displays of what can only be called elephantine delicacy." In his catalog essay, "A Matter of Taste: The Monumental and Exotic in the Qianlong Reign," Harold Kahn recognizes the role of the Qianlong emperor in establishing a long-lasting unified world-view. A self-proclaimed poet and artist, he was an avid collector who amassed a splendid imperial palace art collection. His support of the restoration of historically significant architectural sites throughout his land preserved for his people a rich cultural tradition.

During the twentieth century the role of the patron metamorphosed from consumer to promoter. The achievements of women in promoting avant-garde art in the early decades of the century is documented by Kathleen D. McCarthy in her essay "Women and the Avant-Garde." McCarthy notes the pioneering efforts of women in areas neglected by male connoisseurs. From the Parisian salon of Gertrude Stein to the founding of the Museum of Modern Art in New York, women have been a driving force behind the acceptance of modern art.

Gertrude Stein not only collected works by emerging modernists such as Matisse and Picasso, but also attracted major avant-garde writers, artists, musicians, and choreographers to her salons to socialize and discuss new concepts. One of her protégées, Mabel Dodge Luhan, was instrumental in the success of the groundbreaking 1913 Armory Show in New York, by lending paintings and providing financial backing and publicity. Katherine Dreier's Societé Anonyme (which she co-founded in 1920 with Marcel Duchamp and Man Ray) was devoted to expanding the audience for modernist art and introducing key European modernists, like Kandinsky, Klee, Léger, and Miro, in one-person shows. Her internationally comprehensive Brooklyn Museum exhibition in 1926 presented modern artworks in intimate domestic settings. Dreier's messianic zeal in championing avant-garde art compelled her to try to create her own museum at her home in West Redding, Connecticut, a venture that proved to be financially unfeasible.

More successful in their efforts to establish a museum dedicated to modern art were Abby Aldrich Rockefeller, Lillie Bliss, and Mary Quinn Sullivan, who established the Museum of Modern Art in 1929. Apparently

women were able to take leadership positions in promoting a type of art undervalued by major institutions and traditional collectors. In this way their radicalism and their achievements can be seen as "an index of the growing acceptance of female individualism" in the early twentieth century.

The role of the patron had changed significantly by the early twentieth century. In seventeenth-century Italy the extensive influence of popes, cardinals, and noblemen brought extraordinary artworks to Rome, making this city into a major cultural center in Europe. However, the client retained a certain degree of control over each commission and was influential in securing stylistic preferences. In eighteenth-century China, the Qianlong emperor almost single-handedly established a long-lasting cultural vision. In the early twentieth century women patrons played a crucial role in actively promoting, even proselytizing, for avant-garde artists and establishing museums and galleries to secure the position of modern art in a traditionally male-dominated art domain.

Chapter 4

The Mechanics of Seventeenth-Century Patronage

Francis Haskell

I

"When Urban VIII became Pope," wrote the art-chronicler Giambattista Passeri, looking back nostalgically from the dog days of the 1670s, "it really seemed as if the golden age of painting had returned; for he was a Pope of kindly spirit, breadth of mind and noble inclinations, and his nephews all protected the fine arts. . . ."[1] In fact, the long pontificate of Urban VIII which began in 1623 marked the climax of a most intensive phase of art patronage rather than the opening of a new era—the sunlit afternoon rather than the dawn. For at least thirty years the austerity and strains of the Counter Reformation had been relaxing under the impact of luxury and enterprise. Intellectual heresy was still stamped out wherever possible: artistic experiments were encouraged as never before or since. The rule of Urban VIII not only led to a vast increase in the amount of patronage, but also to a notable tightening of the reins.

Urban's immediate predecessors, Paul V (1605–1621) and to a lesser extent Gregory XV (1621–1623), had set a pattern which he was content to follow. The completing of St. Peter's, the building and decoration of a vast palace and villa, the establishment of a luxurious family chapel in one of the important Roman churches, the support and enrichment of various religious foundations, the collection by a favoured nephew of a private gallery of pictures and sculpture—this was now the general practice. In it we can see reflected the contrasts, and sometimes the tensions, between the Pope as a spiritual and temporal ruler and the man as an art lover and head of a proud and ambitious family.

The Popes and their nephews were by no means the only patrons, but as the century advanced their increasing monopoly of wealth and power made them at first the leaders and then the dictators of fashion. This process reached its climax in the reign of Urban VIII and was in itself partly responsible for the relative decline in variety and experiment. For until the election of this Pope change and revolution were of the very essence of the Roman

scene. ". . . It [is] a strange and unnaturall thing," wrote a correspondent to Lord Arundell in 1620 towards the end of Paul V's sixteen-year rule,[2] "that in that place, contrary to all others, the long life of the Prince is sayd to be the ruyne of the people; whose wealth consists in speedy revolutions, and oft new preparations of new hopes in those that aspire to rise by new famies [families] who, with the ould, remayne choaked with a stand, and loath to blast their future adresses by spending to court those that are dispaired of." Exactly the same point was made with much greater force after the twenty-one years of Urban VIII's reign.[3]

These "speedy revolutions" and the consequent rise of new families moulded the patterns of art patronage. As successive popes came to the throne they surrounded themselves with a crowd of relatives, friends and clients who poured into Rome from all over Italy to seize the many lucrative posts that changed with each change of government. These men at once began to build palaces, chapels and picture galleries. As patrons they were highly competitive, anxious to give expression to their riches and power as quickly as they could and also to discomfort their rivals. After the Pope died they were often disgraced, and in any case their vast incomes came to a sudden end, for nepotism no longer took the form of private empires carved out of the Church's territory. "There is no situation more difficult or more dangerous," said Pope Gregory XV, who certainly knew what he was talking about,[4] "than that of a Pope's nephew after the death of his uncle." With the end of their incomes went the end of their positions as leading patrons. It was especially noted of Cardinal Alessandro Peretti-Montalto, nephew of Pope Sixtus V, that he was still respected and loved even after the death of that Pope, and that artists continued to work for him:[5] This was evidently not the usual state of affairs.

Rome was a symbol rather than a nation. The nobles who formed the papal entourage still thought of themselves far more as Florentines, Bolognese or Venetians than as Romans or Italians; and as the prestige of painting was at its height, it was a matter of some importance for a cardinal to be able to produce several painters of distinction from his native city. We are told that Cardinal Maffeo Barberini (the future Urban VIII) "was most anxious to make use of artists from his native Florence," and that Pope Gregory XV "was a Bolognese so there was little chance for anyone from anywhere else. . . ." The artists naturally made the most of their opportunities. In 1621 Cardinal Ludovisi was elected Pope. Domenichino had some years earlier returned to his native Bologna after a quarrel with Cardinal Borghese, but "this news caused him great excitement, as the new Pope was a compatriot of his and the uncle of one of his friends," and so he hurried back to Rome where he was made Vatican architect by the Pope's nephew Ludovico.[6]

Indeed, if we study the careers of the most important artists who followed Annibale Carracci from Bologna at the beginning of the century and introduced a new style of painting to Rome, a very consistent pattern

emerges. The young painter would at first be found living quarters, in a monastery perhaps, by a cardinal who had once been papal legate in his native city. Through this benefactor he would meet some influential Bolognese prelate who would commission an altar painting for his titular church and decorations for his family palace—in which the artist would now be installed. The first would bring some measure of public recognition, and the second would introduce him to other potential patrons within the circle of the cardinal's friends. This was by far the more important step. For many years the newly arrived painter would work almost entirely for a limited group of clients, until at last a growing number of altarpieces had firmly established his reputation with a wider public and he had sufficient income and prestige to set up on his own and accept commissions from a variety of sources. Once this had been achieved, he could view the death of his patron or a change in régime with some degree of equanimity.

This essential pattern, . . . , determined the sites of the more significant works of modern art in Rome. There were, first, the great town and country houses, all of which—Aldobrandini, Peretti, Borghese and so on—contained early pictures and frescoes by the Bolognese painters. Secondly, there were the churches. The most important was naturally St. Peter's, whose decoration was under the direct supervision of the Pope, but there were many others which were maintained by rich cardinals and noble families. They fall into two classes—those of which a cardinal was titular head or for which he had a special veneration; and those where he wished to be buried. Both, however, had one feature in common: their antiquity. A titular church was, by definition, one that had been handed down from cardinal to cardinal through the centuries; and in general the Popes and their families, perhaps to refute the charge of being nouveaux-riches, chose to be buried in the most ancient and venerable of basilicas such as S. Maria Maggiore and S. Maria sopra Minerva.

There was, besides, one other way in which a noble could add to the splendour of Rome and hope to find a suitable burying place for his family: he could build a complete new church. The demand was enormous. New Orders had sprung up to meet the threat of the Reformation—the Oratorians and the Jesuits, the Theatines, and Barnabites and the Capuchins, and the various foreign communities in Rome, the Florentines, the Lombards and many others, vied with each other in the erection of magnificent new temples. Such building, however, takes a considerable time, and the original estimate of the cost is usually well below the final result. It is rare that the man who decides to have a church built will survive to supervise the decoration; it is still rarer that his heirs will take the same interest as he himself did. And so the chapels have to be disposed of to anyone prepared to decorate them. But the great cardinals were interested primarily in furnishing their own titular churches, family palaces or burial places in the older basilicas. Besides, their acute sense of precedence and rivalry made them reluctant to undertake a relatively

small feature in a church which had been begun by another cardinal. "Although it was objected to him," we are told of Cardinal Alessandro Peretti-Montalto, "that it was not suitable for him to follow in a building [S. Andrea della Valle] which had been begun by someone else, he despised such human considerations and carried on with his plans to the glory of God. . . ."[7] Much more usually, however, the completion and decoration of new churches were carried out by wealthy but politically unimportant patrons, who were not in touch with the most modern artists of the day and who were thus compelled to fall back on well-established favourites. It is therefore paradoxically true that a well-informed traveller in about 1620 would have found that most of the best modern paintings in Rome were in the oldest churches.

II

Within the general framework that has been outlined there was a wide range of variation possible in the relationship between an artist and the client who employed him. At one end of the scale the painter was lodged in his patron's palace and worked exclusively for him and his friends; at the other, we find a situation which appears, at first sight, to be strikingly similar to that of today: the artist painted a picture with no particular destination in mind and exhibited it in the hope of finding a casual purchaser. In between these two extremes there were a number of gradations involving middlemen, dealers and dilettantes as well as the activities of foreign travellers and their agents. These intermediate stages became more and more important as the century progressed, but artists usually disliked the freedom of working for unknown admirers, and with a few notable exceptions exhibitions were assumed to be the last resort of the unemployed.

The closest relationship possible between patron and artist was the one frequently described by seventeenth-century writers as *servitu particolare*. The artist was regularly employed by a particular patron and often maintained in his palace.[8] He was given a monthly allowance as well as being paid a normal market price for the work he produced.[9] If it was thought that his painting would benefit from a visit to Parma to see Correggio's frescoes or to Venice to improve his colour, his patron would pay the expenses of the journey.[10] The artist was in fact treated as a member of the prince's "famiglia," along with courtiers and officials of all kinds. The degree to which he held an official post varied with the patron; though some princes might create an artist *nostro pittore* "with all the honours, authority, prerogatives, immunities, advantages, rights, rewards, emoluments, exemptions and other benefits accruing to the post,"[11] such a position was more frequent with architects than with painters. In most cases within the prince's retinue there was a sliding scale of rewards and positions up which the artist might move on promotion. Thus from 1637 to 1640 Andrea Sacchi was placed in Cardinal Antonio Barberini's household among three slaves, a gardener, a dwarf and

an old nurse; in the latter year he was moved up to the highest category of pensioners with writers, poets and secretaries.[12]

A position of this kind was eminently desirable for the artist, and all writers agree on its enormous and sometimes indispensable advantages.[13] There were occasional drawbacks: some artists had difficulty in leaving the service of their employer, and there were obvious restrictions on personal freedom which might be irksome.[14] On the other hand, paradoxical though it may seem, artists placed in these circumstances had unrivalled opportunities for making themselves known, at least within certain circles. For it has already been pointed out that the patron was not wholly disinterested in his service to the arts. A painter of talent in his household was of real value to him, and he was usually quick to sound the praises of his protégé and even to encourage him to work for others. In the absence of professional critics such support and encouragement was by far the easiest way for a painter to become known. "To establish one's name it is vital to start with the protection of some patron," wrote Passeri when commenting on the early life of Giovanni Lanfranco,[15] for it was only the great families who were in a position to get commissions for their protégés to paint in the most fashionable churches, and this was an indispensable stage in any artist's career.

In view of the powerful national rivalries that prevailed in Rome it is not at all surprising that the artist's birthplace played an even more important part in determining his chances of enjoying *servitu particolare* than in obtaining ordinary commissions. Thus we hear of the Florentine Marcello Sacchetti who, on seeing some works by Pietro da Cortona, "asked him about himself and where he came from. And when he heard that [Pietro] was from Cortona, he called him his compatriot," and put him up in his palace.[16] In the same way, at the end of the century, Cardinal Ottoboni provided rooms for his Venetian fellow-citizen Francesco Trevisani.[17] But good manners—a paramount issue for painters in the seventeenth century—could be almost as important as nationality in securing an artist a position of this kind.

Though this sort of patronage was very desirable in a stable society, the conditions of seventeenth-century Rome with its frequent and sometimes drastic shifts of power were by no means ideal for its furtherance. Too close an association with a disgraced patron could prove a serious bar to advancement when conditions changed. And there were always artists who found the restrictions on their freedom uncongenial despite the security they seemed to guarantee.[18] Besides, there were not many families able or willing to support painters on such terms. And so we often find that this extreme form of patronage was extended to an artist only at the outset of his career. Arriving in Rome from some remote city, what could be more desirable than the welcome of a highly placed compatriot offering hospitality, encouragement and a regular income? But after some years, with a considerable reputation and Rome flooded with foreigners willing to pay inflated prices, the position must have looked rather different. Fortunately a compromise was always possible: the

artist could live and work on his own but continue to receive a subsidy as an inducement to giving his patron priority over all other customers.[19]

It was much more usual, however, for a painter to work in his own studio and freely accept commissions from all comers. Whether or not an actual contract was drawn up between him and the patron would depend on the scope of the commission, but by examining such documents as have survived we can see the sort of conditions under which these independent artists worked. In the following pages the items most usually stipulated will be discussed in turn.

It was natural enough that the *measurements* and site of the proposed work should be laid down in some detail when a fresco or ecclesiastical painting was required, and only one point sometimes caused difficulties: when an altarpiece was commissioned from an artist living in some distant city, the problem of the lighting in the chapel might become acute. For though the painter was naturally told the destination of his picture, it was by no means certain that he always had the chance to inspect the site himself and long exchanges would then be needed to clear up the problem.

The size of pictures for private galleries was also a matter for discussion. Those complete decorative schemes that have survived show that in many cases pictures were used to cover the walls of a room or gallery in symmetrical patterns, and that often enough they were even let into the surface. Where this was the case it was obviously important to regulate the exact measurements of any new picture commissioned, and much surviving correspondence testifies to the patron's interest in the question. Again and again artists were commissioned to paint pictures in pairs, and in many instances it is possible to see how this preoccupation with the decorative and architectural function of paintings influenced their composition as well as their size.[20]

The artist was also usually given the *subject* of the picture he was required to paint, but it is difficult to determine how far his treatment of it was actually supervised by the patron. Clearly a great deal depended on the destination of the work. Stringent control may have been exerted over the subject of a religious fresco or an altar painting, but the contracts themselves only rarely go into much detail. Indeed, a surprising degree of freedom often seems to have been left to painters, even in important commissions, and this depended a good deal on the cultural sophistication of Rome. Contracts from smaller provincial centres show far more detailed instructions than those given to painters in the bigger towns.[21] Usually the outlines of the subject would be indicated, and it was then left to the artist to add to it those elements which he found necessary for its representation.[22] Often the request for further iconographical details came from the painter. Thus, in 1665, when Guercino was required to paint an altarpiece for a monastery in Sicily, he was given the measurements and told that the figures were to include the "Madonna de[l] Carmine with the Child in Her arms, St. Teresa receiving the habit from the Virgin and the rules of the

Order from the Child, St. Joseph and St. John the Baptist; these figures must be shown entire and life-size and the top part of the picture must be beautified with frolicking angels." Not satisfied with such instructions (which in fact were more specific than usual), he wrote to ask whether the Madonna del Carmine "is to be clothed in red with a blue cloak following church custom or whether she should be in a black habit with a white cloak. Should the rules of the Order which the Child is handing to the Saint be in the form of a book or a scroll? In that case what words should be written on it to explain the mystery? Further, should St. Teresa go on the left or on the right?" He also wanted to know how the picture was to be hung and what the lighting would be like.[23]

In secular works, too, there were difficulties. The artist who was given such a vague theme as the Four Seasons was often in something of a quandary as to what he should actually paint, and we know that in these circumstances he would usually apply to a scholar or poet for advice, even if not specifically required to do so in his contract. When Prince Pamfili, for instance, commissioned Pier Francesco Mola to paint the Four Elements in his country house at Valmontone, the artist went to a lawyer of some standing in the district and asked to borrow a genealogy of the gods and a Virgil with a commentary so that he could pick suitable myths for representation. Basing himself on these books and on friendly conversations, he then chose to depict the Element of Air by showing "Juno reputed to be the goddess of Air in the act of leaving the clouds; the Milky Way; the rape of Chloris by Zephyr; the rape of Ganymede; and the apparition of Iris to Turnus."[24]

The artist's treatment of a particular subject could be affected in another way. Because the price of a picture or fresco was often determined by the number of full-length figures it contained, he was sometimes told just how many of these he was to include. Urban VIII, for instance, commissioned an altarpiece for the church of S. Sebastiano on the Palatine to represent "the martyrdom of St. Sebastian, with eight figures" which were evidently left to the discretion of the painter.[25]

The commissioning of pictures for a gallery would naturally leave a freer choice, for complete thematic uniformity of decoration was now only rarely insisted on. More and more the movable gallery picture was coming into its own—a largely Venetian innovation of over a century earlier which had made a decisive impact on Roman collecting. Pictures were bought, sold, inherited, speculated in and exchanged with bewildering speed so that biographers often no longer found it worth recording where a painter's works were at the time of writing. In these circumstances neither subject nor size held the vital importance of earlier days, and, with the added stimulus of connoisseurship, collectors were frequently more interested in choosing the work of specific artists than in going into great detail about what had actually been painted. Thus at the very beginning of the century the Marchese Giustiniani was such a wholehearted admirer of Caravaggio that, when an

altarpiece by that artist had been rejected as unsuitable for i[t]s intended loca-
tion, he acquired it for his gallery and hung it among a series of pictures
which had been assembled far more for their affinities of style than for any
consistency of subject-matter.[26] And some ninety years later another patron,
Giovanni Adamo, when commissioning a work from the Genoese painter
Paolo Girolamo Piola, gave the size and added only: "As to the subject, I leave
it to you whether to make it sacred or profane, with men or with women."[27]
We find here the culmination of an undogmatic approach to art which was
characteristic of the whole century and which led to an invigorating freedom
of experiment and invention. It was an approach that the more conservative
patron could modify by choosing a single theme and commissioning pictures
by different masters to be grouped around it—a suitable compromise
between the old and the new for which there had been many precedents dur-
ing the Renaissance. It occurs frequently in royal commissions where a num-
ber of painters would be required to celebrate the glories of Alexander the
Great, and it was also popular with scholars collecting portraits of great men
or reconstructing elaborate temples of learning. It was evidently some such
scheme that the Duke of Mantua had in mind when he commissioned two
Roman painters to represent for him various episodes from the story of Sam-
son, but ordered them on no account to begin until he had told them just
which ones he wanted.[28] And another great patron, the Marchese del Carpio,
when Spanish Ambassador in Rome, commissioned a number of artists to
draw for him any subject so long as it represented some facet of *Painting.*[29]

Instructions to the artist would also depend on his reputation and tem-
perament. How great, for instance, was the contrast between Pietro da Cor-
tona and Salvator Rosa! Pietro, recognised for years as the most distinguished
painter in Rome, indeed in Italy, refused to choose his own subjects and
claimed that he had never done so in his whole life;[30] whereas Rosa told one
imprudent client who had had his own ideas for a picture to "go to a brick-
maker as they work to order"—though this attitude did not stop him asking
his friends for suggestions.[31] And, of course, certain artists had acquired a
reputation for particular subjects. Thus it was that one collector called on the
French painter Valentin, who specialised in Caravaggesque genre scenes, and
asked him for "a large picture with people among whom were to be a gipsy
woman, soldiers and other women playing musical instruments."[32]

The most effective way by which a patron could keep control over an
artist working for him was by insisting on a preliminary oil sketch (*modello*)
or drawings, but this practice was a good deal rarer during the first half of the
seventeenth century than is sometimes supposed.

It is true that in 1600 Caravaggio agreed with his patron, before execut-
ing his altarpieces of *The Conversion of St. Paul* and *The Martyrdom of St. Peter,*
that he would "submit specimens and designs of the figures and other objects
with which according to his invention and genius he intends to beautify the
said mystery and martyrdom,"[33] but this was exceptional, and Caravaggio

was already notorious as a difficult character. For quite different but equally understandable reasons, Rubens, who was still only an unknown foreigner, was asked in 1606 to show examples of his painting before undertaking an altarpiece in the Chiesa Nuova.[34] In general, more confidence was shown in the painter's ability, though private and unofficial discussions with the patron must have been frequent. Even for such an important commission as the altar paintings in St. Peter's, it appears not to have been obligatory for artists to produce *modelli* (though presumably drawings would have been necessary); when Lanfranco wrote in 1640 to Cardinal Barberini asking to be given the chance to paint the altar picture of *Pope Leo and Attila,* he specially mentioned that he would arrange for the Cardinal to see "in tela il dis egno," but he explained that he was doing this to illustrate the difficulties of the composition, and in any case the suggestion came from him and not from his patron.[35]

None of the Bolognese artists working in Rome is known to have produced a *modello,* and no certain examples survive even from such a great decorator as Pietro da Cortona.[36] On the other hand, the practice became widespread during the second half of the century, and is particularly associated with the painter Giovan Battista Gaulli, who may have been responsible for introducing it from his native Genoa where it was already well established. One factor is clearly important: Professor Wittkower has pointed out that "most of the large frescoes in Roman churches belong to the last 30 years of the seventeenth and the beginning of the eighteenth century"[37] and it is obvious, as Rubens had shown in Northern Europe, that *modelli* could be exceedingly useful both to patrons and assistants in large-scale work of this kind. Moreover, the iconographical significance of these frescoes was often more complex. Ciro Ferri was required in 1670 to produce a coloured *modello* for the cupola of S. Agnese in Piazza Navona, and after it had been approved he was not to make any changes without special permission.[38] Such stringent control is exceptional, but . . . the Pamfili family, who were responsible for this commission, were never altogether happy in their relations with artists. It is also possible that the insistence on sketches at this period was in some way linked to a growing appreciation of their more "spontaneous" character—an appreciation that naturally accompanied the rise of the *amateur,* though the fashion for collecting them did not become general until the eighteenth century.

After the size of the picture and the subject-matter had been decided, there came the question of the *time limit,* a problem of particular urgency during the whole of the Baroque period. Nearly all patrons insisted that work should be finished as quickly as possible, and as often as not they were disappointed by the artists whom they employed. Some frescoes were, of course, such large undertakings that many years were required for their completion. Ciro Ferri was given four years for the cupola of S. Agnese in Piazza Navona, and Gaulli eight for the vault and transept vaults of the Gesu. Holy Years

often provided a special incentive for artists to complete their work in some church,[39] and certain painters had a reputation for exceptional speed. It was claimed that Giovanni Odazzi worked faster than the notoriously rapid Luca Giordano, and Giacinto Brandi too was famous in this respect. Quick work might entitle the artist to greater rewards—we are told that Gaspard Dughet benefited in this way—but by no means always met with critical approval.[40] It was the Venetians who were especially famous for their speed and the fact earned them a certain amount of contempt elsewhere.

The final clause in any contract naturally referred to the *price* and financial arrangements. Certain formulas were always adhered to. Some proportion of the sum agreed was paid at once as a deposit. This ranged widely from a minimum of about one-seventh to a maximum of nearly a half. If the work was a picture, the artist was very often given a further payment when it was half finished and the remainder on completion, together with a final bonus. And, of course, there were many variations possible in this treatment. In the case of large-scale frescoes, the artist was usually paid at a regular monthly rate.[41]

More interesting and significant than obvious arrangements of this kind is the question of expenses incurred by the artist in his work. "The usual thing is to pay painters for the stretcher, the priming and for ultramarine," wrote an agent to a prospective patron in 1647, and this is confirmed in many other documents.[42] Once again variations were possible[43]—sometimes the painter was responsible for all expenses; on other occasions he was given the canvas and had to pay for the ultramarine himself; very rarely he was told, as in mediaeval days, that the colours he bought must be of the very finest quality.[44] The patron invariably paid for the scaffolding needed for ceiling frescoes, and if the work took place away from the painter's residence he would also provide board and lodging for him. It was claimed of Prince Pamfili, for instance, that he treated Pier Francesco Mola, who was decorating his villa at Valmontone, like one of his own retinue, giving him "fowl, veal and similar delicacies."[45]

Prices for the work itself were regulated in widely different ways: many artists had fixed charges for the principal figures in the composition, excluding those in the background. Thus Domenichino was paid 130 ducats for each figure in his frescoes in Naples Cathedral and Lanfranco 100. This system was very widespread and allowed painters to make regular increases in price as their reputations grew.[46] However, the status of the client was often as important as that of the artist in determining the price. In the 1620s the Sienese doctor and art lover, Giulio Mancini, wrote that a munificent patron would not condescend to go into the question at all, but would reward the artist as he saw fit.[47] It is true enough that we do find some examples of this. In 1617, for instance, the Duke of Mantua wrote to Guido Reni asking him for a painting of *Justice embracing Peace*. He gave the measurements, but made no mention of the price beyond saying that Guido would be "generously rewarded."[48]

And artists were clearly glad to respond to such offers. The somewhat eccentric Paolo Guidotti used to say that he gave away his paintings as "free gifts," but he had no hesitation in accepting the most expensive presents in return.[49] Claude Lorrain was equally shrewd: "Or ce que est pire," wrote Cardinal Leopold de Medici's agent in 1662 about the possibility of buying a picture by him, "c'est qu'il faudra le payer largement car il ne fixe un prix qu'aux gens de médiocre condition."[50] But in fact even by Mancini's date it is probable that such aristocratic largesse was the relic of an earlier age and already in decline. Painting was far more commercialised than these rare instances suggest. "If His Highness wants to be served well and quickly," wrote the Mantuan agent in Rome to a ducal chancellor,"he must, indeed it is indispensable that he should, send some money here to give as a deposit to these painters. They have let it be clearly understood that they will only work for those who give them money [in advance]; otherwise it will be quite impossible to get anything good from them."[51] And against the example of a Claude we must record the uncompromising rigidity with which Guercino enforced his own practice of charging a certain sum for every figure painted: "As my ordinary price for each figure is 125 ducats," he wrote to one of his most enthusiastic patrons, "and as Your Excellency has restricted Yourself to 80 ducats, you will have just a bit more than half of one figure."[52]

The type of patronage so far considered had done little more than modify the practice of earlier centuries: a client in direct touch with the artist; clear instructions as to size and, probably, subject; a well-established and recognised relationship. . . .

Notes

1. Passeri, p. 293. For an enthusiastic contemporary account of art patronage—as of everything else under the Barberini—see the Abate Lancellotti's *L'Hoggidi* first published in Venice in 1627 and often reprinted.

2. Letter from Mr. Coke of 8 October 1620—Hervey, p. 183.

3. Ameyden, *Relatione della città di Roma* 1642—MS. 5001 in Biblioteca Casanatense, Rome. Piety, says the author, diminished under Urban VIII because of the excessive length of the papacy "non per colpa alcuna del Prencipe, ma che la nascita del Pontificato elettivo, et ecclesiastico ricerca mutazione più spesso, acciò molti possono godere de gli onori, e dignità ecclesiastiche, ricerche, e cariche della corte."

4. Quoted by Felici, p. 321.

5. Passeri, p. 27.

6. Ibid., pp. 44 and 132.

7. Panciroli, p. 800, quoted by Ortolani.

8. See many references in Pascoli—I, p. 93, and II, pp. 119, 332, 417, 435, etc.

9. Montalto, p. 295, for the important evidence of Alessandro Vasalli, a painter who testified on Mola's behalf in his troubles with Prince Pamfili: "Io so che quando una persona di qualche professione è arrollato tra la famiglia de" Principi e tra

Virtuosi de Principi con assegnamento di pane sono obbligati a preferir qualche Pnpe o Prnpessa per ogni loro operazione, ma però pagandoglieli le sue opere quello che vagliono e perciò non è obbligato a servire quel Pnpe con la sua Professione, senza una mercede, o salario, ma come ho detto deve preferire quel Pnpe ad ogni altro per il tenor dela loro professione e questo lo so perché così ne gli insegna la ragion naturale e per haverlo anco sentito dire tra Pittori in ordine alla Professione. . . ."

10. Pascoli, II, p. 211—Cardinal Pio sent his protégé Giovanni Bonati to Florence, Bologna, Modena, Parma, Milan and Venice; ibid., II, p. 302—Cardinal Rospighosi sent Lodovico Gimignani to Venice.

11. The appointment of Gio. Gasparo Baldoini "per nostro pittore" by Cardinal Maurizio di Savoia—Baudi di Vesme, 1932, p. 23.

12. Incisa della Rocchetta, 1924, p. 70.

13. Pascoli, I, p. 93.

14. For the Duke of Bracciano's reluctance to let Pietro Mulier leave Rome see Pascoli, I, p. 180. Pier Francesco Mola and Guglielmo Cortese had to get special permission to leave Valmontone for a few days when they were employed there by Prince Pamfili—Montalto, p. 288.

15. Passeri, p. 141.

16. Ibid., p. 374.

17. See unpublished life of Trevisani by Pascoli in Biblioteca Augusta, Perugia, MS. 1383 and Battisti, 1953.

18. See later, p. 22 ff., for Salvator Rosa and p. 23 note 3 for Benedetto Luti. Paolo Girolamo Piola "amante di sua libertà" wanted to avoid living in the palace of his fellow Genoese patron Marchese Pallavicini when he came to Rome in 1690 and "benchè a gran difficoltà" he got permission to reside elsewhere—Soprani, II, p. 185.

19. Cardinal Flavio Chigi gave Mario de' Fiori a monthly allowance of 30 *scudi*—Golzio, 1939, p. 267.

20. In relation to Claude see Röthlisberger, 1958.

21. See, for instance, the terms laid down for Saverio Savini in Gubbio in 1608 published by Gualandi, IV, p. 60; or for Mario Minnitti in Augusta (Sicily) in 1617, published by Giuseppe Agnello.

22. Thus in his frescoes for the church of S. Antonino in Piacenza in 1624 Camillo Gavasetti was given the subject by the SS. i Deputati "con libertà al medes.o Pittore d'inventare ed ampliare con prospettive, chori d'Angioli, Sibille, Profeti e come meglio li pararà secondo l'arte e pratica di perito Maestro"—Gualandi, I, p. 91. In 1682 Sebastiano Ricci was required by the Confraternità di S. Giovanni Battista Decollato in Bologna to paint "La Decolatione di S. Gio. Battista con figure et altre conforme richiede il rappresentare detta decolatione"—von Derschau, 1916, pp. 168–9.

23. Ruffo, p. 109.

24. Montalto, p. 290. There is also an undated letter from a certain Vincenzo Armanni (I, p. 215) to Camillo Pamfili with suggestions for the decoration of his villa at Valmontone.

25. The artist was Andrea Camassei—see the receipt published by A. Bertolotti (*Artisti bolognesi* . . . , pp. 161–2). In this connection it would be extraordinarily interesting to find the contracts for such masterpieces of restraint as Guido Reni's and Poussin's treatments of the *Massacre of the Innocents.*

26. The significance of this has been pointed out by Friedlaender, p. 105.

27. Letter of 3 February 1690—Bottari VI, p. 147.

28. Luzio, p. 292.

29. Bellori, 1942, p. 117.

30. Letter from the Savoy Resident in Rome, Onorato Gini, in 1666, summarised by Claretta, 1885, p. 516: "ma prima patto apposto dal Cortona era ch'egli non voleva indursi a far ver una proposta [as regards subject], allegando che non avevane fatta alcuna in tutta la vita e che 'questo sarebbe un non mai volere il quadro.' "

31. Pascoli, I, p. 84.

32. Costello, p. 278.

33. The contract has been published by Friedlaender, p. 302.

34. See later, Chapter 3, p. 70, note 2.

35. Pollak, 1913, p. 26. Letter from Lanfranco in Naples dated 14 July 1640. "In tela il disegno" must certainly mean that the general composition would be sketched in on the canvas. We know that this was a regular practice of Lanfranco's—Costello, p. 274.

36. L. Grassi published in 1957 what he claimed to be a series of *modelli* by Pietro da Cortona for the ceiling of the galleria in the Palazzo Doria-Pamfili, but these have not won general acceptance—see Briganti, 1962, p. 251. Nor is the so-called *bozzetto* for the Barberini Salone, kept in the palace, at all convincing. On the other hand, Professor Waterhouse has pointed out to me the existence of a *modello* by Camassei, *Saints Peter and Paul baptising in the Mammertine prison,* once belonging to the Barberini and now in the Pinacoteca Vaticana—No. 820, formerly 539 m. A number of *modelli* by Andrea Sacchi are also recorded. One of these, for an altarpiece in the Capuchin church in Rome, recently passed through a London gallery (Colnaghi's, May–June 1961, No. 2) and is now in the collection of Mr. Denis Mahon.

37. Wittkower, 1958, p. 218.

38. Golzio, 1933–4, pp. 301–2.

39. Tacchi-Venturi, 1935, p. 147.

40. Pascoli, I, pp. 59, 61 and 132; II, pp. 390 and 395.

41. Many examples of different kinds of payment could be given here. In 1639 Francesco Albani was given an exceptionally high proportion of the total sum as *caparra*—450 out of a 1000 *lire* (Gualandi, I, p. 19). More typical is the case of Pier Francesco Mola who for his frescoes at Valmontone was to be given 300 *scudi* immediately and the remaining 1000 in stages as he worked (Montalto, p. 287); or of Ciro Ferri who was given 50 *scudi* as *caparra* and promised 180 more on completion of an altarpiece in Cortona for Annibale Laparelli (Gualandi, IV, p. 117).

42. "è solito che si paghi a tutti i pittori il telaro, imprimitura, et oltremare . . ."—letter from Berlingero Gessi to Don Cesare Leopardi d'Osimo, dated 10 July 1647, pub-

lished by Gualandi, I, p. 40. And again: ". . . Sappia che questo è lo stile che si pratica con ogni minimo pittore, cioè consegnarli la tela impresa, e qualche denaro anticipato . . ."—letter from Carlo Quarismini to Conte Ventura Carrara, dated 11 July 1696, in Bottari, V, p. 186.

43. In 1633 Camassei agreed in his contract with Urban VIII to pay himself for "tela colore e azzurri"; in 1639 Bonifazio Gozadini promised to supply Albani with the canvas and necessary ultramarine for his altarpiece in the Chiesa de' Servi in Bologna (Luzio, p. 48); in 1657 Prince Pamfili agreed to pay for "il bianco macinato, pennelli, e coccioli smaltini, terra verde, verdetti, lacche fine, e pavonazzo di sole et azzurro oltramare" to be used by Pier Francesco Mola in his frescoes at Valmontone, while the artist was to pay for the remaining colours, paper, etc. (Montalto, p. 287).

44. For instance Camillo Gavasetti agreed in 1624 to use "colori de' più fini" for his frescoes in Piacenza—Gualandi, I, p. 91.

45. Montalto, pp. 287 and 289.

46. See letters from Mattia Preti and Artemisia Gentileschi—Ruffo, pp. 239 and 48.

47. Mancini, I, p. 140.

48. Luzio, p. 48.

49. Faldi, 1957, pp. 278–95.

50. Letter from Jacopo Salviati to Cardinal Leopoldo de' Medici, dated 22 July 1662, published by Ferdinand Boyer, 1931, p. 238.

51. Letter from Fabrizio Arragona, Mantuan agent in Rome, to a ducal chancellor, dated 9 October 1621, published by Luzio, p. 295.

52. Letter from Guercino to Don Antonio Ruffo, dated 25 September 1649, published by V. Ruffo, p. 97.

Chapter 5

A Matter of Taste:
The Monumental and Exotic
in the Qianlong Reign

Harold L. Kahn

Between the middle of the 17th century and the end of the 18th century—a period of 150 years—three great rulers dominated most of the known political world. They were not Louis XIV, Catherine the Great, or George III. Rather, they were the Kangxi emperor (r. 1662–1723), his son, the Yongzheng emperor (r. 1723–1736), and his grandson, the subject of this essay, the Qianlong emperor (1736–1796). They were members of an ethnic minority, the Manchus, from the forests and plains of northeast Asia, who had conquered China in 1644 and created the last dynasty to rule the Chinese people. These three men stood astride the Chinese world order, governed more people than anyone had before in history, created the second greatest land empire of all time—a realm that eventually reached the Pamirs on the west, Vietnam in the south, Mongolia, Korea, and the Russian frontier in the north, and in total area was more than 600,000 square miles larger than the People's Republic of China today. They taxed the most voluminous cotton industry in the world, the most fecund rice crop, the richest silk, tea, and porcelain industries. They administered the world's largest bureaucracy (roughly 20,000 civil appointees in the last decades of the Qianlong reign) dwarfing in size Louis' little court at Versailles; they marched their armies into the great northern deserts and at one point (1792–93) across the Himalayas (a feat not duplicated until 1963); and at home they wrote and painted and collected on a scale not equalled before or since.

It was an age of superlatives—the last brilliant epoch of the old Chinese imperial order. It began with the young Kangxi emperor reimposing order on a nation still riven by doubts and factions and the bitter aftertaste of wars of conquest and dynastic succession. As the chorus in the most famous play of the day, *Taohua Shan* (The Peach Blossom Fan), ruefully sang, "Alas, 'tis never easy to decide/Which be the winning, which the losing side."[1] The age ended in the last decade of the 18th century with the Qianlong emperor, supremely confident and too old, proclaiming to George III in an edict, that "The pro-

ductions of our Empire are manifold, and in great Abundance; nor do we stand in the least Need of the Produce of other Countries."[2]

This was true; the empire was still politically and economically self-sufficient. But now it was wracked internally by widespread rebellion and corruption and beset by a population so great (ca. 300 million) that long familiar social relations and institutions could no longer bear the strain. China was about to come apart at the seams. Lord Macartney, the leader of a British embassy to the court of Qianlong in 1793–94, and much given to nautical metaphor, noted as much: "The Empire of China is an old, crazy, First rate man-of-war, which a fortunate succession of able and vigilant officers has contrived to keep afloat for these one hundred and fifty years past, and to overawe their neighbors merely by her bulk and appearance, but whenever an insufficient man happens to have the command upon deck, adieu to the discipline and safety of the ship. She may perhaps not sink outright; she may drift some time as a wreck, and will then be dashed to pieces on the shore; but she can never be rebuilt on the old bottom."[3]

But in between Kangxi's youthful, iron-fisted reunification of the realm and Qianlong's octogenarian complacency about it, there grew in size, uneven wealth and complexity as diverse a society as China had ever known. It became more monetized than ever before, and the cities, commerce, and literacy grew; it became more minutely divided in the countryside, with landless peasants, household slaves, tenant and subtenant farmers, private smallholders, entrepreneurial landlords and absentee landlords, peddlers, bandits, demobilized soldiers, tax farmers, and pawnshop owners and usurers all competing with each other for increasingly scarce resources. The ruling classes constructed networks of patronage, literary style, and philosophical outlook in their country houses and metropolitan offices. Professional artists and writers produced family portraits and funeral orations, pinups[4] and hackneyed verse, and a lot of local history for their patrons; other artists, amateurs (by profession), dabbled in the market but made their name by painting and writing for each other—landscapes of the mind, vernacular novels to be read in the privacy of their homes while they read the Confucian classics and commentaries and imperial decrees in their public hours. Buddhist bonzes and Taoist charlatans, storytellers and music masters, courtesans, and female impersonators, jugglers at country fairs and schemers at court made life rich and perplexing and the question of taste daunting.

Stratigraphies of Taste

. . . The imperial palaces were filled with curios, the highest examples of specialist craft traditions, but beyond and beneath that, the gulf between "fine" and "folk" art was vast. Ordinary people could not afford to see, let alone buy, Art, but in their crafts they left a stratigraphy of taste—shards of functional necessity and private delight, liturgical affirmations and mechanical skills.

Their religious talismans and kitchen gods, demon-defying amulets, infants' booties and adults' sandals, acupuncture charts, funerary paraphernalia, pillows, and tools constitute a rich source for an archaeology of popular aesthetics.[5] And when social historians get round to these matters they are certain to show us a world of taste as much bounded by canonical prescription as the sphere of high art; an aesthetic defined in the first instance by use-value but no less decoratively and regionally distinctive for that. The domestic imagination awaits discovery.

Moving up the social ladder, into the academies, country mansions, urban villas and imperial court, individuals and households needed literacy, leisure, land, and money to maintain themselves at the top. These conferred on those who had them membership in High Culture, an accumulation of values and sentiments that permitted gentlemen and some gentlewomen, courtiers, princes, monarchs—even some merchants—to share an aesthetic that they believed was universal, true, and beautiful. Not all of those commercial people, for example, were boors, and among the Yangzhou rich were merchants who were more at home with scholars than with bankers—men of impeccable taste who were cultured gentlefolk in their own right: amateur historians, textual critics, builders of some of the great private libraries in a country with no public ones, Ma Yueguan's, for example, containing perhaps the preeminent collection of rare Song and Yuan books in the eighteenth century.[6] They were patrons of the leading artists and writers in the realm, versifiers, famous hosts. One imagines that Wallace Stevens would have felt at home among them.

Within the mental walls of High Culture was much diversity. Young 17th century gentlemen made something of a cult of individualism. A bare generation removed from the violent world of dynastic war which destroyed so many of their families' fortunes, they lived for the moment while proclaiming that they created for posterity. . . . This was the age of great eccentric painters, men who withdrew into "a private world of eccentricity, where they were exempted from social and political responsibilities by the traditional Chinese tolerance of erratic behavior."[7] Chinese history is littered with hermits and angry old men.

By the time of the Qianlong reign, however, the cult of individualism had given way to an orgy of conformity. The state no longer looked the other way at radically idiosyncratic behavior; orthodox taste and conduct were much prized and highly rewarded, and eccentricity, still alive at Yangzhou, was much tamed—a popular posture that could even be indulged in by the emperor dressing up as a Taoist sage. . . . Defiance had been routinized, the venom of the Ming-Qing transition and the following years of consolidation largely drawn. The middle decades of the eighteenth century were marked in social manners, intellectual purpose, and artistic practice by notions of orderliness, by a glittering, complacent, sometimes self-indulgent fascination with "order, regularity, and refinement of life," to borrow G.M. Young's apt description of Victorian England.[8]. . .

The Politics of Monumentalism

The emperor on the throne was both part of the high culture he patronized and above it. He had license to be both greater and different: to flaunt monumentality and indulge, if he chose, in the exotic. It was through precisely these two "modes," the universal and the decorative, that the Qianlong emperor created a legacy of taste for unshakeable imperial pomp, massive projects, and occasional displays of what can only be called elephantine delicacy.

It was practically an imperial requirement to awe—to sponsor that which was monumental, solemn, and ceremonial, literally to be bigger than life. The Qianlong emperor was not exceptional in this respect. Universal kingship, after all, embraced the cosmos, and that grandiose posture demanded suprahuman scale in architecture, ritual, and the performance of the manifold roles required of the emperor. Thus the mausolea and palace cities, encyclopaedias and variorum editions, harems and armies of earlier monarchs set the imperial precedent of doing things big. Qianlong, the quintessential inheritor, completed some of these projects, copied others, and started several of his own devising.

The Qianlong emperor understood as well as any who came before him that monumentalism was essentially a political aesthetic. It did not need to please, only to inspire and command—respect, fear, loyalty, belief. It was a public but not popular art, meant to reaffirm hegemonic sovereignty, omnicompetence, imperial legitimacy and the natural, harmonious order of things. These principles were most notably embodied in the architecture that surrounded the Son of Heaven and made him mysterious. The imperial city in Beijing, walls within walls, comprising almost a thousand palaces, pavilions, terraces and courtyards, pleasances and residence halls, recapitulated the spaciousness and symmetry of the cosmos. Within its 723,600 square meters it encompassed all of humankind, both hid and elevated the emperor, and exhausted, sometimes beyond endurance, generations of officials and courtiers who trod the vast spaces between audience halls in service and submission to the state.

Begun in 1406 by the Yongle emperor, third in the Ming line, and continued, expanded and rebuilt (after frequent fires) by many after him, the imperial city was completed by the Qianlong emperor, and much of the palace complex we know today dates from his time. Construction consumed stupendous quantities of treasure and natural resources—fine hardwoods (*nanmu*, the rarest, grew only in the southwest), marble, ceramic tiles, glazes, clays, gold leaf, mortar, as well as legions of craft specialists and corvée laborers. Thus, for example, the 180-ton slab of seamless marble earmarked for a newly installed dragon way (reserved for the emperor alone) in the Ming, took 20,000 men twenty-eight days to haul from the quarries outside of Beijing to the palace over carefully ice-slickened roads, the only manageable means of transporting such an unwieldy burden.[9] And during his sixty-year reign, the

Qianlong emperor spent at a minimum, 76,482,967 *taels* (ounces) of silver on his reconstructions and additions. The ability of the treasury to meet such expenses represented merely another face of the political economy of monumentalism.

The imperial custodians of this culture of mass and ritual order might be frivolous or profound, intellectually curious or dull-witted, sentimental or ruthless, but they approved the claustrophobia of universal sovereignty, its high solemn walls, and its mythic purpose. When the Kangxi emperor fingered his harpsichord, when the Qianlong emperor sat for his portrait by Jesuit painters, the while engaging the missionary Benoist in talk of the French and Russian royal succession, they were dabbling, condescending to be dilettantes. What counted were home truths. Universalism was incompatible with cosmopolitanism, which implies not just tolerance but acceptance of the validity of competing claims. Neither Kangxi nor Qianlong in this sense were cosmopolitans. In their institutional roles as patrons and collectors, ritualists, *patresfamilias* to all humankind, as administrators and militarists, they and other emperors preferred or provoked the grand, reiterated gesture. Their eyes and, one suspects, their hearts were firmly fixed in the past. . . .

The quantitative *grande geste* was a signature of the Qianlong reign. The emperor of course was capable of temperance, even of ambivalence. It took him over six years at the beginning of his reign to determine just how he should come down on the matter of important fiscal reforms initiated by his father. He was concerned lest draconian measures against corruption be misinterpreted as the work of a tyrant.[10] He could be cautious to the point of being dilatory, and for one long stretch in the middle years of his reign appears to have refused to name, even secretly, an heir apparent. And as a paragon of filial piety, he was almost insufferably attentive to his aged mother, the dowager. But his taste for grandiosity would out, as his famous, if militarily questionable, "ten glorious campaigns" attested.

These expeditions, the most spectacular of which was a crossing of the Himalayas into Nepal to chastise recalcitrant Gurka tribesmen, served to show the flag and reassert imperial supremacy on the frontiers. They were expensive: The Taiwan campaign in 1787 alone required the shipment of almost one-and-a-half million piculs of rice to the front; the total cost of all ten campaigns exceeded 151 million silver *taels*.[11] They were legendary in scale. Above all they were inspirational, or meant to be. The emperor on a memorial stele compared himself to Tang Taizong, consolidator of the second empire in the seventh century, and then sent off to Paris, via French East Indiamen at Canton, to have his exploits graven on copperplate. By 1784 sets of the engravings were widely distributed throughout the realm, hung in imperial villas, palace buildings, garden pavilions and temples.[12] Long after the reasons for the campaigns were forgotten, buried in massive campaign chronicles, the formal pantomimes of victory, frozen in these heroic tableaux,

celebrated the emperor's virtue and accomplishments in the field. The accomplishments, thus ritualized, *became* the triumphs, transcending mere event and historicity.[13] They were his version of the equestrian statue.

It was not as a warrior, however, but as a collector and patron of the arts and letters that the Qianlong emperor excelled as a monumentalist. Himself a writer and painter, he produced more than 42,000 poems, huge volumes of prose writings, massive collections of state papers. He trained from youth as a painter, well-schooled in classical techniques. The results were at best dubious and have been described as "the sort of picture that Queen Victoria might have painted had she been Chinese," though in all fairness he acknowledged his limitations, insisting that he was a mere copyist, a laborer in the august halls of the academy.[14] . . .

The emperor's two most enduring accomplishments in the field of collecting were the compilation of the great Imperial Manuscript Library (*Siku Quanshu*) and the building of the Imperial Palace art collection. The Library was assembled over twelve years, from 1773 to 1785, employed 15,000 copyists, and in the end numbered 3,462 complete works (out of a total of 10,230 inspected) in 36,000 volumes. It was an act of both purification and glorification, for it consigned to the fire or to Bowdlerizers 2,262 books deemed inimical to the dynasty, while it established variorum editions of the rest as an apotheosis of the classical and literary tradition.[15] Seven complete manuscript sets were made and housed in seven great treasure houses constructed for that purpose around the realm.

The Imperial Palace art collection, today divided between the holdings in Taiwan and Beijing, and equally awesome in its dimensions, was largely the work of the Qianlong emperor. That part of it housed today in Taiwan includes roughly 8,800 paintings and examples of calligraphy, 27,870 pieces of porcelain, 8,369 pieces of jade, numerous ancient bronzes, and countless curios. The Beijing collection, figures for which are unavailable, may be larger. Under Qianlong's auspices the unified collection may have been even greater, for since his time it has been periodically devastated by deliberate destruction (at the hands of the British and French in 1860), rebellion (in 1900 during the Boxer uprising), dispersal (after 1911 when the Manchu rump took part of it off to Manchuria), arson (which destroyed at least 1,157 paintings in 1923), and civil war (1945–49).

The Qianlong emperor, who assembled so much of the palace holdings, was clearly an avid, and some say reasonably discerning, collector. He had a keener eye and certainly a more grandiose vision than his forbears.[16] His collection would be the *summa* of imperial taste, an act of historical preservation of what was rarest and best; it would also be an affirmation of splendor; most would be best. His chief supplier was a reluctant Korean salt merchant, An Qi, who appears to have been forced to sell his finest scrolls to the court after a humiliating bankruptcy, the result of a promise to fund privately the reconstruction of a city wall.

This tension between throne and merchant over the disposition and ownership of works of art was not exceptional. The eighteenth century was a collector's century and art changed hands often as merchant princes, art dealers and intermediaries, private individuals, artists and statesmen used paintings and curios as media of exchange, payment for debts, collateral for loans, marks of invidious social or intellectual accomplishment, gifts, bribes, and hoarded wealth.[17] It is tempting, in this respect, to seek a pattern of competition between private (largely merchant) capital and public (bureaucratic) capital—between a commercial bourgeoisie and the imperial court—for the scarce resources of the art market. It might help explain the remarkable drive by the court under Qianlong to collect art quantitatively as well as qualitatively; it might also explain the art dealers' holding back of authentic works in expectation of better prices from the great private collectors.

Commercial capital was accumulated in vast amounts in the eighteenth century but it was never permitted to create an independent bourgeoisie, a middle class with different, independent, more influential tastes than the gentry-imperial culture of court and bureaucracy. Merchant wealth was legally unprotected and always vulnerable to predation by the state. Its sumptuary pretensions were no match for the immense fiscal wealth and cultural hegemony of the throne. Competition was uneven; the market was skewed. And if the art dealers now and then made a killing, their profits, like their paintings, remained subject to expropriation by the state. The emperor's claim to the lion's share of the market was primary and assured. An enthusiast, he could indulge his whims and buy up paintings in job lots; a critic, he could force an owner to present a desired piece to the throne as a gift; an autocrat, he could break a merchant to get what he wanted.

Evidence of the emperor's zeal as a collector can be seen on the paintings he examined. He spent much of his energy as an aesthete writing inscriptions and implanting his more than one hundred state and personal seals all over the masterworks in the collection. This has dismayed art historians and critics ever since, yet there is an explanation for his fervor that transcends bad taste. I have argued elsewhere that there were "extra-aesthetic functions of such exercises. It was not so much the royal prerogative as the royal duty to remain at the head of the arts even if, in the process the art was destroyed. The paintings, after all, were the private possessions of the throne; the imperial script and seals were the possessions of the realm. Their appearance was an assertion not only of artistic sensibility (however warped) but of dynastic grandeur. . . . It could only be hoped that the prince and emperor had taste; it had, however, to be expected that they would leave their marks—preferably, as in earlier ages, with discretion—on the treasures that defined the glory of their reign."[18]

Perhaps the most egocentric aspect of the emperor's lust for collection was the collecting of himself. He had a passion for his own portrait and loved to pose in the roles permitted him as patron and exemplar of the arts and

taste—as aesthete, scholar, connoisseur, calligrapher and poet. . . . The icono-graphic extreme, however, was surely achieved in the portrait of the emperor as the Buddha. . . . It is outrageous, no doubt, but curiously empty of sacri-lege. It is, really, little more than a cardboard carnival pose, beyond innocence and incapable of solemnity. In fact there is a kind of ponderous, studied humor to many of these little portraits, as if the Jesuit masters who painted them and the emperor who permitted them were determined to share a pri-vate, permissible joke while engaged in the too-serious work of imperial aggrandizement.[19]

A final aspect of the Qianlong emperor's penchant for the monumental was the periodic mobilization known as the imperial southern tour of inspec-tion. Ostensibly organized for reasons of state—to show the crown and inspect water works—it was largely an exercise in self-importance and flat-tery. The mobilization of resources for such a trip was massive, the logistics complex. A flotilla of barges and boats had to be requisitioned to carry all the palace ladies and attendants who insisted on following in the emperor's train. One such expedition also required 900 camels and 6,000 horses.[20] The emperor might inveigh against extravagance: All those lanterns and awnings and flower boats were vulgar, the fireworks unnecessary, the woodwind and string ensembles impermissible.[21] But no provincial governor or retired grandee would have dared take the Son of Heaven at his word, and the south-ern tours remained lavish displays of local wealth and overpreparation. The dignity of the throne would be preserved.

Much else was also preserved on these tours. A fortuitous side effect of the emperor's travels was the renovation of a great deal of important archi-tecture, which had to be repaired and refurbished before the imperial eyes could be set upon it, the preservation of much art, and the removal back to the court of local artistic tribute, landscape and garden styles, and whole colonies of artists, scholars and writers who impressed the monarch en route with their works.[22] In fact the tours may be considered to have redressed the aesthetic imbalance between the Yangtze delta culture and the north: They removed the product from the buyers, the market, as it were, from the mer-chants. What was not acquired as gifts was purchased by the throne. The cur-rency used was silk and the idiom that of rewards conferred: so many bolts of satin for so many scrolls or annotated collections of verse or antique curios.[23] There was much decorum in the transfer of this cultural treasure and much prestige conferred upon the donors, but in the end the throne was enriched because it could not be ignored.

The Limits of Exoticism

Monumentality, then, served as a magnet. It overwhelmed, as it was sup-posed to and created in the process the very public it was meant to impress. The court's taste for the exotic, on the other hand, seems to have been limited in influence—a private affair between the emperors and the Western world.

The seventeenth and eighteenth centuries were the great age of the Jesuits in China, men such as Ricci and Schall and later the remarkable painter Giuseppe Castiglione (Lang Shining, 1688–1766). They were admired by the emperors and used by them, as interpreters and diplomats, engineers, armorers, astronomers, architects, landscape gardeners. They were appendages of a world-embracing court (the Heaven-embracing expectations of the Vatican sadly beside the point) and sources of incidental knowledge and pleasure. Beijing in the eighteenth century did not ape or adapt their manners or dress as eighth century Changan did the styles and wares of the Turks and Persians at the outer limits of the Tang empire. Europe in the age of Qianlong was still beyond the horizon to all but a few traders, Catholic converts, and courtiers. Many officials attuned themselves to court tastes without assimilating them. They bought the singsongs (clockwork automata) which the Qianlong emperor prized so much and sent them along to Beijing. They earned points, the emperor wound his clocks, and James H. Cox, the purveyor in London and Canton, and his Swiss counterparts in Geneva, made money.[24] The appropriation of Europe in this fashion was almost an exact stylistic equivalent of the decorative fantasies of Chinoiserie which swept Europe in the same century.

The Yongzheng emperor posed for Castiglione in the manner of Versailles. . . , but knew nothing of it. The Qianlong emperor, much taken with the great houses of Europe as he saw them in his Jesuits' books and his mind's eye, built in a corner of his magnificent summer palace, the Yuan Ming Yuan, an entire Italianate chateau complex. It began as a whim; the emperor wished to have a fountain and he commanded his foreigners to build one. Father Castiglione went to Father Benoist, and Father Benoist, something of a hydraulic engineer, made a working model that delighted his patron. As a result the emperor decided to have himself a villa with all the fixings—palace buildings, formal gardens, an aviary, a maze, reflecting pools and, of course, fountains, lots of them. The style was florid rococo, containing "numerous false windows and doors, excessive ornamentation in carved stone, glazed tiles in startling color combinations, imitation shells and rock-work,. . . pyramids, scrolls and foliage , and conspicuous outside staircases. . . ."[25] To relieve the geometric formalisms, the good brothers, having learned something about Chinese landscaping, added native rockeries and vistas, so that the whole must have seemed a perfectly unreal and hence perfect dream world. Virtually everything was destroyed by British and French soldiers and their officers in 1860 at the end of another of those unequal nineteenth century wars.

The whole was an exchange in superficialities. European monarchs constructed Chinese pagodas and pavilions; Chinese rulers built European mansions. European painters imagined fabulous creatures or simply quaint ones and called them Chinese; Chinese artisans, working from European models and designs sent out in the porcelain trade, rendered Europeans fabulous and funny. If few on either side understood the other, a lot of people profited from

the trade in China ware, silks, and tea, and a lot of others derived harmless pleasure from their fanciful borrowings.

There was room for the frivolous and self-indulgent in the great years of the high Qing. After that, pleasure parks and spinnets would not do. Beleagured nineteenth century court officials looked back nostalgically on the Qianlong reign: Power had been sublime, and if taste had sometimes been ridiculous, it didn't really matter. It was after all the expression of a people still in command of native values. Never again in Chinese history would those values and the taste they generated go unchallenged from without.

The Qianlong emperor, like Kangxi and Victoria, lived too long. His improbable durability—he ruled for the equivalent of two biological generations—became, like theirs, his greatest monument. His longevity was much celebrated, for it reaffirmed the gerontological basis of wisdom (though not necessarily of knowledge) in a culture which prized precedent and regularity as the sources of order and refinement. His life became an Age, to which were attached styles, predilections, norms of behavior, schools of thought, prescribed expectations. It became a cultural as well as political reference point, the last time that a unified and universal Chinese world view would make sense and seem to work. Qianlong was the last of the giants.

Notes

1. K'ung Shang-jen, *Peach Blossom Fan* (Berkeley, 1976), p. 30. I am grateful to Dorothy Ko for help in the preparation of this article.

2. Hosea Ballou Morse, *The Chronicles of the East India Company Trading to China, 1635–1834*, vol. II (Oxford, 1927), p. 248; original in *Da Qing Lichao Shulu*, vol. 1435, p. 15b.

3. J.L. Cranmer-Byng, ed., *An Embassy to China, Being the Journal Kept by Lord Macartney During His Embassy to the Emperor Ch'ien-lung, 1793–1794* (London, 1962), pp. 212–213.

4. Professor James Cahill's term for 17th and 18th century "generalized, semi-erotic portraits of beautiful women." Personal communication, Berkeley, Ca., April 1985.

5. See Tseng Yu-ho Ecke, *Chinese Folk Art* (Honolulu, 1977). For an absorbing discussion of "folk aesthetic" as a problem in popular consciousness, see Ann S. Anagnost, "The Beginning and End of an Emperor: A Counterrepresentation of the State," *Modern China*, vol. 11, no. 2 (April 1985), pp. 149–150.

6. Ho Ping-ti, "Salt Merchants," p. 157.

7. James Cahill, *Chinese Painting* (Skira, 1960), p. 169, referring to the brilliant individualists of the Ming-Qing transition, Kun Can, Hongren, Gong Xian, Zhu Da, Daoji.

8. G.M. Young, *Portrait of an Age* (London, 1957), pp. 5, 7.

9. For these details, see the exquisite and exhaustive new study by Yu Zhuoyun, chief comp., *Palaces of the Forbidden City* (New York, London, 1984), pp. 20, 22, 32, for the Qianlong-era expenses, pp. 326–327.

10. Madeleine Zehn, *The Magistrate's Tael* (Berkeley, 1984), pp. 266–277.

11. Zhuang Jifa, *Qing Gaozong, Shiquan Wugong Yanjiu* (Taipel, 1982), p. 494.

12. Nie Chongzheng, "Qianlong pingding Junbu, Huibu Zhantu'he Qingdai di tongban hua," *Wenwu* (1980, no 4), pp. 63–64.

13. This theme is suggestively developed in Sabine MacCormack, *Art and Ceremony in Late Antiquity* (Berkeley, 1981), p. 271.

14. The quote is from Michael Sullivan, "The Ch'ing Scholar-Painters and their World," *The Arts of the Ch'ing Dynasty* (London, 1965), p. 10; the self-appraisal in Sugimura Yuzo, *Ken-ryū Kōtei* (Tokyo, 1961), p. 27.

15. The major work on the intellectual politics of the Imperial Manuscript Library project is R. Kent Guy, "The Scholar and the State in Late Imperial China" (Unpublished Ph.D. thesis, Harvard University, 1980).

16. The Kangxi emperor, by comparison, was an indifferent collector, prey to unscrupulous dealers who appear to have pawned off second-rate scrolls on the court. Thus Gao Shiqi, one of the preeminent late seventeenth century dealers, devised a category in his catalogue, "For presentation to the Emperor," comprised almost exclusively of inexpensive forgeries. See James Cahill, "Collecting Painting in China," *Arts Magazine* (April 1963), p. 70, for this and the following on An Qi.

17. See James Cahill, "Types of Artist-Patron Transactions in Chinese Painting" (Unpublished ms, 1983; cited with permission); also the same author's "Collecting," pp. 66–72.

18. Harold L. Kahn, *Monarchy in the Emperor's Eyes* (Cambridge, 1971), p. 136.

19. The unsigned portraits outnumber the signed ones, by Castiglione, but conform in style and content with them.

20. Gao Jin, comp., *Nanxun Shengdian* (Preface, 1771), *juan* 114:7b.

21. *Nanxun Shengdian,* 2:2b, 3a; 3:4b; 4:1a, 85:2a.

22. On the transfer of architectural and interior decoration styles, see Chen Congzhou, *Yangzhou Yuanlin* (Shanghai, 1983), p. 4; on the borrowing of garden styles, Wu Sheng, *Yuan Ming Yuan* (Beijing, 1957), p. 4.

23. *Nanxun Shengdian,* 68:3b, 4a,6; 69:2b; 70:2b; 71:4b.

24. David S. Landes, in his magnificent *Revolution in Time* (Cambridge, 1983), pp. 48–52, 268, may exaggerate somewhat the mandarinate's (as distinct from the court's) fascination with clocks, but his discussion is nevertheless the most critically acute—and most charming—that I have seen.

25. Carroll Brown Malone, *History of the Peking Summer Palaces Under the Ch'ing Dynasty* (Urbana, 1934), p. 141. Cf. also Wang, *Yuan Ming Yuan,* and "Yuan Ming Yuan di guoqu, xianzai he weilai," in *Qinghau Daxue Jiangu Gongcheng Xi* (1979) for details on size and staff of the entire summer palace complex.

Chapter 6

Women and the Avant-Garde

Kathleen D. McCarthy

Isabella Stewart Gardner's achievements notwithstanding, women made their most influential contributions by legitimizing new and neglected areas of artistic endeavor, rather than by paraphrasing the cultural activities of men. The decorative arts and, after the turn of the century, folk art and the avant-garde all benefited substantially from women's campaigns to win them a more central place within the nation's artistic canon. Several common denominators linked the avant-garde to other areas in which women successfully adopted a pioneering role. One was the strategy of filling gaps. The women who championed these causes promoted forms of artistic endeavor that had failed to win the respect or the backing of most male connoisseurs. In an era when cultural activities were increasingly viewed as women's pursuits, the promotion of neglected fields offered few incentives to wealthy male connoisseurs. Disdained by established museums and often derided in the popular press, modern art afforded neither the cachet nor the access to powerful institutions accorded to those who amassed the acknowledged masterpieces of the past.

Another common denominator was economic. One of the disadvantages of competing with wealthy male connoisseurs was that they could drive prices far beyond women's acquisitive range, if they so chose. Folk art, laces, textiles, ceramics, and modernist paintings were all relatively inexpensive compared to the prices that men like [J.P.] Morgan were willing—and able—to pay for the masterpieces that they so avidly pursued.

The history of women's involvement in the avant-garde is marked by a progression from Gertrude Stein's salon to the founding of the Museum of Modern Art. Rather than creating a permanent gallery, Stein orchestrated her campaigns from the comforts of her home. She was a woman little given to conformity. Born in Allegheny, Pennsylvania, in 1874, Stein was the youngest of seven children, the daughter of a Bavarian merchant who made a modest fortune selling clothes. She had a cosmopolitan upbringing, spending portions of her childhood in Austria and Paris, as well as in the United States. Unlike many of the female patrons who preceded her, Stein was college-educated, having studied at the Harvard Annex (later renamed Radcliffe College) and the

medical school that Mary Garrett helped to open to women at Johns Hopkins University.

Stein ultimately scrapped her plans for a medical career to follow her brother Leo to Paris shortly after the turn of the century. The two were extremely close, and his enthusiasms served as the catalyst that first interested Gertrude in the visual arts. A talented dilettante, Leo moved to Paris to study painting. He was soon joined there not only by Gertrude but also by his brother Michael and Michael's wife, Sally, who was a professionally trained artist. Leo's artistic leanings led the family into a growing array of friendships with local dealers, as well as with some of the century's most innovative painters. This and his collecting forays in the galleries of the Salon d'Automne brought painters such as Henri Matisse, Pablo Picasso, and Paul Cézanne into the Steins' circle of acquaintances and friends.

By 1905 the family was regularly hosting salons, adding dancers and writers such as Isadora Duncan and Mabel Dodge (later Luhan) to their artistic protégés. Leo dominated these early sessions. . . .

The center of attention shifted to Gertrude after Leo's rift with Picasso began to sour his enthusiasm for the avant-garde. Although initially one of Picasso's most important backers, who bought and exhibited the Spanish painter's works himself and actively encouraged other collectors to do the same, Leo's influence diminished after Picasso turned to cubism in 1907. As his backing began to taper off, Gertrude's enthusiasm for and support of Picasso's work increased. . . . As the avant-garde began to bypass Leo's range of vision and taste, she quietly assumed the lead.[1]

She had a remarkable setting in which to do so. By 1906 Gertrude and Leo Stein had already amassed a superb collection of Gauguins, Cézannes, Picassos, Matisses, and Renoirs, spiced by an occasional El Greco and Manet. Their household museum served a particularly important role before 1910, when few other collectors were purchasing the work of modernists such as Picasso and Matisse. Its importance was increased by word-of-mouth publicity and, indirectly, by the San Francisco earthquake. Sally Stein had continued her artistic training with Matisse, whose works she and her husband collected. When they hastily returned to their San Francisco home to assess the damages from the earthquake, they took several of Matisse's paintings with them. As word of the strange new paintings spread, American tourists began to visit the Steins' Paris galleries with increasing regularity. At a time when few dealers or collectors were showing these works, the Steins' salon served as an impromptu museum, echoing the efforts of earlier patrons such as Luman Reed.

After the First World War, the composition of Gertrude's salon gradually changed, filled instead with composers and expatriate novelists such as Ernest Hemingway and F. Scott Fitzgerald. But in the early 1910s, it stood squarely at the center of some of the Continent's most innovative artistic trends, from cubism to the fauvist movement led by Matisse. Although Stein

played a minimal role in American institutional developments during these years, her salon established a female presence at the forefront of the international avant-garde.

Stein's generosity and her skill in drawing luminaries to her salon helped to bolster the professional careers of her male devotees. Women painters fared less well. . . . Although her salon attracted a variety of female writers and performers such as Duncan and Luhan, women artists remained in the minority. . . .

On the other hand, the Steins' salon served as a school for a number of prominent women patrons. Etta and Claribel Cone, Agnes Meyer, Mabel Dodge Luhan, and Katherine Dreier were all alumnae of these soirees. Indeed, many of the Picassos and Matisses that the Cone sisters collected and later donated to the Baltimore Museum of Art were acquired as a result of acquaintances made in the Steins' salon.[2] . . .

The Armory Show

Mabel Dodge Luhan, . . . [a] vivid personality who embellished Stein's salon, . . . contributed to the success of the Armory Show. Held in 1913, the Armory Show exhibition served to popularize the works of the avant-garde in ways that Stieglitz's single gallery never could. The show was put together by a group of artists headed by Arthur B. Davies. Although their original intention was to highlight the works of the American painters who had been ignored by the conservative National Academy of Design, Luhan was one of several people tapped to help bring together samples of the work of leading European avant-garde painters and sculptors as well. By the time the exhibition opened in New York's Sixty-ninth Regiment Armory on February 17, 1913, almost a third of the thirteen hundred collected works were by Europeans, and it was these pieces that captured the public's imagination. Most Americans had heard only "vague rumors of unusual artistic happenings abroad" and were completely unprepared for the impact of the postimpressionist, cubist, and fauvist paintings that greeted them. Over seventy thousand viewers crowded in to see the show during its one-month run in New York, a presence bolstered by the press reviews that sent shock waves across the nation.[3] . . .

In addition to garnering paintings and providing cash, Luhan helped to publicize the Armory Show through newspaper interviews and articles in periodicals. Other women made significant contributions as well. The interior decorator Clara Davidge did some last-minute fund-raising among her wealthy clients and friends, getting donations from women such as Gertrude Vanderbilt Whitney and Florence Blumenthal. Sally Stein lent two Matisses, Sarah Choate Sears contributed a Cézanne, and Gertrude Vanderbilt Whitney, Katherine Dreier, and Emily Crane Chadbourne lent additional modernist works from their collections. A substantial number of women also exhibited their works, including (among others) Dreier, Cassatt, Laurencin, and Marguerite Zorach.

Mabel Dodge Luhan later recalled "the excitement of new experience in these men and what they were doing." As she explained, "Most people see as far as the eye permits—Picasso came along and used his optic nerve as an instrument that seemed to overcome the natural boundary and brought new experience to the psyche. Seeing freshly, and putting down on his canvases what he saw, he actually extended the field of vision for the whole world. A new vision captured is a gift of a god." Although Davies and his male colleagues coordinated the show, women such as Luhan, Davidge, and Dreier also played an important, albeit unheralded, role in its success.[4]

The Armory Show was one of the key turning points in American cultural history. According to historian Henry May, it marked one of a series of events that heralded "the end of American innocence" and the "complete disintegration of the old order, the set of ideas which dominated the American mind so effectively from the mid-nineteenth century until 1912." Yet despite the exhibition's undeniable importance, the country's acceptance of modernism was not as abrupt as these interpretations might suggest. Although the Armory Show helped to stimulate American interest in the avant-garde, the battle for acceptance was far from won, and most of the major museums remained icily aloof to the art of the new throughout the 1920s. Although postimpressionist exhibitions were held at such conservative repositories as the Pennsylvania Academy of the Fine Arts and the Metropolitan Museum in 1920 and 1921 and Matisse won the prestigious Carnegie Institute prize at mid-decade, these were fairly isolated events. Indeed, the Metropolitan's postimpressionist show was hardly daring, filled with the works of such popular artists as Degas, Renoir, and Monet, as well as Gauguin and Cézanne. Staged at the behest of a small group of collectors that included Agnes Ernest Meyer, Lillie Bliss, Arthur B. Davies, John Quinn, and Gertrude Vanderbilt Whitney, it featured the tamer examples of French modernist works.[5]

Moreover, it was a loan exhibition. Although the Art Institute accepted Helen Birch Bartlett's magnificent collection of Van Goghs, Matisses, Gauguins, and Seurats in 1925, the Metropolitan was strikingly reluctant to add such works to its permanent collections. John Quinn's offer of a Gauguin in 1915 was summarily dismissed, and Bryson Burroughs, the museum's curator of paintings, "nearly lost his job for buying a Cézanne from the Armory Show" in 1913. Even as late as the 1940s, the Metropolitan's trustees clung to "the dictum . . . that nothing significant ha[d] been painted, molded or wrought since 1900," a notion that seemed to increase in authority with time.[6]
. . .

The Société Anonyme

Katherine Dreier's Société Anonyme . . . challeng[ed] the country's complacency by forwarding a highly cosmopolitan vision of the avant-garde that went far beyond the accepted French and American modernist fare. Her career exemplified another important watershed in the history of American

art. Prior to the Armory Show, both the cause of nonacademic painting and that of the avant-garde were promoted primarily by men, as was the exhibition itself. Alfred Stieglitz, Robert Henri, and Arthur B. Davies have all been amply hailed as pioneers. Afterward, however, the mantle of leadership quietly passed to women such as Katherine Dreier, and by the 1920s a striking share of the major institutional initiatives was in their hands.

There was another subtle difference as well. Stein . . . and Luhan were essentially publicists. Professional writers by training and inclination, they used their craft to promote the modernist cause. During the 1920s, professionally trained artists assumed the lead. Rather than asserting their connoisseurship through the kind of certification that surrounded curatorial work—publications, museum experience, and college degrees—they staked a presence in fields in which museums had little interest, on the basis of their artistic qualifications. As gallery owner Edith Halpert explained, since "there were few publications" in these fields, "one had to rely almost entirely on instinct and visual experience," making the artist's impressions an invaluable guide. In the process, professionally trained women artists, patrons, and gallery owners solidified a new basis for female cultural authority, addressing the community as a whole on artistic matters. . . . Artistic training, rather than college attendance or participation in self-study programs, formed the basis for women's growing cultural leadership in the 1920s.[7]

While Luhan helped to stock and publicize the Armory Show, Dreier carried the message of the avant-garde into the 1920s, inheriting Stieglitz's mantle after 291 closed in 1917. Like Luhan, Dreier had come into contact with Gertrude Stein on one of Dreier's many trips to Europe, which bolstered her early taste for modernist fare. The daughter of a prominent and markedly philanthropic Brooklyn clan, Dreier had followed her older sister, Dorothea, into a painting career, and her other sisters into reform. By the time that Dreier was in her early twenties, she was already a trustee of the German Home for Women and Children and the Manhattan Trade School for Girls, and the veteran of several suffrage campaigns. Another sister, Margaret Dreier Robbins, was also prominently involved in a variety of suffrage and settlement house movements and became a leader of the Women's Trade Union League.

Dreier was a lifelong student of art, beginning with private tutors at the age of twelve. These were followed by terms at the Brooklyn Art Students' League, the Pratt Institute, and the Art Students League in Manhattan, as well as extended sojourns studying in the museums and ateliers of Paris, London, Holland, Germany, and Italy. Her first contact with the avant-garde may have come in the Steins' salon, where Matisse's paintings struck her like an "aesthetic shock [that] . . . left one gasping." The Armory Show also helped to influence Dreier's taste for modernist works. In addition to showing two of her paintings, she lent a Van Gogh, bought a Gauguin, and began to develop an interest in Brancusi's work. Her subsequent friendship with Marcel

Duchamp, the French painter whose work so shocked the visitors to the Armory Show, cemented her interest in the avant-garde.[8]

Dreier was a talented woman who sought to blend her professional pursuits with a messianic zeal inherited from her family. Toward that end, she helped to found the Cooperative Mural Workshops in 1914, gathering a number of men and women artists to make murals, pottery, and needlework designs under the rubric of the arts and crafts movement. She also translated *The Personal Recollections of Vincent Van Gogh* as a means of popularizing the Dutch artist's works. Her most important venture, however, was the Société Anonyme, which she cofounded with Duchamp and the photographer Man Ray in 1920.

Formally chartered as the Société Anonyme, Inc., Museum of Modern Art, the venture was dedicated to the task of broadening the audiences for modernist works. Although it habitually operated on a shoestring budget during its twenty-year existence, the society achieved a remarkable record, providing such luminaries as Paul Klee, Wassily Kandinsky, Fernand Léger, and Joan Miró with their first American one-man shows. It began operations in rented galleries on the third floor of an old brownstone in midtown New York. Guided by the irreverent Duchamp, the society initially attracted sizable audiences for exhibits by featuring such outrageous touches as paintings nonchalantly framed in paper doilies.

However, its tenor grew considerably more somber when Duchamp and Man Ray departed in 1921, leaving Dreier to manage its activities on her own. Although Duchamp is occasionally miscredited as the society's sole originator, he did continue to play an important role in its development long after his departure. In a striking mésalliance of temperament and style, Duchamp and Dreier became close friends, and he remained among her few trusted confidantes throughout her career. Both exhibited at the Armory Show and later became habitués of the salon of the collector Walter Arensberg. Their acquaintance deepened into friendship after the brouhaha surrounding Duchamp's submission of a urinal to the Society of Independent Artists' Exhibition in 1917. Labelled "Fontaine" and signed "R. Mutt," Duchamp submitted the piece as an example of dadaist creativity. The hanging committee was not amused and hid his "sculpture" behind a partition to shield it from public view. Duchamp in turn withdrew it and tendered his resignation to the group.

Dreier begged him not to resign, explaining that she had voted against his offering because, as she delicately put it, she thought it was a "ready-made object" and had therefore failed to fully appreciate its artistic merit. Duchamp was undoubtedly struck (and perhaps delighted) by the absurdity of the exchange, initiating an enduring friendship with the normally dour Dreier. Together, they made a compelling team, blending her determination with his wit in ways that brought out the better qualities in both. Years later, she still sought to lure him back to New York, to bolster the society's lagging

fortunes. As she explained, "If you came over again . . . we might build it up very quickly," adding somewhat pathetically, "I am very anxious to paint again."[9]

Her relationship to Man Ray was more strained, highlighting some of the negative aspects of her personality that undoubtedly undermined her success as an administrator. Apparently, the photographer had a greater flair for creativity than for managing details, a fact that constantly grated on Dreier's nerves. In one instance, she caustically rebuked him for misspelling her sister's name on one of the society's programs; later, she complained that the white ink he used to correct the mistake was applied in "an amateurish way." From missed deadlines to errors in their promotional materials, Man Ray proved a constant source of irritation. "Every now and then I am puzzled by you," Dreier critically informed him. "I do not know of a single artist who is more exact as to his own work than you are, yet in connection with the work you do for others, you slip up in the most surprising manner." Apparently he finally decided that he had had enough, and left.[10]

With his departure, Dreier assumed complete responsibility for the society's fortunes. Her dream, which was captured in the organization's title, was to create a permanent museum filled with avant-garde paintings and statuary gleaned from the far reaches of the Continent, as well as the United States. To quote Dreier, she wanted to "build up something which [would] take hold of the community." Sometimes she cast a longing eye at the Metropolitan. As she explained in a missive to one of her backers, "I feel that we are doing the work which the Metropolitan Museum ought to be doing, and I hope the time will come when we will be embodied in the Metropolitan, and lose our identity in it." As she confided to Duchamp, the lone lecture that she delivered there was one of "the most thrilling experience[s]" of her career. Denied the legitimacy of a permanent museum setting, she nonetheless argued that "museums should have experts on the extreme modern subjects as well as on the Old Masters" and continued jousting at windmills over long years of neglect.[11]

In other instances, she rejected the idea of joining with an established institution, in order to promote the idea of a freestanding museum. As she explained to Arensberg, "The only way to become well known is to have our own building, with [a] permanent exhibition" in addition to special one-man shows. Instead, she was forced to abandon the rented galleries due to declining revenues and to take to the road with a series of peripatetic exhibitions held in everything from museums and clubs to trade schools and department stores. Dreier's mission was considerably complicated by the fact that most major American museums still shunned modernist works, as did many galleries. A few of the more adventurous repositories, such as the Worcester Museum of Art, opened their doors to Dreier's exhibitions with works that spanned the stylistic range from Juan Gris to Piet Mondrian. Most, however, resolutely held her at arm's length.[12] . . .

The high point of the Société Anonyme's program came in 1926, when the Brooklyn Museum allowed her to stage a massive exhibition of European and American paintings. Since the Dreiers were among the museum's most prominent and most loyal contributors, the Brooklyn Museum proved more hospitable than many other leading repositories. The resulting exhibit featured works by artists from twenty-three countries, including such unlikely outposts as Iceland and Romania. American artists such as Alfred Stieglitz and Georgia O'Keeffe were invited to submit works for display, while Duchamp and Wassily Kandinsky helped to secure samples from leading European artists, including members of the German Bauhaus group. Although a few important works were omitted—for example, Walter Arensberg refused to lend Duchamp's historic painting *Nude Descending a Staircase* for fear that it might be damaged en route—the exhibition was a resounding success. Over three hundred pieces were seen by over fifty-two thousand viewers, including representative works by many of the leaders of the European avant-garde.

Although the tenor varied considerably, the exhibition was extensively reviewed, with articles in the *New Republic,* the *Nation,* the *New Yorker,* and a number of newspapers. Some focused on the content of the exhibition, others on Dreier herself. She was an inveterate proselytizer. In addition to coordinating the exhibition, she used the Brooklyn exhibit as a podium for her ideas about the spiritual nature of modern art. From the catalogue, *Modern Art,* to the accompanying lecture series, she infused the event with her belief that art was "a fundamental necessity of life," driving home her themes with the tone of "an inspired religious leader guiding her people toward their long-awaited salvation." . . .

The Société Anonyme was hobbled by its tenuous financial situation, as well as Dreier's messianic zeal. . . .

. . . As she candidly confessed, "Since we were a small organization with little means at our disposal in a field which demands untold resources, we were naturally limited." Since the bills for even a modest one-artist show could run as high as $2,500 for shipping, insurance, and advertising costs, constant fund-raising was imperative and, of course, extremely time-consuming, particularly when individual donors sometimes had to be courted for months or even years to yield a single $100 gift. Dreier's sister Mary donated $1,000 toward the building fund, but most of the other donations were sporadically rendered and usually quite small. Like others before her, Dreier financed many of the expenses out of her own pocket in order to keep the organization alive. She also continually tracked potential donors, relentlessly importuning prominent philanthropists such as Gertrude Vanderbilt Whitney and A.E. Gallatin for funds. Sometimes her appeals were quite ingenious, as when she tried to convince Walter Arensberg's wife that a five-year, $500 pledge would constitute a sound "business investment" since they owned so much modern work.

"The more it is desired," she noted, the more its market value would increase. By 1926 she wearily confided to Duchamp that she was "getting desperate, for everything is so high and so little is coming in."[13]

The Brooklyn exhibit marked the high point of the society's activities and was followed by months of tedious work in shipping the paintings back to their European owners. Although Dreier briefly rented an office on Fifth Avenue to disseminate her short-lived journal, *Brochure Quarterly*, in 1928, most of the time she worked alone, with neither volunteers nor staff, from her apartment on Central Park West. By the 1930s the society's subscription lists had dwindled to a trickle and its activities had almost ceased. After an attempt to turn her West Redding, Connecticut, home into a permanent gallery failed for lack of funds, Dreier managed to institutionalize the collection by donating it to Yale University. After two decades of hard labor and dedicated struggle, the Société Anonyme closed its books in 1941.[14]

The society's programs, and its demise, underscored several recurring themes. One was the role of women artists. Although Dreier was an artist herself and a committed suffragist, women artists received short shrift in the society's collections. Georgia O'Keeffe, Anne Goldthwaite, Marguerite Zorach, Dreier, and her sister figured among the small group of women whose works were collected under the society's auspices, but most of the featured works were by men. . . . Dreier set her feminism aside when it came to art.

Money was another important issue. The Société Anonyme suffered from a chronic lack of cash. Its subscribers provided barely enough to cover its ongoing operating expenses, and although Dreier put together a small board, most of the responsibility for raising funds and coordinating the exhibitions and lectures was hers alone. Unable to marshal the necessary funds or to support the venture herself, she amassed a sophisticated collection but never realized her goal of creating a permanent museum. In effect, she sought to run a museum project like a voluntary association. But because it lacked a separatist ethos, the society also lacked the ready pool of female volunteers that helped to keep a spate of earlier women's voluntary associations alive. Art patronage was an inherently expensive proposition, and even with the best professional alliances, it fell beyond the parameters of middle-class sponsorship when fashioned as a lone crusade.

The Museum of Modern Art

Abby Aldrich Rockefeller and her associates were more successful. The Museum of Modern Art (MOMA) was founded in 1929 by three women: Abby Aldrich Rockefeller, Lillie Bliss, and Mary Quinn Sullivan. The common denominator that united them was their shared commitment to the avant-garde. Beyond this, their personal lives differed markedly.

Sullivan hailed from a surprisingly modest background. The daughter of an Irish immigrant, she was a professionally trained artist and art educator.

She came to New York at the age of twenty-two to study art at the Pratt Institute, then went to the Slade School of Art at University College, London. Later she returned to Pratt as an instructor of design and household arts and sciences, boarding with the Dreier family in their Brooklyn home. This brought her into contact not only with the efforts of the Société Anonyme, but also with Rockefeller, Bliss, gallery owner Edith Halpert, and Arthur B. Davies. . . . [H]er transition to the patron's role was facilitated by her marriage in 1917 to the prominent New York attorney and collector of contemporary art Cornelius Sullivan.

Lillie (or Lizzie) Bliss also had a taste for modern art. Bliss was the daughter of a textile merchant who served as secretary of the interior during the McKinley administration. While Sullivan concentrated primarily on the visual arts, Bliss patronized a variety of cultural enterprises, serving on the advisory committee of the Juilliard Foundation as well as privately supporting a number of artists and musicians, including the Kneisel Quartet. She was also a talented musician who "played the piano well enough to have been a professional, but shied away from public performance."[15]

Painting became one of her consuming interests after she met Arthur B. Davies, who had headed the organizing committee of the Armory Show. . . . Beginning with the Armory Show, she increasingly collected Impressionist and Postimpressionist paintings on his advice. She never married, preferring to care for her parents instead. Her mother disapproved of her taste in art, and so Bliss's collection was initially stored in the basement of her Manhattan townhouse, where it was retrieved for interested visitors piece by piece. Schooled by Davies, Bliss maintained her interest in the avant-garde even in the face of public indifference and parental disapproval, becoming one of the country's most discerning collectors. As in the case of Gertrude Stein, her modernist enthusiasms were tinged with rebellion.[16]

. . . While Sullivan and Bliss helped to found MOMA, Rockefeller became "the heart of the Museum, its center of gravity." At first glance, she seemed an unlikely patron for what many still regarded as radical terrain. Abby Aldrich was the daughter of a United States senator from Rhode Island, who was himself an art collector. Like many fashionable young women of her time, she was schooled by private tutors and at a local girl's academy, Miss Abbott's School, in Providence. Her formal education was capped with the first of several European tours in 1894. This, plus her father's enthusiasm and her frequent trips to the Corcoran Gallery in Washington, whetted her lifelong interest in art. As a girl, she collected drawings and watercolors by Degas, to which she added Old Masters and Italian primitives after her marriage to John D. Rockefeller's only son, John D. Rockefeller, Jr. (JDR Jr.), in 1901.[17]

Abby Rockefeller regarded art as "one of the great resources of [her] life," an interest that she shared with her husband. As in the case of the Havemeyers, she was clearly the more adventurous collector of the two, moving

toward contemporary art while her husband resolutely clung to the art of the past. From the outset, her efforts reflected a sense of mission. As she explained, her interest in modernism initially stemmed from her fascination with the Japanese prints that she collected with her husband, as well as their early American prints, Buddhist art, and their extensive china collection. Although she enjoyed these acquisitions, she began to be nagged by questions about their relevance to the present and their impact on contemporary art. She also thought about the relevance relics such as these would have for coming generations. "Gradually there developed in my mind the thought that probably the coming generation would neither be able to buy the sort of things that we had, nor would they be particularly interested to do so," which in turn kindled her interest in contemporary art.[18]

Rockefeller found an able guide through this uncharted terrain in the owner of the Downtown Gallery, Edith Gregory Halpert. . . .

When she created the Downtown Gallery in Greenwich Village in 1926, only six other New York commercial galleries were showing contemporary American art, and only Stieglitz's Intimate Gallery and one other handled it exclusively. Thirteen years after the Armory Show, Halpert noted, "modern art was still a delinquent and American modern art a family skeleton." The fact that she was a woman gallery owner was also novel. Although interior decorators like Clara Davidge had previously created thriving firms, Halpert knew of only one other female gallery owner, Marie Sterner. "All the rest were men," she later recalled, "and this continued for a long, long time."[19]

Fortunately, "practically all the adventurous collectors of modern art and the majority of the gallery visitors were women," including Dreier, Sullivan, Rockefeller, and Bliss. Halpert's ability to lure these women to her renovated townhouse gallery in Greenwich Village was a testament to her lively personality, her taste, and her entrepreneurial skills. Her block on West Thirteenth Street was peppered with speakeasies. Occasionally, the clients of these establishments would wander into the Downtown Gallery by mistake, where they were "usually horrified" by the "distortions, abstractions, expressionist paintings, and voluminous nudes" that greeted them. The "carriage trade" first made their appearance in 1928, when she held an exhibition of American landscapes that featured a combination of more accessible works of men like Childe Hassam and George Inness with modernist offerings from Joseph Stella, John Marin, Max Weber, and William and Marguerite Zorach. To quote Halpert, the combination provided "an excellent come-on. Dignified, established collectors came to see the old masters and found [the] wild moderns less shocking in this unusual juxtaposition."[20]

Halpert also took a keen interest in the artists whose works she so avidly promoted. As she explained, when she opened the gallery in the 1920s few modern American artists were being exhibited and very little of their work was being sold. She also made it a point to display the works of women artists on the same footing with those of men and to ensure that they were

adequately reimbursed for their works. At a time when the Friends of American Art was paying hundreds of dollars for women's paintings, Rockefeller's purchases occasionally ran into the thousands. According to one source, she even paid the (for her) unprecedented sum of $20,000 for a tapestried portrait of her family commissioned from Marguerite Zorach. She also bought substantial numbers of works by Peggy Bacon, Anne Goldthwaite, and Georgia O'Keeffe, many of which were subsequently donated to MOMA.[21] . . .

For her husband, JDR Jr., Rockefeller's growing enthusiasm for modernism was a bewildering transition. As he confided to his biographer, "I wasn't particularly interested in [Italian primitives] at first, but we kept them and studied them and finally commenced to buy them. And then all of a sudden my wife, who was very catholic in her tastes and loved all sorts of beautiful things, became interested in modern art." He responded with the plaintive complaint that "I have spent years trying to cultivate a taste for the great primitives, and just as I begin to see what they mean you flood the house with modern art!"[22]

Despite a shared interest in art, Rockefeller was never able to convince her more conservative spouse of the value of modern paintings and sculpture. Nor were other family members particularly encouraging. Her sister, Lucy, greeted her purchase of a Matisse with suggestions that only a flawed character could have inspired such a choice. Perhaps girded by their resistance, her interest in modern art became a rebellious and "consuming interest." As her biographer explains, Rockefeller "believed devoutly in her own time" and had "a passionate faith in the new and the untried," as well as a desire to aid young artists at an early stage in their careers.[23] Her husband, on the other hand, continued to immerse himself in Chinese and medieval artifacts. . . .

His interest in architectural restoration and medieval art merged in his museum, the Cloisters. JDR Jr. developed several major cultural projects during his lifetime, offering almost $3 million to the French government for the restoration of Versailles, Fontainebleau, and Rheims after the First World War and another $1 million to the Oriental Institute at the University of Chicago. The Metropolitan Museum of Art also received a $1 million gift from him for its endowment in 1924, as well as smaller grants to build up the museum's medieval collections. The idea for the Cloisters gradually took shape through his friendship with the eccentric American sculptor George Grey Barnard. Barnard had made a hobby of combing the European countryside for stray fragments of Romanesque and Gothic sculpture, which he pieced together in his collection in New York.

JDR Jr. was equally enamored of medieval art, and sometime after 1914 Barnard began to sell him assorted pieces from Barnard's collection, which JDR Jr. dutifully carted off to the family's estate in Pocantico Hills. When the sculptor put his entire collection up for sale in 1922, however, JDR Jr. acquired it as a nucleus for his medieval museum, the Cloisters, which opened in Fort

Tryon Park in 1930. Unlike the Société Anonyme, this venture was well endowed from the outset. JDR Jr.'s initial $1 million donation was followed by several others, totalling an estimated $20 million over the course of his lifetime.

Immersed in his medieval collections, he regarded his wife's enthusiasms with "uneasy tolerance." As he explained, "We never lack material for lively arguments. Modern art and the King James Version can forever keep us young." To JDR Jr.'s "more conservative eye the cubes, splotches and distortions of modern art had little to do with beauty, and although he listened patiently to his wife's expositions and calmly observed his home being invaded by modern paintings, he remained unconverted." A friend later recalled a dinner at which Matisse was among the guests. The artist soon was engaged in a spirited discussion with JDR Jr., explaining the similarities between modern abstractionism and the artistic principals of the artisans who crafted Chinese porcelains. To which JDR Jr. replied in impeccable French that, although he remained unconverted and "might still seem to be of stone, he suspected that Mrs. Rockefeller, thanks to her very special gifts of persuasion, would eventually wear him down to the consistency of jelly."[24]

Like her friend and fellow collector Lillie Bliss, Rockefeller deferred to her family's tastes and kept her modern pieces hidden from view on the top floor of their New York townhouse, in the children's old playroom, which she converted into her private gallery. She made her acquisitions from a separate pot of money as well; Rockefeller underwrote her modern art collection with the "Aldrich money" that she had inherited from her father. Her records reveal that most of these paintings were purchased for very small sums. The most expensive single painting was an Odilon Redon, purchased for $2,550 in 1928, followed by a Georgia O'Keeffe, which she bought for $1,900 in 1931. She paid $1,200 for a painting by John Marin and a like amount for a Maurice Prendergast. Diego Rivera was well represented, including a batch of forty-five small watercolors and one pencil drawing for which she paid $2,500. By 1933 her annual art purchases totalled almost $46,000, which was still a fraction of the over $1.2 million that her husband paid for the unicorn tapestries that he donated to the Cloisters.[25]

Despite the disparity in their outlays, JDR Jr. dismissed her plans for MOMA as "Abby's folly." And yet, to quote Raymond Fosdick, "nothing outside her family so captured her interest." Several histories trace the museum's inception to a chance meeting between Rockefeller, Sullivan, and Bliss on a winter tour to Egypt. Rockefeller's own description presents a somewhat different evolution. According to her version, the idea for MOMA was inspired by her visits to comparable European repositories, and her growing conviction that "the time had come when the people of the United States were sufficiently interested . . . to warrant a reasonable expectation that they would support a museum."[26]

She tested this idea in conversations with a number of prominent museum representatives who seemed unusually attuned to the contemporary works that their institutions excluded. Edward Harkness encouraged her "because he felt that the Metropolitan Museum was not the place in which contemporary art should be shown." Chicagoan Martin Ryerson was also an influential counsellor, as was William Valentiner at the Detroit Institute of Arts. "Then I began to think of women whom I knew in New York City, who cared deeply for beauty and bought pictures, women who would be willing and had faith enough to start a (real) museum of contemporary art," Rockefeller recalled, eventually settling on two other Halpert clients, Sullivan and Bliss.[27]

Rockefeller admitted to being "still very much thrilled with the idea of our venture" when the plans were first drafted in 1929. Although the trustees tried to build a broad base of support from the outset, Rockefeller quickly emerged as one of the museum's key backers, regularly supplying a major portion of its operating expenses. She also guided its management, particularly after the other founders passed from the scene. Mary Quinn Sullivan resigned from the board in 1933, after the death of her husband, and Lillie Bliss died in March 1931. Although Rockefeller may have had misgivings about having the institution too closely associated with her family alone, MOMA quickly emerged as a Rockefeller "protectorate."[28]

One of the most surprising decisions in those early years was the selection of A. Conger Goodyear as president. Goodyear was a respected collector and a trustee (and briefly, president) of the Albright Gallery in Buffalo. He had attracted a fair amount of notoriety in his dealings with the Albright by authorizing the purchase of a Picasso and opening its halls to an exhibition from the Société Anonyme. The fact that MOMA began operations by putting a man at the helm remains somewhat puzzling. Most of the women who created museums sought to retain tight control, as did Gardner, or had it wrested from them, which was the case at Cooper-Hewitt. The answer may lie, in part, in Rockefeller's nature. Several sources maintain her aversion to publicity, which may have stemmed from the public attacks that were levelled at her father during his senatorial years and at her husband during the congressional investigations of Standard Oil. By putting a man in charge, she may have sought to deflect attention from her own actions and from the Rockefeller name.[29]

Another puzzling question is why, unlike almost all of the other specialized museums created by women, MOMA was cast as a small "nonprofit corporation" from its inception. Certainly, Rockefeller would have had ample precedents for this type of organizational form. Her father-in-law created (and her husband presided over) some of the country's earliest and most influential foundations; and the University of Chicago was another major Rockefeller project. Many of her most trusted advisors, such as Harkness, Valentiner, and Ryerson, were directors or trustees of major museums. Moreover, she was undoubtedly familiar with Katherine Dreier's efforts, which

may have underscored the problems inherent in institutionalizing relatively unassisted campaigns. As a "nonprofit corporation," MOMA theoretically would have an entire board to garner collections and funds from all parts of the community, rather than relying solely on the efforts of the three founders. Whatever their reasons, MOMA's founders shunned the limelight, preferring to help run their museum from the sidelines while publicly entrusting it to the management of men.

Despite Goodyear's appointment, the founders continued to exercise their control in other, more subtle ways. Goodyear constantly conferred with Rockefeller during the museum's early years, soliciting her advice on almost every decision. She occasionally overruled some of his. For example, Rockefeller suggested that Duncan Phillips might be a good addition to the board, one that could "strengthen our position with the younger artists of the country, for whom he has done so much." Goodyear sought to veto this idea, arguing that Phillips would not be active enough, since "he is so much interested in building up his own collection." Nonetheless, he was invited to serve.[30]

The founders and the organizing committee (which included, among others, Frank Crowninshield, the editor of *Vanity Fair;* Paul J. Sachs of Harvard's Fogg Museum; and Mrs. W. Murray Crane, the widow of the former governor of Massachusetts, and one of Rockefeller's friends) constituted the nucleus of the first board. An advisory committee of younger connoisseurs was soon added, headed by one of Rockefeller's sons, Nelson Aldrich Rockefeller. By 1931 Nelson presided over most of the museum's regular committees as well, and joined the Executive Committee the following year. Even before his graduation from Dartmouth in 1929, Abby confided to him that "it would be a great joy" to her "if you did find that you have a real love for and interest in beautiful things. We could have such good times going about together, and if you start to cultivate your taste and eye so young, you ought to be very good at it by the time you can afford to collect much." In effect, she used the museum as a means of encouraging her son to share her own enthusiasm for collecting and for modern art.[31]

Other slots were filled with the aid of the board. Paul J. Sachs nominated Alfred H. Barr, Jr., to serve as the director. Sachs first met his nominee when Barr was an undergraduate in his museum course at Harvard. In addition to his academic skills, Barr had helped to found the Harvard Society for Contemporary Art, Inc., using two rooms in the university's bookstore, "the Coop," for a gallery. Lincoln Kirstein was a charter member, as was Edward M.M. Warburg, who later served as a MOMA trustee. Barr also developed what may have been the country's first college course on twentieth-century painting, music, theater, and industrial design at Wellesley, which he was teaching when Sachs recommended him. After a couple of interviews at the Rockefeller's summer home at Seal Harbor, Maine, the appointment was approved, and Barr was added to the staff.

Backed by almost fifty charter subscribers, MOMA finally opened in rented quarters in the Heckscher Building at Fifty-seventh Street and Fifth

Avenue in November 1929. The "Founder's Manifesto" promised to hold regular exhibitions of the works of leading contemporary European and American artists, and to create a permanent public museum of modern art. The content of the first exhibition was determined after lengthy negotiations between Rockefeller, Bliss, Barr, Goodyear, and Sachs. While the men opted for a small show of American painters such as Ryder, Homer, and Eakins, to be followed by one of the European masters Seurat, Van Gogh, Gauguin, and Cézanne, Bliss and Rockefeller voted to open with the European group instead. As Rockefeller explained, the European exhibit would be more "chronologically appropriate" and less likely to become embroiled in the factions that surrounded the works of American artists. The "adamantine ladies" prevailed, and the museum opened with an exhibition of ninety-eight paintings by the four Europeans, many of which had been borrowed from private collections and never before publicly seen in New York.[32]

The reviews were almost uniformly enthusiastic. Lloyd Goodrich announced in his article in the *Nation* that "just as the great Armory Show of 1913 was the opening gun in the long, bitter struggle for modern art in this country, so the foundation of the new museum marks the final apotheosis of modernism and its acceptance by respectable society." The *Outlook* predicted that MOMA would serve as a "supplementary museum" to the Metropolitan, testing new art forms, after which the most enduring would be acquired by larger, more established repositories. Others criticized the Metropolitan Museum while lauding MOMA. Thus, noted an article in *Literary Digest*, "efforts to 'crash the gates' of the Metropolitan Museum by the modernists have proved so often a thankless and futile task that now the tide has gone elsewhere."[33] . . .

The 1920s are often viewed as an era when philistinism was paramount. However, the work of Abby Aldrich Rockefeller and Katherine Dreier reveals that it was also a key period of institutional experimentation, particularly within the avant-garde. Women were able to take the lead in these areas precisely because this type of art was undervalued among more traditional collectors, and still held at arm's length by the major museums. Excluded from decision-making roles within the country's major repositories and hampered by relatively limited resources, women cast their lot with contemporary art and artists, laying the groundwork for America's bid for international primacy within the avant-garde.

In many respects, the efforts of women such as Rockefeller, Edith Halpert, and Gertrude Stein constituted a form of rebellion. This was an era when modernism was still steeped in an aura of radicalism. Many contemporary artists such as John Sloan and Robert Henri cut their teeth on radical causes and socialist journals such as the *Masses*, espousing causes that carried over into the careers of other controversial painters such as Diego Rivera. With the advent of the Red Scare in the early 1920s, activities such as these became increasingly suspect. Even the internationalism embodied in avant-garde activities grated against the ethos of Jazz Age isolationism. As Alfred

H. Barr, Jr., explained, "In her position, the outside world took for granted that [Rockefeller] could do almost anything her wealth and power would permit," but "few realize[d] what positive acts of courage her interest in modern art required." Not only was this field "artistically radical, but it is often assumed to be radical morally and politically, and sometimes, indeed, it is. But these factors, which might have given pause to a more circumspect or conventional spirit," did not deter her, "although on a few occasions they caused her anxiety, as they did us all."[34]

Their efforts also served as an index of the growing acceptance of female individualism. . . .[P]atrons like Rockefeller challenged the old constraints in new ways. Their activities reflected the growing array of professional and philanthropic options that opened to women after the turn of the century. Thus, Edith Halpert not only studied art, but pursued a lucrative commercial career after she wed. And Rockefeller, Sullivan, and Bliss pooled their money, as well as their talents, to reshape the "nonprofit corporation" to fit the contours of a highly specialized new field.

Some women, like Isabella Stewart Gardner, had adopted the individualist's role with relish, revelling in their influence and the challenges inherent in their campaigns. Others, like Rockefeller, adopted the role more surreptitiously, quietly refusing to bear the yoke of familial constraints. Still others, such as Katherine Dreier, inherited it by virtue of the unpopularity of their causes, mounting lone crusades. . . .

Their activities . . . differed from those of their male peers in several respects. Women like Dreier and Rockefeller shared their enthusiasm for modernism with a small number of seasoned male missionaries and connoisseurs such as Alfred Stieglitz, Arthur Jerome Eddy, A.E. Gallatin, John Quinn, Alfred Barnes, and Walter Arensberg during the opening decades of the twentieth century. Yet on the whole, their contributions tended to test the outer limits of even this group, in terms of both the scope of their connoisseurship and the importance of the institutions they created. . . .

What distinguished Dreier's efforts, and those of MOMA as well, was the catholicity of their definitions of modernist fare. . . . [A]lthough crusaders like Dreier and Rockefeller shared the field with a number of talented and committed male connoisseurs, they took the lead in testing the most uncharted terrain. In the process, they helped not only to legitimize, but to redefine the avant-garde.[35]

Notes:

1. Madel Dodge Luhan, *European Experiences* (New York: Harcourt, Brace and Co., 1935), 322, 323; Hobhouse, *Everybody Who Was Anybody*, 61.

2. The Cone sisters and their collection are described in Brenda Richardson, *Dr. Claribel and Miss Etta* (Baltimore: Baltimore Museum of Art, n.d.).

3. Milton W. Brown, *The Story of the Armory Show* (New York: Abbeville Press, 1988), 131.

4. Luhan, *European Experiences*, 322–23.

5. Henry F. May, *The End of American Innocence: A Study of the First Years of Our Own Time, 1912–1917* (Chicago: Quadrangle Books, 1959), 393.

6. Avis Berman, *Rebels on Eighth Street: Juliana Force and the Whitney Museum of American Art* (New York: Atheneum, 1990), 172, 440.

7. Edith Halpert, "Folk Art Collecting in America," Downtown Gallery/Edith Halpert MSS, reel 1883, frame 282, AAA.

8. Dreier, quoted in Ruth L. Bohan, *The Société Anonyme's Brooklyn Exhibition: Katherine Dreier and Modernism in America* (Ann Arbor: UMI Research Press, 1982), 6.

9. Katherine Dreier to Marcel Duchamp, April 13, 1917, and April 23, 1925, "Duchamp, 1917–1927" folder, box 14, Société Anonyme MSS (hereafter cited as SA MSS), Beinicke Library, Yale University.

10. Katherine Dreier to Man Ray, April 26, 1921, "Man Ray" folder, SA MSS.

11. Katherine Dreier to Mrs. Louise Arensberg, February 5, 1923, "Arensberg" folder; Dreier to Marcel Duchamp, March 8, 1928, "Duchamp, 1928–29" folder; Dreier to Charles Worcester, February 1, 1923, "Art Institute" folder; all in SA MSS.

12. Katherine Dreier to Walter Arensberg, June 23, 1925, "Arensberg" folder, SA MSS.

13. *Collection of the Société Anonyme: Museum of Modern Art, 1920* (New Haven: Yale University Art Gallery, 1950), xv; Katherine Dreier to Louise Arensberg, February 5, 1923, "Arensberg" file, SA MSS: Katherine Dreier to Marcel Duchamp, January 10, 1926, "Duchamp, 1926–27" folder, SA MSS.

14. The collection is described in *Collection of the Société Anonyme.*

15. "She Fought the Battle for Modern Art," *Literary Digest* 109 (June 6, 1931): 17.

16. Ibid. According to Dore Ashton, "The museum was essentially the dream of an artist, Arthur B. Davies." *The New York School: A Cultural Reckoning* (New York: Penguin Books, 1979), 100. However, years later Rockefeller admitted to being puzzled about people's notions about Davies's connection with the museum's inception. As she explained, although she had purchased some of his watercolors in the late 1920s, "I do not remember meeting him until after [the museum] was well under way." Letter to A. Conger Goodyear, March 23, 1936, p. 2, Museum of Modern Art Archives, Alfred H. Barr, Jr., MSS, reel 3264, frame 1130, AAA, (hereafter cited as Barr MSS).

17. Mary Ellen Chase, *Abby Aldrich Rockefeller* (New York: Avon Books, 1950), 125.

18. Abby Aldrich Rockefeller to A. Conger Goodyear, March 23, 1936, p. 1, Barr MSS, reel 3264, frame 1130.

19. Edith Halpert, "The Village/Past," Downtown Gallery/Edith Halpert MSS, reel 1883, frame 24; Edith Halpert, "Talk at Detroit Institute of Art, September 18, 1963," Downtown Gallery/Edith Halpert MSS, reel 1883, frame 915.

20. Halpert, "Talk at Detroit Institute of Art"; Edith Halpert, "Chicago, November 9, 1948," typescript speech, Downtown Gallery/Edith Halpert MSS, reel 1883, frames 454, 455.

21. The price on the Zorach tapestry is cited in Aline B. Saarinen, *The Proud Possessors: The Lives, Times, and Tastes of Some Adventurous American Art Collectors* (New York: Random House, 1958), 361. The Rockefeller/Halpert alliance spread into other areas as well, particularly folk art. While Candace Wheeler attempted to raise women's traditional household crafts to the level of fine art as a route to female self-support, women like Rockefeller, Halpert, and another of Halpert's clients, Electra Havemeyer Webb, set aside charitable considerations to win these humble artifacts a place in the nation's artistic canon on the basis of their inherent aesthetic merits alone. Halpert was initially attracted to the field for financial reasons. As she later explained with great candor and not a little relish, since contemporary art was not widely appreciated, "dead men" (i.e., folk artists) supported her gallery and paid the deficits. Even when contemporary American art did not sell, folk art did, helping to subsidize the gallery's efforts on behalf of living artists. A few others had already preceded her in the celebration of folk art. For example, the painter and editor Hamilton Easter Field set up a collection at his artists' colony at Ogunquit, Maine, where the Halperts also summered. Another of the Halperts' haunts, the Whitney Studio Club, held the first exhibition of folk art in America in 1924, at about the time that one of her protégés, Elie Nadelman, opened an impromptu folk art museum in Riverdale, New York. Halpert helped to increase the popularity of these art forms, as well as their commercial value. She began collecting old pictures, samplers, and weather vanes at rummage sales on her trips through New England. In 1929 she launched the American Folk Art Gallery as part of her commercial operations. The first of its kind, the gallery pioneered in staging exhibitions at its New York headquarters and in museums throughout the country. In Halpert's opinion, folk art reflected the same reverence for design that distinguished contemporary art. Men also collected these homely artifacts and staged early exhibitions such as the one coordinated at the Newark Museum by Halpert's colleague and Rockefeller's advisor, Holger Cahill. But women took an early lead in institutionalizing folk art within specialized museums. Rockefeller began collecting in this area when Halpert's gallery opened; her acquisitions were later transferred to the Abby Aldrich Rockefeller Museum of Folk Art in Williamsburg, Virginia.

22. Raymond B. Fosdick, *John D. Rockefeller, Jr.: A Portrait* (New York: Harper and Bros., 1956), 328.

23. Mary Ellen Chase, *Abby Aldrich Rockefeller*, 118, 119.

24. Russell Lynes, *Good Old Modern: An Intimate Portrait of the Museum of Modern Art* (New York: Atheneum, 1973), 345; John Ensor Harr and Peter J. Johnson, *The Rockefeller Century: Three Generations of America's Greatest Family* (New York: Scribner's Sons, 1988), 218; Fosdick, *Rockefeller*, quoting Frank Crowninshield, 329.

25. "Fifty-third Street Patron," *Time* 27 (January 27, 1936): 28; Abby Aldrich Rockefeller MSS (hereafter cited as AAR MSS), box 34, Rockefeller Archive Center, Pocantico Hills, New York: "Abby Aldrich Rockefeller Art Account, 1933," Abby Aldrich Rockefeller Personal Correspondence, "Personal General 1909–1937," AAR MSS; Russell Lynes, *Good Old Modern*, 345.

26. Alice Goldfarb Marquis, *Alfred H. Barr, Jr.: Missionary for the Modern* (Chicago: Contemporary Books, 1989), 89, 90; Fosdick, *Rockefeller,* 328; Abby Aldrich Rockefeller (hereafter cited as AAR) to A. Conger Goodyear, March 23, 1936, p. 4, Barr, MSS, reel 3264, frame 1133. For a different interpretation of the museum's genesis, see Russell Lynes, *Good Old Modern,* and Saarinen, *Proud Possessors,* 363–64.

27. AAR to A. Conger Goodyear, March 23, 1926, pp. 2–3, Barr MSS, reel 3264, frames 1130–33.

28. AAR to A. Conger Goodyear, July 26, 1929, Box 25, folder 1, AAR MSS; Russell Lynes, quoted in Harr and Johnson, *Rockefeller Century,* 219.

29. As Mrs. Rockefeller later explained to Goodyear, they settled on his appointment because "we had been told of your efforts in the cause of modern art in Buffalo, and that you had resigned the presidency of that museum because the trustees would not go along with you in your desire to show the best things in modern art." AAR to Goodyear, March 23, 1926, p. 2, Barr MSS, Reel 3264, frame 1130.

30. AAR to A. Conger Goodyear, July 31, 1929; A. Conger Goodyear to AAR, August 7, 1929; both in box 25, folder 1, AAR MSS.

31. Quoted in Marquis, *Alfred H. Barr, Jr.,* 62.

32. A. Conger Goodyear cable, September 4, 1929; AAR to Alfred Barr, Jr., August 23, 1929; both in box 25, folder 1, AAR MSS. As Rockefeller explained to Barr in a missive of August 20, 1929, "Miss Bliss and I feel great hesitation about making the first exhibition only American." I would like to thank Darwin Stapleton for this citation.

33. Lloyd Goodrich, "A Museum of Modern Art," *Nation* (December 4, 1929): 664; "Meeting a Need," *Outlook* 53 (September 18, 1929): 98; "Modern Museum Makes Its Bow," *Literary Digest* 103 (November 23, 1929): 19.

34. Alfred H. Barr, Jr., to Nelson Rockefeller, April 17, 1948, p. 1, Barr MSS, reel 3264, frame 1000. For a fuller account of the association of modern art with radicalism, see Serge Guilbaut, *How New York Stole the Idea of Modern Art: Abstract Expressionism, Freedom, and the Cold War* (Chicago: University of Chicago Press, 1983); and Dore Ashton, *New York School.*

35. Milton W. Brown, *American Painting,* 98, 97.

Part III

Art and Politics

Since antiquity art has been inextricably intertwined with politics. Assyrian reliefs at the Palace of Ashurbanipal, Roman triumphal arches and honorific monuments, Byzantine mosaics at San Vitale in Ravenna—all intended to convey particular concepts of authority to their societies. Throughout civilizations around the world, architecture, painting, sculpture, and prints have made statements regarding specific rulers, liberty and tyranny, government and the individual, war and peace.

In "Art and Freedom in Quattrocento Florence," Frederick Hartt persuasively argues that during the Early Renaissance the development of a humanistic style in sculpture was linked to contemporary political events in fifteenth-century Florence. Statues commissioned by influential workers' guilds for Orsanmichele and Florence Cathedral were responses to repeated political threats to the Florentine Republic by outside tyrants during the first thirty years of the century. Humanistic representations of saints and prophets by Donatello, Ghiberti, and Nanno di Banco, among others, portrayed exemplars of civic pride, *virtùs*, and *probitas*, ideals of Florentine citizenship. The human and personal relevance of these figures extended beyond their realistic features to embody a psychological conflict between duty and private emotion.

According to Hartt, painting was not as progressive in adopting the new style at the beginning of the century; however, in 1425 Masaccio's Brancacci Chapel frescoes established a humanistic pictorial approach. Just as public sculpture provided models for civic-minded action, Masaccio's *Tribute Money* addressed a pressing need for increased revenues for a Florentine treasury severely depleted by war and an economy weakened by bank failures. Through a biblical story *The Tribute Money* declares taxation a civic duty, a discussion soon to be undertaken in Florence in 1427 with the initiation of the *Castato,* an ancestor to our modern income and property taxes.

While early Quattrocento art provided clear paradigms of civic behavior, in early nineteenth-century France painters were commissioned to fashion a popular image for Napoleon Bonaparte. The ambivalence evident in these images is somewhat different from the psychological complexity of images of Florentine saints and prophets. In "The Iconography of Napoleon," from his study *Art in the Age of Bonapartism 1800–1815,* Albert Boime states: "The demand for a new realism to accommodate the new data of experience and the desire to retain the mythic components of tradition stamp the Napoleonic imagery with its hybridized tension." In battle imagery of Napoleon and in portraits as first consul and emperor, one can identify an uneven, sometimes dangerous terrain of political transformations and ideological developments.

Sometimes mythological or historic references within Napoleonic imagery can be startling. Napoleon's self-identification with Ossianic heroes is captured in paintings that blend characters from McPherson's famed Celtic epic with contemporary French military figures. A religious implication may be read into Girodet's *Burial of Attala* with its references to Chateaubriand's Catholic revivalism. Boime likewise explores the propagandistic intention of Gros in his painting *Napoleon in the Pesthouse at Jaffa* as Napoleon is endowed with divine power to heal, projecting and justifying his future elevation to emperor.

Propagandistic art has been an important tool for shaping public opinion for various governments throughout the world, and as Toby Clark demonstrates in "Propaganda in the Communist State," nowhere more so than in the Soviet Union during its formation and halcyon years. A state-mandated artistic style, Socialist Realism, was imposed by Josef Stalin in 1934. Governmental control over the arts did not coincide with the October 1917 revolution and its aftermath, a period when experimentation and abstraction were encouraged, when works by avant-garde artists heralded a new future. This relative freedom of expression was discouraged by the Bolshevick leader Lenin who grew suspicious of non-representational paintings and equated art with the education of the masses.

Unlike Napoleonic paintings, which glorified one man, Soviet Socialist Realism represented a world of heroes and heroines who personified political ideas and the ideal Soviet comrade—workers, soldiers in the Red Army, schoolchildren involved in Communist party activities. Yet they cannot be viewed as the modern Soviet counterparts to the Florentine saints because there is no ambivalence in these images, no deeper psychological complexity. They are eternally optimistic, willing builders of the future greatness of their country, intentionally simplistic.

Stalin, like Napoleon, acknowledged the power of imagery in shaping public opinion and invented a personality cult partially through painted portraits that presented him as a benevolent patriarch, whether shown among workers, soldiers, or fellow politicians. It is interesting to note that after

Stalin's death in 1953 and his renunciation by Nikita Krushchev in 1956, many artworks created during the Stalinist period were destroyed. But Socialist Realism continued to be the official style through which the Soviet citizen was heroicized. It was not until the 1960s and 1970s that dissident art activists promoted unorthodox styles and defied Party regulations by mounting unauthorized exhibitions. During the 1980s, with the increased openness brought about by "glasnost," non-conformist art became increasingly visible.

In a 1984 article published in *The New York Times,* Michael Brenson posed the question, "Can Political Passion Inspire Great Art?" Attempting to understand the pervasive interest in political issues at that particular time, Brenson is concerned that the definition of "politics" has become so all-encompassing that it obscures artistic criteria. Recalling earlier political statements by individual artists like Goya or groups such as the Soviet Agitprop or post-World War I German Expressionists, the author cautions contemporary artists against producing conceptually and aesthetically weak art under the guise of political conviction. Surveying topical issues of interest to 1980s artists (nuclear threat; feminism; violence in the Middle East, Africa, and Central America), he identifies artists who have transcended mere politics to create timeless works of art—including Robert Morris, Barbara Kruger, Nancy Spero, and Leon Golub. Brenson's conclusion that forceful political art can only emerge from a "synthesis of immediate observation, craft, and the lessons of time—from the testing of political facts against one's own experience . . ." can be applied to art from any era and any country, whether it be Quattrocento Italy, Napoleonic France, Soviet Russia, or contemporary America.

Chapter 7

Art and Freedom
in Quattrocento Florence

Frederick Hartt

. . . The present study is an attempt to examine one of [the] classic styles, unpredictable in origin and meteoric in development—the early Florentine Renaissance—in terms of the continued crisis which in the first three decades of the Quattrocento confronted the entire population of Florence, including the artists, with a series of difficult and fundamental decisions, on whose outcome depends to a surprising degree the whole subsequent development of Renaissance and post-Renaissance art and culture. . . .

. . . [B]y common consent, the earliest fully Renaissance work of art seems not to have been a painting but a statue, the *St. Mark* carved in marble by Donatello for the niche of the *Arte dei Linaiuoli e Rigattieri* on the exterior of the grain exchange of Orsanmichele in Florence, between 1411 and 1413,[1] ten years or so before the newly discovered earliest work of Masaccio.[2] Although the surrounding niche was carried out by the minor masters Perfetto di Giovanni and Albizo di Pietro still working in a florid Gothic tradition, it emphasizes by contrast the revolutionary nature of Donatello's statue. The dignity and intensity of the characterization, the forcefulness of the pose and glance, the sense of the three-dimensional structure of the body under the drapery masses, all proclaim this statue as a direct ancestor of the powerful figures of Masaccio. H. W. Janson has written that this statue "is in all essentials without a source. An achievement of the highest originality, it represents what might almost be called a 'mutation' among works of art."[3]

But what of painting meanwhile, surely the leading art in the Florentine Trecento? One may look in vain for a painting datable in the second decade of the fifteenth century which shows a glimmer of the new style. The Florentine pictorial *botteghe* were numerous and active, turning out fantastic quantities of panels and frescoes in a number of personal styles, often highly accomplished and sometimes of the greatest beauty, all generally comprised under the loose category of the late Gothic. Gherardo Starnina, Lorenzo Monaco, Niccolò di Pietro Gerini and Lorenzo de Niccolò, Mariotto de Nardo, Francesco d'Antonio, Rossello di Jacopo Franchi, the Master of the Bambino Vispo, the Master of 1417, the young Giovanni dal Ponte, Bicci di

From *Essays in Honor of Karl Lehmann*, ed. Lucy Freeman Sandler. Copyright © 1971 by New York University, Institute of Fine Arts. Reprinted by permission of the publisher.

Lorenzo, continue working as if Donatello had never created the *St. Mark*. Traditional or visionary architectural settings, Giottesque or fantastic landscape backgrounds, Trecentesque or International Gothic figures and drapery, constitute the repertory of these busy and frequently prosperous practitioners who were not to be deflected from their course until the arrival of Gentile da Fabriano in Florence in 1421 and the first revelations of Masaccio soon thereafter. But when these two formidable revolutionaries had disappeared from the Florentine stage, few of the older artists still alive showed any real recognition of the new possibilities open to the art of painting, and systematically exploited by the sculptors.[4] Not until the first dated works of Fra Angelico, Fra Filippo, and Paolo Uccello in the 1430's does painting begin to occupy in earnest the position Gentile and Masaccio had conquered for it, and not until the middle of the century were the last defenders of the late Gothic subdued in Florence.

The sudden mutation, as Janson puts it, that brought forth Donatello's *St. Mark* is no harder to understand than the astonishing discrepancy between the nature, aims and values of sculpture and painting in the early Quattrocento, a divergence about which no deterministic theory can inform us. In trying to account for this extraordinary split I became conscious of a guilelessly simple fact: all the surviving paintings of the 1420's in Florence were altarpieces and frescoes for the interiors of churches or of chapels within churches, or else street tabernacles, and all were intended for the aesthetic enhancement of worship or the provocation of solitary prayer and meditation. All the statues, and there was a host of them, were destined for the exteriors of two churches of predominantly civic character, and all were addressed to the imagination of the man in the street. Some, in fact, were placed hardly above the street level. To put it simply, in the second decade of the Quattrocento, Florentine painting was characteristically other-wordly, even mystical, dominated by the churches and even the monasteries (Lorenzo Monaco, the leading master, was a monk in the important Camaldolite monastery of Sta. Maria degli Angeli), while contemporary sculpture was increasingly humanistic and naturalistic, dominated by the guilds or by committees chosen by and responsible to the guilds. Between 1399 and 1427 no less than thirty-two over-lifesize male figures made their appearance in the center of Florence, eighteen on the Cathedral and fourteen at Orsanmichele, representing the work not only of the great masters Donatello and Ghiberti, and somewhat lesser artists such as Nanni de Banco and Nanni de Bartolo, but relatively standardized practitioners like Niccolò de Pietro Lamberti and Bernardo Ciuffagni.[5]

The saints at Orsanmichele and the prophets and evangelists at the Duomo share a surprising degree of emotional intensity, resulting in expressions which range from the deeper inner reflection of Ghiberti's *St. Matthew* . . . to the violent excitement of Donatello's *St. Mark* . . . , with his disordered locks, rolling eyes, quivering features and writhing beard. The poses vary

Donatello, **St. Mark.** *Orsanmichele, Florence. 1411–1413, Marble. (Archivi Alinari/Art Resource, NY)*

from the classic balance of Ghiberti and Nanni de Banco, reminiscent of Greek and Roman philosopher portraits . . . , to the extreme turbulence of Donatello's prophets from the Cathedral campanile. But in each case the ideal person is depicted less as a static monument to sanctity, with uncommunicative features in the manner of Gothic cathedral sculpture, than as subject to a psychic state provoked partly by what he perceives in the outer world, partly by his inner contemplation of himself. These saints and prophets seem aware of opposition from without, against which they must summon up the full resources of their personalities. Sometimes they show confidence in their strength, sometimes alarm at the suspicion of their inadequacy, but always their reactions to the world they confront betray a profound realization of the conflicting forces among which they must struggle to maintain an equilibrium. The fact that these unprecedented characterizations owe their existence to their role as protectors and defenders of the guilds suggests a brief reconsideration of the familiar features of the Florentine state.

At the opening of the fifteenth century, Florence was an artisan republic exclusively controlled by the guilds. There were seven major guilds and a constantly varying number of minor ones, some of whom—the so-called *arti median* or median guilds—were eventually admitted on sufferance to the major group.[6] Through the Guelph party, the only legal party in Florence, traditionally but by no means consistently the supporter of the Papacy, the guilds controlled the government of the republic.[7] The great humanistic scholars and writers of the early Quattrocento were guild members and so, by no means incidentally, were all the artists. The painters belonged to the guild of physicians and pharmacists,[8] the sculptors, insofar as they were metal workers, to the guild of silk merchants; both were counted among the all-powerful major guilds. Sculptors who began and continued as stonecutters were relegated to the secondary guild of the masters of stone and wood.

In a series of brilliant studies, summed up and expanded in an indispensable book,[9] Professor Hans Baron has shown in detail how this guild republic, long vigorously maintained through the passing dictatorships, famines, pestilences, financial crashes and revolts of the Trecento, had found itself around the year 1400 engaged in a life and death struggle with a wholly different polity which threatened to engulf it—the fast-growing, militant duchy of Milan. Florentine writers, Baron has shown, spare no words to express their hatred of the Milanese tyranny (whose people are not "citizens but subjects born in subjection")[10] nor their fear of conquest and consequent loss of liberty. By intrigue and threat quite as often as by actual force, the first Duke of Milan, Giangaleazzo Visconti, had absorbed almost all of northern Italy save for the republic of Venice, and had even surrounded Florence to the south controlling the road to Rome, his overlordship being acknowledged by Siena and Perugia, while his control over Lucca and Pisa cut off Florence from the sea and threatened to strangle her trade. The historic liberties of the Florentine people seemed to be doomed. In Baron's words, "From then on the Florentine Republic, protected no longer by membership in any league except for her alliance with Bologna, and enjoying that protection only as long as Bologna could avoid surrender, was left alone to confront one of those challenges of history in which a nation, facing eclipse or regeneration, has to prove its worth in a fight for survival."[11]

At this very moment, Baron pointed out, an apologist for the Duke, the humanist Saviozzo da Siena, compared Giangaleazzo to Caesar encamped on the Rubicon before his march to Rome, and prayed for the success of the enterprise in the name of every true Italian, while deprecating the "detestable seed, enemy of quietude and peacefulness which they call liberty."[12] Poised on the edge of the precipice, Florence was saved by a wholly unexpected event. In the hot summer of 1402 the plague, that faithful companion of Renaissance armies, swept through Lombardy and on September 3 carried off Giangaleazzo himself at the Florentine frontier. In a matter of months the jerry-built Milanese empire had collapsed and Florence again found herself at the head of a league of city-republics in defense of liberty.

His death had been, so people believed, heralded by the appearance of a comet.[13] The Florentines in their joy repeated the verses from Psalm 124. 7–8:

> ... the snare is broken, and we are escaped. Our help is in the name of the Lord, who made heaven and earth.[14]

But, divine intervention or no, the Florentines had been ready for the battle. As Scipione Ammirato puts it, "This, at the end of twelve years, which now with suspect peace, now with dubious truce, now with open war had tormented the Florentine Republic, was the end of Gio. Galeazzo Visconti first Duke of Milan, most powerful prince, who had no impediment to the occupation of Italy greater than the Florentines: whence both then and later it was noted with great wonder, how against such forces could resist a single people without a seaport, without discipline of war, not helped by the ruggedness of mountains, nor by the width of rivers, but only by the industry of men and the readiness of money."[15] In the words of the great Chancellor of later date, Lionardo Bruni, "What greater thing could this commonwealth accomplish, or in what better way prove that the *virtus* of her forebears was still alive, than by her own efforts and resources to liberate the whole of Italy from the threat of servitude?"[16] And it is indeed *virtus*, which might be defined not so much as virtue but as the kind of courage, resolution, character in short, that makes a man a man, which flashes from the eyes of these statues of marble and bronze. In Gregorio Dati's history of Florence, written soon after 1406, we read that "to be conquered and become subject, this never seemed to the Florentines to be a possibility, for their minds are so alien and adverse to such an idea that they could not bring themselves to accept it in any of their thoughts ... a heart that is free and sure of itself never fails to bring it about that some way and remedy is found."[17]

But in only a few years a new menace appeared, from the south this time, in the person of King Ladislaus of Naples. Burning to become a new Caesar, Ladislaus received the submission of papal Rome and all of Umbria in 1408 and in 1409 took Cortona, on the borders of the Florentine state. In 1413 he sacked Rome and stood master of central and southern Italy, poised in 1414 for the attempt to surround Florence to the north, and supported incidentally by the same insidious voices who had prepared the propaganda for Giangaleazzo.[18] To these the aged Niccolò da Uzzano answered "that for the protection of our liberty we must shoulder anything,"[19] and the Florentines in the early summer of 1414 refused any compromise with the tyrant. And then, as before, Florence was saved by a portentous occurrence, accompanied this time by earthquakes. In August, struck by a violent fever and raving that Florence should be destroyed, Ladislaus died in Naples. His empire collapsed, and his sister and successor, Giovanna, instantly sent envoys to make peace with the Florentines.[20] Oddly enough, Ammirato records no feeling on the part of the Florentines that they had again profited by divine intervention.

Florence then embarked upon a period of unexampled prosperity. During the ensuing peace, Poggio Bracciolini found the city "full of every opulence and the citizens universally most abundant with money,"[21] and Cavalcanti wrote, "Our city was on the height of worldly power and its citizens with their sails filled with proud fortune."[22] And then it started all over again. Defeated in the north and defeated in the south by the intervention of sudden death, the menace of absolutism sprang up anew in the north, in the person of Filippo Maria Visconti,[23] who followed in the steps of his ambitious father, Giangaleazzo. The non-aggression pact signed by the Florentines in 1420, apprehensive over their prosperity and disregarding the advice of Niccolò da Uzzano and Gino Capponi, was all Filippo Maria needed to absorb Genoa on the one hand and Brescia on the other. When in 1423 he seized Forlì, on the borders of the Florentine Republic, the time had come to act. The Florentines prepared for war, and although the Pope tried to mediate, they sent defiant messages to both Rome and Milan.

Then, alas, ensued a succession of military disasters, culminating in the fantastic rout of the Florentine forces at Zagonara in July 1424, and the destruction of a whole army at Valdilamone in February 1425. Despite universal dismay in Florence, the Republic pulled itself together and faced the threat of invasion. Antonio de Meglio, the herald of the Republic, wrote inflammatory verses. "Still we are Florentines, free Tuscans, Italy's image and light. Let there arise that rightful scorn which always in the past emerged among us when the time was ripe; do not wait any longer, for in procrastination lies the real danger."[24]

The tremendous challenge before the Florentines and their response in terms of *virtus* to the danger threatening their *libertas* goes far to illuminate the new content we have observed in the race of heroes that populate the center of the city. The fourteen (originally thirteen) niches at Orsanmichele had been assigned to the various guilds since 1339, with only two statues completed before 1400. But immediately after the collapse of Giangaleazzo in 1402 began the march of the statues. In 1406 the council of the Republic quickened the pace by giving the guilds ten years to fulfill their obligations at Orsanmichele.[25] After a lapse of nearly two generations the statues were suddenly recognized as a civic responsibility. Work went on through the war with Ladislaus, the ensuing peace and into the thick of the second Visconti crisis. In fact, after the long series was nearly done in 1425, the very year of the worst Florentine defeat, the powerful wool manufacturers' guild, the *Arte della Lana*, seems to have considered its Trecento statue of St. Stephen lamentably out of date, and commissioned Ghiberti to replace it with a more modern one in bronze at about ten times the cost of marble.[26] And from 1416 to 1427 the same guild, which had charge of all work for the Cathedral of Florence, commissioned from Donatello and Nanni di Bartolo the great series of prophet statues for the Campanile.[27] Right through the three crises the ancient guild of *Calimala*, the dealers and refiners of imported cloth, once but

no longer more powerful than the *Arte della Lana,* financed Ghiberti's great doors for the Baptistery. This even though in 1427 the immense cost of the warfare, which had emptied the Florentine treasury and devastated its banking system, had necessitated as we shall see new and radically altered forms of taxation. In this imposing series of sculptured images, unprecedented in any of the Italian cities since antiquity, paralleled outside of Italy only by the vast sculptural programs of the Gothic cathedrals of France, England and Germany, the new classic style makes its appearance, mingled at first in Ghiberti with strong Gothic element but forthright from the start in Donatello and Nanni de Banco in its commitment to a new conception of the freedom and dignity of the human person.

However seductive, contentions concerning the relations between stylistic development and political history are notoriously difficult to demonstrate beyond a certain point. Luckily, however, we possess several examples in which the character of specific works, involving notable stylistic innovations, seems bound up with events involving the cherished *libertas.* In 1401, with Giangaleazzo breathing down their necks, the officials of the committee for the Baptistery of the guild of *Calimala* proclaimed a competition for the enormous and extremely expensive second set of doors for the Baptistery, to be executed in gilded bronze. Not until 1402, perhaps not until after the death of Giangaleazzo in September, and possibly even in March 1403 (our style), was the competition judged and Ghiberti declared the winner.[28] But the figures to be included were doubtless laid down by *Calimala,* and the story is therefore told in more or less the same way by both the principal contestants. The fact that the deliverance of Isaac from death by divine intervention was chosen out of all possible Old Testament subjects seems worthy of note. In both Ghiberti's and Brunelleschi's reliefs the knife is about to be plunged into Isaac's throat when the angel appears. Of course the sacrifice of Isaac traditionally prefigures that of Christ, but the desired salvation of the state from mortal danger is by no means impossible as a secondary meaning. In Ghiberti's relief the feeling of unexpected deliverance is marked and especially touching, in the joyous upward glance of the kneeling youth. . . . One might note how, in Gregorio Dati's history of the events of the war with Galeazzo, written as we have seen only four years later, the hand of God is constantly discovered intervening for the Republic.[29]

In Donatello's graceful, still Gothic marble *David* of 1408–9, designed for one of the buttresses of the Duomo . . . , the connection between a triumphant Scriptural victor and the contemporary political scene is reinforced by three separate factors, an iconographic attribute, an exact inscription, and a noteworthy historical event. The youthful champion of the chosen people stands, staring out into space, above the severed head of the defeated tyrant. Due to Janson's enquiries,[30] the wreath about David's brow has been identified by Mr. Maurice L. Shapiro as amaranth, a purplish plant whose name in Greek means "non-fading." It was considered the fitting crown for the undy-

ing memory of heroes, and was therefore used by Thetis to cover the grave of Achilles. The amaranthine crown is held out in the New Testament as the ultimate reward of the faithful.[31] Now the statue once bore in Latin the following inscription, "To those who bravely fight for the fatherland the gods will lend aid even against the most terrible foes."[32] In other words, with divine aid a child has put to flight the potent enemy of the people of God. The relevance of the statue to Florence and its political and military situation is especially marked because there are no statues of the youthful, victorious David (as distinguished from the adult King) before this time, and from this time on they are legion.[33]

Lest anything be lacking to reinforce its significance, in 1416, two years after the overthrow of Ladislaus—our second Goliath—the Signoria demanded the statue urgently and without delay from the *Arte della Lana*, so that it could be set up in Palazzo Vecchio in the council halls of the Republic, where it stood for many years. Interestingly enough the same thing happened in Florence almost a century later when the *David* of Michelangelo, also intended for a buttress of the cathedral in 1502, was set up after its completion in 1504 in front of the Palazzo Vecchio itself, as a kind of symbol of the embattled Republic under Piero Soderini, then engaged in the last and tragic phase of its struggle for survival against tyranny. By no means accidentally, Michelangelo's *David* is not only one of the most noble but also one of the last works of art in Florence to embody that classical notion of human dignity and completeness whose origin in Renaissance art we are considering here.

But Donatello's marble *David* is by all accounts not a fully Renaissance work, nor, incidentally, does the blank physiognomy of the entranced victor betray any traces of the deep antinomy of shifting emotional states that darkens the faces of the saints of Orsanmichele or the prophets of the Campanile. What shall we say of the *St. George* of 1415–16?[34] In spite of the obstreperously Gothic niche (probably, as Janson contends, not planned by Donatello), this is a Renaissance statue in the completeness of its individuality, the forthrightness of its stance, the magnificence of its forms. . . . The warrior saint stands supporting his great shield and looking out on a hostile world with the supreme bravery of a man born a coward. Despite all that Vasari, under fashionable Michelangelesque influence, had to say about its "vivacità fieramente terribile," this is a reflective, gentle face, with delicate nose, pinched, nervous brows, sensuous mouth, even a weak chin. Yet with divine guidance he has put on the whole armor of the spirit and summons up all his inner forces to confront the enemy. In this work Donatello's analysis of spiritual duality, of the inner battles of the mind, has reached an even greater stage of development than in his *St. Mark*.[35] As in Castagno's *St. Theodore,* so deeply influenced by Donatello, the Christian Psychomachia is translated "from the language of traditional symbols into that of individual experience."[36]

We do not, of course, see the work as originally intended. Janson has shown that the right hand originally held a sword or a lance (the former

Donatello,
**St. George in a
Niche with Relief
of St. George
Slaying the
Dragon.**
*Oranmichele,
Florence.*
1415–1416, Bronze.
*(The Bridgeman
Art Library
International, Ltd.)*

would seem more probable, considering that the saint is shown on foot and that a lance would have jutted unreasonably into the street) and that the head probably wore a helmet,[37] understandably, considering that the figure was done for the guild of the *Corazzai* or armorers. But how did such a modest guild, not even counted among the *Arti Mediane,* possess itself of a fine niche at Orsanmichele? In the absence of specific knowledge, I suspect that after the close of the second war for the survival of the Republic, the stock of the armorers in political circles had gone sharply up. In any event, we note that only after King Ladislaus had appeared on the borders of Tuscany in 1408 does the definitive change take place between the late Gothic and the early Renaissance in Florence. From 1410–12 the still medieval masters Bernardo Ciuffagni and Niccolò di Pietro Lamberti find themselves replaced at Orsan-

michele by Donatello, Ghiberti, and Nanni di Banco, the founders of the new style.[38] In 1409, in fact, Lamberti is willing to accept the rather humiliating assignment of procuring the marble at Carrara for the *St. Mark* to be executed by the still youthful Donatello.[39]

In these new works part of the forces of the self are directed outward toward a world of obstacles and dangers, the other part inward, assessing with deep anxiety the resources of individual character—like divisions within the Florentine Republic itself, acutely conscious of the threat to its liberties, and quite as deeply of its own inadequacy to meet the challenge. Bitterly had Domenico da Prato cried that Florence's deepest sorrow was caused not by the enemy from without but by the poison in the hearts of her own sons. No new Brutus would arise among a people who knew only the maxim, "Let us make money and we shall have honor."[40] But Rinaldo de' Gianfigliazzi was to say, after the rout of Zagonara, "It is in adversity that men who want to live a free life are put to the test; in times of good fortune everybody can behave properly,"[41] and Niccolò da Uzzano, "Virtue reveals itself in adversity; when things go smoothly anybody can conduct himself well. Liberty is to be valued higher than life. The spirit cannot be broken unless one wills it so."[42] These searching estimates of the resources of human character differ profoundly from the still medieval longing for divine deliverance in 1402.

From an historical point of view, perhaps the most extraordinary aspect of Donatello's *St. George* is not the statue itself so much as the relief on its base. . . . On a grim terrace of rocks, with the opening of a cave on one side and a delicate arcade on the other, St. George on a rearing horse plunges his spear into the dragon's breast, while the captive princess folds her hands in prayer. If the *St. George* statue can stand as a symbol of the Republic at war, this relief may count as an allegorical reenactment of the battle. But the relief is executed in a style the like of which had not been attempted since the first century of our era. The figures, landscape elements and buildings are not, as in medieval reliefs—and still in early Ghiberti and the neighboring reliefs of Nanni de Banco at Orsanmichele—set forth almost in the round against a uniformly flat and inert background slab. Rather they are projected, as it were, *into* the surface of the marble to varying degrees of depth corresponding, not to the actual shapes of the represented objects, but to the play of light across bumps and hollows. Donatello is thus enabled to suggest, by the manipulation of tone, steady recession into depth, distant hills, trees, clouds, a building in perspective, and an all-over play of atmosphere. He was aided, of course, by the position of the relief in a never-changing diffused light on the north side of Orsanmichele, and the effects he obtained were undoubtedly much more delicate before the marble had been corroded by exposure to five and a half centuries of rain and wind.

While Janson is correct in pointing out that the building is not accurately constructed according to the rules of one-point perspective,[43] it

certainly represents the closest approach to such perspective construction before the days of Masaccio. But, even more important, Donatello has grasped in this relief the essential idea on which not only one-point perspective but every other important principle of Renaissance and later art was to be based up to and including nineteenth century Impressionism—namely, that the represented object has no autonomous existence, ideal, tangible or both, for the artist, who is bound to represent it only as it appears to one pair of eyes at a single moment, from a single point of view and under a single set of atmospheric and luminous conditions. The supremacy of the individual implied in this concept is by far the most startling aspect of Donatello's early production. In fact, the basic optical revolution of Renaissance art may be said to have first taken place in the mind of this young man as he contemplated the fine marble slab specially procured from the Opera del Duomo for this relief for the north side of Orsanmichele in February 1417—even a few months earlier if, as seems to me inescapable, the subtle and unprecedented luminary and atmospheric effects carried out with such success in marble were first prepared for in a clay model in which experimentation would have been easier and failure quickly remedied. Regardless of the fact that the analogous optical achievements of the Van Eycks could only have been accessible to the Italians at a much later date, even the earliest reasonable dating for the Hand G miniatures of the Turin-Milan Hours leaves this enormous intellectual conquest securely in the hands of Donatello.[44]

There is a peculiar propriety in the fact that this new conception of the supremacy of the individual should make its first appearance in a work of art celebrating the heroic encounter of a single armed knight against the forces of evil at a moment when the Florentine republic had just won so striking a battle for individual freedom. Baron notes that, "as late as 1413, the psychological interpretation of freedom as the spark struck by equality in competition seems to have been still absent from the mental armory of Leonardo Bruni,[45] so soon to become the greatest apologist for freedom. Yet only a year later he began the first volume of his history of the Florentine people in which, referring to the ancient Etruscan city-states under Roman domination, he said, "For it is Nature's gift to mortals that, where the path to greatness and honor is open men easily raise themselves up to a higher plane, where they are deprived of this hope, they grow idle and lose their strength."[46] In 1427 the general of the Florentine forces, Nanni degli Strozzi, was killed in combat against Filippo Maria Visconti. Bruni was asked to write a eulogy in his honor. Shortly thereafter Bruni became Chancellor of the Florentine Republic, and not until 1428 was he able to finish the work which he modeled on Thucydides' account of Pericles' oration for the first Athenian citizens to fall in the Peloponnesian war. The secret of Florentine greatness, according to the Chancellor at this moment, lay in the fact that "Equal liberty exists for all . . . , the hope of winning public honors and ascending is the same for all, provided they possess industry and natural gifts, and live a serious minded and

respected way of life; for our commonwealth requires *virtus* and *probitas* in its citizens."

But this is not all. Florence, Bruni says, is the great home of writing in the vernacular, the *volgare*, and her Italian speech is the model for the peninsula. At the same time it is Florence alone who has called back the forgotten knowledge of antiquity. "Who, if not our Commonwealth, has brought to recognition, revived and rescued from ruin the Latin letters, which previously had been abject, prostrate and almost dead? . . . Indeed even the knowledge of the Greek letters, which for more than seven hundred years had fallen into disuse in Italy, has been recalled and brought back by our Commonwealth with the result that we have become able to see face to face, and no longer through the veil of absurd translations the greatest philosophers and admirable orators and all those other men distinguished by their learning."[47]

And now let us return to the statues of Orsanmichele. These are the saints of God, chosen to do His work, to carry His banner or His sword.[48] They are also the guardians of the guilds in the maintenance of the Republic, and its spiritual defenders in the battle for the survival of free institutions. As such, they partake of the *virtus* and the *probitas* which were the ideal of the Florentine citizen and the dignity and reflectiveness of the classical philosopher orator or writer.[49] In them becomes explicit the awareness of the historian concerned with the perpetuation of all that is most noble in man. Not only do their cloaks begin to assume the folds of Roman togas, but as soon as the vocabulary of classical architecture is again available, the saints appear in niches framed by Roman orders, as in Donatello's *St. Louis of Toulouse* done for the Parte Guelfa in 1423. . . .

It is doubtless this new equation of citizen-hero-philosopher-saint sustains Masaccio in setting forth with such grandeur the formidable apostles of the Brancacci Chapel, classic exponents of the dignity of the *volgare,* and exemplars of the corporeal massiveness and ample fold structure of Donatello and Nanni de Banco. But what is the meaning of the rarely treated subject of the *Tribute Money* (Matthew 17. 24–27), given such unusual prominence among the frescoes of the Brancacci Chapel, equated with the most exalted apostolic acts of baptism, preaching and healing?

By 1425 the immense burden of the war had emptied the Florentine treasury and the Florentine economic scene was darkened by a rapid succession of bank failures. A new form of taxation was essential in order to support the war, and in 1427 the Signorìa adopted the *Catasto,* the first attempt at an equitable form of taxation in modern history, and in some respects the ancestor of modern income and personal property tax systems—complete with declaration, exemptions and deductions.[50] But the Signorìa did not come to this measure without a fight. In fact the first proposals for the *Catasto* were made by Rinaldo degli Albizzi on February 19, 1425, and repeated again and again throughout that grim spring. It is in this very spring and summer that I have dated, on a combination of stylistic and documentary evidence, the

Masaccio, **The Tribute Money.** *Brancacci Chapel, Florence. c. 1425, Fresco.*
(Art Resource, NY)

Tribute Money of Masaccio as well as the neighboring scenes in the Brancacci series.[51] Although Baron makes surprisingly little out of this fact, the Pope himself, successor of St. Peter, resided temporarily in Florence just before the opening of the final war against Filippo Maria Visconti, from 1419–21, on his way to take possession of the papal throne as the first ruler of a Papacy reunited after more than a century of exile and schism.

The *Tribute Money* not only announces taxation as a civic duty divinely revealed but reinforces the traditional Guelph policy of Florence as the Florentine ambassadors were doing at that moment to the Pope newly reestablished in Rome. "To eternity we will persist to preserve our liberty, which is dearer to us than life. And to that effect we will not spare our substance, our sons and our brothers, but put forth without reserve our lives and likewise our souls."[52] The doctrine of divine approval of taxation for the purpose of defense, embodied in Masaccio's *Tribute Money,* persisted in the interpretation of this very passage from Matthew as late as the 1450's when St. Antonine of Florence set down his immense universal history, the *Opus Chronicorum.*[53] Confronted with the dilemma of apparent submission to earthly authority on the part of Him Who is subject to no one. Antonine

rationalizes the situation by the following quotation from the Gloss: "not as a sign of subjection does the Church give tribute to kings . . . for the Church is not subject to them, but as a subsidy and occasion for defence, therefore it should not be given to them if they do not defend."

Only in the light of the tragic necessity of Florence in 1425 can we understand this monumental rendition of what might otherwise seem a trivial occurrence in the narration of the Gospels. Masaccio has set the solemn group in the midst of the Florentine countryside, with the range of the Pratomagno in the background, and all the atmospheric effects he had learned from Donatello's eight-years-earlier *St. George* relief now greatly expanded and enriched. He has animated the features of the apostles with the earnestness and excitement of the Florentines themselves, confronted with the awesome task of finding the means of preserving their Republic and its threatened liberties, and receiving from supernal authority the new solution and the mission to proceed with it.

Turning to the adjacent wall of the Brancacci Chapel, we find still another fresco dealing with taxation, representing at once the equable distribution of its benefits to the community and the punishment meted out to those who will not share in time of common need. . . . The apostles under Peter are distributing alms to men, women and children, while in the foreground (now so badly damaged as to be easily overlooked) lies the body of Ananias, who held back a part of the price of a farm, and was struck down by God at Peter's feet (Acts 4. 34–37; 5. 1–6). I know of no more eloquent visual sermon on the benefits of taxation or the dangers of evasion. The setting is not specified in the Scriptural account, but Masaccio has placed the scene in an ordinary village in the country surrounding Florence and peopled it with pure *volgare* types, including St. Peter himself.

The moving picture of the little Republic standing alone on the edge of the abyss might tempt one to all sorts of parallels. But this was neither the Battle of Britain nor yet Valley Forge. Despite Bruni's proud boast, all classes in Florence were not free. The fate of the oppressed wool carders who tried in 1378 to effect an entry into the guild system and were mercilessly crushed is eloquent testimony to the exclusiveness of the all-powerful guilds and the essentially oligarchic nature of the Florentine state. Perhaps the Florentine situation in the 1420's might better be compared with that of the Athenians at Thermopylae or at Salamis. Both Florentine and Athenian societies were controlled by mercantile classes which enjoyed internal liberties unprecedented in their eras, however little they were willing to extend these same liberties to the classes on whose labors their commercial prosperity rested; both societies were driven to extreme measures to raise from their essentially non-military citizenry the forces necessary for the repulsion of better armed and organized autocracies. What is most important for us as art historians is that ancient Athens and Quattrocento Florence, so threatened and so triumphant, were the matrices of the two most completely humanistic revolutionary styles in the

history of art. And, as a corollary, the art of their enemies presents a totally opposed spectacle of individual absorption in the general scheme, material luxury, efficient, mechanical regularity of organization and uniformity of detail. For the art of Milan and Naples was Gothic and remained so until the second, Albertian phase of the early Renaissance provided Roman Imperial forms to celebrate the ambitions of mid and late Quattrocento dynasts in both centers. Outside of Florence, the first Renaissance style of the great sculptors and Masaccio is accepted, among major Italian centers, only in Venice, the Florentine ally in the struggles against monarchic absorption. In Florence the early Renaissance is a republican style; its more rigid Albertian phase is never universally welcomed, and Alberti and Piero can develop their full potentialities only in centers of princely rule. The Florentine Renaissance is sapped from within by late Quattrocento tyranny reflected in the "Gothic" art of Botticelli; revived heroically in the second Republic in the defiant masterpieces of Leonardo and Michelangelo for the seat of republican government, the Renaissance is corroded under the Medici dukes in the nightmare art of the Mannerist crisis, and supplanted altogether under the principate by the neo-Gothic Maniera which becomes in the Cinquecento the normative style of the European courts.

It would be satisfying to record that the Florentines won their struggle against Milanese tyranny. Actually nobody won. Unlike his predecessors, Filippo Maria Visconti did not just die. The battle see-sawed on for years, but at least the Florentines did not lose and by virtue of the alliance with Venice were able to preserve for a while their cherished independence. The struggle eventually shifted, as struggles have a way of doing, into other levels with other participants and other principles. The decisive, eventually victorious threat to Florentine freedom arose, as Domenico da Prato had foreseen, not from external threats but from inner weaknesses. In the end it was not foreign but domestic tyrants who undermined the liberties of the Republic in the name of stability.

The solution of every crisis in human affairs leads inevitably to a new crisis. Locked in the bonds of time and his own mortality, man can cope with perils from within and from without only through clear-eyed recognition. Eventually the Florentines lost their liberties through not having recognized in time the subtle threat of the Medici. But their finest hour, to quote Winston Churchill, had still been faced, and in the civic art of the first Florentine Renaissance we have the enduring embodiment of their decision.

We know far too little as yet about the relation between artist and patron in the early Renaissance to pronounce any dogmas, but in this instance it is clear that artists and patrons were intimately allied. The artists, themselves guild members, must have been as concerned as any other Florentines over the fate of their society, as deeply committed to its continuance,[54] as aware of its limitations and dangers, and as influential in the growth of its ideals, all of which are reflected and paralleled in the content and style of the first great

artistic achievements of the early Renaissance. To return to Masaccio's *Trinity*, we behold in the naturalism of these citizens and their rough, human dignity the *probitas* and *virtus* which the Republic exalts; in the classic architecture that enframes them a fitting reference to enobling antiquity and the universal spread of humanistic ideals; in the resignation of the sacrificed Christ to Whose mercy they appeal the ideal of Stoic behavior under adversity; in the simple articulation of the structure leading from man to God, their confidence in the righteousness of their cause and their belief that God helps those who help themselves; in their control over form and space and design the firmness of their moral and intellectual victory over the enemy and over the inner man.[55]

But I am well aware that the foregoing arguments can do no more than hint at the depth and complexity of the factors involved in the appearance of the early Renaissance style in Florence. In the last analysis such matters are as elusive and as mysterious as the nature of creativity or the origins of man's will to resist.

Notes

1. The evidence is ably analyzed by H. W. Janson, *The Sculpture of Donatello*, Princeton, 1957, II, pp. 17ff.

2. The Cascia di Reggello altarpiece, dated 1422; see Luciano Berti, "Masaccio 1422," *Commentari*, XII, 1961, pp. 84–107.

3. Op. cit., II, p. 19.

4. I would like to repeat here the acknowledgment of my indebtedness to Professor Richard Krautheimer for the notion of the continued stimulus of sculpture on painting in the early Quattrocento (see *Castagno*, note 33). Antal, op. cit., p. 305, noted that "at the beginning of the century upper-bourgeois rationalism was most strikingly expressed in religious sculpture, both statues and reliefs, whereas its full expression in painting came somewhat later," without ever telling us why. He has noted (p. 332) the infiltration of some Masaccesque elements into the style of Francesco d'Antonio in the 1429 organ shutters for Orsanmichele. He might have added the somewhat stronger influence of Masaccio in the Grenoble altarpiece by this same master, and the numerous allusions to Masaccio in the work of Giovanni dal Ponte, adduced in part by Salmi, *Masaccio*, Paris, 1935, fig. CCII.

5. The list includes the *St. Luke*, by Nanni di Banco, the *St. Matthew* by Bernardo Ciuffagni, the *St. Mark* by Niccolò di Pietro Lamberti, and the *St. John* by Donatello, all for the facade of the Duomo; the *Isaiah* by Nanni di Banco, the marble *David* and the lost *Joshua* by Donatello, the *King David, Joshua* ("Poggio Bracciolini") and *Isaiah* by Ciuffagni, all for the main fabric of the Duomo; the beardless and bearded prophets, *Zuccone, Jeremiah* and *Abraham* by Donatello, the *John the Baptist* and *Abdia* by Nanni di Bartolo called il Rosso and the prophet by Giuliano da Poggibonsi, all for the Campanile; and finally the *St. Peter* by Ciuffagni, the *St. James* by Lamberti, the *St. John the Baptist, St. Matthew* and *St. Stephen* by Ghiberti, the *St. Matthew, St. George* and *St. Louis of Toulouse* by Donatello and the *Quattro Santi Coronati, St. Eligius* and *St. Philip* by Nanni di Banco, all for Orsanmichele.

6. Antal, op. cit. pp. 16ff., provides a very able introduction to the intricate and shifting structure of the guilds. Of particular importance is his insistence that from 1251 onwards the ". . . guilds had become fighting organizations in the fullest sense of the word." This is one of the most useful and objective sections of the entire book.

7. Despite the characteristically restrictive and opressive role of the *Parte Guelfa* traced by Antal, Baron (op. cit., I, p. 15) cites a surprising redefinition of the *Parte Guelfa* by Leonardo Bruni in 1420 when its Statute was being revised: "If you consider the community of the Guelphs from the religious point of view, you will find it connected with the Roman Church, if from the human point of view, with Liberty—Liberty without which no republic can exist, and without which the wisest men have held, one should not live." For recent bibliography, see ibid., II, pp. 445–446, notes 8 and 9.

8. For the Statues of the *Arte dei Medici e Speziali*, see C. Forilli, "I dipintori a Firenze nell' Arte dei medici, speziali e merciai," *Archivio storico italiano*, II, 1920, pp. 6–74.

9. Baron (op. cit.) has demonstrated full awareness of the importance of his new emphasis for the cultural history of the Renaissance, and in several places invites the application of his ideas to the interpretation of the new art of the Quattrocento, e.g., I, p. 29, "On the other hand, the factor which produced a sudden and incisive change in the art of the first two or three decades of the Quattrocento was the emergence of a new ideal of man, together with the discovery of the laws of anatomy, optics and perspective, knowledge of which was needed to express that ideal and could largely be gained in the school of antiquity," and p. 174, "those who recall Donatello's *St. George* of 1416—the first book of Bruni's *Historiae Florentini Populi* had been written the year before—will be certain that even the arts did not remain entirely untouched by the political climate of the time of the Florentine-Milanese struggle."

10. Baron, op. cit., I, p. 145, quoting from Gregorio Dati, *L'Istoria di Firenze dal 1380 al 1405*, ed. L. Pratesi, Norcia, 1904, p. 14 (supplemented by comparisons with ed. G. Manni, Florence, 1735, p. 5).

11. Baron, op. cit., I, p. 27.

12. Ibid., I, p. 29, quoting from A. D'Ancona, "Il concetto dell'unità politica nei poeti italiani," *Studi di critica e storia letteraria*, I, 1912, p. 41.

13. Scipione Ammirato, *Istorie fiorentine*, Florence, 1647, II, p. 889.

14. Ibid., II, p. 893.

15. Loc. cit.

16. Baron, op. cit., p. 186, quoting from Lionardo Bruni, *Laudatio*, L. fol. 150v–152r.

17. Baron, op. cit., I, p. 159, quoting Dati, op. cit., ed. Pratesi, p. 74 and Manni, p. 70.

18. Baron, op. cit., I, p. 320.

19. Ibid., p. 322.

20. Ammirato, op. cit., II, p. 971.

21. Ugo Procacci, "Sulla cronologia delle opere di Masaccio e di Masolino tra il 1425 e il 1428," *Rivista d'Arte*, XXVIII, 1953, p. 12, quoting *Istorie di M. Poggio fiorentino tradotta di latino in volgare da Jacopo suo figliuolo*, Florence, 1598, p. 135.

22. Procacci, op. cit., p. 12, quoting Giovanni Cavalcanti, *Istorie fiorentine*, Florence, 1838–39; ed. di Pino, Milan, 1944.

23. Eloquently characterized by E.M. Jacob, op. cit., p. 26, as "living in a sort of artistic Kremlin with agents watching everybody. . . ."

24. Baron, op. cit., I, p. 336, quoting messer Antonio di Matteo di Meglio (called Antonio di Palagio), "Rimolatino per lo quale conforta Firenze dopo la rotta di Zagonara," in Guasti, *Commissioni di Rinaldo degli Albizzi*, II, pp. 78–80.

25. Richard Krautheimer, *Lorenzo Ghiberti*, Princeton, 1956, pp. 71–72. This was, of course, one of the innumerable unmet Renaissance deadlines, but it gives an index of the urgency of the need for the statues.

26. Ibid., p. 93.

27. The evidence is summarized and analyzed by Janson, op. cit., II, pp. 33–35.

28. Krautheimer, op. cit., p. 41.

29. Baron, op. cit., I, p. 144.

30. Janson, op. cit., II, p. 6.

31. Janson, op. cit., II, p. 7.

32. Ibid., p. 4.

33. There is, however, Taddeo Gaddi's fresco of the 1330's in the Baroncelli Chapel at S. Croce (Janson, op. cit., II, p. 6). A partial list of the later Davids would include Donatello's bronze, Castagno's shield in Washington, the Martelli *David* by Bernardo Rossellino in the same gallery (for the attribution, see my "New Light on the Rossellino Family," *Burlington Magazine*, CII, 1961, pp. 387–92). Pollaiuolo's little panel in Berlin, and Verrocchio's bronze, not to speak of Michelangelo's colossal marble statue and his lost bronze.

34. I follow Janson's dating, op. cit., II, pp. 28ff.

35. Vividly stated by Janson, op. cit., II, p. 29.

36. If I may be permitted a self-quotation; *Castagno*, p. 233.

37. Janson, op. cit., II, pp. 26ff.

38. This radical change was noted by Krautheimer, op. cit., p. 72.

39. Janson, op. cit., II, p. 17.

40. Baron, op. cit., I, p. 336, quoting "Risposta di Ser Domenico al prefato Messer Antonio, in vice della Città di Firenze," Guasti, op. cit., p. 81.

41. Baron, op. cit., I, p. 338, quoting *Commissioni di Rinaldo degli Albizzi per il Comune di Firenze del MCCCLXCIX al MCCCCXXXIII*, ed. C. Guasti, Florence, 1867–1873, II, pp. 145–9.

42. Baron, loc. cit.

43. Janson, op. cit., II, p. 31.

44. The Hand G miniatures, if by Jan van Eyck, would date between 1422 and 1424 according to the closely reasoned account in Erwin Panofsky, *Early Netherlandish Painting*, Cambridge (Massachusetts), 1953, I, pp. 232–46, but esp. p. 245. If I understand correctly, the recent, still unpublished, researches of Miss Dorothy Miner tend to confirm this dating. A University of Pennsylvania student, whom I have since been unable to identify, pointed out to me the important fact that Donatello's optical predilections are evident as early as the marble *David*, not to

speak of the *St. Mark,* in the handling of projections and hollows. The formal repertory of Donatello's relief betrays no hint of northern influence, but seems to derive from the landscape forms current in Florence at the end of the Trecento, especially in the workshop and following of Agnolo Gaddi.

45. Baron, op. cit., p. 367.

46. Ibid., p. 368, quoting Leonardo Bruni, *Historiarum Florentini Populi Libri XII,* ed. Santini, p. 36.

47. Baron, op. cit., I, pp. 352 and 364, quoting Leonardo Bruni, *Laudatio,* ed. Baluzius, pp. 3–4.

48. God the Father appears in the gable of Donatello's *St. George* and in the gables above all three of Nanni's statues for Orsanmichele, blessing the saints below.

49. For the classical sources of the *St. Matthew,* see Krautheimer, op. cit., p. 342.

50. The most valuable recent treatment of the history of the *Catasto,* rich in new material, is to be found in Ugo Procacci's study cited in note 21 above.

51. For reasons to which I alluded in *Castagno,* p. 163, n 16, but which are not ready for publication.

52. Procacci, op. cit., p. 15, quoting *Commissioni,* II, p. 332.

53. St. Antonine of Florence, *Opus Chronicorum,* Lyon, 1589, I, p. 220.

54. Frequently the artists appear as designers of weapons and systems of defense and offense, as Brunelleschi against Lucca, Leonardo against Pisa, Michelangelo against the Medici.

55. As E.F. Jacob pointed out (cf. note 6, *Italian Renaissance Studies Edited by E.F. Jacob,* p. 47), "A great civilization is not built upon magnificence alone. Self-denial, forethought and forebearing are needed, qualities which historians are not always ready to concede to the makers of the Italian Renaissance." He continues to quote Leonardo (*The Notebooks of Leonardo da Vinci,* ed. Edward McCurdy, London, 1956, I, p. 87), "You can have neither a greater nor a less dominion than that over yourself."

Chapter 8

Iconography of Napoleon

Albert Boime

Gros's early portrait of the dashing young commander in chief raising the standard on the bridge of Arcola has something tentative and indecisive about it; Bonaparte's tight-lipped expression as he twists his head towards his army signifies his condemnation of the troops for not responding to his call in this crucial and costly campaign in Lombardy in 1796. Gros had been with Napoleon at the battle of Arcola and witnessed the murderous fire of the Croatians that pinned down the French and kept them from boldly following their leader.

French artists played a cunning game with Napoleon's cultural demands, dutiful in recentering the hero but careful also not to omit the impact of the enemy other. The artists of the Bonapartist era had experienced too much historical change within their young lifetimes to blithely ignore the consequences of political action. Yes, they were subject to, as much as purveyors of, the propaganda that rationalized the content and purpose of war for the masses of French people, but the decades of upheaval between 1789 and 1814 furnished the dramatic examples of historically conditioned existence—of history that affects daily survival and immediate preoccupations. . . .

The new realism of the Bonapartist period is seen in the account of Barras, the wily Jacobin turned director, who interrupted his memoirs of the Revolution with a reference to the bloody battle at Eylau, free-associating from there to a comparison of the marquis de Sade and Napoleon. For him the butchery at Eylau smacked of the philosophy of de Sade, but on an order of magnitude undreamed of by the aristocratic profligate. Barras then recounts the anecdote of one of the Italian directors of the Roman republic, the physician Camillo Corona, who sought exile in Paris after the Directory fell. Corona visited the Salon of 1808 and was so struck by the view of David's *Coronation of Napoleon* and Gros's *Battlefield of Eylau* hanging face to face that he exclaimed in outrage, "Coronation and Slaughter! That's the story of his life!"[1]

While Barras had plenty of axes to grind and exaggerated as all writers of memoirs do, this anecdote holds up under scrutiny because it belongs to a wider field of discourse that embraced a consensus of criticism permissible under the Napoleonic regime. The catalogue description of Gros's painting

itself did not shirk from the tragic consequences of the event: it observed that the emperor surveying the aftermath of the battle was "filled with horror at the sight of the spectacle," and this text is followed through in the image, with the entire foreground covered with the dead and wounded. Although the statement made certain that the audience understood that, at the time Napoleon passed in review, "the French troops were bivouacking on the field of battle"—that is, they were the self-proclaimed victors of this internecine destruction—it could not deny what the foreign press had reported to its readership and what had been leaked to the French public earlier that year. Even the government's attempt to contain the damage by underestimating the loss of troops backfired because the conservative body count was bad enough. But what is important here is the evidence that the historical progression and understanding since the Revolution could no longer sustain the supersensible image of the invincible ruler of the ancien régime or the over-inflated idealism of the Revolution.

The Battle of Eylau was perhaps a turning point, along with the Spanish insurrection that same year, that revealed huge chinks in the Napoleonic armor; plenty of paint and ink was spilled previously in the effort to mythologize the "Little Corporal" and even to adorn him with divine attributes. For the first time the unprivileged strata of French society experienced France as their own country, as their self-created fatherland which now demonstrated its superiority to the privileged strata of outmoded feudal societies. This invested Napoleon with a mythic component for which there existed only an outmoded symbolism and which was bound to clash with the innovative restructuring of the social order. The demand for a new realism to accommodate the new data of experience and the desire to retain the mythic components of tradition stamp the Napoleonic imagery with its hybridized tension.

Napoleon and David

One way to map this development is to examine the Bonapartist activity of one of Napoleon's favorite artists, Jacques-Louis David (1748–1825). To marshal visual practice Napoleon summoned David, then perhaps the most celebrated painter in France. David was ultimately appointed first painter to the emperor at the end of 1804, the equivalent of the royal position under the old regime. The artist was to receive enormous sums for his official commissions: for example, 52,000 francs for the *Distribution of the Eagles* and 65,000 francs for the *Coronation*—extraordinary when we learn that a well-paid artisan then received about a franc a day!. . .

[B]y the end of 1799, David shared the widespread feeling of his peers that scandal-rocked France was without adequate leadership, civil or military (Napoleon was still in Egypt) and welcomed Bonaparte's coup d'état of *brumaire*, which carried the general to supreme civil power.[2]

Impressed, like everyone else in his social milieu, with Bonaparte's talents and utterly frightened of him, David openly proclaimed him as his new

hero. David's earliest work for Napoleon is frankly propagandistic, starting with the *Napoleon Crossing the Saint Bernard* executed in the years 1800–1801. The work was commissioned for the library of the Hôtel des Invalides, the veterans' hospital which at that time was undergoing extensive refurbishing to transform it into a monument to Napoleon's army. David's painting depicts the dramatic moment of the traversal of the Alpine pass of Saint Bernard foreshadowing the First Consul's decisive victory over the Austrians at Marengo in June 1800. . . .

David depicts Napoleon, who himself suggested the idea, on a rearing horse directing the operation across the difficult passage. The forelegs of the rearing animal point to a large slab of rock in the mountainside in which the name of Bonaparte is carved neatly in capital letters just above the more crudely rendered names of his predecessors who similarly mastered the treacherous Alpine crossings, Hannibal and Karolus Magnus (Charlemagne). . . . The myth of Napoleon as the embodiment of the revolutionary credo had already been energetically shaped by David in contemporary cultural practice.

Jacques-Louis David, **Napoleon Crossing the Saint Bernard Pass.** *1801, Oil on canvas. (Lauros-Giraudon/ Art Resource, NY)*

The representation of the event, however, has been manipulated to slant history in Napoleon's favor. Bonaparte actually crossed the Saint Bernard with the rear guard on a mule led by a peasant from Bourg-Saint-Pierre. The image of the hero spurring the troops on by pointing to some distant summit would indicate total mastery; in fact, the campaign came close to being a total wipeout for the French as a result of the First Consul's blunders. . . . This special talent for self-advertisement forged David's portrayal into Napoleon's ideal self-image. As Laurette Junot rhapsodized, "The index of his powerful hand extended to [Saint Bernard's] icy summits, and the obstacles disappeared."[3]

David nevertheless tried to retain a firm foothold on reality. In the middle distance we see the French columns slogging up the pass, pulling behind them the cannon in improvised sledges, and revealing some of the difficulties and hardships of this arduous undertaking. He painstakingly reproduced the uniform Napoleon wore at Marengo right down to the seams on the breeches, and he ingeniously showed the raised hand of the First Consul without a glove in contrast to the other holding the reins, which gives an irregular cast to the scene. . . .

David's imprint of Napoleon's name in a rock outcropping literally "fossilizes" the event and forms the factual counterpart to the falsified action of the protagonist. Here, the authentic-looking inorganic environment camouflages the purposefully erroneous projection of the organic bodies. This conceptual dualism had to be retained in order to juggle the various metamorphoses of Bonaparte, from general to First Consul, and from First Consul to emperor—a series of avatars that corresponded as well to the contradictory stages of the political evolution from republic to authoritarian government, a process belied by the preservation of the name of the republic in official documents. The transmittal of "truth" took place in the peripheries of civil, military, and cultural life, in areas that barely affected the falsified center.

Distribution of the Eagles

No more striking example exists of [a] conceptual dualism than David's *Distribution of the Eagles,* a painting of an event that occurred three days after the coronation, which the artist also represented as part of a formidable package of imperial iconography. . . . The ceremonies were organized by Percier and Fontaine and took place on a huge grandstand set up against the facade of the Ecole militaire at the Champ-de-Mars. This was a tribute to all branches of the army wherein the regimental commanders took an oath to the emperor to defend to the death their standards mounted with eagles and stay on "the road to victory." According to the program, the emperor said, "Soldiers, here are your flags; these Eagles will be your rallying point; they will be wherever your emperor deems them necessary to protect his throne and his people. You will swear to guard them with your life." At this point, the colonels holding the eagles were to raise them in the air and shout in unison, "We swear!" The

oath was then repeated by all the military and civil deputations to the sound of artillery salvos, and the solemnities ended with the return of the eagles to their respective regiments.

David's role as depicter-in-residence was spelled out two years later with Austerlitz in mind: "Never was an oath better kept. What a variety of stances and expressions! There never was a finer subject for a painting. How it fires the painter's imagination! It is the forerunner of the immortal battles which marked the anniversary of His Majesty's coronation. Posterity looking at this painting will be astonished and marvel, "what an emperor!"[4] It should be recalled that this production was David's third representation of an oath, each portraying a critical stage in recent French history and inevitably referring back and forth to each other. (This is most obvious in both the preparations and final design of *Distribution of the Eagles,* which depend on motifs derived from its two predecessors.) What is critical in David's statement is the obvious appeal of the oath motif and its objective realization for him in material history. My earlier volume, *Art in an Age of Revolution,* showed how the *Oath of the Horatii,* a prerevolutionary work, and *Oath of the Tennis Court,* a revolutionary work, folded into each other; David himself encouraged the connection by exhibiting them together. I need not rehearse the arguments here, except to point out that both represented oaths sworn in behalf of the unity of the reformed state newly expanded to embrace an heretofore excluded citizenry. Thus the oath in these works connoted patriotic commitment to the principle of the commonwealth rather than of the anointed ruler. The *Horatii* contains a military subtext ostensibly derived from antiquity but actually based upon the new discipline promoted by the French army after the Seven Years' War, whereas the *Tennis Court* applied that standard to forge a highly disciplined and committed civil body capable of taking control of the political apparatus. In the later work the fraternal oath binding the initiates has been transmogrified into contemporary life, signifying that present reality had caught up with ideality. The final oath picture maintains reality as the exciting cause, but it subverts the "national" priorities of Rousseau's social contract to align itself with the narrower inclusive model of the old regime. And it does so by rejecting the allegorical model of antiquity as a token example for the present and deliberately forefronting it in modern military life in imitation of the old Roman standard-bearers.

The series of oath pictures may be seen as the coding of key developments in the history of the Revolution and its culmination in Napoleonic authoritarianism. The ancient Roman republican model served as a standard for the moderns, authentically realized in the *Tennis Court* oath, but the collapse of the Revolution paved the way for a despotic figure swollen with the blood of military and foreign conquest indispensable for the retention of his hold over the French people. As under the old regime, obedience and loyalty were sworn to the sovereign. It is by no means fortuitous that the last and final oath was both contemporary and almost exclusively military; the

vaincre ou mourir implied in the *Horatii* was literally written into the Napoleonic ceremony of the eagles and symbolically demonstrated the ascendance of the military over the civil domain and the force of arms over collective expression. The civil pride of French nationalism won during the Revolution had been displaced onto pride in battlefield glory, and the welfare of the French citizenry taken as a whole became subordinated to the prestige of the troops. Symbolically this was further represented by shifting the ancient paradigm from the republic to the empire.

David completed a major drawing in December 1808 for the emperor's approval. Between that time and the initial completion of the definitive tableau in October 1810 Napoleon requested two basic changes: he asked that David eliminate an allegorical personification depicted in the sky above the flags, and at the last minute ordered that the portrait of Empress Joséphine be removed, since he had by then been divorced and remarried to Marie-Louise of Austria. Here in a nutshell are the perimeters of Bonapartist visual and historical "truth." The winged Victory hovering in the air and strewing laurel leaves on the flags was for Napoleon an outmoded form of representation that clashed with his sense of the "true" and the "new." The picture was less an allegory of the state than an ideological commentary on the power of Napoleon, who needed no help from idealized entities. Yet his sense of realism could not extend to the historical past which he was in the process of manipulating to justify and legitimize his hold on power. Joséphine, who had actually been present at the event, had to go because her presence belied his claim to dynastic succession now embodied by Marie-Louise. Joséphine no longer had a historical place in Bonapartist ideology, and the documentary record had to be falsified. This entailed eliminating her ladies-in-waiting as well and replacing them with a group of ambassadors, including Mohammed Said-Heled of the Ottoman empire, who looks upon the occasion with an obvious irritation. It was hardly secret that Napoleon had planned an eastern expedition and the partition of the Ottoman empire that would involve France, Russia, and Austria. Austria's desire to share in the spoils was one of the motivations for Franz I's gift of his daughter to Bonaparte. David (who was not present at the ceremony) himself went to great lengths to document the event with precision, but wound up being "complicit" in the historical manipulation. Indeed, David had his own agenda in reconstructing the ceremony: at the top of the pyramid of military corps we see the conspicuous display of the flags of the Twelfth and Ninth regiments, which were commanded by sons-in-law of David.

This family pride in the opportunity for participation in the Napoleonic machine represents the more popular side of the epoch. Bourgeois artists like Louis Boilly encouraged their sons to attend the Bonapartist military academies where they were certain to get a sound general education. The same year that David sketched his composition for *Distribution of the Eagles,* Boilly submitted several Napoleonic subjects to the Salon in the hopes of gaining a

commission or sale. One was the *Departure of the Conscripts in 1807* and another, the grandiose *Reading of the Bulletin of the Grand Army.* Despite the insatiable appetite for human sacrifice brought on by interminable wars, many of Boilly's recruits can still muster a sense of heroism and adventure. It is symptomatic of the period, however, given the numerous cases of desertion and even rebellion in the military, that at least one critic called the mood of zealousness "unnatural."[5] Indeed, despite Boilly's attempt to ingratiate himself with the regime in 1808 there are enough contradictory elements in the work to indicate the painter's ambivalence. At the far right of the composition, a blind man led by his dog obviously "sees" more clearly than the silly conscripts, while the majordomo energetically raising his baton hardly gets the response from the parade of recruits commensurate with his gesture.

The other work depicts the interior of an artisanal household in which several generations follow on a map of Europe the march of the imperial armies.[6] The reason for their intense absorption is not merely their patriotic duty but the absence of a son, who is at the front. The "XII Bulletin" in the grandfather's hand refers to the German campaign, celebrated at the Salon of 1808. In the background, a mother nurses her infant beneath Canova's bust of Napoleon as First Consul, while in the center the grandfather and his son— the woman's husband—argue the location of the troops. Nearby a young woman, possibly the betrothed of the man at the front, listens intently, neglecting both her knitting and the attentions of a would-be suitor. In the foreground children's war games are disrupted by a feuding dog and cat. Despite the visible strain on family life caused by Napoleon's military ventures, the work endorses the patriarchal family structure, unified under the emperor's aegis. Rarely represented in Napoleonic salons, this depiction of the working class acknowledges the heavy sacrifices made by this group during the bloody years 1807–8.

Napoleonic Effigies

The various avatars of Bonaparte constitute another means of mapping the political transformations. The profile of the leader became synonymous with the state, and the kinds of information processed and communicated in the portraiture at a given time provide an index to the ideological developments. Gros's portrait of the First Consul became the prototype for the official type, and replicas and variants were distributed for display in institutional spaces. This version, dated year 10, was completed sometime after the Peace of Amiens on 25 March 1802. Young Bonaparte is shown with his body facing the viewer, his head turned three-quarters to the right, and his right hand pointing to a list of treaties that have been enacted under his general- and consulship. More precisely, his index finger strikes "Lunéville," the site of a peace treaty of February 1801 which gave France German territories on the left bank of the Rhine, Belgium, Luxembourg, and control of nearly all of Italy. It symbolized the complete failure of the Second Coalition to stop

Bonaparte, and it momentarily isolated England. The way was now open for a truce with that country on terms favorable to the French. The last name on the list is "Amiens," where the signatures were exchanged in March 1802. The First Consul's action is decisive; his feet stand far apart, his left arm is bent at almost a right angle as his left hand grasps a pair of gloves, and his right arm thrusts towards the table. . . . It is this military competence and capacity for strategic planning that Gros conveys: an energetic leader who makes his point effectively and acts decisively. The empty room and simple uniform convey a Spartan quality more in keeping with revolutionary imagery than with the imperial pomp of the next phase.

The most impressive example of the later stage is Ingres's portrait, *Napoleon I on the Imperial Throne*. A student of David, Ingres (1780–1867) early placed his brilliant gifts at the service of the emperor. . . .

Ingres's awe of Bonaparte—or, at least, his calculated vision of awe—manifests itself in his 1806 *Napoleon I on the Imperial Throne,* which projects the emperor as a transcendental being on a celestial throne. His attempt to join the effigy of Bonaparte to an image of eternal authority has elements of both the eerie and the grotesque. The emperor is shown in his coronation robes and carrying all the trappings of dynastic rule: the imperial regalia, the scepter of Charles V, and the hand of justice and the sword of Charlemagne. Ingres's image corresponds to the hierarchical order Napoleon imposed on French society to counteract the excessive individualism of revolutionary social reforms. He reasserted the authority of the state and reaffirmed the social dominance of the middle class. While removing the Old Regime's obstacles to civil equality, Napoleon imposed a system to assure himself virtually unchecked power. Indeed, it was the Corps législatif which commissioned this image—owning up to its lack of independence and total subservience to Napoleon.

To convey a sense of omnipotence, omniscience, and omnipresence, Ingres drew from classical as well as Christian sources. The emperor's frontal pose derived from an engraved Roman gem representing Jupiter and published in the *Recueil* of the comte de Caylus. . . . At the same time, the rigid symmetry and heavy draping recalls Jan van Eyck's image of God the Father at the top of his Ghent altarpiece, exhibited in Paris as part of the war booty during the years 1799 to 1816. A great admirer of van Eyck, Ingres could not have made the point of Napoleon's unquestioned power more explicitly. . . .

Napoleon, who believed in the destiny of his "star," is accompanied in Ingres's picture by an astrological forecast of his rise to power. The carpeted step, covered at the base of the throne with the imperial eagle, is fringed with medallions of the zodiacal signs. At the left of the picture are the signs of Scorpio, Libra, and Virgo, while at the opposite side we can make out Pisces and Taurus. Scorpio (23 October–21 November), lying at the base of the throne and mirrored in the gilt socle, clearly alludes to the coup of 18 *brumaire* (9 November) which brought Napoleon to power, while Taurus must allude to the moment when he was proclaimed emperor (18 May 1804). Thus

Napoleon's unearthly image is accompanied by an astrological chart affirming that his fate was indeed written "in the stars."[7] Here the Corps législatif and Ingres combined to mask the emperor's despotism and rule by force. . . .

Perhaps the most well-known avatar was the one commissioned by Alexander Douglas, heir of an illustrious Scotch family. It was commissioned in 1810 and completed two years later, right in the middle of the war with England. . . . His evident admiration for Napoleon is seen in the fact that his extensive art collection included busts, miniatures, intaglios, and Sèvres vases with images of Bonaparte and his family. Lord Douglas was a loyal member of the Whig party, whose oppositional strategy called for

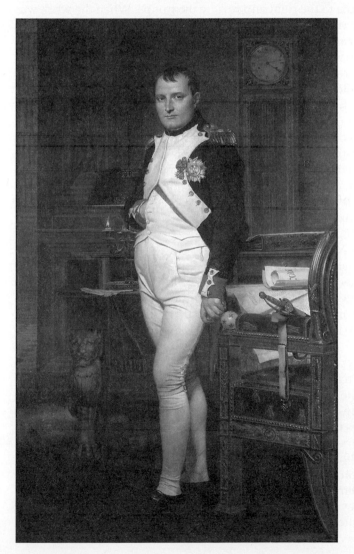

Jacques-Louis David, **Napoleon in His Study.** *1812, Oil on canvas, 2.039 × 1.251 cm. (80¼ × 49¼ in.). (National Gallery of Art, Washington. Samuel H. Kress Collection. © Board of Trustees, National Gallery of Art. Photo by: Lyle Peterzell)*

attestations to Napoleon's invincibility on land, thus indirectly arguing for peace rather than for intervention.[8]

The full-length portrait of Napoleon represents him in the blue uniform of a colonel of the Grenadiers of the Foot Guard, in the act of leaving his study where he has passed the night at work, as indicated by the candles, which have burnt low and are flickering, and by a clock, which registers 4:13 A.M. The emperor did in fact work long hours and go with little sleep. David explained his painting to Alexandre Lenoir: his hero had been up all night drafting the *Code Napoléon* (shown rolled up on the table at the right) and has been so absorbed in his activity that he does not notice it is dawn until the clock strikes four. Then, without a moment of rest, he rises to put on the imperial sword on the sofa to the right and review the troops. When the work was submitted to the emperor before being dispatched to Scotland, Napoleon responded with pleasure, "You have indeed caught me this time, David. At night I work for the welfare of my subjects; in the daytime for their glory."[9]

The effectiveness of this basically flattering political allegory in 1812 lies in its capacity to allow for unflattering features. Napoleon seems to stand before us without physical idealization, his hair thinning, his body stooping and thickening around the waist, his cheeks puffy and pasty. He is no longer the dashing First Consul of Gros's portrayal. At the same time, Napoleon, with his characteristic right hand tucked into his jacket, dominates the picture space articulated by a series of parallel vertical lines. The sofa that he has just pushed aside in rising forms a powerful diagonal that now seems to pin him against the table. He is hemmed in by the furnishings of his study which also lock him into his work. Napoleon is literally a prisoner of his domestic obligations, which make him neglect his troops.

Thus by 1812 Napoleon is portrayed as less the decisive warrior than the compassionate statesman. He is assigned a "nighttime" slot, that is, in behalf of his subjects, with good reason: by 1811 the Continental system was beginning to disintegrate and war with Russia appeared inevitable. This called for a more humanized version of the emperor, which answered to both the ideology of the parliamentary opposition in England and the reality of the weakening military position of France. David makes use of allegory and metonymy to convey the legislative side of Napoleon, but in this later phase the proportion of "reality" to "ideology" has been reversed from what it had been during the time of the crossing of the Alps. The idealization is no longer centered in the body of the hero, but in the arrangement of objects that orders that body and gives it meaning.

Napoleon and the Ossianic Literature

David's distorted projection of Napoleon crossing the Saint Bernard pits the hero against the elements of wind and snow. The meteorological effects and icy heroism convey an Ossianic touch that points to another layer of Napoleon's self-flattery. Even Ingres's chilling portrait reminded one critic of

the cold white light of "moonbeams." It may be recalled that the Ossianic epic had been pieced together from fragments and linked in a fictionalized structure by James MacPherson, who reached an audience of conservative Scots as a symbol of Scottish nationalism. The Ossianic saga told in mournful verse of the battles of Fingal, a glorious king, and the woes of Ossian, his son, who was left old and blind to lament the friends and memories of his youth. The passionate melancholy of Ossian's songs evoked the nostalgia of the aristocracy for older hierarchical structures unthreatened by dissenting voices and republicanism. In addition to Scot aristocrats, Lord North, the abbé Cesarotti—whose Italian translation was the one read by Napoleon—and Chateaubriand represented the kind of conservative mind to whom MacPherson's writings appealed. . . .

Napoleon's infatuation with the Celtic warriors was already known at the end of the century, and by 1800 it was publicized through his portrait medallion of the bard hanging in the First Consul's library at Malmaison.[10] Given this pronounced trait of self-identification, it is no wonder that the Napoleonic years are pervaded by poetic and visual allusions to the Ossianic songs.

Beyond the mere personal attachment to Ossian, however, lies, a calculated exploitation of the sagas for political purposes. . . .

. . . [A]t great personal sacrifice the French followed Napoleon's dreams of glory for the nation. He could not establish himself in the sense of a French king; there had to be military campaigns for him to maintain his place. The regime finally broke down as France became worn out; it grew tired of the sacrifice of its youth on the battlefield. Napoleon's imperialism could endure only as long as he could appear as the champion of the Revolution. The enemies of France were undertaking to set up the old order again—the divine right of kings, the right of the church in its medieval claim—and Napoleon defeated them one after another. It wasn't that Bonaparte was interested in establishing a democracy, but that he fought those who were determined to wipe out the last vestiges of the Revolution. Napoleon's great strengths were his capacity for introducing order, security, into the state; his military genius in defeating the enemies of France; and the attendant power over all the armies of Europe—the ability to stand as a dominant power on the Continent.

If the armies of Napoleon had crushed the enemies of the Revolution, they had not established its principles in the French state. They had established another empire, the Napoleonic empire. There was a definite sense of defeat among the popular classes after the failure to organize a society on the basis of liberty, equality, and fraternity. It is this combination of contradictory circumstances, of a sense of glory and a sense of defeat and failure, that created a climate receptive to the Ossianic poetry. The melancholy mood of the Ossianic poems, the lunar quality, the vague, misty settings, the heroic, unreflective actions, and the fatalistic philosophy fit the mind-set of French society during the peak years of the Napoleonic regime. The Ossianic heroes may

have occupied "aerial places" and cloudy, celestial domains, but their geographical and chronological proximity made them more accessible than the heroes of Greece and Rome, and their pantheistic and pessimistic view of life prevented a sentimental gloss on their actual experience. . . . Thus the eerie Ossianic sagas literally mystified the domestic repression, the sacrifice of a nation's youth, and the destruction wreaked on neighboring countries. . . .

In 1800, planning to make the Malmaison his summer residence, Napoleon commissioned his favorite architects Fontaine and Percier to restore and decorate it. They in turn gave David's students Gérard and Girodet, and three others commissions for six pictures suitable for Bonaparte's residence. . . .

Gérard had begun an Ossianic subject under the direction of Fontaine and Percier, *Ossian Evoking the Shades with His Harp on the Banks of the Lora*. It emphasizes the key function of the blind bard in singing of the heroic exploits of his companions in arms. Ossian consoles himself with the memories of his son Oscar and his daughter-in-law Malvina, seen embracing on the left, his parents Fingal and Roscrana, on the right, as various other warriors and bards gather in the moonlit clouds around him. In the background is seen the aerial palace of Selma, Ossian's birthplace. The lunar lighting adds an eerie touch to the ancestral phantoms. . . .

Gérard's painting, with its array of the Ossianic cast of characters, set the backdrop of its complement by Anne-Louis Girodet-Trioson (1767–1824), which directly links the folklore to Napoleonic propaganda. It is a most perplexing and ambiguous picture which attempts to marry the Ossianic heroes to Napoleon's fallen officers who meet in the "aerial" realm evoked by MacPherson's songs. Girodet makes topical allusions to current political events but deliberately keeps the documentary vague, in tune with Napoleonic aspirations. Girodet dedicated his picture to the First Consul, and his letters to Napoleon in this period are filled with exaggerated homage. . . . The complete description of Girodet's picture is as fantastic as the imagery: *The Ghosts of French Heroes, Killed in the Service of Their Country, Led by Victory, Arrive to Live in the Aerial Elysium Where the Ghosts of Ossian and His Valiant Warriors Gather to Render to Them in Their Voyage of Immortality and Glory a Festival of Peace and of Friendship.*[11]

These two groups constitute the main interest of the composition, the center of which focuses on Ossian and General Desaix, who embrace. "All these heroes admire the French heroes." Ossian, the bard of Morven (MacPherson's name for the highland areas in northwestern Scotland), leads the Celtic contingent as he leans on his upside-down spear. Just to his right Kléber extends a hand to Fingal and with the other helps Desaix support a trophy captured during the Egyptian campaign. Next comes Caffarelli-Dufalga, who carries a broken standard captured from the Turks. In addition to the several French officers lost during the Revolution, there are represen-

tatives of the grenadiers, sappers, dragoons, chasseurs, hussars, and cannoneers, all identified by their uniforms.

The figure of Victory hovers above the central group; with her left hand she presents to the Celtic warriors a caduceus, symbol of peace. In the other hand she holds aloft a sheaf of palm, laurel, and olive leaves, pointing to the "glorious conquests" of the French armies. Above this sheaf is a cock, symbol of France. With an outstretched wing it offers shelter to a dove who had been on the point of being ravished by an eagle, which now flies off at the left.

The Ossianic figures include those receptive to the arrival of the French and those who react negatively to it. Behind and to the left of Ossian is his son Oscar and his father Fingal, who wears a helmet topped with a giant eagle's wing. Fingal clasps Kléber's hand. The maids of Morven welcome the French with flowers, music, and even drinks in cups made from seashells. But the traditional enemy of Morven, the warriors of Lochlin, do not share the general enthusiasm for the French soldiers. Starno, king of Lochlin, at the lower left, is enraged by his daughter's enthusiastic greeting of the French and grabs her by the hair. He is on the verge of slaying her when a French dragoon arrives in time to rescue her. Meanwhile, allies of Starno signal bellicose actions by striking the shield of one of the warriors of Morven with the hilt of a sword and whistling "seditiously."

This abstruse allegory of the political and diplomatic situation in 1801 is submerged in the lunar and meteorological light of MacPherson's tales. The festival of peace in the Ossianic realm contains a direct allusion to the numerous events organized throughout France on the occasion of the peace treaty signed on 9 February 1801 at Lunéville by France, Austria, and other Continental powers.[12] The Continental peace established by this treaty was enthusiastically greeted by all except the English, who continued hostilities. Contemporary patriotic poetry celebrated Napoleon as a hero who established peace through victories and vanquished but did not humiliate his adversaries. Thus the French march triumphantly under the allegorical personification of Victory, topped by the Gallic cock who has chased the Austrian eagle and gives refuge to the dove of peace. The bellicose gestures of the warriors from Lochlin symbolically refer to England's refusal to sign the treaty and its wish to remain at war with France. England was thereupon accused by the French press of attempting to arm the enemies of France and to impede the peace negotiations. It was in England's best interests to keep the war alive. Ironically, however, by the time Girodet finished the picture the Treaty of Amiens was signed (25 March 1802), which proclaimed general peace with all the powers including England. Girodet's allegory was anachronistic at the time of the Salon later that year. . . .

The blending of the Ossianic and Napoleonic in the attempt to justify the human sacrifices necessary for the Lunéville peace treaty demonstrates the political meaning of MacPherson's sagas for Napoleonic France.

Girodet's own mixture of fantasy and fact is the appropriate expression for the ideological role of Ossian. . . . Ossian . . . functioned to lend an air of mystery and enchantment to the sordid realities of Napoleon's imperialism. . . .

Chateaubriand

Génie de christianisme (Genius of Christianity), the larger work from which *Atala* was excerpted, may be understood as a reaction against the sceptical philosophy of the eighteenth century and the deistic outlook of the Revolution. Its author urged a revival of religious fervor among French society, stressing the emotional and aesthetic components of Catholic ritual and symbolism. Chateaubriand admonished readers to reject rationalist arguments about the existence of God and to follow an intuitive, emotional impulse. His writing blends a kind of pagan revelry with Catholic dogma, and in this sense *Atala*, with its combination of devout duty and myriad temptations, exemplifies his attitude. The *Génie* is a full-scale apology for Christianity, designed to demonstrate the inherent superiority of Catholic religion as a source of moral and artistic inspiration.

At the same time, Chateaubriand's work was immensely political and came out at the right psychological moment. Conservatives spearheaded a revival of Christianity to which the masses of French society warmly responded. Bonaparte himself indicated in various ways that he might be favorable to such a revival. He regarded Catholicism as a fundamental principle of order. As he stated before an assembly of priests in Milan in 1800, "It is religion alone . . . that gives to the State a firm and durable support."[13] Here he simply recognized that the anticlericalism of the Revolution only temporarily dampened the religious beliefs of the French populace. Indeed, an "underground" religious movement was closely allied with émigré bishops of the ancien régime. Largely as a practical measure, then, Bonaparte found it necessary to reestablish official Catholicism with a hierarchy loyal to him. This was the background of Napoleon's Concordat with the pope, which was signed in April 1801—the same month in which *Atala* appeared. Chateaubriand had been quick to perceive this opportunity to establish himself as a leading Catholic apologist. . . .

In 1807 Chateaubriand took over the editorship of the *Mercure de France* and seized the occasion to attack the despotism of the government. The emperor retaliated by withdrawing the journal from Chateaubriand's control, installing censors and writers of his own choice. Only the intercession of Fontanes prevented a worse fate for Chateaubriand. It was during this period that Girodet's friendship with the author reached its high point; he painted Chateaubriand's portrait in 1809, and the year before he exhibited his *Funeral of Atala* at the Salon. Chateaubriand himself thanked the artist for his "admirable painting" of *Atala* in his *Les martyres*, published in 1809. Certainly Girodet sought some of the eminence attached to Chateaubriand's book, while at the same time his effort rekindled Napoleon's earlier appreciation

for Chateaubriand's contribution as a defense of his work in reestablishing the church in France.

. . . [T]he book tells the unhappy love story of two Indians separated by religion. Chactas is a member of the Natchez tribe, Atala is a half caste, the illegitimate daughter of a native American Christian-convert mother and a Spanish *hidalgo* named Lopez, owner of a plantation in Florida. The story unfolds through the narrative of Chactas in old age, now blind and led by a young girl, "like Malvina guiding Ossian on the rocks of Morven." Chateaubriand's fascination for the Ossianic epic, which he discovered in England, filters through much of the narrative in the moonlit scenes and the primitive conditions of the New World. In a sense, *Atala* "christianizes" MacPherson's pagan sagas.

There are many contradictory features in the story; while seemingly glorifying purity and abstinence, the author builds up a highly charged situation inviting passion and sensuality. He plays with the "noble savage" theme, but Atala has a Spanish father, who happened to have raised Chactas as a boy (thus hinting also at incest) and indoctrinated him into Western and Christian attitudes. Indeed, Atala even has golden hair and alabaster skin, so transparent that the pale-blue veins can be seen. Thus Chateaubriand's "noble savages" had a head start in their progress toward redemption and salvation. The real native Americans are put to work on Father Aubry's farm and exploited. Here the symbolic association of missionary and indigenous work force is consistent with the outlook of both Chateaubriand and Girodet, who espoused the already age-old colonialist rationale for exploiting native peoples. Christian redemption and social repression could be seen as necessarily linked in the "civilizing " process.

Girodet's choice of scene for his picture of *Atala* incarnates the contradictions of the novel. He selected the moment of the protagonist's entombment to maximize pathos and drama, departing somewhat from Chateaubriand's description of this particular scene in combining the two passages of the burial in the grotto and the nocturnal mourning of Chactas and Father Aubry over Atala's body. The cross on the hill, marking the cemetery of the mission Indians, is silhouetted by the unseen moon. Lunar light also picks out the beatific head of Atala, the cross of ebony she clasps, and the spade on the ground, which symbolizes the Passion and echoes the cross on the hillside. Chactas embraces the legs of his beloved before lowering her into the grave, while Father Aubry gently lowers the top half of her body. The image synthesizes aspects of the *Pietà*, lamentation and deposition, thus striking home repeatedly with the Christian message of the original source. An ardent admirer of Michelangelo, Girodet used the sculptor's self-portrait of the late *Deposition* as the model for the monk—especially appropriate for the theme as well as individual motif. Despite the sentimental overkill, however, Girodet's sinuous compositional curve uniting the three figures, the icy-smooth flesh of the heroine, her exposed shoulders, and the care given to the

outlines of the nipples of her breasts demonstrates to what extent Girodet captured the erotic component of Chateaubriand's evangelizing Christianity. At the same time, the reference to the native American cemetery highlights the intention of the author to exemplify Christian redemption and conversion at the point of death. Chactas's resistance to Christian religion is overcome only when he is broken in spirit like the native Americans working on the mission farm.

The collaboration of Chateaubriand and Girodet was of mutual benefit to each artist's effort and also proved instrumental in the rise of anticlassical approaches. Girodet's rejection of the vigorous classicism of his teacher David in the *Sleep of Endymion* and *Atala* parallels Chateaubriand's message in *Génie,* that the elements of Christianity are just as capable of serving as a stimulus to literary and artistic activity as the classics, and may even surpass the classics in being based on revealed truth. Thus the revival of Catholic prestige at the time of Napoleon contributed to undermining the remnant of revolutionary classicism and promoted its romantic antithesis.

Science and the Marvels of God and Nature

Aiding this transformation was the advance of science, also manifest in both Chateaubriand and Girodet. Chateaubriand's *Génie* identifies the marvels of nature with the grandeur of God: he invokes the immensity of space with its moon and glittering stars as evidence of infinity and the Divine Being. . . .

Medical science was no less subject to ideological considerations. Perhaps the most impressive and highly publicized painting of the 1804 Salon was Gros's *Bonaparte, Commander in Chief of the Army of the Orient, at the Moment He Touched a Pestilential Tumor in the Hospital of Jaffa.*[14] The feverish plague that broke out at the beginning of the campaign in Syria grew worse after the siege of Jaffa, just south of what is now Tel Aviv. Panic spread among the troops, and a plan was formulated to try to convince the soldiers that the disease was not contagious and could be avoided by preventive means. To raise the morale of the men Napoleon made a visit to the provisional hospital set up in a mosque.[15] Accompanied by his chief of staff and the army's physician in chief, Desgenettes, Napoleon fearlessly entered the makeshift hospital and made bodily contact with the victims. The Salon entry states that Desgenettes did not want Bonaparte to prolong his visit, and Gros shows this in the picture by making Desgenettes looking furtively to his left while motioning his chief with his left hand that it is time to go. Even one of the victims, an officer kneeling in front of Bonaparte, tries to prevent him from touching the lanced bubo of the armpit. Napoleon, however, insisted on staying and offering words of consolation and the "healing touch" to inspire courage. Napoleon ordered some of the buboes to be lanced so that he could touch them and demonstrate that there were no grounds for fearing contagion. At the right of the picture, an Ottoman surgeon makes ready to open a

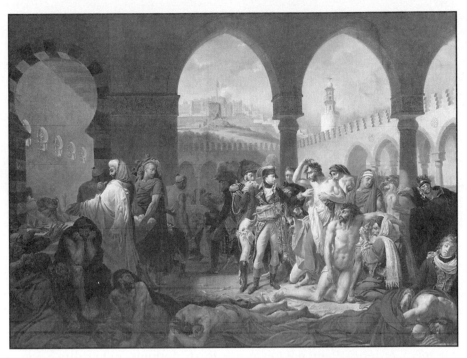

Antoine-Jean Gros, Napoleon Visiting the Pesthouse at Jaffa. *1804, Oil on canvas, 46¾ × 64½ in. (Museum of Fine Arts, Boston. Purchased, Sylvanus A. Denio Fund)*

tumor under another patient's armpit. Gros shows Napoleon calm amid terror, bestowing a divine touch akin to the Christian saints and kings who healed by touching. The catalogue entry expressly stated that Napoleon's act of unprecedented courage has since been emulated by others, that it stands as an example of his benevolence.

Not unexpectedly, the catalogue mixed a kernel of truth with a great deal of propaganda. On 25 July 1798 Bonaparte crossed the Nile and took possession of an undefended Cairo, but his joy was short lived; on 1 August Nelson had sailed into the shallows of Aboukir Bay and destroyed the French fleet. The morale of the French troops was at its lowest level after the news of the Battle of the Nile reached Cairo. In addition, a plague developed whose symptoms were a ferocious fever with carbuncles or buboes developing in the groin and armpits. The plague was particularly devastating in Alexandria, where several naval officers had died. The disease now became rampant in the army; the medical officers tried to cover up suggestions of a plague, hurriedly removing the bodies of the victims, burning their clothes and personal effects, and fumigating the rooms

where they were isolated. Dominique-Jean Larrey, the surgeon in chief, was convinced of the existence of a plague but told only Desgenettes of his fears.[16]

Ideas about the nature of plague were utterly confused, although official policy at the start of the campaign in Egypt was to ignore it and hope it would go away. It was while Larrey and Desgenettes were busily sweeping the facts under the carpet that Bonaparte announced the French army's exodus through Syria. It was during this campaign that the expedition experienced the horrors that attended their assault and sacking of Jaffa. The number of wounded was so great that Larrey set up an improvised hospital in a huge mosque. Evidence of the plague immediately appeared, and this time Larrey reported it to his commander in chief. The military machine was in serious danger of coming to a grinding halt from plague alone. Larrey knew the disease to be contagious, but morale had to be sustained. What the men had to believe they were suffering from, said Bonaparte, was a well-recognized but noncontagious disease: "fever of the buboes," a disease that in some strange way affected those who lacked courage or whose spirit was weak. Larrey accepted this at first, but gradually became vigorously opposed to the idea. Desgenettes, by all accounts, also believed in the contagiousness of plague but proclaimed the opposite. He squared his conscience by having the troops live in bivouacs outside the town, ordering them not to wear Turkish clothing, and burning everything, including uniforms, he judged to be contaminated—a move that infuriated quartermasters.

Yet still the number of cases increased, particularly among the wounded. On 11 March Bonaparte acted to counter the panic of his terror-stricken troops, visiting the mosque that Desgenettes had converted into a plague hospital and spending an hour and a half chatting with the sick and their attendants. At one stage he helped to move a corpse whose tattered clothing was soaked with pus from the buboes. Desgenettes was on tenterhooks and tried to get Bonaparte to leave. The commander replied, "But I only do my duty, am I not the General-in-Chief?"[17] When he visited the hospital for the wounded, where plague was also strife, he was quickly hustled through by Larrey. But these visits served their purpose in raising the tottering morale of his men.

Jaffa had been reached on 3 March and after four days' siege was captured by assault. The horrors of the surrender, culminating in the cold-blooded murder of twenty-four hundred of the garrison, are well known. It was also at Jaffa that the much-discussed, and often-denied, order is said to have been given by Bonaparte for the poisoning of the incurably sick who could not be evacuated, and who if left alive would be supposedly tortured and murdered by the Turks. Bonaparte had suggested that opium might be administered if Desgenettes so decided, an assertion that Napoleon repeatedly denied.

The idea, however, was circulated by Napoleon's enemies, as Chateau-briand made clear during the first Bourbon restoration in 1814. Serving now the cause of the Bourbons, Chateaubriand noted how skillfully Napoleon used artists, especially as evidenced by Gros's picture of the plague house. He wrote that "Bonaparte poisoned the plague victims of Jaffa: a picture was made depicting him touching, by an abundance of courage and humanity these same plague victims. . . This is not how Saint Louis healed the diseased; his royal hands were motivated by a deeply felt religious conviction."[18]

Chateaubriand, nevertheless, put his finger on the image Gros wanted to project, that of a ruler endowed with the divine power to heal the sick and suffering. Napoleon's presence is a healing one, he shares the power with Saint Louis and other kings who have exercised the thaumaturgical ability possessed through the state of kings legitimated by divine right. While Napoleon was then only a general, his new status in 1804 as founder of an hereditary empire is projected in the picture. It is a picture that justified his elevation to emperor and rationalized his authority. . . .

Notes

1. G. Duruy, ed., *Mémoires de Barras,* 4 vols. (Paris, 1895–1896), I:56–59.

2. J. L. Jules David, *Le peintre Louis David* (1748–1825): *Souvenirs & documents inédits* (Paris, 1880), 393.

3. L. Junot [duchesse d'Abrantès], *Memoirs of Napoleon, His Court and Family,* 2 vols. (New York, 1895), 1:22:2.

4. David, pp. 428–429.

5. Cited in M. Delafond, *Louis Boilly:* 1761–1845 (Paris, 1984), 47–48.

6. A. Mabille de Poncheville, *Boilly* (Paris, 1831), 116–117.

7. This was inspired to large extent by J. L. Connolly, Jr., "Ingres and Allegory," a talk delivered at the College Art Association, January 1970.

8. Anonymous, "Duke of Hamilton and Brandon, K. G.," *Gentleman's Magazine,* n.s., vol. 38 (October 1852), 424–425.

9. H. Grant, *Napoleon and the Artists* (London, 1917), 155.

10. H. Toussaint, "Ossian en France," in *Ossian,* ed. H. Hohl and H. Toussaint (Paris, 1974), 73–74.

11. See P. A. Coupin, *Oeuvres posthumes de Girodet-Trioson,* 2 vols. (Paris, 1829), 2:284–297; G. Levitine, *Girodet-Trioson: An Iconographical Study* (New York, 1978). Girodet's explanation to Bonaparte (25 June 1802) reveals the true meaning of Ossian for contemporaries: "I have tried to trace the *apothéose des héros* for whom France mourns."

12. G. Levitine, "L'*Ossian* de Girodet et l'actualité politique sous le Consulat," *Gazette des Beaux-Arts,* 6e pér., vol. 48 (October 1956), 39–56.

13. F. Markham, *Napoleon* (NY 1966).

14. R. Rosenblum, *Transformations in Late Eighteenth-Century Art* (Princeton, 1974), 95–97; W. Friedlander, "Napoleon as 'Roi Thaumaturge,'" *Journal of the Warburg and Courtauld Institutes* 4 (1940–1941), 139–141.

15. There is debate over whether the seventeenth-century building that housed the makeshift hospital was a mosque or an Armenian monastery. See H. H. Mollaret and J. Brossollet, "A propos des 'Pestiférés de Jaffa' de A. J. Gros," *Jaarboek Koninklijk Museum voor Schone Kunsten* (Antwerp, 1968), 263–307, esp. 292.

16. J. H. Dible, *Napoleon's Surgeon* (London, 1970), 31–32.

17. R. G. Richardson, *Larrey: Surgeon to Napoleon's Imperial Guard* (London, 1974), 63.

18. Chateaubriand, *De Buonaparte, des Bourbons, et de la nécessité de se rallier à nos princes légitimes, pour le bonheur de la France et celui de l'Europe* (Paris, 1814), 15.

Chapter 9

Propaganda in the Communist State

Toby Clark

In theory, communism views revolution as a continuous process which transforms consciousness alongside the transformation of social reality. As implemented by state communism, national programmes of reconstruction, like industrialization or the collectivization of agriculture, were intended to have profound effects on people's habits of thought and behaviour, to an extent that would far exceed the mere propaganda of words and images. In practice, communist regimes have represented social change through a screen of censorship and illusion, producing a condition which some have described as dream-like because the official version of reality is so far at odds with everyday life. For the long-lasting regimes, like that of the Soviet Union, the term "propaganda" has not had negative connotations among communists, and because communism is said to provide an objective and scientific understanding of the world, little distinction is made between propaganda and education. In art, the main expression of state communism has been Socialist Realism, formally defined and introduced under Joseph Stalin in 1934 as the official aesthetic of the Soviet Union and later imposed by communist states throughout the world. It has been one of the most widely practised and enduring artistic approaches of the twentieth century.

It has often been argued that Socialist Realism was essentially similar to the official art of Nazi Germany. There are certainly many points of comparison. Both emerged fully in the 1930s and produced images which idealized workers and peasants and elevated their leaders in personality cults. Both used easily readable populist styles. The Soviet and Nazi regimes both backed up the persuasive techniques of propaganda with brutal methods of coercion which included arbitrary imprisonment and mass-murder. But a closer look at the iconographies of the two systems reveals important differences. Ideologically, communism and fascism took very different views of nature, technology, work, warfare, history, and human purpose. These ideological distinctions were moulded by deeply rooted cultural and social traditions specific to each national context. A conspicuous contrast, as noted earlier, was between Nazism's mythic glorification of the past and Soviet communism's enthusiasm for progress. Nazism emerged partly as a reaction

against the instability produced by Germany's rapid modernization. In the Soviet Union, however, as in other communist nations such as the People's Republic of China, Cuba, and the Afro-Marxist states in post-colonial Africa, political revolution took place in advance of substantial modernization. The achievement of modernity was an aspiration closely linked to the establishment of communist society.

"Organizing the Psyche of the Masses"

The imposition of Socialist Realism in 1934 marked a substantial increase in the Soviet state's control over art and was characteristic of Stalin's rule over the Party, exercised since the late 1920s. But it was preceded during the years which followed the October Revolution of 1917 by a period when the leadership had allowed and encouraged the experiments of many different communist art groups and the heated debates between them. These debates were not only about the most suitable style for communist art, but concerned wider questions about the function of art in this new society. From the outset it was clear that the revolution which created the world's first Workers' and Peasants' Government had entirely altered conditions for the patronage, audience, and sites of art. Soviet art was to be principally state-funded, public, and directed to a mass audience. But how were "the masses" to be conceived? What was to be their role in the production of art; what was the status of their tastes; and what was art supposed to *do* to them? These issues provoked a cluster of further questions: Should culture become "proletarian," or should it just be called "socialist" and aspire to be classless? Should it incorporate the achievements of bourgeois culture, or were all traditional kinds of art irredeemably tainted with capitalism and therefore to be abandoned?

Black Square by Kazimir Malevich (1878–1935;) encapsulates a radical view of this unique situation. It consists only of a black square on a white background. Painted shortly before the revolution and exhibited in 1915, Malevich originally conceived it as an extremist avant-garde gesture which announced the end of tradition in painting and the beginning of a transcendental, or what he called "Suprematist," level of perception and representation. He declared: "I have transformed myself into the zero of form and dragged myself out of the rubbish-filled pool of Academic art." The meanings of the painting were altered by the new context of the October Revolution of 1917. From that date, he used it to symbolize a rupture in history, the termination of the old order and the birth of the future out of revolution. For Malevich and his followers in the group UNOVIS (Affirmers of the New Art), old-fashioned approaches to art could only confine the human mind to conservative ways of thinking. Against this, they developed abstract art in which a vocabulary of pure geometric forms, usually brightly coloured, were designed to address the viewer's senses with dynamic effect. The Russian avant-garde had described this effect as *sdvig*—a sudden enlightenment or "shift" of perception. Though he called them "non-objective," meaning

abstract, some of Malevich's paintings refer in their titles and appearance to a cosmic or interplanetary environment signifying the transcendence of earth-bound habits of thought and the creation of a new world. Malevich's ideas drew on Apocalyptic beliefs that had long been nurtured in Russian culture, predicting the revelation of God's will to humanity along with the end of the material world and the creation of a celestial realm of pure spirit. A feature of this belief is the idea that divine knowledge will be revealed in abstract form, unmediated by language. Beyond the partial revelations of the Old and New Testaments, a "Third Text" will communicate directly to the human soul. Malevich saw this as a model for the imminent illumination of the consciousness of the proletariat.

The Bolshevik's leader, Lenin, more pragmatic and suspicious of avant-garde extremes, viewed the function of art as lying within the broader framework of education, for which tackling the illiteracy of 80 per cent of the population and the scarcity of basic technical skills were the real priorities. Conservative in taste, he felt that socialist culture should build on the best achievements of the past and, by developing these, "raise" the cultural standards of the masses. This was linked to his view of the role of the Party, the main theoretical element of Marxism-Leninism. To Lenin, the Russian working classes, mainly rural peasants, were not ready to generate revolutionary consciousness by themselves. The outbreak of strikes and rioting in cities in the winter of 1916–17, which forced the abdication of the Tsar, had been what Lenin called with some disdain "spontaneous": a premature, disorganized rebellion uninformed by political awareness. Lenin himself, like many other Bolsheviks, was in exile at the time and had to return to Russia to take charge of the uprising and oust the weak provisional government in the *coup* of October. The Party was to provide leadership and formulate the theoretical basis of policy. . . .

The October Revolution was followed by almost four years of civil war, which saw an emphasis on "agitational propaganda" or agit-prop, a term that described the more immediate, emotional techniques of propaganda. Of early agit-prop practices, street festivals and mass-action dramas revealed a version of public art which stressed popular involvement. Aiming to maintain the momentum of revolutionary enthusiasm in the face of the hardships of the civil war, agit-prop groups sought to create an atmosphere of colourful celebration. Alongside the posters, murals, and huge decorations on buildings, elaborate floats using trucks, trams, or horse-drawn carts carried tableaux of revolutionary themes. . . .

Lenin . . . wanted a more dignified statement of Bolshevism's cultural standards. His own contribution to this was known as the plan for monumental propaganda, which he announced in April 1918 in *Pravda* under a headline which called for "The Removal of Monuments Erected in Honour of the Tsars and their Servants and the Production of Projects for Monuments to the Russian Socialist Revolution." Lenin proposed putting the unemployed

to work in pulling down Tsarist statues and replacing them with new monuments commissioned to celebrate revered figures of the past. A list of more than sixty of these was to include historic revolutionaries such as Marx, Engels, Robespierre, and Spartacus, as well as cultural figures such as Tolstoy, Dostoevsky, Rublev, Chopin, and Byron. The statues, in bust or full-length, were hastily knocked up in temporary materials like wood and plaster, and formally unveiled in numerous town squares and on street corners.

Lenin's plan was designed to convey a number of messages about his own views on the role of art. Its ethos was educational—each statue bore a plaque with a brief biography and history lesson. Lenin's was an exercise in sober didacticism aimed at elevating the popular taste. The inclusion of politically conservative writers and artists may also have been intended to reassure the non-communist bourgeoisie about the Party's aesthetic tolerance and respect for Russian heritage. Lenin was sensitive about the reputation of Bolshevism in the West, where the press often depicted it as a movement of barbarous criminality. He did not prescribe the style that the statues should take; sculptors were given a free hand and thus the programme also served as a forum for discussion about the virtues of different styles. This relative freedom and the modest scale of the statues contrasts with the later conformity of Stalinist monumentalism, though Lenin's plan would be cited as a precedent for the monstrous statues of political leaders that became *de rigueur* under communist regimes, and that looked down on their citizens as eerie reminders of the omnipresence of state power and surveillance.

Russian avant-garde groups had a troubled relationship with the Party leadership. But in the early years, though small in number, they were well organized, highly energetic, and included some of the relatively few artists who supported Bolshevism. This won them powerful positions in the early Soviet arts administration. Vladimir Tatlin (1885–1953) had been the head of the Moscow branch of *IZO Narkompros* (the Commissariat of Enlightenment's Department of Fine Arts) shortly before conceiving his plans for his famous *Model of the Monument to the Third International* completed in 1920. As an abstract alternative to Lenin's figurative monuments, Tatlin's tower was a model for what would be the tallest building in the world. Suspended inside its skeletal framework, a series of glass buildings was planned to accommodate the government of the future. Like parts in a machine, the buildings would slowly revolve, keeping pace with the movement of the planets. Study of Tatlin's design has revealed layers of esoteric symbolism incorporating astrological and alchemical codes. But the tower was also to act as a centre for mass communication. It would be crowned by a radio station and the whole structure would serve as transmitter of propaganda. Information from around the world would be collected by radio receivers and a telephone and telegraph exchange. The agitation centre would broadcast appeals and proclamations to the city. In the evenings the monument would become a giant outdoor cinema, showing newsreels on a screen hung from the build-

Vladimir Tatlin,
The Finished
Model. *Model for*
the Monument to
the Third
International,
1920. (The
National Swedish
Art Museums/
Moderna Museet)

ing's wings and, in response to current events, appropriate slogans would be written across the skies from a projector station in letters of light. Manifestly impossible to realize at the time, the model acted as an icon for the future accomplishments of Soviet modernization.

Tatlin's tower reveals a highly centralized vision of both government and propaganda and it typified the Russian avant-garde's naïve enthusiasm for mass-media technology. Tatlin's friend, the poet Velimir Khlebnikov (1885–1922), called the radio "the main tree of consciousness;" "The radio will forge the broken links of the world soul and fuse together all mankind." In cinema, photography, and graphic design, techniques of montage were developed to high levels of sophistication in the 1920s by avant-garde film-makers such as Sergei Eisenstein (1898–1948) and designers such as Gustav Klucis (1895–c. 1944), Aleksandr Rodchenko (1891–1956), Varvara Stepanova (1894–1958) and the Stenberg brothers (Georgy, 1900–33, and Vladimir, 1899–1982). The avant-garde artists of the Russian Constructivist movement,

of which Tatlin was a founding figure, viewed design practices linked to mass production as a means of integrating art with the reconstruction of society. With designs for communist clothing, textiles, furniture, architecture, and even entire cities, Constructivists sought the creation of a total design aesthetic for changing the behavioural habits of the Soviet population, or, as they called it, for "organizing the psyche of the masses." Because of the low levels of industrial technology and materials, few Constructivist designs went into production. By the late 1920s, the Constructivists' vision for their project veered between a radical utopianism and a sinister fantasy of social engineering. . . .

Between Lenin's death in 1924 and Stalin's rise to power some five years later, the Party leadership maintained its policy of permitting relative pluralism in the arts, but it became increasingly clear that realist approaches were officially favoured more than the avant-garde's experiments. Among the many artistic groups of the 1920s, the Association of Artists of Revolutionary Russia (AKhRR) had been the largest, and gained support for its realist art among influential trade union and Red Army officials. In 1928 the party launched the Cultural Revolution, which aimed to reinvigorate the revolutionary process, and was expressed by a drive to "proletarianize" the arts. . . . This prepared the ground for the autocratic cultural policies of Stalinism.

The Theory and Practice of Socialist Realism

The definition and enshrinement of Socialist Realism as the only officially sanctioned approach in art was announced at the first All Union Congress of Soviet Writers in 1934, and had been preceded by the abolition of independent art groups in 1932. It accompanied the new imposition of communist orthodoxies in all fields, including science, medicine, and education. The doctrines were justified theoretically by dubious reinterpretations of both Marxist theory and Russian cultural history. Thus it was claimed that Socialist Realism was a natural continuation of Russia's radical heritage. Nineteenth-century revolutionaries like Nikolai Chernyshevsky (1828–89), author of *The Aesthetic Relations of Art and Reality* (1853) and of Lenin's favourite novel *What is to be Done?* (1863), had upheld realism in art as a moral principle: The artist's duty is to interpret, reflect and change reality. . . .

Corn by Tatyana Yablonskaya (b. 1917) is a typical example of Socialist Realism. . . . Yablonskaya produced the painting shortly after being rebuked in a magazine for having succumbed in her earlier work to Impressionism, then held officially to be a deviant type of foreign influence. On exhibiting *Corn* in 1950 she published a statement accepting this criticism and described how on a recent visit to a collective farm—in effect, a symbolic renewal of contact with the "reality" of land and people—she realized that a picture should start from content, not formal concerns. Rehabilitated by this apology, she was awarded a Stalin prize at the exhibition. . . . [S]he depicts a scene of work, but there is no hint of hardship; work under the Soviet system is shown

Two Women Shoveling Coal at Rail Yard. *(Sovfoto/Eastfoto)*

to be joyful and inspiring. There is an air of warm communality among the women workers, whose faces glow with pride and socialist fervour. The colour red, dispersed through the painting, harmonizes the composition while symbolizing the political unity of the people (though with the prud-ishness characteristic of Socialist Realism, the women are spatially segregated from the men in the background).

It is not entirely impossible that Yablonskaya encountered a scene like this on her visit to the collective farm, though at the time this superabundance of food and hi-tech farming equipment might have been more readily found in art than in real life. Yet her picture is not meant to show ordinary reality but *socialist* reality: the view of the world interpreted through socialism as defined by the Communist Party. . . . The theory of Socialist Realism insists that the power to identify and control the direction of . . . historic progression, and therefore to determine the correct representation of reality, is the exclusive property of the Communist Party. To its theorists, the idea that Socialist Realism is old-fashioned in style is irrelevant, for it is founded on four universal principles: *narodnost* (literally people-ness; accessible to popular audiences and reflecting their concerns); *klassovost* (class-ness; expressing class interests); *ideinost* (using topics relating to concrete current issues); and

partiinost (party-ness; faithful to the Party's point of view). These principles were drawn from traditions of Russian Populist, Marxist and Leninist ideas, though the legislative authority which they acquired was strictly Stalinist.

Emblems of Soviet Heroism

In paintings, novels, and films, Socialist Realism created a parallel world peopled by heroes and heroines who personified political ideals. As tireless labourers, courageous Red Army soldiers, diligent schoolchildren or dedicated Party activists, they demonstrated exemplary behaviour and the attitudes of perfect citizens. The concept of the New Soviet Person was in part descended from the original Marxist belief that a harmonious society in the future would enable the full development of the individual. This predicted the mental, moral, and physical improvement of humanity as a long-term and collective endeavour. Under Stalinism the idea became authoritarian and didactic, promoting an élitist cult of superhuman individuals whose powers matched the epic tasks of socialist construction. . . .

Higher and Higher by Serafima Ryangina (1891–1955), showing two young electrical workers climbing a pylon high above the countryside, . . . valorizes one of the earliest Soviet development projects, the building of an electricity network across the nation. Started by Lenin, the State Electrification Campaign was imbued with symbolic significance. It evoked the spread of light, power and energy across the nation, the mastering of the wilderness, and the unification of remote rural communities with the industrial and political centres of power. The painting's style adapts the imagery of mass culture, combining the Hollywood looks of the couple with a composition that resembles a capitalist advertisement or the illustration of a popular novel of romance and adventure. But the relationship between the man and woman, poised like mountaineers, is beyond erotic attachment. The euphoric gaze of the woman is directed upwards to a point in the distance. This formulaic forwards-and-upwards look, which recurs in the codes of Socialist Realism, signifies a temporal overlap in which the present is infused with the spirit of the future. Representations in art and the media of the labourers who worked on construction projects in remote districts often portrayed them as a breed of pioneers on a new frontier. Even landscape paintings, which at first sight would seem free of ideological meanings, often included electricity pylons or a train as signs of the triumph of progress over nature. In reality, though, the vast industrial projects of the 1930s involved the conscription, for "re-education," of hundreds of thousands of convict labourers, including political dissidents. Many of them died under the harsh working conditions. . . .

Although Soviet propaganda was effectively directed by Moscow, its audiences reached far beyond Russia to the Soviet republics of eastern Europe and across Asia, embracing many ethnic groups with different languages and religions. Their control by Soviet power was a continuation of Tsarist imperialism. Stalinist cultural policy vacillated in its view of the non-

M.G. Belsky, **Metalworkers of Donbass.** *(Sovfoto/Eastfoto)*

Russian republics. While the principle of *narodnost* (people-ness) implied some respect for local folk traditions, this was usually waived by Moscow's impulse to spread Russian-oriented conformity. . . .

Carpet-Weavers of Armenia Weaving a Carpet with a Portrait of Comrade Stalin by Mariam Aslamazyan (b. 1907) is . . . complicit with the cynical double-standards of Moscow's cultural colonization of the non-Russian republics. The loose, decorative style would normally have been censured for its lack of realism but was permitted here as a concession to the "exotic" subject-matter. The painting shows a craft workshop in Armenia making the

type of state-commissioned ornament used to decorate public buildings and government offices. It seems to allude to folk traditions only to demonstrate their actual annihilation by Stalinist kitsch.

The greatest hero in Stalinist culture was, of course, Stalin himself. The personality cult invented to revere the supreme achievements and qualities of Stalin matched in scale and extravagance those devoted to Hitler and Mussolini, although a cult of leadership had no basis in Marxist thought. Lenin was opposed to the creation of his own personality cult, and seems to have had a genuine distaste for the élitism and individualism which it would imply. The elevation of Lenin to saintly or godlike status greatly accelerated after his death and was largely instigated by Stalin as a means to justify his own stature as Lenin's successor. Stalinism was able to harness the old legacy of Tsar-worship which had been nurtured since the Middle Ages in Russian peasant folklore. Many images portrayed Stalin as a benevolent patriarch, often showing him in the company of workers, soldiers, or politicians upon whom he bestows his fatherly attention and words of wisdom. In *Stalin's Speech at the 16th Congress of the Communist Party*, Aleksandr Gerasimov (1881–1963) depicted Stalin in a church-like atmosphere in front of the sacred effigy of Lenin.

Stalin employed a stable of court painters to produce hundreds of official portraits, some of which were of immense size and painted by brigades of artists working under production-line conditions. The financial rewards and privileges for favoured artists could be substantial, but painting Stalin was a dangerous occupation. Those who worked closely with him, such as his political colleagues, secretaries, interpreters, and bodyguards, had a tendency to "disappear," to be arrested, executed, or secretly murdered according to his paranoid whims. In reality, Stalin was short, fat, and bandy-legged with a pock-marked face, narrow forehead, and withered left arm. But an official artist would have been unwise to depict his physical appearance with any degree of accuracy.

As a young man at the time of the October Revolution, Stalin had played no more than a peripheral part in the Bolshevik uprising. This potentially embarrassing fact was glossed over by fictional biographies, which exaggerated the revolutionary adventures of his youth, and described his warm friendship with Lenin. Evidence in fact suggests that Lenin viewed him with distrust and personal dislike. Stalin, in turn, came to fear all the "Old Bolsheviks" and anyone who had been involved in the original revolutionary movement. From the mid-1930s, he set about purging the Party leadership and armed forces in waves of show trials and mass-executions. . . .

After Stalin's death in 1953 there was some relaxation of cultural regulations. In February 1956 the new leader, Nikita Khrushchev, formally denounced Stalin at a closed session of the Party Congress, and subsequently thousands of works of art of the Stalinist period, especially those which depicted him, were destroyed or hidden and disappeared from the art history

I. Brodsky, **Portrait of Stalin Making a Speech.** *(Sovfoto/ Eastfoto)*

books. Although the excesses of Stalin's personality cult were not repeated by his successors, the heroization of Soviet workers continued as the principal theme of Socialist Realism. . . . But during the 1960s and 1970s nonconformist and dissident art groups were increasingly active. Technically, it had never been illegal for an artist to work in unorthodox styles, but attempts to exhibit outside the official framework frequently met with police harassment. In the 1970s numerous small exhibitions were held in defiance of Party regulations and were duly closed down, sometimes within hours of opening. In Moscow in September 1974, an open-air exhibition on a patch of suburban wasteland was broken up by bulldozers and water cannons. The "Bulldozer Exhibition" was widely reported in the Western press. Nonconformist art has covered a wide variety of styles and themes. . . . The paintings and sculptures of Grisha Bruskin (b. 1945) comment critically on Socialist Realist formulae. His serial piece, the *Fundamental Lexicon* is a visual catalogue of the symbols and stereotypes of official Soviet culture. With its deadpan literalism, it lays bare the ideological sign systems of communist state art.

Chapter 10

Can Political Passion Inspire Great Art?

Michael Brenson

The most provocative topic in the art world this year is once again the relationship between politics and art. Instead of speculating on suspected artist-dealer-curator-collector-critic-media conspiracies—although there is, of course, still plenty of talk about that—citizens of the fastest and most fashion-plagued art world anywhere are now talking about social responsibility, ideology, nuclear war and changing the world.

Why this has happened now, and whether the quality of the political art that is the subject of widespread critical and curatorial attention is commensurate with the sound and fury that has surrounded it are two of the questions raised by the latest art and politics revival.

Evidence of art that is political in content or ambition is everywhere. It was featured in the two winter exhibitions at the New Museum of Contemporary Art: "The End of the World: Contemporary Visions of the Apocalypse" and "Art & Ideology." It has been or is being featured in a number of university art galleries in Boston and New York. Many of the major figures identified with political art, including Robert Colescott, Leon Golub, Barbara Kruger and Nancy Spero, have recently had one-person exhibitions in New York. The first retrospective devoted to Leon Golub, who is the cornerstone of the present interest in political art, will open at the New Museum next fall.

There have also been articles, benefit exhibitions and group exhibitions presenting artists' responses to the threat of nuclear war, as well as a symposium on "War in Art" at Cooper Union last February. The poster for "Artists Call Against U.S. Intervention in Central America" contained a petition signed by well over 1,000 artists, poets and performers. Artists Call also organized benefit exhibitions at more than 20 New York exhibition spaces, including the prominent Leo Castelbi, Paula Cooper, Terry Dintenfass and Marion Goodman Galleries.

Such political issues, however, as well as political involvement on the part of artists, are hardly new phenomena: What is new both in the current political art and the debate which surrounds it—is that the definition of "politics" has expanded to the point where, at the moment, it seems as if it might

supercede [*sic*] and swallow up all artistic criteria. Within some art and art-critical circles, "political" now applies to cultural imagery, the functioning of the art market, the artist's attitude towards any subject and the creative process itself. In other words, the word "political" has become a filter through which all art can be perceived and judged.

Although the intense debate about politics and art has produced insights into the intersection of culture and art and experiments in new forms of expression, it has also unleashed a potential for dogmatism and intellectual intimidation that poses real dangers for art and artists. For example, it can lead some artists to mistake moral outrage or a correct ideological stance for artistic achievement; it can lead others to pull back from the issues of the day altogether. An attempt to sift through current political art is therefore essential.

Since the road to first-rate art has never been paved with good intentions, or good theory alone, the first question is what makes for good, or great, political art. Historically, examples of such art are surprisingly rare, testifying to the difficulty of transforming political outrage or themes into work that has anything but the most perfunctory effect. It is a telling paradox that the most enduring political art has probably been made by those who were not primarily political artists. When Goya etched his "Disasters of War" and in 1814 painted his "Third of May 1808," whose theme is the savage reprisals of the occupying French forces to the Spanish resistance, he was more than 60 years old, with a lifetime of art and the broadest experience of people behind him. Picasso, like Goya, was steeped in the history of art and concerned throughout his life with the entire human condition. When he painted "Guernica," he was 56, and all that he had lived and painted and thought about up to then went into it. "Guernica" and the "Third of May" remain such huge moral statements—such strong reminders of the need for a vigilant political conscience—because of the human and artistic wisdom that went into them.

In the 20th century, perhaps for the first time, schools and even entire directions in art emerged from and remained in the service of a specific ideology. Of all the examples of 20th century political art, none was more wholly political than Agitprop, the art of revolutionary propaganda in Russia after the Revolution. Agitprop involved a great many artists, including Kasimir Malevich, Liubov Popova and Alexander Rodchenko, who produced all kinds of work for use in daily life, from posters to porcelain to buses and trains.

One of Agitprop's modernist traits was that it identified social change with artistic experimentation. Still, what survives from Agitprop is less the esthetic intelligence that informs some of the works than its extraordinary purpose and hope, which hangs over 20th century art like an artistic Eden. Since Agitprop rejected traditional forms of art and worked outside the commodity system in the service of an all-consuming dream, aspects of it will probably always reappear in art that sees itself as revolutionary. For example,

Mike Glier's paintings of "Women Calling" are like Agitprop posters in the way they try to direct people toward a simpler, less stereotyped society. But Agitprop is a form of propaganda art, and such art is invariably facile outside a shared system of belief.

At about the same time, a number of artists in Germany were making political protest art that grew not out of a revolutionary dream but the nightmare of the Great War and which could hardly be more disabused. The work of George Grosz and, to a much greater degree, Otto Dix and Max Beckmann, has aged well because of its independence and the artistic intelligence behind it. In part because of the corrosiveness with which someone like Dix exposed the face of war and the social and political life of post-World War I Germany, Expressionism will continue to be an essential language of rage and protest. It informs the work of the contemporary American artists Peter Saul and Robert Colescott, who have been making art with political content since the 1950's. It is also present in the paintings of a younger artist like Sue Coe, who builds her jagged compositions and distorts her figures in order to communicate her outrage at violence to women.

The 1930's also produced American Social Realism, which was, in part, a response to the oppressive political and social conditions of the Depression. Artists such as Ben Shahn, Raphael Soyer and Jack Levine wanted their work to be an indictment of society and an instrument of social change. They tended not to preach but to try to use their realistic technique to convince the public of the violence of power and the plight of the common man.

Social Realists considered realism the language of hard truth, and with it produced a body of modest but admirable work. However, a very similar style was used for very different purposes in Soviet Social Realism, which followed in the wake of Agitprop, but which remains the epitome of art serving a monolithic state ideology.

Very little political work being produced today suggests either broad artistic or human knowledge. Of the many dangers of political art, one of the most lethal is that it grants artists the license to believe that what matters is only the immediate outrage of the present.

The claim of one prominent political artist, Hans Haacke, that "so-called political art is scrutinized much more carefully" and that it is much harder for political artists to "get away with mediocre works" is patently unjustified. There is no better evidence of this than the high visibility of his own factual commentaries. His "Isolation Box," displayed at the Graduate Center of the City of New York Mall as part of Artists Call, is an eight-by-eight-by-eight-foot wooden box with a sign on it saying: "isolation box as used by U.S. troops at Point Salines Prison Camp in Grenada." This kind of simplistic piece tells us far less about troubled United States Caribbean waters than the searching non-political paintings by Eric Fischl, which use a black-white tension in the Caribbean as a starting point for an exploration of turbulent emotional and sexual currents.

If it is to appeal to more than a coterie of already convinced sympathizers, political art needs more than theory and a correct point of view. Unfortunately, very little of it produced today has the complexity and mastery to be able to stand on its own merit.

It is impossible to cover the entire territory of contemporary political art. However, it is clear that the most global political issue, the danger of nuclear arms, has produced the broadest range of work. A 1983 painting-sculpture by Robert Morris, called "Untitled," which wound up on the covers of *both Arts* and *Art in America* this month—a highly unusual coincidence—is rare in its combination of commitment and introspection. By giving the painted conflagration in the center of the work a lyrical majesty, Morris makes clear that the idea of a definitive holocaust is also, from a visual artist's point of view, fascinating and compelling. Because of the seductive beauty of the fire storm beginning to build in the central panel, the skulls in the relief above the painting and the defiant fists in the relief below have a complexity and impact that otherwise they would not have.

Beverly Naidus's "This Is Not a Test," an installation in "The End of the World" exhibition, is an example of the kind of sophomoric good will with which so much anti-nuclear art is informed. Consisting of the most primitive kind of ramshackle shelter, with a bed and a lamp inside, it is almost a strong work. The care and craft with which the hut has been pieced together in the service of a transient and troubling statement is undermined, however, by a writing stand in front of the hut on which visitors can write down their thoughts. Suddenly we are back in college and the work becomes tacky.

A major impetus for political art now is feminism. Feminist artists tend to reject existing political and artistic systems and, as a result, to produce work in alternative artistic media. Perhaps the most prominent feminist art depends heavily upon photographs and words, in part in an attempt to expose what is seen as this culture's ideological brainwashing through advertisements and the popular media; in part to create works that are not beautiful objects and therefore less capable of being "coopted" into the art world gallery, museum and commercial system. One of the assumptions in the commercial-art based work of Erika Rothenberg and Barbara Kruger is that what goes on in advertisements is instrumental to the repression of women and to the national tolerance for such events, let's say, as the invasion of Grenada or the mining of Nicaraguan ports.

Barbara Kruger, whose work is presently touring Europe, is the most forceful feminist artist working with the techniques of commercial art. Kruger takes stereotyped photographed images, then blows them up and crops them. Then she adds words. Her works are attempts to question not only general cultural attitudes, but also the conditions in which art is made and sold. She is most involved with questions of class. "I am not concerned with issues if they are not going to be anchored by some kind of analysis or consideration of class," she has said.

In the work of hers that has been acquired by the Museum of Modern Art, the words "You Invest in the Divinity of the Masterpiece" appear in three sections across a photograph of Michelangelo's "Creation of Adam" on the Sistine Ceiling. The painting is a work by a man, of men, that has come to symbolize the divine spark for everyone. Kruger's work is angry and mocking of what some artists and critics see as a mythology of the masterpiece and the genius. The "You" in the work is both declarative and accusatory. Rubbing the two together is clearly intended to create a spark that will make viewers reflect on their own position with regard to the work and to the conjunction of words like "invest" and "masterpiece."

No matter how sharp the insight behind it, however, Kruger's didactic work quickly becomes predictable. At best, it could become a political fact, a kind of moral deterrent. As of now, however, her work remains uneven, and so limited in its intellectual and emotional range that a little bit of it goes a long way.

The work of Nancy Spero, another feminist artist and a founder of the women's art movement, has far greater breadth. Spero studied art and makes use of it, particularly the Primitive and Oriental art traditions. For some time, she has been involved with scrolls which often tell stories about the mistreatment of women. Her 125-foot long "Torture of Women" scroll includes many Amnesty International reports of the brutalization of women alongside an ancient Sumerian myth which expresses, in the artist's words, "what must have already been the timeless fear, hatred and cruelty directed toward women."

Juxtaposed with the words, in different-sized type and in what appear to be disordered and even disoriented patterns, is a lot of empty space and a number of Spero's confused, victimized or defiant figures. In Spero's art, the mistreatment of women and human violence in general is identified with men. Despite her rage, however, and a tendency toward overstatement, her work is not as dogmatic, not as superior in its viewpoint as it may seem. These are works which cry out at us, but which also cry out to us. The balance between outrage and need, defiance and silence is almost impossible to maintain. As much as what she is saying, her attempt to maintain that balance makes her work important.

The best political art has always been art first and politics second. Picasso knew, for example, that it was only by making the bombing of the Spanish town of Guernica into art that people could relate to the bombing enough to experience it as a terrible political act. It is too early to know whether the Swiss painter Gregoire Muller will produce first-rate political art, but the way he used his esthetic intelligence against a political subject in his recent exhibition at the Oil & Steel Gallery makes him an artist worth following. His images of violence in the Middle East and the Philippines create a sense of familiarity on two normally mutually exclusive levels: political events and the history of art. In a painting such as "The Death of Ninoy,"

based on a newspaper photograph of the assassination last year of Philippine opposition leader Benigno S. Aquino Jr., (known to his supporters as "Ninoy"), esthetic intelligence is used against the content to make people feel something strong and terrible, which is a prerequisite to inspiring any political action.

Because of his recent political paintings, Leon Golub has become a subject of widespread interest and even reverence after being virtually ignored for around 15 years. Since 1976 he has been making paintings of terrorists, interrogators and mercenaries. They are big, bold and sometimes beautifully painted canvases with a texture that is raw and sensual at the same time. The paintings usually contain a group of men either just standing around, like men in a bar waiting restlessly for a television football game to begin, or involved in acts of depersonalized violence. In one painting, someone is being stuffed into a car; in another, a naked man is masked and bound in front of what looks like a torture machine. There are no buildings or landscapes in these paintings and the background is usually just one color.

Because the people in these works seem human and there is no specific sense of person and place, Golub's works are not morality plays. Although the images and titles bring to mind images of violence in Africa and Central America, there is no feeling of superiority on the part of the artist toward the victimizers and the subject matter. These works do not present evil as the property of one system, one sex, one race. The thugs in his paintings could be him, and they could be us.

What gives Golub's works their timeliness is that many of the threads not only of current political art but of important contemporary art in general are woven into them. Along with their immediacy and their political subject matter, they are rooted in the history of art—they bring to mind 19th-century history painting, Color Field painting and Abstract Expressionism. They are also rooted in the popular media: trying to understand the mechanisms of sadism and torture, Golub rummages through newspaper photographs, sports pages and pornographic magazines. It is there that he finds his faces, postures, gestures and many of his compositional ideas. Ordering different aspects of our culture by means of a hard-won knowledge of pictorial composition gives his work a scope that almost no other body of contemporary political work in this country has or even seems to feel it needs.

And yet, it is only from such a synthesis of immediate observation, craft and the lessons of time—from the testing of political facts against one's own experience—that convincing and forceful political art can emerge.

Part IV

Public Art

Public art and architecture have traditionally served an important purpose in societies throughout the world. Created for the use, enjoyment, and edification of the public, buildings and artworks in public places may represent or challenge common societal ideals. Architectural historian Spiro Kostof recognizes public spaces as fulfilling a collective need to celebrate a sense of belonging and community spirit. In "The Public Realm," from his longer study *America by Design,* he directs our attention to open public areas, noting the Boston Common as a prototype and as representing "the public face of America." Kostof goes on to review the significance of the urban park and the distinctive vision of Frederick Law Olmsted, designer of Boston's Emerald Necklace and New York's Central Park.

Examining nineteenth-century designs for state capitol buildings, Kostof perceives an increased public appetite for splendor. Nineteenth-century public monuments reflected America's desire to universalize while retaining a sense of its own historical identity. Yet there is an inherent contradiction in late nineteenth-century public building design in America: Libraries, railroad stations, office buildings, even department stores displayed the excessive luxury, worldliness, and ornamentation associated with the European Baroque and Beaux Arts styles. Such grandiosity actually distanced, rather than attracted, the general public, which was perhaps confused by the new domination of commercial structures over government and religious buildings.

During the 1930s, public art took a dramatic turn under federally funded programs. FDR's New Deal campaign to put Americans, including artists, to work during the Great Depression of the 1930s is outlined in Marlene Park and Gerald Markowitz's essay "New Deal for Public Art." Just as the Soviet leaders contemporaneously sought to unite Russians in support of a social ideal (see Chapter 9), the New Deal intended to unite an economically devastated country around a new definition of democracy. The Federal government took on

the role of protector of its citizens; it recognized the right of unions to exist and sought a balance between individualism and collectivity. The New Deal supported the most comprehensive art program ever undertaken by a U.S. government, affirming its commitment to democratizing art and culture.

The Works Progress Administration (WPA) of the Federal Art Project (FAP) employed many artists to provide decorations for federal and public buildings. Two art programs were also supervised by the Treasury Department; the more long-lasting was the Department's Section of Painting and Sculpture, later the Section of Fine Arts. It was organized in 1934 and suspended after almost 1400 commissions in 1943. Unlike WPA artists, who were given work according to financial need, Section artists competed for commissions and were contracted to complete particular projects. Whereas the WPA/FAP encouraged creativity and experimentation, the Section was more conservative, stressing quality and accessibility to the general public. As with Soviet Socialist Realism, in Section murals there is no trace of conflicts precipitated by such far-reaching government patronage. However, a tension—between radicals and conservatives and their notions of the values that must shape public art—is reflected in dialogues over art produced by Section artists. In spite of the differing political views held by artists and politicians alike, certain basic shared assumptions were expressed in government-supported public artworks during the 1930s: a belief in progress, racial injustice as a wrong soon to be righted, comfort with gender roles, and a sense of a unified nation consisting of "the common man."

Public monuments today are significant for reasons other than the expression of commonly shared ideals or the shaping of a common identity for a heterogeneous public. Contemporary public monuments may often serve as a vehicle for the mourning of tragic events. In "Memorializing the Unspeakable: Public Monuments and Collective Grieving," Carole Gold Calo notes a shift in recent public art from static sculpture to experiential installation. Perhaps the most widely discussed and controversial work emphasizing the experience of the viewer is Maya Lin's *Vietnam Veterans Memorial* in Washington, D.C., in which visitors follow a descending walkway to confront on a black granite wall scores of names of American soldiers lost in that war. This direct personal experience is enhanced both by mementos left by mourners and by the elements of motion and time, so that the viewer moves through a process of acknowledgment and grieving.

A similar process makes the New England Holocaust Memorial in Boston such a gripping and ultimately cathartic experience. As the visitor enters into an abstract open glass structure, referential to smoke stacks of the gas chambers, he/she reads statements by survivors of concentration camps. The viewer undergoes a journey toward understanding while grieving for the millions of victims of such horrific cruelty. Increasingly public monuments are combining an opportunity for reflection with an experiential move through stages of grieving. The proposed memorial park to the victims of the

Oklahoma City bombing provides a serene environment in which the public may contemplate this unthinkable tragedy, feel compassion for those directly affected by it, and yet find hope in the strength of the human spirit.

With this emphasis on the experiential, the nature of the public monument has changed dramatically. *The Names Quilt* is a case in point. This memorial moves beyond any traditional definition. Unlike the other memorials discussed, *The Names Quilt* is not permanently situated. It is transported to different sites and presented in varying configurations. Also, it has not been designed by a professional artist or architect. Rather it consists of a collection of individual panels created by members of the public to commemorate loved ones or family members lost to AIDS. There is no stylistic consistency among the thousands of panels; no aesthetic judgment is imposed. Yet no one will deny that *The Names Quilt* is a poignant memorial and a dramatically moving experience for those who have made panels and for visitors who move along rows to view the panels—to mourn, to connect with others, to somehow find meaning in the ravages of this devastating epidemic.

Despite efforts to formulate a common societal vision, many public artworks have been considered controversial. Harriet Senie, in "The Persistence of Controversy: Patronage and Politics," unravels the complex web of expectations and agendas that often lead to public art controversy. Senie reviews the funding premises for government programs such as Art-in-Architecture with percent-for-art components and the Art in Public Places initiative sponsored by the National Endowment for the Arts. The author considers the commissioning processes for the programs. The percent-for-art programs begin with the architecture and treat art as an add-on intended to enhance the space. This method can result in the so-called "plop art" syndrome. The NEA provides matching funds to local organizations for art designed for specific sites. Art can become part of an urban renewal effort and may quite successfully provide a positive self-image for the community. It should be noted, however, that problems arise when public art is used in place of actual urban renewal.

Senie suggests that the requirements of the public be addressed at the time the artwork is commissioned to avoid potential misunderstandings. She recommends a committee of art professionals should select a most appropriate artist for the project, making sure the artist is willing to take into consideration the concerns of the community. Senie advocates for an open demystified selection process and an integrated art education component for the public. While aesthetic criteria for public art is an issue constantly under discussion, and various political agendas may muddy the waters of any project, communication is essential, far more so than consensus. According to the author, truly effective public art invites dialogue, thereby affirming a meaningful role for art in public life today.

Chapter 11

The Public Realm

Spiro Kostof

Boston Common is one of the earliest public places in America. For over three hundred years it has remained an open space—and that is no easy feat in the heart of a thriving city, where land is gold and progress virulent. The Bostonians' open-air living room has survived intact from the seventeenth century—when cows grazed there, and the local militia exercised, and "the Gallants a little before Sun-set walk with their Marmalet Madams," as an English visitor wrote in 1663, "till the nine a clock Bell rings them home to their respective habitations." And so it continued, free of encroachments, a common ground for pleasure and civic use, where all could come and go as they pleased and encounters were easy and unrehearsed.

In time, buildings surrounded the Common—churches with their graveyards, shops, elegant houses along Beacon Hill. The Massachusetts State House, one of the first capitols to go up after Independence, sat on an eminence on the Beacon Hill side, with an imposing set of stairs descending toward the Common. Monuments cropped up, to honor publicly what Boston thought worth honoring—a Civil War memorial, for example, to Colonel Robert Shaw and his regiment of black soldiers from Massachusetts, or on a central knoll, the Army and Navy monument topped by the "Genius of America." When department stores came of age in the 1880s, Filene's, one of the best, turned one side toward the Common, only one block away from it, and the other toward the central business district.

At the far side of the Common, toward Arlington Street, on land reclaimed from the mud of the Back Bay in the mid-nineteenth century, a lovely Public Garden was installed. The great landscape artist Frederick Law Olmsted made this the starting point of a beautiful park system he called the Emerald Necklace. The Public Garden is all the things the common is not—small, fenced in, manicured. It has a choice variety of trees, properly labeled, formal flower beds that change with the seasons, a shallow lake shaded by willows, swan boats. It was meant for the more genteel Bostonian, and to this day it is preferred by people who disapprove of loud radios, winos, and running dogs.

Boston Common represents the public face of America. Every town, however small, designs into its fabric a stage of this sort. We seem to need more from life than just food, shelter, work, and entertainment. Beyond self,

beyond family and neighborhood, there exists a public realm which holds our pride as a people. We need public places to enjoy the unplanned intimacy of civil society and to celebrate that sense of belonging to a broad community—a community with a shared record of accomplishment. We expect public buildings to express the dignity of our institutions. We choose to make monumental gestures that commemorate our heroes and mark the passage of our history.

Early Public Spaces

The public open space was there at the beginning, from the first European towns planted on this continent.

In the middle of their gridded pueblos, the Spanish invariably left a large plaza, one longer than it was wide and surrounded by porticoes where goods were sold. The administrative palace and other public buildings fronted the plaza, and so very often did the main church. But the center belonged to the people, for their fiestas and the customary evening stroll or *corso*, a time of socializing, flirting, showing off. The ghost of one such plaza survives in Santa Fe, New Mexico, where you can still see street merchants set up their stalls in the portico of the Governor's Palace. It was twice the present size originally, extending eastward to the present cathedral. The landscaping and paving are later refinements. A military chapel on the south side of the plaza related to one of its original uses—military exercises.

French towns were on rivers, and the town square, which doubled as a parade ground here too, overlooked the waterfront. The buildings that defined the square usually included a barracks and a hospital. In New Orleans, the capital of the French province of Louisiana, a brick church stood on the inland side of the square, and the quay along the river had a gravel walk planted with orange trees. The square, miraculously, lives still—a charmed, evocative public place, full of shade and pungent odors. There is a later church on that axis now, and the framing buildings span the French, the Spanish, and the early American eras of the city. In the middle is Andrew Jackson poised on his horse. This statue and the landscaping, which turned the square into an urban garden in the 1850s, are American contributions.

Americans, that side of them that derives from the English at least, were never very comfortable with an empty public place. They liked it filled with something, preferably some sort of public building that would provide a good excuse for wanting to be there.

Take the New England common. At first, it was neither an open green nor the grazing ground for local livestock. Boston Common seems to have been an exception. Ordinarily, a common was much too small to sustain more than a few animals. Besides, there was no green on it at all. In the early morning, townsmen on their way to fields at the edge of town led their cattle to the "close" in this open, central area where a herdsman waited to lead them to graze in the common pastures. At dusk the returning men collected their animals and herded them home.

The real reason for the common was the meetinghouse—a religious cen-
ter and town hall in one. When land was first allocated in a new town, a large
plot was set aside for this most important building of community life. Once
the meetinghouse was up, and the graveyard fenced in with a neat stone wall,
other buildings gathered around. There was the nooning house, for example,
where in winter months the parishioners could find shelter and heat during
breaks in the long, cold services of the Sabbath. The tavern was just as good
for this purpose, at least for the less scrupulous. It also served as temporary
courthouse, and later, when regular stagecoach service was established, as a
stage stop—often marked by a huge inn sign that dwarfed everything around
it except the meetinghouse. A blacksmith shop did well on the common, and
so did bootmakers and hatters. There might also be a magazine for the stor-
age of powder, horsesheds for the parishioners, or a schoolhouse.

Otherwise, the common was an unsightly, rutted piece of barren land,
riddled with stumps and stones. The town's militia used it for its quarterly
training, and its other public uses were reflected in its furnishings: the hay
scale, the bulletin board, the well, the whipping post. To turn this stern Puri-
tan civic center into the town green we now admire, the monopoly of the
Congregational church on town life had first to be broken. Then Baptists,
Methodists, and others could stand their own churches on the common and
civilizing improvements could begin.

In New Haven we have a classic example of this transformation. After
the War of 1812, the city cleared its common, then called the Market Place, of
its old buildings and roads, moved the graveyard, and in the middle, where
the old meetinghouse had stood unchallenged, made provision for three
churches—two of them for the Congregationalists and one for Episcopalians.
Planned spaces were also allotted to the Methodists and Baptists at two cor-
ners of the common, now called the Green. The Methodists actually did put
up a church, but the Proprietors of the Green, now full of civic pride, found
the building too crude for such a public stage. They bought the Methodists
out and moved them off the Green, across the street. The Baptists never took
advantage of their allotted site, but chose instead to make their stand in the
less formal Wooster Square nearby. North of the three new churches on the
Green rose the new state house, in temple form, replacing an older building,
which now seemed to spoil the symmetry. Yale's Brick Row faced the state
house across College Street, and on the opposite, Church Street side, the town
hall went up. As a finishing touch, the area was fenced in and edged with
elms. When the elms matured this place became one of the most celebrated
public squares in America.

By the middle of the nineteenth century, in the new railroad towns of
the Midwest and the South, the New England green had found its counter-
part in the courthouse square. It was the central feature of towns that served
as county seats, and it represents as authentic a piece of American urbanism
as Main Street. The courthouse stood in the middle of the one-block square,
on a slight rise, surrounded by trees. In the treeless tallgrass prairie, this leafy

oasis was a statement of survival and permanence. The townfolk spoke of it proudly as the "park" or the "grove." The jail and a clerk's fireproof office might be at the corners of the square. For the rest, it was small, local retail businesses, a hotel, and a restaurant or cafe where the businessmen ate their lunch. Board roofs projecting from the fronts of these establishments furnished shade, and plank seats between the roof supports made it easy to spend time there.

Farmers from the surrounding countryside stopped in regularly to take care of legal and tax matters. In the courthouse were kept land grants and commercial debt-bonds, and so the building would have to be solid, made of stone. To William Faulkner's eyes the courthouse at Jefferson, Mississippi, was "the center, the focus, the hub; sitting looming in the center of the county's circumference . . . protector of the weak, judiciate and curb of the passions and lusts, repository and guardian of the aspirations and hopes."

On the grounds there was room for the weekly market and sometimes the county fair. Here statue-soldiers on pedestals memorialized past wars. In the South none was more sacred than the Confederate monument to the Civil War: Johnny Reb holding a rifle at parade rest, or else with arms folded, or carrying a flag or bugle, most often facing north whence the invasion came. And always an inscription, like this one at Lumberton, North Carolina.

> This marble minstrel's voiceless stone
> In deathless song shall tell
> When many a vanished age hath flown
> the story how they fell.
>
> On fame's eternal camping ground
> Their silent tents are spread.
> And glory guards with solemn round
> The bivouac of the dead.

So a public, urban place like the courthouse square, in these old days, was the setting where all sorts of people came together informally, where collective civic rituals like markets and parades took place, and where the prevalent values and beliefs of the community were made manifest. The institutional building—courthouse or public library or town hall—dominated. The space was well bounded and its scale intimate; it took its shape from the street pattern. It had many uses, some of them unplanned. But the urban square was above all political territory. Within its confines, people knew their place and found strength in their local tradition. The space held them, gave them identity. It is where they learned to live together.

Parks and Cemeteries

The urban park came later and was a different sort of public place. It was anti-city, to begin with, both in form and intent. What it offered visually was an invented romantic landscape, with no relation whatever to the city's street pattern. The sense was of a pleasure ground, a place of quiet and passive

enjoyment. The park would set people free from the structured order of the town, free from its organized but also volatile behavior, its tensions. At the same time, the park would provide a neutral setting where the rich and poor could come together as equals. Alexis de Tocqueville, for one, believed that parks were a necessary instrument of democracy because they neutralized the strains of class consciousness built up within the cities.

So ran the rhetoric. But this outward look of innocent escapism and fraternal equality couched a more serious purpose. It had to do with the imposition of moral order where it was thought most wanting—among the urban poor. The creators and administrators of parks were gentlemen-idealists; in origin they were native-stock Americans, "Yankees." They viewed the park, from the very beginning, as an uplifting experience, a means to improve the social behavior of the citizenry—which really came down to making sure that the working classes, the immigrant labor of Yankee-owned businesses, behaved like their betters, the cultured upper crust. This is how Andrew Jackson Downing, for example, put it in 1848:

> You may take my word for it, [parks] will be better preachers of temperance than temperance societies, better refiners of national morals than dancing schools and better promoters of general good-feeling than any lectures on the philosophy of happiness.

Frederick Law Olmsted thought of the park in the same way. His name more than any other was to govern the philosophy and design of America's parks for the first fifty years of their history. Olmsted's attitude was moralizing from the start. Yes, the purpose of the park was to allow urban folk to enjoy an unadulterated rural experience. But what he really intended to do with his park designs was to wean the working classes away from their ethnic neighborhoods, away from the adventures of city streets, and to make proper Americans out of them.

By training, Olmsted was neither an engineer nor a landscape architect—the two preeminent skills called into use to transform and embellish large tracts of land into carefree "nature." In fact, landscape architecture did not as yet exist as a profession in this country. When he won the competition for the design of Central Park in New York in 1858, Olmsted had behind him the rudiments of surveying, which he learned from an engineer to whom he was apprenticed briefly at age fifteen, some experience at clerking and seafaring, and ten years or so of farming in Connecticut and Staten Island.

Parks were unknown in America at the time, and in Europe, where parks had always been the preserves of noblemen and royalty, publicly owned parks were just beginning to take shape. Birkenhead Park outside Liverpool was Olmsted's immediate model; the example of the informal style of the English landscape garden formed the background of his thinking. At home, besides the newly fashionable Gothic cottages of Downing and his peers sitting in their picturesquely landscaped suburban lots, the only precedent was the rural cemetery.

In Colonial days people were buried in the churchyard, or in grave-yards in the center of town. Burial was the right of every church member; you did not have to pay to get a plot. The graves had headstones with symbolic carvings and instructive inscriptions—reminders of the virtues of the deceased and the fearsomeness of death. These unlandscaped, fully visible churchyards in the center of town were a kind of collective monument that stressed the oneness of the living and the dead.

By 1800 most churchyards were crowded and neglected. Graves, and the stones of their occupants, were commonly reused. The need for larger and more sanitary burial grounds became evident, and one model cemetery was, in fact, planned as early as 1796—the New Burying Ground in New Haven, Connecticut, just north of the town, conceived by James Hillhouse. It was laid out as a regular grid and planted with Lombardy poplars and yews. This rational scheme did not catch on, however. Only after 1850 did the idea of a formal layout, with family plots delimited by iron railings and later on by curbstones, take over. By then the cemetery was a specialized, isolated place, removed from the urban scene. It gave one more proof of that nineteenth-century tendency for family, church, and community to drift apart—a tendency also evinced in the separation of workplace and dwelling and the eventual exit to the suburbs, where the family became a world unto itself.

These planned cemeteries were nondenominational, and you had to pay to be buried. Death here was nothing to be dreaded; it was the way to reunite with your loved ones and with God. The death's head of the Colonial headstone gave way to the neoclassical willow and urn, and the metaphor of the rose on a broken stem. Private, and not collective, commemoration was the ruling order, and cemeteries became showplaces for fancy family monuments. In time, these cities of the dead would reproduce the structure of real cities, with their fashionable and unfashionable neighborhoods, their main streets and alleys, their suburban sprawl and segregation of blacks.

But prior to this institutionalization of burial, in the 1830s death was given an alternate setting—a romantically conceived garden, more for the living than for the dead, with serpentine carriage avenues, graveled footpaths, and statues of patriotic figures. The original inspiration was probably French. The Père-Lachaise cemetery in Paris, designed in 1815, may have started the trend. The first rural cemetery in America was Mount Auburn in Cambridge, Massachusetts, which opened in 1835; in quick order followed Laurel Hill in Philadelphia in 1836, Brooklyn's Greenwood, which was called "The Garden City of the Dead," and others in Baltimore, Lowell, St. Louis. The new cemeteries were, in fact, the first instances in America of public or semi-public gardens associated with cities. They were part cemetery, part experimental garden. At Mount Auburn the carriage avenues carried names of trees and the footpaths, names of flowers. The arrangement insisted on being democratic and nondenominational. Lot owners were allowed to design and decorate their own tombs, and the mood of these rural cemeteries was pastoral,

a view of death culled from ancient Greek and Roman authors. City folk flocked to these peaceful, nostalgic gardens to spend the day among the flowers and the trees.

So from the rural cemeteries of America, and the eighteenth-century aristocratic tradition of English landscape design, our municipal parks drew their inspiration. But this is to put it too simply. What became Central Park was a huge piece of uninviting open land north of Fifty-ninth Street, between Fifth and Eighth avenues—some two and a half miles in one direction and half a mile in the other. Much of it was treeless swamp, large boulders pushed out of a thin hard soil. In other words, the park was a massive public works project, one which presented acute technical and political difficulties. The transformation was nothing short of magical, and the precedent of Central Park forever changed the look of American cities.

Olmsted and his gifted partner Calvert Vaux left the rocky, semi-wild northern section much as they found it, highlighting the terrain with cascades and plantings of evergreens. The southern half they laced with groves, small boating ponds, meadows, and they skirted these with open walks. They arranged the gently curving pedestrian walks, bridle paths, and carriage roads in such a manner that there were no intersections at grade with crosstown traffic, which was kept out of sight in four roads below park level. All these intersections were handled with graceful stone bridges at various heights that served as underpasses and overpasses.

Olmsted was uncompromising on the issue of built structures within his parks. There were to be no monuments, no decorations; the urban square was the proper place for such "townlike things," as his disciple the educational leader Charles Eliot put it.

It took a long time for all this to take shape. And it was a bitter struggle. The beautifully composed picture became the battlefield for two contending social factions: on one side, the cultured, cosmopolitan elite of Olmsted's peers who saw the park as a pristine work of art, a soothing middle landscape between raw nature and the unseemly entanglement of the city; on the other, ward politicians to whom parks were vacant land that could be filled with job-producing structures. And there was the related conflict of use. To the reformers, the park was where the classes could rub shoulders; it was the ideal place for cultural enlightenment. In time, rejecting Olmsted's purism on the subject, educational institutions like museums and conservatories, aquariums, observatories, and zoos were ensconced within the park's bounds, their purpose to combine instruction with pleasure. The working classes, on the other hand, were far more interested in a sturdy playground, a place to have a good time.

These conflicts were never resolved. It is in the nature of public places to act as fields of interaction and to change character in the process of mediating social behavior. The working classes insisted on, and got, their own playgrounds, distinct from the refined pleasure-garden of the middle class.

After 1900 the urban park itself responded to their pressures. A new type of park that stressed organized activity gained currency. This was an accessible lot of ten to forty acres, ringed by shrubbery, with a straightforward layout and a dominant indoor plant called the field house, which had an assembly hall, club rooms, and gymnasiums. No meadows or undulating paths, no attempt to block the views of the city round about. Now there were shorter work weeks, longer vacations, early retirement. All this was creating what came to be known as "leisure time"; and it was best if it could be filled in an orderly way. So throughout the land came a sudden profusion of municipal beaches, stadiums, tennis courts, picnic areas, and public playgrounds.

But Olmsted's vision held its own. During his long career, he managed to give substance to twenty urban parks of his particular brand, and to go far beyond, toward a notion of the city as a landscape at large. He preached tirelessly that each city should be aired with a whole constellation of parks, linked together in an integrated system. Connectors would be green boulevards and parkways. Boulevards were broad and straight, with landscaped medians, and were meant to be bordered by elegant houses behind dense rows of trees. These were often run diagonally across the street grid. Later on cars would find these expansive connectors a godsend for fast, unencumbered travel and would change their intended character as tranquil, idyllic stretches, suitable for pedestrians and slow coaches, into dangerously paced fast-traffic lanes. But parkways, once out in the suburbs, moved in gentle curves along natural contours, looking out on broad expanses of landscape. Commercial traffic was allowed, but only at the far sides of the roadways.

Olmsted started it all with the magnificent Emerald Necklace in Boston, a loosely strung system of pleasure drives, ponds, and parks that followed the city's suburban edge along the grassy marshland of the Muddy River. He laid out six other park systems before his death, and his disciples added others—George Kessler in Kansas City and Cincinnati, and Horace W. S. Cleveland in Minneapolis where a chain of lakes was incorporated into a continuous greenbelt.

The American Renaissance

The boulevards and parkways used stately public buildings as focal points. In the time between the Civil War and the Chicago Fair the scale of our public buildings had steadily escalated. This was true for traditional institutions, like government agencies, libraries, and museums, and for more modern structures, chief among them railway terminals and department stores. By the end of the century a spectacular monumentality had seized our cities, which made prewar courthouses, state capitols, and colleges look almost residential by comparison. Size was not all. There were sheathings of lavish materials, sculptural ornament and stained-glass windows, painted friezes and showy furnishings. Something had changed. America's vision of itself was not what it had been.

Nothing shows this escalation of public splendor more clearly than the nation's state houses. Like the later skyscraper, the state capitol was a uniquely American building type, and it struggled from the start to achieve a degree of monumental dignity and a suitable symbolic image. Jefferson's design for Virginia, interpreted in white stucco on an eminence in Richmond, resurrected an ancient Roman temple. Bulfinch's grandly domed State House for Massachusetts, overlooking Boston Common, took a contemporary English governmental building, Somerset House in London, for its model. But neither of these early capitols set a trend. What became the accepted formula was a building with balancing chambers on either side of a domed rotunda, and a portico up front. The obvious inspiration for this was the U.S. Capitol which was started in 1792, was burnt down by the British in 1814, and was revived along the same lines almost immediately.

Whatever their look, these early capitols were fairly modest structures. The walls and columns on the outside were usually of brick or wood, covered with a coat of stucco which was scored to imitate masonry blocks. The scale of the interior spaces was almost intimate; the furnishings, plain. The senate and house chambers were small rooms crowded with wooden desks. Flags and portraits of statesmen hung on the walls. A gallery for the public ran along one side just across from the speaker's dais. The airy, bright rotunda,

Thomas Jefferson, **Virginia State Capitol.** *Richmond, 1785. (Virginia Tourism Corp.)*

John C. Cochrane and Alfred H. Piquenard, **Illinois State Capitol.** *Springfield, 1868–1888. (Illinois Bureau of Tourism)*

or saloon, might hold a statue of George Washington, not much bigger than an ordinary human, elevated on a pedestal and accented by the dome above.

In the decade or two before the Civil War, we see a rise in the level of rich effects. On occasion, real stone is used outside—Kentucky marble or the granite of Maine and New Hampshire—and marbling and graining inside. Even so, the workings of government are still accessible, direct, in these relaxed surroundings. Filled by these well-worn offices in a historic building like the old Illinois state house today, with their spittoons and cast-iron stoves, we can hear the echo of eloquent orations and sense a raw ingenuousness in the rituals of caucusing and favor-trading.

Yet after the Civil War, and especially from about 1885 onward, architecture and bureaucracy combine to distance us from this homey feel of the democratic process. Government is encumbered with the mechanisms of taxation, the pension system, land grants, and transportation. The capitol bulges outward and up, offices and corridors and stairs multiply infectiously. Along with its spreading size, pomp increases. A bright Classical mantle of stone drapes the imposing bulk, over which towers some version of the great dome by Thomas U. Walter that completed the U.S. Capitol in the closing years of

the Civil War. Foreign materials—marbles from Italy, tiles from Liverpool—contribute to a dazzling surface opulence, and a whole new repertoire of monumental imagery is carved and painted in every prominent corner.

Until this time, public art was uncommon in America and limited in scale and subject. National imagery centered on George Washington and a handful of symbols like the eagle and the flag. Two of the earliest civic monuments to be designed, both of them by Robert Mills, were in honor of Washington. One was begun in 1815 in a landscaped setting in Baltimore—a shaft of white marble with a statue at the top. The other, of course, was the Washington Monument in the nation's capital. Mills described it as a "grand circular colonnaded building . . . from which springs an obelisk shaft." In the original design of 1833 a tomb for the president was to be at the base of the obelisk, surrounded by statues of the heroes of the Revolutionary War. But when the monument was finally completed twenty years after the Civil War, nothing remained of the original design save the Egyptian obelisk—a stark, stripped accent on the great axis of the Mall.

Monument means "to bring to mind." And the nation in the later nineteenth century was in a mood to remember. The Civil War had created a new mythology of heroism, a mythology of noble leaders and foot soldiers. There was pride in the resurgence of a united nation; and for the unvictorious side there was the gallant sacrifice of the Lost Cause. Meanwhile, the Philadelphia Centennial celebration of 1876 had broadcast our maturity and forced us to ask who we were and where we had been. So we started to look backward to our beginnings; and, at the same time, we started to commemorate the feats and actors of the Civil War, the bitter national conflict that reaffirmed the strength of our institutions and launched our ambition to cut a dashing figure in the world.

All this we could now do in the grand manner. Since the 1860s American artists had been studying painting and sculpture in European academies—in Dusseldorf and Munich, in the Hague and in the premier art school of all, the Ecole des Beaux-Arts in Paris. They came back armed with sophisticated techniques and a style that stressed historical pageantry and the rhetoric of allegory. These they applied to native themes. So in the capitols, along the walls and in the vaults, in fresco, mosaic, or low relief, you found epic friezes of local history: pioneer life in Illinois or *Minnesota, Granary of the World;* Classical figures representing abstract principles of law or government—Justice, Peace, Equality; and appropriately draped personifications of continents and nations that connected us to universal history.

At the same time, our public places were peopled with monumental sculpture. In Springfield, Massachusetts, a full-bodied statue called *The Puritan,* by the best of our sculptors, Augustus Saint-Gaudens, was raised in 1881, and near Boston, Concord got Daniel Chester French's *Minute Man,* a fitting memorial to that town's past. Civil War monuments sprang up everywhere—equestrian statues of Lee and Sherman, reliefs of battles and

marching regiments. All were mounted onto finely proportioned architectural frames, fixed with studied care in urban open spaces—at the entrance to parks, in public squares, as terminal markers of avenues and landscaped vistas. A triumphal arch in honor of our soldiers and sailors went up in Brooklyn's Grand Army Plaza. In Richmond, Virginia, the equestrian statue of Robert E. Lee rose on a tremendous pedestal in the middle of a square, at the head of Monument Avenue—a grand boulevard lined with statues of other Confederate heroes.

Most dramatic of all was the Statue of Liberty, a gift from France, dedicated on a foggy October afternoon in 1886. It was the work of the Alsatian sculptor, Auguste Bartholdi, and stood poised on a massive base in the Doric mode designed by Paris-trained Richard Morris Hunt. The site could hardly have been more masterful. *Liberty Enlightening the World,* to use her formal name, towered over Bedloe's Island at the entrance to New York Harbor, greeting ships that steamed into The Narrows at the end of their long transatlantic voyage. At the time, nothing matched the grandeur of this colossal statue except perhaps the obelisk of the Washington Monument.

This new worldliness, which aimed to put us on a par with Europe, came at a price. The rich harvest of allusions in our public art left most viewers far behind. Unable to absorb the erudite references that kindled the artist's work, they settled for an overall look or some plain, straightforward message to attach to it. The Statue of Liberty they knew simply as the crowned lady who ushered oppressed people from abroad into the New World. Her learned pedigree—stretching back to the ancient goddess of Liberty, to her Christian reincarnations as Faith and Truth, and later to the heroine of the Romantic era who banished ignorance and beamed enlightenment—all this would be beyond most visitors to Bedloe's Island.

A similar distancing was taking place between our daily rituals and their aggrandizement through architecture. Reading, shopping, traveling were now being ensconced in luxurious settings, far grander than the functions themselves called for.

A visit to a public library, for example, had been a simple business until the Eighties. The building was small, without show even when dignified, and books were stored in alcoves, arranged around a central reading room. The idea of a free public library itself ranks as a great American institution. It originated in the 1830s (Peterboro, New Hampshire, is said to be the first), and it was meant to make knowledge broadly accessible and to encourage reading. But by the end of the century, the central libraries of many large cities were so monumental, so ornate, that they tended to intimidate the average user and discourage casual visits.

The Boston Public Library on Copley Square was the earliest of this resplendent breed. You climbed marble stairs and entered through fine iron gates—these enclosed within three spacious Roman arches and flanked by statues of seated women in classical garb, personifying Science and Art.

Frederic-Auguste Bartholdi, **Statue of Liberty.** *1886.* *(PhotoDisc, Inc.)*

Inside rose a grand staircase more appropriate, perhaps, to the great opera houses of Europe than to a library. At the top, the main reading room was a great vaulted hall that occupied the entire front of the building. Around an arcaded courtyard were rooms faced in rich marbles and decorated with sculpture and murals, where rare books and drawings were on display. This was indeed "a palace for the people," as the trustees had specified it would be. But it is also arguable that this cultural facility became so magnificent that it alienated the very people it sought to serve. And besides, in the opinion of some librarians, it did not function well as a library at all.

The enjoyment of art, once a domestic pleasure of wealthy Americans and their friends, was also elevated to a public spectacle. Great private

collections were opened to the people by bequest or grant, and most were housed in monumental buildings. Cities raised their own civic monuments to art, in the manner of the European palace-museums like the Louvre. Boston had its Museum of Fine Arts, Chicago its Art Institute. New York's Metropolitan Museum of Art gave its Fifth Avenue side a resplendent frontispiece of Roman imperial grandeur. Symphony halls and opera houses, and even small theaters like the Century in New York, smothered their frames with ornament.

The New Public Domain

The new tendency to design and build for show as much as for utility was not confined to institutions of government and culture. Metropolitan railroad stations now sat ponderously in the modestly scaled old townscapes. They were built of fine materials on a colossal scale and, in contrast to the older stations which tended to be picturesque, polychrome sheds with tall towers rendered in romantic styles, had uniformly white exteriors using a narrow range of Classical forms. Inside, the concourses were vast and vaulted like Roman bathing halls. The facades were opened up with deep Roman arches, or else screened by long, impressive colonnades. At the same time, the three- or four-story office buildings of earlier decades were growing into spectacular towers which, while still retaining the archaic floor plan partitioned into rows of small cubicles, were clothed in embroidered skins and topped with fanciful ornate crowns. And, finally, shopping areas in the old downtowns and along Main Street were being preempted by yet another palace for the people—this one a palace of consumption known as a department store.

Macy's, Marshall Field's, Wanamaker's, Jordan Marsh, Lord & Taylor—between 1880 and 1910 these stores became the true centers of our cities. Here was a creation that was genuinely popular, more so certainly than museums or public libraries, and openly expressive of the excitement and vigor of urban life. The scale, the variety, the luxury were mesmerizing. In one, block-size architectural envelope there might be as much as forty acres, or one million square feet, of floor space. The block would commonly have a rotunda with a leaded glass skylight on the ground floor and, above this, galleries opening onto a central courtyard. On display you could find everything being produced in the factories of America, from ready-made clothing to furniture and appliances, attractively designed and packaged. Much of it was novel, unfamiliar, astonishing. You were introduced to new cosmetics and medicines, to typewriters and fountain pens, to kitchen gadgets of all sorts, and you were made to feel that you could not do without them. And while you were entrapped in this wondrous showcase of the nation's horn of plenty, you could also make use of lavish lounges and rest rooms, restaurants, beauty salons and nurseries.

Department stores were large retail shops in the center of town and were revolutionary in a number of ways. First, they were accessible to every-

one; they had none of the exclusivity of fine stores or the low-grade populism of markets, even though some department stores were considered smarter than others. They had a fixed-price policy, which dispensed with the customary rituals of bargaining. They advertised extensively in newspapers, and they offered services like charge accounts and free delivery. They combined the traditional features of public-minded architecture, the grand staircase for example, with modern materials and conveniences. It was for a department store, A. T. Stewart's in New York, that the largest iron building of its day was erected in 1862. Cast-iron made for a light structure, with slender supports that opened up the floors. In conjunction with the new large sheets of plate glass, it turned conventional windows into show windows and conventional floors into airy, spacious display areas. And it was in a department store, the Haughwout Department Store on Broadway, that the elevator found its first regular use.

Most of these consumers' palaces began modestly and expanded incrementally. The first Macy's was a fancy dry goods store on New York's Sixth Avenue, near Fourteenth Street. It opened in 1858 and sold ribbons, embroideries, feathers, hosiery, and gloves. R.H. Macy was a young unsuccessful merchant when he arrived in New York that year after a string of retail ventures that did not make it—two in Boston, one in California catering to the gold rush forty-niners, and the last in Haverhill, Massachusetts, which ended in bankruptcy. This time was different. The store on Sixth Avenue prospered. Macy bought another store at the back in 1866, and so he continued, annexing neighboring property until, at the time of his death in 1877, his business occupied the ground area of eleven stores with separate departments for drugs and toilet goods, glassware, silver and china, home furnishings, luggage, toys and musical instruments. In the 1880s a new facade unified the look of this collection of buildings, and in 1902 Macy's Herald Square opened on Broadway at Thirty-fourth Street—a nine-story building with thirty-three hydraulic elevators and four escalators that could move 40,000 customers every hour; there was even a pneumatic tube system that could shoot sales checks and cash from one part of the store to another.

The change brought about through this imperial monumentality of American cities was two-pronged. First, railroad stations, department stores, and office towers set up a colossal public domain that overwhelmed the once dominant scale of churches and government buildings. Over time, government and religion had ceased to be focuses of real power anyway. The church no longer anchored whole communities in the way a meetinghouse, say, ruled the New England town. Government turned progressively more impersonal as an institution and seemed perennially subject to corruption; by the end of the century, it spread out licentiously and impressed many as an imposition rather than a moral force.

Traditionally steeples and domes punctuated the skyline of American cities. The domes which rose over government buildings were a feature of the

nineteenth century. But they were preempted in the 1890s by libraries and campus buildings. What happened is that the same monumental dress covered a whole range of buildings, banks as well as state capitols, clubs and apartment houses as well as town halls; the same puffed up scale might prevail in the business district and upper-class residential avenues beyond. It was hard in this grand unity of the monumental townscape to assign symbolic priorities among individual institutions.

Chapter 12

New Deal for Public Art

Marlene Park and Gerald E. Markowitz

Perhaps what was most remarkable about the 1930s was the optimism. Despite the real suffering that Americans endured because of the Great Depression, the belief grew that an energetic and expanding government could work for the individual and the local community to alleviate misery, restore political faith, and improve the very structure of society. The attitude is perfectly symbolized in the play and film *Dead End,* in which slum kids, aided by an architect and a city planner, are given a "break," a second chance in life. At the same time that industry was faltering and banks were closing— they were still closing in 1939—New Deal administrators were developing fresh ideas and formulating new programs, some lasting and some short-lived. As FDR told a campaign audience in 1932, "It is common sense to take a method and try it. If it fails, admit it frankly and try another. But above all, try something."[1] Roosevelt's administration, in fact, tried to deal with everything: rural poverty and backwardness, agricultural overproduction, soil erosion, unemployment, malnutrition, municipal bankruptcies, bank closings, and dilapidated housing. The proliferating New Deal agencies worked to find new solutions to these problems. Like other historic movements, the New Deal had a characteristic ideology and tone, which were reflected in its programs. Though federal welfare, or relief, was begun at that time, the essence of the New Deal was putting people, even artists, to work.

One of the most important tendencies of the New Deal was the centralization of power in Washington, and especially in the presidency. Through his masterful use of radio, FDR was able to reach people directly and personally. Through the creation of the Executive Office of the President, power was centralized not only in Washington, but in a small group of appointed officials who helped the President make important decisions. The federal government exerted its power in many ways, and particularly by creating the various alphabet agencies that mediated or regulated nearly every sphere of American life. Those agencies determined the amount of acreage farmers planted, the manner in which securities were traded on the New York Stock Exchange, the way unions conducted elections, and the provision of electricity to poor farmers. They even provided art. No government had made such decisions before. These new federal initiatives shifted power and influence away from local and state governments to the national government, and

people increasingly looked to Washington to propose legislative remedies for America's ills.

Yet Washington also wished to use its new power to extend democracy. Though such goals were inadequately pursued and implemented, the New Deal did extend traditional democratic rights to blacks and Indians. To benefit the poor, the New Deal broadened the concept of democracy and based it in the economic sphere. FDR declared in one fireside chat that liberty had to include "greater security for the average man than he has ever known before in the history of America."[2] The New Deal's accomplishment fell far short of its rhetoric. Unemployment remained well over 10 percent until the economy was spurred by World War II, and one-third of the nation remained "ill-housed, ill-clad and ill-nourished" even after Roosevelt declared war on poverty in 1937. Political power was extended somewhat with the growth of labor unions in the late thirties, but the halls of Congress remained the province of the well-to-do, and segregation remained the law, written or unwritten, of the land.

The New Deal did not originate from one idea or from a single movement, but rather from a coalition of interests that involved compromises for all concerned. Nationalist reformers saw state and local governments' inability to cope with the Depression as an opportunity to expand the power of the national government and to promote the earlier Progressive Party's idea of uniting the country around a conscious social ideal. Some enlightened business leaders supported the New Deal as a way to save capitalism and make the economy move again. Many social reformers worked to alter the relationship of the individual to the federal government and to ensure a minimum standard of living for all Americans. Other groups, such as labor, conservationists, and public housing advocates, seized on the general reform atmosphere to attack more particular problems. Many socialists and communists supported major parts of the New Deal because they felt that it was moving society away from an individualist ethic toward a more socially conscious one that could lead to a collectivist future.

One of the ironies of the New Deal was that while Roosevelt was pursuing a relatively moderate course that preserved the basic structure of American capitalism, many businessmen were denouncing "that man in the White House" for leading a revolution against private property. When FDR took office, the banks were in a state of utter collapse and bankers were the object of derision and scorn, but he did not nationalize the banks. Instead, he reformed the banking system to ensure fiscal stability and public confidence. The Depression seemed to many proof that capitalism was in its death throes, and they blamed private capital for destroying the economy, but the trend toward big business continued during the New Deal, and big corporations acquired more power at the expense of small and medium-sized ones. Despite all the programs to aid the poor, income distribution remained relatively constant during the thirties.

Although the system was preserved, we should not ignore the radical notions that were incorporated into New Deal policy. For example, the state clearly assumed the role of protector in a way it had not done before. Whatever the inadequacies of particular programs or agencies, their very existence established the principle that the national government should take responsibility for the unemployed, the old, the sick, the poor, and the displaced. Government would henceforth guarantee a minimum standard of subsistence for all people. Declaring that "government has a final responsibility for the well-being of its citizenship," Roosevelt said that if private enterprise could not provide work or sustenance for the people, they had "a right to call upon the Government for aid; and a government worthy of its name must make fitting response."[3]

Another major reform that the New Deal initiated was the recognition of the right of unions to exist and to bargain on more or less equal terms with capital. This acknowledgment of labor's importance and role in society occurred within the context of a tremendous upsurge of worker militancy that included violent demonstrations and sit-down strikes. In 1935 almost a third of the American unionized labor force was involved in strikes. At the end of 1936, workers at two Fisher Body plants in Flint, Michigan, sat down in the factory for six weeks, until an agreement was reached with General Motors. In 1937 steelworkers struck Little Steel, a group of medium-sized companies, and at a Memorial Day meeting of strikers in South Chicago, police fired upon the workers and their families, killing ten and wounding fifty-eight. Roosevelt did not order federal troops or the National Guard to protect property rights, as previous presidents had done, but instead supported legislation that would assure "labor of the untrammeled right, not privilege, but right to organize and bargain collectively with its employers."[4] While not revolutionary in intent or effect, this was a major structural change in American law and labor relations.

A more ephemeral change, and one not as long lasting, was the shift of emphasis away from individualism toward collectivity. In the 1930s people were fighting against what Roosevelt characterized as "those forces which disregard human cooperation and human rights in seeking that kind of individual profit which is gained at the expense of his fellows."[5] With the economy in ruins, the entrepreneur and the "robber baron" were less popular figures than in previous periods of American history. Roosevelt sought to achieve a balance between individualism and collectivism: "In our personal ambitions we are individualists. But in our seeking for economic and political progress as a nation, we all go up, or else we all go down, as one people."[6] During the decade of the Depression , the Common Man and "the people" became popular ideals. Carl Sandburg's long poem "The People, Yes" was an expression of this idea. And Roosevelt, always the master of political rhetoric, declared in one campaign speech: "Always the heart and the soul of our country will be the heart and soul of the common man."[7]

In keeping with these ideals, the New Deal committed itself to the largest art program ever undertaken by the federal government. To the educated New Dealer, who was no philistine, the fine arts went hand in hand with a strong economy, the two together creating a distinctly American culture. Art, it was thought, might actually help the people to weather the Depression by giving them meaningful and hopeful communal (and governmental) symbols. Besides, artists were out of work and hungry, too. As Harry Hopkins said, "Hell! They've got to eat just like other people."[8] Many even feared that if the Depression continued for very long, a generation of artists would be lost and a fatal blow would be dealt to American culture. New Dealers developed the most innovative and comprehensive program for government art patronage in American history. Administration officials, prodded by unemployed artists, initiated a series of art projects to provide work for artists and to bring art to people of every age and circumstance. Between 1933 and 1943 the government employed and commissioned over ten thousand artists, many young or virtually unknown, some established and famous, but most in desperate need. They produced a staggering amount of work: 100,000 easel paintings, 18,000 sculptures, over 13,000 prints, and more than 4,000 murals, not to mention posters and photographs. In the process they created a public art expressing the ideals, fulfilled and unfulfilled, of that era.

The New Deal sought to change the relationship between the artist and society by democratizing art and culture. Art project officials wrote that the mass of people were "underprivileged in art," and they endeavored to make art available to all, whether poor children in urban slums or shopkeepers in small towns. The projects were a uniquely American blend, combining an elitist belief in the value of high culture with the democratic ideal that everyone in the society could and should be the beneficiary of such efforts. As

William Calfee, **Agriculture Scenes in Virginia.** *Oil on canvas, H. 9' × W. 20'. (Public Buildings Administration, Section of Fine Arts)*

Edward Bruce, the head of the Treasury Department's Section of Fine Arts, wrote in support of the art projects:

> Our objective should be to enrich the lives of all our people by making things of the spirit, the creation of beauty part of their daily lives, by giving them new hopes and sources of interest to fill their leisure, by eradicating the ugliness of their surroundings, by building with a sense of beauty as well as mere utility, and by fostering all the simple pleasures of life which are not important in terms of dollars spent but are immensely important in terms of a higher standard of living.

The dividends of the government investment in art would be "in material wealth, in happiness, contentment, and well-being."[9]

In addition to the democratic ideals of federal patronage, New Dealers expected that the art projects would help create a national culture. Roosevelt asserted that government support had infused a new national spirit into the land that contrasted favorably with the view Americans had of their art in the past. He said:

> A few generations ago, the people of this country were taught by their writers and by their critics and by their teachers to believe that art was something foreign to America and to themselves—something imported from another continent and from an age which was not theirs—something they had no part in, save to go to see it in a guarded room on holidays or Sundays.
>
> But recently, within the last few years, they have discovered that they have a part. They have seen in their own towns, in their own villages, in schoolhouses, in post offices, in the back rooms of shops and stores, pictures painted by their sons, their neighbors—people they have known and lived beside and talked to. They have seen, across these last few years, rooms full of paintings by Americans, walls covered with all the paintings of Americans—some of it good, some of it not good, but all of it native, human, eager and alive—all of it painted by their own kind in their own country, and painted about things they know and look at often and have touched and loved.[10]

The art projects were clearly an ambitious cultural and social experiment and were buffeted by the same political winds as the other New Deal experiments. The Roosevelt administration's initial foray into art patronage was successful but short-lived. During the winter of 1933–34, the Public Works of Art Project (PWAP) employed artists, including painters, sculptors, and printmakers, who were in need of work and had professional credentials. Administered by Edward Bruce, PWAP was part of the first national work-relief effort, the Civil Works Administration, but because work-relief was extremely controversial and accepted only as a stop-gap measure, funding was ended in the spring of 1934. Support for new, more permanent programs increased as it became clear that the Depression represented a long-term crisis and that short-term emergency measures were not enough. The New Deal set up a number of more ambitious projects, which had different administrators, goals, and constituencies, but which functioned together to give comprehensive support and encouragement to art and artists. The largest and most famous of these, the Works Progress (later

Projects) Administration's Federal Art Project (WPA/FAP, 1935–43), sought to aid artists by employing those who were already on relief. It focused on large cities, where most of the artists lived, and the work produced went to state and municipal, rather than federal, institutions. The WPA/FAP employed as many artists and artisans and served as much of the public as it could. To provide decorations for federal buildings, the Treasury Department, which at that time built and administered those buildings, also directed two art programs. One, the Treasury Relief Art Project (TRAP, 1935–39), like the WPA/FAP, largely employed artists on relief. The other . . . was the longest lived of these agencies, the Treasury Department's Section of Painting and Sculpture, later the Section of Fine Arts.

The Section was organized by order of the Secretary of the Treasury, Henry Morgenthau, Jr., on October 16, 1934.[11] The original idea for the Section came from Edward Bruce, who proposed that a "Division of Fine Arts" be established in the Treasury Department and that the President, by executive order, set aside one percent of the cost of new federal buildings for their embellishment. Under this plan, the new Division would produce pictorial records of the Civilian Conservation Corps (CCC) camps, the Public Works Administration's (PWA) projects, the Tennessee Valley Authority (TVA), and national parks. The initial funding for administrative expenses was to come from funds that the PWA held, but disagreements between Morganthau and Secretary of the Interior Harold Ickes, who controlled PWA funds, killed the

Daniel Celentano, **The Town Store and Post Office.** *Oil on canvas, H. 4' × W. 6'. (Public Building Administration, Section of Fine Arts)*

plan. In the end Morganthau and Bruce agreed on a less ambitious plan to decorate new federal buildings. In the nine years of its existence, the Section gave out almost fourteen hundred commissions. On June 30, 1943, because of the war effort, the program was officially concluded, though some murals were painted under the Public Building Service as late as 1949.[12]

The leaders of the Section were typical New Dealers in that they were not part of an entrenched bureaucracy, but brought new ideas and new idealism to their work. Like Harry Hopkins and Frances Perkins, who came from a social work background to develop programs to help the hungry and unemployed, the Section leaders all had a background in art. Edward Bruce (1879–1943) and Edward Rowan (1898–1946) were painters, and Forbes Watson (ca. 1880–1960) was an art critic. They worked extremely well together. Bruce formulated general policy and ran interference with Roosevelt and Morgenthau; Watson continued to be an important art critic and publicized the Section's work in countless newspaper and magazine articles; and Rowan made the day-to-day artistic and administrative decisions.

Bruce, the son of a Baptist minister and of a writer of children's stories, wanted from childhood to be a painter but for financial reasons took a B.A. from Columbia College in 1901 and an LL.D. from Columbia Law School in 1904. After practicing law for several years he moved to Manila and then to China, where he became president of the Pacific Development Company. When the company failed in 1922, he decided to pursue his first love and become a professional painter. He went to Italy, studied with Maurice Sterne, and painted mainly landscapes, which he exhibited successfully in 1925 and 1927. In 1929 he returned to New York, and in 1932 he painted a mural in the board room of the San Francisco Stock Exchange. In 1933 he was called to serve as a silver expert on the United States delegation to the London Economic Conference. Upon his return to Washington, he organized and directed the first federal art project, the Public Works of Art Project, in the winter of 1933–34 and organized and became Chief of the Section in 1934. As Drew Pearson and Robert S. Allen described him, he was "a natural lobbyist, convivial, gay, handsome, a convincing speaker—a perfect choice to head new programs."[13] Watson's background was equally varied. After graduating from Harvard and Columbia Law School, he became an art critic for the Brooklyn *Eagle* and the New York *Evening Post* and the *World* while also serving as owner, editor, and publisher of *The Arts*. He was the author of *American Art Today* and a book on Winslow Homer, and in 1936 he and Bruce published a book on the Section, *Art in Federal Buildings*. Rowan graduated from Miami University and received a master's degree in art history from Harvard. He was a well-known watercolorist and exhibited often. As director of the Little Gallery, a community fine arts center in Cedar Rapids, Iowa, between 1928 and 1934, and as a member of the Stone City Art Colony in the summer of 1932, he was associated with the midwestern Regionalists. Before joining the Section, he was assistant director of the American Federation of Arts.[14] Under the leadership of these men, the

Section extended the ideals of the Roosevelt administration into areas that political and social legislation could not reach. For though its staff consisted of only nineteen people, including secretaries, a carpenter, and two photographers, it had an impact in virtually every congressional district of the United States.

We can see in the workings of the Section all the grand ideas of the New Deal applied to government patronage and to the creation of public art. Like the New Deal itself, the Section was essentially conservative in that it preserved the notion of the artist as an entrepreneur who contracted for a particular job. Unlike the WPA/FAP artists, who were given work on the basis of financial need and were employed directly by the government, the Section artists competed for individual commissions and signed contracts for the completion of particular murals or sculptures. Whereas the WPA/FAP artists were often assigned to a group supervised by a master artist and often felt the importance of their collective effort, on the whole the Section artists worked alone in their studios and delivered their product before they received final payment. Yet the use of anonymous competitions avoided favoritism and gave opportunities to young and unknown artists. And in a time of extraordinary ideological conflict, the Section commissioned artists of every political persuasion, awarding contracts to artists identified not only with the Democratic and Republican parties, but also to socialists, communists, and every other variety of radical political artist. Though commissioning only three black artists, the Section gave many commissions to women. Over one-sixth, or about 150, of the 850 artists working for the Section were women. The Section made special efforts to commission Native American and western artists who had never before been recognized by the federal government. Whereas the WPA/FAP stressed creativity and experimentation, the Section stressed the quality of the product. In defining quality in a more or less traditional way, it excluded the avant-garde styles. Its goal was to create a contemporary American art, neither academic nor avant-garde, but based on experience and accessible to the general public.[15] Bruce wrote in 1934: "I think the mere fact that the Government has organized this Section and undertaken this work is bound to have a very beneficial effect on the whole art movement in the country, and especially along the lines of taking the snobbery out of art and making it the daily food of the average citizen."[16]

The New Deal sought to make the national government's presence felt in even the smallest, most remote communities. The Section, for its part, was committed to making art a part of daily life, not only in cities but also in small towns and rural areas across the country.[17] The means for realizing this vision were eleven hundred new post offices, places where art would be seen daily by ordinary citizens conducting the normal business of their lives. The post office was "the one concrete link between every community of individuals and the Federal government" that functioned "importantly in the human structure of the community."[18] Usually on a street near the center of town, running perpendicular or parallel to Main Street, these rectangular brick

buildings, slightly set back, perhaps to make room for the flag pole, brought to the locality a symbol of government efficiency, permanence, service, and even culture. Thus, the post office became the emblem of the new policy.

The federal government could have chosen to make the post offices symbols of its power by decorating them with murals depicting national heroes or with emblems such as eagles, flags clutched in their talons, their wings outstretched over the postmaster's door. Instead, it chose to make the murals mirrors of local communities, stressing the primacy of the welfare of the ordinary citizen. In 1934 Bruce said that the main objective was "to keep away from official art and to develop local cultural interests throughout the country."[19] Most of the artists agreed with this conception. One sculptor, Carl L. Schmitz, explained why a realistic subject was more appropriate than a symbolic one for a small Kentucky post office:

> I think that persons entering the building, would get more local pride out of a design having to do with their own activities than a mythological figure which the average man does not even understand and which may give him the feeling of the majesty and might of his government, rather than the feeling of his own personal relation to it and the concern of the government towards him.[20]

Schmitz in fact articulated one of the dilemmas that the New Deal created: the diminution of democratic control in the face of expanded national power. At the time its proponents argued that any loss of local control would be more than compensated for by what the New Deal would accomplish. The Section believed that people would naturally like art if it was of high quality, and that they would accept the artistic intrusion into their daily lives if the art was relevant to their lives: a family enjoying a picnic, a farmer putting cows into the barn, citizens marching in a hometown parade, laborers washing up after work, men unloading a packet boat on the Mississippi, New Englanders maple-sugaring in a winter landscape, glass blowers practicing their craft, women curing tobacco on a small farm, families and friends picking oranges, neighbors talking over the fence, spectators at a stock sale, and children waiting for rural mail delivery.

In the peacefulness and productivity of this imagery, one sees no trace of the conflicts engendered by this extraordinary, perhaps unprecedented, experiment in government patronage. But administrators, artists, local officials, and others had conflicting assumptions about what art was, about its audience, and about the artist's role. New Dealers assumed that art was a necessary, desirable, and essential part of any culture and as such should be fostered by the government. Conservatives assumed that art should be the province of an elite, and radicals that it should be both government-sponsored and a weapon for social change. The audience and the artist's responsibility were defined accordingly: the artist should serve the society as a whole, should continue to serve educated and discriminating patrons, or should unite with the working class in its battle against capitalism. We see all these assumptions at work in the various Section commissions.

Conflicting values shaped public art in the 1930s: the desire for quality in art and the commitment to make art democratic; the effort to create an art embodying national ideals and values and the wish to make art relevant to people in various regions of the United States; an allegiance to traditional artistic values and a willingness to create contemporary styles. If no consensus was achieved, these positions were articulated clearly and repeatedly in the discussions of and controversies over Section murals and sculpture.

Yet despite the tensions between conservatives and radicals, despite the sometimes conflicting desires for an art that was both high and popular, national but regional, the government-sponsored art of the 1930s, in retrospect, seems amazingly, almost naively uniform. Although artists held widely differing political ideas, they shared even deeper assumptions. Almost to the man and woman, they believed in progress. Whether by hard work and self-reliance or through dialectical processes, society moved ever upward. Science and technology were unmitigated goods and completely in harmony with nature and the past. Unquestionably the greatest event in North American history was the arrival of the European, whose pioneering efforts showered improvements not only upon his descendants but upon everyone. Even those few murals showing strife between races (Native American vs. European, never African American vs. European) or injustice between classes (Worker vs. Boss) carried the implicit message that such conflict was in a very distant past, was necessary for progress, or was an aberration, a wrong which had been or soon would be righted. Issues of gender and sex do not even appear, women, on the whole, being happily engaged in their role of motherhood and creators of the domestic arts. As in the Hollywood Production Code of the same era, homosexuality did not exist. Strangest of all, the USA was not a country of ethnic and racial rivalries, not even a melting pot, but a nation, a people, made up, as proponents of all ideologies agreed, of something called "the common man." To him and to this national ideal the public art of the 1930s was consecrated.

Notes

1. Quoted in Dixon Wecter, *The Age of the Great Depression* (New York, 1975), p. 52.
2. Second "Fireside Chat" of 1934, September 30, 1934, Franklin D. Roosevelt, *The Public Papers and Addresses of Franklin D. Roosevelt* (New York, 1938), vol. 3, p. 422.
3. Annual Message to Congress, January 3, 1938, Roosevelt, *Public Papers* (New York, 1941), vol. 6, p. 14.
4. Speech to Teamsters Convention, September 11, 1940, Roosevelt, *Public Papers* (New York, 1941), vol. 9, p. 409.
5. Address Delivered at Green Bay, Wisconsin, August 9, 1934, Roosevelt, *Public Papers* (New York, 1938), vol. 3, p. 372.
6. Second Inaugural Address, January 20, 1937, Roosevelt, *Public Papers* (New York, 1941, 1969), vol. 6, pp. 5–6.
7. Campaign Address at Cleveland, Ohio, November 2, 1940, Roosevelt, *Public Papers* (New York, 1941), vol. 9, p. 553.

8. Quoted in Robert E. Sherwood, *Roosevelt and Hopkins* (New York, 1948), p. 57.

9. Bruce, memorandum in support of project to employ artists under Emergency Relief Appropriation Act of 1935, enclosed in Bruce to Roosevelt, May 1, 1935, Record Group 69, Box 432, National Archives, Washington, D.C. See also Jane De Hart Mathews, "Arts and the People: The New Deal Quest for a Cultural Democracy," *Journal of American History* 62 (1975): 316–39, especially p. 325: "These three elements then comprised the concept of a cultural democracy: cultural accessibility for the public, social and economic integration for the artist, and the promise of a new national art."

10. Extract from the address by President Roosevelt at the dedication on March 17, 1941, of the National Gallery of Art, Washington, D.C., Section of Fine Arts, Special Bulletin, National Archives, Record Group 121, entry 122. (Hereafter the record group and entry numbers will be abbreviated: e.g., 121/122.) See Francis V. O'Connor, *Federal Support for the Visual Arts: The New Deal and Now,* 2d ed. (Greenwich, Conn., 1971), pp. 137–43, for a guide to the Section records in the National Archives. See note 20 for further explanation.

11. C. J. Peoples, Treasury Department Order, October 16, 1934, 121/124, folder "W."

12. There are several important published and unpublished studies that the reader should consult. There are four sources in particular for the location of Section murals and sculptures, for reproductions of some of them, and for information about the color sketches. In 1936 Edward Bruce and Forbes Watson published the first book on the Section, *Art in Federal Buildings* (Washington, D.C.). It contains reproductions, plans, and descriptions of many of the early commissions. In 1941 the *American Art Annual* published a "Geographical Directory of Murals and Sculptures Commissioned by Section of Fine Arts, Public Buildings Administration, Federal Works Agency," vol. 35 (July 1938–July 1941): 623–58. The only complete listing was compiled by Karel Yasko in the 1971–72 Fine Arts Inventory for the General Services Administration in Washington, D.C. Mr. Yasko keeps a computerized list on the condition of the murals and sculptures. There are some Section color sketches in the National Museum of American Art in Washington, D.C., but the largest collection is in the University of Maryland. In 1979 Virginia Mecklenburg published an illustrated catalogue of them. See *The Public as Patron: A History of the Treasury Department Mural Program Illustrated with Paintings from the Collection of the University of Maryland Art Gallery* (College Park, Md.).

 Two major studies deal with the Section. The first, by Belisario R. Contreras, is a careful administrative history of the Treasury Department Art Programs—PWAP, Section, and TRAP. His work chronicles the establishment of the Section, the difficulties of the Section's commissions in the Federal Triangle, its achievement of permanent status in 1938, and the effect of World War II. See "The New Deal Treasury Department Art Programs and the American Artist: 1933–1943" (Ph.D. dissertation, American University, 1967). The second is Karal Ann Marling's *Wall-to-Wall America* (Minneapolis, 1982). Marling argues that "the Section was not an art program. It was, in the final analysis, a social program that employed artists" (p. 25), and that "Section art looks pretty dismal" (p. 293); her "book is about taste in the Depression decade" (p. 3). . . . She considers mainly the controversies engendered by the Forty-Eight State Competition, which was not in fact typical of Section competitions. By limiting the material she chose to consult, Marling overlooks the many distinguished Section murals, the

Section's relation to the New Deal, and its broader ideas, whether nationalism, competing conceptions of history, or the extension of cultural democracy.

The most ambitious studies place the Section in the context of federal patronage during the 1930s and on the whole prefer both the methods and results of the WPA/FAP. The earliest is Erica Beckh Rubenstein's "The Tax Payers' Murals" (Ph.D. dissertation, Harvard University, 1944). In 1969 Francis V. O'Connor published the results of his comparison of New Deal and postwar patronage, *Federal Support for the Visual Arts*, mentioned in note 10. O'Connor's work includes charts giving statistics, lengthy bibliographies including contemporary articles, and a guide to the archival sources. In 1973 Richard McKinzie published his well-illustrated and lively account, *The New Deal for Artists* (Princeton). In 1984 Contreras published a general survey, *Tradition and Innovation in New Deal Art* (Lewisburg, Pa.). . . . For bibliographies of all the federal art projects, see Francis V. O'Connor's *Federal Art Patronage Notes*, vols. 3 (Summer 1979) and 4 (Summer 1983).

For photographic material, in addition to the National Archives and the Archives of American Art, also consult Erica Beckh Rubenstein's materials in the Franklin Delano Roosevelt Library at Hyde Park, New York, and John C. Carlisle's slide sets, produced by Interphase II Productions in Merrillville, Indiana.

13. Drew Pearson and Robert S. Allen, "Washington Merry-Go-Round," n.d. Bruce MSS, Reel D 84, Archives of American Art, Smithsonian Institution, Washington, D.C.

14. A biography of Bruce, by Olin Dows, appeared in the *Dictionary of American Biography*, Supplement 3, 1941–1945 (New York, 1973). Information about Watson's life is derived from two obituaries, one in the Summer 1960 *Art Students League News*, and the other in the *New York Times*, June 1, 1960. The clippings are in the New York Public Library artists' files. Rowan's biography appeared in the 1947 edition of *Who's Who in American Art.*

15. Bruce wrote to Arthur Millier on December 12, 1934: "in this project I am working for the long pull to get the maximum Federal support for the art movement in this country, and in the early stages of it I do not want to have the beans spilled by having too conservative or too radical work done." Bruce MSS, Reel D 88, Archives of American Art.

16. Bruce to Admiral Peoples, November 14, 1934, Bruce MSS, Reel D 89, Archives of American Art.

17. Bruce wrote to Eleanor Roosevelt in a letter of December 7, 1939, that the Section was refused permission to put murals in sixteen out of eighteen postal stations in New York City: "I believe it was considered that the postal stations were located in sections where art would not be appreciated. In other words, poor people don't rate art." Bruce MSS, Reel D 90, Archives of American Art.

18. New Deal art records, General Services Administration (GSA), Washington, D.C.

19. Bruce to Maurice Sterne, June 25, 1934, Bruce MSS, Reel D 89, Archives of American Art.

20. Carl Schmitz to Inslee Hopper, April 16, 1940, 121/133, Covington, Kentucky. (Entry number 133 refers to the "case files concerning embellishment of federal buildings." It is arranged alphabetically by state and within each state by city.)

Chapter 13

Memorializing the Unspeakable: Public Monuments and Collective Grieving

Carole Gold Calo

At 9:02 A.M. on April 19, 1995, a bomb ripped through the Alfred P. Murrah Federal Building in Oklahoma City, killing 168 people, including nineteen children in the building's daycare center. In a single horrific moment, the life of a community was forever changed.

The rubble-filled site where the building once stood has been transformed into a memorial park. This memorial is not, cannot be, a traditional heroic monument. Instead, like so many recent memorials, it must not only remind us of this unspeakable tragedy, but must also serve to heal a community whose heart had been torn apart.

Since the 1960s, there has been a revival of monumental sculpture in the United States and elsewhere, commemorating a wide range of events, including not only the Oklahoma City victims, but also the Vietnam War Veterans, the civil rights movement, and those murdered in the Holocaust. It is as if there is a societal need to remember and to mourn, even years after the actual occurrence. According to Andreas Huyssen in his essay "Monument and Memory in a Postmodern Age":

> Remembrance as a vital human activity shapes our links to the past, and the ways we remember define us in the present. As individuals and societies, we need the past to construct and to anchor our identities and to nurture a vision of the future. . . . (James E. Young, ed., *The Art of Memory: Holocaust Memorials in History*, Prestel, 1994.)

Public memorials, of course, date back to the earliest civilizations: Assyrian kings commemorated their victories in vast inscriptions on palace walls; Roman generals and emperors celebrated their triumphs in columns and arches. Traditional monuments, whether combining the architectural and the sculptural or simply standing as independent sculptures, preserve the memory of inspiring historical events or figures for posterity. But it is apparent that in the past several decades the concept of the

This essay originally appeared in *Art New England*, October/November 1998 and was revised for this anthology. Reprinted with permission of publisher and author.

monument has changed significantly. A comparison of two memorials on the Mall in Washington, D.C., the *Marine Corps Memorial* and the *Vietnam Veterans Memorial*, illustrates the transformation.

The *Marine Corps Memorial*, more popularly called the *Iwo Jima Memorial*, is a classic example of the traditional war memorial. Dedicated in 1954 "In honor and memory of the men of the United States Marine Corps who have given their lives to their country since 10 November 1775," its imagery is based on a photograph of marines straining with taut muscles to raise the American flag on the field of victory. Figurative and unambiguous, this sculpture honors patriotic duty and self-sacrifice. In stark contrast, the 1982 *Vietnam Veterans Memorial*, designed by Maya Lin, has been described as America's "wailing wall." The monument consists of two 250-foot-long polished black granite walls meeting at a 125 degree angle at the bottom of an incline. Rather than celebrating victory, the *Vietnam Veterans Memorial* is dedicated to the individual sacrifices of those caught up in an unpopular war. Carved into the granite are 58,169 names of American soldiers who died in Vietnam in chronological order of death. Unlike the government-sponsored Iwo Jima sculpture, the *Vietnam Veterans Memorial* was initiated in 1977 by Jan Scruggs, a Vietnam veteran and founder of the Vietnam Veterans Memorial Fund, and supported by a grassroots effort.

The controversy surrounding the design of the *Vietnam Veterans Memorial* has been highly publicized, reflecting the country's polarization over the war itself and conflicting ideas concerning the nature of memorial monuments. As a concession to critics of Lin's abstract design, which some felt was critical rather than heroic, it was agreed that three racially diverse, over-lifesize bronze soldiers would be placed next to the wall—Frederick Hart's *Three Fighting Men*. Nonetheless, the *Vietnam Veterans Memorial* was intended to assist in the healing of a nation and to offer family members and friends of victims the opportunity to mourn their loss. Unlike earlier monuments, this memorial is experiential, participatory, and involves the visitor directly. Walking from one end to the other, one descends into a seemingly endless labyrinth of names; standing before the wall, one's reflection becomes part of the monument. Visitors often leave notes, flowers, mementos for lost loved ones. Maya Lin explained her intentions in her original design statement: "It is up to each individual to resolve or come to terms with this loss. For death is in the end a personal and private matter and the area contained within this memorial is a quiet place, meant for personal reflection and private reckoning." (as quoted in Harriet F. Senie, *Contemporary Public Sculpture: Tradition, Transformation, and Controversy,* Oxford, 1992). Maya Lin's design reflects a growing tendency in memorial sculpture to personalize war by drawing us into the experience. Many of the more than forty Vietnam memorials that have sprung up in the past two decades have used Lin's design as a prototype.

Maya Lin's design for the *Civil Rights Memorial*, commissioned by the Southern Law Center for its office building in Montgomery, Alabama, in 1988

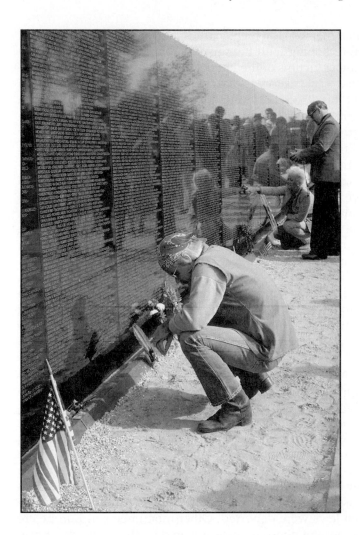

*Maya Lin,
Vietnam Veterans'
Memorial.
Washington, D.C.,
1982. (Wendy
Watriss/Woodfin
Camp &
Associates)*

(dedicated in 1989), extends the concept of the memorial as ritualistic experience through movement and the passage of time. A 9 × 40′ curved black granite wall serves as a backdrop for the memorial. Inscribed on this wall is a quotation from Martin Luther King, which he paraphrased from a passage in the Book of Amos: " . . . until justice rolls down like water and righteousness like a mighty stream." In front of this wall is an asymmetrical water table inscribed with a historical time line of the civil rights movement. Also included are the names of those who died in the struggle, ordinary people who were victims of racial hatred or were killed because of their own nonviolent activism. Like the *Vietnam Veterans Memorial,* the *Civil Rights Memorial* is both a shared and private experience. People come to touch the names, to grieve. Lin also hopes that the monument is educational, a way for Americans to learn about the past and to achieve a more just future.

The experiential memorial, which enables the viewer to enact a rite of passage, a personal reckoning with the unspeakable, has provided a meaningful way to remember victims of the Holocaust. It is as if there is a desperate need to establish a legacy before the last survivors are gone, to make sure that we never forget this atrocity. Among the many recent examples, certain monuments distinguish themselves by providing the visitor with the opportunity to learn, to grieve, and to resolve—Never again.

One of the first Holocaust monuments, *Yad Vashem,* was built in Jerusalem in 1953. *Yad Vashem* is a shrinelike complex that merges architecture, landscape design, and art. It includes a history and art museum, a Hall of Names, a Hall of Remembrance, a Children's Memorial, a synagogue, a Memorial Cave, a library with archives, memorial paths, and commemorative sculptures. Like the *Vietnam Veterans Memorial,* it is experiential, involving passage (both in terms of time and state of mind) and provides an appropriate environment for mourning and introspection.

A memorial on the site of one of the most infamous concentration camps at Treblinka, Poland, was designed by Fransusyek Duszendo and Adam Haupt in 1964. Visitors walk along railroad tracks for 200 meters simulating the journey of Jews arriving in the camp. They reach a symbolic graveyard of 17,000 granite "broken" tombstones surrounding a central obelisk, commemorating the 17,000 who were killed there. Contemporary German artists have been creating "antimonuments" to deal with a nation's struggle to build a new and humane state while the memory of past crimes is still fresh. Hors Hoheisel's installations attempt to deal with the collective guilt of post-Hitler generations and to save victims from obscurity. For *Denk-Stein-Sammlung (Memorial Stone Collection),* (1989–1993), the artist asked schoolchildren in Kassel to dedicate a palm-size stone to honor a Jewish victim of that city whose story they had read in a book. The children wrapped their stones in paper on which they had written personal messages. Then, these 1,007 stones were placed in a glass baggage trolley and secured on Platform 3, the boarding area from which Jews were deported. Other monuments in Europe are dedicated to the memory of non-Jews exterminated by the Nazis, like Karin Daan's *Homomonument* (1987), a triangular marble plaza in Amsterdam dedicated to homosexual victims.

In the United States, Holocaust memorials also provide the opportunity to mourn and remember, but additionally they often reflect American ideals and attempt to reinforce our identity as a nation committed to preserving liberty and human rights. Nathan Rappaport's *Liberation,* a bronze sculpture of an American soldier rescuing a victim of the concentration camps, stands in Liberty State Park, New Jersey, in full view of the Statue of Liberty, reasserting the notion of America as champion of the oppressed.

One of the newest monuments to victims of the Holocaust is Boston's *New England Holocaust Memorial,* designed by architect Stanley Saitowitz and, significantly, sited next to the Freedom Trail. The memorial, dedicated to Jews

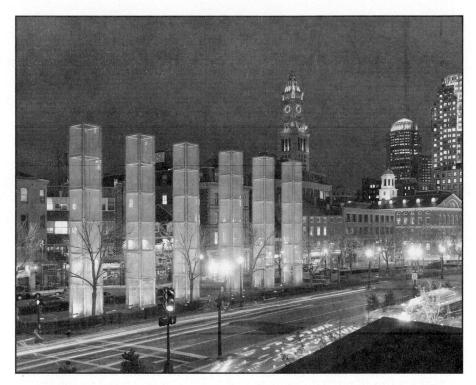

Stanley Saitowitz, **New England Holocaust Memorial.** *Boston. Dedicated October, 1995. (Steve Rosenthal/The Friends of the New England Holocaust Memorial)*

who perished in the Holocaust but also referring to other victims as well, "evokes communal experience and individual memory simultaneously with profound metaphors that remind us of the personal horror, as well as the collective history." (*New England Holocaust Memorial Catalog*). The effectiveness of this award-winning memorial stems from a perfect merging of meaning, site, and design. It consists of six fifty-four-foot glass towers, illuminated from within; six million numbers are etched in the glass, a reference to the tattoos the Nazis put on victims. As with the *Vietnam Veterans Memorial*, this memorial requires the visitor to walk along a path. Text educates the viewer and provides personal testimony by survivors, ranging from the unimaginable terrors of camp life to courageous acts of resistance or escape. Beneath each tower is a steel grate, with the name of a concentration camp. The word REMEMBER appears at both ends of the walkway, first in English and Hebrew, then in English and Yiddish. The following inscription summarizes the meaning of this monument for contemporary viewers:

> Those who perished have been silenced forever. Those who witnessed and survived the horrors carry with them the burden of memory. Through their voices,

we seek to comprehend the acts of inhumanity that can stem from the seeds of prejudice. To remember their suffering is to recognize the danger and evil that are possible whenever one group persecutes another. As you walk this Freedom Trail pause here to reflect on the consequences of a world in which there is no freedom—a world in which basic human rights are not protected. And know that wherever prejudice, discrimination, and victimization are tolerated, evil like the Holocaust can happen again.

A three-acre memorial park has recently been dedicated on the site of a more recent horror, the bombing of the Alfred P. Murrah Federal Building in Oklahoma City. The design model, created by Hans-Ekkehard Butzer, Torrey Butzer, and Sven Berg, was unveiled in July 1997. In keeping with most contemporary memorials, the visitor walks from one point to another, experiencing the wrenching impact of this event. Over the eastern entrance gate is the inscription: "We come here to remember" and the time 9:01, the minute just before the explosion. Grass covers the area where the Federal Building was situated. One-hundred-sixty-eight empty chairs (including nineteen smaller chairs for the children) commemorate those who were killed in the blast. Each of the stone-and-glass chairs, arranged in nine rows for the nine floors of the building, each contains the name of a victim. A reflecting pool and evergreen trees enhance the contemplative setting. A "Survivor Tree," an elm that survived the blast, is surrounded by a low wall engraved with the names of survivors. The visitor leaves through the western gate inscribed with the time 9:03. Since the bombing occurred at 9:02 A.M., the visitor participates in this life-transforming moment. The exit is marked by the words: "May all who leave here know the impact of violence. May this memorial offer comfort, strength, peace, hope, and serenity."

The contemporary memorial, then, serves many purposes: to commemorate the victims of tragedy, to offer friends and family the opportunity to grieve communally and privately, to ensure remembrance, and to educate the public. Yet the monument must also extend beyond the present to help shape the future:

> . . . we realize that the art of memory neither begins with a monument's groundbreaking nor ends with the ceremonies conducted at its base. Rather, this art consists in the ongoing activity of memory, in the debates surrounding these memorials, in our own participation in the memorial's performance. For, in the end, we must also realize that the art of memory remains incomplete, an empty exercise, until visitors have grasped—and then responded to—current suffering in the world in light of a remembered past. (James E. Young, *The Art of Memory: Holocaust Memorials in History*).

A logical extension of the memorial as engaged in the "ongoing activity of memory," which encourages personal and communal grieving while addressing present suffering, is the *Names Project Quilt*. Unlike the other monuments discussed here, this memorial is itself ever changing, and does not have a permanent form or site. It has not been created by a professional artist

or architect, but by many individuals whose personal grief compelled them to contribute panels to acknowledge loved ones lost to AIDS. It is as if personal mementos and notes like those left by mourners at the *Vietnam Veterans Memorial* have been transformed into art. Like the *Vietnam Veterans Memorial,* the *Names Quilt* was born of a grassroots effort. In 1985, Cleve Jones, after learning that the AIDS death toll in San Francisco had reached 1,000, was inspired by individual placards he saw hung on the Federal building to preserve the memories of AIDS victims in some significant form. In February of 1987, Jones made the first panel of what would evolve into an ongoing project embracing thousands. His $3 \times 6'$ panel was spray painted with the name of Marvin Feldman, adorned only with stars of David, each containing a pink-red triangle, the Nazi identification mark for homosexuals. The NAMES Project was formally organized on June 21, 1987, and in 1988 over 8,000 panels were displayed in a polygon behind the White House. The quilt has grown to include over 78,000 names and more than 40,000 panels. The reference to the American folk art of quilting is not coincidental. It identifies AIDS as a domestic rather than a foreign epidemic, one that requires communal involvement.

The NAMES Project offers people the opportunity to create tributes in the form of an $8' \times 6'$ panel and most choose to make a personal, intimate, even humorous statement. In an article titled "Stitches in Time," published in the July 1995 issue of the *Yale Review,* Peter S. Hawkins distinguishes the testimonials that comprise the *Names Quilt* from conventional epitaphs: " . . . the Quilt not only embraces venerable American memorial traditions but also . . . subverts those traditions with laughter, hysteria, mischief, indiscretion—the spilled beans of intimate life. This amounts to a reinvention of inherited ways to mark death and cope with bereavement, the discovery of new protocols of grief in the Age of AIDS."

The design of each panel is as individual as its makers. The only requirement concerns size and the inclusion of the name of the deceased. Otherwise, anything can be included: ties, baseball caps, martini glasses, wedding rings, computer-generated images, teddy bears, credit cards, photographs. Additionally, the *Names Quilt* is constantly evolving as panels are added and venues change. The only organizational constant is that panels are grommeted together to form 12' squares.

None have denied the inspirational significance of the *Names Quilt,* but some have questioned whether it is, in fact, art. In his essay, "Is the NAMES Quilt Art?" E. G. Chrichton contends that this communal effort "bridges the gap between art and social consciousness. . . . What is communicated is as complex as any art would strive for, something that will have historical significance beyond all our lives." (in *Critical Issues in Public Art,* ed. Harriet Senie and Sally Webster, Harper Collins, 1992). In this way, the *Names Quilt* fulfills the ultimate function of a memorial to the unspeakable, by personalizing tragedy, ensuring remembrance of the victims, and motivating people to take action to realize a more hopeful future.

Chapter 14

The Persistence
of Controversy:
Patronage and Politics

Harriet Senie

Controversy and public sculpture appear to have been joined at birth. In its traditional form as monument or memorial, public sculpture represented the ruling classes and their values, and as such was rightly seen as an extension of their authority. When power changed from one regime to another, so did public art. Public sculpture was only as secure as its patron. Although public art still exists in a political arena, the relationship of art and politics is much less clear. As soon as art is taken out of the sequestered spaces of the museum and the gallery system, it immediately becomes embroiled in a spectrum of non-art issues. With the advent of modern art and the development of abstract styles (understood primarily by the art-educated), the issue of elitism versus populism was added to the other issues of controversy surrounding public art in a democracy. At work, too, are the various conflicting attitudes toward art imbedded in our culture.

Rodin, whose work marks the beginning of modern sculpture, created a number of monuments whose history was a harbinger of things to come. *The Burghers of Calais* (1885–95) and *Balzac* (1891–98) were rejected by the very groups that commissioned them. The prototypical public art problems encountered by Rodin's *Thinker* (1880–81), documented by Albert Elsen, included the selection process, the rationale for having public sculpture, the problem of siting, issues of interpretation of modern sculpture (especially as seen against traditional standards of decorum and taste), and the vulnerability of public sculpture to attack (both verbal and physical).[1]

A century after Rodin, in 1983, an exhibition at the Milwaukee Art Museum entitled "Controversial Public Art from Rodin to di Suvero" also included works by Maillol, Lipchitz, Picasso, Oldenburg, Calder, and Segal, now considered classic examples of successful modern public sculpture.[2] Common to the controversies surrounding these works of widely divergent styles were problems concerning the understandability of the artist's aesthetic or formal approach, interpretation of political or moral content, and appropriateness of the work to subject or site. Underlying many of these

problems were stated and unstated expectations for both the sculptures and the sites.

Recent public sculpture, as we have seen, often took the literal place of traditional monuments without fulfilling their memorial function. Never intended as memorials, these works nevertheless raised public expectation that they would convey some commemorative or, in any event, at least some understandable content. However, most contemporary sculpture does not speak in a visual language accessible to those without some art background. It does not depict easily identifiable subjects, and it does not celebrate common values. Often it occupies sites that are unattractive and inhospitable, problems that the sculpture can hardly solve or even mitigate. Given these circumstances, it is not surprising that controversies are almost as frequent as commissions.

Too often the unstated expectations and agendas that lead to public art controversy are embedded in the patronage system. Who commissions public art and why? To date there are more than 150 public art programs at all levels of government. The best known are at the federal level: the General Services Administration with its Art-in-Architecture program and the National Endowment for the Arts' Art in Public Places program. The GSA had a percent-for-art component in its building program intermittently between 1963 and 1972 and steadily thereafter. The funding premise is that a small percentage of the building costs (usually around 1 percent) will be used for art. This is also the basis for most local public art programs around the country. Philadelphia, with the first privately funded public art program already in place at the Fairmount Park Art Association since 1872, was also the first to enact municipal percent-for-art legislation in 1959.

Percent-for-art programs are based on the assumption that art is a necessary and desirable part of architecture, and by extension, of the built environment. Indeed the traditional practice of western European architecture throughout history included painting and sculpture in an integral way. In the twentieth century, Bauhaus ideology, having excluded traditional sculptural ornament from modern architecture, nevertheless continued to call for the integration of the arts. The specific impetus for the creation of the GSA's current program came from a report issued in 1962 by the President's Ad Hoc Committee on Federal Office Space. This report, *Guiding Principles for Federal Architecture*, recommended that "where appropriate, fine art should be incorporated in the designs [of new Federal buildings] with emphasis on the work of living American artists." The committee was motivated by what was perceived to be "the increasingly fruitful collaboration between architecture and the fine arts."[3] Then, as now, the idea was attractive even though existing projects were few and successful results rare.

Since percent-for-art programs began with architecture, the commissioning process, at first, began with the architect. He (rarely she) would determine the location for any artworks and recommend at least three possible

artists to the GSA.[4] New selection processes were introduced in 1973 that gave the power to recommend the artists (and therefore to determine the kind of art) to a panel of "qualified art professionals" appointed by the NEA. Nevertheless, GSA and other percent-for-art–sponsored projects still begin with the building and usually treat the art as an add-on. Implicitly, therefore, the function of the art is to enhance the architecture or the open space around it.

Although it has resulted in much uninspired art that appears to be "plopped" onto a site without consideration of stylistic or local appropriateness, this premise, much maligned in recent years, does not preclude the creation of good public art. From the vantage point of the art community, this approach narrows the role of the artist, reducing it to one of decorator. However, just because a sculpture may enliven a boring building or urban space doesn't automatically "reduce" it to a "merely" decorative function. A sculpture may be visually good for the site and good art at the same time. This is true of Calder's *Flamingo* in Chicago as well as Sugarman's *Baltimore Federal* in Baltimore, both GSA commissions.

The NEA's Art in Public Places program proceeds from a different premise.[5] It offers matching funds to local organizations for art intended for specific sites. Art is thus purchased or created in response to local demand and becomes the property of the locale rather than the federal funding agency. The reasons for local demand are varied and sometimes difficult to ascertain. Often the work of art is part of a larger urban renewal project. There is ample precedent for this. To cite just one famous example, Michelangelo's Capitoline Hill in Rome with the antique sculpture of *Marcus Aurelius* (until recently) at its center, was part of a remodeling project initiated by Pope Paul III in 1537 to strengthen his papacy. Calder's *La Grande Vitesse*, the first sculpture commissioned by the NEA's Art in Public Places program, was also part of an urban renewal project. Subsequently, when an image of the piece appeared, as a civic logo on official stationery as well as garbage trucks, it functioned as a cultural sign of a decidedly upscale urban identity. Thus, although the sculpture itself did not provide actual urban amenities, it helped provide the community with a positive self-image, part of the goal of any urban renewal project.

Problems result not when public art is part of an urban renewal project, but when it is used in place of (rather than as an accompanying sign of) urban renewal. Rafael Ferrer's *Puerto Rican Sun*, installed in a South Bronx community garden park in 1979 as a result of an NEA grant, was intended as a symbol of local pride for an economically deprived residential neighborhood. But no art can make up for a lack of decent housing. Implicitly, commissioning public sculpture for this unstated purpose is comparable to painting the facade of an abandoned building as if it were inhabited—complete with curtains, flowers, and an occasional cat on the window ledge. Both mask actual problems that are then more easily overlooked and consequently remain unaddressed. Urban sculpture is not and cannot be a substitute for urban renewal, although the two are by no means mutually exclusive.

Richard Serra,
Tilted Arc. 1981
(destroyed 1989),
Federal Plaza,
New York City.
(Dith Pran/New
York Times
Pictures)

Existing expectations for a site are easily transferred to a work of art, which is then held responsible for not addressing them. In 1985, at the much-publicized hearing for Richard Serra's *Tilted Arc,* commissioned by the GSA for Federal Plaza in New York City, many people expressed the desire for a working fountain, some seating space, and, in general, a more attractive open area. *Tilted Arc* clearly did not provide these much-needed urban amenities. Nor was it intended to do so. Many who voiced criticism of the art were actually expressing their dissatisfaction with the plaza. The GSA finally added some catalogue standard-order planters and benches only after the sculpture was removed.[6]

The needs of the site and its public must be considered at the time that the art is commissioned. If useful urban amenities are desirable, then sculptors who regularly incorporate these functional aspects into their work should be considered. Today there are many public sculpture options that may include elements of urban renewal rather than mask their absence. Although public sculpture, as a rule, is not deliberately used to

mask deficient urban sites, art used as a cover or a company logo (or both) is a critical issue in corporate sponsorship. There the actual business of the corporation may be masked behind the activity of supporting art. The public thus inhales art and corporate largess instead of noxious fumes or obnoxious politics. Even though corporate support for art has not been predominantly support for public art, many corporations do have public sculptures in front of corporate headquarters. Several also have outdoor sculpture collections open to the public, the corporate equivalent of a museum sculpture garden. Indeed, some enterprising corporations appear to be going into the museum business themselves. A case in point is the recent enlargement of the General Mills outdoor sculpture program in Minneapolis, nearly coincident with the Walker Art Center's foray into this field.[7] Both include specially purchased and newly commissioned work. General Mills even chose two artists not usually known for outdoor sculpture (Jonathan Borofsky and Mel Kendrick) to create works for their collection, thereby adopting an innovative curatorial role for a corporation. Thus, as museums become increasingly entrepreneurial and frequently look like department stores with their restaurants and gift shops, some corporations are beginning to look more and more like museums. To what end?

A recent survey of patterns of corporate collecting suggests that businesses acquire works of art mostly for purposes of public relations.[8] A number of years ago architect Gordon Bunshaft of Skidmore, Owings & Merrill bluntly stated, "Art is for the client, just like he buys good furniture."[9] A blue-chip art collection outside corporate headquarters is a sign of prestigious respectability. By transferring a museum aura to the corporation, it changes corporate identity in a subliminal way. It also transforms art into an advertising tool, an enhancer of the corporate image, and as such potentially neutralizes its power. As critic Nancy Princenthal observed, Richard Serra's *Core* at General Mills, like Jonathan Borofsky's *Man with Briefcase,* "frames the corporate structures behind it and is framed by them; it is a kind of logo."[10] The corporate site implicitly changes the content of the piece.

It is reasonable to view corporate support for art with some skepticism. Corporations are in the business of making money and spend it only when they perceive it to be in their best economic interest to do so. But this does not necessarily mean that the resulting art is not also a true public amenity. Some of the most interesting and challenging public sculpture of our time has been privately funded in this way. The Poiriers' *Promenade Classique* in Alexandria, Virginia . . . , is one such example. However, the responsibility remains with the viewer to filter out the auxiliary advertising impact of the context.

One advantage to corporate patronage is that the commissioning process may be considerably simplified and restricted to a relatively small number of individuals. When public funds are involved, however, the role of the public in the selection process becomes an important issue. At once a number of difficult questions come into play. Who is the public? Is it

restricted to those who live and/or work around the site? Clearly not everyone can have a voice. How do you choose a representative from such a diverse and changing group?

A more basic question, however, is whether a representative of this amorphous public should be given a vote in the selection process. In a representative democracy such as ours, we elect officials to represent us in making decisions on issues with global implications as well as those with only local impact. In most areas we are willing to follow the advice of the professionals that our public representatives consult. This is true of economic and scientific issues, and even architectural ones. But the question of choosing art in our culture appears more problematic.

Does choosing art require professional training and expertise? Even though people outside the art community may answer that question in the affirmative, they often behave as if the opposite were true. As the cliché goes, they know what they like, and they don't want something they don't like in their space. However, what a general audience likes is usually something they already know, something familiar. That narrows the possible choice to something safe and unchallenging, something like standard television programming or canned music. The primary function of art professionals is to provide other alternatives. Artists, art historians and critics, museum curators, and arts administrators with training in looking at art and a broad familiarity with the work of contemporary public artists have experience and expertise in evaluating the potential success of individual artists and specific proposals. Even though these individuals may be subject to the vagaries of art-world politics, by and large they are in a better position to make the best possible choice. However, restricting the votes in the public art selection process to those with proven professional expertise does not mean that members of the public will not be heard.

Here the architecture process may serve as a model. People don't demand a role in the selection of architects or architecture (which has a far greater impact on the quality of their day-to-day lives), presumably because it is viewed as too complex. However, a responsible architect working with a client will go to great lengths to establish the client's needs and wishes. These become the basis of the building program. The design, if possible, both incorporates and transcends these requirements through the architect's vision. Representatives of the using public thus serve as advisors, articulating both essential needs and more general wishes.

In the public art selection process, representatives of the immediate using community (members of local boards and other organizations) should always be invited to express their concerns, problems, and expectations for a specific site. This important information (ranging from safety factors to less tangible aspirations for the community) is only available to those who live or work in close proximity to the intended location and varies widely from one locale to another. Thus, at one meeting of a selection panel for a public art

commission in New York, community representatives from the Spanish Harlem section of Manhattan expressed resentment of the "Gramercy Park style" of the already-designed site designated for the art. Accordingly, a Hispanic artist sensitive to a different esthetic was chosen. About two weeks later, representatives of a community in South Philadelphia with a different minority population expressed the desire for just such an esthetic for a corner park that was part of a redevelopment project. Again, the artist selected was the one who most directly addressed their concerns and wishes.

Using available information, a committee of art professionals can then select the best artist for the project, making sure that he or she is informed of community needs and is willing and able to work with those parameters. The selection process (slide viewing and discussions among panel members and artists) should be open to the community. This both demystifies the process and makes obvious the professional skills involved. It also provides an opportune time for questions. Early open dialogue among all those involved with the commission is the first step toward securing successful public art. As Brian O'Doherty aptly observed:

> Though community involvement can be a disguise for many philistinisms—some of them sophisticated—the concept depends on the patient exercise of a kind of trust intrinsic to the democratic process, which presumes that a body of people—a community—are fundamentally good-willed, and that good will can see beyond short-term goals and immediate self-interests.[11]

At every step of the way of a public art commission, the inclusion of an art-education component is essential. Public art at present is, for the most part, launched into the public domain with little or no information—far less than is available in a museum as a matter of course to a more informed audience. The larger public for public art must be given access to the art context within which contemporary sculpture can be understood and appreciated. The situation is critical. Art education in our public school system is totally deficient and shows no sign of improvement. A study sponsored in 1985 by the J. Paul Getty Trust (*Beyond Creating: The Place for Art in America's Schools*) revealed some appalling statistics.[12] Eighty percent of all students graduate from high school without any art courses whatsoever (studio, appreciation, or history). This says nothing about the quality or quantity of art education that the remaining 20 percent have had. In addition, the Getty study found that the public believed that art was not an academic subject but a frill, and that people needed little or no formal education to experience, create, or comprehend it. (It is this attitude that underlies the belief that anyone is competent to choose art.)

At work here are various conflicting attitudes toward art. Public funding to commission art is sanctioned, while funds for art education are usually the first to be cut. Art in museums is admired and respected, while art in the street is vandalized and despised. Art elicits violent feelings, as evidenced in

the recent brouhaha over NEA funding of certain controversial exhibitions, yet the vast majority of people don't look at art (including those most violently opposed to it) and know very little about it. Even though art is generally ignored, except as the object of controversy, theft, or the expenditure of great sums of money, our culture displays a truly ambivalent love-hate relationship toward it. How can we understand the violent feelings that art arouses?

Seeing is a sense we are born with. It is not learned in school. It is a vital process of identification upon which our survival depends. Simplistically, if we can't identify a moving car as such, we are physically at risk. If we can't place a work of art in an understandable context, we are intellectually and emotionally threatened. The impulse is to follow the "looks like" or metaphorical process of identification that gets us safely through the day. It is our way of making the unknown familiar.

When this process is applied to art, the results may be both funny and fatal. A few years ago a proposed public sculpture by Joel Shapiro became the object of a furious debate when the public and press, excluded from art-commission meetings, dubbed the rather innocuous-looking sculpture with a heavy price tag "the headless Gumby." T-shirts with this image were manufactured at once and became an immediate success. Identifying the abstract sculpture with Gumby brought it into an accessible frame of reference and made it an object of easy attack and ridicule. A similar translation of high art into vernacular terms occurred when Noguchi's *Landscape of Time,* a GSA commission of 1975 in Seattle, was related to the contemporary pet rock craze.[13] Michael Heizer's *Adjacent, Against, Upon* (1977), also in Seattle, was subject to the same comparison. Invariably in this context, cost becomes a red flag for controversy. Although material costs are easily grasped, the creative process is difficult to evaluate in monetary terms. Referring once again to Noguchi's *Landscape of Time,* the National Taxpayers Union was quoted as saying:

> The rocks . . . look for all the world like common boulders. Though the boulders were available for $5.50 a ton, or a total value of $44, when they were mined, the hard bargainers at GSA purchased the entire collection for $100,000.[14]

If a work of art is not tamed or framed by placing it within a familiar context, a sense of unease persists, sometimes to the point that the work of art itself is perceived as threatening. Richard Serra's *Tilted Arc* was compared to the Berlin Wall, and a physical security specialist for the Federal Protection and Safety Division of the GSA went so far as to contend that the sculpture presented "a blast wall effect . . . comparable to devices which are used to vent explosive forces. This one could vent an explosion both upward and in an angle toward both buildings."[15] Charles Ginnever's *Protagoras* (1974), a GSA commission in St. Paul, was seen as "a potential machine-gun nest" and the "undercarriage of a UFO-type flying saucer."[16] The perceived threat of

physical violence is not unique to monolithic Minimal sculpture. George Sugarman's open colorful and playful *Baltimore Federal* (1978), also a GSA commission, was seen as threatening because theoretically it "could be utilized as a platform for speaking and hurling objects by dissident groups . . . its contours would provide an attractive hazard for youngsters naturally drawn to it, and most important, the structure could well be used to secrete bombs or other explosive objects."[17]

Although initially amusing, these comments and others like them reveal that serious issues are at stake for those who utter them. When their anger or unease leads to vandalism, the victim (here the sculpture) is blamed. Thus, at the hearing on *Tilted Arc* the sculpture was blamed for being a magnet for graffiti and encouraging antisocial behavior.[18] Much of this can be addressed through proper art education, which could make the art understandable instead of frightening. Although there have been a number of significant reports advocating the need for increased and improved art education in the public school system, this is unlikely to occur in a time of tight budgets as long as art education is perceived as a frill. In the meantime public art is proliferating, and with it the need for an education component that will provide the context in which to understand (although not necessarily like) a work of art.

A public art education program should begin with representatives of the public educating the selection committee about their community. But it is the responsibility of the sponsoring organization to continue to educate the public. The reasons for the choice of a particular artist, for example, can and should be clearly articulated. The artist (or his or her representative), once the project is designed, can and should "explain" and discuss it with representatives of the public, particularly community groups and politicians. The finished work should be accompanied by information about the artist and the piece. This might include a statement of intent as well as critical comments and technical information; the last is often an effective initial "hook" for a general audience.

The forms a public art education program can take are limited only by the imagination of the commissioning agency. Public discussions, news stories, local radio and television coverage, advertising, as well as permanent documentation in any form may all be used. This information should be available as close to the piece as possible with appropriate signage making its existence known. In addition, outreach programs in local schools, libraries, hospitals, and even corporations can be implemented.

An outstanding education program is already in place in the Art in Public Places Trust in Metro-Dade County in Miami.[19] It includes teacher-education workshops given biannually to familiarize participants with the historical context, philosophy, and technology of public art. An instructional package with lessons, slides, and discussion topics is also available. Local college and university students work as interns in the trust's offices and are

trained in project, educational, and conservation management. The trust also organizes exhibitions and lectures, offers tours, and produces video presentations and publications on specific projects.

The place of art education in the public art process is evolving. The significance of this component is now regularly addressed at conferences and symposia on public art. What education programs can do is provide information and in this way mitigate the distinctions that separate the public into those who know (who have had a privileged education or are privy to local references) and those who don't (because the context, art or any other, eludes them). Such programs would help deflect the kind of criticism motivated solely by prejudice against or fear of new approaches that challenge the status quo. They cannot (and should not) establish or legislate esthetic criteria, but they can articulate and explain them. This is an important function, since the art expectations of a general audience usually differ greatly from those of an art-informed public.

Without some knowledge of contemporary art and its evolution, the very materials of which it is made can be shocking and enraging. Serra's *Tilted Arc* was criticized so frequently for being rusty that one of the artist's attorneys, Gerald Rosen, observed, "Now the whole thing about rust shows a kind of prejudice against the oxidation of steel." To an audience familiar with contemporary sculpture, Cor-Ten steel, the self-rusting material frequently used by contemporary sculptors, is as usual (and to some as beautiful) as marble and bronze were in earlier times. Similarly, a neon sculpture by Stephen Antonakos for the Tacoma Dome was attacked by some who felt that neon was appropriate for beer signs but not for art.[20] Information about materials is easily transmitted and easily understood. Having such information obviates the shock value; the material then becomes an element that can be judged on its own esthetic merits. Art is always appreciated on many different levels, depending on the audience, but an informed audience is usually a more open minded one. Familiarity, as a rule, breeds greater understanding, not contempt.

Unfortunately this is not true of all elements in the public art process. Far more difficult to address and even to ascertain are the various hidden political agendas. Usually unstated, they may nevertheless trigger hostile responses and impossible demands. Public art may easily become the pawn of politicians or bureaucrats who use a commission to further their own careers. Public sculpture may also become the focus of any pre-existing community tension and thus mask the actual problem. The more insightful and politically adept the local public art administrator, the more easily these issues can be isolated and resolved ahead of time.

Frequently political issues, and controversy in general, are exacerbated by media coverage. The popular press, an all-too-powerful vehicle in our culture, as a rule, has one driving motivation—to get a good story—and controversy fills the bill. Regardless of accuracy, controversy usually makes the

front pages while refutations are relegated to the back. As the focus of public art press coverage, controversy not only encourages but validates whatever antagonism already exists.[21] Journalists may convey that public art is put up in a casual way or that artist and the art establishment are trying to put one over on the public. Naturally glib writers easily create unfortunate comparisons to Gumby, a pet rock, etc. These images lodge in the public mind and often become permanently associated with a work of art. Members of the press are not deliberately pernicious; but they may be unthinking and uninformed. Public art administrators can help the press do a better job by including them in the education process. The same methods used by a museum to provide the press with information may be used to advantage by a public art agency. Members of the press should be invited to observe the selection process at various stages, thereby ensuring their understanding of the seriousness of the endeavor.

Even with an ideally informed audience and press, the continuing proliferation of public art will continue to pose serious questions. Before any commission is undertaken, it should be considered whether public art in any form is desirable. "Never use a sculpture where a tree will do as well" is a precept that might be considered, the burgeoning public art industry notwithstanding. The needs of the site and the surrounding community must be carefully and thoughtfully scrutinized.[22] Public art should not be confused with public amenities, although they are by no means mutually exclusive.

If public art is deemed desirable, what form should it take? Would an independent or site specific object be best or should the public art component comprise the entire site? Although there has been much criticism of independent object public sculpture, it should not be dismissed out of hand. As George Sugarman observed, "If you give up the object, you give up a sense of astonishment."[23] Some might argue that you also give up sculpture (or art) altogether. In general, such public sculpture works best on a site that already has urban amenities and is quiet enough to allow for the concentration that looking at and experiencing art requires and rewards.

At what point should the artist be brought into the process? Ideally, artists should be involved in the initial planning process, determining where public art is desirable and what forms it might take. An artist may be part of a design team at the start of a commission. Working with the architect(s), an artist may help to develop the art program as a whole or determine the nature and placement of a specific piece. Collaboration between artists and architects has been much praised in theory but has been difficult to implement. It is time-consuming and requires a very careful pairing of personalities as well as esthetic approaches. If an artist is not to be involved at the start of a commission, at what point should he or she be engaged? A cogent but perhaps unpopular argument could be made to involve the artist only after the basic parameters of the project have been established. One of the problems encountered by some of the artists initially involved in the Wiesner

building at M.I.T. was that the areas they were assigned to work on changed radically during the development of the building design. As a result, much of their work was unnecessarily frustrating, and on occasion, totally unnecessary. The advantage of involving an artist only after the building or site is nearing or at completion is that they then know exactly what the site looks like and any practical limitations it may pose. The obvious and significant disadvantage is that the artist can play no role in determining the nature and scope of the project.

Regardless of the degree of the artist's involvement, esthetic criteria for public art remain a murky issue. The public art revival of the mid-sixties began with the unstated assumption that a successful museum and gallery artist would be a successful public artist. However, as has been amply proven, this is not necessarily the case. Certain esthetics don't translate well from a carefully controlled environment to the changing unpredictability of contemporary urban spaces. Concepts of site specificity evolving from museum and gallery installations are much more problematic in an urban environment. Unlike a pristine gallery setting with fixed delimiters and no distractions, an urban location is full of competing visual stimuli. Furthermore, it is always subject to change. The very buildings that once defined a site may be razed or radically altered. New buildings in a different style may be added to the visual parameters. The landscape is subject to seasonal change as well as long-term alteration. A sculpture that now sits happily next to a sapling may be totally hidden by the mature tree. Nevertheless, public art will continue to be judged on its appropriateness to its site, even though the artist can do no more than consider the physical characteristics and needs of a site or a community at the time of commission.

The recent proliferation of public sculpture is a sign of a culture in search of unifying symbols. But we have diverse and often conflicting cultural values, and most of our cities, deteriorating at an alarming rate, lack a coherent civic identity. In the public domain the fame of artists may supply the illusion of culture, but not the content. Although civic logos may be commercially useful, they offer little in the way of inspiration. Images of victims and a shattered past remind us of what we have lost or destroyed. Although it may lack an identifiable art content, public sculpture that creates new sites and spaces has thus far made the most significant contribution to the quality of contemporary urban life.

Assessing the success of art is never easy, but in the realm of public art it is especially difficult. Controversy is loud and appreciation often silent and unmeasurable. Submitting public art to a popularity contest is hardly a valid criterion by any standard. The public and art factors must both be considered, but in different ways. Public concerns may be addressed through an open, informed public art process. Art concerns must be addressed by artists, because the esthetic function of public art, no matter what form it takes, must be the same as that of museum art: to communicate a vision according to the

formal vocabulary chosen by the artist. If art concerns become less than primary, we end up with something that is not primarily art and that is to no one's best interest.[24]

What we need in public art today is not consensus but communication. Public art can provide a genuinely enriching experience—more than a civic logo or urban amenity. Good public art (good for the public and for art) functions as an invitation to dialogue, not an inaccessible monologue. It exists as an affirmation that art has an active and meaningful role in public life. Although dependent on the patronage of establishment organizations, artists still find room for individual creative expression. The fact that some of the most interesting artists of our time are once again willing and even eager to work in the difficult arena of public art is both a welcome sign of private commitment to public good and a step in the healing process of a fractured society.

Notes

1. Albert Elsen, *Rodin's Thinker and the Dilemmas of Modern Public Sculpture* (New Haven: Yale University Press, 1985).

2. Curated by Gerald Nordland, the exhibition was held at the Milwaukee Art Museum from October 21, 1983, to January 15, 1984. It did not travel.

3. The GSA's *Factsheet: Art-in-Architecture for Federal Buildings* includes a brief history of the program as well as a summary of the current commissioning process.

4. For a history of the GSA's commissioning practices, see Donald W. Thalacker, *The Place of Art in the World of Architecture* (New York: Chelsea House Publishers and R. R. Bowker Company, 1980); Lois Craig and the Staff of the Federal Architecture Project, *The Federal Presence: Architecture, Politics, and Symbols in United States Government Building* (Cambridge, Mass.: The MIT Press, 1977); JoAnn Lewis, "A Modern Medici for Public Art," *Artnews*, April 1977, pp. 37–40; Kate Linker, "Public Sculpture II: Provisions for the Paradise," *Artforum*, Summer 1981, pp. 37–42.

5. For an analysis of the different commissioning practices of the GSA and the NEA, see Judith H. Balfe and Margaret J. Wyszomirski, "Public Art and Public Policy," *The Journal of Arts Management and Law*, Winter, 1986.

6. For a fuller discussion of the fate of Serra's *Tilted Arc*, see the author's "Richard Serra's *Tilted Arc*: Art and Non-Art Issues," *Art Journal*, Winter 1989, pp. 298–302, and the forthcoming *Dangerous Precedent: Richard Serra's Tilted Arc in Context* (Berkeley, Calif.: University of California Press, 1993).

7. The December 1988 issue of *Art in America* included articles on both projects. Sue Taylor's "Garden City," pp. 28–37, on the Minneapolis Sculpture Garden at the Walker Art Center was followed by Nancy Princenthal's "Corporate Pleasures," pp. 38–41, on the new outdoor art at General Mills.

8. See Rosanne Martorella, *Corporate Art* (New Brunswick and London: Rutgers University Press, 1990), p. xi.

9. Personal interview with Gordon Bunshaft in 1978.

10. Princenthal, "Corporate Pleasures," p. 39.

11. Brian O'Doherty, "Public Art and the Government: A Progress Report," *Art in America*, May/June 1974, p. 45.

12. Other significant studies in the area of art education are *Coming to Our Senses: The Significance of the Arts for American Education* (New York: McGraw-Hill Book Company, 1977) and *Toward Civilization: A Report on Arts Education* (Washington, D.C.: National Endowment for the Arts, 1988).

13. The fate of this commission was related to the author in a private interview with a person closely involved with the project. The Noguchi–pet rock comparison is mentioned by Thalacker, *The Place of Art in the World of Architecture*, p. viii.

14. Ronald G. Shafer, "A Touch of Class? Washington Planners Beset by Critical Public over Their Efforts to Put Art into Architecture," *The Wall Street Journal*, September 21, 1976, p. 48.

15. This and other testimony is available in the unpublished proceedings on the GSA hearing on *Tilted Arc*, which took place on March 6–8, 1985.

16. Thalacker, p. vii.

17. For a summary of the controversy see JoAnn Lewis, "People Sculpture: Objections Overruled," *Artnews*, December 1976, pp. 83–85. A more detailed narrative is provided in Thalacker, pp. 8–13.

18. One judge complained that "It invites vandals to place graffiti upon it [and] transients have actually been seen urinating on it." Another judge objected, "Graffiti is written all over it, most of which is obscene and unmentionable. . . . Some animals use it as a waste deposit."

19. Information on these programs may be obtained from Pat Marx, Education Coordinator, Metro-Dade Art in Public Places Trust, 111 N.W. First Street, Suite 610, Miami, Fla. 33128. Although the education programs as well as the art commissioned by the trust have been much praised by the public art community, the fate of the overall program remains somewhat in question at the time of this writing. See David Joselit, "Public Art & Public Purse," *Art in America*, July 1990, pp. 142ff.

20. See Pilar Viladas, "Art for Whose Sake?" *Progressive Architecture*, April 1985, p. 29; and "Neon Sculpture Controversy in Tacoma," *Interior Design*, May 1985, p. 70.

21. For example, Thalacker, *The Place of Art in the World of Architecture*, p. xi, attributes the suspension of the GSA's Art-in-Architecture program in 1966 to specious reporting in the *Boston Herald* about a mural by Robert Rauschenberg installed in the John F. Kennedy Federal Building in Boston.

22. Various interesting ways of considering the meaning of site are discussed in *Design Quarterly*, vol. 122 (1983), entitled *Site: The Meaning of Place in Art and Architecture*.

23. Sugarman made this remark at a panel discussion at the annual meeting of the College Art Association in 1986.

24. A cogent argument for maintaining the primacy of the artistic vision is made by Douglas Davis, "Public Art: Taming of the Vision," *Art in America*, May/June 1974, pp. 84–85.

Part V:

Issues Concerning Race and Ethnicity

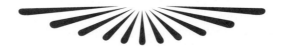

Non-Whites in America have historically struggled to assert their respective cultural identities in the face of overwhelming obstacles: misunderstanding and prejudice, economic and social inequities. Perhaps the most damaging misconception, which prevailed until recently, is that people of diverse racial and ethnic descent need to be "enlightened" and fully assimilated into an American melting pot dominated by white values and attitudes.

Native Americans historically have been subjected to invented identities in representations by white artists. Julie Schimmel, in her essay "Inventing the Indian," written for the exhibition catalog *The West as America*, concludes that white America has perceived Native Americans through preconceived cultural assumptions. This "attitudinizing" resulted in Indians' being portrayed in various roles, roles imagined by white Americans. Portraits by Charles Bird King and George Catlin painted in the 1820s and 1830s present the Indian as a noble savage, the "natural" man. However, beginning in the 1840s two different interpretations of Indian life emerged in scenes of conflict between Indians and white settlers and in melancholy visions of "doomed" Indians. These images were the result of events that occurred following the passage of the Indian Removal Act of 1830, which opened the way for white speculators, entrepreneurs, and settlers to occupy what had previously been traditional Indian lands west of the Mississippi. Conflict paintings often pitted notions of white innocence against implied Indian savagery. Vistas of abandoned Indian villages and close-ups of Native American families contemplating their ominous future suggested that the Indian was doomed to extinction.

The resolution to the problematic nature of Indian/white American relations was acculturation and assimilation as legislated in the 1887 General

Allotment (Dawes) Act. Family lands were confiscated and families were encouraged to assimilate into American society through education and social programs. Government legislation denied Indians their true ethnic and cultural viability, so too did American artists of the late nineteenth and early twentieth centuries deprive them of their true identity. Instead, depictions of Indians represented white attitudes about nature, conquest, and the supremacy of "civilization."

Just as Native Americans were envisaged according to white American ideas, African Americans' portrayals during the nineteenth-century pre-Civil War era tended toward the stereotypical: images of the childlike banjo-playing slave and the domestic "Mammy." While the Civil War and Reconstruction periods forced a re-evaluation of the role of Blacks in American society, most images were created by white artists; only a small number of African Americans (for example, Mary Edmonia Lewis and Henry Osawa Tanner) received recognition.

It was not until the decade between 1919 and 1929 that a true Black cultural awakening occurred, the so-called Harlem Renaissance, chronicled in a 1987 exhibition at the Studio Museum in Harlem—*Harlem Renaissance: Art of Black America.* It was during the 1920s that a Black vision of American life, fueled by the impact of the New Negro Movement, found expression in the visual arts, in literature, and in music. While no one style was embraced by all Harlem Renaissance artists, many were inspired by a rich tradition of Black folklore and integrated an appreciation for the African past with the realities of Black American experience. Sculptor Meta Warrick Fuller drew upon an African aesthetic while confronting the struggle for freedom and self-definition in a violent America. Painter Aaron Douglas traced the emergence of a Black identity in an extensive cycle executed in a modernist style. Black American life, legend, and folklore were compelling sources for Palmer Hayden, while the portraits made by fashionable photographer James Van Der Zee captured a sense of the pride and elegance of Harlem sophisticates which was, as Mary Schmidt Campbell wrote in "Introduction to Harlem Renaissance: Art of Black America," partially constructed, partially real.

Yet, as Campbell surmises, the success of Harlem artists during the Harlem Renaissance was tempered by a separatism inherent in American cultural life. The philanthropic Harmon Foundation held national competitions exclusively for African-American artists; exhibitions were segregated. In addition, hostile critics misrepresented and underappreciated the achievements of Black artists. "Disappointingly, the legacy of the Harlem Renaissance has been a cultural separatism that to this day persistently lingers in the history of American art."

In her book *Mixed Blessings* Lucy Lippard explores issues of identity as they relate not only to Native Americans and African Americans, but also to Asian Americans and Hispanics. The title of her essay "Naming" identifies

an important vehicle for contemporary "minority" artists to work through questions of self-identification, societal stigmas, and cultural pride. Many artworks from the past two decades reflect a vulnerability experienced by artists of color resulting from a collision of each artist's own inner vision of self with societal constructions.

Most artists in general move constantly between private space and the larger sphere that is the community. For "minority" artists, in particular, the images they produce can assist in redefining self and the world in which that self exists. The "hyphenated" American denotes double identification and bicultural pride. Yet ultimately self-naming requires that relational factors be integrated into the process so that one's own assumptions are balanced with an understanding of the assumptions of others and a recognition of belonging to a larger community. Names and labels will continue to change as dialogues evolve and the effort to unravel the complexities of modern identity intensifies. Meanwhile, Lippard calls for a "theory of multiplicity" in the arts that transcends the assimilative and the separative to be truly relational. She suggests that a significant step is to engage in discourse *by* and not only *about* artists and writers of color in America and in Third World countries.

Chapter 15

Inventing "the Indian"

Julie Schimmel

No sooner had the first representation of American Indians appeared on canvas than the question was raised as to whether or not it was accurate. From that day until the present it has been the issue most frequently debated in judging portraits of Indian life. During the nineteenth century, in particular, questions about accuracy superseded judgments about artistic merit, so convinced were critics and commentators on Indian habits and customs that "real" Indians could be isolated and identified.

A journalist writing for the *Missouri Republican* in 1848, for example, described "a home scene" of Indian life by Seth Eastman as if it were possible for an artist to create without a point of view. The painting, he wrote, was "quite unlike the vast mass of Indian pictures it has been our bad luck to see—for it is true. There is no attitudinizing—no position of figures in such a group that you can swear the artist's hands, and not their own free will, put them there."[1] Yet George Catlin's self-portrait among the Mandans, painted just a decade later, suggests just how much "attitudinizing" permeated the relationship between whites and Indians. . . . Catlin stands dressed in a contrived buckskin outfit that makes of western garb a fashionable eastern suit. Poised with brush in hand before his easel, he paints the Mandan chief Máh-to-tóh-pa as a reflection of his own self-conscious, controlling image. The artist's stance among a spell-bound crowd of half-nude Indians leads the viewer to believe that nothing but reality is being recorded, but Catlin's relationship to his subjects comes straight from the drawing rooms of eastern society, as Indians are submitted to a portrait process that cherishes individuality, material status, and vanity—all notions less highly regarded in Indian culture.

Whether from the spheres of religion, politics, commerce, or ordinary walks of life, white Americans perceived Indians through the assumptions of their own culture. As a result, Indians were seen in terms of what they might become or what they were not—white Christians. Or Indians were not seen at all, at least in terms of the cultural organization particular to Indian tribes or in terms of the negative impact white contact had on Indian culture. . . .

By the time American artists first ventured forth to paint Indians in western territories, the latter had long been perceived in the light of contrasts

made between white and tribal cultures. As historian Patricia Limerick states in *The Legacy of Conquest* (1988): "Savagery meant hunting and gathering, not agriculture; common ownership, not individual property owning; pagan superstition, not Christianity; spoken language, not literacy; emotion, not reason."[2] Whether the comparison was represented overtly or not, Indians were judged according to these contrasts, as Fanny Palmer's well-known Currier and Ives lithograph of 1868 makes clear. . . . America's growth is expressed in terms of the Indians' decline. On the left, a white community bustles with activity. The major features of the town are the public school, the foundation of "enlightened" citizenry; the woodsmen, who prepare the way for future settlement; and the telegraph and railroad lines, the technological lifelines of civilization. These last two forms of invention—communication and transportation—most explicitly separate the two Indians on the right from civilization. Astride their horses, which suggest their nomadic life-styles, partially obliterated by smoke from the train, they stand rooted, while lines of so-called progress reach toward the horizon. . . .

Noble but Savage

Artists drew on both [positive and negative] interpretations but more often at first (particularly in the 1830s and 1840s) on an idealized Indian representing the "natural" man conceived by whites as an alternate role model—the independent male who lived beyond the bounds of civilization but who embodied wilderness "virtues." The "dark side," the superstitious, godless "savage" in conflict with white civilization (and a hierarchy of Anglo-Saxon values), emerged in significant numbers on canvas in the 1840s and has persisted to the present.[3]

Paintings by Charles Bird King from the 1820s and by Karl Bodmer, Catlin, and Alfred Jacob Miller from the 1830s portray Indians as separate from white civilization, as if colonization had not yet introduced epidemics, alcoholism, and tribal disintegration caused by removal from traditional to distant lands. Artists ignored current realities in favor of earlier literary and artistic traditions, which placed Indians in remote and pristine environments. Here were earthly paradises, where life, supported by the beneficence of nature, proceeded in an orderly fashion. At one with their surroundings, Indians were seen as innocent, simple, devoid of guile and deception.

While rarely revealing the ideas that formed their attitudes, painters drew on well-established European intellectual constructs regarding primitivism and the Noble Savage.[4] . . .

[Charles Bird King was among the first to paint numerous portraits of Native Americans.] The consummate Noble Savage portrait, *Young Omahaw, War Eagle, Little Missouri, and Pawnees,* was completed in 1822 in King's Washington studio. The painting subsumes Indians and their individuality in the artistic tradition and romantic sentiments of the late eighteenth century. Derived from a convention of multiple portraits of the same or different

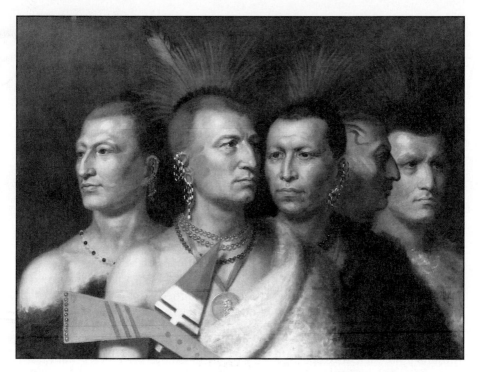

Charles Bird King, Young Omahaw, War Eagle, Little Missouri, and Pawnees. *1822, Oil on canvas. (Art Resource, NY)*

subjects, the four heads, despite the painting's title, are probably based on the likenesses of two Pawnee chiefs, Petalesharro, chief of the Pawnee Loups, and Peskelechaco, chief of the Republican Pawnees, whom King painted when they traveled to Washington with a tribal delegation in late 1821.[5] The partly shaven heads are capped with deer-hair crests, with loops of wampum hanging from their pierced ears. One wears a silver peace medal bearing the image of President James Monroe. The Indians' bare shoulders, buffalo-skin robes, and body decorations imply that they are "primitive," yet their impressive physiques and countenances suggest more. Having seen the Pawnee delegation of which Petalesharro and Peskelechaco were members, one observer pointed to just those features that probably inspired King's multiple portrait: "All of them were men of large stature, very muscular, having fine open countenances, with the real noble Roman nose, dignified in their manners, and peaceful and quiet in their habits."[6] Conceived as Roman nobles, these are men to be admired for physical prowess as well as reason. They represent a race that could perhaps be persuaded by rational argument as well as the formidable presence of the United States government to abandon tribal tradition for a more civilized life-style.

Catlin's 1834 portraits of the chief of the Osage, Clermont, and his wife, Wáh-chee-te, reveal other preconceptions about savage life. . . . The two adults assume conventional poses. Catlin's loose brushwork, pastel pinks and blues, and mottled sky suggest romantic portraiture styles of the day. . . . But Catlin's subjects are placed outdoors; their home is not in the city but in nature. The attire and hairstyles of husband and wife suggest their "natural" state. Both wear animal skins. Wáh-chee-te's hair hangs loosely to her shoulders, while her part is painted with vermilion. Clermont's head has been shaved with the exception of a strip of hair, or roach, decorated with horse hair dipped in vermilion. Each is only partly clothed. He sits bare-chested. She exposes her shoulders, while their child is nude. Civilized customs have not been introduced by barber or dressmaker. Yet neither is the couple uncivilized. Clermont may wear leggings and hold a war club fringed with scalp locks, but his war trophies, brass armlet, and wampum earrings are as decorative as they are menacing. His club is not held aggressively but is cradled in his arms. His threat as warrior is further diminished by his passive seated pose and by the peace medal hung around his neck. Presumably obtained as gifts from the United States government, these medals symbolize white curtailment of Indian power. Wáh-chee-te has been similarly, if more lightly, touched by civilization. Although still "primitive," her demeanor is gentle. Also, her portrait touches on one of the few points of approval accorded to Indians by whites. As Robert Beverly wrote in 1705 in his *History and Present State of Virginia:* "Children are not reckon'd a Charge among them, but rather Riches."[7] . . .

Scenes of Indian life from the 1830s through the 1850s also suggest that the intellectual concept of the Noble Savage still influenced painters of the American West. Typical of paintings from the 1830s, which frequently presented Indians at one with nature in a sweeping panorama, are Miller's *Surround of Buffalo by Indians,* circa 1848–58, and Catlin's *Bird's-eye View of the Mandan Village,* 1837–39. . . .[8] A spacious landscape, lit by a golden sky encompassing Indians and buffalo below, evokes an earthly paradise in Miller's painting. To the left, an Indian woman sits mounted on an elaborately caparisoned horse. In the distance, Indian hunters ride to entrap the buffalo herd, a scene Miller described in romantic hyperbole: "The activity, native grace, and self-possession of the Indians, the intelligence of their well-trained horses, and the thousands of Buffalo moving in every direction over the broad and vast prairies, form a most extraordinary and unparalleled scene."[9] In such statements (and paintings) Miller conjures "savages," whose grace and freedom (reason and intuition) put them in tune with nature. But by the mid-1850s others were ready to offer a conflicting view. A traveler in the Southwest, who might have witnessed a similar scene, wrote:

> As horsemen they are unrivaled; they sit very ungracefully, lolling about as they ride, as if drunk or too indolent to sit up; but when roused to action, their energy is fearful. Their hideous yells—in making which they pass the hand

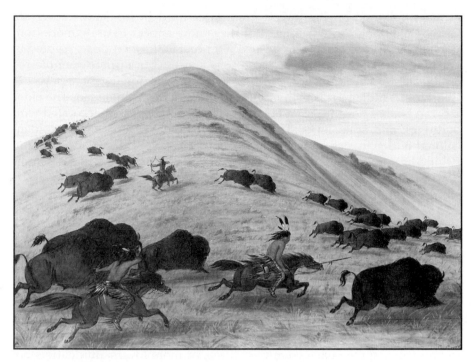

George Catlin, **Group of Sioux Indians and Buffalo.** *Oil on canvas.*
(Courtesy of the American Museum of Natural History)

rapidly over the mouth—and diabolical attire, are as appalling as the sudden-
ness and fierceness of the attack. There is really nothing in them to command
our admiration.[10]

Scenes of village life could also be viewed with an ambivalence reflect-
ing cultural stereotypes. In *Mandan Village* . . . earthen huts set amid a verdant
landscape shelter "stern warriors" and "wooing lovers" (as Catlin described
them). Yet Indians at leisure, whether stern or amorous or asleep on lodge
rooftops, might also be scorned by a culture that valued industriousness. The
"Bible-toting mountain man" Jedediah Smith, encountering a Sioux camp
that must have appeared as inviting as Catlin had found the Mandan village,
commented in his journal that the scene would "almost persuade a man to
renounce the world, take the lodge and live the careless, Lazy life of an
indian."[11] It is well to remember that one person's Noble Savage was hope-
lessly indolent to another, and that white audiences probably viewed paint-
ings such as *Mandan Village* with mixed reactions. Indians might not suffer
from the ills of progress and civilization, but neither did they exhibit the
virtues admired by white society.[12]

John Mix Stanley spent more than ten years traveling the West from
Oklahoma to California and Texas to Oregon. The field sketches and Indian

artifacts collected on his travels were later used in his studio to create "actual" paintings of Indian life. But these now appear to draw more from popular stereotypes than from his experiences. *Barter for a Bride,* painted in Washington, D.C., sometime between 1854 and 1863, is a prime example. . . . Sitting astride a beautiful horse with arched neck and flowing mane, a young (Blackfoot?) Indian presents himself to the father of the intended. The elder wears a feather headdress, and both are clothed in buckskin decorated with quillwork and scalp locks. The prospective bride, in unadorned golden-colored buckskin, lies on her stomach in the grass and gazes at her suitor. Behind her, grouped in a monumental pyramid that predicts a stable, continuous life cycle, are various members of her family. From the spacious landscape at right four mounted figures proceed toward the central group. Two horses drag travois presumably bearing gifts for the father of the bride. The benign landscape promises that the gifts will be plentiful.

Although Indian marriages depended everywhere on economic considerations, there was much diversity in marriage customs among North American tribes.[13] For some the presentation of gifts to the bride's parents, the apparent subject of Stanley's painting, legitimized a marriage. But titillation was equally part of Stanley's image. The provocative young woman reveals her availability rather than her chasteness. She exemplifies an aspect of Indian life described by Prince Maximilian: "Prudery is not a virtue of the Indian women; they have often two, three, or more lovers: infidelity is not often punished."[14] The ceremony uniting man and woman was conspicuously pagan—material goods were exchanged for sexual possession. Such a "barter" may have intrigued contemporary whites, but it was not a practice openly endorsed. . . .

Indian "Massacres" and White "Battles"

Beginning in the 1840s paintings representing a more or less positive view of Indian life were challenged by two other subject categories. These were scenes of Indian-white conflict and, to a lesser extent, images of "doomed" Indians. Patronage no doubt broadened at this point. Bodmer, Catlin, and Miller painted for a limited clientele—the government, selected scientists and adventurers, and, later in their careers, a few easterners and European aristocrats. Revealing a more aggressive attitude toward westward expansion, the taste of the next generation was generally guided by the American Art-Union and popular prints made after conflict paintings. The source of this attitude was the political and social climate of the Jacksonian era.

President Andrew Jackson, in office from 1829 to 1837, argued pragmatically in his second annual address to Congress for the geographical separation of Indians and whites, which he described as beneficial to both:

> The consequences of a speedy removal will be important to the United States, to individual States, and to the Indians themselves. The pecuniary advantages which it promises to the Government are the least of its recommendations. . . .

It will separate the Indians from immediate contact with settlements of whites; free them from the power of the States; enable them to pursue happiness in their own way and under their own rude institutions; will retard the progress of decay, which is lessening their numbers.[15]

Typifying Jacksonian Indian policy, these self-serving, widely shared sentiments had already caused passage of the Indian Removal Act in 1830. This legislation provided Jackson with the authority to remove Indians from lands between the Great Lakes and Gulf of Mexico, which were desirable to land speculators, farmers, railroad magnates, bankers, and entrepreneurs of every stripe. Consequently sixty thousand Indians from tribes including the Cherokee, Chickasaw, Choctaw, Creek, and Seminole were removed from traditional lands to Indian territory west of the Mississippi.

Subsequent to Indian removal, Senator Thomas Hart Benton of Missouri and like-minded expansionists urged the country to explore and settle the vast territories of the West. Their desires were finally satisfied when the Northwest was secured in 1846 and the Southwest in 1848, new territories that established the continental boundaries for the nation. Now the dreams of expansion could be met. Opening western land to white settlement, however, ensured Indian-white conflict, since overland trails carried increasing numbers of emigrants through or to lands occupied by indigenous and newly removed Indian tribes. In 1790 the American population of 3.9 million lived within fifty miles of the Atlantic Ocean; by the next half-century 4.5 million Americans had crossed the Appalachians.[16] The presumed necessity of this kind of rapid expansion thrust on Americans (and American artists) the need to resolve racial encounters precipitated by the appropriation of Indian lands. In effect, three different strategies emerged, one without an artistic counterpart (in itself revealing) and two that spawned new iconographies.

Indian removal was a singularly brutal and dramatic moment in the history of the United States, yet no hint of it ever appeared on canvas. Instead artists turned to conflict scenes in which Indians were cast as villains who prevented a peaceful appropriation of western lands. Such scenes gradually made obsolete the group of images first discussed in this chapter, which were often pejorative but not provocative. Conflict iconography (in both painting and literature) was a manufactured response to Indian hating, which gained renewed energy as settlers encroached on Indian land. The third strategy resolved the issue in another way by presenting Indians as doomed relics of the past. After more or less lamenting their fate, paintings in this group concede that the Indians' only recourse was to deliver their lands to a superior white race.

In the context of Indian removal and westward expansion Indians changed from denizens of the wilderness to barbaric savages. As historian Francis Jennings observes in *The Invasion of America* (1975): "Myth contrasts civilized war with savage war by accepting the former as a rational, honorable, and often progressive activity while attributing to the latter the qualities of irrationality, ferocity, and unredeemed retrogression. Savagery implies

unchecked and perpetual violence."[17] Indians in battle were consistently viewed as barbarians who staged massacres while whites courageously defended themselves. . . .

Typical of early conflict paintings, which often feature a female victim (see note 3), is *The Murder of David Tally [Tully] and Family by the Sissatoons, a Sioux Tribe*, circa 1823–30, by the Swiss émigré Peter Rindisbacher. . . . On the right, David Tully fights for his life against three Indian warriors who brandish war clubs and tomahawk. Tully's own gun is presumably empty, since he uses it simply as a club. In the foreground, the most feared atrocity against white settlers transpires. A white woman with three children, one apparently torn away from her breast, is assaulted by three Indians. The woman is sheltered by a frail tent that offers no defense against the arsenal of weapons raised against her. The final, dreadful outcome of the encounter is preordained, along with the unprovoked savagery of the Indians and innocence of their victims. . . .

Stanley's statement regarding Indian savagery is more complicated than that of Rindisbacher. At the center of *Osage Scalp Dance*, 1845, kneels a white woman clutching to her side a partially naked child. . . . She raises her right arm to ward off a threatened death blow from one of the sixteen muscular warriors who surround her. Brandishing spears, bows, and war clubs, the warriors wear only loincloths and leggings. While the seminudity of the child suggests his vulnerability, that of the warriors indicates their brutality.

The drama of the painting rests with the struggle between the forces of civilization and those of savagery, between the forces of light and darkness, which Stanley so conspicuously indicates when he contrasts the fair skin of the heroine, who is highlighted and dressed in white, and the dark skin of the Indians who surround her. The presumed chief lifts his spear to prevent the raised war club from falling and killing the innocent victims. The rescue of the white woman and child, standard nineteenth-century symbols of civilization, indicates that barbarism has been arrested by the forces of reason. The Indian poised to deliver the death blow is the most menacing, both because of his gesture and suggestive fur breech-cloth. In contrast, the Indian who moves to protect the mother and child is the most civilized, not only because of his stance but because of the medal he wears around his neck. Alone among his fellow tribesmen, he has been visibly touched by white culture. . . .

Conflict scenes presume the innocence of whites, who usually are represented as victims, not aggressors. Typical of this more common image is Arthur F. Tait's *Prairie Hunter, "One Rubbed Out!"* 1852. . . . Clad in buckskin tunic and leggings, a trapping races for his life before a party of Indians, one of whom he has just "rubbed out." Outnumbered, with no place to take refuge, his rifle, perhaps out of ammunition, held downward, his fate appears sealed. In an earlier day, however, independent trappers and those associated with fur companies lived and hunted alongside Indians. Indeed

John Mix Stanley, **Osage Scalp Dance.** *1845, Oil on canvas. (Art Resource, NY)*

Indians were major suppliers of pelts to the fur companies. . . .

But the fur trade had actually been in decline for twenty years by the time Tait painted *The Prairie Hunter.* The artist views nostalgically a figure that popular writers and printmakers had elevated to a new pantheon of frontier heroes.[18] That he was portrayed in the 1850s at the mercy of "savage" Indians had less to do with history than with increasing demands to remove Indians from the pathway of settlement.

One of the most common subjects found in paintings of the American West at midcentury was the pioneer caravan under Indian attack. So popular was it, in fact, that Carl Wimar painted *The Attack on an Emigrant Train,* 1856, while studying in Düsseldorf (where high drama was the prevailing style) and brought it home to sell.[19] Intersecting diagonals formally announce the raging conflict between white settlers and Indians. Inside the lead wagon the wounded are tended to, while the able-bodied fire from behind, beside, and inside the wagon. Their shots have successfully hit two Indian assailants. Although the wagon train has been halted by the fierce assault, the battle is no more than a temporary setback to westward travel. A careful count suggests that the intrepid settlers are holding their own. And behind the lead wagon, stretching along the receding diagonal, are three more wagons and inevitably behind these, yet more settlers on the move. . . .

American Expansion, Indian "Doom"

During the same period that paintings of Indian-white conflict appeared with such frequency so did those of another major theme, the doomed Indian. The belief that Indians would succumb to the forces of civilization reaches back to the seventeenth century, but by the nineteenth century what had been expressed as sentiment began to look like fact. . . .

One of the first paintings featuring the doomed Indian, Tompkins H. Matteson's *Last of the Race,* 1847, typifies images with similar titles that followed over the next decades. . . . A tribal elder, surrounded by his family, stands at land's end, contemplating the ominous procession of clouds on the horizon. Generations of Indian life end here, the painting implies. The ocean is an abyss at the family's feet, the setting sun parallels their waning life and power. The mood is contemplative and melancholy. The young male on the right sits with bowed head, while the woman resting near him angrily stares back toward the ground already traveled. A dog looks up at its master, as if to ask "what next?" Aware of sentiment in the East for pictures that constructed a romantic fade-out of Indian life, the American Art-Union offered to its subscribers prints of *Last of the Race* for distribution in 1847. . . .

Valentine Walter Bromley painted *Crow Indian Burial,* one of the most arresting images of the doomed Indian, in 1876, the year Custer was defeated at the Little Bighorn. . . .[20] Unlike many other images of Indian grave sites, this painting does not attempt to document a burial custom. Death as an element of melodramatic narrative is the subject. The wrapped body of the deceased rests on a tree branch in the upper-right corner of the painting. When compared to the grisly scene at the center of the composition, the human seems the easier death. A cadaver-like horse, using its last energy, strains at its lead to drink from a nearby stream. Either the horse will choke itself or die of thirst, a grim metaphor for the plight of western tribes. Bromley reinforces the symbolism with his representation in the background of an Indian village silhouetted against a lurid sunset. The body of the deceased points directly toward the village, indicating that not a single Indian has been buried but a whole tribe, a whole race.

The material for this painting was supposedly collected by Bromley, an English painter, during a six-month expedition through Colorado, Montana, and Wyoming territories in 1874. The trip had been financed by Windham Thomas Wyndham-Quin, fourth earl of Dunraven, an Irish adventurer wealthy enough to satisfy his desire to hunt in far-off places. Traveling with physician, cook, steward, and artist, Windham perceived the West as a rosy place for future investment. The earl and his company owned land in Estes Park, Colorado, where they planned to establish a hunting lodge, game preserve, and cattle ranch. For Bromley's patron, then, the paintings must have served a dual purpose: they lament the past and the demise of the Indian, but they simultaneously acknowledge that barbaric customs must give way to a more "productive" use of the land. . . .

At the turn of the twentieth century elaborate international exposi-tions—grand entertainments as well as advertisements of the country's developing industrialism—were organized to celebrate American culture. Painters and sculptors often contributed to these expositions images of the West that served as allegorical reminders of the nation's frontier past. James Earle Fraser modeled *End of the Trail* in the 1890s and enlarged it to monu-mental size for display at the Panama-Pacific Exposition of 1915 in San Fran-cisco. . . . The exposition marked the completion of the Panama Canal and a watershed in California history, separating the state's pioneer past from its future as a center for Pacific commerce. Fraser's sculpture is, in effect, a bow to the modern world. The profile of the despondent Indian and his tired horse describes a series of downward arcs that eloquently reinforce the mood of the piece. A symbolic wind whips the pony's tail and bends the rider's back. Body drained of energy, the Indian slumps lifelessly, his spear, once raised in war and the hunt, hangs downward, as if about to slip to the ground. Even the land beneath horse and man has been shrunk to provide but precarious footing. This particular formulation of the ill-fated Indian has projected a powerful stereotype through the twentieth century. It can be seen today on belt buckles, in advertisements and commercial prints, and, in perhaps its most ironical manifestation, on signs designating retirement communities.

White philanthropists held but one hope for the supposedly doomed Indian and that was acculturation (or assimilation, as it was called). It was presumed that to survive, the subordinate Indian culture must adopt the beliefs and habits of the dominant white culture. President Thomas Jefferson spoke to such a belief when in 1803 he wrote to Creek agent Colonel Benjamin Hawkins:

> In truth, the ultimate point of rest and happiness for them is to let our settle-ments and theirs meet and blend together, to intermix, and become one people. Incorporating themselves with us as citizens of the United States, this is what the natural progress of things will, of course, bring on, and it will be better to promote than to retard it.[21]

The acculturation movement sputtered along until the latter third of the nineteenth century, when a spirited alliance of government and religion attempted to enforce the so-called civilizing process. Christian philanthro-pists inside and outside government wished to lead Indian-white relations away from the sword and toward the Bible. Such tactics were initiated with President Ulysses S. Grant's Indian "peace policy." In his first annual message to Congress in 1869, Grant sought to reverse the policy based on war and removal: "A system which looks to the extinction of race is too horrible for a nation to adopt without entailing upon itself the wrath of all Christen-dom and engendering in the citizen a disregard for human life.[22] Grant also specified that religious leaders, rather than political appointees or military personnel, would now administer Indian policy. But the system that Grant

had in mind was still essentially paternalistic. Referring to the model of the Society of Friends among the Indians, he wrote, "I have attempted a new policy toward these wards of the nation (they can not be regarded in any other light than as wards), with fair results so far as tried."[23]

The next step in the acculturation process, the passage of the General Allotment (Dawes) Act in 1887, again raised hopes, for few comprehended how devastating the results would be. Well-meaning philanthropic organizations insisted on the overthrow of tribalism and communal organization.[24] As a result, reservations were broken up into 160-acre homesteads and distributed to individual families of each tribe. Indians became subject to white law, and Indian children were required to attend English-speaking schools provided by the government.[25] The philanthropic organizations "acted on the assumption that inside every Indian was a white American citizen and property holder waiting to be set free; the job of reform was to crack the shell of traditional tribal life and thus free the individual."[26]

One of few contemporary doubters of this scheme was Senator Henry Teller of Colorado. He and four delegates from the Cherokee and Choctaw tribes submitted to the Senate in 1881 a memorial that concluded: "This experiment has seductive allurements for visionary persons who have not carefully studied the subject, but is full of mischief for us."[27] Their conclusion was accurate: in 1887 Indians held 138 million acres; by 1934, when the Dawes Act was canceled, that number was reduced to 51 million acres.[28] And Indian culture suffered proportionately. Artist Ernest L. Blumenschein, in an 1899 issue of *Harper's Weekly,* sardonically portrays the future results of Grant's peace policy and the Dawes Act in *Wards of the Nation—Their First Vacation from School.* . . . White-sponsored schools, operating often at great distance from the reservations, had indeed separated Indians from their tribal heritage.

If acculturation came to an unhappy ending, it nevertheless was an attractive concept for some nineteenth-century patrons. Several early images present intermarriage as a means of intermingling races, although these are mostly limited to liaisons between white fur traders or trappers and Indian women. These relationships were commonly recognized as expedient, either because Indian women were the only women available or because they provided a useful link with their tribes. At one of the annual rendezvous of the fur traders, a notoriously bawdy and drunken event, a reluctant participant and lay missionary, William H. Gray, observed: "Today I was told . . . that Indian women are a lawful commerce among the men that resort to these mountains, . . . thus setting at defiance every principle of right, justice and humanity, and law of God and man."[29]

The Trapper's Bride, 1850, by Miller, may, in fact, be a chaste rendering of contemporary reports describing Indian women as "lawful commerce" among fur trappers. . . . In Miller's words, "the scene represents a Trapper taking a wife, or purchasing one. . . . He is seated with his friend to the left of

the sketch, his hand extended to his promised wife, supported by her father and accompanied by a chief, who holds the calumet, an article indispensable in all grand ceremonies."[30] The trapper wears garments made from animal hides, which are cut with an eastern flair. Adorned with beads, feathers, and bear-claw necklace, the chief wears more "primitive" dress. He sits astride a horse, which to nineteenth-century viewers might have seemed no more tamed than its owner. The Indian woman occupies a position between the two males, between white and Indian cultures. She appears shy but not pre-cisely demure; Miller describes her as "pensive" and "dreamy."[31] She stands barefoot, literally in touch with nature, dressed in yellow buckskin, which fairly glows with warmth. Other than her hand, the part of her anatomy clos-est to the trapper is her pelvis. She represents, in other words, a male fantasy, an encounter with the exotic other, the sort of liaison a white Victorian male might contemplate as a means of escaping a confining moral and social envi-ronment. Perhaps as proof of this appeal, *The Trapper's Bride* was Miller's best-selling image.[32]

The *Trapper's Bride* broached the suggestion of union, not only between races but between nature and civilization. The large tepee in the background defines the apex of a triangle embracing savage life, while the smaller trian-gle on the left, which includes the groom, a colleague, and an Indian with a peace pipe, represents the ameliorating effect of civilization, a subtheme of most pictures illustrated in this chapter. . . .

The White Man's Indian

The treaty existed as a form of negotiation with the Indians until the early 1870s, when Congress ceased to consider tribes as independent nations. . . .

Nahl painted the astonishing *Treaty with the Shoshone Indians in 1866* at the request of Caleb Lyon, both governor and superintendent of Indian affairs in Idaho. . . . Lyon had mediated a peace settlement with the western Shoshone and white settlers. The negotiations led to Indian cession of lands in southern Idaho in exchange for a reservation on the Bruneau River. The treaty was never ratified by Congress, but Lyon, who had moved to Califor-nia several months after the negotiations, commissioned Nahl to commemo-rate the event.[33]

Treaty with the Shoshone Indians was probably painted in the artist's San Francisco studio. In an effort to create an aura of authenticity Nahl drew on various sources. Photographs in common circulation provided models for the woman seated with two prairie dogs in the center foreground and for the man who stands with his hand on his hip to the left of the treaty table.[34] Nahl also included Indian artifacts, each accurate in themselves but not commonly used by the Shoshone. The woman standing along the left edge of the picture is dressed in a fiber-and-feather skirt of California origin; the Indian standing beside the minister wears a Northwest Coast woven cap; and three Pima bas-kets appear in the lower-right corner.[35]

Nahl's attempt to enhance the authority of the painting with anthropological details is continued in the formal strategy he adopts to represent whites and Indians. In the center of *Treaty with the Shoshone Indians* stands Dr. Hiram Hamilton, a minister, and Governor Lyon. The reverend and the governor, the latter patriotically dressed in red, white, and blue, are woodenly erect representatives of government authority. A military regiment, arranged in tight rows in the background, mimes the posture of the white officials. Between the two white men stands the treaty table, fancifully decorated with an American flag and a spray of peacock feathers. Below the table lies a mound of gifts for the Indians, including trade blankets, beads, peacock feathers, and copper and brass pots. A few of these pledges of good faith already appear on their recipients, since to the right of Lyon are presumably tribal leaders smoking a pipe of European origin and wearing a calico trade coat.

Once specific anthropological items are identified, the Shoshone who fill the foreground represent little more than popular stereotypes of western Indians. Nahl presents a naive, unruly, and licentious group. Indeed, as many interpreted the state of savagery, the Indians appear to represent the childhood of humanity. Surely Horace Greeley concurred when he wrote in 1859: "The Indians are children. Their arts, wars, treaties, alliances, habitations, crafts, properties, commerce, comforts, all belong to the very lowest and rudest ages of human existence."[36] If the Shoshone understood the consequences of the treaty, it is not apparent in Nahl's presentation. Whites and Indians hardly look at one another, each occupying a separate world.

Animals, both dead and alive, are scattered throughout the crowd of Indians. The mix of skins—raccoon, fox, and cougar—is a reminder of the barbaric yet exotic state of the tribe. The live animals—pairs of fawns, prairie dogs, prairie hens, and cubs—suggest fertility and represent gifts to the white negotiators. Adding to the "primitive" quality of the scene, bare-breasted women are conspicuous in the lower-left corner of the painting, two with children and one confronting the spectator in a bold, suggestive manner.

Nahl distinguishes between civilized and uncivilized peoples to imply the rightness of the treaty just concluded, which supposedly gives to whites land they know how to develop and takes from Indians resources they cannot use productively. The sentiments expressed in 1817 by President James Monroe in his first message to Congress continued to affect Americans long after Monroe's time: "The earth was given to mankind to support the greatest number of which it is capable, and no tribe or people have a right to withhold from the wants of others more than is necessary for their own support and comfort."[37]...

Real Indians never inhabited the paintings of white artists. Paintings in which Indians were represented were created to embody whites' attitudes about nature, the right of conquest, and the priorities of civilization. To

Mix-Ke-Mote-Skin-Na, **The Iron Horn Blackfoot Warrior.** (*The Smithsonian Institution*)

whites, Indians at odds with Anglo-Saxon culture, refusing to abandon tribal custom and become "productive" citizens, were either primitive, savage, or doomed. Over the nineteenth century Indians had been reduced to a few stereotypes or worse, as Alexander Pope suggests in *Weapons of War*, 1900. . . . In this image Indian culture no longer possesses even the myth of corporeal presence but has been reduced to an aesthetic arrangement of bric-a-brac devoid of function, impoverished of meaning, and displayed against yet another grid of white construction.

Notes

I am indebted to the Office of Professional Development, Northern Arizona University, Flagstaff, for research support toward completion of this essay.

1. Quoted in John F. McDermott, "The Art of Seth Eastman," in *Smithsonian Report for 1960* (Washington, D.C.: Smithsonian Institution, 1961), 584.
2. Limerick, *Legacy of Conquest*, 190.

3. A few major examples are earlier, like John Vanderlyn's *Death of Jane McCrea,* 1804 (Wadsworth Atheneum, Hartford), as well as a number of popular images.

4. Material drawn from Berkhofer, *White Man's Indian,* 72–80.

5. Cosentino, *King,* 63.

6. Quoted ibid., 66.

7. Quoted in Szasz, *Indian Education,* 8.

8. *Surround of Buffalo by Indians* is a later version of a scene Alfred Jacob Miller first conceived in the 1830s.

9. Quoted in Michael Bell, introduction to *Braves and Buffalo: Plains Indian Life in 1837* (Toronto: University of Toronto Press, 1973), 160.

10. J.D.B.S., "Wanderings in the Southwest," *Crayon,* 3, pt. 2 (February 1856): 40.

11. Quoted in Saum, *Fur Trader and Indian,* 95.

12. However George Catlin might criticize civilization and admire Indian life, his distance from primitive culture is suggested by the use of words such as "curious" and "strange" to describe the Mandan village. As Patricia Limerick has written, Catlin "enjoyed denouncing the vices of 'civilization,' but he was fully loyal to its virtues" (Limerick, *Legacy of Conquest,* 185).

13. Frederick W. Hodge, *Handbook of the American Indians North of Mexico* (Washington, D.C.: Smithsonian Institution, Bureau of Ethnology, 1907), 1:808.

14. Quoted in Thomas and Ronnefeldt, *People of the First Man,* 242.

15. Israel, *State of the Union Messages,* 1:334.

16. Rogin, *Fathers and Children,* 3–4.

17. Jennings, *Invasion of America* (1975 ed.), 146.

18. Illustrations, engravings, and chromolithographs after western paintings by Charles Deas, William Ranney, and Arthur F. Tait were widely known in the 1850s (see Amon Carter Museum, *American Frontier Life,* 51–77, 79–107, 109–29).

19. While in Düsseldorf, Carl Wimar gleaned frontier "experience" from a number of sources. *Attack of an Emigrant Train* was apparently inspired by an episode in *Impressions de voyages et aventures dans le Mexique, la Haute Californie, et les régions de l'or* (1851) by the French author Gabriel Ferry (see Rathbone, *Wimar,* 15–16).

20. Perhaps because the painting was commissioned by an English lord, it expresses sympathy for Indians at a time when Americans in general felt little.

21. Quoted in Drinnon, *Facing West,* 83.

22. Israel, *State of the Union Messages,* 2:1199–1200.

23. Ibid., 2:1199.

24. The ground for this act was laid in the early 1880s by various philanthropic associations formed with the intention of aiding the Indians. These groups included the Boston Indian Citizenship Committee, Indian Rights Association, Women's National Indian Association, and, most influential, Friends of the Indians.

25. Prucha, *Indians in American Society,* 23.

26. Limerick, *Legacy of Conquest,* 196.

27. "Senate Debate on Bill to Provide Lands in Severalty, January 20, 1881," in Wilcomb E. Washburn, comp., *The American Indian and the United States: A Documentary History* (New York: Random House, 1973), 3:1695.

28. Limerick, *Legacy of Conquest*, 198.

29. Quoted in Tyler, *Miller*, 31.

30. Quoted in Glanz, *How the West Was Drawn*, 37.

31. Tyler, *Miller*, 43.

32. Ibid., 57.

33. "Caleb Lyon's Bruneau Treaty, April 12, 1866," *Idaho Yesterdays* 13 (Spring 1969): 17–19, 32+. Appreciation is extended to Joan Carpenter, curator of exhibitions, Thomas Gilcrease Institute of American History and Art, for searching the Gilcrease files for information.

34. Appreciation is extended to Paula Fleming, National Anthropological Archives, Smithsonian Institution, for identifying photograph sources.

35. Appreciation is extended to William C. Sturtevant, William L. Merrill, and John C. Ewers, National Museum of Natural History, Smithsonian Institution, for information regarding the Indian tribes portrayed in *Treaty with the Shoshone Indians*.

36. Quoted in Rogin, *Fathers and Children*, 117.

37. Israel, *State of the Union Messages*, 1:152.

Chapter 16

Introduction
to Harlem Renaissance:
Art of Black America

Mary Schmidt Campbell

The Studio Museum in Harlem's exhibition *Harlem Renaissance: Art of Black America* adds a new chapter to the story of this hotly debated period in American cultural history. From 1919 to 1929, as the poet Langston Hughes wrote, "Harlem was in vogue." Black painters and sculptors joined their fellow poets, novelists, dramatists, and musicians in an artistic outpouring that established Harlem as the international capital of Black culture. Almost as soon as the Renaissance announced itself, however, the artistic merits of Black America's great cultural awakening came under sharp attack. Although scathing criticism greeted all of the participants, contemporary critics accused painters and sculptors, in particular, of cultural isolationism and hopeless conventionalism. . . .

Building on recent scholarship and exhibitions that have begun to examine carefully the oeuvres of individual Harlem Renaissance artists, The Studio Museum in Harlem has assembled for *Harlem Renaissance* a core of over one hundred works by a small but representative group of artists—sculptor Meta Warrick Fuller, painters Aaron Douglas, Palmer Hayden, and William H. Johnson, and photographer James Van Der Zee—in order to take an in-depth look at some of the most compelling images by artists whose work first came to prominence in Harlem during the 1920s. It was this period of intense creative activity by Black Americans that gave the artists an identifiable artistic context for their work, propelled them to the forefront of the New Negro Movement, and inspired their art for the remainder of their careers. . . .

The exhibition . . . seeks to restore some critical balance to the reputations of the Harlem Renaissance artists and to consider the urgent issues of cultural identity and social and political tensions so often implicit in their images. These tensions, which percolated beneath the carefree surface of the Jazz Age, were evident in the very manner in which the Harlem Renaissance artists were patronized, exhibited, and presented to the American public. What this exhibition makes painfully evident is that the Harlem Renaissance

artists were the victims of a segregated culture, a culture that separated its artists as emphatically as it segregated its public schools. For the most part, the artists were represented by a White philanthropy, The Harmon Foundation, which held national competitions exclusively for Black artists. After it halted its programs in the 1930s, private support for the artists virtually disappeared. . . .

Before the Harlem Renaissance, painting and sculpture were not professional options for Black Americans. Most Blacks lived in the South and were constrained by Jim Crow laws which disenfranchised Black citizens and separated them from Whites in virtually every aspect of public life. There was also the very real and very constant threat of violence. In the years after the turn of the century, the South witnessed the rising power of the Ku Klux Klan, the Knights of the White Camelia, and the White Citizens' Council, whose self-appointed role was to enforce the Jim Crow laws and mete out their own brand of vengeance when a transgression was perceived. Race riots and ceremonial executions by lynching occurred with alarming regularity. In such an environment, Black people were not encouraged to make fine art.

Yet, even as the South grew increasingly oppressive, an artistic fervor at the popular level, at least, took root. The separate traditions and circumstances of a segregated, largely agrarian, and oftentimes feudal existence cultivated an aesthetic spawned by the experience of slavery and seeded with the half-remembered fragments of an African past. In the grass-roots music, religion, and oral traditions of the Black South, a distinctive brand of American culture was flourishing. As the cultural identity of the Black American citizen emerged, so too did his sense of political and social hegemony. By the 1920s a "New Negro" had evolved, with a personality crystallized by two major events: World War I and the mass migration of Blacks from the South to the cities of the North. . . .

. . . The pursuit of a new life in the North gave rise to the concept and identity of the New Negro. In his classic anthology of the era, *The New Negro*, Alain Locke, the leading Black philosopher and cultural arbiter of the Harlem Renaissance, described the metamorphosis of migration as "shedding the old chrysalis of the Negro problem" and "achieving something like a spiritual emancipation."

The impact of the New Negro Movement was enormous. Politically, the decision to migrate in and of itself was an act of defiance against the social order and political constraints of the South, and a vote cast for the liberating possibilities of the North. The new sense of political activism was reflected in the massive shift in Black affiliation from the Republican to the Democratic party and in the increasing influence of Black organizations. The National Association for the Advancement of Colored People (NAACP) was founded in 1909 and dedicated to securing full civil and political rights for Black Americans. The Urban League was founded in 1910 with the goal of acclimating recent migrants to the rigors of urban life. Perhaps the most dramatic

evidence of the newfound sense of purpose and activism was the popularity of the Universal Negro Improvement Association (UNIA). Driven by the charismatic zeal of Marcus Garvey, a Jamaican who had migrated to New York, the Harlem-based UNIA captured the grass-roots sensibility of the New Negro in much the same way the civil rights movement under the visionary leadership of Martin Luther King, Jr., or the presidential bid of Jesse Jackson inspired hundreds of thousands of Black Americans. The UNIA's goals were romantically ennobling. The association planned to raise money to buy a ship and return Black Americans to Africa, the land of their origins. Garvey's movement, replete with an elaborate organizational hierarchy, parades, pageantry, uniforms, emblems, and other regalia, raised several hundred thousand dollars and actually purchased a steamship. More important, it symbolized the militant ethnic pride of the New Negro, the fervent belief in the beauty and nobility of an African homeland, and the deep cultural cleft between Black and White America.

If Garvey's movement was evidence of a breach between the races in the promised land of the North, art was the hope for a reconciliation. For intellectuals like Locke and W.E.B. Du Bois, a Harvard-educated historian and the brilliant editor of *The Crisis* magazine (the organ of the NAACP during the Renaissance), art could bridge the gap between the Black and the White worlds if only the Black artist was allowed the opportunity to hone his talents. Given his rich folk background, his African heritage, and his ethnic pride, the Black artist had an aesthetic and a message to impart. Art, the essence of the civilized man, would be final proof that the New Negro not only had something positive to contribute to American life but had, indeed, ascended to new cultural heights. Harlem, the center of the New Negro Movement and the capital of Black America during the 1920s, was naturally the center of the artistic movement as well.

America in the 1920s, however, made reconciliation elusive. On the one hand, the very positive notion of a Black vision of American life that drew upon the cultural wealth of Black folklore and interpreted the African past along with the realities of Black American history and the day-to-day experience of Black life did in fact engender images and stylistic approaches that were fresh and new. On the other hand, the separatism of American life, which required a separatist foundation to hold segregated exhibitions, the absence of repositories to collect and preserve the art, and the distortions of critics hostile to the very notion that Black people could make high art only served to widen rather than narrow the breach. Disappointingly, the legacy of the Harlem Renaissance has been a cultural separatism that to this day persistently lingers in the history of American art.

The principals in *Harlem Renaissance* represent the range of professional and creative options open to the Black artist in America during the 1920s. Meta Vaux Warrick Fuller (1877–1968), an elegantly Victorian, deeply spiritual sculptor, was one of the most important precursors of the Renaissance. She was trained at the Pennsylvania Museum and School for Industrial

Meta Warrick Fuller, **The Awakening of Ethiopia.** *ca. 1914, Bronze, 67 × 16 × 20". (Shomburg Center for Research in Black Culture, Art & Artifacts Division, The New York Public Library, Astor, Lenox, and Tilden Foundations)*

Arts and studied with Rodin in Paris at the turn of the century. When she returned to the United States, Meta Vaux Warrick married a Liberian physician, Dr. Solomon Fuller. Thereafter, she spent most of her career in Framingham, Massachusetts. . . . Inspired by W.E.B. Du Bois's Pan-Africanist philosophy, which emphasized Black Americans' common African heritage, her finest works, *Ethiopia Awakening* (1914) and her 1919 *Mary Turner* (*A Silent Protest Against Mob Violence*), are among the earliest examples of American art to reflect the formal exigencies of an aesthetic based on African sculpture. They are also important indictments of the prevailing political and social climate.

Relying more on an Egyptian rather than a West African sculptural concept, *Ethiopia Awakening,* with its condensed, simplified forms, looks like an ancient funerary statue. Fuller seemed to portray a woman awakening from the deep sleep of the past, but she tempered her romanticism with a very clear-eyed view of the contemporary condition of Black people in America. The years immediately following the war witnessed some of the worst violence toward Black citizens since the antebellum period. In July 1917, more than ten thousand Black citizens protested the obsessive violence, the mobs, the lynchings, and the sporadic, unpredictable outbursts against Blacks by marching down Fifth Avenue in New York City in a silent parade. The parade commemorated the lynching of Mary Turner, a Black woman from Valdosta, Georgia, who along with her husband and two other Black men had been accused of planning to murder a White man. Mary Turner's lynching, reported in the *New York Times* as well as in the Black press, had become a rallying point for the UNIA and had come to symbolize the lawlessness that threatened Black life. Impressed by the account she read of the parade in *The Crisis* magazine, Fuller memorialized the awakening defiance of her people in her sculpture of 1919. Considerably more classical than *Ethiopia Awakening,* *Mary Turner* is, nonetheless, a poignant portrayal of a woman struggling to define and free herself. . . .

Painter Aaron Douglas (1899–1979) was perhaps the most well known of Harlem's visual artists in the 1920s. He came to New York in 1924, shortly after graduating from the University of Nebraska. In Harlem, Douglas quickly developed a highly stylized aesthetic, characterized by spatially compressed compositions and chromatically subdued forms. Soon after the young painter came to New York, he had the good fortune to meet the Philadelphia collector Albert Barnes. Barnes, a contributor to Alain Locke's *The New Negro* and a White patron and supporter of Black artists, permitted Douglas to see his outstanding collection of West African sculpture as well as his superlative modern European paintings. Ironically, at a time when most of the American art establishment was experiencing ambivalence toward modernism and the influence of so-called primitivism, Douglas had access not only to the very best examples of African sculpture, but also to its influence in the paintings of such masters as Gauguin, Picasso, and Matisse. Strongly influenced by the modernists' shallow depth of field, the monochromism of Analytic Cubism, and the extreme simplifications and stylizations of African sculpture, Douglas developed a style for his paintings and illustrations that came to be regarded as the prototypical visual expression of the Harlem Renaissance.

Indeed, the illustrations gave the young artist wide visibility. His work appeared on the pages of *Opportunity* and *The Crisis,* the magazines of the Urban League and the NAACP, respectively; in such fashionable periodicals as *Harper's* and *Vanity Fair;* and in James Weldon Johnson's popular book of Black sermons, *God's Trombones: Seven Negro Sermons in Verse.* The culmina-

tion of Douglas's art, however, came several years after the Harlem era. In 1934, during the Depression, he completed a monumental mural series entitled *Aspects of Negro Life*. Four large panels document the emergence of a Black American identity. The series begins with a rather stereotypical portrait of life on the African continent, complete with tribal music and drums. The two middle panels depict slavery and emancipation in America, the rebuilding of the South, the birth of Jim Crow laws, and the flight of Blacks to the cities of the North. The final panel returns to the theme of music, as a jazz musician, saxophone in hand, stands atop the cog of a wheel. Although Douglas's mural has the lean contours of the Precisionists, unlike Demuth or Sheeler he does not celebrate the strength and efficiency of the industrial landscape; rather, his vision of an American machine age concentrates on the intrinsic tension between individual freedom and the grinding routine of the machine. . . .

. . . *Aspects of Negro Life,* originally mounted in the 135th Street branch of The New York Public Library (now The Schomburg Center), had a dramatic influence on the next generation of Black artists. The grand scale of the murals, the unique blend of history, religion, myth, politics, and social issues in a stylistically daring, epic framework made a lasting impression on young Harlem artists of the 1930s such as Jacob Lawrence and Romare Bearden. . . .

The deep, almost spiritual kinship which both Meta Fuller and Aaron Douglas felt for their African heritage was but one hallmark of the Harlem Renaissance artist. An alternative approach was a newfound attentiveness to Black American life, legends, and folk heroes. Palmer Hayden (1890–1973), a World War I veteran who supported his painting career in the 1920s with menial jobs, was one of the first painters to offer a candid, if somewhat controversial, interpretation of Black life. Like Langston Hughes's poetry, his canvases often portrayed Harlem street life or recounted the customs and lore of the small-town folks from his native Virginia and from West Virginia, where he worked on the railroad before going to war. Hayden was eventually sponsored by a wealthy White patron who financed a trip to Paris in 1927. The following year, he showed at the Bernheim-Jeune Gallery, an important outpost of Paris's modern artists. . . .

Hayden was often criticized for lapsing into a portrayal of Blacks that seemed to be rooted in cultural stereotypes. Late in his career, he became extremely sensitive to this kind of criticism of his work, and his paintings from the 1940s and 1950s depict Black people in a much more sympathetic manner. One particularly striking example of Hayden's sensitivity to his critics was his decision to repaint *The Janitor Who Paints,* a major work now in the collection of the National Museum of American Art. Originally painted in 1939, the painting in its current state pictures a Black man wearing a beret with a brush and a palette in his hand, sitting in front of an easel. The subject of his painting within the painting is a beautiful young Black woman holding a child. Their apartment is modestly furnished, with a delightful little

Palmer Hayden,
**The Janitor Who
Paints.** *1939, Oil
on canvas.* (*Art
Resource, NY*)

painting on the wall of a cat curled up in a ball. The painting is suffused with domesticity, the earnest efforts of the janitor, and a charming, almost sweet naiveté. An earlier version of this painting, however, which is clearly visible in a recent X-ray scanning of the painting performed by the National Museum of American Art, shows quite another point of view of the aspiring janitor. In the earlier version, the janitor looks like a caricature of a Black person, a grinning monkey with fleshy lips and a head that has been distorted into a bulletlike shape. In place of the beautiful Black woman and her lovely newborn are a minstrel-faced mammy and a grinnin' child. On the wall hangs a portrait of Abraham Lincoln, a reminder that Lincoln and the Republicans were still the great liberators in the South. . . . Hayden's deliberately self-effacing interpretation of his efforts as an artist, his insistence on portraying Blacks with the masks of the minstrels—that is, as performers for a White audience—and his ingratiating reference to the benevolence of his liberators, are probably honest, if not particularly ennobling, portrayals of Hayden's very real feelings about his efforts as making art. . . . It is to Hayden's credit

that his later genre scenes are sensitive records of the small, day-to-day social rituals that prevailed in urban communities. Similarly, his scenes based on Black folklore are sensitive documents of the oral tradition that framed his past. . . .

William H. Johnson (1901–1970), a handsome adventurer from Florence, South Carolina, began his career as an academic painter. As his art matured, however, he shed his learned realism for a deliberate primitivism. Johnson studied at the National Academy of Design in New York and was invited to assist the painter George Luks in Provincetown. Yet, like Hayden and so many other Black artists of the 1920s, Johnson left the United States in 1926 to seek his fortune in Europe. His travels brought him into contact with the art of Vincent van Gogh, Edvard Munch, and Chaim Soutine whose intensely expressive, angst-ridden paintings deeply moved the young artist. Johnson's early paintings, skillful, realistic tableaux, done in somber tones, were now followed by bright, dramatically simplified scenes of religious subjects and Black life. Johnson's self-enforced primitivism puzzled many Harlem Renaissance observers: but it was a style that allowed him to express the deeply felt emotions inherent in the scenes he conveyed. . . .

James Van Der Zee (1886–1983) was a popular Harlem photographer with a Lenox Avenue studio where New Negroes came to document the important rites and ceremonies of their lives. With his camera, Van Der Zee was able to bear witness to Harlem's weddings, funerals, and parades, as well as its bridge clubs, fraternities, school groups, and church organizations. He photographed Harlem's sights: famed patron A'Lelia Walker's Dark Tower, a chic salon for artists and socialites; the Reverend Adam Clayton Powell, Sr.'s Abyssinian Baptist Church; the elaborate, complex ceremonies of Marcus Garvey's UNIA; or the Theresa Hotel, which, in the days of segregated residences, was one of the country's finest Black hostelries. Above all, he captured the extraordinary sense of self-esteem, style, and optimism that was Harlem in the 1920s. Van Der Zee's Harlem was the site where the modern Black identity was born, where the New Negro forged an urban personality.

The Black urban immigrants needed a means of legitimizing their newfound identity in the city. In New York, Van Der Zee's photographs served that purpose. . . . His studio portraits are identifiable by a few carefully composed sets, which were meant to represent an orderly bourgeois life. . . . Sartorially, his subjects are impeccable. All of them, men, women, and children, wear the most stylish clothes, made from the most luxurious fabrics and tailored with the most intricate detailing. . . . In fact, Van Der Zee touched up imperfections, straightened teeth, sketched a few extra pieces of jewelry, smoothed out skin color—whatever was necessary to make his clients fit the New Negro mold. . . . The image of the Harlem Renaissance, captured by Van Der Zee's photographs, was partially real pride and partially carefully constructed artifice. . . .

James Van Der Zee,
The Van Der Zee
Men. *c. 1909,*
Photograph.
(Copyright ©
Donna M.
Van Der Zee. All
rights reserved)

The principal spokesman for the Black artist during the 1920s was the scholar Alain Locke. Locke, an urbane, Harvard-educated philosopher and Howard University professor, articulated an innovative aesthetic theory which called for the Black artist to acknowledge his African heritage. In 1925, Locke wrote "The Legacy of the Ancestral Arts," a classic essay in which he maintained that if the Black American were to lay claim to the rich African sculptural tradition which, he noted, was already a potent force in the evolution of European modernism, he would have the power to create an art that would add a new dimension to Black America's cultural identity. Locke's arguments appeared in his 1925 anthology of Harlem Renaissance writers, *The New Negro,* a collection of short stories, essays, and poems of the era with illustrations by the German artist Winold Reiss, as well as woodcuts by Aaron Douglas. Douglas's stylized tableaux, patterned after African designs, suggested the possibilities for Locke's ideas of an authentic African American aesthetic. Locke, the author of what would become a hotly debated theory of Black art, was also one of the chief architects of a controversial system of

patronage, a system designed to make Harlem the center of Black art in America.

To give substance to his philosophical goals, the resourceful philosopher persuaded a wealthy White real-estate magnate and philanthropist, William Harmon, to sponsor an annual national competition, exhibition, and award program for Black artists under the auspices of The Harmon Foundation. The foundation, originally organized in 1922 to "assist in the development of a greater economic security for the [Black] race," inaugurated in 1926 the first achievement awards for Black Americans in literature and in the visual arts. When the call for entries went out nationally in the Black press, however, only nineteen visual artists responded. . . . By 1933, the last year of the competition, over four hundred entries were exhibited at the International House on Riverside Drive in New York, where the annual show was held.

. . . Under the auspices of The Harmon Foundation, the Black artist emerged for the first time in great numbers. Indeed, Harlem, spiritual home to the New Negro, became home to the Black artist as well. In the strictest sense of the word, however, these artists by no means constituted a movement. They never organized formally as a group, in contrast to both the next generation of Black artists supported by the Works Project Administration (WPA) and the artists of the civil rights movement, who were compelled to unite by the urgency of political and social events. Although some of the artists were cognizant of Locke's aesthetic and as a group did in fact celebrate their ancestral connections with Africa, they did not openly subscribe to one theory of Black art or, for that matter, to any one aesthetic point of view. Nonetheless, the annual competition, the accompanying exhibition in Harlem which was circulated to major cities, and the ancillary shows of individual artists in local civic organizations did create a loose amalgam of Black artists which previously did not exist.

Yet even as Black artists made their debut on the American cultural stage, critics—Black and White—excoriated their efforts. Supporters like W.E.B. Du Bois and Alain Locke expressed reservations about the conservatism and conventionalism of most Black artists. Misguided White critics such as Albert Barnes, a strong supporter of young Black artists, wrote in Locke's *The New Negro:* "That there should have developed a distinctively Negro art in America was natural and inevitable. A primitive race, transported into an Anglo-Saxon environment and held in subjection to that fundamentally alien influence, was bound to undergo the soul-stirring experiences which always find their expression in great art." Such well-meaning comments only contributed to a patronizing misinterpretation of the Harlem Renaissance. Other White critics were deliberately harsh. On the occasion of one of The Harmon Foundation's traveling exhibitions, a reviewer for the *New York American* referred to the artists as so "peculiarly backward, indeed so inept as to suggest that painting and sculpture are to them alien channels of expression."

The Harmon Foundation itself promoted a set of questionable attitudes. In organizing its segregated exhibitions, the foundation published catalogues in which it was argued that there were "inherent Negro traits"—a point of view that was condescending at the very least. The repertoire of Negro characteristics included "natural rhythm," "optimism," "humor," and "simplicity." And in linking the Black artist to Africa, the foundation was less concerned with the nobility of the African heritage than with the African personality as evidence of a natural primitivism that has "deeply rooted capacities and instincts capable of being translated into vital art forms.". . .

The most scathing criticism, however, came from fellow Black writers and artists. The novelist Wallace Thurman referred to all of the principals of the Renaissance—visual artists and literary artists alike—as a "motley ensemble without cultural bonds." In his 1932 roman à clef, *Infants of the Spring,* a bitter satire of the Harlem Renaissance, he pictured the one Black visual artist as a self-destructive effete. Even more stinging chastisement came from the young Romare Bearden. About to embark on a career as a painter, Bearden wrote a commentary on the Harlem Renaissance artists in a 1934 essay entitled "The Negro Artist and Modern Art," which appeared in *Opportunity* magazine: "Their work is at best hackneyed and uninspired and is only a rehashing of the work of any artist who may have influenced them. They have looked at nothing with their own eyes—seemingly content to use borrowed forms. They have evolved nothing original or mature like the spiritual or jazz music." He counted among the reasons for these shortcomings the absence of a critical standard, the intervention of philanthropic societies like The Harmon Foundation, and the absence of ideology or social philosophy in their work. By the mid-1930s, the reputations of the Harlem Renaissance artists had plummeted.

Thurman's point of view was echoed by many during the Renaissance who saw Black American culture as essentially no different from American culture in general. The famous exchange between the poet Langston Hughes and the editor George Schuyler in the pages of *The Nation* magazine in 1926 exemplified the debate. In his essay "The Negro Art Hokum" of June 1926, Schuyler argued that it was a farce to pretend that Black people were any different from other Americans and that all talk of a cultural Renaissance based on a separate culture was a hoax. Hughes responded the following week with "The Negro Artist and the Racial Mountain," in which he argued that there was a Negro soul, separate and distinct, molded by the special experience and heritage of Black people. The debate continues in more recent studies of the period. Nathan Huggins, in his outstanding and controversial study of the era, *Harlem Renaissance* (1971), built a substantive case against the Renaissance, calling it a "historical fiction."

. . . Thus, fifty years after the Harlem Renaissance the artists, falsely saddled with an aesthetic now considered obsolete, isolated by a segregated

patronage system, and critically dismissed, had virtually disappeared from American cultural history.

. . . What is perhaps most perturbing about . . . these critical assessments . . . is the fact that the Harlem Renaissance artists are rarely, if ever, discussed within the context of the crucible of ideas that was Harlem in the 1920s and 1930s. . . .

Furthermore, the images are not discussed within the context of American art of the 1920s and 1930s, which was emphatically conventional. Even after the Armory Show attempted to introduce modern European artists to America in 1913, a strong nationalistic flavor was laced throughout American imagery of the 1920s. Although there was no mainstream, no dominant style or approach to art to speak of, as there would be after World War II, portrayal of the American character was a primary concern throughout the artistic community. Whether it was the boosterism of regionalists like Thomas Hart Benton, Grant Wood, or John Steuart Curry, the more somber critiques of the American life-style in the paintings of Edward Hopper or Charles Burchfield, or the appreciation of industrial landscapes in the paintings of Charles Demuth or Charles Sheeler, the identity and expression of the American character was the leitmotif. . . .

The search for visual images—hewn from memory, experience, and history—that convey a Black American identity is the achievement of the Harlem Renaissance artists. In many ways the images of these artists created a watershed: before the 1920s Black painters such as Henry O. Tanner and Edward Bannister and the sculptor Edmonia Lewis rarely portrayed the day-to-day realities of Black life. The Black community, when it appeared in American art, was most often represented in the works of White American artists. Winslow Homer, Eastman Johnson, and Thomas Eakins made use of aspects of Black life for their own aesthetic and iconographic purposes. Eastman Johnson's *My Old Kentucky Home* (1859), for example, is part of a pictorial tradition that defines slavery as a bucolic existence. The enlightened noblesse oblige of the former slave owner and the dignified humility of the former slaves in Homer's *A Visit from the Old Mistress* (1876) are not images which Black American artists had any part in creating. Often iconographically complex narratives, these images contrast sharply with the simplicity and directness of the images of Harlem Renaissance artists. Their work has the look of something new, something raw and deliberate, a tradition freshly crafted and conceived. If they contributed anything, they contributed the sense that for the first time the Black artist could take control of the images of Black America.

Chapter 17

Naming

Lucy R. Lippard

So where we are now is that a whole country of people believe I'm a "nigger,"
and I *don't*, and the battle's on! Because if I am not what I've been told I am, then
it means that you're not what you thought *you* were *either!* And that is the crisis.
James Baldwin[1]

For better or worse, social existence is predicated on names. Names and
labels are at once the most private and most public words in the life of an
individual or a group. For all their apparent permanence, they are suscepti-
ble to the winds of both personal and political change. Naming is the active
tense of identity, the outward aspect of the self-representation process,
acknowledging all the circumstances through which it must elbow its way.
A person of a certain age can say wryly, "I was born colored, raised a Negro,
became a Black or an Afro-American, and now I'm an African American or
a person of color,"[2] or, "I was born a redskin, raised an Indian, and now I'm
a Native American, an indigenous person, a 'skin,' or the citizen of an Indian
nation."[3] Each one of these names had and has historical significance; each
is applied from outside or inside according to paternalistic, parental, or per-
sonal experience. . . .

Three kinds of naming operate culturally through both word and
image. The first is self-naming, the definition one gives oneself and one's
community, reflected in the arts by autobiography and statements of racial
pride. The second is the supposedly neutral label imposed from outside,
which may include implicitly negative stereotyping and is often inseparable
from the third—explicit racist namecalling.

Cultural pride is a precious commodity when it has survived genera-
tions of social undermining. Yet it also opens rifts no one wants to consider
long enough to change. It is easier to think of all Americans moving toward
whiteness and the ultimate shelter of the Judeo-Christian umbrella than to
acknowledge the true diversity of this society. Too often, self-naming must
battle the self-loathing created by the larger society, not to mention suspicion
and prejudice between cultural groups.[4] Such internal struggles may be
buried deep in a work of art, invisible except when inferred through style and
approach. . . .

From *Mixed Blessings: New Art in a Multicultural America* by Lucy R. Lippard. Copyright © 2000
by The New Press. Reprinted by permission of the author.

I write this at a moment in the late '80s when solidarity and coalition-building among the various ethnic groups is a priority. As cross-cultural activity becomes a reality within ethnic categories that appear homogenized only from the outside, it is occurring in both the political *and* the esthetic realms. The project of understanding the intercultural process is perhaps evenly divided between understanding differences and samenesses. Every ethnic group insists, usually to deaf ears, on the diversity within their own ethnicity, stressing the impossibility of any one individual or group speaking for all the others.

We have not yet developed a theory of multiplicity that is neither assimilative nor separative—one that is, above all, relational. In the '70s cultural identity in "high art" was largely suffocated in the downy pillow of a "pluralism" in which the SoHo galleries resembled network television—lots of channels, all showing more or less the same thing and controlled by the same people. The intercultural enterprise is riddled with sociological complexities that must be dealt with before esthetic issues are even broached. There are classes and cultures within cultures, not to mention the infinite individual diversities that disprove both external stereotypes and group self-naming alike. At the same time, the alienation that rides on individualism in this country is unenviable, and an individual "identity" forged without relation to anyone or anything else hardly deserves the name. I have to agree with Elaine Kim when she insists, "Without the reconciliation of the self to the community, we cannot invent ourselves."[5] Art speaks for itself only when the artist is able to speak for her- or himself, but the support of a sensed or concrete community is not easy to come by. Much of the art reproduced in this book exposes the vulnerable point where an inner vision of self collides with stereotypes and other socially constructed representations.

In order to confirm identity in the face of ignorance or bigotry, a name may have to be changed, or even *be changing*. In some cultures a person has a secret name, a nickname, a public name, and/or a name given or earned later in life or on coming of age. In the United States, Native Americans may have an Anglo name and an Indian name in addition to their own inherited and given names; the Indian name may be translated into English and acquired in different ways, according to different tribes and different individual experiences. A name may be received in a vision, conferred by an elder, or taken from an ancestor. (Vine Deloria, Jr., has pointed out that there is nothing "personal" about a name like George Washington, which primarily refers to a genetic line.)[6] Latino and Asian immigrants may anglicize their given names as a gesture toward their new identities as North Americans; African Americans may rename themselves not into but out of the dominant culture by taking a new African or Islamic name, attempting to bypass the history of slavery, just as some women, by renaming themselves after places or within a female line, have attempted to bypass the history of the patriarchy. . . .

The most pervasive and arguably most insidious term artists of color must challenge is "primitivism." It has been used historically to separate the supposedly sophisticated civilized "high" art of the West from the equally sophisticated civilized art it has pillaged from other cultures. The term locates the latter in the past—usually the distant past--and in an early stage of "development," implying simplicity on the positive side and crudity or barbarism on the negative. As James Clifford has written, the notion of the primitive in Western culture is "an incoherent cluster of qualities that at different times have been used to construct a source, origin, or alter ego confirming some new 'discovery' within the territory of the Western self," assuming "a primitive world in need of preservation, redemption and representation."[7]

I should not even have to touch upon this anthropological problem in a book devoted to the contemporary art of my peers, but the Western concept of primitivism denigrates traditions with which many contemporary artists identify and fortify themselves. The term "primitive" is also used to separate by class, as in "minor," "low," "folk," or "amateur" art—distinguished from the "fine," "high," or "professional" art that may in fact be imitating it. There is an inference that such work is "crude" or "uncooked," the product of "outsiders."[8] "Primitives" are those who "naively" disregard the dictates of the market and make art for the pure joy of doing so. In fact, much "primitive" art is either religious or political, whether it is from Africa or from today's rural or urban ghettos. It is not always the quaint and harmless genre, the ideological captive, pictured in the artworld.

And yet, as Jerome Rothenberg has pointed out, "primitive means complex."[9] The West has historically turned to the Third World for transfusions of energy and belief. In less than a century, the avant-garde has run through some five centuries of Western art history and millennia of other cultures with such a strip-mining approach that it has begun to look as though there were no "new" veins to tap. Where the Cubists appropriated the *forms* of traditional cultures and the Surrealists used their dreamlike *images* to fantasize from, many artists in the '70s became educated about and fascinated with the *meanings* of unfamiliar religions and cultures. The very existence of the international mini-movement called "primitivism" constituted an admission that Western modernism once again needed "new blood." In the '80s the overt rampage through other cultures was replaced by postmodernist "appropriation" (reemploying and rearranging borrowed or stolen "readymade" images from art and media sources)—a strategy warmed over from '60s Conceptual Art and often provocatively retheorized. Some of this work is intended to expose as well as to revise the social mechanisms of image cannibalism. The "appropriation" of anything from anywhere is condoned as a "critical" strategy. Yet as Lowery Stokes Sims has pointed out, such "visual plagiarism" has its limits, especially when it reaches out into other cultures "in which this intellectual preciosity has no frame of reference. . . . Appropriation may be, when all is said and done, voyeurism at its most blatant."[10]

There are more constructive ways of seeing the "primitive." Cuban art critic Gerardo Mosquera has pointed out that "for Latin Americans, the 'primitive' is as much *ours* as the 'contemporary,' since *our* 'primitivism' . . . is not archeological material, but an active presence capable of contributing to *our* contemporary world."[11] Judith McWillie, a white scholar of black Atlantic art, has pointed out that the art of self-educated black artists closely paralleled the works of early modernists. . . .

A name less obviously irritating than "primitive" for the creations of people of color and "foreign" whites is "ethnic art." Although it was originally coined with good intentions and some internal impetus, it has since been more coldly scrutinized as a form of social control that limits people's creative abilities to their culture's traditional accomplishments; both Left and Right have been accused of harboring this "separate but equal" agenda of "ethnic determinism."[12] There are categories and contexts where "ethnic" artists are supposed to go and stay, such as folk art and agitprop, community arts centers, ghetto galleries and alternative spaces. The Los Angeles artist Gronk, whose zany expressionist paintings and performances fit no Chicano stereotypes, says, "If [well-known white artist] Jon Borofsky makes a wall painting, it's called an installation. If I do one, it's called a mural, because I'm *supposed to be* making murals in an economically deprived neighborhood."[13]

The National Endowment for the Arts has a program called "Expansion Arts," which uses its "community-oriented" mandate to fund art that can't get past the mainstream-oriented panels in other granting categories. (The "Art in Public Places" program also sometimes tries to integrate such projects.) In the United Kingdom and Australia, community arts is a respected domain into which "high" artists can cross while still showing their studio art in the artworld. In the United States, however, there are few such "crossovers" and most of them are white. The short-lived rages for graffiti art in the '70s and again in the '80s demonstrated clearly that the time had come for only a handful of black and Latino artists to move—temporarily—from subways and streets into galleries and museums. . . .

At the very least the "ethnic arts" have often provided a base for self-naming among artists who prefer not to leave their own communities or have, for ideological reasons, turned their backs on the "centers." At their best ethnic arts programs and "specialized" museums like San Francisco's or Chicago's Mexican Museums or New York's Studio Museum in Harlem open channels to new audiences, to an exchange between artists and their communities; they offer parallels to the shelter afforded (mostly) white artists by the national network of "alternative spaces," but with a far lesser degree of economic independence. Yet despite, or because of, their success, they are accused of "ghettoizing" the artists they exhibit. There is, however, no question that culturally targeted funding encourages self-determination and has on occasion provided arenas where truly "multicultural" interaction can take place. The interfaces within even a single racial community may be intricate,

providing a linguistic and cultural microcosm of the larger society. African-Americans, for instance—involuntary early settlers of the United States and for two centuries more homogeneous than other "minorities"—now find their ranks swelled with African peoples from Brazil, Colombia, Central America, Cuba, Haiti and other Caribbean islands, who speak Portuguese, French, Spanish, patois, or West Indian English.

For young artists yearning to have their art freed from labels and seen extraculturally (especially those working in abstract modes), contradictions within ethnicity can be baffling on two levels. First, they will encounter people who insist, and may even believe, that color makes no difference, even as artists of color are systematically excluded from galleries and exhibitions. Then they will encounter others, like me, who have sadly observed that within a racist society you will be called on your race no matter how much you try to avoid it, so you might as well stand up and be counted. The question remains whether there is a conflict between recognition of one's full potential as a human being and entrance into the mainstream where that potential may be swept away in the general flow. . . .

Visual artists are conscious, and unconscious, agents of mass dreams, allowing forbidden or forgotten images to surface, reinforcing aspects of identity that provide pride and self-esteem, countering the malignant imprint of socially imposed inferiority. As namers, artists participate in an ongoing process of call and response, acting in the space between the self- or individual portrait and the cluster of characteristics that supposedly define a community. In the expansion from one to many, from the mirror to its frame, visual images play an increasingly important role. Just as dreams may precede or parallel reality, images often precede texts, and elusive self-images can precede new names, though they are rarely understood at the time they appear. Visual images can also offer positive vision to those whose mirrors are clouded by social disenfranchisement or personal disempowerment. The naming process involves not only the invention of a new self, but of the language that creates the context for that self—a new world.

Yolanda López, a Chicana artist from San Francisco who is education director for the Mission Cultural Center, has concentrated for more than a decade on the positive and negative aspects of images of Mexicans on both sides of the border. . . . She deconstructs some of the most familiar stereotypes in a half-hour videotape called *When You Think of Mexico*. Two narrators, male and female, comment with humor and indignation on the Mexicans in advertising, the media, and Hollywood films. The images range from Frito Banditos (which imply that Mexicans—and revolutionaries in general—are, among other things, out to rob "us"), to the "picturesque and nonthreatening" lazy Mexican asleep under an oversized sombrero and a cactus, to religious symbols borrowed to sell food ("one bite and you'll be speaking Spanish"), to skewed versions of Mexican masculinity (a rooster) and femininity ("the hot little Latin"). The narrator says of "the new Mexi-

can Aunt Jemima" on a corn flakes box that there are some Chicanas who wear their hair parted in the middle or hoop earrings or peasant blouses— "but *all at once?*"

In another section, analysis is focused on the 1956 *Giant,* a self-consciously pioneering movie that offered unprecedented if paternalistic respect to Mexican Americans and looked relatively calmly on interracial marriage. At the film's end a shot of the two grandchildren—one white, one brown—is superseded by a shot of a white lamb and a black kid (goat), demonstrating, says López, that "we are still seen as different species."

Intent on teaching Chicanos to look critically at the way they are represented and controlled, López declares "We have to be visually literate. It's a survival skill." Her prime subject has been the ubiquitous "Brown Virgin" of Guadalupe. López deconstructs her idealization in the Mexican community, scrapes off the Christian veneer, and transforms "La Lupita" into a modern indigenous image echoing pre-Conquest culture. . . . "Why," she asks, "is the Guadalupe always so young, like media heroines? Why doesn't she look like an Indian instead of a Mediterranean . . .?"[14]

At the same time, López perceives the Guadalupe as an instrument of social control and oppression of women and Indians. She points out that the Church first tried to supress the "Indian Virgin" and only accepted her when her effectiveness as a Christianizing agent became clear. The Virgin of Guadalupe was the Americas' first syncretic figure, a compromise that worked. She became the pan-Mexican icon of motherhood and *mestizaje,* a transitional figure who emerged only fifteen years after the Conquest as the Christianized incarnation of the Aztec earth and fertility goddess Tonantzin and heiress to Coatlicue, the "Lady of the Snaky Skirt," in her role as blender of dualities. The Guadalupe is a unifying symbol of Mexican "mystical nationalism" equally important to Indians, mestizos, and *criollos* (American-born Spaniards), fusing indigenous spiritual concepts of the earth as mother with "criollo notions of liberty, fraternity, and equality, some of which were borrowed from the atheistical French thinkers of the revolutionary period," and a symbol of the "power of the weak."[15] More recently, La Lupita has become a Chicana heroine, representing, with Mexican artist Frida Kahlo, the female force paralleling male heroes like Emiliano Zapata and Diego Rivera.

Discovering one's own difference from the so-called norm—on TV, in schoolbooks, movies, and all the other social mirrors—can be a wrenching but illuminating experience. . . .

Adrian Piper is a black woman who often involuntarily passes for white. A daring performance artist and a Harvard-educated philosophy professor, Piper addresses her multiple identities directly, charging her art with a unique intensity. In fifth grade Piper's poise was such that a hostile teacher asked her mother, "Does she know she's colored?" In the '60s, when she was in art school, a professor asked a friend of Piper's, "Is she black? She's so aggressive." In recent years, because she not only acknowledges but flaunts

and insists upon her racial heritage, Piper has been accused of masochism, of purveying bourgeois guilt by "passing for black" when she could pass for white. She considers unthinkable the alternative: to deny the sufferings of her family and of African Americans in general. Finding herself in the curious position of being able to "misrepresent herself," Piper writes:

> Blacks like me are unwilling observers of the forms racism takes when racists believe there are no blacks present. Sometimes what we observe hurts so much we want to disappear, disembody, disinherit ourselves from our blackness. Our experiences in this society manifest themselves in neuroses, demoralization, anger, and in art.[16]

As an artist, Piper has concocted a number of complex devices to let people know that she knows who she is. Her use of masks or disguises is as complex as her analysis of her situation. In her "Catalysis" pieces, performed in the streets and public places in the early '70s, Piper "mutilated" and "barbarized" her image as an attractive young woman (by wearing vile-smelling clothes and performing bizarre, nonviolent but antisocial acts) to mirror in repulsive exaggeration how the Other is perceived. By simultaneously emphasizing her difference and dissolving the usual means of communication between herself and a viewer of her art, she discovered a destabilizing strategy, a way of subverting social behavior to make it reflect upon itself.

For several years in the mid-70s, Piper assumed an alter ego, the "Mythic Being," who also appeared in public and in poster pieces. A slight young man in shades, Afro, and a pencil mustache, he permitted Piper to experience a cross-sexual, androgynous identity, as well as to become the black or Latino street kid she could never fully transform into as a teenager. The Mythic Being was often hostile or threatening. He offered his creator a way of being both self and other, of escaping or exorcising her past and permitting her to re-form herself.

In the Mythic Being pieces Piper emerged in "blackface." In her concurrent performance pieces, however, she was made up in whiteface, as well as in a curious kind of drag, with long flowing hair and sensuously female dance movements unbalanced by a pencil mustache, a vestige of the Mythic Being's street persona. Piper's work since the early '70s may have provided the model for Cindy Sherman's shifting personae, which, detached from the anger about racism that fuels Piper's art, became a fashionable (and perceptive) individual exploration with full theoretical potential for both feminism and the mainstream.

In the autobiographical *Three Political Self-Portraits* of the late '70s, Piper made mass-produceable posters with long narrative overlays in which she detailed her experiences of conflicts in the categories of gender, race, and class. She recalls being called "paleface" by her neighbors in Harlem and "colored" at the private school she attended on scholarship. In the 1980 *Self-Portrait Exaggerating My Negroid Features*, Piper tried to embody "the racist's

nightmare, the obscenity of miscegenation, the reminder that segregation has never been a fully functional concept, that sexual desire penetrates the social and racial barriers, and reproduces itself."[17] In all of her work, Piper enacts, as Homi Bhabha has said of Frantz Fanon's achievement in his classic *Black Skin, White Masks:* "the intricate irony of turning the European existentialist and psychoanalytic traditions to face the history of the Negro that they had never contemplated."[18]

As the internal search intensifies for names to counter anachronistic impositions, names that will reflect and reinforce the difficult coalitions being forged among Asian, African, Latino, Native, and European Americans, it becomes clear that ethnicity itself, as Michael M. J. Fischer has pointed out, is

> something reinvented and reinterpreted in each generation by each individual and it's often something quite puzzling to the individual, something over which he or she lacks control. . . . It can be potent even when not consciously taught; it is something that emerges in full, often liberating flower, only through struggle.[19]

He goes on to say that today, as we reinvent ethnicity, it's also something new: "To be Chinese-American is not the same thing as being Chinese in America. . . . The search or struggle for a sense of ethnic identity is a (re)invention and discovery of a vision, both ethical and future-oriented."

Thus a "hyphenated" American is not "just an American" but a particular kind of American. All double identifications, awkward as they sound, make clear that the user acknowledges and is proud of her or his biculturalism. Nevertheless, the choices for artists of color in the United States, as well as for exiles and expatriates from the Third World living in North America, can seem irreconcilably polarized. There is a good deal of internal ambivalence and conflict about the degree to which they want to, or are able to, assimilate in their art. . . .

Although for artists of color looking back to suppressed traditions, self-portraiture and autobiography might be expected to be seen as anachronisms—the unwanted or unfamiliar products of a self-conscious Western experience—in fact, personal narratives continue to be revitalized and clearly play a significant role in the naming process. Robert Lee, director of the Asian American Arts Centre in New York, has suggested that "the Asian art of calligraphy is the nearest traditional equivalent to self portraiture."[20] Margo Machida has pointed out that for an Asian American, self-exposure and autobiography constitute "a crossing of a code of silence, transgression of the tradition of keeping problems within the family."[21] Her own use of "psychological self-portraiture" (from Polaroids of her own body) as a means of "self interrogation," is therefore "a radical step in affirming my experiences and presence in the society."[22]

Machida is a Japanese American artist raised in Hilo, Hawaii, who has lived for twenty years in New York, where she has been active in the Asian

American political and cultural communities. Her self-images are introspective but also unexpectedly harsh and critical, incorporating a level of psychic violence repressed in most Asian American art. She studied psychology and art, and, deeply affected by the '60s vision of a counterculture based on humanist values, worked for ten years as a counselor and art therapist in mental institutions, halfway houses, and schools for the emotionally disturbed and developmentally disabled. Her contact with the struggles of clients living on the edge of society led to a series of disturbing narrative paintings in 1984.

Machida's work . . . is based in her own "paralyzing feelings of culture shock, isolation, disorientation, and marginalization in New York," having come from "a small, conservative Asian community with close ties to traditional Oriental culture." As in all Pacific Island cultures, she recalls, there was a deep appreciation of natural forces, personified in a pantheon of goddesses, gods, and spirits manifested in volcanic eruptions, typhoons, and earthquakes. . . .

The waves, typhoons, and volcanoes of Hawaii are both metaphors and realities that continue to haunt the artist's nightmares. In *Tidal Wave* (1986) a child holds tightly to a red ball, in an attempt to ward off her fear of impending doom. This image has been read as representing the Asian awash in a dangerous sea of Occidental extroversion, employing introversion as a defense.[23] In many of her self-portraits since 1985, Machida calls upon animals as guardians and alter egos as well as images of personal power. In *Charmed* she is a snake handler, a metaphor for "confronting the dangers of self-discovery." In *First Bird* she represents herself as a ghostly geisha (the Asian female stereotype) and a skeletal Jurassic archaeopteryx (the transitional creature who straddled reptilian and avian worlds). She cites the influences of Francis Bacon, underground comics, and Frida Kahlo, "whose arrestingly frank, graphic and bizarre imagery of her body, sexuality, cultural and political identity showed how much more was possible to express." Like Kahlo, whose work and life have become models for women of all cultures, Machida uses skeletal references as images of illness, vulnerability, and mortality. . . .

The co-optation of images through reductive and restrictive stereotypes coexists with the loss of language, the loss of the original name, which inevitably includes the loss of culture and identity itself. In Hawaii, Machida's dilemmas about bicultural identity are reflected in the threat to the islands' lingua franca. Pidgin is a creole language that sounds strange to the English ear, "a spare, direct, and often delightfully irreverent patois" that is for many Hawaiians "a crucial link to a rich past that is quickly being bulldozed for tourist and commercial development."[24] It is a full language, "the mother song" for non-Anglo Hawaiians, the communicative link that blends Japanese, Chinese, Filipino, South Pacific, Portuguese, Puerto Rican, and other components into a unique culture that can stand up against the growing influx of mainlanders.

"Indian people still speak English as a second language, *even if we no longer speak our own languages*," says Cherokee artist, Jimmie Durham.

Native Americans and Mexican Americans are still punished for using their own languages in schools, a practice that did not end in the early twentieth century; there are Chicano students in college today who recall being made to stand next to the blackboard on tiptoes for extended periods, placing their noses in a circle of chalk, for the crime of speaking their own language. The "English Only" movement—now law in several states—is attempting a total eradication of bilingual education and day-to-day commerce that might even be applied to Puerto Rico if it "achieves" statehood. "Official English" is a vestige of the discredited melting pot concept, lamented only by those who are threatened by diversity. . . .

The visual arts might be able to make a contribution to the intercultural process far greater than that of literature, due to language barriers and the gaps between written and oral traditions. Yet that has not been the case so far, in part because art is the prisoner of its status as object and commodity—its bulk and expense, and the perceived elitism that results. It is therefore necessary to broaden our definition of naming to include the processes and vehicles by which these names are transmitted and received.

North American critics and intellectuals have begun only recently to look with respect rather than rapacity at Third World cultures. The progressive postmodern sensibility (including the rejection of *all* "sensibility" as crippled by culture or ideology) has focused first on "decentering" and then on the relationship between center and margins. Yet it has been the discourse *about* rather than *by* Third World artists and writers that has risen to the surface via feminist and French theories about difference and the Other in the last decade. Most of the debate has been within white control. In addition, it has been inaccessible to many working artists because scholars tend to prefer the illusory coherence of theory to the imperfections of practice. This bias against artists' attempts to expand or experiment with theoretical premises curtails the development and effectiveness of the art itself and permits theory to sail off into the ozone, unanchored by the difficulties of execution and direct communication with audiences.

African American literary critic Henry Louis Gates, Jr., says that rather than shying away from "white power—that is, literary theory" (and its hegemonic style), African Americans must translate it "into the black idiom, *renaming* principles of criticism where appropriate, but especially *naming* indigenous black principles of criticism and applying them to explicate our own texts." However, by questioning the ownership of the language itself, he seems to imply that renaming is not enough:

> In whose voices do we speak? Have we merely renamed terms received from the White Other? Just as we must urge that our writers meet this challenge, we as critics must turn to our peculiarly black structures of thought and feeling to develop our own language of criticism. We must do so by turning to the black vernacular, the language we use to speak to each other when no white people are around. My central argument is this: black people theorize about their art and their lives in the black vernacular.[25]

In his book *The Signifying Monkey*, which elaborates on this theory, Gates uses the figure of the Yoruba trickster deity, Eshu-Elegbara, god of the crossroads, as a bridge—a precarious, teasing suspension bridge. However, while recommending a new vernacular, Gates is also aware that his medium is an analytical language incomprehensible to the black community he writes about and for. He runs the risk of alienating not only the white critical establishment, but also the black audience, which is not monolithic in the first place and is often unwilling or unequipped to deal with "the principles of criticism" in any case. Black visual artists find themselves in a similar position. . . .

The young African American artist Lorna Simpson has fused current theory with her practice, which consists of life-size color photographs of female figures and cryptic texts that serve as both captions and speech. Raised by parents politicized in the '60s, she is one of the generation that includes filmmakers Spike Lee and Julie Dash, actress Alva Rogers, performance artist Lisa Jones, artist Carrie Mae Weems, and writers Trey Ellis, Michele Wallace, Greg Tate, and Kellie Jones. Originally a documentary street photographer, Simpson moved into more ambiguous territory when she went to graduate school at the University of California at San Diego, partly because she had become uncomfortable with invasions of privacy endemic to documentary work. She remained interested in both the gestural and the linguistic aspects of "body language," and in the stereotypes they incorporate: "We need to shave off even the fictions that we've created for ourselves in terms of who we think we are as blacks."[26]

Appearance and disappearance, the invisibility of the "I witness" who because of race or gender is disbelieved by society, is another one of Simpson's themes. She prefers not to limit her subjects to specific issues (such as South Africa) because she wants "an echo that I'm also talking about America . . . so that the viewer realizes I'm also talking about your life. . . . I leave the reconstruction to the viewer. . . . I'm not so interested in morally defining what should be, [as in] exposing chichés that seem quite harmless."[27] Simpson is questioning roles and how they are "played." She looks back at the history of role-playing by using as sources game books from the '50s, remarking at the same time how "fade-cream" (skin lightener) ads have reappeared in the '80s. Given the apparent conservatism of the upwardly mobile black community and some of the student generation, Simpson is critical of a political ignorance abetted by national historical amnesia. Her images are of day-to-day experience, the mundane as entrance to common ground, and she connects this to a trend (paralleling the early women's movement) "where everyone works from their personal experience or from incidents in their own lives." Kellie Jones sees in Simpson's allegories of "the archetypal Black woman" a "suave innuendo of the Blues and the duality of use and meaning in the Black community (e.g. , bad = good)."[28] . . .

Self-naming is a project in which such relational factors—balancing one's own assumptions with an understanding of others—are all-important. When names and labels prove insubstantial or damaging, they can of course be exposed as falsely engendered and socially constructed by those who experience them; they can be discarded and discredited. But they can also be chosen anew, even if only temporarily, to play a part in the "polyphonous recuperation" that Gerardo Mosquera looks to from the Caribbean.[29] James Clifford seems to suggest the possibility of a changeable, relational identity when he says, "There can be no essence except as a political, cultural invention, a local tactic."[30] This seems a healthy compromise that allows historical and cultural commonality a role—and a political role at that—without freezing it into another instrument of control. As names and labels change, the questions change too. And as consciousness rises and dialogues take place, any single, unified resolution becomes more unlikely.

Notes

1. James Baldwin, "A Talk to Teachers," originally delivered in 1963; published in *Graywolf Annual Five: Multicultural Literacy,* ed. Simonson and Walker, p. 8.

2. See "Many Who Are Black Favor New Term for Who They Are," *New York Times* (Jan. 31, 1989). In Britain, "black" is applied to Africans, Asians, and all other people of color by racists as well as by people of color taking a political stance to emphasize a shared colonial history and experience of oppression.

3. In the nineteenth century, both here and in England and continental Europe, "Red Indian" was used as a semantic distinction from East Indian. "Squaw" is another insulting term, rumored to have originated because "we squawked when we were raped," according to Jaune Quick-To-See Smith.

4. The *New York Times* (Sept. 9, 1989) reported that today, as in Dr. Kenneth Clark's famous "black doll" experiment two generations ago, black children asked to select the "prettier, cleaner, smarter" image, chose the white over the black.

5. Elaine Kim, "Defining Asian American Realities Through Literature," *Cultural Critique* no. 6 (Spring 1987), p. 109.

6. Vine Deloria, Jr., quoted in Jamake Highwater, *The Primal Mind*, p. 173.

7. James Clifford, "Histories of the Tribal and the Modern," *Art in America* (April 1985), pp. 164–77. See also Lucy R. Lippard, "Give and Takeout," in *The Eloquent Object,* ed. Manhart and Manhart, pp. 202–27.

8. See John Berger, "Primitive Experience," *Seven Days* (March 13, 1977), pp. 50–51.

9. Jerome Rothenberg, "Pre-Face," *Technicians of the Sacred,* p. xix ff. Rothenberg suggests the term "archaic" as "a cover-all term for 'primitive,' 'early high,' and 'remnant,'" which also encompasses "mixed" cultural situations and a vast variety of cultures.

10. Lowery Stokes Sims, "Race, Representation, and Appropriation," in *Race and Representation,* p. 17.

11. Gerardo Mosquera, *Contracandela* [collected essays] (Havana: Editorial José Martí, forthcoming).

12. Rasheed Araeen, "From Primitivism to Ethnic Arts," *Third Text* no. 1 (Autumn 1987), p. 10.

13. Gronk, in conversation with the author, Dec. 8, 1988.

14. Yolanda López, in conversation with the author, Oct. 1988. Her 28-minute videotape *When You Think of Mexico: Commercial Images of Mexicans* is distributed by Piñata Productions in Oakland, Cal.

15. Victor Turner, *Dramas, Fields, and Metaphors* (Ithaca: Cornell University Press, 1974), pp. 152–53.

16. See the exchange between Barbara Barr and Adrian Piper, *Woman Artists News* (June 1987), p. 6; the debate continued with letters from readers in subsequent issues.

17. Adrian Piper, "Flying," in *Adrian Piper* (New York: Alternative Museum, 1987), pp. 23–24.

18. Homi Bhabha, "Remembering Fanon," in *Remaking History,* ed. Kruger and Mariani, p. 146.

19. Michael M. J. Fischer, in *Writing Culture,* ed. Clifford and Marcus, pp. 195, 196.

20. Robert Lee, "Introduction: A Feather's Eye," in *The Mind's I: Part I,* p. 4.

21. Margo Machida, quoted on National Public Radio, Jan. 28, 1988, about the "Cut-Across" exhibition in Washington, D.C.

22. All quotations from Margo Machida here and below are drawn from a series of unpublished statements on her work, a published statement in *Cultural Currents* (San Diego: San Diego Museum of Art, 1988), and answers to a questionnaire from Arlene Raven (1989).

23. Dominique Nahas, in *Orientalism: Exhibition of Paintings by Margo Machida and Charles Yuen* (New York: Asian Arts Institute, 1986), n.p.

24. Robert Reinhold, *New York Times* (Dec. 13, 1987).

25. Henry Louis Gates, Jr., "Authority, (White) Power and the (Black) Critic; Or, It's All Greek to Me," from *Cultural Critique,* No. 7 (Fall 1987), pp. 33, 37.

26. Lorna Simpson, unpublished interview with Moira Roth, 1989.

27. Ibid.

28. Kellie Jones, in *Lorna Simpson* (New York: Josh Baer Gallery, Oct. 1989).

29. Mosquera, *Contracandela.*

30. James Clifford, *Predicament of Culture,* p. 12.

Part VI

Art and Gender

Gender constructions, represented in imagery created by both male and female artists from different periods, reflect historical and societal ideas concerning gender and sexuality, social conventions, and concepts of identity. The essays chosen for this section approach the topic from various perspectives, yet all challenge or deconstruct conventional Western white male-dominated universals.

The function of the nude in European painting is the focus of two essays by Richard Leppert: "The Female Nude: Surfaces of Desire" and "The Male Nude: Identity and Denial." Rejecting the formalized and aestheticized approach of Kenneth Clark, Leppert considers the erotic nature of the act of spectatorship, the discourse concerning power, and the politics of gender difference implied in images of female and male nudes. The complexity of the response to these representations involves both individual and general history; response is rooted in one's personal experience and beliefs and is affected by the ever-changing dynamics of culture and societal ideas.

Leppert attributes the denigration of the female nude so apparent in Medieval Christian art to notions of Eve's sin and her influence over Adam. He contends that this negative attitude toward Eve has subsequently been the driving force behind images of the female nude that subtly warn of the dangers of pleasure. These images may reflect the desire for dominance and perhaps revenge in the act of looking by the male observer. Paradoxical depictions of erotic desire appear in Bronzino's *Venus, Cupid, Folly, and Time* and Boucher's *Pan and Syrinx*, while limitations are imposed on the male gaze in Ingres' *Valpincon Bather.* Cultural and sexual domination are couched in exoticism by Gérôme in *The Slave Market,* and Victorian notions of aggressive female sexuality are playfully mythologized by Bouguereau to justify the necessity for male domination.

Whereas the female nude has historically almost always been assigned meaning as the object of the male gaze, the male nude is more ambiguous.

The male response to a male nude is often ambivalent. For example, the author refers to the conflicted nature of male reactions to Michelangelo's *David*—the societal taboo in taking pleasure in looking at a body of their own sex compounded by the cultural requirement to make their "own specific bodies pleasurable sights to themselves and, presumably, to women." Some traditional images of male martyrs in ecclesiastical painting embody this paradox in homo-eroticized representations. In mythological paintings by Botticelli, particularly *Venus and Mars*, sexual identities and roles seem visually reversed with a more dominant Venus gazing at a passive, androgynous Mars. Yet as paradoxical as this imagery might be, considering a predominantly heterosexual male audience, Leppert contends that a visual exchange such as this is crucial to understanding masculinity and may expand the boundaries between "either-or sexualities."

Sexuality, gender roles, and societal expectations are also explored by Griselda Pollock in "Modernity and the Spaces of Femininity," more specifically in relation to Modernism and "its sign, the bodies of women." In examining late nineteenth-century French paintings, she ascertains that what men and women painted was determined not so much by biological distinctions as by the "social structuration of sexual difference."

Pollock's study focuses on two women artists who were part of the Impressionist circle—Berthe Morisot and Mary Cassatt—and their depiction of "space." Most locations in their works appear to be domestic or private, although there are examples of women engaged in bourgeois activities in the public domain, such as attending the theater, boating, or driving through the park. Mary Cassatt, in particular, examined the spaces of domestic labor in her images of mothers caring for their children. What is significant is that women Impressionists did not depict the same subject matter as did their male counterparts, who explored places off-limits to respectable women: bars, cafés, dance halls, and backstage at the theater or ballet.

Pollock also includes in her broad definition of "space" the spatial order within the paintings or prints themselves. Morisot often juxtaposed two separate spatial systems or compartments in a single painting; a balustrade may demarcate the division between the spaces of femininity and the masculine realm. Cassatt, like Morisot, often showed characteristics of proximity while compressing space; however, more commonly Cassatt created a shallow space dominated by a figure whose gaze is averted, thereby denying the viewer visual and psychological connection. In Cassatt's work conventions of traditional perspective are replaced by "phenomenological space," in which visual cues refer to the way space is experienced through sight, touch, and texture.

The reality of life for bourgeois women in the late nineteenth century is embodied in both the subject matter and formal composition of works by Morisot and Cassatt—the male public vs. female private domains, the susceptibility of women out in public to a compromising male gaze, the division between the world of respectable upper middle class women and lower

class women who were seen as sexualized commodities. In their social and psychological positionality, Berthe Morisot and Mary Cassatt reflect the vision of the female spectator of their time. Yet their work is relevant today as women artists, struggling to break free of these sexualized structures, create their own visual means for "negotiating modernity and the spaces of femininity."

This challenge was taken up early in the twentieth century by women artists associated with the Surrealist movement and more recently by artists who in many ways have continued the Surrealist legacy. According to Whitney Chadwick, in "An Infinite Play of Empty Mirrors: Women, Surrealism, and Self-Representation," women artists found in Surrealism a venue for social liberation. Whereas Morisot and Cassatt reflected feminine spaces proscribed by their society, Surrealist women artists engaged in self-representation as a means to explore their personal identity.

Chadwick identifies specific thematic interests: "fabulist narrative rather than shocking rupture, a self-consciousness about social constructions of femininity as surface and image, . . . a preoccupation with psychic powers assigned to the feminine, and an embrace of doubling, masking, and/or masquerade as defenses against fears of non-identity." The author approaches each theme by considering particular Surrealist artists and then analyzing work by more contemporary women artists who continue to explore the theme. In the section on Self as Other, Chadwick examines ambiguous constructions of self in paintings by Dorothea Tanning, Leonor Fini, Remedios Varo, and Frida Kahlo, as well as artists for whom Surrealism may have served as a springboard for their own mid-to-late twentieth-century self-explorations. Another theme prevalent in works by Surrealist and post-Surrealist women artists is Self as Body, defamiliarized, fragmented, torn apart or exposed, in which interior and exterior reality are conflated. Louise Bourgeoise, Eva Hesse, and Kiki Smith have continued to invalidate the traditional integrity of the whole figure (as presented in Leppert's essay) by presenting the visceral, the body fragmented or deformed, or as in Annette Messager, the body commodified.

Finally, Chadwick investigates femininity as masquerade in Surrealist and post-Surrealist imagery. Female cross-dressing and gender ambiguity are apparent in Surrealist art; the thread is continued in certain 1980s photographs by Cindy Sherman. Masquerade and the use of costume and "props" are evident in paintings by Kahlo, Fini, and Tanning while doubled self-images serve as a means to express dualities inherent in one's identity. Surrealist women artists initiated a dialogue concerning women and their sense of self, their attitudes towards their bodies, and their relation to the outside world, a dialogue that women artists continue even today as they reframe femininity.

During the 1990s, the purview of so-called "women's studies" or "feminist studies" was expanded to embrace the complexity of gender as related to both

femininity and masculinity, heterosexuality and homosexuality. In a catalog essay accompanying an exhibition at the MIT List Visual Arts Center entitled *The Masculine Masquerade*, Helaine Posner acknowledges that while Western civilization has invested mainstrean white heterosexual masculinity with tremendous power, firmly establishing it as a measure against which all others are judged, for many males today this definition has little true meaning. As the images in this exhibition prove, considerations of race, ethnicity, class, and sexual orientation require more fluid parameters for defining masculine identity.

Mary Kelly's installation *Gloria Patri* deals with "the psychological structure of masculinity" through themes of heroism and war. Michael Clegg & Martin Guttmann consider the socially acceptable male role of the corporate executive in photographed "group portraits." Tina Barney's photographs reveal the private, often emotionally vacuous, realm of the upper middle class affluent male. Memories of boyhood experiences are captured by midwesterner Dale Kistemaker and Chinese-American Michael Yue Tong. Keith Piper presents media representations of the interface between black and white masculinity as acted out in the "emblematic space" of the boxing ring. Sports as gender performance, mixing erotic undercurrents with physical and psychological intensity, hero worship, and voyeurism, are the subjects of videotapes by Matthew Barney. Donald Moffett brings homosexuality out of the private sphere to advocate for positive homosexual identity and social action, especially as regards AIDS. Lyle Ashton Harris addresses issues of racial and gender identity through cross-dressing and racial masquerading.

Clearly issues of gender and sexuality have been explored in art for centuries. Increasingly the social constructs that have traditionally defined femininity and masculinity are being studied and challenged by both artists and scholars. As a result, the rigid boundaries established between male and female identities have become more flexible, allowing for a more inclusive concept of gender open to various permutations and personal considerations.

Chapter 18

The Female Nude: Surfaces of Desire

Richard Leppert

In painting, nude or naked: What to call it? What are the stakes of the difference? A generation ago Sir Kenneth Clark, in his monumental study of nudity and nakedness in art, established the principles defining a difference. Nakedness, he said, describes a state of being without clothes; nudity, by contrast, is a category of artistic representation. The former, he argues, "implies some sort of embarrassment" most people feel from being deprived of clothes, but the latter "carries, in educated usage, no uncomfortable overtone." . . . Nudity for Clark operates as a manifestation of aesthetics, as representation and at a remove from mundane reality. . . .

Within the confines of a broadly defined Western tradition, Clark universalized the body as an unproblematic entity, divorced from history other than the history of art and art-making. In particular, he ignored any specific investigation of the function of the nude (the "why" question) or of the act of spectatorship (the "who's looking" question). As a result, his book (immensely insightful regarding formalist art history) oddly separates the nude from discourses about power and, a little ironically, from the politics of gender difference. Further, it identifies but quickly backs away from eroticism's role as a driving force to portray the nude in art from time immemorial. . . .

The pleasure of looking at beautiful naked bodies in art, for Clark, is principally contemplative, not physical, a view predicated upon preserving "in educated usage" a sharp division between mind and body.

The first substantial, if brief, critique of Clark's book was mounted by the art critic John Berger in 1972.[1] He argues that the nude in art responds to, and in turn reinforces, the principal power differential that partly defines the social and cultural functions of gender hierarchy. He reasons that man's "presence" in the world articulates a "power which he exercises on others," whereas a woman's presence articulates "what can and cannot be done to her". . . . As far as art is concerned, he relates gender difference to the separate acts of looking and of being looked at: A man's look is directed outward toward others, a woman's inward toward herself. One surveys and surveils; the other is surveyed and surveils herself. . . .

Berger argues that the painted nude is, essentially, the painted nude female. Historically, however, this is the case only since the nineteenth century, before which there is a reasonably close balance between the sexes in representations of the nude. Berger further notes that the female's nakedness is not expressive of her own feelings but is a sign of "her submission to the [art] owner's feelings or demands." To be naked, Berger suggests, is to "be oneself"; but to be nude is to be seen by others "and yet not recognized for oneself. . . . Nakedness reveals itself. Nudity is placed on display."[2] Finally, Berger reiterates the character of power difference by noting that female nudity in art conventionally, though by no means always, includes men who are clothed or no men at all, leaving but one man implicit, the spectator-owner of the image who stands, clothed, outside the frame. In sum, whereas Clark defines the nude in terms of beauty, Berger defines it in terms of politics. . . .

Needing to See

The nude body in art is always "about" the removal of clothes; nudity does not constitute Westerners' natural state. To make available the sight of nudity in art is to respond to sociocultural needs not otherwise met in lived experience.[3] The question to ask is: What is this need, and how is it met in representation? The fact is that the need is not singular, nor is the means by which representational response (the making and the seeing) occurs. Whatever the representation, viewers project back onto and into the image their own sets of interests, desires, investments, phobias, and the like. We see differently from each other because our lives are never identical. . . .

Seeing helps make us what we are, whether we choose to confirm, to deny, or to mediate the "reality" we construct. Yet neither the misogynic nor the feminist image leads us toward any necessary or specific response. Either may strengthen or weaken our beliefs, whether they are regressive or progressive. This does not mean that no moral consequence attaches to either, only that no moral consequence is guaranteed from looking at one image as opposed to another. Each response is located within personal and general history, embedded in experience and belief, never the same in two individuals, and established within the complicated dynamics of culture, which is always a changing process and never static.

Originating in Sin

The glorification of the naked male body in ancient pagan art is matched by the denigration of the female body in much of Christian art. Eve's *sin*—not Eve herself—is the source for the female nude in Western painting. Her eating of the apple from the forbidden Tree of Knowledge, the meal shared with Adam that "universalized" the sin, produces the necessity of clothing to hide the shame that both, having sinned, suddenly experience. Their sense of shame is not the product of sensitivity to nakedness as such. Instead, shame develops from an awareness that nakedness is constituted by uncovered genitals made vulnerable by being visible to others. Having sinned, Adam and

Eve do not wrap their entire bodies; they merely sew together fig leaves to wear—just that much and no more (Genesis 3:7). Since the late Middle Ages, nudity and sin are linked, and the *visual* account of the sinning body is marked by the appearance of sexual organs.

In the clothed culture of the West, the removal of drapery references Eve's sin, even when female nudity is represented in purely secular subjects. Indeed, the arousal upon which the functional success of the painted nude depends is connected to Eve's shame. The pleasure of the painted nude is driven in part by the act of looking *in judgment* on evil personified. Eve's importance to the history of art is not because she was "first mother" to Adam as "first father." Her real significance is her sin and its catastrophic conse- quence, the Fall of Man (the word is gender-specific). . . . It is not surprising, therefore, that Eve in pictures is almost always positioned upright—phallic— visually very much Adam's equal; they usually form a matched pair. But in Western painting those later women who, posed nude like Eve, were "heirs" to her sin, are usually preferred supine. . . . In art, female nudes are over- whelmingly longitudinal, anchored to the horizon, to nature, to earth—and to bed. The bed serves as the sign of eternal submissiveness for a woman's having led Adam astray. . . .

[Hans Baldung's *Eve, the Serpent, and Adam as Death*] situates Eve as both a biblical figure and a modern sinner. Her body is provided with the con- summate beauty of youth and (blond, Germanic) perfection, and it is dis- played without shame. By crossing her legs, she displays a degree of modesty despite her nakedness. But her most distinct trait is a frank sexuality typified by a lack of self-consciousness about her nakedness. . . . Eve's historical modernity is marked especially in her face, which is at specific odds with the rest of her body. Her expression hints of sophistication, allurement, and seductive power. It is the look of a coquette, dangerously like that of a whore—the "sideways glance" that would establish itself so firmly in West- ern iconography as one mark of female sexual evil and power of entrapment. Eve's modernity is further evident in the slightly smug mouth and, of course, by her hiding behind her back the apple that she will produce for Adam once she has worn down his resistance.

Like Eve, Adam marks the uneasy relation of prehistorical timelessness to the historical time of Baldung's modernity. He reaches up to pluck the apple that will be his poison but in fact has not yet tasted the fruit, the act of consumption that will guarantee his physical death. This notwithstanding, his body is fast decomposing before our eyes. Before Adam can sire his future children, his flesh rots: His own agency disappears, and that agency—so Baldung makes visually clear—was phallic. (The serpent biting Adam's wrist is profoundly phallic, emphasized by its engorgement.) In effect, because of the advanced decay of facial flesh that exposes his teeth, Adam appears to leer at Eve. His blank stare not only implies sexuality but also sexual violence. The relaxed hand he lays on Eve's fleshy arm does not grasp but seems

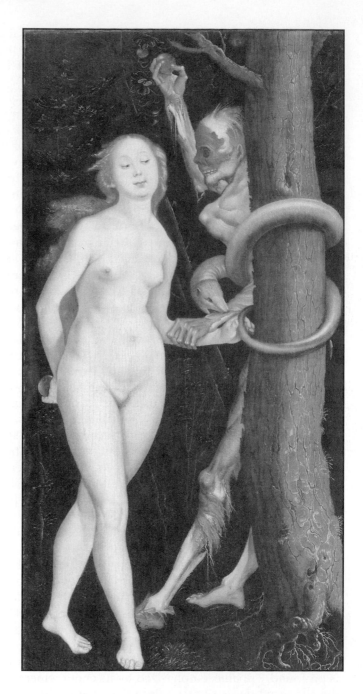

Hans Baldung,
**Eve, the Serpent,
and Death.**
*c. 1510–1515,
Oil on linden,
64 × 32.5 cm.
Ottawa,
purchased, 1972.
(National Gallery
of Canada)*

virtually to caress; by contrast, his shoulder muscles are tensed as though he were attacking. This mixed message or body language suggests that he will eat the apple, then rape her—but she, in the meantime, will have seduced him. The male force is transmitted from first father to father of Death (Adam's rotting body), and Death equates with violence, with Eve's just desserts. Moreover, sexuality itself is mapped onto a grid of mortal combat. . . .

Indeed, Baldung fashions "an erotic art that itself arouses the desires that reflect a viewer's kinship with Adam. And Baldung punishes those desires through the viewer's experience of revulsion in encountering himself in the habit of the corpse."[4] Our eyes are not held entirely in the thrall of Eve's nudity. The painting's focal point, following a line traced by Eve's right leg, is occupied by Adam as Death's ugly hand laid atop Eve's arm, and Eve's hand fingering the snake. This connective link to the price of sin's pleasures is compositionally powerful and marks a transference of action and reaction. . . .

It is necessary to keep in mind that Baldung's remarkable painting operates via a pervasive eroticism that invites our libidinal investment; this makes us complicit children of the first parents and acknowledges that we bear the stain of their guilt. As other scholars have noted, Baldung is the first painter to have linked the Fall to an erotic act.[5] . . .

Baldung's painting helps us to understand the stakes of looking. In essence, the history of the nude in art finds in Baldung's Eve its driving force. In the Beginning, it seems, *Eve* possessed the look, a look so powerful that men thereafter have been made to pay the price—and to seek revenge.

Cold Comforts

Bronzino's *An Allegory with Venus and Cupid,* painted only a few decades after Baldung's picture, is a product of Italian mannerist sensibilities par excellence that anticipates the wholly sexualized secular nudes that principally define the subject in modern consciousness. The rhetorical power of Bronzino's painting, when set against the tradition of painted nudes as a whole, derives from its overtly frank acknowledgment of the erotic pleasure of scopophilia, with none of the tiresome overlay of moral justification, a shadowed reference to bad conscience, that so heavily marks the female nude in the nineteenth century.

Bronzino's Venus is surrounded by other figures who factor into a complex (and now very uncertain) allegory dominated by the male figure of Time, who spreads a neon-blue cloak as an enfolding frame or mantle around the central figures. The other figures may be Folly, at the right, Pleasure behind and to Folly's left, and Jealousy, behind Cupid. . . .

Cupid, provided with a highly sexualized adolescent body but the face of a child, moves to kiss Venus while sexually exciting her by fondling her breasts, whose nipples are erect. Venus, no stranger to the ways of love, takes pleasure in Cupid's attention *and* disarms him. She has reached down to his

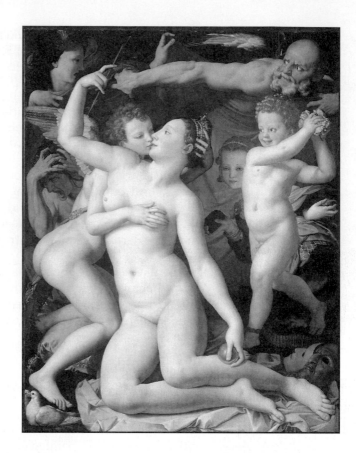

Bronzino, **Venus, Cupid, Folly, and Time (The Exposure of Luxury).** *c. 1546, Oil on wood, approx. 61 × 56¾ in. (National Gallery, London)*

quiver and has taken from it the sharply pointed, emphatically phallic arrow that she now holds delicately and *provocatively* in her hand. His body is tensed to his sexual "work"; her body, no less contorted but nonetheless extraordinarily relaxed, shows every sign thereby of controlling the situation of their mutual excitement.

Bronzino paints Venus as physically powerful, and she is literally posed so as to maintain complete control over her own dramatically elongated body. She dominates the much smaller boy. Cupid's body, however, as much a spectacle as Venus's, is also made sexually accessible to a degree that hers is not. In an extraordinarily homoerotic pose, Cupid's phallic sexuality is diminished—metaphorically, it is visually taken from him by Venus. He is emphatically feminized. . . .

However, the painting's kinky and incestuous[6] omnisexuality (Cupid is Venus's son) is not quite all it might at first seem, especially when seen in color. Bronzino's Venus and Cupid violate a host of sexual taboos: incest,

homoeroticism, prostitution via Venus's wantonness, and gender reversal via Venus's sexual domination of Cupid. But the sexualized bodies we gaze upon seem oddly distant and inaccessible. The light illuminating both figures is nearly fluorescent, giving a distinctly cold cast to their skin, and the painting's overall highly reflective surface only increases the impact of this lighting effect. As a result, their bodies appear, if not exactly corpselike, not quite alive.

The patriarchal figure of Time "controls" the allegorical text by framing the various figures within his cosmic-blue cloak. . . . Time, in everything, is the essence. Time is wasted, *and* time wastes. The intense pleasures of sex, pleasures most desired and most sought, are profoundly time bound. . . . In short, time is a principal dimension of life within which the body "makes sense" and within which it senses. Time, in other words, is an external and abstract manifestation of the experience of life lived through the body. Embodied life is made possible by sexuality. Our sense of the sexual body is largely determined by desire, just as our sense of time is in part determined, and made an issue of, by our awareness that it is a finite dimension eternally working against our abilities to realize our desires (Time flies).

Erotic desire, driven by the viewer's response to the sights offered by Bronzino's painting, remains paradoxical. Bronzino visualizes for us the violation of taboos, evoking desires of the most culturally dangerous sort. But while holding us in the momentary thrall of sexual possibility, he seems to hint at two sobering facts. First, the pleasures of looking are just that. What we see is not only not real, or realized, but impossible. The highly sexualized bodies of both Venus and Cupid are the result of visual fantasies; their contortions are physiologically impossible. . . . Bronzino deftly informs us that the delicious omnisexuality he is offering produces a desire that cannot be satisfied except in the imagination; it has no fleshly parallel. Its reality is abstract. . . .

The image is controlled by an elaborate conceit. The painting insists on our recognizing its textual complexity and by that means, of course, acknowledges the educated audience for which it was intended. In any event, the undeniability of the allegory, whatever it may turn out to be, confirms Bronzino's deference to his patron, usually thought to be Cosimo de' Medici (1519–1574), the first grand duke of Tuscany and a moral puritan, which by itself might suggest the paradoxical nature of the picture, that it is more than high-grade pornography. Cosimo is supposed to have sent this painting as a gift to King Francis I (1494–1547) of France,[7] providing him with (1) a striking sexual fantasy, (2) an allegory about life but with quasi-moral overtones—nothing explicit—appropriate as a gift from one Catholic sovereign to another, and (3) an elaborate riddle that the French king by presumption had the ability to solve, an implicit and diplomatically valuable compliment to his intelligence. . . .

Turning the Tables

François Boucher's *Pan and Syrinx*, painted more than two centuries after Bronzino's *Venus and Cupid*, is an altogether less complicated image as far as its "story" goes. . . . The old story of the Arcadian nymph Syrinx, whom the randy Pan pursues, is transformed into a ménage à trois. According to Ovid's[8] account, Pan chases Syrinx to the banks of a river that impedes her escape from what is, after all, an intended rape. Syrinx successfully pleads for deliverance and, just as Pan grabs for her, she is transformed into a bunch of reeds. Hearing the sounds made by wind blowing across the open ends of the plants' hollow stems, Pan fashions from them/her the first panpipes. Music is thereby accounted for as the twin result of violence against a woman and *as* woman in another, disembodied form. To avoid a sexual assault, she becomes music, though at the expense of her body.

The Pan and Syrinx myth thus has a serious side. It tells a male story, yet it acknowledges paradox and contradiction as it addresses gender, desire, violence, and loss. And not least important, it posits music as a consolation for failure: Pan's being outwitted by a woman, but also a woman's sacrifice of her selfhood to avoid a presumably worse alternative. . . .

Western mythology slowly transformed Pan from handsome youth to half-man half-goat, as in Boucher's painting. Driven by his lower region, he has only partway "evolved," being provided in art with the torso of a heroic, if a bit beefy, god and the lower, furry torso of the quadruped. . . . As an imagined inhabitant of Arcadia, as a pastoral shepherd, Pan marks a time of male "innocence"—when the world was presumably less complex, when a boy could just be a boy, with the girls there to help him, wittingly or not, play the role well.[9] . . .

Boucher's *Pan and Syrinx* was designed for the courtly gaze at Versailles. In that its subject involves a female nude, it is significant that the picture acknowledges a *female* rather than a male spectator, though it otherwise offers up the usual image of Arcadia. . . .

Boucher's Syrinx is *not* the victim of naked male sexual aggression, as Ovid's story recounts. Boucher's Syrinx does not flee for her virginity or her life. Instead she *relaxes*. . . . Pan seems to rush onto the scene, his fur trailing behind him, as though still the mythically sanctioned aggressor. The nymphs, meanwhile, privately disrobed in the deep woods at the river bank, their pink skin entirely unused to exposure, simultaneously engage him *and* each other. Aside from one nymph's surprised look and upraised arm with opened hand—the standard theatrical-rhetorical gesture for fending off attack—both women are virtually languid. In other words, Boucher places the viewer at a critical moment, ripe with ambiguity and possibility: rape or seduction, with the question of who is seducing whom left open.

Boucher plays off a theme of lesbianism, to the extent that the nude women, positioned to provide a back and front view, one complete female

anatomy, seem to move apart from an embrace, as though their bodies, just prior to the moment represented, had enmeshed (the hand of one lies atop the other's shoulder, and their lower torsos are composed like two puzzle pieces destined for perfect interlock). Meanwhile, a little Cupid illuminates Pan's way and holds a daggerlike arrow that defines an anticipated action—that will not occur. Pan is set to resituate this all-girl love scene back into "natural" order. He will come between the women, in essence penetrating their ovular pink enclosure, a fact broadly hinted at by the line of separation Boucher delineates between them, as sign of Pan's sexual interpolation. What is interesting here is that Boucher provides no hint of Pan's failure. . . .

. . . Boucher lavished considerable labor on the picture, especially regarding the commanding presence claimed for the women's bodies, seen in the care he takes to model their every fleshly fold. He explores their bodies' surfaces with enormous attentiveness, subtly shading and modulating every square centimeter of the canvas that their bodies occupy. . . .

It seems to me that Boucher frankly plays to the well-documented rampant libidinal pleasures of the court of Louis XV—long exploited by the artist's chief patroness, Madame de Pompadour (1721–1764). Madame de Pompadour became the king's mistress in 1745 when she was twenty-four. In 1750 their sexual relationship ended, though they maintained a close friendship until her death nearly fifteen years later. Boucher began to work for Madame de Pompadour in the same year that her sexual partnership with the king ended.[10] This painting (from 1759) acknowledges her interests, at the same moment that it putatively exists to please and help entertain the king via pictures of young, pretty, and naked women. . . .

Boucher explicitly acknowledges women's own sexual desires, via his lightly veiled reference to lesbianism (which, to return to the myth, may *not* be set straight by Pan). His nymphs, in other words, can succeed at their own pleasures, ones in which the male presence seems clumsy and almost comical. Pan intrudes on the nymphs, and he intrudes on the pleasure of our looking, in essence interrupting or preventing a more pleasurable voyeurism. . . . Ultimately, however, the issue in question is not female homosexuality; that would be a ludicrous claim. The issue is female sexuality, a sexuality that men cannot ultimately understand, control, or—like a problem—"solve" to their satisfaction. It literally remains out of grasp. . . .

Boucher makes it patently clear, by means of a few subtle decisions, how easily the cultural discourse can be changed. To paint a nude woman for the delectation of a man guarantees nothing, least of all woman's objectification as such. To represent a woman's delicate touch on the shoulder of another woman, delineating a trace of their arrested self-absorption, remakes the meaning of the women's nudity. The sight of them posed accordingly takes back what it promises at first glance. Their bodies remain their own and, in this instance at least, at the specific expense of a man.[11] . . .

Figments of an Imagination

The nude woman in Jean-Auguste-Dominique Ingres's early nineteenth-century *Valpinçon Bather* displays her back and a small bit of backside. Her nakedness dominates the canvas, yet it yields surprisingly little as a sight for voyeuristic pleasure, despite promising more. The tiny waterspout at the lower left explains her nakedness as resulting from her preparation for a bath, and that fact marks the viewer as an unseen intruder in a distinctly private space. . . . The picture's basic elements are these: young woman, vaguely exotic, sitting naked on a white-sheeted bed. The connotations are as unambiguously sexual; they also are made to appear less than "natural." Ingres thus puts distance between the viewer and what the viewer looks at by defining the view as imaginary. What is "there" is not really there except as a fiction. . . .

For a nude study, Ingres's painting is noteworthy for its extreme reserve, evoked not least by a pervading sense of *silence*. The only sound to be imagined comes from the small stream of water flowing from the bath spout. Moreover, the picture space is mostly given to sound-absorbing drapery: bedding, a white sheet suspended at the back, and the greenish drape at

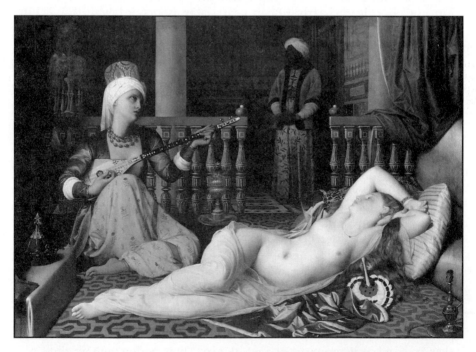

Jean-Auguste-Dominique Ingres, **Odalisque with a Slave.** *1839–1840, Canvas mounted on panel, oil on canvas, 72.07 cm. × 100.33 cm. (Fogg Art Museum, Harvard University Art Museums, Bequest Grenville L. Winthrop)*

the left. What our looking produces, at least with a little concentration, is an awareness of the act of *listening*—not looking.[12] . . .

Ingres's allusion to hearing and sight, his separating one from the other, establishes the limits of the masculine gaze at precisely the point at which its purported powers should claim victory—the visual taking-in (metaphorical possessing) of the vulnerable female body. Ingres acknowledges that male voyeurism is a self-defeating principle for the establishment of masculine supremacy (I am not arguing that he was a feminist). In essence, the power of the male gaze depends on its being *noticed* by the person subject to the gaze. . . . She *must* somehow display her awareness of, and reaction to, male spectatorship, or the power supposedly embedded into the act of his looking is principally undercut. . . . In the end what Ingres leaves us with is uncertainty. He in no sense disregards scopophilia; instead he clarifies the uncertainty of its effects. The *Valpinçon Bather,* ironically named this by art history after one of the painting's owners, reflects by its title an unwitting displacement of possession, as though owning the *canvas* substitutes for owning control of the spectacle. . . .

Ingres's *Odalisque with a Slave,* commissioned by his friend M. Marcotte d'Argenteuil, whose portrait he had previously painted. . . . It employs a visual rhetoric quite different from . . . the previously discussed [painting]. This time Ingres resorts to color and abundant detail to establish a cultural and visual ground against which to set his inordinately white-pink, and *distinctly* (northern, blond) European, nude model. Her own color is striking, in comparison with what surrounds her (a black eunuch, a brown slave playing the *tar*; red curtain and column, green-and-red tiled floor, red-and-blue tiles on the back wall, with much of this being richly patterned). . . .

Ingres adapted this nude's supine pose from numerous European paintings of the reclining Venus dating back to the Renaissance, though with one distinct alteration. He rearranged her body into a quasi-contortionist pose, at once both unnatural and uncomfortable to maintain, but nonetheless particularly frank about the function of her state of undress. That is, Ingres unabashedly arranged her *as a sight* defined compositionally by a pronounced geometric triangulation of navel and nipples and by a soft anatomy, virtually deskeletalized. In effect, Ingres disciplined her soft flesh for his and our viewing, shaping her into complex curvilinear outline *and* twisting her into something of a corkscrew. She is like silly putty in his hands. And yet despite Ingres's attempt to subject her to his and our gaze by placing her in a pose that responds to the command, "I want to look at you," she comports herself as a figment of the male imagination and not as the representation of a real woman—though ironically of course she was: that is, he employed a model. The issue does not hinge on the faulty ethnography of Ingres's fabricated seraglio or on his supplying a Nordic Brunhild instead of an odalisque. Rather, I think, it hinges on the limited ability to represent a fantasy without making it apparent that what is represented *is* merely a fantasy. Indeed,

Ingres's overload of gorgeous, colorful details comes off as profoundly staged. For example, the balustrade and columns, both quite distinctive visual features of the picture, seem flat, undercutting the viewer's sense of space, the reality-confirming third dimension. . . .

When Ingres deals with the nude, paradox asserts itself and entirely unmasks the elements of theatrical realism as mere props belonging to the theater of the absurd. In the end what is available is something to be seen and something to be wished, but *not* something to be had. Access to the secret interior of the seraglio provides the male European voyeur no greater access to the European woman of his dreams. Not able to claim her, he can only acknowledge her ability to traverse his imagination. . . . [Ingres's *Odalisque*] is not objectified in and by the male gaze; instead she invites the recognition that sometimes a look is just a look. . . .

Colonizing the Body

Jean-Léon Gérôme's *The Slave Market* is the product of one of the most successful French painters of the nineteenth century. . . . [He was] the foremost orientalist painter in the world. Two-thirds of his roughly 550 paintings were devoted to orientalist subjects. He traveled widely in the Middle East between 1856 and 1880, going to Palestine, Syria, Sinai, and North Africa, but he especially favored Egypt and the cities of Cairo and Constantinople.[13] On these excursions he made numerous sketches and obtained many photographs; these served as stock images—some were used repeatedly—for paintings produced later in France, sometimes long afterward. He also purchased numerous items to serve later as studio props: "clothing, shoes, armor, helmets, swords, daggers, rifles, pistols, yards of materials, tables, stools, saddles, boots, tiles, pots, hookahs, and other artifacts. At his death the inventory of his studio included an immense store of oriental costumes and properties."[14]

The nude in *The Slave Market* is not exhibited supine, like so many female nudes positioned that way to demonstrate their sexual powers of attraction; instead, she is standing—in order to be examined. Her owner, just behind, has stripped off her white drapery, which he holds. Its pure white color unsubtly marks her presumed virginity. Her would-be buyer is luxuriantly overdressed, his costume conventionally then perceived in the West as a sign of oriental decadence—and even effeminacy! His face is mostly hidden, but a bit of it shows, along with one hand: He is very dark, the Certified Other, his color in sharp contrast to the nearly white (European) skin of the young woman he violates. His examination involves her teeth, a humiliation in the West associated with commerce in horses. Gérôme, a supposed stickler for nearly photographic accuracy of detail, actually *enlarges* the hand, notably elongating the outstretched fingers that penetrate her mouth—the better to make a point of this lurid detail.

That the penetration is sexual requires little imagination. The man's gesture is profoundly phallic and assertive, and her response, head languidly

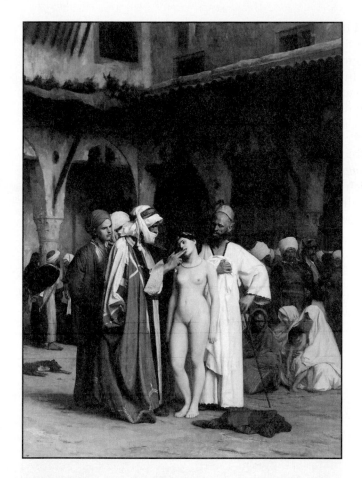

Jean-Léon Gérôme,
The Slave Market.
*c. 1867, 1955.53,
Oil on canvas.*
(© *Sterling and
Francine Clark
Art Institute,
Williamstown,
MA*)

flopped to one side, utterly passive and *receptive,* hints of pleasure and offers no sign of revulsion. Indeed, Gérôme paints her to stand *relaxed,* weight shifted to one leg, the other leg bent at the knee. Her pubic area is shaved (this was the custom), to Western eyes not only making her more available to the gaze but also more fully obliterating her agency.

. . . Gérôme painted in tiny, exacting brush strokes that are invisible on the finished surface. In this way, his paintings vie with contemporary photographs for clarity of detail. Gérôme's paintings distance themselves from photographs because of their dramatically deep colors, a principal means by which he successfully competed with the new black-and-white technology. Moreover, the close attention to detail—such as the architecture in the background of *The Slave Market*—seemingly rendered with photographic "accuracy," provided Gérôme with a way of meeting photography on its home turf. His paintings could claim—and indeed came to depend upon—similar degrees of "objectivity," hence "scientific" accuracy and truth.[15]

Gérôme could thus provide his Western spectators with a painting of a slave market under the guise of "this is just how it is over *there*," at once laying the necessary groundwork for moralizations regarding Western moral superiority (except in America where slavery had not yet been abolished) *and* for a scopophilia concocted of an unstable mix of sexual desire, cultural domination, and misogyny. . . .

Inviting Revenge

It is nearly impossible today to take seriously William Adolphe Bouguereau's gigantic canvas *Nymphs and Satyr*. By all our "standards" the painting's erotic impact, upon which Bouguereau concentrates his entire rhetorical effort, does not so much fall flat as appear ridiculous. But to laugh is not the point. Instead, I want to think about the painting as a serious effort by a major and

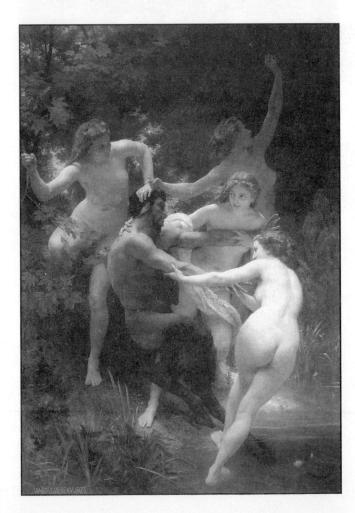

Adolphe William Bouguereau, French, (1825–1905), **Nymphs and Satyr.** *1873, Oil on canvas, 102⅜ × 70⅞ in. (© Sterling & Francine Clark Art Institute, Williamstown, MA)*

highly successful late nineteenth-century artist to respond to the demand for nude spectacle that came from his largely upper-bourgeois buyers on both sides of the Atlantic.[16] It is a commonplace that during the Victorian age painting provided a principal and socially sanctioned outlet for representing the otherwise unrepresentable in a society obsessed with the human sexuality it worked so hard to control. As regards the male spectators of Bouguereau's paintings, the question to ask is what might they have seen, that is, how might they have "read" the image?

Typical of a number of pictures by Bouguereau, the male remains singular and solitary as a common denominator, around which women, much pluralized, seem held in his sway like electrons around the atomic nucleus. The painting's rhetorical impact is driven by an apparent, but unreal, reversal of power, to the extent that the male remains virtually static, placed in a reactive position, while the women move assertively and thus determine his action. The male is a satyr, at once highly sexualized but not quite a man, so that the apparent power reversal does not appear to apply to "real" men. The potential excitement from the image, in other words, derives from what the women—too many of them—*do to* a male. The nymph upon whom Bouguereau concentrates our attention at the right, and her companion facing us, both pull at the satyr's arms, in essence to make him rise, the erotic import of which is made the more apparent by his stiffened arms and outstretched fingers. In essence, they metaphorically coax his sexual excitement; they take control of his sexuality. But, contrarily, the nymph furthest to the left does exactly the opposite. She pushes her full weight against his head, forcing him down, while a fourth nymph grasps in her tight-fisted hand his goat's horn, the tip of which remains visible and vulgarly phallic.

The nymphs attempt to pull him into a pool—the clichéd reference to women's sexuality and, of course, to sea-born Venus—and he resists with all his might, if we pay attention solely to his feet. His upper torso is somewhat at odds with this resistance. The nymphs' facial expressions are unambiguously of the "come hither" variety, and they look more nineteenth-century French than mythological, as was noted in Bouguereau's own time. . . . All the allusions to Greek mythology cannot conceal the fact that these women are no goddesses but high-class courtesans. Bouguereaus were hung in the drawing-rooms of bankers, industrialists and politicians, to be discussed 'scientifically' by the host and his male guests after the ladies had withdrawn for a conversation of their own."[17]

The painting's energy is dialectical. The male, heroic of body, attracts women by the swarm. Yet their very surplus seems to overwhelm him. Their sexual demands, in essence, threaten drowning. Bouguereau thus plays off a theme common to the late nineteenth century concerning female sexuality: Once awakened, it was (oddly) unnatural, unquenchable, and socially, morally, and physically destructive—notably of men.[18] Bouguereau attempts to make his appeal by simultaneously stimulating two enormously powerful,

universally acknowledged male prerogatives: sexual desire (in the Victorian age officially denied to "good" women), and the will to dominate. The pleasure of looking at the women's bodies is clear enough. Their breasts and lower torsos are exaggerated, and Bouguereau takes fullest advantage of the particular Victorian fixation on women's backsides as a representational substitute for their genitals.[19] The will to dominate is stimulated by the apparent power reversal, in itself a call to action. That is, these women need to be firmly put in their place within the fantasy of the male spectator as he acts out revenge on yet another manifestation of Medusa. The mythological Medusa was repeatedly painted and sculpted during the nineteenth century. At once the object of hate and desire, she offered pleasure via her purportedly limitless and aggressive sexuality. Entwined snakes, supplanting her hair, visually overdetermined her aggressive phallic powers in an in-your-face manner. And for her rampant transgression of gender hierarchy, she *must* be punished. Her beheading by Perseus is her own castration and also the restoration of male sexual normalcy, the return of the phallus.[20]

Once again, however, there is a difficulty for the male spectator. To entertain the fantasy, to sense the need to reassert dominance, is to acknowledge that men's hierarchical superiority over women is not natural, but imposed, and that domination can never relax its grip, lest it be challenged. That men must force the issue admits to both the self-interest and the historical contingency of unequal gender relations. Finally, Bouguereau's decision to set his scene in a mythic past accomplishes two related feats: It provides a "cover" for painting the otherwise startlingly modern female flesh; and it accounts for women in nature *as nature,* undeveloped and primitive, driven by out-of-control physical appetites. The convenience of the satyr, as the male force, thereby is explained: Real men in essence have evolved (they do not look like satyrs); women have remained the same. Men are *not* satyrs, so Bouguereau informs us, solely driven by their goatlike sexual urges. The better to illustrate the claim, Bouguereau represents the satyr as already caught up in the evolutionary process. Bouguereau provides him with an upper torso that would be the envy of Apollo, a torso surmounted by a *thinking* head that already knows enough to control his lower, goat half by resisting the women. . . .

Notes

1. John Berger, *Ways of Seeing* (London: British Broadcasting Corporation, and Harmondsworth: Penguin Books, 1972), pp. 45–64.

2. Ibid., pp. 52, 54.

3. See Anne Hollander, *Seeing Through Clothes* (New York: Penguin Books, 1978), pp. 84–89.

4. Joseph Leo Koerner, *The Moment of Self-Portraiture in German Renaissance Art* (Chicago: University of Chicago Press, 1993), p. 295. This is a brilliant study on all accounts, and as regards the discussion at hand, the chapter "Death as

Hermeneutic" is particularly apropos; see pp. 292–316; this painting is discussed on pp. 309–310. For a briefer, earlier account by the same author see "The Mortification of the Image: Death as a Hermeneutic in Hans Baldung Grien," *Representations* 10 (Spring 1985), pp. 52–101. Two other essays on this painting are noteworthy: A. Kent Hieatt, "Eve as Reason in a Tradition of Allegorical Interpretation of the Fall," *Journal of the Warburg and Courtauld Institutes* 43 (1980), pp. 221–226; and by the same author, "Hans Baldung Grien's Ottawa *Eve* and Its Context," *Art Bulletin* 65 (1983), pp. 290–304.

5. Koerner, *Moment of Self-Portraiture,* p. 298, and p. 503 n. 18.

6. See Emmanuel Cooper, *The Sexual Perspective: Homosexuality and Art in the Last 100 Years in the West* (London: Routledge and Kegan Paul, 1986), p. 17, re this and other Bronzino paintings evoking incest.

7. On the issue of the painting's commission, see *National Gallery: Illustrated General Catalogue,* 2d ed., rev. (London: The National Gallery, 1986), p. 73; Braham, *Italian Paintings of the Sixteenth Century,* p. 64; and Gould, *Sixteenth-Century Italian Schools,* p. 43.

8. Ovid, *Metamorphoses,* trans. Rolfe Humphries (Bloomington: Indiana University Press, 1955), pp. 24–25 (1:690–712).

9. See further N.G.L. Hammond and H. H. Scullard, eds., *The Oxford Classical Dictionary,* 2d ed. (Oxford: Clarendon Press, 1970), p. 773; and Catherine B. Avery, ed., *The New Century Classical Handbook* (New York: Appleton-Century-Crofts, 1962), pp. 808–809.

10. The exhibition catalog *François Boucher, 1703–1170,* catalog entries by Alastair Laing (New York: The Metropolitan Museum of Art, 1986), p. 252.

11. Concerning engravings, drawings, similar images, and copies related to this painting, see Alexandre Ananoff and Daniel Wilderstein, *François Boucher,* 2 vols. (Paris: La Bibliothèque des Arts, 1976), vol. 2, p. 190.

12. See on this point Norman Bryson, *Tradition and Desire: From David to Delacroix* (Cambridge: Cambridge University Press, 1984), p. 130. See also Robert Rosenblum, *Jean-Auguste-Dominique Ingres* (New York: Harry N. Abrams, 1985), p. 78; and Eldon N. Van Liere, "Solutions and Dissolutions: The Bather in Nineteenth-Century French Painting," *Arts Magazine* 54 (May 1980), pp. 104–105.

13. Richard Ettinghausen, "Jean-Léon Gérôme as a Painter of Near Eastern Subjects," in the exhibition catalog *Jean-Léon Gérôme (1824–1904)* (Dayton, Ohio: The Dayton Art Institute, 1972), pp. 16–17.

14. Gerald M. Ackerman, "Gérôme's Oriental Paintings and the Western Genre Tradition," *Arts Magazine* 60 (March 1986), p. 75; and by the same author, *The Life and Work of Jean-Léon Gérôme, with a Catalogue Raisonne* (London: Sotheby's Publications, 1986), p. 46.

15. See MaryAnne Stevens, "Western Art and Its Encounter with the Islamic World, 1798–1914," in the exhibition catalog Stevens, ed., *The Orientalists: Delacroix to Matisse,* p. 21.

16. Louise d'Arnencourt, "Bouguereau and the Art Market in France," in *William Bouguereau, 1825–1905* (exhibition catalog) (Montreal: The Montreal Museum of Fine Arts, 1984), p. 95: His works were collected by a wealthy international clientele "most vividly personified by the millionaires of the New World, who were

as eager to decorate the newly plastered walls of their luxurious mansions as they were to construct the pedestals of their infant culture."

17. Alfred Werner, "The Return of Monsieur Bouguereau," *Art & Artists* 9, 12 (March 1975), p. 28.
 From the early 1880s to 1901 the painting was hung in the bar of the Hoffman House Hotel in New York, following a sale by its original American owner. There it was seen "by the wealthy and influential, since the Hoffman House was the social center for the rich and famous of business, politics, and show business— from Buffalo Bill to Ulysses S. Grant." From William H. Gerdts, *The Great American Nude: A History in Art* (New York: Praeger Publishers, 1974), p. 103.
 There is a considerable bibliography for this painting, for which, together with much additional information about its history, see the exhibition catalog *William Bouguereau (1825–1905)*, pp. 182–186. This volume contains useful essays on French *pompier* art in general, a biography and assessment of Bouguereau's work, and information on the marketing and collecting of his paintings. See also Hollis Clayson, *Painted Love: Prostitution in French Art of the Impressionist Era* (New Haven: Yale University Press, 1991), an excellent account of related subject matter (the discussion of a once-famous painting by Henri Gervex, *Rolla* [1878], pp. 79–90, is particularly good). Probably the most famous painting of a nude prostitute is Manet's *Olympia*, on which see T. J. Clark, *The Painting of Modern Life: Paris in the Art of Manet and His Followers* (Princeton: Princeton University Press, 1984), pp. 79–146; and Peter Brooks, "Storied Bodies, or Nana at Last Unveil'd," *Critical Inquiry* 16 (1989), pp. 1–32.

18. Michel Foucault, *The History of Sexuality*, vol. 1, *An Introduction*, trans. Robert Hurley (New York: Pantheon Books, 1978).

19. See Sander Gilman, "Black Bodies, White Bodies: Towards an Iconography of Female Sexuality in Late Nineteenth-Century Art, Medicine, and Literature," *Critical Inquiry* 12 (1985), pp. 204–242.

20. See, for example, Neil Hertz, "Medusa's Head: Male Hysteria Under Political Pressure," and a series of exchanges ("More About 'Medusa's Head' ") by Catherine Gallagher, Joel Fineman, and Neil Hertz, in *Representations* 4 (Fall 1983), pp. 27–72.

The Male Nude:
Identity and Denial

Richard Leppert

For Western painting over the past several centuries, the nude male body has presented a host of problems that intersect with but are distinct from those attached to the nude female body. These problems have confronted not only artists and the original audiences for their work but also the academic discipline of art history, responsible for organizing the more or less "official" discourse on the subject. . . .

For the male viewer, access to the sight of the nude female ordinarily serves as confirmation of male power, if only imagined. Access to the sight of the male nude is more complicated. If nudity is associated with shame, it is likewise associated with sexuality. Yet to be *looked at sexually* is to be consumed or taken *by sight*. Not for nothing is the gaze—the stare—said to be penetrating. The look per se is constituted wholly within the history of gender relations. Until recently if a man stared at a woman, she was expected to avert her eyes, thereby marking her awareness of his look and quickly deferring to its putative power, allowing herself to be taken in by him. But if one man stares at another, and the two are strangers, a confrontation is likely: "What are you looking at?" might be the query, uttered as a challenge, unless there is an unspoken sexual interest that they share. The stare, in other words, functions—and is by men *expected* to function—as a challenge, and the historical constancy of this fact is evident in Western literature dating back to the ancients.

Let me begin with a nude so well known and so often reproduced that there is no need to illustrate it here, the sculpture *David* (1501–1504) by Michelangelo, in marble and eighteen feet high. In the presence of this sculpture in situ in the Academy Gallery, Florence, it is nearly as interesting to watch the people looking as it is to gaze at the sculpture itself. What I have noticed is that women tend to take it in easily and comfortably and that men often do not. Viewers of both sexes seem to find the piece riveting, but men exhibit signs of being disconcerted. There is, of course, the simple fact that the sculpture is so profoundly different from what most men see in their bathroom mirrors. But there is more to the problem of looking than the male failure to measure up. Michelangelo virtually demands that viewers take pleasure in confronting David's body. Enormous, heroic, physically perfect, a technical tour de force to be sure, and—most of all—powerfully sexual. It is David's sexuality that Michelangelo demands that we acknowledge, though

not specifically as a sign of David's male agency but as a pleasurable sight in itself. Set on a pedestal, viewers must literally *look up* to take in the figure. The space of its current setting is somewhat confined in light of the sculpture's size; the viewer cannot take it in without active eye movement. The eyes must sweep from the figure's feet to its head, and since it is freestanding, viewers may move entirely around it, taking it in from every possible angle. The polished white body is there to be cruised; it is a spectacle, and the sculpture's confronting power is radically increased by the setting—a separate gallery in the museum, in which there is nothing else to look at.

If the male viewer looks away from the sculpted David, he is forced to acknowledge and confront his own discomfort; yet to look is to take in what in normal circumstances cannot be looked at. In the locker room, males learn early where *not* to focus their eyes and therefore go to self-conscious lengths to avoid such looking (or at least to avoid being caught at it). In short, in the presence of *David* many men do not know what to do with their eyes. Michelangelo is powerfully adept at making us want to look, but in looking we are forced to acknowledge, and at least partly to violate, a taboo. In essence, men are culturally forbidden to take pleasure in the look of the body of their own sex, though they are culturally required, at least in the present moment, to make their own specific bodies pleasurable sights to themselves and, presumably, to women.

The long-standing, still-current model for the most desirable and perfect body specimen is not from life but from art, not really from *David* but from its antecedents in the ancient world, in Greece and Rome. Yet from these beginnings the male body as an object of simultaneous emulation and desirability is also one of a contradiction that manifests itself in explicitly physical terms. As a sight, the ideal male body in art—and hence, so it would seem, in life—conflates with some sense of the physically and spiritually heroic, an embodied state and spiritual virtue seldom made available to women. Yet throughout the history of art the sort of male body that has been designated as "ideal" is consistently and paradoxically infused with female characteristics.

Thus ancient representations of Hercules commonly provided him with extremely exaggerated musculature distinctly, if oddly, feminizing—not unlike that of modern bodybuilders who attempt to emulate Hellenistic sculpture not only by isolating and hyperdeveloping separate muscles that can be pumped up for posing, but also by shaving all (presumably) but genital body hair and oiling their skin to replicate the surface texture of polished marble. Accordingly, their bodies become object-sights *as such*. The "strength" that they possess is literally for show only. Pumping iron is in part an activity preparatory to one's *being looked at by other men,* who populate the audience in posing competitions (so it seems, if to confuse things further, mostly for "straight" men). In contrast, exhibiting the same effect by different

means, many nineteenth-century paintings represent a distinctly soft, even slight, and explicitly feminized male as the ideal form, as we shall see.

The affecting power of the male nude in art lies in its ability to produce tension *in the male viewer*, who, when looking, is forced to acknowledge the power exerted on him by the ideal body of another male. Conversely, the nonideal male nude in art is incapable of producing this tension, thereby transferring agency entirely to the viewer, who may look in contempt, not desire, on the body of the lesser male. Yet to exert this power, the idealized body must become an object of desire, a transformation that culturally feminizes both the figure represented *and* the male viewer, given the culturally established rules of gendered looking.

Until recently the academic discipline of art history has maintained a general silence on the male nude, except to treat it as a subject of formal or compositional interest. That is, the literature on the male nude has largely avoided (and seemingly claimed no investment in) the sociocultural and sexual issues that so powerfully inform the general subject. This is unquestionably a reflection of male art historians—like other men—being uncomfortable discussing the male body in a public forum, despite the centrality of the subject in the history of art. This situation began to change only with the development of feminist studies in the human sciences, and most recently, with the appearance of gay and lesbian studies. For example, well into our own century, the homosexuality of Michelangelo—let alone that of numerous other canonic artists of highest caliber—was barely acknowledged, as though it was an "unfortunate" and embarrassing fact best kept quiet, *especially* concerning its real or potential impact on his art. . . .

Saintly Looks

In ecclesiastical painting, the representation of Saint Sebastian exemplifies how the male nude defines the paradoxes I have delineated. Sebastian was a Roman martyr, said to be a member of the Praetorian guard in the third century, secretly a Christian, and was executed for his beliefs by Emperor Diocletian. First shot through with arrows, he survived only to be beaten to death.[1] In this devotional picture, Sebastian is paired with the sainted Pope Fabian, because they share the same feast day in the Roman Catholic Church (at the bottom are also two small figures representing Brothers of the Misericordia). Sebastian is represented as a handsome and well-developed youth, his body repeatedly and rather decoratively pierced with arrows—which produce very little blood flow. Sebastian's refined face and elegant gestures acknowledge no suffering from his ordeal.

The sexuality of Sebastian's body is emphasized in numerous ways. In addition to his youth and general good looks, particular attention is given to highlighting his curly hair. His eyes are feminized by arching the eyebrows and exaggerating their almond shape—no such sexualization is awarded to

Fabian's features. The mouth is small and delicate. Typical of many early representations of this subject, the saint's loincloth, slung very low, is diaphanous, a type of fabric usually associated with women's costume. It allows the skin of his thighs to show through, though the genitals are discreetly, if barely, hidden. Sebastian's torso is heroic, almost surprisingly so in comparison with Fabian, virtually smothered in robes whose volume denies all sense of his corporeal being. Giovanni di Paolo carefully models Sebastian's chest and groin, delineating the anatomy—however inaccurately—and thereby making a visual issue of it. The sharply converging lines outlining the groin lead our eyes to what will *not quite* be shown and which, by being denied, is made all the more the focus of visual desire. In classical sculpture, male genitals are "stated"; they form part of a larger idealized whole, and relative to overall body proportions, they are often somewhat undersize, so that attention is taken from them. In much later art (by no means all), male genitals are, like those of women, hidden from view. But the hiding, characteristic of ecclesiastical art, often renders them a real issue, as an acknowledged taboo. The viewer is visually teased—and thereby made to want to look; officially speaking, the tease is a device for getting us to invest in the saint, and ideally, to desire to emulate him as we are drawn to his image. (Needless to say this is dangerous terrain; the desire produced can easily lead to its most secular of forms or to idolatry, or to both.)

The association of arrows to sexual love—Cupid's dart—is ancient, as is their association with male sexuality. . . . The penetration of Sebastian's body by arrows draws attention to his body and to his would-be martyrdom. But the lack of disfigurement, blood, and apparent suffering produce other effects. The arrows' explicitly decorative character, the attractive patterning they produce on his body, serve as adornment: The pierced body is made still more beautiful and desirable, an effect not out of keeping with religious veneration. . . .

The altarpiece of Saint Sebastian's martyrdom ascribed to Antonio and Piero del Pollaiuolo presents a particularly theatrical spectacle, richly colored and infinitely detailed. The viewer's eyes are tempted by a visual feast but supplied with one main course, Sebastian's body, at once entrée and dessert. The painting's religious sentiment is driven by secular pleasure, by *embodied* desire mapped onto the panel and transposed onto the viewer. The practically naked Sebastian is set on a pedestal of sorts that forms the apex of a compositional triangle whose base is outlined by the other men shooting arrows at him. The viewer's eyes are almost forcibly drawn upward to Sebastian's white body, bound *loosely* to the tree, weight shifted to one leg to affect a nearly relaxed stance, *almost* as though he were there voluntarily. The picture's climax is reached in Sebastian's face and head, inclining slightly backward and to the side, which thereby creates a visual tension by throwing the pyramid slightly off balance at its peak. The tilted head and the facial expression together replicate the look of ecstasy. . . .

Attributed to Antonio Pollaiuolo, **The Martyrdom of St. Sebastian.** *c. 1475, Wood panel. (Archivi Alinari/Art Resource, NY)*

The painting's eroticism depends upon, and is partly driven by, the drapery covering the saint's body: "In the figurative arts, eroticism appears as a relationship between clothing and nudity."[2] Indeed, as Anne Hollander has shown, the nude in art is usually rendered in relation to the clothed figure of the same historical moment. The nude depends on its clothed "other," or counterpart, for its effect on the viewer, for its meanings, and indeed, for its very form. "The more significant clothing is, the more meaning attaches to its absence, and the more awareness is generated about any relation between the two states."[3] Sebastian's drapery produces the satisfaction in looking that comes from the frustrated realization that one can never be satisfied by looking. The painting freezes an action, an undressing that will only go *this* far. Sebastian is made the more sexual by his loincloth's not only being wrapped

too low on his hips but also fastened by an obviously phallic knot that sub-stitutes for and reminds the viewer of what is hidden. These sexual effects are increased by a subtle bit of color change at the groin that hints of pubic hair on his otherwise entirely smooth body.

Male homoerotic sexual desire is repeatedly inscribed in the bodies of his torturers, not least in the man in the lower left center who bends down to load his crossbow and, in the process, extends his well-shaped backside for our viewing pleasure. More important, there is an explicit pleasurable tension between the passive, even languid, Sebastian and the archers whose bodies, muscles bulging, are tensed to their aggressive task. Sebastian waits to be penetrated—deeply: The arrows in the bows are far longer than the visible parts of those already piercing him. The active-passive binary driv-ing the relationship is virtually one of violent courtship. In short, it is nei-ther accidental nor surprising that the Saint Sebastian story provided a narrative through which homoerotic desire could be sanctioned as a sight.[4] . . .

Phallic Disappointment

Antonio del Pollaiuolo's famous engraving from the late fifteenth century of a combat of nude men erases the quasi-passive, feminized discourse typical to Saint Sebastian imagery in favor of an aggressive, highly physical mas-culinity, yet one at least as improbable as the sort imagined for the saint. Pollaiuolo exaggerates musculature: He shows each body in tension, even that of the man at the lower right at the moment of his impaling. The black and white of the print, subtly modeled, adds to the starkness of the overall effect. The male bodies are inexplicably nude, since nudity in battle renders them more vulnerable to attack. The illogic of their nudity serves to focus more attention on the state of nudity itself. It makes an issue of the nude body as a metaphor, perhaps, as some scholarly work suggests, providing a cri-tique of the "despicable body" as the prison of the soul.[5]

The engraving strips men of their clothes, provides them with heroic bodies, and *duplicates* them. Masculinity is portrayed as a *physical* trait, entirely divorced from the abstractions of character, notably *virtus* (manly excellence). Masculinity *is* aggression. . . . The battleground serves as a prin-cipal site on which to display the "reality" and impact of masculinity envi-sioned in hyperbolic physical form: Entire Body as Phallus. But herein lies a problem for the very masculine identity the image attempts so forcefully to imagine.

It is worth noting that the majority of male nudes in the history of West-ern painting have their genitals shielded from view, a representational deci-sion that is about more than modesty. Shielding gives to the male body an effect similar to that of the female whose sexual parts are by nature anatom-ically "invisible," hence never quite to be visually "had." The crucial myth constituting masculinity remains intact by not being subjected to visual test-ing. That is, to make visible the male sexual parts in art causes considerable

risk to the fragile state of male identity that hinges, culturally speaking, on genital accounts of masculinity (men constructing themselves by the common denominator of their sexual parts, to which are assigned putatively heroic tasks and physical proportions).

But as Pollaiuolo's image broadly hints, the male genitals when made visible prove to be the *least* heroic parts of their otherwise heroic bodies. Every muscle in Pollaiuolo's nude combatants is tensed save the "muscle" of their sexual erectal tissue. That hangs limply and with extreme vulnerability, given the circumstances of the narrative. To "tense" that organ, after all, would only render it more vulnerable and also admit to a different kind of excitement in the presence of other men, thereby violating one of the strongest cultural proscriptions. . . .

There is a related issue concerning the male genitals and the act of looking, namely, *who* is looking and what they make of what they see. Most art was acquired by men, and it therefore functioned principally in their interests and as a barometer of their concerns. But for art to function to its full potential as a sociocultural agent, it must be seen by others and not just by its "owner." With very few exceptions, art was displayed with the presumption that both men *and women* would see it. In regard to the male nude, exposure of the penis to the sight of women presented a psychological and political problem for men, to the extent that men's own identity and agency visibly hung by such a visually disappointing thread: "Women may feel cheated, as if the terrorist who has held them hostage and threatened with the pistol in his pocket, turns out to be armed only with a finger!"[6] During the Renaissance, the reawakened fascination with the male body was by no means confined to visual art. It was, for example, powerfully articulated as well in upper-class male fashion. In their costuming, men sought to accentuate their sexual bulges. They inserted codpieces to amplify their genitals to a degree that now appears almost comical and wore brightly colored, attention-getting, form-fitting tights that accentuated their buttocks—not least because they were seamed in the back. All was kept fully visible by wearing only very short doublets that barely extended below the waist.[7]

Body Reversal?

Sandro Botticelli's *Venus and Mars* invests heavily in the nude male. The painting's unusual dimensions—its extreme and unconventional horizontal length—at once makes possible the supine repose of the principal protagonist and attracts viewers' attention by its strange shape. In essence a bedroom scene,[8] the painting's subject is denoted, if problematically, by the phallic lance pointing paradoxically *toward* Mars, as though it were an instrument of Venus, and not Mars's own weapon. Venus's eyes, and ours, are on his body, whose head assumes roughly the same pose and "look" of Pollaiuolo's Saint Sebastian. In this instance, by nature of the identified subject, involving two of mythology's most famous lovers, the erotic intent is underscored.

Anne Hollander argues that the painting's erotic content is precipitated by the fashion of a completely dressed Venus wearing a modern costume, in contrast to Mars, whose drapery is merely standard issue for a mythological deity, having nothing to do with Renaissance modernity. "It is her complete, unruffled clothing that provides the sexual voltage for his nakedness, to a much greater degree than if she, too, were wearing loose drapery. Her modern clothes show her sexual dominance as much as her wakefulness does, and they make his bareness more erotic, despite his mythological trappings."[9] The eroticism of Botticelli's painting depends upon a stark reversal in which the nude male is made subject to a woman and to the gaze, both hers and ours.

The articulation of Mars's body employs rhetorical devices conventionally reserved in Western painting for the female body. The warrior god is transformed into a piece of well-shaped, smooth and highly refined (vaguely delicate), and oddly *soft,* sculpture. His lower torso is virtually feminine, his color is notably light, and his body is hairless in those locales where painters would commonly hint of hair, at the groin and armpits. On balance, Mars is very much something to look at, and he is made a sight by means of a quite obvious fiction. He assumes—quite theatrically—a *pose* of sleep, for the position he assumes does not replicate any body position in which true sleep is possible. He actually props himself up slightly—there is nothing behind him to support the upper part of his back. His left arm, though limp, implies its use as a support for his position. His right leg, prominently bent, would fall to the side, were he asleep. Yet his right hand and his facial expression resonate with loss of consciousness. The myth, told by Homer and Ovid,[10] makes clear a sexual adventure, and his own nudity essentially insists on that as a pretext to the picture—valorous Mars, god of war, does not let down his guard for no purpose.

Mars sleeps, but only sort of; postcoital bliss is hinted at, though the lovers do not lie side by side but face one another. Venus's facial beauty is striking, and her full breasts and left leg are emphasized and well defined under the thin drapery, all of it making her distinctly sexual. Yet she is *not* in a postorgasmic state. . . . [Venus] is pensive, reserved, and indeed, she very much commands the scene by her own act of looking. She holds Mars in *her* gaze and by this means leads our eyes to him, where we find our own point of concentration.

Mars's very name carries the cachet of masculinity. This allows Botticelli the opportunity to preserve the prerogative of masculinity's conventional associations simply by naming him Mars—rather like calling him John Wayne today. At the same time, he takes off Mars's armor to show what is underneath: his sensual body, whose powers are more subtle but no less real. Mars captivates Venus and the viewer, who must be presumed to be male. Venus's staring at Mars tacitly acknowledges that she cannot take her eyes off him. Even in a state of unconsciousness, in other words, Mars's agency

remains intact. Nonetheless, what those riveted eyes see is Mars having lost himself to a woman, having *become* a sight instead of using his own gaze as a sign and source of his power.

The Mars mythology, virtually a cliché to Botticelli's audience, defines one side of his power; his physical beauty defines another. . . . [Mars is] androgynous—a characteristic in the Italian Renaissance that more than once defined the ideal *imaginary* male. As one sixteenth-century art theorist put it with regard to Titian's 1554 painting of Venus and Adonis, a man having "a touch of the beautiful woman [was] a difficult and pleasing mixture."[11] On balance, the painting plays brilliantly with a visually destabilizing blend of excitement, attraction, response, and—not least important—with reversal of culturally assigned sexual identities and sexual roles, as well as with an alternative to sanctioned discourses of seeing. Seeing *Venus and Mars,* in other words, invites us to imagine physical and psychic delights that might result from seeing things differently.

Youth, Death, and Sanctioned Desire

The Genesis story of Cain's murder of his brother Abel (4:1–15) provided artists with an opportunity for display of the male body in a state of collapse, specifically the young and athletically beautiful body, whose nudity was sanctioned by scriptural account, paralleling the sanction available by resorting to the mythologies of pagan deities and heroes. Abel was a shepherd, an "early" version of the human, hence "naturally" close to nature. His parents' expulsion from the Garden of Eden had been told only two Bible verses prior to the introduction of Abel's character (Genesis 3:24, the final verse of the chapter, and Genesis 4:2, respectively). In God's eyes, Abel is the good brother, whose sacrifice of the first of his flock to God's honor serves to prefigure Christ as the Good Shepherd, whose self-sacrifice brings the promise of salvation to all children of Adam. The moral good spiritually embodied in Abel is made visible in representation by the usual means, by assigning him great physical beauty and showing him in the tragic state of his recent demise, cut down in his early prime.

In a culture long since given to marking the body as, at best, the prison of the nobler soul and, at worst, as that which drives our sinful, notably lustful natures, the sight of Abel's body lends itself to a paradoxical reading. Abel's story prefigures Christ's self-sacrifice, hence it carries enormous theological significance. But François-Xavier Fabre's *Death of Abel* treats its subject more like a fallen god, as much at home in a Homeric myth as a scriptural narrative. Anything that might pass for specifically religious convictions attending the representation is extinguished by the powerful impact of Abel's beautiful dead body, essentially made a *sexual* spectacle—with no sign of disfigurement from his being murdered. The painting's devotional content, overwhelmed by its sensualism, is not terribly surprising in that the painting was produced during the French Revolution, a period in French

history not noted for its ecclesiastical fervor. It is fair to say that this painting, like many other erotic images produced during the eighteenth and nineteenth centuries, fundamentally made use of both religious and mythological stories as convenient "covers" for representing what otherwise might not be represented. . . .

Fabre's Abel is painted as an ephebe, in ancient Greece an athletic youth of eighteen to twenty years—part boy, but mostly man. And entirely typical of ephebe representations from the late eighteenth century and throughout the nineteenth, he is masculine but also feminine. The ephebe is not hard and heroic in the Herculean sense. . . . Instead, he is marked with boyish softness. The ephebe resonates with sexuality precisely to the extent that his sexuality is ambiguous or, perhaps better, unstable. His body and its beauty is unfixed, momentary, and evolving. It is represented at an *imagined* moment, frozen in art, suspended between states, as omnisexual: boy-man, feminine-masculine. . . .

The audience for this art was principally male and, it must be presumed, not on balance homosexual, despite the obvious homoerotic appeal.[12] It is this seeming paradox that lays challenge to any neat boundaries we prefer to establish between either-or sexualities. All people learn by looking: Establishing identity depends on looking at one's own gender, at others like oneself. That is, "the stability of masculinity depends upon the visibility of the male body; to be learnt or consolidated, masculinity requires a visual exchange between men."[13] Furthermore, looking engenders not only "education" but also desires, which by their very nature inevitably involve the body and commonly—though not always—the erotic, narrowly conceived. Yet because of powerful proscriptions against homoeroticism, the male looking at the self through the same-sex Other is at best problematic. In no small part this explains why men organize their looking at other men in specifically sanctioned venues, those of professional sports especially, which, after all, exist to be viewed.[14] . . .

. . . Representation played a crucial role as part of the discursive apparatus through which identities were constructed and projected. As such, representation is entirely caught up in the process both as mirror and agent: "A confusion at the level of sexuality brings with it a disturbance of the visual field."[15] Ephebe imagery provided men, whether hetero- or homosexual, with a visual source by which to re-view themselves not as they were but as they might be (or might have been): young and literally physically free to be what culturally was disallowed—beautiful, ambiguous, and *desirable*. Bodybuilding equipment advertising smartly plays off identical ambiguities regarding desire. It avoids both the dangerous choice of same-sex desire and the cliché of opposite-sex attraction such as 1950s comic book back-cover ads for Charles Atlas bodybuilding (how to get the girl of your dreams with a dream body). Nowadays, such advertising centers around narcissism—whose referent, Narcissus, was long a popular theme in painting—the

desirous looking at the male self, a self-directed, but still homoerotic, falling in love *with a look,* one that conveniently excludes women by making them entirely irrelevant. This narcissism, however, does not ignore the feminine but, in effect, "colonizes" it, takes it in as part and parcel of the masculine. In one sense we might argue for a progressive masculinity that both acknowledges and valorizes the feminine, but this is an insufficient accounting, to the extent that a masculinity defined in these terms simultaneously seems to excise the female (as opposed to the feminine) entirely from the visual field.[16]. . .

Notes

1. James Hall, *Dictionary of Subjects and Symbols in Art* (New York: Harper and Row, 1974), pp. 276–277; and Louis Réau, *Iconographie de l'art chrétien,* 3 vols. in 6 (Paris: Presses Universitaires de France, 1955–1959), vol. 3, part 2, pp. 1190–1199.

2. Mario Perniola, "Between Clothing and Nudity," trans. Roger Freidman, in *Fragments for a History of the Human Body,* ed. Michel Feher, with Ramona Naddaff and Nadia Tazi, 3 vols. (New York: Zone, 1989), vol. 2, p. 237.

3. Anne Hollander, *Seeing Through Clothes* (Harmondsworth: Penguin Books, 1988), p. 83; see also p. xiii.

4. For more on this painting see Leopold D. Ettlinger, *Antonio and Piero Pollaiuolo: Complete Edition with a Critical Catalogue* (Oxford: Phaidon, 1978), pp. 48–51, 139–140.

5. See further Patricia Emison, "The Word Made Naked in Pollaiuolo's *Battle of the Nudes,*" *Art History* 13 (1990), p. 265. Also on this engraving see Ettlinger, *Antonio and Piero Pollaiuolo,* pp. 146–147; and L. Richards, "Antonio Pollaiuolo, *Battle of Naked Men,*" *Bulletin of the Cleveland Museum of Art* 55 (1968), pp. 62–70.

6. Kent, "Looking Back," p. 72.

7. Hollander, *Seeing Through Clothes,* p. 234.

8. See Herbert P. Horne, *Botticelli: Painter of Florence* (Princeton: Princeton University Press, 1980), p. 140, according to whom it was "probably executed for the panel of a bed, or couch, or some such piece of furniture."

9. Hollander, *Seeing Through Clothes,* p. 179.

10. See Hall, *Dictionary of Subjects and Symbols in Art* (New York: Harper and Row, 1974), p. 320.

11. Quoted in Sharon Fermor, "Movement and Gender in Sixteenth-Century Italian Painting," in *The Body Imaged: The Human Form and Visual Culture Since the Renaissance,* ed. Kathleen Adler and Marcia Pointon (Cambridge: Cambridge University Press, 1993), p. 129. For information concerning homoerotic themes in the Renaissance, see Leonard Barkan, *Ganymede and the Erotics of Humanism* (Stanford: Stanford University Press, 1991); James M. Saslow, *Ganymede in the Renaissance: Homosexuality in Art and Society* (New Haven: Yale University Press, 1986); and Emmanuel Cooper, *The Sexual Perspective: Homosexuality and Art in the Last 100 Years in the West* (New York: Routledge and Kegan Paul, 1986), pp. 1–23. For more on Botticelli's *Venus and Mars,* including detailed accounts of the allegory it unfolds, see Ronald Lightbrown, *Sandro Botticelli: Life and Work* (Berkeley and

Los Angeles: University of California Press, 1978), pp. 90–93; Liana Cheney, *Quattrocento Neoplatonism and Medici Humanism in Botticelli's Mythological Paintings* (Lanham, Md.: University Press of America, 1985), pp. 35–37, 60–61, 66–70; and Homan Potterton, *The National Gallery, London* (London: Thames and Hudson, 1977), p. 36.

12. See Solomon-Godeau, "Male Trouble," pp. 311–312 n. 37.

13. Michael Hatt, "Muscles, Morals, Mind: The Male Body in Thomas Eakins' *Salutat*," in *The Body Imaged: The Human Form and Visual Culture Since the Renaissance,* ed. Kathleen Adler and Marcia Pointon (Cambridge: Cambridge University Press, 1993), p. 63.

14. See the valuable study by Whitney Davis, "Erotic Revision in Thomas Eakins's Narratives of Male Nudity," *Art History* 17 (1994), pp. 301–341.

15. Jacqueline Rose, *Sexuality in the Field of Vision* (London: Verso, 1986), p. 228.

16. I am taking the notion of colonization from Solomon-Godeau, "Male Trouble," p. 295.

Chapter 19

Modernity and the Spaces of Femininity

Griselda Pollock

Introduction

. . . [W]e must inquire why the territory of modernism so often is a way of dealing with masculine sexuality and its sign, the bodies of women—why the nude, the brothel, the bar? What relation is there between sexuality, modernity and modernism? If it is normal to see paintings of women's bodies as the territory across which men artists claim their modernity and compete for leadership of the avant-garde, can we expect to rediscover paintings by women in which they battled with their sexuality in the representation of the male nude? Of course not; the very suggestion seems ludicrous. But why? Because there is a historical asymmetry—a difference socially, economically, subjectively between being a woman and being a man in Paris in the late nineteenth century. This difference—the product of the social structuration of sexual difference and not any imaginary biological distinction—determined both what and how men and women painted.

I have long been interested in the work of Berthe Morisot (1841–1896) and Mary Cassatt (1844–1926), two of the four women who were actively involved with the Impressionist exhibiting society in Paris in the 1870s and 1880s who were regarded by their contemporaries as important members of the artistic group we now label the Impressionists.[1] But how are we to study the work of artists who are women so that we can discover and account for the specificity of what they produced as individuals while also recognizing that, as women, they worked from different positions and experiences from those of their colleagues who were men?

Sexuality, modernism or modernity cannot function as given categories to which we add women. That only identifies a partial and masculine viewpoint with the norm and confirms women as other and subsidiary. Sexuality, modernism or modernity are organized by and organizations of sexual difference. To perceive women's specificity is to analyze historically a particular configuration of difference.

This is my project here. How do the socially contrived orders of sexual difference structure the lives of Mary Cassatt and Berthe Morisot? How did

From *The Expanding Discourse* by Norma Broude and Mary D. Garrard. Copyright © 1992. Reprinted by permission of Perseus Books LL.

that structure what they produced? The matrix I shall consider here is that of space.

Space can be grasped in several dimensions. The first refers us to spaces as locations. What spaces are represented in the paintings made by Berthe Morisot and Mary Cassatt? And what are not? A quick list includes:

dining rooms
drawing rooms
bedrooms
balconies/verandas
private gardens

The majority of these have to be recognized as examples of private areas or domestic space. But there are paintings located in the public domain—scenes, for instance, of promenading, driving in the park, being at the theater, boating. They are the spaces of bourgeois recreation, display and those social rituals which constituted polite society, or Society, *Le Monde*. In the case of Mary Cassatt's work, spaces of labor are included, especially those involving child care. In several examples, they make visible aspects of working-class women's labor within the bourgeois home.

I have previously argued that engagement with the Impressionist group was attractive to some women precisely because subjects dealing with domestic social life hitherto relegated as mere genre painting were legitimized as central topics of the painting practices.[2] On closer examination it is much more significant how little of typical Impressionist iconography actually reappears in the works made by artists who are women. They do not represent the territory which their colleagues who were men so freely occupied and made use of in their works—for instance, bars, cafés, backstage and even those places which Clark has seen as participating in the myth of the popular—such as the bar at the Folies-Bergère or even the Moulin de la Galette. A range of places and subjects was closed to them while open to their male colleagues, who could move freely with men and women in the socially fluid public world of the streets, popular entertainment and commercial or casual sexual exchange.

The second dimension in which the issue of space can be addressed is that of the spatial order within paintings. Playing with spatial structures was one of the defining features of early modernist painting in Paris, be it Manet's witty and calculated play upon flatness or Degas's use of acute angles of vision, varying viewpoints and cryptic framing devices. With their close personal contacts with both artists, Morisot and Cassatt were no doubt party to the conversations out of which these strategies emerged and equally subject to the less conscious social forces which may well have conditioned the predisposition to explore spatial ambiguities and metaphors.[3] Yet although there are examples of their using similar tactics, I would like to suggest that spatial devices in the work of Morisot and Cassatt work to a wholly different effect.

A remarkable feature in the spatial arrangements in paintings by Morisot is the juxtaposition on a single canvas of two spatial systems—or at least of two compartments of space often obviously boundaried by some device such as a balustrade, balcony, veranda or embankment whose presence is underscored by facture. . . . In *On the Balcony,* 1872 the viewer's gaze over Paris is obstructed by the figures who are nonetheless separated from that Paris as they look over the balustrade from the Trocadéro, very near to Morisot's home.[4] The point can be underlined by contrasting a painting by Monet, *The Garden of the Princess,* 1867, where the viewer cannot readily imagine the point from which the painting has been made, namely a window high in one of the new apartment buildings, and instead enjoys a fantasy of floating over the scene. What Morisot's balustrades demarcate is not the boundary between public and private but between the spaces of masculinity and of femininity inscribed at the level of both what spaces are open to men and women and what relation a man or woman has to that space and its occupants.

In Morisot's paintings, moreover, it is as if the place from which the painter worked is made part of the scene, creating a compression or immediacy in the foreground spaces. This locates the viewer in that same place, establishing a notional relation between the viewer and the woman defining the foreground, therefore forcing the viewer to experience a dislocation between her space and that of a world beyond its frontiers.

Proximity and compression are also characteristic of the works of Cassatt. Less often is there a split space but it occurs, as in *Susan on a Balcony,* 1883. More common is a shallow pictorial space which the painted figure dominates, as in *Young Woman in Black: Portrait of Mrs. Gardner Cassatt,* 1883. The viewer is forced into a confrontation or conversation with the painted figure while dominance and familiarity are denied by the device of the averted head of concentration on an activity by the depicted personage. What are the conditions for this awkward but pointed relation of the figure to the world? Why this lack of conventional distance and the radical disruption of what we take as the normal spectator-text relations? What has disturbed the "logic of the gaze"?

I now want to draw attention in the work of Mary Cassatt to the disarticulation of the conventions of geometric perspective which had normally governed the representation of space in European painting since the fifteenth century. Since its development in the fifteenth century, this mathematically calculated system of projection had aided painters in the representation of a three-dimensional world on a two-dimensional surface by organizing objects in relation to each other to produce a notional and singular position from which the scene is intelligible. It establishes the viewer as both absent from and indeed independent of the scene while being its mastering eye/I.

It is possible to represent space by other conventions. Phenomenology has been usefully applied to the apparent spatial deviations of the world of

Van Gogh and Cézanne.[5] Instead of pictorial space functioning as a notional box into which objects are placed in a rational and abstract relationship, space is represented according to the way it is experienced by a combination of touch, texture, as well as sight. Thus objects are patterned according to subjective hierarchies of value for the producer. Phenomenological space is not orchestrated for sight alone but by means of visual cues refers to other sensations and relations of bodies and objects in a lived world. As experiential space this kind of representation becomes susceptible to different ideological, historical, as well as purely contingent, subjective inflections. . . .

The spaces of femininity operated not only at the level of what is represented, the drawing room or sewing room. The spaces of femininity are those from which femininity is lived as a positionality in discourse and social practice. They are the product of a lived sense of social locatedness, mobility and visibility, in the social relations of seeing and being seen. Shaped within the sexual politics of looking they demarcate a particular social organization of the gaze, which itself works back to secure a particular social ordering of sexual difference. Femininity is both the condition and the effect.

How does this relate to modernity and modernism? As Janet Wolff has convincingly pointed out, the literature of modernity describes the experi-

Mary Cassatt (1844–1926), **A Cup of Tea**. *1880, Oil on canvas. (Museum of Fine Arts, Boston)*

ence of men.[6] It is essentially a literature about transformations in the public world and its associated consciousness. It is generally agreed that modernity as a nineteenth-century phenomenon is a product of the city. It is a response in a mythic or ideological form to the new complexities of a social existence passed among strangers in an atmosphere of intensified nervous and psychic stimulation, in a world ruled by money and commodity exchange, stressed by competition and formative of an intensified individuality, publicly defended by a blasé mask of indifference but intensely "expressed" in a private, familial context.[7] Modernity stands for a myriad of responses to the vast increase in population leading to the literature of the crowds and masses, a speeding up of the pace of life with its attendant changes in the sense and regulation of time and fostering that very modern phenomenon, fashion, the shift in the character of towns and cities from being centers of quite visible activities—manufacture, trade, exchange—to being zoned and stratified, with production becoming less visible while the centers of cities such as Paris and London become key sites of consumption and display producing what Sennett has labeled the spectacular city.[8]

All these phenomena affected women as well as men, but in different ways. What I have described above takes place within and comes to define the modern forms of the public space changing as Sennett argues in his book significantly titled *The Fall of Public Man* from the eighteenth-century formation to become more mystified and threatening but also more exciting and sexualized. One of the key figures to embody the novel forms of public experience of modernity is the flâneur, or impassive stroller, the man in the crowd who goes, in Walter Benjamin's phrase, "botanizing on the asphalt."[9] The flâneur symbolizes the privilege or freedom to move about the public arenas of the city observing but never interacting, consuming the sights through a controlling but rarely acknowledged gaze, directed as much at other people as at the goods for sale. The flâneur embodies the gaze of modernity which is both covetous and erotic.

But the flâneur is an exclusively masculine type which functions within the matrix of bourgeois ideology through which the social spaces of the city were reconstructed by the overlaying of the doctrine of separate spheres on to the division of public and private, which became as a result a gendered division.

As both ideal and social structure, the mapping of the separation of the spheres for women and men on to the division of public and private was powerfully operative in the construction of a specifically bourgeois way of life. It aided the production of the gendered social identities by which the miscellaneous components of the bourgeoisie were helped to cohere as a class, in difference from both aristocracy and proletariat. Bourgeois women, however, obviously went out in public, to promenade, go shopping, or visiting or simply to be on display. And working-class women went out to work, but that fact presented a problem in terms of definition as woman. For

instance, Jules Simon categorically stated that a woman who worked ceased to be a woman.[10] Therefore, across the public realm lay another, less often studied map which secured the definitions of bourgeois womanhood—femininity—in difference from proletarian women.

For bourgeois women, going into town and mingling with crowds of mixed social composition was not only frightening because it became increasingly unfamiliar, but because it was morally dangerous. It has been argued that to maintain one's respectability, closely identified with femininity, meant *not* exposing oneself in public. The public space was officially the realm of and for men; for women to enter it entailed unforeseen risks. . . .

The private realm was fashioned for men as a place of refuge from the hurly-burly of business, but it was also a place of constraint. The pressures of intensified individuality protected in public by the blasé mask of indifference, registered in the equally socially induced roles of loving husband and responsible father, led to a desire to escape the overbearing demands of masculine domestic personae. The public domain became also a realm of freedom and irresponsibility if not immorality. This, of course, meant different things for men and for women. For women, the public spaces thus construed were where one risked losing one's virtue, dirtying oneself; going out in public and the idea of disgrace were closely allied. For the man going out in public meant losing oneself in the crowd away from both demands of respectability. Men colluded to protect this freedom. Thus a woman going out to dine at a restaurant even with her husband present was scandalous, whereas a man dining out with a mistress, even in the view of his friends, was granted a fictive invisibility.[11]

The public and private division functioned on many levels. As a metaphorical map in ideology, it structured the very meaning of the terms masculine and feminine within its mythic boundaries. In practice as the ideology of domesticity became hegemonic, it regulated women's and men's behavior in the respective public and private spaces. Presence in either of the domains determined one's social identity and therefore, in objective terms, the separation of the spheres problematized women's relation to the very activities and experiences we typically accept as defining modernity.

In the diaries of the artist Marie Bashkirtseff, who lived and worked in Paris during the same period as Morisot and Cassatt, the following passage reveals some of the restraints:

> What I long for is the freedom of going about alone, of coming and going, of sitting in the seats of the Tuileries, and especially in the Luxembourg, of stopping and looking at the artistic shops, of entering churches and museums, of walking about old streets at night; that's what I long for; and that's the freedom without which one cannot become a real artist. Do you imagine that I get much good from what I see, chaperoned as I am, and when, in order to go to the Louvre, I must wait for my carriage, my lady companion, my family?[12]

These territories of the bourgeois city were, however, gendered not only on a male/female polarity. They became the sites for the negotiation of gen-

dered class identities and class gender positions. The spaces of modernity are where class and gender interface in critical ways, in that they are the spaces of sexual exchange. The significant spaces of modernity are neither simply those of masculinity, nor are they those of femininity, which are as much the spaces of modernity for being the negative of the streets and bars. They are, as the canonical works indicate, the marginal or interstitial spaces where the fields of the masculine and feminine intersect and structure sexuality within a classed order.

The Painter of Modern Life

One text above all charts this interaction of class and gender. In 1863 Charles Baudelaire published in *Le Figaro* an essay entitled "The Painter of Modern Life." In this text the figure of the flâneur is modified to become the modern artist while at the same time the text provides a mapping of Paris marking out the sites/sights for the flâneur/artist. The essay is ostensibly about the work of a minor illustrator Constantin Guys, but he is only a pretext for Baudelaire to weave an elaborate and impossible image of his ideal artist, who is a passionate lover of crowds and, incognito, a man of the world.

> The crowd is his element as the air is that of birds and water of fishes. His passion and profession are to become one flesh with the crowd. For the perfect flâneur, for the passionate spectator, it is an immense joy to set up house in the heart of the multitude, amid the ebb and flow of movement, in the midst of the fugitive and the infinite. To be away from home and yet feel oneself everywhere at home; to see the world and to be the centre of the world and yet remain hidden from the world—such are a few of the slightest pleasures of those independent, passionate, impartial natures which the tongue can but clumsily define. The spectator is a *prince* and everywhere rejoices in his incognito. The lover of life makes the whole world his family.[13]

The text is structured by an opposition between home, the inside, the domain of the known and constrained personality and the outside, the space of freedom, where there is liberty to look without being watched or even recognized in the act of looking. It is the imagined freedom of the voyeur. In the crowd the flâneur/artist sets up home. Thus the flâneur/artist is articulated across the twin ideological formations of modern bourgeois society—the splitting of private and public with its double freedom for men in the public space, and the preeminence of a detached observing gaze, whose possession and power is never questioned as its basis in the hierarchy of the sexes is never acknowledged. For as Janet Wolff has recently argued, there is no female equivalent of the quintessential masculine figure, the flâneur; there is not and could not be a female flâneuse.

Women did not enjoy the freedom of incognito in the crowd. They were never positioned as the normal occupants of the public realm. They did not have the right to look, to stare, scrutinize or watch. As the Baudelairean text goes on to show, women do not look. They are positioned as the *object* of the flâneur's gaze. . . .

Indeed woman is just a sign, a fiction, a confection of meanings and fantasies. Femininity is not the natural condition of female persons. It is a historically variable ideological construction of meanings for a sign W*O*M*A*N, which is produced by and for another social group, which derives its identity and imagined superiority by manufacturing the specter of this fantastic Other. WOMAN is both an idol and nothing but a word. Thus when we come to read the chapter of Baudelaire's essay titled "Women and Prostitutes," in which the author charts a journey across Paris for the flâneur/artist, where women appear merely to be there as spontaneously visible objects, it is necessary to recognize that the text is itself constructing a notion of WOMAN across a fictive map of urban spaces—the spaces of modernity.

The flâneur/artist starts his journey in the auditorium, where young women of the most fashionable society sit in snowy white in their boxes at the theater. Next he watches elegant families strolling at leisure in the walks of a public garden, wives leaning complacently on the arms of husbands while skinny little girls play at making social class calls in mimicry of their elders. Then he moves on to the lowlier theatrical world, where frail and slender dancers appear in a blaze of limelight admired by fat bourgeois men. At the café door, we meet a swell while indoors is his mistress, called in the text "a fat baggage," who lacks practically nothing to make her a great lady except that practically nothing is practically everything for it is distinction (class). Then we enter the doors of Valentino's, the Prado or Casino, where against a background of hellish light, we encounter the protean image of wanton beauty, the courtesan, "the perfect image of savagery that lurks in the heart of civilization." Finally by degrees of destitution, he charts women, from the patrician airs of young and successful prostitutes to the poor slaves of the filthy stews.

Baudelaire's essay maps a representation of Paris as the city of women. It constructs a sexualized journey which can be correlated with Impressionist practice. Clark has offered one map of Impressionist painting following the trajectories of leisure from city center by suburban railway to the suburbs. I want to propose another dimension of that map, which links Impressionist practice to the erotic territories of modernity. . . . From the loge pieces by Renoir (admittedly not women of the highest society) to the *Musique aux Tuileries* of Manet, Monet's park scenes and others easily cover this terrain where bourgeois men and women take their leisure. But then when we move backstage at the theater, we enter different worlds, still of men and women but differently placed by class. Degas's pictures of the dancers on stage and rehearsing are well known. Perhaps less familiar are his scenes illustrating the backstage at the Opéra where members of the Jockey Club bargain for their evening's entertainment with the little performers. Both Degas and Manet represented the women who haunted cafés, and as Theresa Ann Gronberg has shown, these were working-class women often suspected of touting for custom as clandestine prostitutes.[14] . . .

Women and the Public Modern

The artists who were women in this cultural group of necessity occupied this map but partially. They can be located all right but in spaces above a decisive line. *Lydia at the Theater*, 1879, and *The Loge*, 1882 [by Cassatt], situate us in the theater with the young and fashionable but there could hardly be a greater difference between these paintings and the work by Renoir on this theme, *The First Outing*, 1876 (London, National Gallery of Art), for example.

The stiff and formal poses of the two young women in the painting by Cassatt were precisely calculated, as the drawings for the work reveal. Their erect postures, one woman carefully grasping an unwrapped bouquet, the other sheltering behind a large fan, create a telling effect of suppressed excitement and extreme constraint, of unease in this public place, exposed and dressed up, on display. They are set at an oblique angle to the frame so that they are not contained by its edges, not framed and made a pretty picture for us as in *The Loge* by Renoir, where the spectacle at which the scene is set and the spectacle the woman herself is made to offer merge for the unacknowledged but presumed masculine spectator. In Renoir's *The First Outing* the choice of a profile opens out the spectator's gaze into the auditorium and

Mary Cassatt (1844–1926), **In the Loge (At the Opera).** *1879, Oil on canvas, 32 × 26 in. (Museum of Fine Arts, Boston. The Hayden Collection. 10·35)*

*Pierre Auguste
Renoir,* **The Loge.**
*1874, Oil on
canvas. (The
Bridgeman Art
Library
International Ltd.)*

invites her/him to imagine that she/he is sharing in the main figure's excite-ment while she seems totally unaware of offering such a delightful spectacle. The lack of self-consciousness is, of course, purely contrived so that the viewer can enjoy the sight of the young girl.

The mark of difference between the paintings by Renoir and Cassatt is the refusal in the latter of that complicity in the way the female protagonist is depicted. In a later painting, *At the Opera,* 1879, a woman is represented dressed in daytime or mourning black in a box at the theater. She looks from the spectator into the distance in a direction which cuts across the plane of the picture, but as the viewer follows her gaze another look is revealed stead-fastly fixed on the woman in the foreground. The picture thus juxtaposes two looks, giving priority to that of the woman, who is, remarkably, pictured actively looking. She does not return the viewer's gaze, a convention which confirms the viewer's right to look and appraise. Instead we find that the viewer outside the picture is evoked by being as it were the mirror image of the man looking in the picture.

This is, in a sense, the subject of the painting—the problematic of women out in public being vulnerable to a compromising gaze. The witty pun on the spectator outside the painting being matched by that within should not disguise the serious meaning of the fact that social spaces are policed by men's watching women and the positioning of the spectator outside the painting in relation to the man within it serves to indicate that the spectator participates in that game as well. The fact that the woman is pictured so actively looking, signified above all by the fact that her eyes are masked by opera glasses, prevents her being objectified and she figures as the subject of her own look.

Cassatt and Morisot painted pictures of women in public spaces but . . . [t]he other world of women was inaccessible to them while it was freely available to the men of the group and constantly entering representation as the very territory of their engagement with modernity. There is evidence that bourgeois women did go to the cafés-concerts but this is reported as a fact to regret and a symptom of modern decline.[15]

To enter such spaces as the masked ball or the café-concert constituted a serious threat to a bourgeois woman's reputation and therefore her femininity. The guarded respectability of the lady could be soiled by mere visual contact, for seeing was bound up with knowing. This other world of encounter between bourgeois men and women of another class was a no-go area for bourgeois women. It is the place where female sexuality or rather female bodies are bought and sold, where woman becomes both an exchangeable commodity and a seller of flesh, entering the economic domain through her direct exchanges with men. Here the division of the public and private mapped as a separation of the masculine and feminine is ruptured by money, the ruler of the public domain, and precisely what is banished from the home.

Femininity in its class-specific forms is maintained by the polarity virgin/whore which is a mystifying representation of the economic exchanges in the patriarchal kinship system. In bourgeois ideologies of femininity the fact of the money and property relations which legally and economically constitute bourgeois marriage is conjured out of sight by the mystification of a one-off purchase of the rights to a body and its products as an effect of love to be sustained by duty and devotion.

Femininity should thus be understood not as a condition of women but as the ideological form of the regulation of female sexuality in a familial, heterosexual domesticity ultimately organized by the law. The spaces of femininity—ideologically, pictorially—hardly articulate female sexualities. That is not to accept nineteenth-century notions of women's asexuality but to stress the difference between what was actually lived or how it was experienced and what was officially spoken or represented as female sexuality.[16]

In the ideological and social spaces of femininity, female sexuality could not be directly registered. This has a crucial effect with regard to the use

artists who were women could make of the positionality represented by the gaze of the flâneur—and therefore with regard to modernity. The gaze of the flâneur articulates and produces a masculine sexuality which in the modern sexual economy enjoys the freedom to look, appraise and possess, in deed or in fantasy. . . .

It is not the public realm simply equated with the masculine which defines the flâneur/artist but access to a sexual realm which is marked by those interstitial spaces, the spaces of ambiguity, defined as such not only by the relatively unfixed or fantasizable class boundaries Clark makes so much of but because of cross-class sexual exchange. Women could enter and represent selected locations in the public sphere—those of entertainment and display. But a line demarcates not the end of the public/private divide but the frontier of the spaces of femininity. Below this line lies the realm of the sexualized and commodified bodies of women, where nature is ended, where class, capital and masculine power invade and interlock. It is a line that marks off a class boundary but it reveals where new class formations of the bourgeois world restructured gender relations not only between men and women but between women of different classes.

Men and Women in the Private Sphere

. . . ["Spaces of femininity"] include . . . the domestic sphere the drawing room, veranda or balcony, the garden of the summer villa and the bedroom. . . .

The majority of works by Morisot and Cassatt deal with these domestic spaces: for instance, *Two Women Reading,* 1869–70, and *Susan on a Balcony,* 1883 (Washington, D.C., Corcoran Gallery of Art). These are painted with a sureness of knowledge of the daily routine and rituals which not only constituted the spaces of femininity but collectively trace the construction of femininity across the stages of women's lives. As I have argued previously, Cassatt's oeuvre may be seen to delineate femininity as it is induced, acquired and ritualized from youth through motherhood to old age.[17] Morisot used her daughter's life to produce works remarkable for their concern with female subjectivity, especially at critical turning-points of the feminine. For instance, her painting *Psyché* shows an adolescent woman before a mirror, which in France is named a "Psyché" (1876; Lugano, Thyssen-Bornemisza Collection). The classical, mythological figure Psyche was a young mortal with whom Venus's son Cupid fell in love, and it was the topic of several paintings in the Neoclassical and Romantic period as a topos for awakening sexuality.

Morisot's painting offers the spectator a view into the bedroom of a bourgeois woman and as such is not without voyeuristic potential, but at the same time the pictured woman is not offered for sight so much as caught contemplating herself in a mirror in a way which separates the woman as subject of a contemplative and thoughtful look from woman as object—a contrast

may make this clearer; compare it with Manet's painting of a half-dressed woman looking in a mirror in such a way that her ample back is offered to the spectator as merely a body in a working room, *Before the Mirror,* 1876–77 (New York, Solomon R. Guggenheim Museum).

But I must stress that I am in no way suggesting that Cassatt and Morisot are offering us a truth about the spaces of femininity. I am not suggesting that their intimacy with the domestic space enabled them to escape their historical formation as sexed and classed subjects, that they could see it objectively and transcribe it with some kind of personal authenticity. To argue that would presuppose some notion of gendered authorship, that the phenomena I am concerned to define and explicate are a result of the fact that the authors/artists are women. That would merely tie the women back into some transhistorical notion of the biologically determined gender characteristics. . . .

Nonetheless the painters of this cultural group were positioned differently with regard to social mobility and the type of looking permitted them according to their being men or women. Instead of considering the paintings as documents of this condition, reflecting or expressing it, I would stress that the practice of painting is itself *a site for the inscription of sexual difference.* Social positionality in terms of both class and gender determine—that is, set the pressure and prescribe the limits of—the work produced. But we are here considering a continuing process. The social, sexual and psychic construction of femininity is constantly produced, regulated, renegotiated. This productivity is involved as much in the practice of making art. In manufacturing a painting, engaging a model, sitting in a room with someone, using a score of known techniques, modifying them, surprising oneself with novel and unexpected effects both technical and in terms of meanings, which result from the way the model is positioned, the size of the room, the nature of the contract, the experience of the scene being painted and so forth—all these actual procedures which make up part of the social practice of making a painting function as the modes by which the social and psychic positionality of Cassatt and Morisot not only structured their pictures, but reciprocally affected the painters themselves as they found, through the making of images, their world represented back to them. . . .

How sexual difference is inscribed will be determined by the specificity of the practice and the processes of representation. In this essay I have explored two axes on which these issues can be considered—that of space and that of the look. I have argued that the social process defined by the term modernity was experienced spatially in terms of access to the spectacular city which was open to a class and gender-specific gaze. (This hovers between the still-public figure of the flâneur and the modern condition of voyeur.) In addition, I have pointed to a coincidence between the spaces of modernity and the spaces of masculinity as they intersect in the territory of cross-class sexual exchange. Modifying therefore the simple conceit of a bourgeois world

divided by public and private, masculine and feminine, the argument seeks to locate the production of the bourgeois definition of woman defined by the polarity of bourgeois lady and proletarian prostitute/working woman. The spaces of femininity are not only limited in relation to those defining modernity but because of the sexualized map across which woman is separated, the spaces of femininity are defined by a different organization of the look.

Difference, however, does not of necessity involve restriction or lack. That would be to reinscribe the patriarchal construction of woman. The features in the paintings by Mary Cassatt and Berthe Morisot of proximity, intimacy and divided spaces posit a different kind of viewing relation at the point of both production and consumption.

The difference they articulate is bound to the production of femininity as both difference and as specificity. They suggest the particularity of the female spectator—that which is completely negated in the selective tradition we are offered as history.

Women and the Gaze

In an article entitled "Film and the Masquerade: Theorizing the Female Spectator," Mary Ann Doane uses a photograph by Robert Doisneau titled *An Oblique Look,* 1948, to introduce her discussion of the negation of the female gaze in both visual representations and on the streets.[18] In the photograph a petit bourgeois couple stand in front of an art dealer's window and look in. The spectator is hidden voyeur-like inside the shop. The woman looks at a picture and seems about to comment on it to her husband. Unbeknownst to her, he is fact looking elsewhere, at the proffered buttocks of a half-naked female figure in a painting placed obliquely to the surface/photo/window so the spectator can also see what he sees. Doane argues that it is his gaze which defines the problematic of the photograph and it erases that of the woman. She looks at nothing that has any meaning for the spectator. Spatially central, she is negated in the triangulation of looks between the man, the picture of the fetishized woman and the spectator, who is thus enthralled to a masculine viewing position. To get the joke, we must be complicit with his secret discovery of something better to look at. The joke, like all dirty jokes, is at the woman's expense. She is contrasted iconographically to the naked woman. She is denied the picturing of her desire; what she looks at is blank for the spectator. She is denied being the object of desire because she is represented as a woman who actively looks rather than returning and confirming the gaze of the masculine spectator. Doane concludes that the photograph almost uncannily delineates the sexual politics of looking.

I have introduced this example to make somewhat plainer what is at stake in considering the female spectator—the very possibility that texts made by women can produce different positions within this sexual politics of looking. Without that possibility, women are both denied a representation of their desire and pleasure and are constantly erased so that to look at and

enjoy the sites of patriarchal culture we women must become nominal trans-
vestites. We must assume a masculine position or masochistically enjoy the
sight of woman's humiliation. . . .

In a recent article titled "Desiring Images/Imaging Desire," Mary Kelly
addresses the feminist dilemma wherein the woman who is an artist sees her
experience in terms of the feminine position—that is, as object of the look—
while she must also account for the feeling she experiences as an artist occu-
pying the masculine position as subject of the look. Different strategies have
emerged to negotiate this fundamental contradiction, focusing on ways of
either repicturing or refusing the literal figuration of the woman's body. All
these attempts center on the problem: "How is a radical, critical and pleasur-
able positioning of the woman as spectator to be done?" Kelly concludes her
particular pathway through this dilemma (which is too specific to enter into
at this moment) with a significant comment:

> Until now the woman as spectator has been pinned to the surface of the picture,
> trapped in a path of light that leads her back to the features of a veiled face. It
> seems important to acknowledge that the masquerade has always been inter-
> nalized, linked to a particular organization of the drives, represented through a
> diversity of aims and objects; but without being lured into looking for a psychic
> truth beneath the veil. To see this picture critically, the viewer should neither be
> too close nor too far away.[19]

Kelly's comment echoes the terms of proximity and distance which have been
central to this essay. The sexual politics of looking function around a regime
which divides into binary positions, activity/passivity, looking/ being seen,
voyeur/exhibitionist, subject/object. In approaching works by Cassatt and
Morisot we can ask: Are they complicit with the dominant regime?[20] Do they
naturalize femininity in its major premises? Is femininity confirmed as pas-
sivity and masochistic or is there a critical look resulting from a different posi-
tion from which femininity is appraised, experienced and represented? In
these paintings by means of distinctly different treatments of those protocols
of painting defined as initiating modernist art—articulation of space, reposi-
tioning the viewer, selection of location, facture and brushwork—the private
sphere is invested with meanings other than those ideologically produced to
secure it as the site of femininity. One of the major means by which femininity
is thus reworked is by the rearticulation of traditional space so that it ceases to
function primarily as the space of sight for a mastering gaze, but becomes the
locus of relationships. The gaze that is fixed on the represented figure is that
of equal and like and this is inscribed into the painting by that particular prox-
imity which I suggested characterized the work. There is little extraneous
space to distract the viewer from the intersubjective encounter or to reduce the
figures to objectified staffage, or to make them the objects of a voyeuristic
gaze. The eye is not given its solitary freedom. The women depicted function
as subjects of their own looking or their activity, within highly specified loca-
tions of which the viewer becomes a part.

Mary Cassatt, American (1844-1926), **Woman Bathing (La Toilette).** *1891, Drypoint and aquatint in color, H. 14^{15}⁄$_{16}$ × W. 10^{9}⁄$_{16}$ in. (Metropolitan Museum of Art, Gift of Paul J. Sachs, 1916)*

The rare photograph of Berthe Morisot at work in her studio serves to represent the exchange of looks between women which structure these works. The majority of women painted by Cassatt or Morisot were intimates of the family circle. But that included women from the bourgeoisie and from the proletariat who worked for the household as servants and nannies. It is significant to note that the realities of class cannot be wished away by some mythic ideal of sisterhood among women. The ways in which working-class women were painted by Cassatt, for example, involve the use of class power in that she could ask them to model half-dressed for the scenes of women washing. Nonetheless they were not subject to the voyeuristic gaze of those women washing themselves made by Degas which, as Lipton has argued, can be located in the maisons-closes or official brothels of Paris.[21] The maid's simple washing stand allows a space in which women outside the bourgeoisie can be represented both intimately and as working women without

forcing them into the sexualized category of the fallen woman. The body of woman can be pictured as classed but not subject to sexual commodification.

I hope it will by now be clear that the significance of this argument extends beyond issues about Impressionist painting and parity for artists who are women. Modernity is still with us, ever more acutely as our cities become, in the exacerbated world of postmodernity, more and more a place of strangers and spectacle, while women are ever more vulnerable to violent assault while out in public and are denied the right to move around our cities safely. The spaces of femininity still regulate women's lives—from running the gauntlet of intrusive looks by men on the streets to surviving deadly sexual assaults. . . . The configuration which shaped the work of Cassatt and Morisot still defines our world. It is relevant then to develop feminist analyses of the founding moments of modernity and modernism, to discern its sexualized structures, to discover past resistances and differences, to examine how women producers developed alternative models for negotiating modernity and the spaces of femininity.

Notes

1. Tamar Garb, *Women Impressionists*, Oxford, Phaidon Press, 1987. The other two artists involved were Marie Bracquemond and Eva Gonzales.

2. Rozsika Parker and Griselda Pollock, *Old Mistresses: Women, Art and Ideology*, London, Routledge & Kegan Paul, 1981, 38.

3. I refer, for example, to Edouard Manet, *Argenteuil, Les Canotiers*, 1874 (Tournai, Musée des Beaux Arts) and to Edgar Degas, *Mary Cassatt at the Louvre*, 1879–80, etching, third of twenty states (Chicago, Art Institute of Chicago). I am grateful to Nancy Underhill of the University of Queensland for raising this issue with me. See also Clark, op. cit., 165, 239ff., for further discussion of this issue of flatness and its social meanings.

4. See also Berthe Morisot, *View of Paris from the Trocadéro*, 1872 (Santa Barbara, Museum of Art), where two women and a child are placed in a panoramic view of Paris but fenced off in a separate spatial compartment precisely from the urban landscape. Reff, op. cit., 38, reads this division quite (in)differently and finds the figures merely incidental, unwittingly complying with the social segregation upon which the painting's structure comments. It is furthermore interesting to note that both these scenes are painted quite close to the Morisot home in the Rue Franklin.

5. See, for instance, M. Merleau-Ponty, "Cézanne's Doubt," in *Sense and Non-Sense*, translated by Hubert L. Dreyfus and Patricia Allen Dreyfus, Evanston, Illinois, Northwestern University Press, 1961.

6. Janet Wolff, "The Invisible Flâneuse; Women and the Literature of Modernity," *Theory, Culture and Society*, 1985, 2 (3), 37–48.

7. See George Simmel, "The Metropolis and Mental Life," in Richard Sennett (ed.), *Classic Essays in the Culture of the City*, New York, Appleton-Century-Crofts, 1969.

8. Richard Sennett, *The Fall of Public Man*, Cambridge, Cambridge University Press, 1977, 126.

9. Walter Benjamin, *Charles Baudelaire; Lyric Poet in the Era of High Capitalism,* London, New Left Books, 1973, chapter 11, "The Flâneur," 36.

10. Jules Simon, op. cit., quoted in MacMillan, op. cit., 37. MacMillan also quotes the novelist Daniel Lesuer, "Le Travail de la femme déclasée," *L'Evolution féminine: ses résultats economiques,* 1900, 5. My understanding of the complex ideological relations between public labor and the insinuation of immorality was much enhanced by Kate Stockwell's contributions to seminars on the topic at the University of Leeds, 1984–85.

11. Sennett, op. cit., 23.

12. *The Journals of Marie Bashkirtseff* (1890), introduced by Rozsika Parker and Griselda Pollock, London, Virago Press, 1985, entry for 2 January-1879, 347.

13. Charles Baudelaire, "The Painter of Modern Life," in *The Painter of Modern Life and Other Essays,* translated and edited by Jonathan Mayne, Oxford, Phaidon Press, 1964, 9.

14. Theresa Ann Gronberg, "Les Femmes de brasserie," *Art History,* 1984, 7 (3).

15. See Clark, op. cit., 209.

16. Carl Degler, "What Ought to Be and What Was; Women's Sexuality in the Nineteenth Century," *American Historical Review,* 1974, 79, 1467–91.

17. Griselda Pollock, *Mary Cassatt,* London, Jupiter Books, 1980.

18. Mary Ann Doane, "Film and the Masquerade; Theorizing the Female Spectator," *Screen,* 1982, 23 (3–4), 86.

19. Mary Kelly, "Desiring Images/Imaging Desire," *Wedge,* 1984 (6), 9.

20. There are of course significant differences between the works by Mary Cassatt and those by Berthe Morisot which have been underplayed within this text for reasons of deciphering shared positionalities within and against the social relations of femininity. In the light of recent publications of correspondence by the two women and as a result of the appearance in 1987 of a monograph (Adler and Garb, Phaidon) and an exhibition of works by Morisot it will be possible to consider the artists in their specificity and difference. Cassatt articulated her position as artist and woman in political terms of both feminism and socialism, whereas the written evidence suggests Morisot functioning more passively within the haut bourgeois formation and republican political circles. The significance of these political differences needs to be carefully assessed in relation to the texts they produced as artists.

21. For discussion of class and occupation in scenes of women bathing see Eunice Lipton, "Degas's Bathers," *Arts Magazine,* 1980, 54, also published in Eunice Lipton, *Looking into Degas: Uneasy Images of Woman and Modern Life,* University of California Press, 1986. Contrast Gustave Caillebotte, *Woman at a Dressing-Table,* 1873 (New York, private collection), where the sense of intrusion heightens the erotic potential of a voyeuristic observation of a woman in the process of undressing.

Chapter 20

An Infinite Play of Empty Mirrors: Women, Surrealism, and Self-Representation

Whitney Chadwick

... In mobilizing the body as a primary signifier of its cultural politics, Surrealism established new parameters within which women artists might begin to explore the complex and ambiguous relationship between the female body and female identity. Women were not among Surrealism's founding "fathers." Although their significance to the movement continues to be debated, they left a collective body of self-portraits and other self-representations that in taking the artist's own body as the starting point and in collapsing interior and exterior perceptions of the self (regardless of how that word was/is understood), continues to reverberate within contemporary practices by women that articulate how the body is marked by femininity as lived experience, subjectivity produced through new narratives, and the possibility of a feminine imaginary enacted. This body of work appears to have no parallel in the work of male Surrealists more inclined to project their desires outward, locating moments of rupture between conscious and unconscious, subject and object, in bodies Other to theirs, and almost exclusively of an otherness assigned to the feminine. ...

Putting the psychic life of the artist in the service of revolutionary politics, Surrealism publicly challenged vanguard modernism's insistence on "art for art's sake." But Surrealism also battled the social institutions—church, state, and family—that regulate the place of women within patriarchy. In offering some women their first locus for artistic and social resistance, it became the first modernist movement in which a group of women could explore female subjectivity and give form (however tentatively) to a feminine imaginary.

The young women who joined the Surrealist circle in Paris in the 1930s—or, in the cases of Leonor Fini and Frida Kahlo, declared themselves *not* Surrealist while nevertheless exhibiting with the group on occasion and adopting many of Surrealism's core tenets—saw Surrealism as supporting their desire to escape what they perceived as the inhibiting confines of middle-class marriage, domesticity, and motherhood. Although in many

From *Mirror Images: Women, Surrealism, and Self-Representation* by Whitney Chadwick. Copyright © 1998 by M.I.T. Press. Reprinted by permission of the publisher.

cases they lacked a clear sense of what being an artist meant (or perhaps they perceived all too clearly that the roles of women and those of artists are often incompatible), they thought of themselves as artists. And they saw Surrealism, rather than direct political action, as their best chance for social liberation.[1]

Women artists associated with the Surrealist movement came from widely different social and cultural backgrounds. Differences in political allegiances, sexual preferences, and social identifications shaped their self-images, as did a range of literary and artistic conventions: from Frida Kahlo's indebtedness to nineteenth-century Mexican portraiture, medical illustration, and the representational traditions of the *retablo* and Leonora Carrington's predilection for fourteenth-century Italian painting, Celtic literary sources, and English nursery rhymes to Leonor Fini's cultivation of the Flemish primitives and German romantics. Even so, points of connection do exist among them, though we should not seek their effects too aggressively.

In general, the works of women associated with the Surrealists display an affinity for the structures of fabulist narrative rather than shocking rupture, a self-consciousness about social constructions of femininity as surface and image, a tendency toward the phantasmic and oneiric, a preoccupation with psychic powers assigned to the feminine, and an embrace of doubling, masking, and/or masquerade as defenses against fears of non-identity. . . .

Dorothea Tanning, **Eine Kleine Nachtmusik (A Little Night Music).** *1946, Oil on canvas. (The Bridgeman Art Library International Ltd.)*

The words *surrealist* and *surrealism* appear frequently in discussions of the work of many contemporary women artists who employ strategies of disruption and/or images of the body fragmented, deformed, or doubled. Often references to specific antecedents (both male and female) appear: Cindy Sherman, Francesca Woodman, Kiki Smith (Hans Bellmer, Claude Cahun); Louise Bourgeois, Dorothy Cross, Michiko Kon, Yayoi Kusama (Meret Oppenheim); Ana Mendieta, Paula Santiago (Frida Kahlo); Lindee Climo (Leonora Carrington). . . .

Self as Other

Even before 1936, when psychoanalyst Jacques Lacan first presented his paper arguing for the origins of selfhood in a "mirror stage" (the "misrecognition" of another in the mirror that produces the self, or subject), theories of subjectivity and sexual identity had revolved around seeing. Lacan's theory of subjectivity, which derives from Freud's concepts of narcissism and the "specular" ego (the formation of the subject around a dynamic of seeing/not-seeing that initiates the castration anxiety around which male sexuality is formed) left Woman in the position of signifier for the male other, her subjectivity (or "femininity") determined by the discourse of patriarchy.

It is in the nature of the self-portrait to produce the subject as object. . . . For women artists, the problematics of self-representation have remained inextricably bound up with the woman's internalization of the images of her "otherness": "Mirror of male desire, a role, an image, a value, the fetishized woman attempts to locate herself, to affirm her subjectivity within the rectangular space of another fetish—ironically enough, the 'mirror of nature.' "[2] Positioned to collude in their objectification, unable to differentiate their own subjectivity from the condition of being seen, women artists have struggled toward ways of framing the otherness of woman that direct attention to moments of rupture with—or resistance to—cultural constructions of femininity.

The Surrealists. . . were indebted to Freud's and Lacan's theories of the connection between vision and sexuality. The female visionary—childlike, criminal, or mad—became the central figure in both Surrealism and the emerging literature of psychoanalysis after World War I, and the woman invoked in the poetry of André Breton, Paul Eluard, Benjamin Peret, and others is at once compelling, gifted, dangerous, nocturnal, and fragile, a composite being "drawn from the legacy of the Romantic and Symbolist imagination and reinterpreted through Freud."[3] Her sister image in the visual arts remains more emphatically marked by the signs of psychoanalytic deviance: fetishism, sadism, voyeurism, etc.[4]

Dorothea Tanning's *The Mirror* (1952), a painting executed fifteen years after the artist first encountered Surrealism at the exhibition "Fantastic Art, Dada, Surrealism" at New York's Museum of Modern Art, illuminates some of the more problematic aspects of femininity and self-representation. In Tanning's painting, an anthropomorphic sunflower bud holds up an open

flower, gazing into the petaled "mirror" in an apparently rapt contemplation of its own blossoming. This vegetal parody of the traditional *vanitas* image (in which the sin of vanity is represented by the image of a woman staring into a mirror) is frozen within a second "frame," an outer aureole of fiery petals that collapses the imagery of flower, mirror, and eye into an ironic meditation on femininity, nature, and artistic vision. No matter how intently one gazes into this compelling but disturbing image, there is nothing more to see. Tanning's sunflower/mirror remains opaque, the little vignette of looking and mirroring incomplete.[5]

In Western culture the image of the mirror has signified the social construction of femininity as specular consumption and the narcissistic identification of the woman with her reflected image. Tanning's painting, however, resists such overdetermined readings. It is not, after all, a woman who occupies the feminine position here but a hybrid, an anthropomorphic flower, a grotesque being that blurs the boundaries of animal/vegetal/human worlds and collapses the binaries of sexual difference. The careful structuring of the image to capture a gaze from outside the frame—the spectator's—and redirect it within the frame implicates the viewer in more than one kind of seeing and challenges the privileged link between seeing, knowing, and possessing as functions of the masculine.

It is too easy to suggest that Tanning merely reproduced the common trope that identifies Woman as the objectified other, the object of the male gaze, for the woman is both absence and presence here: unrepresented as Woman but evoked through the cultural association of femininity with narcissism and the self revealed in the mirror. Tanning's hybrid being, simultaneously self-reflexive and vegetal, stands at the boundary of nature and culture. In Surrealism, the mirror image, rather than confirming our assumptions about the nature of the real (and its replicability), defamiliarizes the real and opens it up to the forces of the dream, the irrational, and the unconscious.[6] Tanning's mirror both affirms and denies the self. . . .

Self-portraits by women associated with Surrealism often bear visible signs of the slippage between Woman and women and between nature and culture. Collapsing the projection of the body as sight or spectacle and the awareness of the body as site of meanings (assigned, fabricated, manipulated), the woman artist reproduced herself as a multiplicity of roles/identities within the signs of an elaborately coded femininity "which always derives from elsewhere."[7] Many works by women Surrealists both recreate and resist the specular focus and voyeuristic gaze of Western representation. Others reimagine the Surrealist woman as a figure of agency and transformation. The unruly woman of the male Surrealist imagination—dismembered, mutable, eroticized—is recreated through women's eyes as self-possessed and capable of producing new narratives of the self. Leonor Fini's *Au bout du monde* (At the Ends of the Earth, 1949) and Remedios Varo's *Harmony*, painted in Mexico around 1955, share with many other self-images by women Surrealists ambivalent, or ambiguous, constructions of self.

In Fini's painting, the woman—isolated within the frame, her bare breasts partially exposed above the dark waters of a primordial swamp that is also home to rotting vegetation and bird and animal skulls—gazes directly out at the viewer. Narcissistic? Perhaps. Certainly references to the myth abound: watery reflections, invitations to the spectator, intimations of self-absorption. Yet Fini's painting replaces the beautiful male body with that of a woman. Is this Echo perhaps, silenced and condemned to an eternal life of voiceless stone? Finally, Fini's female image, while linked to a darker, indistinct face—reflected back as an image of the mysterious, the animal, the repressed that is also the feminine in Western culture—is too commanding to slide easily into the position of passive object of contemplation.

Varo's painting, which depicts an artist/composer alone in a cell-like room manipulating her knowledge of science, art, nature, and mysticism into musical compositions, resists specularity by absorbing the central figure into a swarm of surface detail that deflects the gaze and interrupts the compositional hierarchies that dominate Western painting after the Renaissance. The figure itself, attenuated and androgynous in its cropped hair and baggy suit, is neither reducible to a single identity nor fixed within the signs of sexual difference.

Fini's and Varo's paintings suggest that the female self, no matter how relentlessly pursued in the images reflected back to it, can neither be fully captured by its representations nor escape them.[8] Women Surrealists often astutely wove self-awareness into images of identity as a juggling of incompatible roles, a balancing act, a series of performances that leave the subject frayed around the edges, fragmented, not one but many, into complex narratives that simultaneously project and internalize the fragmented self, reproduce and resist dominant discourses. . . .

Many women . . . [artists] adopted strategies that more recently have been referred to as "self-othering." Identifying with moments prior to historical time and/or outside the "civilized" cultural spaces identified with patriarchy, they sought the sources of the "feminine" and "woman" in epochs and places in which women were believed to have exercised spiritual and psychic powers later repressed under patriarchy.[9] . . .

Image of fecundity and barrenness, rich imaginings and fearful isolation, self and other, interior and exterior, the female body in the works of women Surrealists served as an important harbinger of women's desire to image themselves by speaking through their own bodies. It is perhaps through their many and diverse images of embodied femininity that women Surrealists left their most powerful and pervasive legacy to subsequent generations of women artists.

Self as Body

In today's visual culture, images of the female body function as carriers of complex and contradictory messages while in feminist debates about essentialism and constructionism, the meaning of the body itself remains under

intense debate. In the work of artists like Louise Bourgeois, Cindy Sherman, Rona Pondick, Michiko Kon, Paula Santiago, Marta Maria Perez Bravo, Francesca Woodman, Dorothy Cross, and others, the body has become the site of cultural mediations, the sign of political and social challenges to assigned meanings, and an important measure of female subjectivity.[10] Bodies and body parts swell, mutate, dissolve, double, and decompose before our eyes as the body registers cultural, as well as personal, fears and anxieties. Artists increasingly deploy the body as a site of resistance and a locus for expressions of death, disintegration, horror, and presymbolic forms of expression.

Breaking with the notion of unitary self that dominated post-Enlightenment thinking, the Surrealists embraced incoherence, disjunction, fragmentation. Women deeply internalized this refusal of bodily and psychic fixity, often representing themselves using images of doubling, fragmentation, projection. The defamiliarized body of Surrealism has become the unknown body of contemporary art, most often female and Other: threatening, uncontrollable, and uncontainable. "Beauty will be convulsive or it will not be at all," Breton wrote in 1937. "Convulsive beauty will be veiled-erotic, fixed-explosive, magic circumstantial."[11] Breton's convulsive beauty located the disruptive force of Eros in the body of Woman, but the radical violations that collapsed the female body into parts "exploding with erotic energy" in the works of male Surrealists like Hans Bellmer or dissolved it into the insubstantial, the *informe,* in the writings of dissident Surrealist Georges Bataille, were often turned in different directions by women in the movement.

Kahlo exposed her own body, cutting it open to reveal its physical and psychic scars, transcending the specificities of its wounds by surmounting it with the masklike face of enduring sainthood. Tanning projected eroticism onto the bodies of children who, in works like *Children's Games* (1942) and *Palaestra* (1949), release an incendiary energy that shreds wallpaper and transforms interior spaces into highly charged environments. Oppenheim exposed her skull to radiation and captured the self as glowing skeletal frame. Claude Cahun—as well as Oppenheim and Kahlo—used her own body to destabilize the boundaries of gender and sexual identity.

Since the early 1970s, when women artists mobilized the female body as marker of a new sexual and cultural politics, they have continued to use the body to challenge social constructions of gender and sexuality. Although the body seems the logical point of departure from which to identify a sense of self, its location at the boundaries between the biological and the social, the natural and the cultural ensures that our relationship to its forms and processes is always mediated by cultural discourses. . . .

Contemporary expressions of the artist's body that refuse the conventions of specular pleasure open the body to apprehension through other senses and often recall the visceral and tactile nature of certain Surrealist objects, like those of Meret Oppenheim, which shift from hard to soft, inor-

ganic to organic (the fur-lined teacup), and exterior to interior (*Pair of Gloves* and *X-Ray of M.O.'s Skull*). Many current images of the body as unfamiliar, uncanny, grotesque, unbounded, transitional, etc. owe much to Surrealism's collapse of interior and exterior reality, its reimagining of the body as a signifier of absence and deformity. Distorting heads, erasing features, substituting parts—as René Magritte does in *Le Viol* (The Rape, 1934), a painting of a woman's head in which pubic hair replaces the mouth, and breasts the eyes—Surrealism challenged the rational ordering of the body and with it distinctions between mind and body, reason and sexuality, human and animal, higher and lower.

As feminist theorists have begun to seek less determinist and confining models of female subjectivity, the work of women artists has provided an important focus for attempts to move beyond the polarities of sexual difference. In many cases Surrealism has provided the starting point for works that challenge existing representations of the feminine through reimaginings of the female body as provisional and mutable, or at least intimating a shift away from the phallic organization of subjectivity.[12]

Louise Bourgeois is almost always positioned in some relationship to Surrealism, though she herself has disavowed the connection, stating in 1993 that she is an existentialist not a surrealist.[13] The disavowal hasn't silenced speculation about her artistic roots. She has been placed within the Surrealist tradition for her psychological motivations, for her use of the dream and the unconscious, for her adherence to Georges Bataille's notions of the transgressive and the *informe* (his anti-rationalist, anti-idealizing embrace of the shapeless detritus of being human, of excrement, filth, and decomposition.[14] . . . I would . . . like to consider a single work/theme of hers (the *Femme-Maison* drawings) framed in relation to a single Surrealist example: André Masson's *Mannequin* from the 1938 International Surrealist Exhibition in Paris.

Bourgeois's own accounts absorb the question of artistic parentage into the oedipal drama of a single family—hers—in France in the 1920s. It is unclear whether or not she attended the Surrealist exhibition of 1938, which opened at the Galerie des Beaux-Arts in January. Certainly she was in Paris at the time (she did not move to New York until October of that year). The exhibition attracted large crowds and extensive press coverage. As visitors paraded past the row of display mannequins transformed into Surrealist gorgons that guarded the portals of the Surrealist world within, one in particular stood out.

Masson's object included a female mannequin, nude, her head covered with a wicker bird cage, pansies tucked into her mouth and armpits, and her pubic area adorned with tiger's eyes. The figure, a recasting of another famous Surrealist image, also resonated with allusions to a historical circumscribing of middle-class femininity within images of cages and caging.[15] . . .

In 1946 Bourgeois, now living in New York, married, and the mother of three sons, began a series of drawings titled *Femme-Maison*, in which an

Man Ray,
Mannequin. *1938.*
Photograph of
André Masson's
Mannequin at the
"Exposition
Internationale du
Surrealisme,"
Galerie des Beaux-
Arts, Paris, Jan. -
Feb. 1938.
(Masson/Telimage)

image of a house replaces a woman's head. Despite the presence of the caged head, Bourgeois's and Masson's images differ in striking ways. Masson's piece disturbs in rewriting the female body as exoticized other, its juxtapositions of images of femininity and masculine control, its fetishistic substitutions of the signs of nature—flowers and feathers—for the sites of female sexual pleasure. Bourgeois's piece troubles in conflating the woman's identity with the house and its powerful connotations of a control that silences as surely as Masson's flowered gag.[16] Yet rather than seen as an assault on the body, literal or metaphorical, Bourgeois's *Femmes-Maisons* have most often been read in terms of the biographical, the literary, or the allegorical.[17]

According to Bourgeois, the woman in trying to hide reveals herself to be naked.[18] The dry, linear drawing schematizes the figure, turning it into sign rather than object and stripping it of specular eroticism. As sign rather than image of the female body, Bourgeois's representation lies outside the category of fetish object. Instead it becomes a signifier of self-perception and

self-deception, in which silence and repression, domesticity and confinement, vulnerability and retreat simultaneously resonate and contradict.

Bourgeois's representation, although it draws on Surrealism's reliance on the unconscious as a source and on deforming the visible, emphasizes structure and rests on a rational, if subversive, ordering of the anarchic forces of the id.[19] This striving toward a conscious organization of meaning distances Bourgeois's representation from Surrealism's commitment to breaking down rational structures. Bourgeois's *Femmes-Maisons* are not Surrealist (and may, in fact, owe only a passing formal resemblance to Masson's mannequin). Yet they intervene in the territories of Surrealist representation in ways that underscore the complexity of the dialogues between generations of artists.

As early as the 1940s Bourgeois had begun symbolically merging male and female in totemic wood figures that evoked Max Ernst's and Alberto Giacometti's objects, but it was during the 1960s—as part of a wider rejection of minimalist geometries in favor of a deployment of the referential and the embodied that owed much to Surrealism—that Bourgeois, Yayoi Kusama, and Eva Hesse began to produce works that mobilized the body to challenge the gendered binary oppositions that supported modernist art as a masculine enterprise.

Bourgeois's latex pieces of the 1960s, like those of Hesse, evoke multiple and shifting associations with skin, interior and exterior bodily spaces, and orifices. During that decade she developed the biomorphism of polymorphous sexuality and fusion that has characterized much of her work. Examples include *Portrait* (1963), an early latex piece with rounded, indeterminate forms bulging against a rubbery skin that resembles a flayed animal hide; the self-described self-portrait *Sleep* (1967), with its rounded and hard, phallic yet flaccid forms; and *Torso (Self-Portrait)* (1963), a quasi-abstract body mask covered with penile, scrotal, and labial shapes.

Bourgeois often displayed pieces comprised of breast and penislike forms in groups. Recalling Freudian and Surrealist condensations of images, they also imply a dispersal of power in which the phallus, no longer simply part of a larger organism, multiplies. Its threatening potential is tamed as Bourgeois's hand shapes her forms as if they were plants. Phallic form, subdued and softened in works like *Germinal* (1967) and *Untitled* (1970), is equated finally with the kind of generative power historically assigned to the feminine.[20]

Bourgeois's biomorphic forms, with their references to mutating metamorphic forms of Jean Arp, Masson, and other Surrealists and their suggestion of male and/or female genitalia, resist the construction of female subjectivity around notions of difference and otherness. . . .

By the mid-1960s the new expressionist strain in New York art was often linked to postminimalism's embrace of non-art materials like rope and latex, and its reliance on the gestural, the temporal, and the conceptual. Since 1966, when critic Lucy Lippard and artist Mel Bochner first remarked on the strong

bodily associations of Hesse's art, critics have often pointed to the surface tac-
tility of Hesse's expanded repertory of materials and the multivalent associ-
ations of her imagery.[21] . . .

Lippard, drawing on the work of Yale psychologist Gilbert J. Rose, used
the term body ego to describe how an image might refer simultaneously to
inner and outer bodily sensations.[22] *Ishtar* (1965), *Nine Nets* (1966), and other
works of these years also exploit the sensuous, tactile, and flexible qualities
of latex and net through multiple and shifting significations that evoke both
male and female.[23]

Hesse's work of the mid-1960s, like that of Bourgeois . . . , remains
focused on the interplay of material and concept, an acceptance of the medi-
ating effects of gender on subjectivity, and a resistance to gender stereotypes.
This work also announced an extension of transgressive practices derived
from Surrealism that explored viscerality, the language of the body, and bod-
ily deformation as a challenge to Western culture's insistence on the inviola-
bility and integrity of the human body. . . .

By the 1980s attitudes toward representations of the body that derived
from earlier Surrealist practices mingled easily with the legacies of body art,
feminist performance, postmodernist appropriations, parody and critique,
and an expanding politics of the transgressive body. Growing attention to
femininity as the repressed encouraged many contemporary women artists
self-consciously to explore the primal body, to present bodily images stripped
of personal or social context and re-present them as disturbing symbols of
social breakdown and/or psychological fixation, and to dislodge meaning
and identity.

Kiki Smith's misshapen females viscerally bear, and bare, the signs of
their femininity as they manifest the hidden markings of the feminine.
Although she has resisted conscious self-representation as a motivating factor
in her female images, her work—with its echoes of the Surrealist *informe*—has
significantly reshaped the contemporary female body in representation. . . .

. . . "I always feel that my identity as a woman and as an artist is divided,
disintegrated, fragmented, and never linear, always multifaceted . . . always
pictures of parts of bodies. . . . I always perceive the body in fragments,"
Annette Messager has written.[24]

Messager, a Frenchwoman, has frequently acknowledged her debt to
the Surrealists: to their interest in artifacts, ethnographic articles, and collec-
tions and, above all, to Surrealist photography with its bodily and psychic
dislocations produced through the montage and the manipulated photo-
graph. Yet Messager's fragmented imagery relates directly to the production
of gender through a commodification and objectification of the female body.
Pièce montée, no. 2 (1986) incorporates acrylic and oil paint with photogra-
phy. Both horrifying and parodistic—Messager locates one of its sources in
a 1930 photograph of a human tongue by the Surrealist Jacques-André Boif-
fard—Messager's disembodied head vomits forth a cascade of fragmented
body parts.

Other contemporary artists have sought a new focus for female subjectivity in hybridization, fetishization, and the displacing of self onto artifacts of the body. Annette Messager's dresses, Paula Santiago's garments, and Dorothy Cross's objects covered with cowhide and cow udders explore the self through substitutions and deferrals of meaning while Marta Maria Perez Bravo fuses Afro-Cuban religiosity and feminine experience in large-scale photographs that site the maternal body (hers) between the personal, the social, and the ritualistic. . . .

The articulation of self through strategies that identify the self and the exterior world or that register the self through traces, absences, or disguises both affirm and deny the embodied self. Masking, masquerade, and performance have all proved crucial for the production of feminine subjectivity through active agency.

Self as Masquerade/Self as Absence

Psychoanalyst Joan Rivière's essay theorizing the concept of femininity as a masquerade, a decorative surface hiding the woman's lack and enabling her to negotiate a subject position within patriarchy, appeared coincidentally in 1929, the same year as André Breton's *Second Manifesto* of Surrealism.[25] While Rivière theorized a masquerade that was indistinguishable from feminine non-identity, Breton's manifesto seems to repudiate the very idea of disguise. Over and over he invoked Surrealism as the means to clarification, illumination, self-knowledge. Nevertheless, throughout the 1930s disguise and masquerade functioned as weapons in Surrealism's assault on the foundations of the "real." In 1938 Marcel Duchamp extinguished the lights and "hid" the architecture of the Galerie des Beaux-Arts, the site of the international Surrealist exhibition, under 1,200 hanging sacks of coal. A row of mannequins, embellished with found objects, lined the corridor outside the gallery like prostitutes in the Rue St.-Denis, pointing the way to the surreal universe within. If Rivière's masquerade of femininity enabled the woman to assume a place within a masculine world, the Surrealist masquerade challenged the rational parameters of that world.

A decade earlier the deployment of masks in Dada performances at the Cabaret Voltaire had enabled the performers to sustain an illusion of becoming one with the Other, of shedding inhibitions and releasing the so-called totemic and primitivizing forces associated with the unconscious.[26] By 1929 these irrational and primitivizing forces had clearly been reformulated under the sign of the feminine.

Many Surrealist masks and costumes—like the elaborate feathered headdresses that Max Ernst wore to signal a shamanistic identification with his alter ego Loplop, the Superior of the Birds—identified the wearer with non-European cultural traditions and beliefs. Others, like the masks produced by Meret Oppenheim and Leonor Fini out of fur and feathers, exoticized their creators as part of that otherness. Still others, however, encouraged the enacting of different sexualities and gender roles.

As early as 1925 Claude Cahun had begun using mirrors to double and distort her image. Photographing herself in a series of disguises, her face painted or heavily made-up, she appeared in the guises of androgyne, sailor, mime, acrobat, Buddha, wrestler.[27] Cahun's iconography of fluid, transgendered identity no doubt owed as much to the pioneering lesbian culture that supported Romaine Brooks's striking *Self-Portrait* (1923) and Radclyffe Hall's novel *The Well of Loneliness* (1928) as to Surrealism. The results of her interventions into the representational terrain of sexual difference have recently been seen as articulating gender and sexuality as positional rather than fixed. Examining this work in the more historically specific context of lesbianism in the 1920s and 1930s—marginalized within Surrealism by Breton's homophobia and within broader culture by medical discourses of homosexuals as a "third sex"—suggests a more urgent political stake in the struggle to place herself.

Cahun's are not the only Surrealist images of female cross-dressing (Kahlo's *Self-Portrait with Cropped Hair,* 1940, and Varo's *Harmony,* c. 1956, come immediately to mind), but her interest in the theater identifies that genre's performative model, as well as the presence in that milieu of sexually ambiguous figures like Sarah Bernhardt, Ida Rubinstein, and Beatrice Wanger, as key sources for Cahun's explorations. Cahun's photographs have often been read as prefiguring the imagery of the unstable self produced by Cindy Sherman's mediated self-images, though there is no evidence to suggest that Sherman was aware of Cahun's work at the time she began inserting her own self-image into film stills and other media-based representations.[28]

Although Sherman has consistently denied historical influences, her work of the 1980s is often discussed in relation to Surrealism and frequently related to Surrealist practices that refigure the body's meaning through its parts. "Even her most dutiful and intoxicating references to disaster films and *film noir* pale before her homage to Hans Bellmer," notes critic Andrew Menard, "[and] several of the new pieces (the sex pictures) rather slavishly mimic photographs from the *Poupée* series."[29]

Such readings, however, fail to account for the extent to which Bellmer's bodily dislocations (almost always sexualized and coded female) have been absorbed into a contemporary culture in which physical reorderings of the body (through disease, organ transplants, etc.) have become a fact of life rather than a weapon in a Surrealist assault on Western assumptions of bodily wholeness and integrity.[30] The cultural codes of Sherman's critiques of pornography are nowhere to be found in Bellmer's fetishized bodies. Indeed many of Sherman's substitutions and deformations point toward an earlier interest in locating the transgressive body at the boundary between the human and the machine.

Sherman's *Untitled #261* (1992) and Max Ernst's *Anatomy of a Bride* (c. 1921) share a fascination with mannequins, simulacra, and machine function that derives from the sexualized bachelor machines of Dada fantasy. The

Cindy Sherman,
Untitled. *1977,*
Black and white
photo, 10 × 8 in.
(Courtesy Metro
Pictures)

Dada *machine-célibataire,* however, emerged from the tangled strands of the Kafkaesque literary imagination and the literal replacement parts of bodies torn apart in battle. Sherman's prostheses, on the other hand, belong to a marriage of medical technology and cyborg fashion. This parodic element of Sherman's work, with its double references to film and fashion, technology and virtual reality, adds a level of miming and appropriation that does not collapse back into historical Surrealism or Dada. In introducing a note of irony she neatly distances her representations from Surrealism's enthusiastic assaults on bodily integrity.[31]

Constituted as Other, as object, in Western representation, the woman who speaks must either assume a mask (masculinity, falsity, simulation) or

set about unmasking the opposition within which she is positioned. Yet cross-dressing and performative practices have enabled women artists from Cahun to Sherman to embody what Judith Butler has called the "three contingent dimensions of significant corporeality: anatomical sex, gender identity, and gender performance."[32] "Under this mask, another mask," Cahun wrote, "I will never be finished carrying all these faces."[33]

Masquerade for women has functioned both as an element in rituals of seduction that rely on costuming and as a means of blurring gender boundaries by using coded signs, the meaning of which shifts from historical moment to historical moment and from culture to culture. Freud and Cixous have pointed to the apparently greater bisexuality of the woman, for whom assuming the clothes that signify masculinity suggests her ability to assume a mastery over the image and the look. Adopting the imagery of the Other, the signs of male sexuality and masculinity as coded through dress, gestures, bearing, and look—as Cahun does in many of her *Self-Portraits* (1920s), Kahlo in *Self-Portrait with Cropped Hair* (1940), and Sherman in the untitled self-portraits that reference Mick Jagger, Andy Warhol, and other male performers of ambiguous sexuality—the woman who cross-dresses blurs the signs of sexual difference. The Surrealists' fascination with androgyny is well-documented.[34]

Like Cahun, Meret Oppenheim often used masks and masquerade to produce images of the self that blurred gender roles.[35] The practice continues in the work of contemporary artists interested in exploring gender and sexual roles through performative strategies and in producing the self through juxtaposition and layering with, or in relation to, external objects. Japanese artist Michiko Kon surrounds and overlays her body with elaborate hybrid constructions using raw fish, flowers, and vegetables to create images with the visually and viscerally disruptive potential of Oppenheim's objects and the allegorical resonances of Arcimboldo's sixteenth-century portraits.

Performative strategies also encourage agency and externalized perceptions of self. Many paintings by Fini, Tanning, and Kahlo suggest the use of masquerade to control external perceptions of women. Kahlo, for example, often staged her self-presentation through carefully chosen symbolic images and cultural "props.". . .

The fetishization of nature, costume, and attributes evident in many of Kahlo's self-portraits also defends against a fear of barrenness, of non-identity. At times, new meanings collapse back into old images, into the fear that beneath the facade, the mask, the costume, there is nothing to be seen. Surrealist self-portraits by women often reveal a tension between the investment of self in the reflected Other and the fear that behind the elaborate productions that stage the feminine as Other there lies only emptiness.

Confrontation with a self that offers nothing new is the subject of Varo's *The Encounter* (c. 1955). Here a woman stares bleakly into space as she raises the lid of a box and discovers that it holds nothing except her own image. As

Frida Kahlo, **Las Dos Fridas.** *1939, Oil on canvas, 173 × 173 cm. (Museo de Arte Moderno, Mexico D. F. Photo by Bob Schalkwijk. Art Resource, NY. © Frida Kahlo/Licensed by VAGA, New York, NY/INBA)*

Varo's biographer Janet Kaplan explains, quoting the artist, the woman approaches the box in anticipation of finding intriguing self-revelations within, but finds not another but the self: "Bound by a fraying fabric to that other head in the box, she confronts the reality of self-exploration—that one is tied to the self one already knows."[36]

Varo's painting suggests an ironic play in which otherness becomes sameness in a scenario that recapitulates Freud's account of sexual difference: a scenario in which the male subject gradually distances himself from the mother (the first object of desire), whereas the girl child is denied the distance that comes with knowledge and must become that original object of desire

through an identification with the female (maternal, for Freud) body. This identification with the maternal body that Freud and subsequent psychoanalytically inclined critics posit as a condition of female subjectivity produces femininity through doubling.[37]

The doubled image in Surrealism has often been read as a means of breaking with unitary meaning or, as Rosalind Krauss has elaborated, a device for signifying the real and the unreal simultaneously.[38] The doubled image, however, also provided women artists with a way of complicating otherness by reproducing it as sameness, by making the woman Other to herself and engaging her in a dialogue with the self that produces her life as narrative. Discussing literary autobiography, Paul de Man noted that the subject of autobiography is not an objective fact but a "textual production," and dialogism often characterizes self-narratives by women artists.[39]

Kahlo's *Two Nudes in the Jungle* (1939), with its play of light and dark, its doubling of vegetation behind the two nude figures, alludes to a sexuality based on sameness rather than difference. A series of remarkably gentle gestures—a hand stroking hair, a foot resting on another's thigh—break with assertions of difference by suggesting the possibilities of self-identification and self-pleasuring. Here the otherness is also the otherness of cultural difference, an acknowledgment of Mexico's multiplicity of cultural heritages and traditions.

Kahlo frequently used doubled images of the self—as she does in *The Two Fridas* (1939) and *The Tree of Hope* (1946)—to position herself within the dualities out of which she formed the narratives of her identity: European/Mexican, nature/culture, body/body politic. They indicate her dual cultural heritage, her simultaneous existence as the loved woman and the rejected lover, the self located within a physical body that bore the signs of both disabling pain and conventionalized beauty.

Kahlo's continuing renegotiation of boundaries—between past and present, illness and health, Mexican and European culture, Diego and herself—also informs the work of the contemporary Mexican artist Paula Santiago and the Cuban-American artist Ana Mendieta. Both have enacted the self/body through a registering of its traces and through images that suggest the absent body.

Partial exile from the body, recording the body through its absence or trace, or imprinting it elsewhere may reveal psychological dimensions of the self, political understanding, emotional awareness, or all of these. Such strategies, common both to Surrealism and to later performative acts by women that refuse the body as biologically determined or visually objectified, cannot be reduced to single meanings. Mediated by the specificities of culture and historical moment, they reveal the body as marker of identity, as border between multiple awarenesses of self, and as the source of complex images that challenge the specularization of the body in Western representation.

The work produced by women working historically in the context of Surrealism neither reduces easily to contemporary theoretical paradigms nor offers simple answers to the problems of female subjectivity and representation. Nevertheless, in making women's consciousness of self, body, and exterior world the subject of representation, it initiated a set of conditions through which to frame femininity that remain as powerful for women today as they were in the 1930s.

Notes

1. As noncitizens, there was little to encourage them into oppositional politics in France, and by the 1930s the battle for suffrage was over in England and the United States. Moreover, the Surrealists had publicly declared themselves opposed to the social institution of bourgeois marriage in a manifesto of 1927 supporting Charlie Chaplin's right to exercise his genius independently of the legal responsibilities of marriage and paternity. Reprinted in Maurice Nadeau, *History of Surrealism,* trans. R. Howard (New York: Collier Books, 1965), 262–71.

2. Elizabeth Wright, "Thoroughly Post-Modern Feminist Criticism" in *Between Feminism and Psychoanalysis* ed. Teresa Brennen (London: Routledge, 1989), p. 83.

3. Elisabeth Roudinesco, *Jacques Lacan & Co.: A History of Psychoanalysis in France, 1925–1985,* trans. Jeffrey Mehlman (Chicago: University of Chicago Press, 1990), 20.

4. I do not entirely agree with Xavière Gauthier's distinction between the Surrealist woman of poetry and that of visual art, but clearly the concreteness of the visual image and the personal proclivities of male Surrealist artists led to significant differences in the literary and visual representation of Woman. Gauthier, *Surréalisme et sexualité* (Paris: Gallimard, 1971), 71–190.

5. For a fuller discussion of these points, see Marsha Meskimmon, *The Art of Reflection: Women Artists' Self-Portraiture in the Twentieth Century* (New York: Columbia University Press, 1996), 1–7, and passim.

6. As critic Rosalind Krauss has suggested in another context, Surrealism did not confine itself to the given but "explored the possibility of a sexuality that is not grounded in an idea of human nature, or the natural, but instead, woven of fantasy and representation, is fabricated." "Corpus Delicti," in *L'Amour Fou: Photography and Surrealism,* ed. Rosalind Krauss and Jane Livingston (Washington, D.C.: The Corcoran Gallery of Art, and New York: Abbeville Press, 1985), 95. Representations that articulate sexuality and identity as fabricated, shifting, and unstable, reducible to neither essence nor social convention, often resist dominant stereotypes.

7. Abigail Solomon-Godeau, "The Legs of the Countess," *October 39* (Winter 1986): 76.

8. Meskimmon, *The Art of Reflection,* 37.

9. The term is used by Miwon Kwon in "Bloody Valentines: Afterimages by Ana Mendieta," in de Zegher, ed., *Inside the Visible,* 168.

10. These issues were taken up in the exhibition "Corporal Politics" at the List Visual Art Center at MIT (1992).

11. "L'Amour fou," as quoted in Nadeau, *History of Surrealism,* 313.

12. For the girl child, according to Freud, seeing and knowing are simultaneous, a matter of bodily identifications. The boy child, however, first ignores or disowns what he has seen. A second stage is necessary, and only the perceived threat of castration prompts him to endow what is seen/unseen with a meaning, to read the maternal lack as threat and to initiate compensatory mechanisms to allay the threat, among them fetishism (the substitution of an image or object for the missing part), voyeurism (the institution of a visual distance between desire and its object), and scopophilia (sexual pleasure through looking). The female, on the other hand, possesses no parallel distancing mechanism, and the closeness of the body continually reminds her of the castration that cannot be "fetishized away."

 Mary Anne Doane explores the implications of traditional psychoanalytic theorizations of subjectivity for spectatorship in *Femmes Fatales: Feminism, Film Theory, Psychoanalysis* (New York: Routledge, 1991), 20–26. The theme of the closeness of the female body to itself is discussed in the work of numerous contemporary psychoanalytically inclined critics; see, for example, Luce Irigaray, "Women's Exile," *Ideology and Consciousness* 1 (May 1977), 65; Sarah Kofman, "Ex: The Woman's Enigma," *Enclitic* 4 (Fall 1980): 20; and Michele Montrelay, "Inquiry into Femininity," *m/f* 1 (1978): 91–92. Both Freud's and Lacan's descriptions of the construction of the subject turn on a knowledge of sexual difference organized in relation to looking, to the visibility of the penis. More recent theorizations of female subjectivity have led to an important body of writings on the girl child's relationship to the maternal body and on pre-Symbolic forms of signification that are not necessarily linguistically derived. Some recent critics, including Bracha Lichtenberg Ettinger, have argued for resisting the positioning of Woman outside the Symbolic by *changing* symbolic structures of meaning to produce a symbolic linked to invisible female bodily specificity, a matrix, or in Ettinger's words, "a feminine unconscious space of simultaneous co-emergence and co-fading of the I and the stranger that is neither fused nor rejected. Links between several joint partial subjects co-emerging . . . indicate a sexual difference based on webbing of links and not on essence or negation." In de Zegher, ed., *Inside the Visible,* 108.

13. Cited in Terrie Sultan, "Redefining the Terms of Engagement: The Art of Louise Bourgeois," in *Louise Bourgeois: The Locus of Memory, Works 1982–1993,* exhib. cat. (Brooklyn: The Brooklyn Museum, 1994), 28.

14. Georges Bataille, *Visions of Excess: Selected Writings, 1927–1939,* ed. and trans. Alan Stoekl (Minneapolis: University of Minnesota Press, 1985).

15. Man Ray's photograph of a woman with a strangely shaped wire-mesh hat pulled over her head was reproduced in *Le Surréalisme au service de la révolution,* no. 1 (1930). The trope of caged femininity runs strongly through Victorian art and literature; see Walter Deverell, *A Pet* (1852–53), Collection The Tate Gallery, London; reproduced in my *Women, Art, and Society* (London: Thames and Hudson, 1990), pl. 95.

16. For further discussion of this theme in Bourgeois's work, see Julie Nicoletta, "Louise Bourgeois's *Femmes-Maisons:* Confronting Lacan," *Woman's Art Journal* 13 (Fall 1992/Winter 1993): 21–26; Pamela Kember, "The Home of Dreams and

All Delirious Wanderings: The Woman-House in the Art of Louise Bourgeois," in *Louise Bourgeois* (Oxford: Museum of Modern Art Papers, vol. 1, 1996), 46–51.

17. See Deborah Wye, *Louise Bourgeois,* exhib. cat. (New York: Museum of Modern Art, 1982), 14; Julie Nicoletta, "Louise Bourgeois's *Femmes-Maisons:* Confronting Lacan," *Woman's Art Journal* 13 (Fall 1992/Winter 1993): 21; Ian Cole, "Brokering Madness," in *Louise Bourgeois* (Oxford), 58.

18. Louise Bourgeois and Lawrence Rinder, *Louise Bourgeois: Drawings and Observations* (Berkeley: University Art Museum, 1996), 45.

19. See Bourgeois and Rinder, *Louise Bourgeois,* 45; I am grateful to Julie Linden for pointing this out.

20. Rosi Huhn, "Louise Bourgeois: Deconstructing the Phallus Within the Exile of the Self," in de Zegher, ed., *Inside the Visible,* 135–43; Bourgeois's subsequent cultivation of a perception close to that of schizophrenia, or hysteria, enabled her to move beyond the rationality and structure associated with phallic order while resisting essentializing projections of Woman as irrational. See her *Cells* and the hysterical arches, which reference Dali's earlier use of this form.

21. Lucy Lippard, *Eva Hesse* (New York: New York University Press, 1976), 113.

22. For the importance of this concept to Hesse criticism, see Lippard, "New York Letter," *Art International* 10 (May 1966): 64; also Anne Wagner, "Another Hesse," *October* 69 (Summer 1994): 64.

23. More recently, Anne Wagner has elucidated a subsequent history of critical readings that continues to return us (though not always in consistent ways) to the problematic terms in which "the body might be said to be present in Hesse's art" and the artist and her art collapsed into a single entity. Wagner, "Another Hesse," 63.

24. As quoted in Sheryl Conkleton and Carol S. Eliel, *Annette Messager* (New York: Museum of Modern Art, 1995), 70.

25. "Womanliness as a Masquerade," originally published in *The International Journal of Psychoanalysis* 10 (1929); the essay has been widely reprinted. See, for example, *Formations of Fantasy,* ed. Victor Burgin, James Donald, and Cora Kaplan (London: Methuen, 1986), 35–44.

26. "Each mask," wrote Hugo Ball, describing an early dada performance in Zurich, "dictated not only what costume should be worn with it, but also certain precise, pathetic gestures which approached madness. . . . The masks transmitted their power to us with an irresistible violence." As quoted in Hans Richter, *Dada: Art and Anti-Art* (New York: McGraw Hill Paperbacks, 1965), 23. Evan Maurer notes, "When an African dancer dons a mask for a sacred ritual he also becomes the vehicle of the spirit the mask represents. The mask is therefore a significant element in the process of the transformation of the individual's consciousness from the human to the mythic." "Dada and Surrealism," in *Primitivism in 20th-Century Art* (New York: Museum of Modern Art, 1984), 539; see also my "Fetishizing Fashion/Fetishizing Culture: Man Ray's *Noire et Blanche,*" *Oxford Art Journal* 18 (1995): 3–17.

27. The major source on Cahun's life and work is Francois Leperlier, *Claude Cahun: L'Ecart et la métamorphose* (Paris: Jean Michel Place, 1992); see also Laurie J.

Monahan, "Radical Transformations: Claude Cahun and the Masquerade of Womanliness," in de Zegher, ed., *Inside the Visible*, 125–33, and the exhibition catalogue *Mise en Scène* (London: Institute of Contemporary Arts, 1994). The imagery of Cahun's multiple personae often derives from a visual culture of cross-dressing that by the 1920s provided a visible means of renegotiating the culturally defined categories of masculinity and femininity with their more structured and restrictive roles for women; see Susan Gubar, "Blessings in Disguise: Cross-Dressing as Re-Dressing for Female Modernists," *The Massachusetts Review* (Autumn 1981): 478.

28. Cahun's work has yet to be fully explored in relation to its sources in the popular culture of the 1920s.

29. Andrew Menard, "Cindy Sherman: The Cyborg Disrobes," *Art Criticism* 9 (1994): 38–48; I want to thank Michelle Sullivan and Julie Linden, M.A. candidates at San Francisco State University, for their research and assistance in this area.

30. Sidra Stich elaborates on this point in *Anxious Visions: Surrealist Art* (Berkeley: University Art Museum, and New York: Abbeville Press, 1990), 26–80; see also Norman Bryson, "House of Wax," in *Cindy Sherman* (New York: Rizzoli, 1993), 218 and passim, and Hal Foster, *Convulsive Beauty* (Cambridge: MIT Press, 1993).

31. Bellmer's dolls participate in a sexual fetishization first identified in 1887 by Alfred Binet; in *Anatomy of Love* Bellmer claimed that desire has its point of departure not in the whole but in the detail, the body fragment isolated and compulsively repeated. See Dawn Ades, "Surrealism: Fetishism's Job," in *Fetishism: Visualizing Power and Desire*, ed. Anthony Shelton (London: The South Bank Centre, and Brighton: The Royal Pavilion, Art Galleries and Museums, 1995), 81.

32. Judith Butler, *Gender Trouble: Feminism and the Subversion of Identity* (New York: Routledge, 1990), 137.

33. As quoted in Therese Lichtenstein, "A Mutable Mirror: Claude Cahun," *Artforum* 30 (April 1992): 66.

34. The literature is too vast to cite exhaustively. Albert Beguin's "L'Androgyne," published in *Minotaure* in 1938, traces the historical roots of the myth, elaborating it as a "celebration of love," "refletent l'anxiété de l'homme devant la dualité des sexes et le mystère de l'amour." "L'Androgyne," *Minotaure* 11 (May 1938): 10. See also Robert Knott, "The Myth of the Androgyne," *Artforum* 14 (November 1975): 38–45; also, my "Eros or Thanatos: The Surrealist Cult of Love Reexamined," *Artforum* 14 (November 1975): 46–56. More recent explorations of the theme of androgyny in Dada and Surrealism include Amelia Jones, "The Ambivalence of Male Masquerade: Duchamp as Rose Sélavy," in *The Body Imaged: The Human Form and Visual Culture Since the Renaissance* (Cambridge: Cambridge University Press, 1993), 21–31. The Surrealist androgyne (as celebrated by Breton, Masson, and others) remained primarily a way of annexing an aspect of femininity to a masculine self. For women, assuming male dress may simply provide a separation from social constructions of femininity, allowing for new ways of enacting identity.

35. The two photographs are reproduced in Nancy Spector, "Meret Oppenheim: Performing Identities," in *Meret Oppenheim: Beyond the Teacup*, ed. Jacqueline Burckhardt and Bice Curiger (New York: Independent Curators, Inc., 1996), 40–41.

36. Varo, as quoted in Janet Kaplan, *Unexpected Journeys: The Art and Life of Remedios Varo* (New York: Abbeville Press, 1988), 178.

37. Sigmund Freud, "Some Psychological Consequences of the Anatomical Distinction Between the Sexes," *Sexuality and the Psychology of Love,* ed. Philip Rieff (New York: Collier Books, 1963), 87–88. The work of Irigaray, Julia Kristeva, Hélène Cixous, Catherine Clement, and others has been particularly important in offering ways to understand the feminine body as exceeding its discursive limits.

38. "Corpus Delicti," in *L'Amour Fou: Photography and Surrealism,* 78.

39. "Autobiography as De-facement," *MLN* 94 (December 1979): 919–30.

Chapter 21

The Masculine Masquerade:
Masculinity Represented
in Recent Art

Helaine Posner

In his insightful essay on the Hollywood film *Picnic* (1955) starring William Holden, Steven Cohan focuses on the character of Hal, an egotistical drifter whose easy charm and physical strength, emphasized by the prominent display of his muscular bare chest, have a powerful effect on the women of a small Kansas town. Does the virile Hal embody "the cultural assumption that masculinity is the essential and spontaneous expression of maleness"? In other words, Is this man in his natural and authentic state?[1] As the story progresses, we see the "naturalness" of Hal's potent masculinity repeatedly called into question. His lying, his swagger, and his exhibitionism reveal both the inadequacy of his masculinity and the tremendous effort required to sustain his gender role. Cohan's point of view is quite clear, as the title of his essay—"Masquerading as the American Male in the Fifties"—indicates. The notion of the masquerade, as originally theorized in relation to the artificiality of femininity, actually applies to both genders and is manifested as a demanding and "ongoing performance" by men and women alike.[2]

An understanding of gender as historically variable and socially constructed is one that feminist theorists have long championed, supported in recent years by their colleagues in gay studies. From this perspective, to be constructed as a male means to perpetually exhibit a complex array of cultural codes that signal one's sexual identity and family, work, and social status. These signals are under constant scrutiny, certainly by women, but no less by other men who engage in a rigorous and unending regimen of "intermale surveillance."[3] Mastering one's gender role is a strenuous endeavor, different, yet no more demanding, for the male than the female. Looking to the contemporary visual arts for representations of masculinity, we soon see that the creation of a strong and unconflicted masculine imagery is difficult, if not impossible, to achieve, which reflects the true complexity of establishing and sustaining a viable masculine identity.

On the other hand, viewed through the lens of psychoanalysis, as in the art historian Norman Bryson's brilliant study of the paintings of Géricault,

From *The Masculine Masquerade: Masculinity and Representation,* eds. Andrew Perchuk and Helaine Posner. Copyright © M.I.T. Press, Cambridge, MA. Reprinted by permission of the publisher.

the formation of masculinity and its discontents lies in the development of the positive Oedipus, or the young male's identification with the father. There is, however, an inherent contradiction within this model, for while impelled to identify with his father, the male must *not* be like the father in one highly critical respect: he may never possess the father's sexual power and privilege. According to Bryson, "The crucial result is the experience of inauthenticity within the production of the masculine, that the male can never fully achieve phallic power, however great the exertion toward that end. However much the markers of the masculine proliferate, what subtends that proliferation is lack within the position of the masculine, the deficit at its very center."[4] The desire to identify (with the father, with other men), while very powerful, remains deeply problematic and forever incomplete.

While masculinity is a personal narrative—which Freudians emphasize to the exclusion of gender's other, very real aspects—it is also, as feminists have argued persuasively, a social and political phenomenon. The male may, in practice, seek to resolve his sense of Oedipal inferiority by attaining status within the social order—thereby resolving the psychological within the social—compensating for private feelings of failure by active participation in the hierarchy. Access to patriarchal authority is not, of course, available to all males on an equal basis. Western society has an enormous investment in mainstream masculinity, typically defined as white, heterosexual, and dominant. This holds true both for those who possess power and those who seek the privileges associated with it. Until recently this standard definition remained largely unexamined. Man was posited as the generic human or universal against which all others are measured (and found lacking) which permitted men to remain blind to their own subjectivity. It has become evident that the conventional notion of mainstream masculinity, while societally sanctioned and rewarding to the few, has limited meaning in the lives of the majority of males and is, in fact, a repressive concept. As earlier studies of the construction of femininity have demonstrated, any attempt to understand the male gender also requires an acknowledgment of its social diversity and an expansion of its traditional parameters, to include such important, and often overlooked, factors as race, class, ethnicity, and sexual orientation. . . .

In her recent installation, *Gloria Patri,* Mary Kelly focuses on the themes of heroism and war, as means of investigating the psychological structure of masculinity. Set against the background of the Persian Gulf War, Kelly explores the identification of both men and women with the masculine ideal of mastery, most evident in the hierarchical and paternal order of the military, and the failure of the ambivalent individual to attain this ideal. The use of macho language and reference to physical display in *Gloria Patri* may constitute another version of the masquerade, a show of intimidation that serves to mask both the individual and the collective lack of mastery. These frustrated energies often find their deadly outlet in war.

Gloria Patri consists of over thirty polished-aluminum shields, trophies, and disks arranged on the wall in three imposing tiers. It is a glistening—and intimidating—spectacle that refers to two of the outward signs of masculine glory and pride: the sports trophy and the military medal. Hybrid montages screen-printed on the disks variously depict the insignia of the army, air force, and ROTC, among others. Six of the trophies are topped by male figures, each holding a letter of the word *Gloria*. At the base of each trophy is etched a statement made on television by an American soldier during the Gulf War. From the astonishingly naive "not enough gees and gollies to describe it" to the starkly bellicose command to "cut it off and kill it," these transcribed sound bites illustrate the insecurity at the center of the pathological masculinity that Kelly sees as characteristic of the military mindset. Five short narratives, written by the artist and etched on aluminum shields, tell confessional tales of such everyday challenges as fishing for trout, a turn at bat, the birth of a son, boyhood rebellion, and a physical workout. In each case, the adventure, competition, or crisis at hand throws the narrator into despair, as he (or possibly she) valiantly tries and poignantly fails to measure up to the task. As the narrators reveal their precarious relationship to a role of mastery, we are reminded of Bryson's postulate of inauthenticity at the core of masculine identity. Our would-be heroes will never personify the "virtues" of the powerful fighting force that engenders patriotic zeal and public adulation. In *Gloria Patri,* Mary Kelly has deftly examined a locus of predominantly male activity and revealed the vulnerability beneath its hard and polished surface.

Like Mary Kelly, Michael Clegg and Martin Guttmann turn their attention to the construction of a highly overdetermined and socially sanctioned male role, in this case the corporate executive, who [m] they depict in a series of formal photographic portraits. These men—white, heterosexual, and aggressively capitalist—embody our definition of mainstream masculinity. Using a circumscribed set of codes pertaining to dress, pose, gesture, and expression, Clegg & Guttmann have produced a contemporary equivalent of seventeenth-century Dutch group portraiture, which signified the patriarchy's attainment of a comfortable, bourgeois social status. Both the history of art and the annual corporate report have provided source material for the artists' analysis of "the way power organizes itself as imagery."[5] While the portrait painter and the commercial photographer typically provide the patron with an idealized version of reality, it is a version of reality nonetheless; in pointed contrast, fiction and artifice pervade every aspect of Clegg & Guttmann's formidable life-sized portraits.

When they began their collaboration in 1980, Clegg & Guttmann hired actors to pose as corporate brass, as for example in *Executives of the Steel Industry vs. Executives of the Textile Industry.* Ironically, these skillfully simulated portraits of the powerful led to actual commissions of group portraits, such as *The Financiers* and *The Assembly of Deans.* The artists retained the right to determine the final version of each portrait, resulting in both accepted and

Tina Barney, John's Den. *1985, Photograph. (Janet Borden, Inc.)*

rejected commissions. Clegg & Guttmann regularly manipulate the image to include false or montaged backgrounds and often combine several individual portraits to create a single picture. In their photographs, anonymous well-groomed men wear the prescribed white shirt, tie, and dark business suit, pose rigidly against a darkened interior, and stare expressionlessly under the intense glare of the lights. Occasionally, a woman adopts these conventions and succeeds in effacing herself in a traditionally male role. As established by the artists and accepted by the subjects, these tightly defined parameters serve to virtually erase personal identity in favor of producing emblems of authority. As in the military, the attitude and attire adopted by this elite provide a protective camouflage, while simultaneously exerting a considerable degree of intimidation. There appears to be nothing at all natural in either the production of white-collar male privilege or in its representation by the artists. Ostensibly critiquing corporate culture when they began their enterprise in the early eighties, Clegg & Guttmann's photographs increasingly collude with it to reinforce one of the most consciously constructed manifestations of the masculine masquerade.

The photographer Tina Barney takes us into the private world of the white, upper-middle-class power brokers who (in theory) populate Clegg & Guttmann's corporate realm. In place of the deliberately stiff formality of that

team's posed portraits, Barney makes large-scale color images, resembling snapshots, of family and friends at leisure. She is, in fact, an insider, opening a window onto the discreet and tasteful lives of the wealthy WASPs who inhabit her social sphere. Barney depicts the everyday activities that take place within the luxurious homes and exclusive playgrounds of the privileged. A highly domesticated, socially and psychologically repressed version of the patriarchy prevails in this calm realm, with conventional marriage serving as its facilitating factor.

Although they may appear to be candid shots, Barney's photographs are actually quite carefully composed to achieve the most harmonious effects of color, light, and spatial organization. Often multiple exposures are required to gain the desired results. *John's Den* is a view into the well-appointed, oddly feminine interior (floral draperies, plush red brocade sofa, vase of pink lilies) inhabited by the conservatively attired, *Barron's*-reading John and his two school-aged sons. In the hushed atmosphere of this elegant setting, with its view of New York from above, we can imagine male privilege passing smoothly from father to son. . . . Barney's private realm may, in fact, be as highly codified as Clegg & Guttmann's public sphere. The upper-middle-class is America's iconic class, representing the status for which many strive. Money is, of course, a prerequisite, but one must also possess the gloss of culture, education, and style to gain acceptance. The apparent ease of patrilineal succession is, perhaps, not as effortlessly achieved as it would seem at first glance. Throughout Barney's work, intimations of boredom, isolation, lack of emotional connection, and anxiety multiply, suggesting the real difficulties of meeting the outward demands of class and resulting in the psychological strains that threaten to disturb an otherwise placid surface. . . .

. . . In his utterly banal *Self-Portrait* [Charles] Ray challenges the notions of identity and anonymity in his representation of the artist as a regular guy or "everyman." *Self- Portrait* is a mannequin of Ray; dressed in nondescript suburban mall attire, he is "inconspicuous and the essence of ordinary."[6] However, this is an oddly unnerving sculpture—while absolutely specific, it is also curiously vague. Here is the artist as a department-store dummy, a nearly identical yet dubious double. However, if one begins to scrutinize this replica of Ray in an attempt to elicit some sense of the self, he seems to disappear; his public image as an "average Joe" turns out to be an ingenious disguise. In an elaborate game of conceptual hide and seek, the artist asserts his physical being, then slowly fades from view. Ray's persona as the normal male is a form of camouflage. He blends with the background, lacking ego, personality, or definition. . . .

The artists Dale Kistemaker and Michael Yue Tong investigate the psychology of boyhood experience within the context of two very different cultures—midwestern America during the postwar period, and China after the Cultural Revolution. In the intimate space of *His Bedroom*, Kistemaker returns to some of the most treasured artifacts of his youth—items that retain, in his words, "intense personal meaning." In this austere space, furnished

only with a stylized twin bed and night table mounted by an illuminated globe, slides of "Plasticville," a toy village invented by the artist as a child, are projected on the wall. Kistemaker's miniature universe centers on the traditional boyhood preoccupation with the building of toy trains and model buildings and imitates the adult role of man as empire builder. Also appearing in slides (projected on the bed) are the artist's report cards, pages from autograph books, and childhood drawings of such subjects as a schooner and rocket ships. The sounds of a model train and children at play are heard in the background.

As in the village he created in his childhood, this installation is a blend of Kistemaker's dreams and his reality. It is an earnest look at the acculturation of an American boy, examining the codes of male behavior expected and values taught at school and at play, the violence implied in boy's verbal taunts, and the desire for escape into a safer fantasy land. Seen from the perspective of an adult, "these stereotypes of a make-believe world in which everyone was content and everything was in its place become charged with a sense of wonder and loss."[7] "Plasticville" is America during the postwar period, an era dominated by the 1950s' rhetoric of optimism, the virtues of progress, the triumph of democracy and capitalism, and the remaking of the world in our own image—a peculiarly male vision of success. Kistemaker's work speaks directly to the loss of innocence both on the individual and the national level, as revealed through the eyes of a pre-adolescent boy facing the difficult process of gender socialization.

In his achingly personal, yet historically distanced sculpture, Michael Yue Tong explores traditional Chinese family and social relations, which are based on patriarchal authority and filial duty, and fulfilled, in part, by the ancient practice of ancestor worship. According to the Confucian philosophers, the rules of hierarchical behavior were codified in the "three bonds," wherein the leader dominates his subjects, the father rules his sons, and the husband controls his wife. The status conferred upon the man of the family, therefore, parallels the absolute authority of the ruler over his subjects. The observance of these time-honored values was disrupted in China during the Cultural Revolution and, for the artist and his parents, further diffused by the challenges of cross-cultural negotiation engendered by their relocation to the United States. Tong's work is a thoughtful study of the formation of a masculine identity forged within China's highly structured, male-dominated society, the psychological effects of his dislocation from that culture, and the eventual collapse of its system of values.

Tong's *Red Sky at Morning* commemorates an actual event, the ritual performed by the artist's father and uncles at his grandfather's gravesite to ensure the honor and well-being of their ancestor. The ceremony was laden with political significance, as the site had been neglected and later damaged during the Cultural Revolution, when ancestor worship was condemned as an antirevolutionary activity. Tong recreated the original wooden coffin in steel, and lined this sculpture with black-and-white photographs documenting the

ritual in which he participated as a young boy. This sturdy yet poignant shrine signifies the artist's affirmation of his ancestry, acknowledging both his male elder's attempts to respectfully reclaim their past and his own efforts to build a bridge across a cultural and historical divide. The endurance of patriarchal power and filial obligation was sorely tested during Tong's adolescence in America. The *Father Altar* chronicles the history of the artist's abuse at the hands of his father through the metaphorical presence of Chairman Mao. This political patriarch, whose image occupies the altar, becomes Tong's surrogate father in the installation's audiotaped account of the artist's formative years. It is a classic study of a father's violent attempts to reinforce an old paternal order in a new world, whose standards of success he is unable to meet, and of the son's Oedipal struggle to conform to and ultimately distinguish himself from his father's failed masculinity.

The British artist Keith Piper turns our attention to representations of masculinity within the public sphere. He focuses on the emblematic space of the boxing ring and on the public personas of two heavyweight icons, Muhammed Ali and Mike Tyson, in a video-installation interrogating black masculinity as a "social identity in crisis."[8] Ali and Tyson are examined within the context of the shifting cultural and political terrain of the sixties and the eighties. In Piper's view, these powerful black athletes represent two very different types of hero, but nevertheless each meets a regrettable fate. Muhammed Ali personifies the smart, verbal, politically active champion of the sixties who knowingly provokes the white establishment with his renegade stance. Mike Tyson typifies the invincible fighting machine, all brute force and no nonsense; he is the professional prizefighter of the eighties who gets the job done and collects the purse. In *Another Step into the Arena*, Piper orchestrates a dynamic video blend of fast-paced imagery, saturated color, assaultive sound, and journalistic text to illustrate the downfall of these diverse exemplars of hypermasculinity; Ali, due to the punishing effects of his years as a fighter, and Tyson, due to imprisonment for his unregulated acts of violence. The artist's deft use of video underscores the media's exploitation of these fallen heroes.

Piper is alert to the pervasive antagonism against black men in our culture but also acknowledges the ambivalent nature of their response to a white-supremacist society. The artist reasons that the "scarcity of work about ourselves by heterosexual Black men is in my opinion, the difficulty we have in looking at ourselves without blinking. This comes from the fact of being at one and the same, victim and victimizer, torn between opposing and contradictory forces. It comes from the sense of one's self as the site over which numerous macro-global contests of territory are being played out," a site subject to the projection of society's fears and frustrations.[9] The black male cultural icons that Piper sets in his sights, from Ali and Tyson to Malcolm X and Martin Luther King, are all prominent national figures who challenged the white male power structure and were destroyed or else self-destructed. For

Piper, they symbolize the precarious and turbulent state of black masculinity in our culture.

Both Keith Piper and Matthew Barney recognize in sports an illuminating metaphor for certain aspects of male behavior. For Piper, as we have seen, they serve as a stage on which certain social and political dramas are played out. For Barney, too, athletics becomes "an intensely personal form of theater."[10] The videotaped image of the artist's muscular, seminude body engaged in demanding tests of physical endurance in works such as *Field Dressing (orifill)* and *MILEHIGH Threshold: FLIGHT with the ANAL SADISTIC WARRIOR* has always suggested an underlying eroticism. Barney's ongoing gender performances in the strenuous roles of the freeclimber, bodybuilder, or football player tap into a psychologically charged male realm where sports, hero worship, voyeurism, sexuality, and unconscious urges seem to meld.

The subliminal undercurrent of male sexual desire present in Barney's earlier sculpture, performance, and video-installation works is gloriously released in the unbridled sexual energy of the cavorting satyrs in *Drawing Restraint 7.* In this case, we are the voyeurs, gazing up at the sylvan fantasy unfolding on three video monitors positioned over our heads. These half-human, half-goat creatures of Greek mythology appear to be emissaries from the id—spinning, pursuing, or wrestling in a feverish state, but not without a tinge of humor (how else would one describe two satyrs struggling in the backseat of a limousine driving through the tunnels of New York?). Barney's impulse-driven, homoerotic satyrs—although they are not quite human—arouse our passions. In this acutely visceral work, Barney, who has before appeared in his work as an accomplished athlete and, occasionally, as a drag queen, here dispenses with the conventional codes of sexual and gender identity and affirms the polymorphous nature of erotic yearning.

The artist Donald Moffett unabashedly rejects our culture's traditional definition of masculinity as an exclusively heterosexual construct. Drawing on his wit, intelligence, and highly developed formal sensibility, Moffett asserts his sexual and social consciousness in a body of work that both seduces and provokes. He brings his interests as an AIDS activist and skills as a graphic designer to bear on his art, creating a positive representation of homosexual identity and desire. Whereas Matthew Barney remains free-floating and self-absorbed in his sexuality, Moffett delivers his message loud and clear. He is dedicated to making the homosexual body visible in our culture and to voicing his opinions about a range of private and public concerns, including the expression of desire, promotion of safer sex, wider availability of current treatments for AIDS, and greater governmental commitment to AIDS research. He promotes his weighty agenda with a light touch, focusing on the body, particularly its orifices, as the site of sexual pleasure and suggesting a greater openness, regardless of one's object choice, to the body's erotic potential.

Each work in Moffett's series of marbleized bowling balls sports a single large drill hole, framed with the words "choke," "glory," or "mon amour" in luscious gold lettering. These banal objects are elegantly transformed into funny, sexy signs for anal intercourse, the focus of homosexual desire as well as trepidation as the location of HIV transmission. They are works that "refuse guilt," proclaiming the artist's closely allied goals of homosexual assertion and social action.[11]

Moffett's *Sutured Snowman,* covered with pristine white floral appliqués marred by red floral "scars," is a poignant and poetic metaphor for a wounded masculinity. Slightly bowed, the snowman wears his wounds as a badge of the pain he has endured due, in part, to the devastation of the gay community as a result of the AIDS epidemic. Moreover, this snowman's battered state visibly manifests the sense of inadequacy and failure we have

Donald Moffett,
Sutured Snowman.
1992, Acrylic, felt,
nylon, and screws.
(Donald Moffett)

noted at the core of masculinity—a condition that most often remains masked. Moffett here provides a courageous and moving symbol for this psychic loss, with implications for all men.

Lyle Ashton Harris explodes all conventional gender and racial categories in a series of seductive photographic self-portraits in which he represents himself as both male and female, dominant and passive, black and white. He subscribes to Judith Butler's notion of gender as an impersonation wherein both masculinity and femininity are elaborately designed masquerades. According to Kobena Mercer, Harris's "strategic use of masquerade, which carnivalises the gendered surface of the body, renders Black masculinity into a strangely ambiguous version of femininity; that is, a category of identity characterised by its own highly constructed and composite artificiality."[12] In Harris's theatrical tableaux, gender is a completely fluid concept and male and female identities are easily interchanged as the artist traverses our culture's overdetermined codes. In Harris's photograph *Alexandra and Lyle,* two people embrace; one, with close-cropped hair wears a black leather jacket and directly meets our gaze, the other, in a black chiffon dress and full makeup looks askance. "He" is Alexandra and "she" is Lyle. Our attempt to locate or define masculinity has been quite thoroughly destabilized by the artist's provocative gender exchange. . . .

Lyle Ashton Harris, **Alexandra and Lyle.** *Photograph. (Courtesy of Lyle Ashton Harris)*

The masculine, it seems, is not a monolithic and immutable gender but a complex conflation of personal, sexual, social, and historical conditions. Once assumed to be the normative, or authentic, gender role, defined in marked contrast to the masquerade of the feminine, masculinity is finally revealed to be, like femininity, an artificially constructed identity. From the mainstream masculinity policed by the superego, as seen in the work of Mary Kelly and Clegg & Guttmann, to the more transgressive identities forged by the id, as in Matthew Barney's and Lyle Ashton Harris's work, and allowing for multiple ego negotiations in between, masculinity proves itself to be a highly variable and often vulnerable construction. The personal and psychological demands of maleness, coupled with the political and social pressures to conform to its manifold codes, require the subject to be constantly vigilant, lest he suffer internal and external sanctions. In life as in the contemporary visual arts, the performance of the male role presupposes the presence of a discriminating audience, and the performer knows that the success or failure of the masquerade is ultimately measured in the eyes of others.

Notes

1. Steven Cohan, "Masquerading as the American Male in the Fifties: *Picnic,* William Holden and the Spectacle of Masculinity in Hollywood Film," in *Male Trouble,* eds. Constance Penley and Sharon Willis (Minneapolis: University of Minnesota Press, 1993), 221.

2. Cohan, 227.

3. Norman Bryson, "Géricault and 'Masculinity'," in *Visual Culture: Images and Interpretations,* eds. Norman Bryson, Michael Ann Holly, and Keith Moxey (Hanover, N.H., and London: University Press of New England, 1994), 231.

4. Bryson, 244.

5. Clegg & Guttmann quoted in Mary Ann Staniszewski, "Dressed for Success," *Afterimage,* September 1989, 25.

6. Bruce Ferguson, *Charles Ray* (Malmö. Sweden: Rooseum—Center for Contemporary Art, 1994), 19.

7. Andy Grundberg, in a wall text written for Dale Kistemaker's *His Bedroom,* exhibited at The Friends of Photography. Ansel Adams Center, San Francisco, 1994.

8. Kobena Mercer, "Engendered Species," *Artforum* (summer 1992), 74.

9. Keith Piper, *Step into the Arena: Notes on Black Masculinity and the Contest of Territory* (Rochdale, Eng.: Rochdale Art Gallery, 1991), 7.

10. Marc Selwyn, "Matthew Barney Personal Best," *Flash Art,* October 1991, 133.

11. Scott Watson, *Felix Gonzales-Torres Donald Moffett: Strange Ways Here We Come* (Vancouver, B.C.: Fine Arts Gallery. The University of British Columbia, 1990), 15.

12. Kobena Mercer, "Dark & Lovely Notes on Black Gay Image-Making," *TEN. 8* (Birmingham, Eng., spring 1991), 85.

Part VII

Art, Science, and Technology

Art and science may interface in numerous and diverse ways as evidenced in the following four essays. During the Renaissance, Leonardo's study of anatomy, botany, and hydraulics reflected a growing interest in empirical observation of nature. The science of psychology has increasingly penetrated the world of art history in the application of psychoanalytical methods to art analysis. In the past several decades, technological advances and electronic media have expanded the traditional definition of art. Artists have created a forum to voice environmental and ecological concerns in sculpture, installations, earthworks, and reclamation art. At each intersection with science and technology, art and its methodologies and context are significantly altered to reflect new knowledge, a changing world, and the artist's vision transformed.

The Renaissance, with its new focus on direct human experience, precipitated an interest among artists in anatomical and botanical study. Scientific investigation and curiosity about the natural world distinguish Leonardo da Vinci's drawings and paintings of the human figure and landscape from those of his predecessors. As James Ackerman explains in his article, "Leonardo da Vinci: Art in Science," while Leonardo's knowledge may have originated from books, he proceeded to base his sketches on empirical observation of the natural world. The precision of the anatomical studies recorded in his notebooks indicates Leonardo's ability to fuse the theoretical with direct experience. Leonardo's artworks demonstrate the innovative nature of his approach to representation through utilizing new techniques such as foreshortening to make his images appear more realistic.

In comparing Leonardo's early drawings to those done later in his career, Ackerman notes an increasing focus on diversity in nature, with each

form determined by function. In earlier studies of moving matter, especially the action of water in different circumstances, Leonardo theorized a universal scheme similar to those proposed by the scholastics and humanists, searching for verification through observation. It was his innate empiricism that led him to challenge artificial perspective construction in painting by studying physiological optics and visual perception with the assistance of the *camera obscura*. Late embryological drawings combine accuracy and speculation since the artist had not actually witnessed a Caesarean operation. Yet, for one of his last studies, the heart of an ox, Leonardo did work directly from observation, thereby producing a work so specific as to advance scientific understanding of pulmonary function.

Leonardo's genius, however, does not simply lie with an ability for replication. He brought to his investigations an understanding of light, atmosphere, texture, and vision as well as knowledge of engineering principles and botany. What makes his artwork so distinctive is his ability to present "all objects of his attention as manifestations of an overarching scheme. . . Leonardo's vision was of a breathing, mobile Nature; revealed in the diurnal tides, and in microcosm, in the human body." Leonardo was able to persuasively replace the typical conceptual method with a more experiential approach.

The science of psychoanalysis is relatively young, a 100 year old phenomenon. Laurie Schneider Adams in "Psychoanalysis I: Freud" explains an essentially art historical method which explores the unconscious significance of works of art. In a psychoanalytical approach to art, the work itself is analyzed; the artist's biography is related if relevant; the aesthetic response of the spectator is examined; and the cultural context is considered.

In this essay, the author first reviews the psychosexual stages of development as identified by Freud—oral, anal, phallic, and genital —as well as Freud's explanation of the mechanisms of dream formation. Adams then proceeds to analyze specific works; for example, Rousseau's *The Dream* may illustrate Freud's dream theories. The Oedipus Complex is also defined. Sculptural interpretations of the David and Goliath theme by Donatello, Michelangelo, and Bernini are compared and interpreted in light of "negative" and "positive" Oedipal resolution. Psychobiography is applied to Caravaggio's painting in which the artist portrays himself in the severed head of Goliath held by a youthful, androgynous David, evidence, according to Adams, of Caravaggio's "conflicted bisexual identifications, the terror of castration and the sense of his psychic existence as living death."

Psychoanalytical methodology provides a modern perspective on art from previous centuries. It offers an alternative to more traditional art historical analysis and may complement other critical approaches. However, the reader of the essay might question certain assumptions. How viable is the application of Freudian theories to pre-Freudian artworks? Is the interpreter reading too much into a particular painting or sculpture? Does psychobiography violate an artist's

right to privacy? Donald Kuspit in his study *Signs of Psyche in Modern and Postmodern Art* alerts us to the possibility of overanalysis, warns of psychoanalysis' imperialism and of the dangers of oversimplification to the point of trivialization. The reader must decide when a psychoanalytical method enhances understanding and when it might detract from our experience of a work of art.

Another development that has changed conventional definitions of art and the nature of artmaking is the expansion of art media to embrace new technologies. According to Margot Lovejoy in "Electronic Media and Postmodernism," the electronic invasion into public consciousness and every part of contemporary life has effected a shift from modernism to postmodernism. Postmodernism challenges the linearity of the modernist concept, envisioning life and the world as "an experience of continually changing sequences, juxtapositions, and layers, as part of a decentered structure of associations."

Lovejoy reviews early exhibitions which specifically addressed art and technology and seemingly launched the electronic era in art. The establishment of the organization "Experiments in Art and Technology" (E.A.T.) in 1967 by artist Robert Rauschenberg and scientist Billy Klüver, was intended to facilitate the collaboration with engineers and scientists required for artists to successfully and innovatively work with new technologies. Also significant were exhibitions based on collaboration between artists and engineers such as the one conceived by Maurice Tuchman for the Los Angeles County Museum of Art in 1971. Twenty-two artists were paired with corporations that provided technical, production, and maintenance support.

By the mid-seventies the computer was already emerging as a valuable tool for artists. Photographic strategies including appropriation of earlier imagery and texts and absorption of popular motifs also led to the deconstructing of modernism. In Barbara Kruger's work mass media/mass culture and high art intersect to challenge the established order or representation.

Television, in particular, has been responsible for evolving a new definition of culture since its inception over fifty years ago, with its lightning-quick fluid imagery; compressed text; and the merging of theatrical effects, information, bits of everyday life, art, music, culture, and science. Additionally, perception and consciousness have been altered, and our experience of time, space, and distance are distorted, by the Internet, fax machine, and interactive CD-Rom. Not surprisingly, the postmodern fusion of social, institutional, and conceptual contexts has affected public art. From the efforts of Group Material, founded in 1979, to "question perceived notions of what art is and where it should be seen" to Krzysztof Wodiczko's large-scale night projections onto city monuments, the nature of public art is being transformed.

The new technologies of television, video, digital imaging, and Internet communication have revolutionized seeing. Through the expanded options

available through rapidly evolving electronic capabilities, artists are able to reflect and reflect upon the dynamics of late 20th century (and now, early 21st century) life.

Interestingly, as a byproduct of technological advances and the transformation of nature and the world through mechanization, environmental crises have resulted. Earthworks, "green art," and reclamation art have been created by artists who feel compelled to inform the public about critical environmental concerns, possibly suggesting ways to avoid future ecological destruction. In her article "Environment, Audience, and Public Art in the New World (Order)," Mara Adamitz Scrupe describes the responses of five contemporary sculptors to specific issues and sites.

Stacy Levy creates sculptural installations informed by her interest in the biotic processes in nature and her professional commitment to restoring the landscape. Incorporating technology to achieve simulations of natural phenomena (for example, the movement of the waves in her site-specific *A Month of Tides* for Miami-Dade Community College) Levy tries to reconnect us with nature's cycles through sensory experience.

Jackie Brookner's installation *Of Earth and Cotton* was not created for just one site, but went through various manifestations at a number of exhibition sites in the southern United States. Combining a physical and multi-sensory approach, the artist captured the difficult work of growing and harvesting cotton, thereby inviting viewers to reevaluate their connection with the earth by documenting rural life spent working the land. Implicit in these installations is the "ecological impoverishment of urban life" and the need for city dwellers to forge a more vital relationship with nature.

Scrupe also discusses Patricia Johanson's design for the Fair Park Lagoon project in Dallas, Texas in which the artist incorporated sculptural elements as walkways and included plantings which served to revitalize the area's ecosystem. The author also mentions Steven Siegel's site-specific sculptural installations comprised of recycled materials, trash, and nature's detritus as ecologically conscious-raising, for they draw attention to the alarming amount of waste produced by our consumer society. Yet, unlike much of our modern society's garbage, some of Siegel's sculptures eventually decompose to actually nourish, rather than pollute, the land.

All the artists included in Scrupe's study express certain shared ideas: the dichotomy between nature's innate timeclock and the human conception of time; the need for us to philosophically reposition ourselves to live among, not dominate, the living creatures on the planet; and the ongoing destruction of the environment caused by our society's "capitalist ethic of accumulation and disposal." While these artists may not be able to effectively solve problems, in alerting viewers to serious ecological issues, they inform the public and may even, hopefully, inspire environmental activism.

Chapter 22

Leonardo da Vinci:
Art in Science

James S. Ackerman

. . . Leonardo made the faculty of vision—or more precisely, the gift and
patience for intensive observation—the foundation of both his scientific
investigations and his work as a figural artist. He was a protoscientist in the
modern sense of what constitutes science, bringing to his investigation of
the natural world not only an extraordinary artistic imagination, which led
him to innumerable original discoveries, but a unique and idiosyncratic
intellectual position that helped him to circumvent the mental blocks of his
contemporaries.

Science in the century preceding Leonardo was based almost entirely
on texts surviving from antiquity; experiment and the pursuit of new chal-
lenges was rare. The Aristotelian scientific tradition had been sustained by
scholastic writers, primarily within the church. Humanist scholars, a new
class comprised of teachers, poets, and court secretaries, sought to redis-
cover and edit Greek, Latin, and ultimately Hebrew texts and to improve
literary style in these languages; while their primary interests were liter-
ary and historical, they also made available—often as editors for the new
printing houses—what had remained of mathematical and scientific trea-
tises and their epitomes, such as those of Euclid and Archimedes, Galen
and Ptolemy. They restored to circulation, in Latin, medieval Arabic texts;
in the discipline of optics alone, this included the work of Avicenna and
ibn al-Haytham, as well as their later Western heirs, Bacon, Vitellius and
Pelacani.

Trained as a painter, sculptor, and designer of machines, Leonardo da
Vinci was no humanist. At the start of his career he was unable to read the
texts upon which he would have to base his scientific knowledge. He admit-
ted that he had the reputation of an *omo sanza lettere* (an illiterate), meaning
that he did not have a good command of Latin. During the 1490s in Milan, he
struggled to improve his Latin; both as a result of this effort and of an increas-
ing number of Italian epitomes, he acquired as much information as he
needed in the innumerable fields of his interest.

Science in Leonardo's time was predominantly descriptive. The fields
in which progress was made were those that could be investigated with the

This essay originally appeared in *Daedalus,* "Science in Culture," Winter 1998, Vol. 127, No. 1.
Reprinted with permission of *Daedalus,* Journal of the American Academy of Arts and Sciences.

eye—anatomy, botany, cartography, zoology, and ornithology. Copernicus stands virtually alone in the two centuries prior to Galileo and Kepler in being productively engaged in theoretical science.

An astonishing number of studies and notebooks, only some of which have survived, records Leonardo's intense drive for a comprehensive knowledge of creation on the model of Aristotle. Like Aristotle, Leonardo was an empiricist, in contrast to adherents of the Platonic tradition who worked with logic and mathematics on abstract hypotheses conceived intellectually.

Leonardo starts from books, but in almost every field of investigation he moves from traditional explanation to one based on his own experiments and experience. Since early writing often copied from traditional texts, one cannot always be certain whether Leonardo himself agreed with a statement that he wrote down.

A vivid early drawing of a skull sectioned vertically and horizontally illustrates the point. Although astonishingly precise in detail—there are a number of anatomical features overlooked in the earlier literature—major aspects of the drawing illustrate points determined theoretically rather than empirically. The grid of lines, for example, is intended to illustrate the conformity of the head to a system of privileged geometrical proportions. Further, the drawing illustrates the medieval doctrine that the vertical and horizontal axis of the skull must cross at the site of the *sensus communis,* or common sense, where all perceptions—of sight, sound, touch, and so on— were believed to be gathered; this was considered the seat of the soul. According to Plato and Hippocrates, whom Leonardo quotes, the soul must activate the entire body and, in particular, must transmit seeds for reproduction from the brain to the genitals. Accordingly, a channel must be provided through the marrow. The top of the spine in this drawing has a large interior channel, which Leonardo would not have found in his skeleton. If in this instance books triumphed over observation, the radically innovative character of the representation, which employs techniques of foreshortening just being devised at the end of the fifteenth century, is manifested by comparison to other works of this period.

In his early work, Leonardo tried to coordinate natural phenomena into an overarching design revealed in similarities of behavior among disparate natural phenomena. By contrast, experiments and observations in the later manuscripts focus on the diversity of nature: every form becomes determined by its function. An understanding of the extent to which Leonardo's scientific method matured over the course of his life has become possible only in the last twenty-five years through the painstaking determination of the chronology of the many notebooks and separate drawings.

For example, in an early sheet from the Codex Atlanticus, Leonardo attempts to establish a unitary—percussion—theory of the transmission of sense impressions. The figures, drawn as similarly as possible, are accompanied by explanatory notes:

How lights or rather luminous rays, can only pass through diaphanous bodies.

How the surface *x, o* illuminated through point *p*, generates a pyramid that finishes in point *c*, and ends up at an other surface at *r, s*, which receives what is in *x, o* upside down. [This illustrates the *camera obscura*, a device discussed already by ibn al-Haytham in his eleventh-century treatise on optics.]

If you put a colored piece in front of each light you will see the surface colored by it. [While this observation seems obvious to us, it served to demonstrate that light "rays" emanate from the object of vision and are not emitted from the eye, as some ancient writers had claimed.]

How the lines of a blow pass through any wall. [Thus sound "rays" behave like their visual counterparts, except that they can pass through opaque barriers.]

How, finding a hole, many lines [of sound] spread; all others are weaker than *a-b*.

Voice in echo. [angle of incidence = angle of refraction.]

How the lines of the magnet on iron are drawn in the same way.

Smell spreads the same way as a blow.

Every point generates infinite bases.

Every base generates infinite points.

Alternatively, Leonardo discovered such universal analogies in the behavior of moving matter. His almost obsessive effort to understand the action of water in response to a variety of constraints is the concern of a hydraulic engineer. Indeed, he was hired in that capacity in Milan and in Florence, where he was charged to study the feasibility of making the Arno navigable from Florence to the sea. His observations are concentrated primarily in two notebooks, Manuscript A of the Institut de France, and the Leicester Codex, now the property of Bill Gates.

Probably the painstaking care taken in observing the movement of water throughout his career laid the groundwork for the late series of drawings depicting an earthly chaos, an Armageddon, in which the exploding landscape takes on equivalent forms—in this case, for art's sake. Like the transmission of sense impulses, the flow of liquid is also part of a universal scheme in early notes, as in this passage: "If a man has a lake of blood in him whereby the lungs expand and contract in breathing, the earth's body has its oceanic sea which likewise expands and contracts every six hours as the earth breathes." Leonardo goes on to associate underground springs with veins; a drawing in the Leicester Codex illustrates this.

These are the types of observations that support Foucault's characterization of the protoscience of Leonardo's time as based on similarities and analogies. Leonardo makes great claims for experiment, experience, and observation to distance himself from the scholastics and humanists who commented chiefly on texts, but in reality he was strongly directed by the textual tradition, constantly seeking—and only rarely finding—formulations of the causes of the effects he observed.

We may try to define the method with examples from two areas: first, physiological optics and visual perception; and second, anatomy, which Leonardo approached as a scientist, and only peripherally to help his art.

I begin with Leonardo's observations on the most widely used method of constructing painter's perspective in his time—*perspectiva artificialis.* The sketches reproduced in [*Perspective Distortion of Nearby Objects* and *Perspective Distortion of a Row of Columns Seen Close Up*] illustrate his observation that when one gets close to the objects to be depicted, the rule by which objects appear to diminish in size as they are more distant from the eye no longer holds. The central ball or column in these drawings will be projected on the picture plane as smaller than those farther away, due to distortions resulting from a viewing point too close to the plane. This is an issue of perception; Leonardo's passion for observation gave him the capacity to challenge the dicta of artificial perspective, which were strictly geometric and abstract, unrelated to perception. They posited that all light rays converge in a point at a hypothetical eye—a single eye in a fixed position, as Leonardo's diagram shows.

His answer was not to seek an improved construction procedure but to try to understand how the eye actually works. Over the course of the following decades, but mostly around 1505 and at the end of his life, he tried to move beyond the literature of medieval optics from ibn al-Haytham on, with which he was thoroughly familiar, by devising experiments and trying to interpret their results. Two lines of investigation led him to conclusions that further diminished the hold of artificial perspective. The first was derived from the use of the *camera obscura* as a model of the eye. The *camera* appeared in the early drawing illustrating the propagation of sense stimuli but was used there only to study the behavior of light rays. Later Leonardo saw that the eye, with its lens and pupil, must function in the same way.

In [Leonardo's *Diagram of the Eyes Reception of Images Compared to camera obscura*], the two are compared on the same page from a small notebook—Manuscript D of the Institut de France—on optics and the physiology of vision. At the top of the margin Leonardo drew a horizontal section of the eye, and below, a horizontal section of a *camera obscura*, indicating that the two function in the same way. His notes on this page read:

> The experience [experiment] which shows how objects transmit their species or similitudes through an intersection inside the eye in the albugineous humor is demonstrated when species of illuminated objects penetrate through some small round hole [in an iron plate] into a very dark habitation. Then you will receive these images on a sheet of white paper placed inside this habitation somewhat near to this small hole, and you will see all of the mentioned objects with their true figure and colors, but they will be smaller and they will be upside down because of the said intersection (the paper should be very thin and seen from behind).

Most of Leonardo's drawings cut through the eye horizontally and therefore do not show that rays entering from above and below the aperture would also cross, casting an image upside down as well as reversed. The *camera,* apart from helping Leonardo to understand the physiology of vision, later became a tool for artists, who could sketch images received on the piece of paper.

In the section of the eye at the top of the manuscript page, we see Leonardo struggling with a problem he never solved; while the *camera obscura* reverses the image, we do not perceive the world as reversed. The answer, he thought, must be that some mechanism within the eyeball sets the image right by re-reversing it; in these drawings, it is the crystalline sphere, which is posited as a spherical lens. It is not the right answer; but what is right about Leonardo's understanding of vision is that it reveals the problematical nature of the theory of linear rays meeting at a point. This would lead to con-structing pictures in quite a different way.

The rays do not come to a point because light rays are sensed on the whole surface of the cornea, but nevertheless pass through the pupil by being refracted. Leonardo's conviction that the entire cornea is sentient was based on an experiment demonstrating that a small obstacle placed directly in front of the pupil does not block a full view of the image before us. His explanation of this result is given in a sketch. [*Demonstration of the Capacity of the Eye to "See Through" a Small Nearby Object*]. The top of the cornea will see it at position *e* and the bottom at *a*. The refraction, Leonardo reasoned, weakened the periph-eral rays so that images looked fuzzier at the edges than at the center. But, as in medieval optics and in perspective theory, the central ray always has the sharpest and strongest effect because it hits the target unbent—as if, Leonardo says elsewhere, a bullet were to be shot *into* the barrel of a gun. If these stud-ies did not lead directly to increasing modulation and haziness in Leonardo's painting and drawing, they must at least have urged him away from the sharp edges and strong local color of his fifteenth-century predecessors.

Let us now turn from optics to anatomy, and specifically to the evolu-tion of Leonardo's investigations in the years following the drawing of the skull. The large size and striking conception of the drawing of the female torso rendered transparent in order to reveal the viscera have made it the best known of Leonardo's second Milanese period in the years following 1506–08. It belongs to the large category of hypothetical studies combining animal dis-section with traditional anatomy, making it a direct descendant of the medieval *situs* figure, of which two woodcuts from the 1495 printing of the anatomical work of Mundinus, showing the internal organs in a largely sym-bolic form, were the most recent examples. But while Leonardo's drawing appears to represent a great advance in accuracy over its predecessors, there is no sign of new empirical knowledge despite the fact that he had already performed human dissections; the progress is exclusively in drawing tech-nique, particularly in the use of wash to enhance relief and in the combina-tion of section, relief, and full and partial transparency. The uterus has "horns" to illustrate Mundinus's hypothesis that it is bound to the hips by two pairs of ligaments (one pair of which is a misunderstood transformation of the Fallopian tubes, which enter near the cervical region—at the bottom rather than at the top).

The celebrated image of the uterus, out of which a wedge has been cut to reveal a fetus within that looks like a year-old child, is one of a number of

embryological studies dating from either 1510–13 or 1515, which places them among Leonardo's last anatomical observations. While the fetal position is accurately rendered, the drawing represents in other ways a reversion to those done before the turn of the century, based largely on speculation, with the addition of information gained from the dissection of a cow (whence the representation of the cotyledons binding the placenta to the uterine wall). Apparently Leonardo had not had the opportunity either to perform or to attend a Caesarian operation, though he does imply on a sheet from the same series that he had examined the fetus that appears in the drawings.

The artist's approach is entirely different in one of the last studies, done on a textured bluish paper, representing the heart of an ox. Here he was able to work entirely from direct experience. While speculation and traditional theory had a role in his understanding of pulmonary function, they did not impinge on his powers of observation, and in this sheet he made major advances applicable to the understanding of the heart. The drawings, showing the organ from the front and rear, exemplifies Leonardo's precept that the body parts should be represented in more than one view. It is the first anatomical description of the coronary arteries; to fully depict their form, Leonardo removed the pulmonary artery, and this served also to reveal the three cusps of the pulmonary valve.

Leonardo da Vinci, **Mechanisms of the Ventricles of the Heart.** *(The Royal Collection Enterprises, Ltd.)*

The problem that most concerned Leonardo in investigating pulmonary function was how to explain the warming of the blood. In his early notes he suggested that it resulted from external forces of nature, comparing it to the rising of sap in trees. After 1508, he compared the heart to a stove that heats and then propels the blood through the veins. The heating process is explained in a note on the upper left of the drawing of the ox heart:

> The blood is more subtilized where it is more beaten, and this percussion is made by the flux and reflux of the blood generated from the two intrinsic ventricles of the heart to the two extrinsic ventricles called auricles . . . which are dilated and receive into themselves blood driven from the intrinsic ventricles; and then they contract, returning the blood to those intrinsic ventricles.

The rendition of the heart is impressive not just as a record of significant advances in empirical observation—which, had they been known to others, might have led to an early discovery of the circulation of the blood—but for the extraordinary draftsmanship that reveals the object in a natural ambience of light and atmosphere. The very viscousness of the flesh is rendered in a way that has never since been matched in anatomical illustration.

For over twenty-five years of anatomical investigation, from the earliest representations of the skull to the late studies of the heart, Leonardo produced indelibly memorable images. But I should describe the skulls as marvels of draftsmanship—unsurpassed as such, yet of a much lower ambition. The drawings seek to give objects represented the palpability of sculpture and architecture, to make the pen virtually replace the skull itself. But conceptually they belong to the previous generation, with their concern for accommodating the object to external geometrical rules of perspective and proportion. Furthermore skulls, human though they may be, are inanimate objects, not different in essence from spheres with penetrations; in fact, they communicate nothing of the function of the human body. The heart, by contrast, is a lately pulsating organ of flesh and moisture, and not subject to the disciplines of mathematics. Such representations drew Leonardo far from the atmosphere of calculation and rationality of his early years into the almost indescribable mystery and complexity of life itself. One might ask why the depiction of the fetus, drawn only a few years before, looks more like the skull than like the heart. The answer is that it was an almost entirely hypothetical construction of the mind, on which the senses could be brought only peripherally into play; to draw it Leonardo had to fall back on the mode of theoretical construction. In fact, his experiments had taught him almost nothing of the process of gestation.

Whatever the progress made in the disciplines of physiology and anatomy following these drawings, it was not rivaled by progress in illustration. Anatomists after Leonardo and Vesalius were simply anatomists with, at best, rudimentary skills for recording their discoveries in images, and artists did not dissect people and oxen except perhaps to study musculature. In the five centuries since Leonardo performed his first dissection, the skill, artistry, and

didactic potential of anatomical illustration has regressed, while the degree of advance in scientific accuracy has been in some respects less than Leonardo's advance over his immediate predecessors and followers prior to Vesalius.

But my point is that Leonardo was not simply an artist skilled in achieving verisimilitude; in this he had many rivals who, for all their talents, did not contribute significantly to anatomy. It is that his unbounded curiosity led him to pursue a vast range of natural effects and physiological responses, so he could bring to the recording of an animal heart an understanding of light, atmosphere, texture, and vision, as well as hydraulics for the flow of blood, botany for the branching of veins and arteries, mechanics for the expansion and contraction of the organ, and so forth. It was not simply Leonardo's grasp of these many natural processes that gives any one of his images a unique persuasiveness, but rather his desire to see all objects of his attention as manifestations of an overarching scheme. Yet "scheme" is not the right word, because it suggests something static, nor does the cliché "clockwork of the universe" fit, because it suggests something regular and mechanical. Leonardo's vision was of a breathing, mobile Nature—characterized by "flux and reflux" in the passage cited above, and revealed in the diurnal tides and, in microcosm, in the human body.

Do Leonardo's universal interests make him the fabled Renaissance man? Yes, in the sense of the range of his investigations, though not in the sense of his having achieved the kind of scholarly command of ancient texts that constituted the foundation of true knowledge for Renaissance humanists. In his scientific studies, Leonardo made earnest efforts to master the basics of traditional wisdom in each field; that meant knowing, at least indirectly, major Greek and Latin texts or modern summaries of them and, where relevant (as in the study of optics), medieval Arabic and Western works. Leonardo did not seek—as did his Florentine predecessor Leon Battista Alberti—celestial harmonies that might be emulated on earth; instead he sought a universal vital spirit animating all of creation. The two approaches may seem similar, but in fact they differ fundamentally. Alberti's is hierarchical, suggesting that we on earth try to emulate a celestial order in mathematical forms. Leonardo's, by contrast, is egalitarian. He posits that heaven, earth, man, and beast share and contribute to a mutually sustaining energy. It is more pagan than Christian.

Simultaneously with his achievements in describing objects in the natural world, Leonardo was opening new horizons in conveying the experience of vision itself. A small sketch of a copse of trees in the corner of another sheet at Windsor is a token of one of the most consequential changes in the history of Western art. Medieval and fifteenth-century drawn and painted trees, like those of Fra Angelico, Botticelli, or Leonardo's own early *Annunciation,* are discrete solid objects that one can count and distinguish from neighboring trees; they are as concrete as Leonardo's skull and come from a pictorial tradition that isolates every figure by its outline and local color. Leonardo

approached the copse optically; he tried to catch the visual continuum at a particular time of day, as Monet would do four hundred years later. The trees are not individuals but the common recipients of a particular light and atmosphere. In a sense, it is inadequate to call the tree drawing "optical": every representation of nature could be called optical. But I mean to contrast optical to *conceptual* representation, which shows an object as one believes that one knows it to be, not as it appears to an interpreting personality at a particular moment.

It is tempting to say that [*The Heart of an Ox*] is objective in recording the heart as it really looks and that the copse is subjective in conveying a differentiated continuum of light and shade as experienced by an individual observer in particular temporal and physical conditions. But the image of the heart is also informed by those particularities, and one's visual and psychological faculties do not shift at will from an objective to a subjective mode of reception. I would rather suggest that the two are more alike than different in revealing the willingness of the artist to replace a conceptual approach to the world with an experiential one—leading to the end of a new art in the one sheet, and the end of a new science in the other.

Leonardo da Vinci, **Copse of Trees.** *c. 1508, Red chalk. (The Royal Collection Enterprises, Ltd.)*

Chapter 23

Psychoanalysis I: Freud

Laurie Schneider Adams

The psychoanalytic approach to art history deals primarily with the unconscious significance of works of art. This is a complex method, which involves not only the art itself but also the artist, the aesthetic response of the viewer, and the cultural context.[1] It is a method that has been partially integrated with iconographic methods, as well as with feminism, Marxism, and semiotics. Psychobiography, which examines the artist's psychological development in relation to his art, is also a feature of psychoanalytic methodology. . . .

Although art history and psychoanalysis are distinct disciplines, they have much in common. Both fields are concerned with the power of images and their symbolic meaning, with the process and products of creativity, and with history. Just as works of art involve images, so too do dreams, daydreams, fantasies, jokes, and neurotic symptoms. Interpreting imagery is a significant aspect of both psychoanalysis and art history.

Freud: Some Basic Concepts

When Freud developed psychoanalysis, he was fully aware of its cultural applications. As early as 1896, he compared the clinical process of psychoanalysis with archaeology, and declared that "rocks speak—*Saxa loquuntur!*"[2] Like an archaeologist, the psychoanalyst searches for buried material from the past. The former does so by excavating a physical site, uncovering ancient fragments such as broken pottery and ruined buildings, and clearing away the debris of later periods. The latter takes the artifacts of mental life, such as dreams and memories, which also tend to be fragmentary, and connects them to an earlier time in the life of the individual. Both the archaeologist and the psychoanalyst try to reconstruct fragments and their history. The archaeologist situates the physical ruins within the historical layers of a site, while the psychoanalyst connects mental fragments to a layer of psychosexual development.

The psychosexual stages of development as construed by Freud are the oral, anal, phallic, and genital stages. Each has its own set of conflicts and is located in a specific zone of the body. The oral stage is bound to the sexual excitation of the mouth. During the anal stage, the child learns control of his execretory function. In the phallic stage, both girls and boys focus on the

Henri Rousseau, **The Dream.** *1910, Oil on canvas, 6′ 8½ ″× 9′ 9½″ (204.5 ×
298.5 cm.) (The Museum of Modern Art, NY. Gift of Nelson A. Rockefeller.
Photograph © 2000. The Museum of Modern Art, NY)*

phallus, and fears of castration (in the boy) and a sense of having been cas-
trated (in the girl) predominate. The latency period lasts roughly from five
years to the beginning of puberty, which marks the onset of the genital stage.
At this point, according to Freud, the genital zones of the body achieve pri-
macy, and operate in "the service of reproduction."[3]

Just as each new archaeological discovery leads to a revision of history,
so in psychoanalysis dreams, memories, and fantasies shed new light on
one's childhood. When Freud undertook the only known self-analysis, he
compared what he found out about his childhood to Heinrich Schliemann's
excavation of Troy.[4] Years later, in 1931, he realized that the Oedipus complex
(see below) of the girl was not parallel to the boy's—as he had originally
thought. He likened this insight to Sir Arthur Evans's discovery of the
Minoan civilization, which until the early twentieth century was known only
in myths.[5]

Freud's archaeological metaphor of the mind, which assumes a
dynamic relationship between past and present, informed many aspects of
his work. His 1910 psychobiography of Leonardo da Vinci, which was the
first of its genre, was made possible by his ability to connect the pictures and
writings of the artist, as well as his adult behavior, to the developmental
stages of childhood. In order to interpret a dream, the mechanisms of which

Freud had discovered before 1900,[6] it is necessary to locate its link to childhood. He identified the four mechanisms of dream formation as representability, displacement, condensation, and symbolization, all of which are used to disguise a forbidden wish. When they can be interpreted, according to Freud, dreams are the "royal road to the unconscious."

Rousseau's *The Dream* of 1910 illustrates all four mechanisms, which disguise the dreamer's wish to be charmed (the snake charmer) and seduced (the serpent). The fact that it is a painting means that it is the pictorial representation of an idea, or set of ideas, and thus corresponds to the dream mechanism of representability. The dreamer is the woman, whose pose evokes the reclining nudes of Titian's *Venus of Urbino* and Manet's *Olympia*. Her upholstered divan has been displaced from a French drawing room to a jungle. This condenses the space separating France from the tropics. Day and night are also condensed, for we see the moon in a bright—sunlit—sky. The serpent approaching the dreamer and the flowers are sexual symbols by association with their forms, as well as with their content, and the dark jungle forest symbolizes the instinctual depths of the unconscious mind. Although Rousseau's painting illustrates Freud's account of dream mechanisms, it does not actually replicate a dream. For the dreamer . . . is both the author of, and a participant in, the image. Works of art, in contrast to dreams, must be accessible to a cultural audience and have a cultural style.

Freud believed that creativity was fueled by the instincts, which have an aim (usually sexual or libidinal, and/or aggressive) and an object (the person or thing at which the aim is directed). In the course of development, children begin to *re*direct their instincts from original (infantile) aims to other aims, which are culturally valued. Freud called this process sublimation.

An example of sublimation would be the redirection of a child's instinct to urinate on fire into firefighting.[7] Instead of indiscriminately extinguishing fires to satisfy an instinct, the firefighter puts out only those fires that are destructive to life and property. By thus sublimating his instinct, the firefighter stands for the rational control of fire and the forces of civilization. . . .

In the view of Freud and his followers, the process of making art was energized by the instincts but controlled and formed by the synthetic functions of the ego. Freud also discovered the power of the unconscious mind, and the fact that conscious thinking is only a small part of our mental activity. Most of it resides in the unconscious, and is inaccessible except in fragmentary or metaphorical form—for example, in dreams, symptoms, slips of the tongue, and so forth. When an artist creates a work, therefore, he must be able to tap into his past infantile instincts, which are lodged in the unconscious, and organize them in the present. This procedure, which has been termed "regression in the service of the ego"[8] and "access to childhood"[9] by two prominent Freudian analysts writing on creativity, is possible because there is no time in the unconscious.

In addition to characterizing the process of creative work, Freud identified certain universal fantasies, which are pictorial in nature. Of these, the Oedipus complex and the primal scene are particularly applicable to some of the conventions of artists' biographies and to the interpretation of imagery.

The Oedipus Complex

The Oedipus complex, in Freud's view, is a biologically determined mental construct. It forms the core of child development—beginning (about age three) in the course of the anal stage, and dissolving around the end of the phallic stage (age five to six)—and hence the nucleus of neurosis. Freud's literary "text" for the Oedipus complex was Sophocles' tragedy *Oedipus Rex,* his autobiographical "text" was his self-analysis, and his clinical "text" was the accumulation of more than thirty years of listening to patients. He formulated the theory of the Oedipus complex gradually, and modified it as he collected new data. A schematic account of its operation in boys is as follows: The three- to five-year-old boy wants an exclusive attachment to his mother, which requires the elimination of his father. He is jealous of his father, who possesses his mother, and also fears retaliation from him. In the child's fantasy, his father's retaliation—literally the talion law ("an eye for an eye")—takes the form of castration. Hence, the formation of the castration complex during the phallic stage (see above). This was Freud's first construction, and it is referred to as the "positive" Oedipus complex.

In 1923,[10] Freud published his account of the "negative" Oedipus complex, which is the reverse of the positive. By then, he had discovered the bisexual character of the complex, and the fact that the boy also identifies with his mother and wishes to be the passive love object of his father. The positive and negative constellations operate dynamically, and when the positive predominates, the boy becomes heterosexual. When the negative predominates, the outcome is a homosexual one. . . .

The girl's Oedipus complex is more complicated and more difficult than the boy's, because her first love object—like the boy's—is the mother. But, in order to achieve a heterosexual outcome, she has to change from a female to a male love object, with a concomitant change from clitoral to vaginal sexual primacy. The heterosexual boy retains the female object, and thus, according to Freud, makes a smoother and usually more complete transition than the girl.

Artists and the Oedipus Complex

Among artists, the operation of the Oedipus complex is facilitated by the construction of genealogies as described by Pliny and Vasari. In the unconscious, concepts that are distinct in conscious thought can be interchangeable. For example, the male gods, kings, older artists, patrons of art, and even artistic tradition are experienced similarly in unconscious thinking, for they share a kind of traditional, patriarchal authority. . . .

David and Goliath: An Oedipal Reading

The story of David and Goliath provided Western artists with a well-known biblical text that lends itself to a rich variety of oedipal readings. In I Samuel 17, David, the shepherd boy, plays the harp for King Saul. They love each other well, and Saul—in the manner of Cimabue and Giotto—asks David's father, Jesse of Bethlehem, "let David stand before me." David overhears the Israelites talking about Goliath of Gath, the hero of the Philistine army arrayed against Saul's kingdom. "The man who killeth him," they say, "the king will enrich him with great riches, and will give him his daughter, and make his father's house free in Israel." David offers to fight Goliath in single combat, and Saul accepts the offer. Saul provides David with armor and weapons, but the young hero takes instead his shepherd's bag, a sling, and a stone.

The Bible is eloquent in describing the giant size and might of Goliath. He stands six cubits and a span tall, is covered in armor made of brass, and the head of his spear is equivalent in weight to six hundred shekels of iron. He taunts David, who uses his sling to hurl a stone at Goliath's forehead. The giant falls, and David, who is without a sword, kills and beheads Goliath with his own sword.

Up to this point in the story, several oedipal ingredients have emerged. David can be read as the young boy who eliminates the father in order to win a woman and become rich. But here there are three paternal figures—the king (Saul), who promises his daughter to the victor; Goliath, who represents the dangerous aspect of the father, and Jesse, David's biological father, who is elevated in stature through his son's success (his house is made "free in Israel"). David's decapitation of Goliath is read by the unconscious as castration.[11] Because David has "split off" the negative father figure (Goliath), he successfully destroys him and retains the more positive facets of the father (Saul and Jesse).

Splitting is an unconscious process of the ego that allows two contradictory thoughts to coexist.[12] Its purpose is to preserve a positive attitude (such as David's love for Jesse and Saul), while also satisfying an instinct (here to destroy the dangerous father in the form of Goliath). An oedipal reading of the biblical text recognizes that Jesse, Saul, and Goliath are split-off facets of the boy's view of his father. That is, they are experienced consciously as three different men—and are represented as such by the text—but they are the same in the unconscious. In consciousness, Jesse is the reality father, Saul is the wished-for royal father, and Goliath is the feared, castrating father.

In I Samuel 18, Saul's son Jonathan and David become close friends. Their souls are "knit" as one, which is evident when Jonathan gives David his clothes and his sword. As David's reputation and popularity grow, Saul becomes envious and makes several attempts to kill him. Saul tries to trick David with his daughters and sends him against powerful armies. Hoping for David's death, Saul asks him for a hundred Philistine foreskins—

symbolically a prelude to castration and death. But David succeeds, and Saul finally gives him his daughter Michal as a wife. By now, Saul's envy toward David is manifest (which is also the father's ambivalence when he experiences his son as a rival). The oedipal quality of this relationship is reinforced by the fact that David has become Saul's *son-in-law.*

In I Samuel 19, Saul tries to enlist Jonathan and all his servants in the effort to have David killed. But Jonathan defends David, and Michal saves him. Eventually (in II Samuel), David becomes a king himself, marries Bathsheba, and is the father of Solomon. In the New Testament Gospels, David is the ancestor of Christ. The biblical emphasis on genealogy, like the genealogical conventions of artists' biographies, facilitates oedipal dynamics.

Aspects of these dynamics are present in the art that depicts the story of David and Goliath. Four works from the Renaissance and Baroque periods will serve to illustrate some of these. The oedipal dynamics operate in relation to the cultural contexts of the works, to the personalities of the artists who made them, and to their iconography.

In fifteenth-century Florence, David's victory over Goliath was imbued with several levels of meaning. Politically it stood for Florentine liberty, which was threatened by the powerful dukes of Milan and other tyrants. David's biblical reputation resonated with the new Renaissance interest in fame as a way of achieving immortality through one's deeds. The Renaissance theme of the adolescent hero, identified with a particular deed that resulted in fame was frequently associated with David. In a Christian context, David as the destroyer of Goliath was paired typologically with Christ's victory over Satan. As a result of these thematic convergences, David became a symbol of Florence itself and the subject of several important artistic commissions.

Donatello's bronze *David* originally stood in the courtyard of the Medici Palace in Florence. In 1495, it was placed in the Palazzo Vecchio courtyard, outside the seat of government. The sculpture reflects the complex, synthetic character of fifteenth-century Florence. In addition to the political and Christian meaning of the statue, Donatello has given his *David* a uniquely effeminate quality compared with other representations of the subject. He included in it Neoplatonic references that correspond to his homosexual reputation,[13] and also reveal the erotic quality of the boy's relation to his father in the negative oedipal constellation.[14] In Plato's *Symposium*, Phaedrus says that Eros, the Greek god of love, inspires and protects soldiers when they are Platonic (that is, homosexual) lovers. Pausanias argues in the same Dialogue that tyrannical states discourage homosexuality, whereas republics are more liberal in their tolerance of it. Plato thus provides a model in Classical antiquity for representing a heroic fighter in a homosexual light, especially in the context of a republican state. In the Bible, furthermore, the relationship between David and Jonathan, whose souls are "knit" as one, evokes the homosexually tinged friendships of adolescence.

Donatello
(1386–1466),
David. *1437,*
Bronze, H. 135 cm.
(Museo Nationale
del Bargello,
Florence, Italy)

Not only is Donatello's David effeminate, and somewhat androgynous, but he expresses the narcissism of homosexuality by his self-absorption. The live wing that rises from Goliath's helmet along the inside of David's thigh indicates the erotic interchange between victor and vanquished. David smiles, and allows his toe to play with Goliath's beard and mustache. In the relief represented on Goliath's helmet, a group of Cupids enacts a triumph of love between boys.

Michelangelo's marble *David*, commissioned in 1501 to adorn a buttress of Florence Cathedral, was placed instead before the Palazzo Vecchio. This work represents a different moment in the story of David and Goliath than Donatello's bronze. Michelangelo's figure has not yet killed his adversary, and anxiously sights him. He holds the sling in his right hand, and the stone in his left. Considered in an oedipal context, Michelangelo's David displays

an expression of ambivalence toward the symbolic pa[t]ricide he is about to commit. That this *David* also reflects contemporary political and religious tensions in no way minimizes Michelangelo's personal identification with his subject.

Along the lines of identification, it is noteworthy that the original block of marble from which the artist carved the *David* was known as "the Giant." This reinforces the ambivalent character of the finished statue. By the association of giant size with Goliath, Michelangelo defeats his own "Giant"—the father who beat him for his ambition to be a sculptor. . . .

The marble *David* of 1623 by Gian Lorenzo Bernini represents an unambivalent man of action. It reflects the artist's positive oedipal identifications, and his ability to perform without hesitation. David grasps the sling and stone with fierce determination. His entire body twists in violent contrapposto as he concentrates on Goliath and begins his attack. The armor provided by Saul is behind David, as if to show the superiority of his intelligent strategy over brute force.

The predominance of the positive oedipal constellation in Bernini's representation of David is consistent with elements of his biography. His father, Pietro Bernini, was a Mannerist sculptor, who worked for Pope Paul V. As a result of his position, and of his inclinations, Pietro used his connections on behalf of his precocious son. He introduced him to Cardinal Scipione Borghese, the pope's nephew, who became an enthusiastic patron. According to Bernini's biographers, he carved the face of the *David* from his own features, and Cardinal Maffeo Barberini, himself a future pope (elected August 6, 1623), reportedly held up the artist's mirror for this very purpose. In Bernini's biography, therefore, a number of positive paternal figures combined to foster his success—his own father, high-level ecclesiastical patrons, and popes.

In contrast to Michelangelo, who had to fight an abusive father for the right to be a sculptor (which means for the right to be himself), Bernini was encouraged from the start. His father's enlightened attitude minimized the inhibitory effects of oedipal conflict by allowing his son to "succeed" without guilt and hence without fear of retaliation. The relationship between Pietro and Gian Lorenzo conforms to the psychologically ideal circumstance for a creative child—that his father work in the same field, be less gifted than he, and be willing to concede victory realistically.[15] . . .

Caravaggio's childhood is little documented, but what is known suggests conflict between himself and his father. He left his home in Milan and went to Rome, where he denied a brother who was a priest. During his early years in Rome, his most prominent patron, Cardinal del Monte, was a well-known homosexual. After leaving del Monte's household, Caravaggio repeatedly ran afoul of the law, and racked up an extensive record of arrests for violence. Eventually he killed a man and was exiled from Rome. Much of Caravaggio's iconography reflects his taste for violence, particularly in the form of decapitation. And it seems that he identified with his beheaded

Caravaggio, **David with the Head of Goliath.** *1605–1610, Oil on canvas. (Archivi Alinari/Art Resource, NY)*

subjects—especially those he represented as simultaneously dead and alive. A case in point is the head of Goliath in his painting *David with the Head of Goliath,* in which the David is a portrait of the artist's young lover and Goliath is a self-portrait.

The oedipal character of this iconography is quite complex. For Caravaggio does not identify with David, but with his victim. He is shown as defeated by homosexual love, which has placed him in a precarious dependency on a younger man. His head is literally "in David's hands," thereby depicting the dangers (to himself) of identification with his father (Goliath). He displays his own image not with the vigorous, youthful determination of Bernini's *David,* but as the older, decapitated, symbolically castrated Goliath.

The biblical text resonated with Caravaggio's violent tastes, and he embellished it to suit them. There is no reference in the Bible to David behaving as he does in this painting, and no description of Goliath's severed head. In addition to Goliath, Caravaggio represented the beheading of Holofernes

by Judith, and painted a Medusa head on a tournament shield as a wedding present. The latter, which was reputed to have contained the features of the artist, has a curiously androgynous quality. As such, it reflects Caravaggio's conflicted bisexual identifications, the terror of castration, and the sense of his psychic existence as a "living death." Whether as the "positive" oedipal boy afraid of his father's retaliation, as the "negative" oedipal boy identifying with his mother—these are combined in the Medusa head—or as the negative father (Goliath) targeted by the boy, Caravaggio depicts a beheaded self. . . .

Notes

1. See my *Art and Psychoanalysis* (New York, 1993), for a more extensive discussion of this subject.

2. Sigmund Freud, "The Aetiology of Hysteria," S.E. III, 1896, pp. 191–221.

3. For a fuller discussion of these stages see the relevant entries in J. Laplanche and J.-B. Pontalis, *The Language of Psychoanalysis,* trans. Donald Nicholson-Smith (New York, 1973).

4. See Suzanne Cassirer Bernfeld, "Freud and Archeology," *American Imago* 8 (1951): iii.

5. Freud, "Female Sexuality," S.E. XXI, 1931, pp. 225–43.

6. Freud, *The Interpretation of Dreams,* S.E. IV and V, 1900.

7. Freud, "The Acquisition and Control of Fire," S.E. XXII, 1932, pp. 187–93.

8. See Ernst Kris, *Psychoanalytic Explorations in Art* (New York, 1952).

9. See Phyllis Greenacre, "The Childhood of the Artist" (1957), in *Emotional Growth,* vol. 2 (New York, 1971), pp. 505–32.

10. Freud, "The Ego and the Id," S.E. XIX, 1923, pp. 12–66.

11. See Freud, "Medusa's Head (1922)," S.E. XVIII, 1940, pp. 273–74.

12. Freud, "Splitting of the Ego in the Process of Defence," S.E. XXIII, 1940, pp. 273–78.

13. See Laurie Schneider, "Donatello's Bronze *David,*" *Art Bulletin* LV, no. 2 (1973): 213–16, for specific references.

14. See Laurie Schneider, "Donatello and Caravaggio: The Iconography of Decapitation," *American Imago* 33, no. 1 (Spring 1976): 76–91.

15. On this concept, see Greenacre.

The Electronic Era and Postmodernism

Margot Lovejoy

The Postmodern Shift

The transitional moment between the end of an entire epoch and the arrival of a new age was encapsulated in a 1968 exhibition "The Machine As Seen at the End of the Mechanical Age." Curated by Pontus Hultén at the Museum of Modern Art, it was a response to the demise of a modern manufacturing society based on manufacturing machines as the "muscle" of industry and the rise of a postindustrial, postmodern information society culture based on instant communication services. Besides showing artworks which either commented on technology, or were a demonstration of the machine aesthetic as part of style, it previewed computer and video electronic media works as new aspects of representation. A major feature of these powerful media is their ability to transmit sound, image, and information over long distances, invading every aspect of contemporary life, deeply affecting the public consciousness, forcing an end to a modernist culture based on suppression of the outside world. The new media became the threshold to a new territory of postmodern conditions and cultural issues.

In the sixties, architecture, a cultural form always a direct barometer of change because of its direct ties to economic, technological, industrial, and social development, began to revise radically its formalist tendencies. "International Style" buildings, seemed suddenly irrelevant and out of place in turbulent times. Everywhere images of war, environmental pollution, and political upheaval seemed to challenge the purity of polished glass and steel curtain walls.

Architects Robert Venturi and Denise Brown reacted against the utopian, austere International Style's rationally determined steel and glass boxes and concrete bunkers, criticizing their failure to reflect the times. The dispiriting effects and aloofness of Modernist buildings, which fell short of acknowledging cultural memory, context, living patterns, and individual needs, led them to write in the 1970s their now famous essay "Complexity and Contradiction in Architecture: Learning from Las Vegas." They called for a return to the vernacular, to the "complexity of Main Street" and for reform

of architecture's elitist language. This essay has been said to have announced the arrival of the postmodern condition. Mies Van der Rohe's 1920 statement "Less is more" now became "less is a bore."

At the same time, television,[1] projected the world of the sixties directly into the public's consciousness transmitting dramatic, disturbing images of the Vietnam War mixed with scaled-up images of consumer objects which attempted to hook the viewer into believing that both kinds of images were of equal importance. With the "delirious circularity of the channel dial," all assumptions of coherence vanished in the new cultural infrastructure. The disorganization and nonlinearity of the networks defined television as a site of multiple intensities. This chaotic form in which information and theatrical effects were mixed with the totally banal, in which art, culture, politics, science, and so forth, were all brought together outside of their usual contexts and connections, began to create a vast meltdown within the public consciousness. Television became the arena of a confusion, a melting pot of forms, concepts, and banalities, which acted as the crucible for a postmodern consciousness.

It was Venturi's interrogation and condemnation of Modernism's purist International Style which inspired the term "postmodern." He rejected the rational utopian ideology inscribed in architectural forms of representation. Because architecture must be lived with, Venturi saw that Modernist aloofness and cool distance was inconsistent with the chaotic contradictions, complexity, and diversity of everyday life. Formal glass and concrete slab buildings could not satisfy a populace who wanted and needed a more accessible architecture, one less monumental, more human in scale, one which was more messily vital, multivalent and layered—"like life"—rather than one with a dominantly formal structure. His more "vernacular architecture" accepted the needs of the public to be factored into the architectural equation, along with the chaos, instability, many-layered complexity of commercial mass culture. He called for a return to "the difficult whole" where various parts, styles, or subsystems are used to create a new synthesis. Postmodern architecture began to embrace pastiche as a strategy, creating an aesthetic of quotation, appropriation, and incorporation of traditional styles to provide recollection of the past.

The postmodern presumes the modern, and includes both an academic, or "high" aspect and a "low," or vernacular one. Postmodernism views texts and images as radically polyvalent. Around 1960, French Structuralist and Post-Structuralist theorists such as Foucault, Barthes, and Lyotard attacked the very concept of objectivity and of fixed meaning—especially in language. Making use of linguistic theory these writers argued how much our interpretation of the world is shaped by the language we use to describe our experiences. While modernist beliefs are based on a linear view of progress, a defining feature of postmodernity is the impossibility of that kind of evolution. The world began to be seen as an experience of continually changing

Mark Tansey, **The Secret of the Sphinx.** *1984, Oil on canvas, 60" × 65".*
(Private Collection, Courtesy Curt Marcus Gallery, NY)

sequences, juxtapositions, and layerings, as part of a decentered structure of associations. . . .

"Post Machine" Electronic Art and Technology Exhibitions

Several exhibitions with art and technology as a theme celebrated the arrival of the electronic era. Although they focused on electronic media, the work was still based on Modernist premises in its aesthetic attitudes. These early works can provide useful measures of the extent to which technologically based art works have been reflected in aesthetic change from the 1970s to the present.

"Cybernetic Serendipity," curated by Jasia Reichard, a large-scale exhibition which included computer printouts of musical analysis, computer-designed choreography, and computer-generated texts and poems, opened at

the Institute of Contemporary Art in London and later traveled to Washington. Other exhibitions with art and technology as a theme were in preparation. "Software" at the Jewish Museum opened in 1970. At the Smithsonian Institute, Washington, D.C., "Explorations" opened in the same year. This exhibition was curated by Gyorgy Kepes, director of MIT's important new Center for Advanced Visual Studies, which was established in 1968.

The guiding principle of MOMA's 1970 exhibition "Information" was that art exists only conceptually and as such is "pure information." The computer was a natural metaphor for this exhibition. Many of the works demonstrated the concept of systems analysis and its implications for art. "Information" explored groups or networks of interacting structures and channels as a functionally interrelated means of communication. These exhibitions were part of the avant-garde movement of the sixties and seventies which moved toward a dematerialized view of art that refused the object.

They were also a tribute to the new spirit of openness towards use of industrial techniques in art-making which had an especially dramatic impact on the art of the sixties and seventies. By the time of the 1961 "International Exhibition of Art and Motion" at the Stedelijk Museum in Amsterdam (also curated by Pontus Hultén) and the 1964 "Documenta" exhibition in Kassel, Germany, interest in kinetics had grown in Europe toward an escalation of technical means. The Zero and Grav groups (Neo-Dadaist and Neo-Constructivist kinetic sculptors) began serious work using industrial machine technologies. In the United States, sculptors especially began to harness new electronic tools that were rapidly being developed: electronic communication systems and information technologies , computers and lasers with their scanning possibilities, along with innovation in television and video; light- and audio-sensor controlled environments; programmable strobe and projected light environments with sophisticated consoles.

Although computer graphics research was, by the late sixties, being conducted internationally in the highly industrialized countries of Europe, North America, and in Japan, few artists had access to equipment or were trained in the specialized programming needed at that time to gain control over the machine. Those artists, primarily from the fifties Neo-Constructivist tradition, whose main interests lay in the formal modernist study of perception and the careful analysis of geometrically oriented abstract arrangements of line, form, and color, rather than descriptive or elaborated painting, were especially drawn to finding a means of researching their visual ideas on the computer. They sought the collaboration of computer scientists and engineers as programmers. By 1965, advances in television technology had spawned the new medium of video. The first video camera/recorder, Portapak, was released in New York by the Sony Corporation. This relatively portable equipment drew widespread interest amongst artists[2] because of its transmission-receiving aspects and its implications for low-cost immediate

feedback in comparison with film. The medium was ideal as the starting point for informal, studio closed-circuit experiments with concepts of time and motion—as a continuation of the formalist tradition of kinetic sculpture. The first video artists conceived their works as modernist sculptural installations and performance.

Experiments in Art and Technology: Collaborations in Two Kinds of Thinking—Art and Science

Convinced there was a need for an information clearinghouse to make technical information and advice available, and a service for arranging individual artist-engineer collaborations in the United States, artists felt the need to seek collaborations with engineers and scientists to help in producing innovative work using new technologies. The artist Robert Rauschenberg and scientist Billy Klüver formed a new organization called "Experiments in Art and Technology" (E.A.T.), which published its first bulletin in January 1967. Because of its governmental and corporate contacts, E.A.T. was in an ideal position to act as a liaison between artists,[3] engineers, and corporations and to provide a meeting place where seminars, lectures, and demonstrations could be presented.

Bell Laboratory physicist Billy Klüver's friendship with members of the progressive Swedish avant-garde such as poet and painter Oyvind Fählstrom and Moderna Museet Director Pontus Hultén, had brought him into contact with both European artists (as an advisor for Hultén's 1961 Stedelijk Museum kinetic exhibition) and with the New York art world. "Klüver saw many parallels between contemporary art and science, both of which were concerned basically with the investigation of life . . . [he had] a vision of American technological genius humanized and made wiser by the imaginative perception of artists . . . Klüver seemed to speak two languages, contemporary art and contemporary science."[4]

In 1965, when an invitation came to American artists from a Swedish experimental music society to contribute to a festival of art and technology, Klüver became the logical liaison between artists and engineers. Although the project fell through, it helped to establish a relationship between a group of choreographers associated with the Judson Memorial Church, and musicians John Cage and David Tudor, multimedia artist Robert Whitman, and Oyvind Fählstrom. They began to combine technology with performance events known as "Happenings" named after the interactive participatory performance-based work of John Cage and Alan Kaprow. The excitement and energy of the emergent avant-garde were characterized in the efforts of Rauschenberg and Klüver, who in 1966 brought together thirty Bell Laboratory engineers to work with visual artists, dancers, and musicians. They raised funds for an ambitious project called "Nine Evenings: Theater and Engineering" by contacting individual corporations, foundations, art dealers, and collectors. However, from the start, the artist-engineer collaboration system encountered difficulties, for the engineers were not used to working

against theatrical deadlines and frustrated artists were unable to rehearse properly without finalized technical support. . . .

Artists and Industry

The most costly and ambitious exhibition of collaborations between artists and engineers was "Art and Technology," an exhibition curated by Maurice Tuchman, which opened at the Los Angeles County Museum in 1971. Five years in preparation, the show featured the work of 22 artists who had been paired to work with specific corporations under an elaborate contract system that covered costs of technical assistance, production, and maintenance of the work for the three-month duration of the exhibition. The contracts represent probably the most consciously thorough practical attempt of all the art and technology exhibitions to ensure there would be no pullouts or inadequate provisions for technical assistance in case of malfunctions. There were three categories of artists using new technologies: first, those whose formalist work was primarily concerned with the direct use of machines to explore the aesthetics of light and kinetic movement. These included Robert Whitman, Rockne Krebs, Newton Harrison, and Boyd Mefferd. The second category was comprised of well-known New York artists whose experimental work made use of fabrication technology (i.e., using the machine as a tool to produce their work), such as Claes Oldenburg, Roy Lichtenstein, Richard Serra, Tony Smith, Andy Warhol, and Robert Rauschenberg. The final group—James Lee, Ron Kitaj, and Oyvind Fählstrom—provided poetic and humorous relief in their serendipitous works by using the machine as an icon. . . .

The critics attacked—insinuating that the exhibition represented a nefarious marriage between advanced technology, the museums, and big business. They coined new terms—"corporate art" and the "culture of economics."[5] A serious economic depression followed the ten-year [Vietnam] war. It signaled a significant cutback in government and corporate support for the arts, a serious threat to costly technological collaborations. A crisis was also brewing in the art world.

In the early seventies, the costly formal experiments (especially those kinetics employing computer technologies) that had taken place in the realm of high technology in the service of the arts, confined mostly within conceptual framework, had led to an art not easily displayed in conventional museums and galleries. The work presented physical problems related to technological maintenance, obsolescence and sheer size, problems related both to the preserving and to marketing functions of art institutions. There were few curators and critics who had the institutional training or interest to go beyond the usual parameters of art to explore the new aesthetics presented by the various technological thresholds of the new work. A consensus between museum curators and critics, arose from these realizations, which resulted in a major change in their attitudes towards the validation and inclusion in the fine art canon of art works which relied directly on technological means, except for the new electronic medium of video.

Art as Pure Information

. . . By the midseventies, important advances in technology opened possibilities for the computer to become a truly personal tool for artists. The invention of the microprocessor and more powerful miniaturized transistor chips, (integrated circuits), changed the size, price, and accessibility of computers dramatically. Commercial applications in design, television advertising, and special image processing effects in film and photography became an overnight billion dollar industry, providing the impetus for increasingly powerful image-generating systems. The need for such intimate collaboration between scientists and engineers with artists now seemed no longer so urgent, for custom "paint system software" and "image synthesizers" began to appear on the market. Artists began to challenge the computer to go beyond the formal tasks it had up to then performed and found it could be used as both a tool and a medium. Imagery becomes dematerialized information in the computer's data base. When digitized, this information affects a completely new outlook on the visual field. Digital modeling began to create a crisis in representation. Because any kind of imagery can be digitized and reformulated, the computer, by the 1990s, had subsumed photography, video, and film.

Photography Becomes a Tool for Deconstructing Modernism

. . .[I]n line with refusal or violation of the formal purist aesthetic of Modernism, the photographically represented world (with all its media, genres, and materials) was drawn fully into the arena of mainstream expression. Ironically, once photography was accepted into the fine art canon, issues denied for so long under the rubric of modernism became the very focus and the means of its deconstruction. Strategies used were appropriation or quotation of pre-existing historical images, texts, forms, and styles. Mass media influences originating in ironic "Pop" imagery were brought into a new, more political forum. . . .

Barbara Kruger's work offers a good example of these major tendencies in art and its relationship to technology because she raises ironic questions about representation relative to social constructs. She uses the copy and appropriation as the major strategies for her conceptually based work. She reproduced found images from mechanically produced sources and adds texts to them so that they function effectively as active commentary. Her pieces, as she says, "attempt to ruin certain representations, to displace the subject and to welcome a female spectator into the audience of men." Kruger's media conscious work is at the intersection of mass media/mass culture and high art. Her work is confrontational, agitational, and is aimed at destroying a certain order of representation: the domination of the "original," which up to now has largely been male identified. . . .

Mike Bidlo ([an] artist who . . . appropriates other artists' work in order to critique the originality, authorship, and market system) has created an

Barbara Kruger,
Untitled. 1982,
Unique Photostat,
71¾" × 45⅝".
(Collection, The
Museum of Modern
Art, NY. Acquired
through an
Anonymous Fund)

entire exhibition of Bidlo Picassos including "Guernica," the Gertrude Stein portrait, and "Les Demoiselles d'Avignon," which he showed at the Castelli gallery. His work poses the questions: When is a copy an original? And what is its market value in relation to the original? Bidlo . . . challenge[s] the authenticity of the original, the primacy of the creative act, and the mastery or genius of the artist. . . .

Neo-Pop works, which have dazzled gallery viewers with their punk sensibility since the early eighties, have used photography and have appropriated commercial images from comics and media along with collage and an effluvia of found materials. However, the new Pop differed in its implicit critique of commercial culture by unmasking the "manipulative nature of the message-bearing images fed . . . through various media and designed to keep

us consuming goods, goods produced solely to be consumed. The result is not only an appropriation of that imagery but also an appropriation of the power of that imagery."[6] The methods used by artists such as Keith Haring, Kenny Scharf, Rodney Alan Greenblatt, and Jeff Koons to convey their messages make use of the same mannerism, exaggeration, and sense of easy fun mixed with wrenching disjuncture that characterizes television itself. While sixties Pop established an equation between aesthetic appreciation and commodity consumption of images, and as a result, made their works more accessible to the public, the work had a "disinterested" non-political subjectivity to it which in effect refashioned the images, abstracted them, and effectively detached them from the context of their social relations. The reincarnation of Pop however, was socially aware and used incongruous, out-of-context imagery of all kinds to make its point. This new work aped the energy and the glitzy unabashed directness of commercial advertising style, of television and magazine style, but with its own political agenda. . . .

The New Consciousness

After fifty years, television has contributed strongly to a new cultural condition, a shift of assumptions and attitudes. A chaotic condition—in which information and theatrical effects are mixed with the totally banal, where art, culture, politics, science, etc., are all brought together electronically outside of their usual contexts and connections, has created a vast meltdown of forms within the public consciousness. Use of compressed, intensified images and messages, with their edited forced sequences and shock value, has now become part of everyday visual vernacular, by now, an absorbed aspect of Western aesthetic tradition and mass culture. Television's image flow has created a visual cultural phenomenon surpassing, and subsuming, the influence of the printed word, radio, and cinema. Television has the power to communicate, intensely mediate, and transform the public mind set.

Television itself is now undergoing a major change. In today's home entertainment center, TV is only one of many options which vie for the public's attention. With the rise of computer technologies, the public may surf the Internet rather than the TV airwaves. Computer games, CD-ROMs and CDIs are beginning to make inroads in the public consciousness. Watching rental videos of films on the home VCR, and Home Box Office Channel TV rentals, is causing the demise of the public cinema where "cineplex" projection facilities are becoming smaller and smaller, offering as much variety as possible for the viewers, rather like choosing another "channel." Interactive shopping channels are replacing the trip to the department store. The affordable small hand-held Hi-8 camcorder with NTSC broadcast capability built into its technology is creating a whole new arena where the public are becoming videomakers, showing their works on their own TV monitors. The public is thus brought face to face with itself.

On MTV, now available by satellite around the world, visual effects borrowed from earlier independent artists' films and video are routine, producing a mass public with a far more sophisticated visual sense than ever before. One spin-off of global TV is the large number of films being produced with startlingly innovative visual effects. Films are becoming more visual, designed to avoid language problems in the culture of the global market.

For the Body: A New Kind of Time and Space

The contemporary body as it now exists inhabits a new kind of simulated environment in which time and space have become obsolete. Celeste Olalquiaga, in her book *Megalopolis: Contemporary Cultural Sensibilities*, describes the postmodern experience.[7] The contemporary body now exists in a new kind of simulated environment in which our conception of the corporeal self has been altered. Connected by the 800 (or 900) number and the ubiquitous, all pervasive plastic card, confused by a video landscape that has made a simulacra of reality in one's image, stripped of identity by controlled government and corporate information processing and surveillance to the point of total exposure, the postmodern individual is experiencing a major transformation of perception and consciousness.

The skewing of time by the constancy of artificial compressed viewing of TV, its distortion by time/distance factors of jet lag, faxing, E-mailing,

Carolee Schneeman, **Cycladic Imprints.** *1993, Four slide projectors, dissolve units, stereo sound collage, 360 slides, 17 motorized violins. (Carolee Schneeman)*

communicating on the Internet—our hours jammed with sensory overload—results in a strange kind of distracted state of exhaustion. "Spatial and temporal coordinates end up collapsing: space is no longer defined by depth and volume, but rather by a cinematic (temporal) repetition, while the sequence of time is frozen in an instant of (spatial) immobility." As a result, the body yearns for concrete intense experiences of reality, saturating itself with food, consumer goods, and an unhealthy fixation on sex.

Postindustrial urban space is artfully designed to create a feeling "of being in all places while not really being anywhere."[8] Lost in a maze of well-lighted continuous display windows of architecturally transparent shopping malls with similar stairs, elevators, and facilities, the consumer wanders disoriented in a flat homogeneous space trying desperately to remember which spiraling space is the parking lot needed for the escape back to reality.

Walter Benjamin commented on the way new knowledge is acquired through apperception and distraction. "The tasks which face the human apparatus of perception at the turning points of history cannot be solved by optical means, that is, by contemplation alone. They are mastered gradually by habit, under the guidance of tactile appropriation." In reducing experience to the efficient common denominator of information, aspects of the body and of the computer have begun to transmigrate. The body becomes more mechanized at the same rate as the computer becomes more "friendly." The

Larry List, An Excerpt from the History of the World. *1990, Color photocopy print, 10½" × 17". (Courtesy Larry List)*

boundaries between the spheres of the body and of technology have begun to transgress, overlap, and blur. The computer's capability to create completely simulated worlds has further distanced the body from tactility. Alice Yang comments that the body as a physical dimension is not only a *subject* of representation,

> but is the means through which we make and experience art. It is through the bodily process of looking, touching, and moving around in space that we have come to apprehend art. Thus the impact of technology has significant repercussions also for notions of art making and art viewing . . . slowly and perhaps inevitably, technology is uprooting aesthetic experiences located in the body such as tactility and human vision."[9]

A concrete example of this change is the degree to which the interactive CD-ROM has changed the bodily experience of reading and of looking at visual images. Instead of the touching and feeling relationship the view[er] has with the book as an interactive object, the computer provides an immaterial interactive experience. It allows for the branching out of visual or textual material to present choices to the viewer through a series of document blocks linked to different pathways. It creates interconnected webs of information and is able to link various kinds of image files and other types of documents, network them and create paths and nodes to connect them. CD-ROM multimedia implies visual or textual material or sound with possible electronic linkages which can be manipulated and rearranged at the viewer's command.

Technological Conditions Lead to a More Public Art

Proliferation of electronic technologies has increased cultural participation of the public in art events (as a form of empowerment and education). With roots also in avant-garde art attitudes from the 1960s and 1970s, derived from the "Happenings" movement, which focused on public participation and performance and in conceptual projects, a more public art began to evolve. Conceptual art was immaterial with no object value. Meaning resided not in the autonomous object, but in its contextual framework. The postmodern idea that the physical, institutional, social, or conceptual context of a work as being integral to its meaning, took root and became the basis for expanded notions of sculpture and of a more public art in the 1970s.

This hybrid cultural practice with its intentions of connecting to a wider audience and as a means of subverting the usual commercial forms, became an activist art which encouraged collaboration amongst artists. Some of these collaborations were anonymous group entities such as Gran Fury, and the Guerrilla Girls. Others challenge art world notions of individual authorship, the cult of the artist and of private expression, by assuming group names, such as Group Material or the Artist and Homeless Collaborative. It was felt that anonymity provided a greater focus on the work itself instead of the usual attention to artists as personalities. The goals of these groups were to

act as critical catalysts for change and to create an arena for public participation. Their work took the form of a combination of grassroots activity using media tools. Reaching out for media coverage of their work is an important part of their strategy.

Group Material, founded in 1979, describes itself as an organization of artists "dedicated to the creation, exhibition, and distribution of art that increases social awareness." It believes strongly that art should not be just for "initiated audiences of the gallery and museum" but is intended to "question perceived notions of what art is and where it should be seen." Its work, also seen in exhibitions throughout the United States and internationally, bridges the culture gap between high and low, elite and popular. The group organizes public lectures and discussions for important forums such as the Dia Art Foundation. For example, their part of the 1988 program centered on issues of the crisis of democracy. Ironically, the artists' galleries—Mary Boone, Josh Baer, Barbara Gladstone, Metro Pictures, and John Weber cooperated. Paradoxically, the artists expanded public image in the community helps them to attain the status and recognition which will increase interest in their public voice. Grants and sales of their work support some of their public activities.

In May 1988, Group Material (funded by the Public Art Fund) created a project called "INSERTS"—a twelve-page newsprint booklet to be inserted in the Sunday magazine supplement of the *New York Times*. The insert contained copies of ten art works created specifically for the project by well-known artists—Barbara Kruger, Louise Lawler, Richard Prince, Nancy Spero, Jenny Holzer, Hans Haacke, Mike Glier, Felix Gonzales-Torres, and Carrie Mae Weems. Their project was designed to get art off the wall, out of the plaza, and into everyone's hands through the daily paper. The Guerrilla Girls have also created a powerful public dialogue through their strategies of anonymity, theater, irony, and humor. They have scored stronger feminist points, by their collective spirit and their strategy of using information and its print technology in the form of posters and billboards, than any one painting could have. . . .

Dennis Adams's bus shelter projects with their double-sided illuminated display panels are similar to regular bus shelters but use large photographic transparencies to comment on history or to underscore the politics of poverty and wealth apparent in city neighborhoods. Krzysztof Wodiczko's mammoth night projections beamed onto city buildings and monuments create a strong political statement whenever they appear. Using the idea of spectacle and risk in the urban environment, he dramatizes the architecture of public buildings to supply the real identity of its public function. For example, he projected the image of a missile on a war monument; the figure of a homeless man on a public monument in Boston.

Another aspect of the greater public stance of art, made possible through the agency of technology, is in the field of artists' books. Printed Matter, in New York, the leading distributor of artists' books, carries more than

Krzysztof Wodiczko, "Works". Image projected onto the Hirshhorn Museum, October, 1988. (Hirshhorn Museum and Sculpture Garden/Smithsonian Institution)

3000 titles by 2500 visual artists. Artists such as Paul Berger, Keith Smith, Johanna Drucker, Paul Zelevansky, Warren Lehrer, Joan Lyons, Phil Zimmerman, and Sue Coe are committed to the project of creating part of their work in book form, thus creating a gallery of ideas available in bookstores as art for a broader public. Although artist book outlets mostly exist in museums and small specialty shops, the movement is being strengthened by quality electronic reproductive equipment like the laser photocopy machine and computerized "desktop publishing." Recently, "Galerie Toner" in Paris took advantage of this technology and commissioned several artists to create books.

Extensions of Modernism and Crosscurrents of Postmodernism

. . . Postmodernism has led to new attitudes and new understandings and a pluralistic acceptance of many approaches to art-making, including formal ones. However, the impact of technology is gradually uprooting aesthetic

practices which supplant art's mimetic functions, just as photography did. Computer imaging allows for the fabrication of immaterial worlds which are increasingly severed from the human observer, and which are capable of invading the image and destabilizing it.

The split we have been following in artists' attitudes toward representation has continued to be present. Some see values eternal to the human condition and inscribed in their work as overriding all other considerations. Others point to imperatives of today's issues and the need to reflect the technological culture we live in, commenting on it through the use of contemporary media tools. Rather than seeing that the postmodern thrust toward appropriation, instability, decentering, intertextuality, and acceptance of diversity, leads to decay of meaning, it is possible, say some, to see an enrichment of ideology and style taking place.

Looking back on this century, Roland Barthes remarked that "in a way it can be said that for the last hundred years, we have been living in repetition." When we examine his premise, from the vantage point of the visual arts, it projects an overview of all the major ideas and movements of the modern period from the early 1900s. Abstraction and Cubism, Constructivism, Dadaism, Expressionism, have all been repeated through Neo-Dada, Neo-Constructivism, Neo-Expressionism. In the eighties and nineties there has been a replay of mainstream movements from the fifties and sixties including Neo-Minimalist, Neo-Pop, Neo-Conceptualist. This has occurred with slight progressions and extensions, but with no real new break in the field of perception or systems of meaning which offer a serious challenge to traditional western notions of representation. Technologized seeing and forms of representation have now, however, passed well beyond photography and cinema, to embrace the radically new aspects of electronic representation opened by TV, video, globalized electronic Internet communications, and to the computer with its revolutionary capacity to create digitized structures that produce "virtual" images and interactive possibilities. . . . Nonetheless, the social and economic implications of their use have affected society since the early sixties.

New York Times critic Michael Brenson comments on the Postmodern shift: Art can now "be conceptual, photographic, figurative, or expressive. It [can] mirror and engage the mass media, particularly the visual media like television and film. It [can] have mythical, personal, and social subject matter . . . It [has] something to say about the giddy excitement and awful conflicts of late twentieth-century life." Whether it is conservative or progressive, the need for aesthetic experience is felt more deeply than ever before by a larger number of people as they strive to situate themselves in the complexity of the electronic age.

Notes

1. Guy de Bord wrote *The Society of the Spectacle* (published by Buchet-Chastel in 1967). By 1958, 42 million American homes were fed by broadcasts from 52 sta-

tions. As a result of the wild barrage of images that flowed through its TV sets from all over the world, the public participated collectively, in the comfort and privacy of their living rooms, in a new cultural condition. Apart from the commercial junk, they saw documentary reportage of the moon landing, Kennedy's assassination, the far-away Vietnam War, Martin Luther King's funeral, and the civil rights marches. These compelling images were mixed in with an odd assortment of cultural manifestations ranging from soap operas, game shows, religious sermons, science programs, cooking lessons, gym classes, and reruns of old movies.

2. Video was welcomed in the art community also as a means of documentation. Those artists doing large-scale Earth Art environmental projects rely heavily on video films and photographs as documentation of their far-away work both for funding purposes and for public awareness of their work. In the spirit of fusing art and life and locating real objects in real space, the earth artists engaged material reality—desert, sky, water, land—and executed their projects in real locales. As a testament, the photographs could never transmit the spirit and the experience of the work's true scale and presence. However, the concept of documentation of a project through the use of all aspects of photography and video became a firmly established practice for all artists, including those in the dance, theater, and performance genres. Funding sources for these costly environmental works also began to dry up during the economic depression of the early 1970s.

3. By 1967, E.A.T. arranged for a juried exhibition "Some More Beginnings" at the Brooklyn Museum in the form of an international competition. Prize-winning works were to be included in the Museum of Modern Art's "The Machine" exhibition.

4. Calvin Tomkins, *Off the Wall* (New York: Penguin Books, 1985), p. 252.

5. Among the most virulent of the reviews was that of Artforum's Max Kozloff. According to the art historian Jack Burnham, "Multimillion Dollar Art Boondoggle" was "probably the most vicious, inflammatory and irrational attack ever written on the art and technology phenomenon." It posed the museum, Tuchman, and most of the artists connected with Art and Technology as lackeys of killer government, insane for new capitalist conquests in Southeast Asia. Kozloff depicted half of the artists involved as "fledgling technocrats, acting out mad science fiction fantasies." Jack Burnham, "The Panacea that Failed," *The Myths of Information*, ed. Kathleen Woodward (Madison, WI: Coda Press, Inc. 1980), pp. 200–215. Later, bitterly, Burnham commented in the October 1971 Artforum: "Whether out of political conviction or paranoia, elements of the art-world tend to see latent fascist aesthetics in any liaison with giant industries; it is permissible to have your fabrication done by a local sheet-metal shop, but not by Hewlett-Packard."

6. Peter Frank and Michael McKenzie, *New Used, Improved: Art of the Eighties* (New York: Abbeville Press, 1987), p. 90.

7. See Celeste Olalquiaga, *Megalopolis: Contemporary Cultural Sensibilities* (Minneapolis: University of Minnesota Press, 1992).

8. Celeste Olalquiaga, Ibid.

9. Alice Yang, "Cyborg Aesthetics," essay for the exhibition "The Final Frontier,"The New Museum of Contemporary Art, New York, May 7 to August 15, 1993.

Chapter 25

Environment, Audience, and Public Art in the New World (Order)

by Mara Adamitz Scrupe

Issues concerning environmental conditions have informed the creative work of many contemporary artists and writers. For some, the effort has been undertaken as a means of suggesting solutions or, at the very least, approaches, to the pressing and critical problems making up what we refer to as "issues of the environment."[1] For others, their work makes no claim to world-altering ambitions. Rather, the artworks, which are created as a result of these artists' environmental concerns, seek to describe and illustrate the issues, informing viewers about them and predicting what certain behaviors might yield in terms of future environmental degradation.

Stacy Levy's sculptural work addresses the essence of time and the relentless unfolding of biotic processes in nature. In a brochure accompanying one of Levy's recent exhibitions, critic Penny Balkin Bach writes: "Levy's studies in sculpture, forestry, environmental science, and landscape architecture, her interest in cartography and geography, as well as her professional involvement in the landscape restoration firm that she founded, conspire to integrate her thinking about the relationship of science, art, and life. She is, indeed, an artist for the 21st century, expanding and often ignoring the boundaries that tend to classify and compartmentalize our thinking as we grapple with the ineffable and try to name it."[2]

A Month of Tides, created by Levy in 1993, approached the immensity of natural systems, using the conjunction of technology and nature to fuel her presentation. The work, composed of a huge pulley- and cable-driven tubular indicator, 60 feet tall and fabricated from plastic and steel-reinforced sea-blue vinyl fabric, hung in a six-story atrium located on the campus of Miami-Dade Community College. The arrow-like indicator responded to an electronic timer, which raised and lowered the mechanism in correspondence with the rising and falling of nearby Atlantic tides. This simple, visually arresting device exposed and re-created the relentless movements of the sea during a month-long exhibition.

A Month of Tides revealed itself slowly, requiring patience and a prolonged attention span, reminding viewers of physical and metaphysical rela-

From *Sculpture Magazine,* March 2000—Vol. 19 No. 2. Reprinted by permission of the author.

Stacy Levy, **A Month of Tides, (A View at High Tide).** *1993, Miami-Dade Community College. (Courtesy of Stacy Levy)*

tionships we share with other life forms and processes. Who among us doesn't involuntarily respond to the shifting of the tides, the aural experience of the waves corresponding to our breathing as we inhale and exhale? As she reminds us of our participation in the cycles of nature, Levy prods us to revive our ancient memories as animals *within* nature's systems.

Through the elegant incorporation of modern technology and respectable craftsmanship with sensory and intellectual references to the urges of our ancient animal past, Levy exhorts her audience to reconsider 21st-century feelings and attitudes toward nature. While clearly acknowledging humanity's technologized present, hers is an effort to reconnect us with our animal selves, in the hope that we might be brought to understand our rightful place in nature's community.

Stacy Levy, A Month of Tides, (A View at Low Tide). *1993, Miami-Dade Community College. (Courtesy of Stacy Levy)*

Jackie Brookner is a sculptor and installation artist, teacher, and writer whose recent installation, *Of Earth and Cotton,* traveled to regional museums and public sites across the Southern states. Exhibition curator Susan Harris Edwards writes: "*Of Earth and Cotton* is designed to invite people from all walks of life to consider their relationship to the source of their survival. By the time of the Great Depression, more people in the South owed their daily existence to cotton than to any other enterprise. The historical photographs of cotton workers [projected as part of the installation] capture the dawn to dusk drudgery of planting, chopping, and picking cotton by hand. *Of Earth and Cotton* . . . provides an opportunity to feel and reflect upon the connection each of us has with the earth and each other. At each exhibition site, [the artist] locates former cotton workers and invites them to participate as models and speak about their memories and experiences of working the land. The rich smell of soil, the feeling of these feet upon the earth, and the absorbing quiet trigger a sensory awareness of presence, of the earth underfoot, and of one's own physical stance."[3]

The installation explicitly portrays the arduous existence of the rural worker, while implicitly reminding the audience of the ecological impoverishment of urban life, which offers no real physical experience of, or kinship with, the rhythms of nature. As city-dwellers, we are removed from concerns about daily subsistence: we don't grow our own food or raise animals on land

we care for, nor do we keep generational memories of a particular farm or home place. Our overwhelmingly urbanized society has distanced us from the requirements of our animal bodies and thereby from the cycles of nature. Missing the workings of our sensuous selves in nature, we've filled the breach with accretions of manmade material possessions.

Brookner's work is a reminder that artists can foster a keener sense of the physical and psychological links between audience and nature. But, she further reminds us, if we attempt to do so, then we are obliged, by some convincing method, to deal with the obvious and impressive materiality of nature and the power of our own natural physicality to move us in confusing and frightening ways.

On this subject Brookner has noted, "I really want people to understand the installation with their bodies—the smell and weight of the cotton, the density of the dirt, the physical presence of the feet. Matter is so much the issue here, and what we make of it. I guess I want to redeem matter. This is what sculpture can do. We can feel the materials so actively, and they can carry layers of meaning through association."[4]

Brookner's art connects with many viewers from all social strata, in part because she brings the work to them, conversing with them through physical and sensory experience. She is not averse to meeting her audience on its own terms, implicitly acknowledging that not all of its members may have a breadth of experience with the often arcane forms and languages of contemporary art. As a writer, Brookner extends herself beyond the social conflicts inherent in hierarchical human cultures to tackle the ancient struggles between humans and the forces of nature. In *Unity? Man? Nature? Reality?* she states that "reach[ing] across the barriers we have erected between humans and nature, mind and nature, subject and object, male and female involves recognizing that being human means each of us is part of the physical world, embodied—that we are animals."

According to Wendell Berry, conservationist, philosopher, and farmer, "The most characteristically modern behavior, or misbehavior, was made possible by a redefinition of humanity which allowed it to claim, not the sovereignty of its place, neither godly nor beastly, in the order of things, but rather an absolute sovereignty, placing the human will in charge of itself and of the universe . . . Having placed ourselves in charge of Creation, we begin to mechanize both the Creation itself and our conception of it. We begin to see the whole Creation merely as raw material, to be transformed by machines into a manufactured paradise."[5] In tacit agreement, Brookner writes: "We must control nature, control matter, show who is boss. We must dismiss its power as passive and inert—mere matter, something for us to use or, better yet, possess. In frantic glut we have lost our senses, in fury fled our bodies. Fled into the arms of a consuming Capitalism where what grows is money."[6]

Writing for the preface of *ART AND SURVIVAL*, a monograph on the work of environmental artist Patricia Johanson, Caffyn Kelly comments:

Patricia Johanson, **Saggitaria Platyphylla.** *Fair Park Lagoon, Dallas, Texas, 1981–1986, Gunite, plants, animals, 235' × 175' × 12'. (Photo by William Pankey)*

"Johanson's graceful designs for sewers, parks, and other functional projects not only speak to deep human needs for beauty, culture and historical memory. She also answers to the needs of birds, bugs, fish, animals, and microorganisms. Her art reclaims degraded ecologies and creates conditions that permit endangered species to thrive in the middle of urban centers." Johanson responds: "To me it's all equally important, the microscopic bacteria and the man who contributes a million dollars to build the project."[7]

Growing out of an exhibition of her drawings in a New York gallery, Johanson's design for the Fair Park Lagoon project in Dallas, Texas, transformed an ecologically degraded shoreline containing almost no living creatures into, in her words, "a raw functioning ecology." In tandem with this reinvigorated waterscape, her sculpture allows visitors to physically access this environment, discovering "a marvelous new world."[8]

Johanson's plans for the lagoon's sculptural elements, which provide walkways among its natural features, were based on two plants native to the local environment, the Delta Duck-Potato and the Texas Fern. Both plants play important roles in providing microhabitats for plants, fish, turtles, and birds. To complement the sculpture's practical function in the water, other plant materials were selected and planted along the shoreline: some afford habitats, others provide food and shelter for visiting birds and other wildlife. Fish were also introduced into the microhabitats best suited to their needs.

In the 13 years since its completion, Fair Park Lagoon has, by all accounts, been a success, for both the people who find it a friendly and entertaining place to visit and for the insects, reptiles, birds, and mammals who thrive in its environment. The Lagoon's food chain, once utterly destroyed, has over time been reestablished, and now represents a richness and diversity of biotic life, which has not been seen or experienced in that location in recent memory.

Steven Siegel's site-specific sculptural installations comment on the state of the environment and the plethora of consumer materials that are produced and discarded at an alarming rate in our capitalist society. Through his temporal, environmentally attuned installations, which have been publicly sited on university campuses, in public parks and private lands, and on the grounds of art museums, Siegel attempts to address these and other ethical and environmental questions. He constructs huge, organically shaped forms from stacked and compressed recycled newspapers, rubbish, and nature's detritus, which are designed to decompose over the length of an exhibition period, anywhere from two to 15 years, sometimes longer. Through these public works, he makes a small, but worthwhile dent in the actual physical magnitude of these materials, as well in the complacent attitude with which our culture has, until relatively recently, regarded its trash. Over time, the sculptures, which are physically and conceptually integrated with their chosen sites, break down to disappear into and nourish the earth from which they originally emerged.

Steven Siegel, **Round.** *1995, Plastic bottles, 4' × 30' diameter. (Courtesy of Steven Siegel)*

Lacking the first hint of the cleverness or easy cynicism so popular in much contemporary artwork, the artist seems to say that art can "make a difference" in the wider world to a broader audience, whether or not the art world cognoscenti take it seriously. His installations are almost always built with the assistance of people from the communities within which they are sited, and they often appear in places that are open to public interaction. Made from humble and easily obtainable materials, but nevertheless beautifully and artfully crafted, they attract admiration for the quality of their workmanship and engineering, while they question what makes a thing beautiful and why.

Siegel's works are convincing examples of what artist David Pye calls the "craftsmanship of risk." Their success is dependent on the artist's skillful, but not necessarily premeditated, manipulation of material at the service of an idea, in full recognition that the finished sculpture may or may not "work" as originally conceived.[9]

It is not difficult to respect Siegel's craftsmanship and his concepts, whether one comes to his work as an educated art historian or as a casual passerby. Moreover, he is a moral artist, delivering a message based on a fully developed ethic, one his audience can trust that he actually believes in. His

Steven Siegel, **Ursula.** *Wood and paper, 9' × 10' × 11'. (Courtesy of Steven Siegel)*

site works are successful as explanations of the processes of nature, while reminding the viewer that the products of economic and scientific progress do not exist without a price. Apparently unafraid of being taken for a naïf, he asks that the viewer care as much as he does about the issues he explores. Through the pristine presentation of a seemingly ludicrous accretion of trash combined with natural flora, the artist asks us to carefully consider the meaning of a beautiful object made from the castoff accumulations of a disposable society. He places the sculptures in handsome natural settings to remind us, all the more poignantly, of our capitalist ethic of accumulation and disposal, which contributes so tragically to the ongoing destruction of the planet. The ephemeral quality of Siegel's work serves as a reminder that the products of human ingenuity and indeed the very existence of human beings on earth will ultimately prove to be a relatively brief and inconsequential evolutionary event.

Siegel's installations, like those of Levy, Brookner, and Johanson, integrate the concept of nature's time versus human notions of time, as a central conceptual and formal element. Nevertheless, in their efforts to create public displays that effectively reveal, explain, or otherwise treat critical issues in the natural environment, which have been millennia in the making, these artists find themselves addressing a modern world in which there is little time to foster the breadth of understanding necessary for people to fully experience either nature or art.

What is essential in contemporary art? Is the interaction between artwork and audience truly essential? In view of the strategies adopted by many contemporary artists and curators, the casual observer might be led to conclude that the only important interaction between artist, artwork, and audience is one that, in the end, results in the sale of the art, and/or the arrangement of the artist's participation in the next, even more prestigious, art world event. Pulitzer prize-winning scientist and environmentalist Edward O. Wilson has written, "If a price can be put on something, that something can be devalued, sold, and discarded." Although he is referring to the dilemmas of living in a technologized and biologically impoverished world, he might also be offering a critique of contemporary artists who willingly devalue their own work and potential for service to society by an easy acceptance of the capitalist paradigm as a model for their artmaking endeavors.[10] These artists have determined that they will serve up work that meets the media-inspired public taste for the "visual equivalent of the soundbite." So specialized in their work, they focus their efforts on appealing to a very small group of art connoisseurs, who are themselves specialists. Consequently, they've prohibited themselves from developing work that conscientiously and responsibly speaks to a more inclusive audience, wherever that audience might be found.

In her inspiring and insightful book *The Vocation of the Artist*, Deborah J. Haynes proposes that "There are alternatives to the practice of art based on

self-promotion and self-aggrandizement. Here I am thinking of the idea that the work of art is a gift rather than a commodity to be sold . . . In giving a gift the artist is not necessarily anonymous, but the presence of a second person, and a second consciousness, radically transforms the work of art into a full aesthetic and moral event."[11]

Given the surfeit of factors alienating people from new art, perhaps those of us engaged in creating an earth-based, more physical and sensual form of public art may be presented with a singular opportunity. It seems obvious that in order to present artwork that is viewed seriously by the art-consuming public, as well as by those people who are generally uninvolved with contemporary art, artists must make their work essential to the world in ways that are not currently commonplace. Continuing to create our work in a cultural vacuum, with little concern for the criticisms leveled at it from inside and outside the art world, is a terrible mistake and the reason we are so often dismissed from important, broad-based dialogues regarding the environment and other pressing issues. In view of larger planetary concerns, ego-gratification and self-indulgence as artistic strategies are not only self-serving, but small and petty, bespeaking a convenient and distressing amorality.

The artists presented in this article are representative of a small but growing number who live or create their work in rural settings or in provincial cities, away from art world centers. Traveling their work to local and regional sites, some of which are art venues, but many of which are not, they don't limit the presentation of their work to urban situations or to overwhelmingly urban, highly educated art consumers, electing instead to expand their opportunities by appealing to a more inclusive audience. Their genuine commitment to individual value systems is evidenced by the ways in which they run their professional and personal lives. Their engagement with environmental ideas, as well as with other issues within their communities and the larger world, is heartfelt, not a promotional tool to further their individual careers. And because they actually encounter, in their daily lives, natural processes and phenomena other than those available in Central Park or at the National Zoo, theirs isn't a romanticized, ersatz representation of nature. Instead, they attempt to engage viewers of many backgrounds, who have a variety of life experiences, in a dialogue concerning the relationships between people and human-derived technologies and their influences on and interactions with the whole of the biotic community. The lives and creative efforts of these and other artists of similar inclination represent attempts to reach a holistic balance, integrating concern and care for the natural world and for the life of the community with their professional obligations and their vocations as artists.

As early as 1949, acclaimed teacher and conservationist Aldo Leopold wrote, "No important change in ethics was ever accomplished without an internal change in our intellectual emphasis, loyalties, affections, and convictions."[12] Addressing the need for a change in philosophical values with

respect to the existence of conscience and duty beyond self-interest in human relationships with nature, Leopold might also have been speaking directly to contemporary artists regarding their relationships with human and biotic communities. Artists who make work that participates in the environmental discourse, especially public artists, must understand that this engagement requires a level of participation which is more akin to community service than it is to self-service. Because so few of us are privileged to lead lives that put us in daily contact with nature or with the places where our artwork will eventually reside, we must recognize that we enter into an implied contract with these communities and audiences. This contract demands that we respect the people, traditions, rituals, and evidences of nature that already exist there. Perhaps equally important to the success of our proposed projects is the acknowledgment that artists must come as students of the community and the biosphere first, and teachers later.

In *The Diversity of Life,* Edward O. Wilson makes a plea on behalf of a new environmental ethic. His words might also be read as an appeal to all those who truly care about the place and meaning of art in the new world order: "The stewardship of environment is a domain on the near side of metaphysics where all reflective persons can surely find common ground. For what, in the final analysis, is morality but the command of conscience seasoned by a rational examination of consequences? And what is a fundamental precept but one that serves all generations? An enduring environmental ethic will aim to preserve not only the health and freedom of our species, but access to the world in which the human spirit was born."

Mara Adamitz Scrupe is an artist who is interested in environmental issues. This article is adapted from a paper presented at the Arts Now Conference.

Notes

1. Rachel Carson correctly identified the consequences of our easy acceptance of the pollution of our air, water, and soil, pointing out that the damage will probably not be repaired with scores or even centuries of concerted human effort. See Silent Spring, New York: Houghton Mifflin Company, 1994, pp. 4–13.

2. Watercourse, A site-specific installation mapping the rivers and streams of the Delaware River, exhibition brochure, Rosenwald-Wolf Gallery, The University of the Arts, Philadelphia, 1996.

3. Susan Harris Edwards, Of Earth and Cotton, exhibition brochure McKissick Museum, University of South Carolina, 1994.

4. Jackie Brookner, Natural Reality: Artistic Positions Between Nature and Culture, exhibition catalogue, Ludwig Museum, Aachen, Germany: 1999.

5. Wendell Berry, The Unsettling of American Culture & Agriculture, Sierra Club Books, 1986, pp. 55–56.

6. Brookner, op. cit.

7. See ART AND SURVIVAL/Creative Solutions To Environmental Problems, Gallerie Women Artists' Monographs, 1992.

8. Patricia Johanson, quoted in ART AND SURVIVAL/Creative Solutions To Environmental Problems, op. cit.

9. See Kathleen Whitney, "Skilled Labor," Sculpture, May 1999, pp. 24–29. Whitney further defines this as "a means of distinguishing processes that bear no risk in terms of the manufacture of something, in comparison to processes where at any minute, the entire object may be ruined because of some mechanical/physical mistake in eye-hand coordination."

10. Edward O. Wilson, The Diversity of Life, New York: W.W. Norton, 1993, p. 348.

11. Deborah J. Haynes, The Vocation of the Artist, Cambridge: Cambridge University Press, 1997, p. 89.

12. Aldo Leopold, A Sand County Almanac, Oxford: Oxford University Press, 1949, pp. 209–10.